A WORLD OF ART

FIFTH EDITION

HENRY M. SAYRE

Oregon State University-Cascades Campus

Upper Saddle River, New Jersey 07458

Library of Congress Cataloging-in-Publication Data Sayre, Henry M., 1948-A world of art / Henry M. Sayre.—5th ed. p. cm. Includes index. ISBN 0-13-222186-1 1. Art. I. Title. N7425.S29 2007 700—dc22 2006035703

Senior Acquisitions Editor: Amber Mackey Editorial Assistant: Carla Worner Assistant Editor: Alexandra Goldmacher Huggins Media Project Manager: Anita Castro Director of Marketing: Brandy Dawson Executive Marketing Manager: Marissa Feliberty AVP, Director of Production and Manufacturing: Barbara Kittle Senior Managing Editor: Lisa Iarkowski Project Manager/Liaison: Harriet Tellem Production Assistant: Marlene Gassler Manufacturing Manager: Nick Sklitsis Manufacturing Buyer: Sherry Lewis Creative Design Director: Leslie Osher Art Director: Amy Rosen Interior and Cover Design: Amy Rosen Manager, Visual Research: Beth Brenzel Photo Researcher: Francelle Carapetyan Manager, Rights and Permissions: Zina Arabia Image Permission Coordinator: Debbie Latronica

Editor-in-Chief: Sarah Touborg

Manager, Cover Research and Permissions: Karen Sanatar Cover Image Permission Coordinator: Rita Wenning Pearson Imaging Center Manager: Joseph Conti Project Coordinator: Corin Skidds Scanner Operators: Corin Skidds and Robert Uibelhoer Copy Editor: Faye Gemmellaro Proof Readers: Alison Lorber/Jan Stephan Production Editor: Assunta Petrone Composition: Preparé Printer/Binder: Courier-Kendallville Cover Printer: Phoenix Color Corporation Cover Photo: Andy Warhol, San Francisco Silverspot, from the Endangered Species Series. 1983. Screenprint, 38 × 38 inches. Courtesy of Ronald Feldman Fine Arts, New York. Photo: Dr. James Dee. © 2006 The Andy Warhol Foundation for the Visual Arts/ Artists Rights Society (ARS), NY.

Credits and acknowledgments borrowed from other sources and reproduced, with permission, in this textbook appear on appropriate page within text.

Copyright © 2007, 2004, 2003, 2000, 1997, and 1994 by Pearson Education, Inc., Upper Saddle River, New Jersey, 07458. All rights reserved. Printed in the United States of America. This publication is protected by Copyright and permission should be obtained from the publisher prior to any prohibited reproduction, storage in a retrieval system, or transmission in any form or by any means, electronic, mechanical, photocopying, recording, or likewise. For information regarding permission(s), write to: Rights and Permissions Department.

Pearson Education LTD. Pearson Education Australia PTY, Limited Pearson Education Singapore, Pte. Ltd Pearson Education North Asia Ltd Pearson Education, Canada, Ltd Pearson Educación de Mexico, S.A. de C.V. Pearson Education–Japan Pearson Education Malaysia, Pte. Ltd

109876543

IZBN 0-13-22519P-7 IZBN 0-73-55579P-7 As always for my boys, Rob and John, and for Sandy

BRIEF CONTENTS

PREFACE	xiii
PRENTICE HALL DIGITAL ART LIBRARY	
DISCOVERING ART CD-ROM	
STUDENT TOOLKIT	XXV
CHAPTER 1 A WORLD OF ART	
CHAPTER 2 DEVELOPING VISUAL LITERACY	17
CHAPTER 3 THE THEMES OF ART	
CHAPTER 4 SEEING THE VALUE IN ART	
CHAPTER 5 LINE	
CHAPTER 6 SPACE	
CHAPTER 7 LIGHT AND COLOR	
CHAPTER 8 OTHER FORMAL ELEMENTS	
CHAPTER 9 THE PRINCIPLES OF DESIGN	
CHAPTER 10 DRAWING	
CHAPTER 11 PRINTMAKING	
CHAPTER 12 PAINTING	
CHAPTER 13 THE CAMERA ARTS	
CHAPTER 14 SCULPTURE	
CHAPTER 15 OTHER THREE-DIMENSIONAL MEDIA	
CHAPTER 16 ARCHITECTURE	
CHAPTER 17 DESIGN	
CHAPTER 18 THE ANCIENT WORLD	
CHAPTER 19 THE CHRISTIAN ERA	
CHAPTER 20 THE RENAISSANCE THROUGH THE BAROQUE	
CHAPTER 21 THE EIGHTEENTH AND NINETEENTH CENTURIES	
CHAPTER 22 THE TWENTIETH CENTURY	
THE CRITICAL PROCESS	
GLOSSARY	
PRONUNCIATION GUIDE	541
INDEX	
A WORKSHEET COMPANION	

CONTENTS

	PREFACE PRENTICE HALL DIGITAL ART LIBRARY DISCOVERING ART CD-ROM STUDENT TOOLKIT	xviii xx
	IAPTER 1 A WORLD OF ART THE WORLD AS ARTISTS SEE IT Works in Progress: The Creative Process THE WORLD AS WE PERCEIVE IT The Critical Process: Thinking about Making and Seeing	4 10 12
8	HAPTER 2 DEVELOPING VISUAL LITERACY WORDS AND IMAGES DESCRIBING THE WORLD Works in Progress: Lorna Simpson's <i>The Park</i> The Critical Process: Thinking about Visual Conventions	18 21 22
	HAPTER 3 THE THEMES OF ART THE REPRESENTATION OF THE WORLD THE POWER OF IMAGINATION THE IDEA OF THE BEAUTIFUL Works in Progress: Pablo Picasso's Les Demoiselles d'Avignon The Critical Process: Thinking about the Themes of Art	38 41 44 52
	HAPTER 4 SEEING THE VALUE IN ART ART AND ITS RECEPTION ART, POLITICS, AND PUBLIC SPACE Works in Progress: Guillermo Gómez-Peña's <i>Temple of Confessions</i> The Critical Process: Thinking about the Value of Art	58 63 68
CI	HAPTER 5 LINE	73
	VARIETIES OF LINE OUALITIES OF LINE Works in Progress: Vincent van Gogh's <i>The Sower</i> Works in Progress: Hung Liu's <i>Three Fujins</i> The Critical Process: Thinking about Line	74 77 80 88
	VARIETIES OF LINE QUALITIES OF LINE Works in Progress: Vincent van Gogh's <i>The Sower</i> Works in Progress: Hung Liu's <i>Three Fujins</i> .	74 77 80 98 94 95 95 95 95 97 98 99 104 109

PART 1 THE VISUAL WORLD Understanding the Art You See

PART 2 THE FORMAL ELEMENTS AND THEIR DESIGN Describing the Art You See

CHAPTER 7 LIGHT AND COLOR	
Works in Progress: Mary Cassatt's In the Loge.	
COLOR	
Works in Progress: Chuck Close's Stanley	
Works in Progress: Sonia Delaunay's <i>Electric Prism</i>	
The Critical Process: Thinking about Light and Color	
CHAPTER 8 OTHER FORMAL ELEMENTS	
PATTERN TIME AND MOTION	
 Works in Progress: Jackson Pollock's No. 29, 1950 	
The Critical Process: Thinking about the Formal Elements	
CHAPTER 9 THE PRINCIPLES OF DESIGN	
BALANCE	
EMPHASIS AND FOCAL POINT	
Works in Progress: Diego Velázquez's Las Meninas	
SCALE AND PROPORTION	
Works in Progress: Judith F. Baca's La Memoria de Nuestra Tierra	
REPETITION AND RHYTHM	
UNITY AND VARIETY	
The Critical Process: Thinking about the Principles of Design	

PART 3 THE FINE ARTS MEDIA Learning How Art Is Made

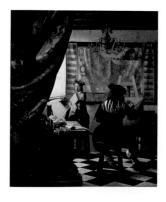

CHAPTER 10 DRAWING DRAWING AS AN ART	
DRAWING MATERIALS	
Works in Progress: Raphael's Alba Madonna	
Works in Progress: Beverly Buchanan's <i>Shackworks</i>	
The Critical Process: Thinking about Drawing	
CHAPTER 11 PRINTMAKING RELIEF PROCESSES	
Works in Progress: Utamaro's <i>Studio</i>	
INTAGLIO PROCESSES	
Works in Progress: Albrecht Dürer's Adam and Eve	
LITHOGRAPHY	
Works in Progress: June Wayne's <i>Knockout</i>	
SILKSCREEN PRINTING	007
MONOTYPES	
The Critical Process: Thinking about Printmaking	

CI	HAPTER 12 PAINTING	
	ENCAUSTIC	
	FRESCO	
103	Works in Progress: Michelangelo's Libyan Sibyl	
	TEMPERA OIL PAINTING	
	Works in Progress: Milton Resnick's <i>U</i> + <i>Me</i>	
	GOUACHE	
	SYNTHETIC MEDIA	
	MIXED MEDIA	
100	Works in Progress: Hannah Höch's <i>Cut with the Kitchen Knife</i>	
	The Critical Process: Thinking about Painting	
	The Ghubar Frocess. Thinking about Funding	
C	HAPTER 13 THE CAMERA ARTS	
	PHOTOGRAPHY	
	FILM	
	VIDE0	
155		
	COMPUTER- AND INTERNET-BASED ART MEDIA	
10	The Critical Process: Thinking about the Camera Arts	
С	HAPTER 14 SCULPTURE	
	CARVING	
	Works in Progress: Jim Sardonis's <i>Reverence</i>	
	MODELING	
	CASTING	
	ASSEMBLAGE	
100	Works in Progress: Eva Hesse's Contingent	
	INSTALLATION	
	EARTHWORKS	
	PERFORMANCE ART	
101	Works in Progress: Goat Island's <i>How Dear to Me the Hour</i> When Daylight Dies	
10	The Critical Process: Thinking about Sculpture	
0	WARTER 45 OTHER TURES DIMENSIONAL MEDIA	
U	HAPTER 15 OTHER THREE-DIMENSIONAL MEDIA	005
	CERAMICS	
	GLASS	
-	Works in Progress: Peter Voulkos's X-Neck	
55	Multi December Fred Mileser's Mining the Museum	
	FIBER	
	METAL	
	WOOD	
10	The Critical Process: Thinking about Othor Throo-Dimensional Media	

PART 4 THE VISUAL ARTS IN EVERYDAY LIFE

Recognizing the Art of Design

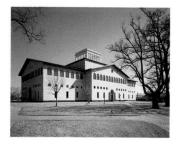

PART 5 THE VISUAL RECORD Placing the Arts in Historical Context

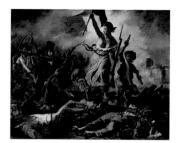

C	HAPTER 16 ARCHITECTURE	361
	TOPOGRAPHY	362
	TECHNOLOGY	365
R	Works in Progress: Frank Lloyd Wright's Fallingwater	378
	COMMUNITY LIFE	386
	Works in Progress: Mierle Laderman Ukeles's Fresh Kills Landfill Project	390
	The Critical Process: Thinking about Architecture	394
CI	HAPTER 17 DESIGN	395
	THE ARTS AND CRAFTS MOVEMENT	396
	ART NOUVEAU	401
	ART DECO	404
	THE AVANT-GARDES	
	THE BAUHAUS	409
	STREAMLINING	410
	THE FORTIES AND FIFTIES	414
	CONTEMPORARY DESIGN	416
100	The Critical Process: Thinking about Design	419

CHAPTER 18 THE ANCIENT WORLD421THE EARLIEST ART422MESOPOTAMIAN CULTURES424EGYPTIAN CIVILIZATION426AEGEAN CIVILIZATIONS429GREEK ART430

 ROMAN ART
 435

 DEVELOPMENTS IN ASIA
 438

CHAPTER 19 THE CHRISTIAN ERA EARLY CHRISTIAN AND BYZANTINE ART	
CHRISTIAN ART IN NORTHERN EUROPE	
ROMANESQUE ART	
GOTHIC ART	
DEVELOPMENTS IN ISLAM AND ASIA	
CHAPTER 20 THE RENAISSANCE THROUGH THE BAROOU	E 459

HAPTER 20 THE RENAISSANCE THROUGH THE BARO	QUE 459
THE EARLY RENAISSANCE	
THE HIGH RENAISSANCE	
ART IN CHINA AND JAPAN.	
PRE-COLUMBIAN ART IN MEXICO	
MANNERISM	
THE BAROQUE	

CHAPTER 21	THE EIGHTEENTH AND NINETEENTH CENTURIES483
THE ROCOCO	
NEOCLASSICISM	486
ROMANTICISM	

Works in Progress: Théodore Géricault's The Raft of the Medusa	491
REALISM	494
IMPRESSIONISM	
POST-IMPRESSIONISM	501

CI	HAPTER 22 THE TWENTIETH CENTURY	
	THE FAUVES	
	GERMAN EXPRESSIONISM	
	FUTURISM	
	DADA AND SURREALISM	
100	Works in Progress: Pablo Picasso's Guernica	
	AMERICAN MODERNISM AND ABSTRACT EXPRESSIONISM	
	POP ART AND MINIMALISM	
	POSTMODERN DIRECTIONS	
100	Works in Progress: Frank Gehry's Guggenheim Museum Bilbao	
	The Critical Process: Thinking about the History of Art.	

THE CRITICAL PROCESS: Thinking Some More

about the Chapter Questions	30
GLOSSARY 5	32
PRONUNCIATION GUIDE	41
INDEX	43

A WORKSHEET COMPANION

TO PAINTINGS, DRAWINGS, AND PRINTMAKING	. 560
TO SCULPTURE AND INSTALLATION	563
TO ARCHITECTURE	. 567

PREFACE

A WORLD OF ART

hen I began working on the first edition of this book in the late 1980s it was my goal to make it unique. I wanted to write an art appreciation text that truly reflected "a world of art" by including significantly more work by women, ethnic minorities, and artists from around the globe than the other books available. At that time, work by women, ethnic minorities, and global artists had only recently begun to find its place in the canon of art history, and the very idea of writing about "a world of art," instead of just the masterpieces of the Western canon, seemed daring, even radical. Today, many of the innovations that drove the earlier editions of this book are part of the mainstream. Almost all art appreciation surveys incorporate the work of so-called "marginalized" voices to a greater degree than ever before. But this book remains unique not only because of its commitment to reflect "a world of art," but in its organization and approach.

The book is organized into five parts. The first four parts show you how to understand the art you see, introduce the elements and principles of design, and detail how art is made using the different media, including architecture and design. These first four parts provide a particularly strong foundation. Part V, The Visual Record: Placing the Arts in Historical Context, introduces the historical styles. A unique running timeline appears at the top of every page in Part V, which serves to quickly orient you to the time frame of the works under discussion. Users of this text tell us the running timeline is invaluable to those who are new to the study of art.

CREATIVITY BEGINS WITH CRITICAL THINKING

Another way this book is unique, is its emphasis on the critical thinking process—a process of questioning, exploration, trial and error, and discovery that you can generalize to your own experience. Critical thinking is really a matter of putting yourself in a questioning frame of mind. Without critical thinking, art appreciation can become just a boring exercise in memory work. Our culture is increasingly dominated by images and all students today must learn to see and interpret the images that surround them. If you just passively "receive" these images, like some television set, you will never come to understand them. We have worked very hard to provide the tools with which to engage works of art as critical thinkers.

TOOLS FOR THINKING CRITICALLY ABOUT ART

A STUDENT TOOLKIT

This short section is designed to introduce the overarching themes and aims of A World of Art, as well as provide you with a guide to the basic elements of art that you can easily access whenever you interact with works of art-in these pages, in museums, and anywhere else you encounter them. The topics covered here are developed much more fully in later chapters, but this overview brings all this material together in a convenient, quick-reference format. In addition, you will find a one-page feature entitled "Seven Steps to Thinking Critically about Art" and another "Dos-and-Don'ts Guide to Visiting Museums." The first is the outline of a process that, by the time you finish the book, will probably be second nature, but at the outset you will find it useful. The second is a response to the many requests that we help students feel comfortable in what for a surprisingly large number is their first experience in visiting an art museum. Many of these students are asked by their instructors to write about the works they see in museums, and so we have additionally provided museum worksheets in an appendix that are designed to help students ask the right questions of the works they are seeing and engage them in a thoughtful manner.

WORKS IN PROGRESS

Since the second edition, a major feature of *A World of Art* has been the series of over thirty twopage spreads called *Works in Progress*. *Works in Progress* show students an artist's process as they take a project from start to finish. They are intended to give students insight into the process of artistic creation, to demonstrate that art, like most things, is the result of hard work and, especially, of a critical thinking process in its own right.

Coordinating with the Works in Progress feature is a series of 10 half-hour videos available from Annenberg Media. Each program in the series is devoted to a contemporary artist who takes one or more works through from start to finish. For more information, visit www.learner.org or ask your Prentice Hall representative for more information.

THE CRITICAL PROCESS

At the end of each chapter is another feature designed to further your critical thinking abilities. Called *The Critical Process*, each of these sections poses a number of questions based on the chapter material for you to think about on your own. The questions raised in these Critical Process sections are by no means easy. Nor do they often lead to pat answers. But they should generate thought and provoke classroom discussion. Nevertheless, in order not to leave students completely on their own, at the back of the book are short paragraphs addressing each of the Critical Process sections. By comparing these responses to their own, students can test the quality of their own thinking.

REASONS TO USE THE NEW FIFTH EDITION

To keep the book as fresh and friendly to students as possible, we have made the following updates and changes for the fifth edition, taking into account valuable input from our reviewers:

- Over 110 new pieces of art; exciting and compelling new works appear in nearly every chapter of the book.
 - A wide representation of contemporary art has always been a strength of this book and the fifth edition carries on in this fashion by including new works from many contemporary artists including: Christo and Jeanne-Claude, Andy Goldsworthy, Matthew Ritchie, Steve DiBenedetto, Terry Winters, Gerhard Richter, Teresa Hubbard and Alexander Birchler, Anselm Kiefer, William Kentridge, Fred Tomaselli, Damien Hirst, Robert Gober, Fred Wilson, and Mike Kelley.
 - Reflecting "a world of art," this book features diverse art by women and ethnic minorities, and art from around the globe. Some examples new to the fifth edition come from artists such as Mary Flanagan, Roni Horn, Ida Applebroog, Laylah Ali, Laurie Reid, Shirin Neshat, Do-Ho Suh, Kara Walker, Kerry James Marshall, Yinka Shonibare, Shahzia Sikander, Ana Mendieta, Cai Guo-Qiang, and Zaha Hadid.
- *The Critical Process*—six new sections. Six chapters have new discussion and new art for *The Critical Process* sections. They include the following: Jean-August-Dominique Ingres in Chapter 5, Theresa Duncan and Jeremy Blake in Chapter 10, a different Andy Warhol in Chapter 11, Fred Tomaselli in Chapter 12, Eleanor Antin in Chapter 14, Troy Brauntch and Jennifer Allors in Chapter 22.
- Organizational changes to refine clarity in Part III, The Fine Arts Media: Learning How Art is Made. Our chapter on The Camera Arts, now Chapter 13, has been relocated; previously the last chapter in Part III, this chapter now follows Chapter 12 on Painting so that all the twodimensional media discussed in this part are organized consecutively. Chapter 15 on Other Three-Dimensional Media has a new focus on Craft. To create this new focus, sections previously appearing in this chapter have been relo-

cated: sections on Installation and Performance Art now appear in the Chapter 14 on Sculpture and the section on Collage now appears in the Chapter 12 on Painting. These changes reflect, we believe, a new organization the majority of instructors will prefer.

We have designed the new content and improvements in the fifth edition to benefit readers with current and compelling material, in addition to building on the goals of the text's earlier editions: helping readers to understand "a world of art" and to develop their critical thinking abilities.

ACKNOWLEDGMENTS

The vidco series Works in Progress was conceived ten years ago in response to the demands of creating a distance education curriculum for the Annenberg/CPB Project. The video series continues to stand as one of the important contributions to our understanding of the working processes of contemporary artists, in no small part due to the visionary work of the folks at Oregon Public Broadcasting who worked with me on the project. In particular, John Lindsay, who served with me as co-executive producer of the series, videographers, Greg Bond and Steve Gossen; sound engineers, Merce Williams, Bill Dubey, and Gene Koon; editor Milt Ritter, and series producer Bobbi Rice. Our wonderful team of directors included Dave Bowden, Peggy Stern, John Booth, Marlo Bendau, and Sandy Brooke. Marlo especially did yeoman's service, and with the highest degree of skill.

The artists for the series were chosen in consultation with an advisory board, whose members oversaw the project at every level: David Antin, of the University of California, San Diego; Bruce Jenkins, of the Walker Art Center in Minneapolis; Lynn Hershman, of the University of California, Davis; Suzanne Lacy, of the California College of Arts and Crafts; the late George Roeder, of the School of the Art Institute of Chicago (whom we all miss very much); and John Weber, of the San Francisco Museum of Modern Art. In addition, two members of the Annenberg/CPB staff made major contributions, Hilda Moskowitz and Pete Neal.

The contributions of all the people at Oregon State University who originally supported mc in getting this project off the ground—Jeff Hale, two chairs of the Art Department, David Hardesty and Jim Folts, two deans of the College of Liberal Arts, Bill Wilkins and Kay Schaffer, two university presidents, John Byrne and Paul Risser—cannot be forgotten, and I owe them all a special debt of gratitude. John Maul deserves special mention. John has taught this book, shown these videos, written to the teacher's guides, and continually helped me to improve the project as a whole. Finally, in the first edition of this book, I thanked Berk Chappell for his example as a teacher. He still knows more about teaching art appreciation than I ever will.

A number of colleagues made valuable suggestions to this revision, and I'd like to thank them for their contributions: Dorothy Pulsifer, Bridgewater State College; Beverly Twitchell Marchant, Marshall University; Harry D. Korn, Ventura College; Lynn Metcalf, St. Cloud State University; Michael Slabaugh, Weber State University; Lindsey Pedersen, Arizona State University; Aviva Weiner, California State University; and Scott Robinson, North Central Texas College.

At Prentice Hall, Norwell "Bud" Therein remains the visionary behind this project, and Amber Mackey has knowingly guided it through to this fifth edition. My discussions with all of my colleagues at Prentice Hall are what makes this work as enjoyable as it is. I'm especially grateful for the good work of project manager, Harriet Tellem and photo researcher, Francelle Carapetyan.

Finally, as always, I owe my greatest debt to my colleague and wife, Sandy Brooke. She is present everywhere in this project. It is safe to say she made it possible. I can only say it again, that without her good counsel and better company, I would not have had the will to get this all done, let alone found the pleasure I have in doing it.

Henry M. Sayre Oregon State University-Cascades Campus

SPECIAL FEATURES

WORKS IN **PROGRESS**

Works in Progress show an artist's process as he or she takes a project from start to finish. Providing insight into the process of artistic creation, Works in Progress show that art is the result of hard work and a process of critical thinking that involves questioning,

and discovery.

WORKS IN PROGRESS

All

THE CRITICAL PROCESS Thinking about Making and Seeing

n this chapter, we have discovered that the world of art is as vast and various as it is not only because different artists in different cul-tures see and respond to the world in different ways, but also because each of us sees and re-sponds to a given work of art in a different way. Artists are engaged in a creative process. We respond to their work through a process of *critical thinking.* At the end of each chapter of *A World of Art* is a section like this one titled *The Critical Process*, in which, through a series of questions, you are invited to think for your self about the issues raised in the chapter. In each case, additional insights are provided at the end of the text, in the section titled *The* Critical Process: Thinking Some More about the Chapter Questions. After you have thought about the questions raised, turn to the back and see if you are headed in the right direction.

Here, Andy Warhol's Race Riot (Fig. 17) depicts events of May 1963 in Birmingham, Alabama, when police commissioner Bull Connor employed attack dogs and fire hoses to disperse civil rights demonstrators led by

Reverend Martin Luther King, Jr. The traditional roles of the artist-to record the world; to give visible or tangible form to ideas, philosophies, or feelings; to reveal hidden or universal truths; and to help us see the world in new or innovative ways-are all part of a more general creative impulse that leads, ulti-mately, to the work of art. Which of these is, in your opinion, the most important for Warhol in creating this work? Did any of the other traditional roles play a part in the process? What do you think Warhol feels about the events (note that the print followed soon after the events themselves)? How does his use of color contribute to his composition? Can you think why there are two red panels, and only one white and one blue? Emotion-ally, what is the impact of the red panels? In other words, what is the work's psychological impact? What reactions other than your own can you imagine the work generating? These are just a few of the questions raised Warhol's work, questions to help you initiate the critical process for yourself.

THE CRITICAL PROCESS sections

exploration, trial and error, revision,

appear at the end of each chapter and are designed to help develop your critical thinking skills. Each of these sections poses a number of questions about a work or works of art related to the chapter material. The questions are designed to help you learn to ask similar questions of other works of art. The questions posed do not lead to easy, pat answers; they are designed to generate thought and provoke classroom discussion.

Fig. 17 Andy Warhol, Race Biot. 1963 Acrylic and silkscree canvas, four panels, each 20 × 33 in.

16 Part 1 The Visual World

Seven Steps to THINKING CRITICALLY about Art

1. Identify the artist's decisions and choices.

Begin by recognizing that, in making works of art, artists mevitably make certain decisions and choices—What color should I make this area? Should my line be wide or narrow? Straight or curved? Will I look up at my subject or down on it? Will I depict it realistically or not? What medium should I use to make this object? And so on. Identify these choices. Then ask yourself why these choices were made. Remember, though most artists work somewhat intuitively, every artist has the opportunity to revise or redo each work, each gesture. You can be sure that what you are seeing in a work of art is an intentional effect.

2. Ask questions. Be curious.

Asking yourself why the artist's choices were made is just the first set of questions to pose. You need to consider the work's title: What does it rell you about the piece? Is there any written material accompanying the work? Is the work informed by the context in which you encounter it—by other works around it, or, in the case of sculpture, for instance, by its location? Is there anything you learn about the artist that is helpful?

3. Describe the object.

By carefully describing the object-both its

5. Avoid an emotional response.

Art objects are supposed to stir up your feel ings, but your emotions can sometimes get in the way of clear thinking. Analyze your own emotions. Determine what about the work set them off, and ask yourself if this wasn't the artist's very intention.

Don't oversimplify or misrepresent the art object.

Art objects are complex by their nature. To think critically about an art object is to look beyond the obvious. Thinking critically about the work of art always involves walking the line between the work's susceptibility to interpretation and its integrity, or its resistance to arbitrary and capricious readings. Be sure your reading of a work of art is complete enough (that it recognizes the full range of possible meanings the work might possess), and, at the same time, that it doesn't violate or misrepresent the work.

7. Tolerate uncertainty.

Remember that the critical process is an exercise in discovery, that it is designed to uncover possibilities, not necessarily certain truths. Critical thinking is a process of questioning; asking good questions is sometimes more important than arriving at "right" answers.

STUDENT TOOLKIT

The Student Toolkit is convenient quick-reference to some of the key topics to consider in beginning your study of art. The Toolkit discusses why we study art and the critical process, including 7 Steps to Thinking Critically About Art. It also includes a quick-reference guide to the elements of art and guidelines on visiting a museum, including a list of dos and don'ts.

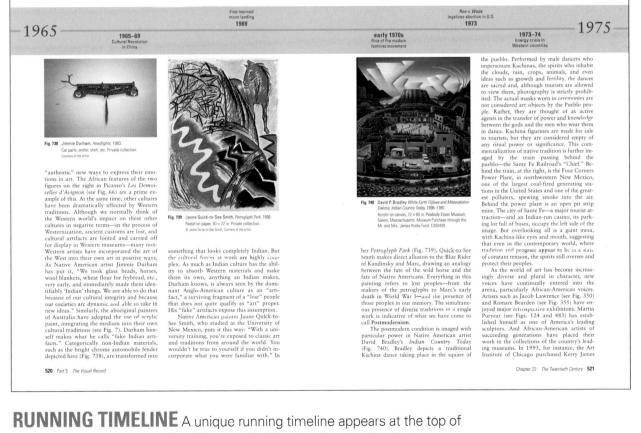

RUNNING HIMELINE A unique running timeline appears at the top of every page in Part V, The Visual Record: Placing the Arts in Historical Context. The timeline quickly orients you to the time frame of the works under discussion, which is invaluable to those beginning their study of art.

THE NEW PRENTICE HALL DIGITAL ART LIBRARY

This innovative in-class presentation tool will change the way you prepare and present your art lectures. Available in both DVD and CD formats, it contains all the images, line art drawings, and maps from Sayre's *A World of Art*, fifth edition. All images are in the highest resolution and pixelation possible for optimal projection and easy download. Compatible with all digital image management systems including Luna Insight[®], MDID, and proprietary systems.

The unique ZOOM feature

allows instructors to provide the class with a close-up view of a work of art. The metadata for each image is included, but can be suppressed for in-class testing purposes using the "Hide" option.

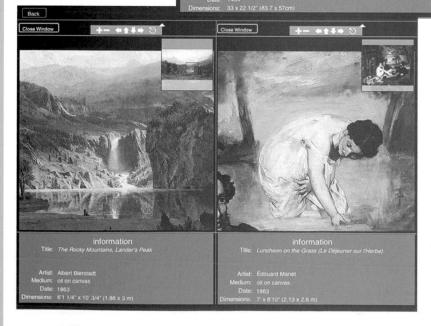

The innovative COMPARE AND CONTRAST

feature allows instructors to present two images side-by-side and examine each more closely with the Zoom feature. The metadata for each image is included, but can be suppressed for in-class testing purposes using the "Hide" option.

xviii Prentice Hall Digital Art Library

Library

PowerPoint[™] Presenta

wina Fe

Video and Audio Clips

S.

Every image in the Prentice Hall Digital Art Library is available in .jpeg format for EASY ONE-CLICK

download. A folder is automatically created on the desktop for downloaded images, and metadata is provided in an easyto-download Excel® file.

All the images in the Prentice Hall Digital Art Library are available in **READY-MADE POWERPOINT**[®] **SLIDES**—including metadata—to save valuable class

preparation time.

 Select from the Following Features:

 Image: Construction of the following features:

 I

ibrar

rentice Hal

DISCOVERING ART 2.0 CD-ROM An Overview

his interactive CD-ROM is designed to help you get the most out of your art appreciation course and this textbook. Icons throughout the book point you to resources and activities contained on this CD-ROM. As you can see from the introductory screen, the program is divided into five main areas.

Mrs. Charles Kramer Collection, Gift of Mr. and Mrs. Charles Kramer, 1979. 1979.620.50. © 1983 The Metropolitan Museum of Art/ © 2003 E so/Artists Rights Society (ARS), New York

Color can also be added to a print by creating a series of different blocks, one for each differ-ent color, each of which is aligned with the others in a process known as registration. In 1959, Picasso, working with linoleum instead of wood, simplified the process. This linoetur, as it, its called is mode from one linoleum of wood, simplified the process. This linocut, as it is called, is made from one linoleum block. After each successive stage of carving is completed, the block is printed. An all-yellow run of the print in Figure 302 was first made from an uncarved block. Picasso then cut into the linoleum, hollowing out the areas that ap-pear yellow on the print so that they would not print again. Then he printed in blue. The blue area was then hollowed out, the plate reprinted again, in violet, and so on, through red, green, and finally black.

INTAGLIO PROCESSES

any proce plate

INTAGLIO PROCESSES Relief processes rely on a raised surface for printing. With the intaglio process, on the other hand, the areas to be printed are below the sur-face of the plane below the sur-face of the plane below the sur-from engraving, "a from engraving," a from engraving, "a from engraving, "a from engraving," a suff the son of Progress, p. 22 any process in

Video Demo Printmaking: Intaglio

discoveringART Introduction

Fig. 303 Intaglio printmaking technique, ger

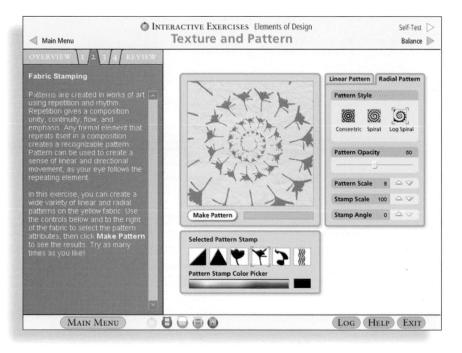

INTERACTIVE Exercises

allow you to experiment with basic design concepts and principles and test yourself on elements of form, space, color, light, and design.

VIDEO Demonstrations

show you works in progress as studio artists create art in different media. Watch printmaker Yugi Hiratsuka make an original woodblock print to demonstrate relief, or watch sculptor Tom Morandi make a plaster cast of a face to demonstrate modeling.

FLASH CARD Library

helps you learn important terms and their definitions. You can choose a card and test yourself by saying or writing down the definition. Click on the card again to see the correct definition of the term. When you believe you have learned the term, drag it into the "mastered terms" stack, then you can quiz yourself on those terms to test your knowledge. Also included in this section is an audio pronunciation guide.

Gallery

helps you develop your visual memory, learning basic facts about 200 works of fine art. You can choose to study by period, sort randomly or chronologically, and select the number of images for each study session. You can choose to show or hide information for each image, including artist, title, date, medium, and period.

museum Tour

provides practical advice on how to enjoy your visit to an art museum, along with exercises that will help you make your visit more meaningful and rewarding. You will also find links to some of the most famous museums in the United States and around the world.

Museum of Modern Art New York, NY http://www.moma.org

Guggenheim Museum New York, NY Las Vegas, NV http://www.guggenheim.org

Art Institute of Chicago Chicago, IL http://www.artic.edu/aic

Philadelphia Museum of Art Philadelphia, PA http://www.philamuseum.org

National Gallery of Art Washington, DC <u>http://www.nga.gov</u>

International

The Louvre Museum Paris, France

Faculty and Student Resources for Teaching and Learning with

SAYRE'S A WORLD OF ART.

FIFTH EDITION

Prentice Hall is pleased to present an outstanding array of high quality resources for teaching and learning with Sayre's A World of Art, 5th edition. Please contact your local Prentice Hall representative for more details on how to obtain these items, or send us an email at art@prenhall.com

DIGITAL AND VISUAL RESOURCES

THE PRENTICE HALL **DIGITAL ART LIBRARY**

Instructors who adopt Sayre's A World of Art are eligible to receive this unparalleled resource. The Prentice Hall Digital Art Library contains all images from the book in the highest resolution (over 300 dpi) and pixelation possible for optimal projection and easy download. Developed and endorsed by a panel of visual curators and instructors across the country, this resource features images in jpeg and in PowerPoint, an instant download function for easy import into any presentation software, along with a zoom feature, and a compare/contrast function, both of which are unique and were developed exclusively for Prentice Hall. ISBN: 978-0-13-222234-1

ONEKEY is Prentice Hall's

exclusive course management system that delivers all student and instructor resources all in one place. Powered by Blackboard and WebCT, OneKey offers an abundance of online study and research tools for students and a variety of teaching and presentation resources for instructors, including an easy-to-use gradebook and access to an image library. For more information, go to www.prenhall.com/onekey.

DISCOVERING ART CD-ROM

This interactive CD-ROM offers students a highly visual exploration of art. Students will see and hear video demonstrations of studio processes, view 200 images in a virtual image gallery, and learn how-and where-

to visit a museum. Plus, interactive exercises help students to review and reinforce the material under study. This CD-ROM is included with every new copy of the text.

CLASSROOM RESPONSE SYSTEM (CRS) IN CLASS QUESTIONS

Get instant, classwide responses to beautifully illustrated chapter-specific questions during a lecture to gauge students comprehension-and keep them engaged. Available for download from the instructor support section at www.prenhall.com.

Hear it. Get it.

VANGO NOTES

Study on the go with VangoNoteschapter reviews from your text in

downloadable mp3 format. You can study by listening to the following for each chapter of your textbook: Big Ideas: your "need to know" for each chapter; Practice Test: a check for the Big Ideastells you if you need to keep studying; Key Terms: audio "flashcards" to help you review key concepts and terms; Rapid Review: a quick drill session-use it right before your test. VangoNotes are flexible; download all the material directly to your player, or only the chapters you need. For more information, go to www.vangonotes.com.

COMPANION WEBSITE

Visit www.prenhall.com/sayre for a comprehensive online resource featuring a variety of learning and teaching modules, all correlated to the chapters of Sayre's A World of Art, 5e.

PRENTICE HALLTEST GENERATOR

This is a commercial-quality test management program on CD-ROM available for both Microsoft Windows and Macintosh environments, containing hundreds of sample test questions. ISBN: 978-0-13-222189-4

FINE ART SLIDES AND VIDEO

These are also available to qualified adopters. Please contact your local Prentice Hall sales representative to discuss your slide and video needs. To find your representative, please use our rep locator at **www.prenhall.com**.

PRINT RESOURCES

Instructor's Manual

This is an invaluable professional resource and reference for new and experienced faculty. Each chapter contains the following sections: Chapter Overview, Chapter Objectives, Key Terms, Lecture and Discussion Topics, Resources, and Writing Assignments and Projects. ISBN: 978-0-13-222188-7

ONLINETEST ITEM FILE

The Test Item File contains hundreds of sample test questions in various formats, including multiple choice, short answer and essay questions. In addition to various formats, the test item file contains an array of question types designed to evaluate a range of learning abilities and learner outcomes. The Test Item File is available for download from the instructor support section at **www.prenhall.com**.

ARTNOTES

This notebook lecture companion for students features reproductions of the works in the text, with captions and page references for each. Space is provided next to each object for note taking in class. ISBN: 978-0-13-222222-1

TIME SPECIAL EDITION: ART

Featuring stories like "The Mighty Medici," "When Henri Met Pablo," and "Redesigning America," Prentice Hall's TIME Special Edition contains thirty articles and exhibition reviews

on a wide range of subjects, all illustrated in full color. This is the perfect complement for discussion groups, in-class debates, or writing assignments. With the TIME Special Edition, students also receive a three-month pass to the TIME archive, a unique reference and research tool. ISBN: 978-0-13-191848-1

UNDERSTANDING THE ART

By Barbara Beall. This handbook gives students essential museum-going guidance to help them make the most of their experience seeing art outside

of the classroom. Case studies are incorporated into the text, and a list of major museums in the United States and key cities across the world is included. ISBN: 978-0-13-195070-3

PRENTICE HALL GUIDE TO RESEARCH NAVIGATOR

In addition to offering handy information on citing sources and avoiding plagiarism, this guide helps students with finding the right articles and journals in art. Students get exclusive access to three research databases: The New York Times Search by Subject Archive, ContentSelect Academic Journal Database, and Link Library. ISBN: 978-0-13-243753-0

STUDENT TOOLKIT

This short section is designed to introduce the over-arching themes and aims of *A World of Art* as well as provide you with a guide to the basic elements of art that you can easily access whenever you interact with works of art—in these pages, in museums, and anywhere else you encounter them. The topics covered here are developed much more fully in later chapters, but this overview brings all this material together in a convenient, quick-reference format.

Why Study the World of Art?

We study art because it is among the highest expressions of culture, embodying its ideals and aspirations, challenging its assumptions and beliefs, and creating new visions and possibilities for it to pursue. That said, "culture" is itself a complex phenomenon, constantly changing and vastly diverse. The "world of art" is composed of objects from many, many cultures-as many cultures as there are and have been. In fact, from culture to culture, and from cultural era to cultural era, the very idea of what "art" even is has changed. It was not until the Renaissance, for instance, that the concept of fine art, as we think of it today, arose in Europe. Until then, the Italian word arte meant "guild"-any one of the associations of craftspeople that dominated medieval commerce-and artista referred to any student of the liberal arts, particularly grammarians.

But, since the Renaissance, we have tended to see the world of art through the lens of "fine art." We differentiate those one-of-akind expressions of individual creativity that we normally associate with fine art-painting, sculpture, and architecture-from craft, works of the applied or practical arts like textiles, glass, ceramics, furniture, metalwork, and jewelry. When we refer to "African art," or "Aboriginal art," we are speaking of objects that, in the cultures in which they were produced, were almost always thought of as applied or practical. They served, that is, ritual or religious purposes that far outweighed whatever purely artistic skill they might evidence. Only in most recent times, as these cultures have responded to the West's ever-more-expansive appetite for the exotic and original, have individual artists in these cultures begun to produce works intended for sale in the Western "fine arts" market.

To whatever degree a given object is more or less "fine art" or "craft," we study it in order to understand more about the culture that produced it. The object gives us insight into what the culture values—religious ritual, aesthetic pleasure, or functional utility, to name just a few possibilities.

The Critical Process

Studying these objects engages us in a critical process that is analogous, in many ways, to the creative process that artists engage in. One of the major features of this text is a series of spreads called *Works in Progress*, 11 of them accompanied by half-hour videos. These videos follow individual artists as they create a work from start to finish. They are meant to demonstrate that art, like most things, is the result of both hard work and, especially, a process of critical thinking that involves questioning, exploration, trial and error, revision, and discovery.

One of the greatest benefits of studying art is that it teaches you to think critically. Art objects are generally "mute." They cannot explain themselves to you, but that does not mean that their meaning is "hidden" or elusive. They contain information—all kinds of information—that can help you explain and understand them if you approach them through the critical thinking process outlined on the next page.

Seven Steps to THINKING CRITICALLY about Art

1. Identify the artist's decisions and choices.

Begin by recognizing that, in making works of art, artists inevitably make certain decisions and choices—What color should I make this area? Should my line be wide or narrow? Straight or curved? Will I look up at my subject or down on it? Will I depict it realistically or not? What medium should I use to make this object? And so on. Identify these choices. Then ask yourself why these choices were made. Remember, though most artists work somewhat intuitively, every artist has the opportunity to revise or redo each work, each gesture. You can be sure that what you are seeing in a work of art is an intentional effect.

2. Ask questions. Be curious.

Asking yourself why the artist's choices were made is just the first set of questions to pose. You need to consider the work's title: What does it tell you about the piece? Is there any written material accompanying the work? Is the work informed by the context in which you encounter it—by other works around it, or, in the case of sculpture, for instance, by its location? Is there anything you learn about the artist that is helpful?

3. Describe the object.

By carefully describing the object—both its subject matter and how its subject matter is formally realized—you can discover much about the artist's intentions. Pay careful attention to how one part of the work relates to the others.

4. Question your assumptions.

Question, particularly, any initial dislike you might have for a given work of art. Remember that if you are seeing the work in a book, museum, or gallery, then someone likes it. Ask yourself why. Often you'll talk yourself into liking it too. But also examine the work itself to see if it contains any biases or prejudices. It matters, for instance, in Renaissance church architecture, whether the church is designed for Protestants or Catholics.

5. Avoid an emotional response.

Art objects are supposed to stir up your feelings, but your emotions can sometimes get in the way of clear thinking. Analyze your own emotions. Determine what about the work set them off, and ask yourself if this wasn't the artist's very intention.

6. Don't oversimplify or misrepresent the art object.

Art objects are complex by their nature. To think critically about an art object is to look beyond the obvious. Thinking critically about the work of art always involves walking the line between the work's susceptibility to interpretation and its integrity, or its resistance to arbitrary and capricious readings. Be sure your reading of a work of art is complete enough (that it recognizes the full range of possible meanings the work might possess), and, at the same time, that it doesn't violate or misrepresent the work.

7. Tolerate uncertainty.

Remember that the critical process is an exercise in discovery, that it is designed to uncover possibilities, not necessarily certain truths. Critical thinking is a process of questioning; asking good questions is sometimes more important than arriving at "right" answers. There may, in fact, be no "right" answers.

At the end of each chapter in this book you will find a section called *The Critical Process*, which poses a series of questions about a work or works of art related to the material in that chapter. These questions are designed both to help you learn to ask similar questions of other works of art and to test your understanding of the chapter materials. Short answers to the questions can be found at the back of the book, but you should try to answer them for yourself before you consult the answers.

Critical thinking is really a matter of putting yourself in a *questioning* frame of mind. Our culture is increasingly dominated by images, and all students today must learn to see and interpret the visual world around them. As you question what you see, as you actively engage the world of art—and not just passively "receive" its images, like some television set—you will find that you are at once critical and self-critical. You will see better and understand more—about both the work of art and yourself.

A QUICK-REFERENCE GUIDE TO THE ELEMENTS OF ART

Basic Terms

Three basic principles define all works of art, whether two-dimensional (painting, drawing, printmaking, and photography) or threedimensional (sculpture and architecture):

- Form—the overall structure of the work;
- Subject Matter—what is literally depicted;
- Content—what it means.

If the subject matter is recognizable, the work is said to be representational. Representational works that attempt to depict objects as they are in actual, visible reality are called realistic. The less a work resembles real things in the real world, the more abstract it is. Abstract art does not try to duplicate the world, but instead reduces the world to its essential qualities. If the subject matter of the work is not recognizable, the work is said to be nonrepresentational, or nonobjective.

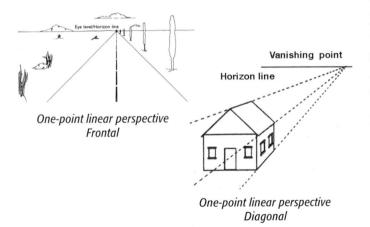

The Formal Elements

The term form refers to the purely visual aspects of art and architecture. Line, space, levels of light and dark, color, and texture are among the elements that contribute to a work's form. Line is the most fundamental formal element. It delineates shape (a flat two-dimensional area) and mass (a solid form that occupies a three-dimensional volume) by means of outline (in which the edge of a form or shape is indicated directly with a more or less continuous mark) or contour (which is the perceived edge of a volume as it curves away from the viewer). Lines can be implied—as in your line of sight. Line also possesses certain emotional, expressive, or intellectual qualities. Expressive line is loose and frec, gestural and quick. When line is precise, controlled, and mathematically and rationally organized, it is said to be analytical or classical.

Analytical or classical line

Line is also fundamental to the creation of a sense of deep, three-dimensional space on a two-dimensional surface, the system known as linear perspective. In one-point linear perspective, lines are drawn on the picture plane in such a way as to represent parallel lines receding to a single point on the viewer's horizon, called the vanishing point. When the vanishing point is directly across from the viewer's vantage point, the recession is frontal. When the vanishing point is to one side or the other, the recession is diagonal.

In two-point linear perspective, more than one vanishing point occurs, as, for instance, when you look at the corner of a building.

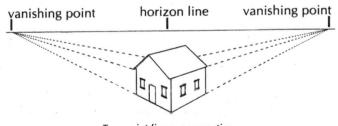

Two-point linear perspective

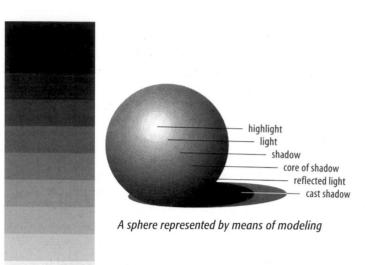

Gray scale

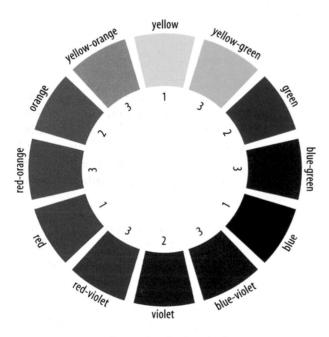

Conventional color wheel

Light and Dark are also employed by artists to create the illusion of deep space on a two-dimensional surface. In atmospheric perspective—also called aerial perspective objects further away from the viewer appear less distinct as the contrast between light and dark is reduced by the effects of atmosphere. Artists depict the gradual transition from light to dark around a curved surface by means of modeling. Value is the relative degree of lightness or darkness in the range from white to black created by the amount of light reflected from an object's surface (see the gray scale).

Color has several characteristics. Hue is the color itself. Colors also possess value. When we add white to a hue, thus lightening it, we have a tint of that color. When we add black to a hue, thus darkening it, we have a shade of that color. The purer or brighter a hue, the greater its intensity. Different colors are the result of different wavelengths of light. The visible spectrum-that you see, for instance, in a rainbow-runs from red to orange to yellow (the so-called warm hues) to green, blue, and violet (the so-called cool hues). The spectrum can be rearranged in a conventional color wheel. The three primary colors-red, yellow, and blue (designated by the number 1 on the color wheel)—are those that cannot be made by any mixture of the other colors. Each of the secondary colors-orange, green, and violet (designated by the number 2)—is a mixture of the two primaries it lies between. The intermediate colors (designated by the number 3) are mixtures of a primary and a neighboring secondary. Analogous color schemes are those composed of hues that neighbor each other on the color wheel. Complementary color schemes are composed of hues that lie opposite each other on the color wheel. When the entire range of hues is used, the color scheme is said to be polychromatic.

Texture is the tactile quality of a surface. It takes two forms: the actual surface quality—as marble is smooth, for instance—and a visual quality that is a representational illusion—as a marble nude sculpture is not soft like skin.

Visiting Museums

Museums can be intimidating places, but you should remember that the museum is, in fact, dedicated to your visit. Its mission is to help you understand and appreciate its collections and exhibits.

One of the primary functions of museums is to provide a *context* for works of art—that is, works are grouped together in such a way that they inform one another. They might be grouped by artist (all the sculptures of Rodin might be in a single room), by school or group (the French Cubists in one room, for instance, and the Italian Futurists in the next), by national and historical period (ninetcenth-century British landscape), or by some critical theory or theme. Curators—the people who organize museum collections and exhibits—also guarantee the continued movement of people through their galleries by limiting the number of important or "star" works in any given room. The attention of the viewer is drawn to such works by positioning and lighting.

A good way to begin your visit to a museum is to quickly walk through the exhibit or exhibits that particularly interest you in order to gain an overall impression. Then return to the beginning and take your time. A set of worksheets that poses questions for you to consider as you look at the works in a museum can be found in the appendix to this book. Remember, this is your chance to look at the work close at hand, and, especially in large paintings, you will see details that are never visible in reproduction-everything from brushwork to the text of newsprint incorporated in a collage. Take the time to walk around sculptures and experience their full three-dimensional effects. You will quickly learn that there is no substitute for seeing works in person.

A DOS-AND-DON'TS GUIDE TO VISITING MUSEUMS

- Do plan ahead. Most museums have Web sites that can be very helpful in planning your visit. The Metropolitan Museum of Art in New York, for instance, or the Louvre in Paris are so large that their collections cannot be seen in a single visit. You should determine in advance what you want to see.
- *Do* help yourself to a museum guide once you are at the museum. It will help you find your way around the exhibits.
- Do take advantage of any information about the collections—brochures and the like that the museum provides. Portable audio tours can be especially informative, as can museum staff and volunteers—called *docents*—who often conduct tours.
- *Do* look at the work *before you read about it*. Give yourself a chance to experience the work in a direct, unmediated way.
- *Do* read the labels that museums provide for the artworks they display after you've looked at the work for a while. Almost all labels give the name of the artist (if known), the name and date of the work, its materials

and technique (oil on canvas, for instance), and some information about how the museum acquired the work. Sometimes additional information is provided in a *wall text*, which might analyze the work's formal qualities, or provide some anecdotal or historical background.

- *Don't* take photographs, unless cameras are explicitly allowed in the museum. The light created by flashbulbs can be especially damaging to paintings.
- *Don't* touch the artwork. The more texture a work possesses, the more tempting it will be, but the oils in your skin can be extremely damaging to even stone and metal.
- *Do* turn off your cell phone out of courtesy to others.
- *Don't* talk loudly, and be aware that others may be looking at the same piece you are. Try to avoid blocking their line of sight.
- *Do* enjoy yourself, don't be afraid to laugh (art can be funny), and if you get tired, take a break.

THE VISUAL WORLD Understanding the Art You See

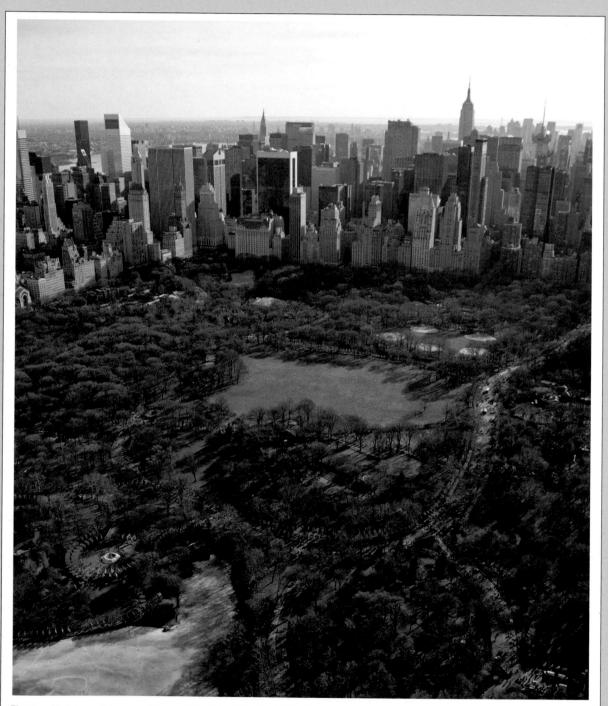

Fig. 1 Christo and Jeanne-Claude, *The Gates, New York City, Central Park*, aerial view, 1979–2005. Photo: Wolfgang Volz. © 2005 Christo and Jeanne-Claude.

A World of Art

n February 12, 2005, across the 843-acre expanse of New York City's Central Park, 7,503 saffron-colored fabric panels were dropped from the top of 7,503 saffron-painted steel gates, each 16 feet tall, to billow in the wind about 7 feet above the ground. The gates were positioned 12 feet apart (except where low-hanging tree branches extended above the walkways) and were of various widths, depending on the widths of the walkways they covered (there are 25 different widths of walkways in the park's 23 miles of paths). Seen from the skyscrapers that surround the park, the gates looked like golden-orange rivers meandering through the bare branches of the park's trees (Fig. 1). In the bright sun of New York's chilly February days, they glowed with an autumnal warmth. To the throngs that flocked to the park to see them after it snowed, the night of February 20 and into the next day, the gates suddenly took on the aspect of passageways through the snow, bright orange shelters from the storm (Fig. 2).

THE WORLD AS ARTISTS SEE IT

An American Vista A Chinese Landscape An Aboriginal "Dreaming" A Modern Earthwork Works In Progress The Creative Process

THE WORLD AS WE PERCEIVE IT

The Physical Process of Seeing The Psychological Process of Seeing The Critical Process

Thinking about Making and Seeing

1

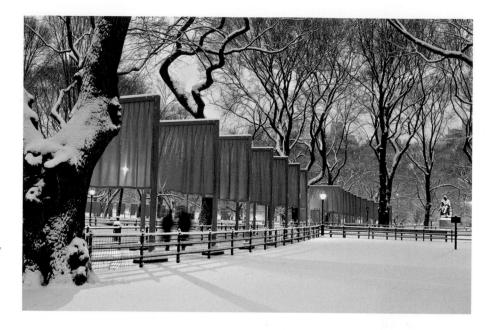

Fig. 2 Christo and Jeanne-Claude, The Gates, New York City, Central Park, 1979–2005. Photo: Wolfgang Volz. © 2005 Christo and Jeanne-Claude

The Gates, New York City, Central Park was the creation of Christo and Jean-Claude, the husband-and-wife team that for the last 40 years has wrapped buildings around the world, including the Riechstag, the German Parliament building, in Berlin; surrounded islands in Miami's Biscayne Bay with bright pink fabric; installed an 18 1/2-foot-high curtain/fence that ran across the hills and pastures of Marin and Sonoma Counties to the Pacific Ocean more than 24 miles away; and created a trans-Pacific work of art consisting of 1760 yellow umbrellas over the landscape of Tehon Pass in Southern California and 1340 blue umbrellas in the prefecture of Ibaraki, Japan-all temporary works, up for a few weeks and then dismantled, leaving no trace of their presence behind. The Gates were in place from February 12-28. The total cost of the project was \$21 million, financed entirely by the artists, as is true of all their projects, through the sale of preparatory studies, drawings, collages, scale models, and other works (Fig. 3). All of the materials used in the project were recycled-the fabric went to a firm in Pennsylvania, where it was shredded and respun; the vinyl framing was ground into half a million pounds of orange chips used to make fencing; and the steel, including the screws, went to a scrap yard in New Jersey, where it was melted down and sold worldwide. Christo and Jeanne-Claude donated merchandising rights to a not-for-profit

environmental organization dedicated to preserving nature in New York City's urban setting, which in turn shared its profits from the project with the Central Park Conservancy.

New Yorkers generally received The Gates with enthusiasm. For many, the work represented the rejuvenation of the city after the tragedy of 9/11, a festive celebration of life. The gates' presence certainly revitalized the city's economy, as more than 4 million people visited the park in just over two weeks, contributing an estimated 1/4 billion dollars to city businesses. Those who complained generally found the steel, vinyl, and fabric constructions an intrusive violation of the natural landscape. But, Christo was quick to point out, the geometric grid pattern of the hundreds of city blocks surrounding Central Park-to say nothing of the rectangular design of the park as a whole-was reflected in the rectangular structure of the gates themselves. Furthermore, the park itself was a man-made construction. More than 150 years ago, the original architects, Frederick Law Olmsted and Calvert Vaux, were commissioned by the city to create a park out of a rocky, swampy, and almost treeless landscape to the north of what was then the city proper. So barren was the area that the soil was inadequate to sustain the trees and shrubs, so Olmsted and Vaux had 500,000 cubic feet of topsoil carted in from New Jersey. They created lakes, blasted out boulders, and sculpted

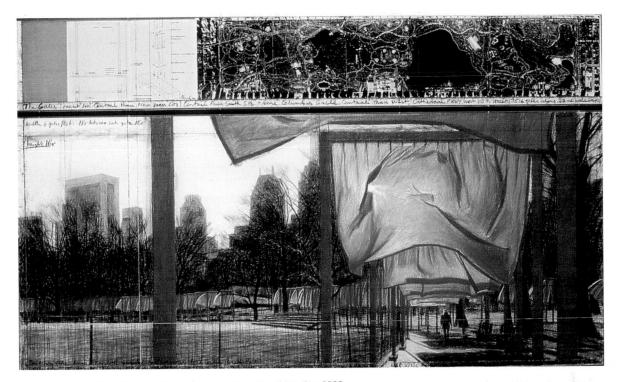

Fig. 3 Christo, The Gates, Project for Central Park, New York City, 2003.
 Drawing in two parts, pencil, charcoal, pastel, wax crayon, technical data, fabric sample, aerial photograph, and tape on paper, 15 × 96 in. and 42 × 96 in. Collection Christo and Jeanne-Claude. Photo: Wolfgang Volz © Christo 2003/Getty Images, Inc.

hillsides. By 1873, more than 10 million cartloads of material had been hauled through the park, including more than 4 million trees, shrubs, and plants, representing the more than 1,400 species that form the basis of the park's botanical variety to this day. Olmsted and Vaux had also envisioned surrounding the park with a stone wall, with gates at each entrance. That part of the project was abandoned, but the name "gates" survives at various park entrances: Artists' Gate, Emigrants' Gate, Explorers' Gate, Boy's Gate, Girls' Gate, and so on. The Gates, in other words, is of a piece with Central Park itself. If today the park looks natural, it was originally as artificial-as constructed-as Christo and Jeanne-Claude's work of art.

If, as critic Michael Kimmelman wrote in *The New York Times*, "*The Gates* is a work of pure joy, a vast populist spectacle of good will and simple eloquence, the first great public art event of the 21st century," viewers from Japan saw it in a different light. For them, it echoed the famous Fushimi Inari Shrine in Kyoto (Fig. 4), dedicated to the Shinto god of rice,

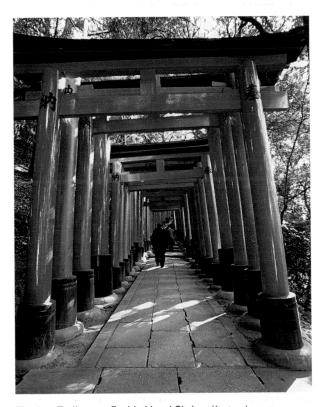

Fig. 4 Torii gates, Fushimi Inari Shrine, Kyoto, Japan, 8th century. Plioto. © David Samuel Robbins / CORBIS All Rights Reserved.

where more than 10,000 orange and black torii gates line 4 kilometers of mountain trails. As opposed to Christo and Jeanne-Claude, who accept no corporate funding or sponsorship for their works, each of the torii at the Kyoto temple is inscribed with the name of a sponsoring business or family (the god Inari is associated with financial success). But the Japanese detected an important environmental message in the similarity between The Gates and the Fushimi Inari shrine. They saw it, especially in its commitment to recycling and its support of the environmental organization, as a commentary on the refusal of the United States to sign the 1997 Kyoto Protocol, an agreement made under the United Nations Framework Convention on Climate Change, signed by 163 other countries to reduce their emissions of carbon dioxide and five other greenhouse gases.

If the experience of The Gates project was undoubtedly different for its Japanese and American viewers, both groups nevertheless asked themselves the same questions. What is the purpose of this work of art (and what is the purpose of art in general)? What does it mean? What are the artists' intentions? How did they create it? What do I think of it? Is it beautiful? Is it fascinating? What makes it beautiful or fascinating? Or do I consider it, as many did in the case of Christo and Jeanne-Claude's work, an almost ridiculous waste of time, energy, and, above all, money? What do I value in works of art? Are there formal qualities about the work that I like-such as its color, its organization, its size and scale? What does it mean not to be able to see it all at once? These are some of the questions that this book is designed to help you address. Appreciating art is never just a question of accepting visual stimuli, but of intelligently contemplating why and how works of art come to be made. By helping you understand the artist's creative process, we hope that your own critical ability, the process by which you create your own ideas, will be engaged as well.

THE WORLD AS ARTISTS SEE IT

The Gates project demonstrates how two different cultures might understand and value the same landscape in different ways.

Let us consider four different approaches to the landscape—works by a nineteenth-century American, a Chinese, an aboriginal Australian, and a twentieth-century American—in order to see how four different artists, from four very different times and places, respond to the same fundamental phenomenon, the world that surrounds them. But rather than emphasizing their differences, let's ask if they have anything in common.

An American Vista

Albert Bierstadt's The Rocky Mountains (Fig. 5), painted in 1863, was one of the most popular paintings of its time. An enormous work, six feet high and ten feet long, it captured, in the American imagination, the vastness and majesty of the then still largely unexplored West. Writing about the painting in his 1867 Book of the Artists, the critic H. T. Tuckerman described it in glowing terms: "Representing the sublime range which guards the remote West, its subject is eminently national; and the spirit in which it is executed is at once patient and comprehensive-patient in the careful reproduction of the tints and traits which make up and identify its local character, and comprehensive in the breadth, elevation, and grandeur of the composition." In its breadth and grandeur, the painting seemed to Tuckerman an image of the nation itself. If it was sublime-that is, if it captured an immensity so large that it could hardly be comprehended by the imagination-the same was true of the United States as a whole. The Rocky Mountains was a truly democratic painting, vast enough to accommodate the aspirations of the nation.

But if it was truly democratic, it was not true to life. Despite Tuckerman's assertion that Bierstadt has captured the "tints and traits" of

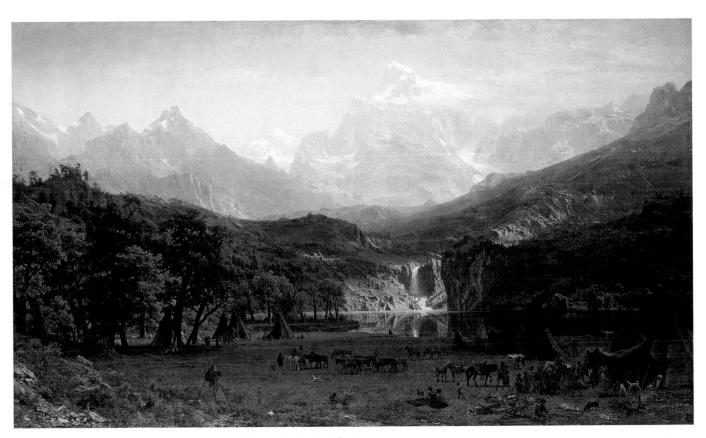

Fig. 5 Albert Bierstadt, The Rocky Mountains, Lander's Peak.
 Oil on canvas, 73 ¹/₂ × 120 ³/₄ in. Signed and dated lower right. A. Bierstadt/1863. The Metropolitan Museum of Art, Rogers Fund, 1907 (07.123).
 Photo © 1979 The Metropolitan Museum of Art.

the scene, no landscape quite like this exists in the American West. Rather, Bierstadt has painted the Alps, and the painting's central peak is a barely disguised version of the Matterhorn. Trained as a painter in Europe, Bierstadt sees the landscape through European eyes. He is not interested in representing the Rockies accurately. Rather, it is as if he secretly longs for America to be Europe, and so he paints it that way.

Tuckerman assumes that Bierstadt's aim in painting this scene was to record it accurately. And, in fact, one of the traditional roles of artists is to record the world, to make a visual record of the places, people, and events that surround them. To a certain degree—in his accurate representation of Western flora and fauna, and in his equally accurate depiction of native dress and costume—Bierstadt accepts this role. But he also clearly wishes to accomplish something more. If the painting does not accurately reflect the American scene, it almost certainly reflects Bierstadt's own *feelings* about it. The Rockies, for him, are at least as sublime as the Alps. He wants us to share in his feeling.

Fig. 6 Wu Chen, The Central Mountain, 1336.
 Handscroll, ink on paper, 10 ¼ × 35 ¼ in. Collection of the National Palace Museum, Taipei, Taiwan, Republic of China.

A Chinese Landscape

A second traditional role of the artist, it follows, is to give visible or tangible form to ideas, philosophies, or feelings. Wu Chen's classic handscroll, The Central Mountain (Fig. 6), is a masterpiece of Chinese art. Composed according to strict artistic principles of unity and simplicity, it elevates the most bland, plain, and uninteresting view—the kind of scene the Chinese call p'ing-tan—to the highest levels of beauty, and reveals, in the process, profound truths about nature. In fact, if Wu Chen's deep feelings and reverence for nature are evident in his handscroll, it is clear that he wants to reveal something more.

Wu Chen was one of the Four Great Masters of the Yuan Dynasty, the period of history dominated by Mongol rulers and lasting from 1279 until 1368, when Zhu Yuanzhang drove the Mongols back to the northern deserts and restored China to the Han people. Wu Chen worked in an intensely creative cultural atmosphere, dominated by gatherings of intellectuals organized for the appreciation and criticism of poetry, calligraphy, and painting, and for the appreciation of good wine. In addition, the culture was dominated by deep interest in both Buddhist and Taoist thought. Of the Four Masters, Wu Chen's tastes were perhaps the simplest and most devout. *The Central Mountain* embodies the teachings of the Tao.

In Chinese thought, the Tao is the source of life. It gives form to all things, and yet it is beyond description. It manifests itself in our world through the principle of complementarity known as yin and yang. Representing unity within diversity, opposites organized in perfect harmony, the ancient symbol for this principle is the famous *yin* and *yang*:

Yin is nurturing and passive, and is represented by the earth in general and by the cool, moist valleys of the landscape in particular. *Yang* is generative and active. It is represented by the sun and the mountain.

In the natural world, the variety of visual experience obscures these principles, making it

difficult to recognize them. The goal of the artist, therefore, must be to reveal the artist's feeling that the Tao is present in nature. In Wu Chen's handscroll only trees and mountains are depicted. The trees are simple dots of ink; the grassy slopes of the mountainsides are painted in a uniform flat, gray wash. There are no roads, houses, or people to distract us. The scene is without action, devoid of any movement or sense of change. The mountains roll across the scroll with a regular rhythm, as if measuring the serene breath of the spectator. The entire composition, composed of both mountains and sky, is symmetrically balanced around the central mountain. Heaven and earth, solid and void, fold into one, as if to reveal the absolute essence and universal presence of yin and yang lying at the heart of all our visual experience. In fact, The Central Mountain, the work of art, unites viewer and landscape in a greater harmony and whole.

An Aboriginal "Dreaming"

Wu Chen's painting suggests the third role of the artist: to reveal hidden or universal truths. Like Wu Chen, the Australian aboriginal artist Erna Motna wishes to reveal something larger than himself in his *Bushfire and Corroboree Dreaming* (Fig. 7) The organizing logic of

Fig. 7 Erna Motna, *Bushfire and Curruboree Dreaming*, 1988. Acrylic on canvas, 48 × 32 in. Australia Gallery, New York. Courtesy of the Australian Consulate General.

most Aboriginal art is the so-called Dreaming. a system of belief unlike that of most other religions in the world. The Dreaming is not literally dreaming as we think of it. For the Aborigine, the Dreaming is the presence, or mark, of an Ancestral Being in the world. Images of these Beings-representations of the myths about them, maps of their travels, depictions of the places and landscapes they inhabited-make up the great bulk of Aboriginal art. To the Aboriginal people, the entire landscape is thought of as a series of marks made upon the earth by the Dreaming. Thus the landscape itself is a record of the Ancestral Being's passing. Geography is thus full of meaning and history. And painting is understood as a concise vocabulary of abstract marks conceived to reveal the ancestor's being, both present and past, in the Australian landscape.

Ceremonial paintings on rocks, on the ground, and on people's bodies were made for centuries by the Aboriginal peoples of Central Australia's Western Desert region. Acrylic paintings, similar in form and content to these traditional works, began to be produced in the region in 1971. In that year, a young art teacher named Geoff Bardon arrived in Papunya, a settlement on the edge of the Western Desert organized by the government to provide health care, education, and housing for the Aboriginal peoples. Several of the older Aboriginal men became interested in Bardon's classes, and he encouraged them to paint in acrylic, using traditional motifs. By 1987, prices for works executed by well-known painters ranged from \$2,000 to \$15,000, though Western buyers clearly valued the works for their aesthetic appeal and not for their traditional meanings.

Each design still carries with it, however, its traditional ceremonial power and is actual proof of the identity of those involved in making it. Erna Motna's *Bushfire and Corroboree Dreaming* depicts the preparations for a *corroboree*, or celebration ceremony. The circular features at the top and bottom of the painting represent small bush fires that have been started by women. As small animals run from the fire (symbolized by the small red dots at the edge of each circle), they are caught by the women and hit with digging sticks, also visible around each fire, and then carried with fruit and vegetables to the central fire, the site of the *corroboree* itself. Other implements that will be used by the men to kill larger animals driven out of the bush by the fires are depicted as well—boomerangs, spears, clubs, and spear throwers.

Unlike most other forms of Aboriginal art, acrylic paintings are permanent and are not destroyed after serving the ceremonial purposes for which they were produced. In this sense, the paintings have tended to turn dynamic religious practice into static representations, and, even worse, into commodities. Conflicts have arisen over the potential revelation of secret ritual information contained in the paintings, and the star status bestowed upon certain painters, particularly younger ones, has had destructive effects on traditional hierarchies within the community. On the other hand, these paintings have tended to revitalize and strengthen traditions that were, as late as the 1960s, thought doomed to extinction.

A Modern Earthwork

The abstract marks that make up Erna Motna's painting are not readily legible to us in the West. In fact, it is difficult for Westerners to view the painting in terms of landscape. Yet Robert Smithson's giant earthwork, *Spiral Jetty* (Fig. 8), is a large-scale mark very similar to Motna's. It exemplifies the fourth traditional role of the artist: *to help us see the world in a new or innovative way*. It is designed to transform our experience of the world, jar us out of our complacency, and create new ways for us to see and think about the world around us.

Stretching into the Great Salt Lake at a point near the Golden Spike monument, which marks the spot where the rails of the first transcontinental railroad were joined, *Spiral Jetty* literally *is* landscape. Made of mud, salt crystals, rocks, and water, it is a record of the geological history of the place. But it is landscape that has been created by

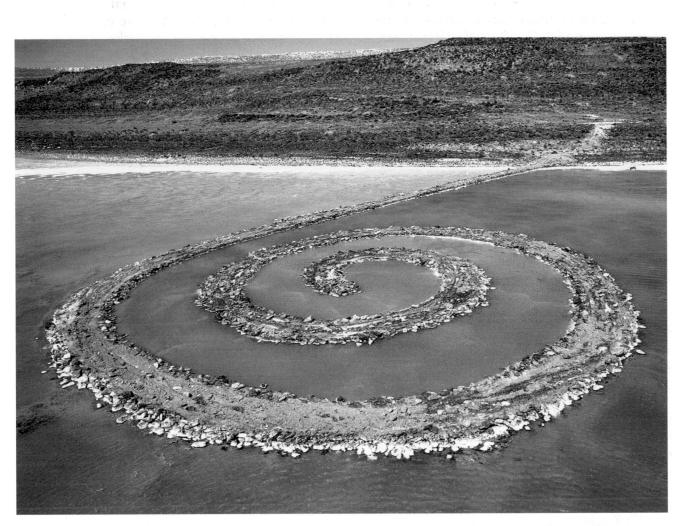

Fig. 8 Robert Smithson, Spiral Jetty, April 1970. Great Salt Lake, Utah. Black rock, salt crystals, earth, red water (algae). 3 ½ in. × 15 in. × 1500 in. Art © Estate of Robert Smithson/Licensed by VAGA, New York. Courtesy James Cohan Gallery, New York. Collection: DIA Center for the Arts, New York. Photo: Gianfranco Gorgoni.

man. The spiral form makes this clear. The spiral is one of the most widespread of all ornamental and symbolic designs on earth. In Egyptian culture, the spiral designated the motion of cosmic forms and the relationship between unity and multiplicity, in a manner similar to the Chinese *yin* and *yang*. The spiral is, furthermore, found in three main natural forms: expanding like a nebula, contracting like a whirlpool, or ossified like a snail's shell. Smithson's work suggests the way in which these contradictory forces are simultaneously at work in the universe to reveal that hidden truth. Thus the *Jetty* gives form to the feelings of contradiction he felt as a contemporary inhabitant of his world. Motion and stasis, expansion and contraction, life and death, all are simultaneously suggested by the 1500-foot coil, the artist's creation extending into the Great Salt Lake, America's Dead Sea. It literally causes us to open our eyes to possibility.

WORKS IN PROGRESS

o a greater or lesser degree, all four of the artists we have discussed assume all four of the traditional roles of the artist. To review. they record the world; give visible or tangible form to ideas, philosophies, or feelings; reveal hidden or universal truths; and help us see the world in new and innovative ways. But they share something even more basic as well. However diverse their backgrounds and their worlds, all four create visual images. All people are creative, but not all people possess the energy, ingenuity, and courage of conviction that are required to make art. In order to produce a work of art, the artist must be able to respond to the unexpected, the chance occurrences or results that are part of the creative process. In other

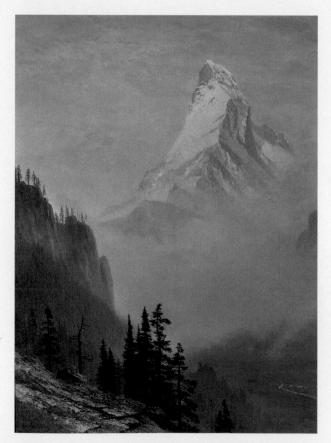

Fig. 9 Albert Bierstadt, "Sunrise on the Matterhorn". Lyman Allyn Art Museum, New London, Connecticut. Photo: Rick Scanlan Photography, CT.

words, the artist must be something of an explorer and inventor. The artist must always be open to new ways of seeing. The landscape painter John Constable spoke of this openness as "the art of seeing nature." This art of seeing leads to imagining, which leads in turn to making. Creativity is the sum of this process, from seeing to imagining to making.

For example, in discussing Albert Bierstadt's The Rocky Mountains (see Fig. 5), we claimed that his central mountain is more European than American, more a figment of his imagination than a reality. If we compare the final picture to an earlier painting of the Matterhorn, the famous pinnacle near Zermatt, Switzerland (Fig. 9), we can recognize the source of Bierstadt's central peak. This tells us something important about Bierstadt's creative process. He evidently felt no compulsion to be "true" to the scene. He felt it his right, even his duty, to "elevate" the scene, to move his audience emotionally as much as possible. In 1859, Bierstadt had written to The Crayon, one of the leading art magazines of the day. describing his trip: "A lover of nature and Art could not wish for a better subject. I am delighted with the scenery. The mountains are very fine; as seen from the plains, they resemble very much the Bernese Alps, one of the finest ranges of mountains in Europe, if not the world. They are of granite formation, the same as the Swiss mountains and their jagged summits, covered with snow and mingling with the clouds, present a scene which every lover of landscape would gaze upon with unqualified delight." Evidently, Bierstadt painted The Rocky Mountains to match not the scene itself, but his description of it.

Robert Smithson's sketches for the Spiral Jetty (Fig. 10) seem to tell us something quite different. Smithson appears to be intent on exploring how the earthwork will appear from 20 different, mostly aerial, points of view. What are we to make of this? Smithson realized that the remoteness of the site precluded large numbers of people actually visiting it.

The Creative **PROCESS**

Fig. 10 Robert Smithson, Spiral Jetty (Movie Treatment), 1970 (20 panels). Pencil on paper, 19 × 24 in. Collection of Virginia Dwan. Art © Estate of Robert Smithson/Licensed by VAGA, New York, NY.

The Jetty would exist, for most people, as in the work of Christo and Jeanne-Claude, only in its photo-documentation, and Smithson is anticipating that "photo-reality" in these drawings for the film he made of the Spiral Jetty's installation. Smithson also understood that, in time, this monumental earthwork would be subject to the vast changes in water level that characterize the Great Salt Lake. In fact, not long after its completion, the *Spiral Jetty* disappeared as the lake rose, only to reappear in 2003 as the lake fell again. The work was now completely transformed, encrusted in salt crystals (Fig. 11), re-created, as it were, by the slow workings of nature itself.

This book sets out to explore the creative process through examples such as these. Throughout the book, you will encounter *Works in Progress* spreads, such as this one, in which the creative process that generated a given work is explored in depth. But more than helping you to appreciate a given work of art, these examples are designed to help you understand the importance of

thinking creatively for yourself. We hope you take from this book the knowledge that the kind of creative thinking engaged in by artists is fundamental to every discipline. This same path leads to discovery in science, breakthroughs in engineering, and new research in the social sciences. We can all learn from studying the creative process itself.

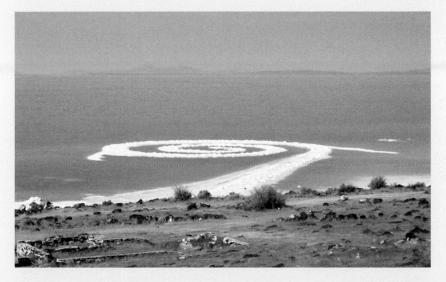

Fig. 11 Robert Smithson, Spiral Jetty, as it appeared in August, 2003. Photo: Sandy Brooke.

THE WORLD AS WE PERCEIVE IT

Many of us assume, almost without question, that we can trust in the reality of what we see. Seeing, as we say, is believing. Our word "idea" derives, in fact, from the Greek word *idein*, meaning "to see," and it is no accident that when we say "I see" we really mean "I understand."

Nevertheless, though visual information dominates our perceptions of the world around us, we do not always understand what we see. More to the point, no two people, seeing the same thing, will come to the same understanding of its meaning or significance. Consider figures 12 and 13. Almost all of us can agree, I think without difficulty, on the subject matter. Both images depict flags. Childe Hassam's Allies Day, May 1917 (Fig. 12) is patriotic in tone. It celebrates the American entry into World War I, something that the nation put off until April 6, 1917, after five American ships had been sunk in a span of nine days. The scene is Fifth Avenue in New York City, viewed from 52nd Street, and the flags decorated the route of the parades held on May 9 and 11 to honor the Allied leaders who had come to New York to consult on strategy.

If Hassam's painting seems straightforward, Jasper Johns's Three Flags (Fig. 13) is, at first sight, a perplexing image. It is constructed out of three progressively smaller canvases that have been bolted to one another, and because the flag undeniably shrinks before your eyes, becoming less grand and physically smaller the closer it gets to you, it seems to many viewers to diminish the very idea of America for which it stands. According to Johns, when he created this work the flag was something "seen but not looked at, not examined." Three Flags was painted at a time when the nation was obsessed with patriotism, spawned by Senator Joseph McCarthy's anticommunist hearings in 1954, by President Eisenhower's affirmation of all things American, and by the Soviet Union's challenge of American supremacy, shown clearly by the launching of Sputnik, the first artificial satellite, in 1957. Against that background, Johns's work asks us to consider just what the flag means to us. It asks us to examine our assumptions about ourselves.

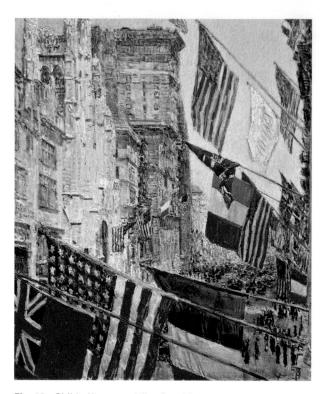

Fig. 12 Childe Hassam, Allies Day, May 1917, 1917.
Oil on canvas, 36 ¹/₂ × 30 ¹/₄ in. Gift of Ethelyn McKinney in memory of her brother, Glenn Ford McKinney.
© 1999 Board of Trustees, National Gallery of Art, Washington, D.C.

However we feel about the Johns painting, however easily we all *read* it as the image of a flag, its meaning is not clear. In a book called The Languages of Art, Nelson Goodman suggests why. "The eye," he says, "functions not as an instrument self-powered and alone, but as a dutiful member of a complex and capricious organism. Not only how but what it sees is regulated by need and prejudice. It selects, rejects, organizes, discriminates, associates, classifies, analyzes, constructs. It does not so much mirror as take and make." In other words, the eye mirrors each individual's complex perceptions of the world. There are at least two sets of eyes at issue when we discuss Johns's work: Johns's (what exact ideas influenced him when he chose to paint the flag?) and ours (what needs and prejudices regulate our vision?). In the next two sections, we will explore the related processes of seeing and perceiving.

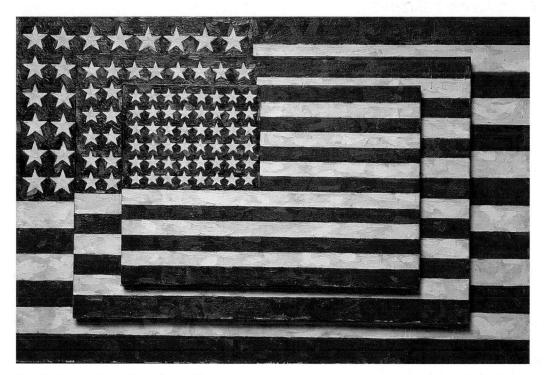

Fig. 13 Jasper Johns, *Three Flags*, 1958.

Encaustic on canvas, $30.\% \times 45.\% \times 5$ in. 50th Anniversary Gift of the Gilman Foundation, Inc., The Lauder Foundation, A. Alfred Taubman, an anonymous donor, and purchase 80.32. Collection of Whitney Museum of American Art, New York.

Photo: Geoffrey Clements. Art © Jasper Johns/Licensed by VAGA, New York, NY.

The Physical Process of Seeing

Seeing is both a physical and psychological process. We know that, physically, visual processing can be divided into three steps:

reception \rightarrow extraction \rightarrow inference

In the first step, reception, external stimuli enter the nervous system through our eyes-"we see the light." Next, the retina, which is a collection of nerve cells at the back of the eye, extracts the basic information it needs and sends this information to the visual cortex, the part of the brain that processes visual stimuli. There are approximately 100 million sensors in the retina, but only 5 million channels to the visual cortex. In other words, the retina does a lot of "editing," and so does the visual cortex. There, special mechanisms capable of extracting specific information about such features as color, motion, orientation, and size "create" what is finally seen. What you see is the inference your visual cortex extracts from the information your retina sends it.

Seeing, in other words, is an inherently creative process. The visual system makes con-

clusions about the world. It represents the world for you by selecting out information, deciding what is important and what is not. What sort of information, for example, have you visually assimilated about the flag? You know its colors-red, white, and blue-and that it has 50 stars and 13 stripes. You know, roughly, its shape-rectangular. But do you know its proportions? Do you even know, without looking, what color stripe is at the flag's top, or what color is at the bottom? How many short stripes are there, and how many long ones? How many horizontal rows of stars are there? How many long rows? How many short ones? Of course, even looking back at Johns's painting will not help you answer the last three questions, because it was finished before Hawaii and Alaska were admitted to the Union. The point is that not only do we each perceive the same things differently, remembering different details, but also we do not usually see things as thoroughly or accurately as we might suppose.

Recently, the New York City Police Department began taking newly promoted

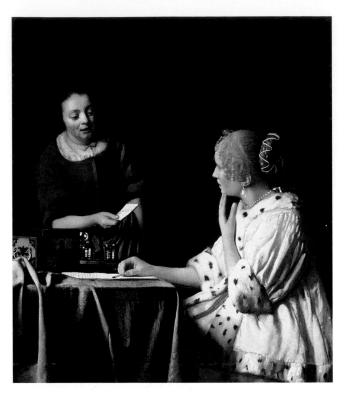

Fig. 14 Jan Vermeer, *Mistress and Maid*, 1665–70. Oil on canvas, 35 1/2 × 31 in. Frick Collection, New York. Henry Clay Frick Bequest.

officers, including sergeants, captains, and uniformed executives, to the Frick Collection, an art museum in New York's Upper East Side, in order to improve their observational skills by having them analyze works of art. Similar classes are offered to New York medical students to help them improve their diagnostic abilities when observing patients, teaching them to be sensitive to people's facial expressions and body language. An article on the program in *The Wall Street Journal* reports Captain Ernest Pappas's response when asked to describe Johannes Vermeer's *Mistress and Maid* (Fig. 14):

"This woman is right-handed, of well-todo means, and the pen appears to be in the dropped position," Mr. Pappas said, assessing the mistress. Unsure about the other figure in the picture, the maid, the 42-year-old asked his colleagues whether they thought she was delivering bad news. "Is she assuming a defensive position? Do you think that's a smirk?" Though he hadn't so carefully analyzed a painting before, Mr. Pappas immediately saw how it related to his detective work in Queens: "Crime—and art—can be solved by looking at the little details."

Captain Pappas is drawing inferences from the scene in the painting before him, creating a plausible story from the details of Vermeer's painting.

The Psychological Process of Seeing

Viewers other than Captain Pappas might interpret the expressions in Vermeer's painting very differently-for instance, seeing in the maid's face a certain compassion and in her mistress's a certain doubt or confusion. Mere attention to details-the pearl earring, the ermine coat-can only tell you so much. You can infer the mistress's wealth, as Captain Pappas did, but not her psychological makeup. And not only does the psychological make-up of Vermeer's subjects come into play as you interpret the scene, but so does your own. Everything you see is filtered through a long history of fears, prejudices, desires, emotions, customs, and beliefs-both your own and the artist's. Figures 15 and 16 show three widely different approaches to the symbolic nature of the flag. In Faith Ringgold's God Bless America (Fig. 15), the American flag has been turned into a prison cell. Painted during the Civil Rights Movement, as Martin Luther King, Jr., was delivering the great speeches that mark that era, the star of the flag becomes a sheriff's badge, and its red and white stripes are transformed into the black bars of the jail. The white woman portrayed in the painting is the very image of contradiction, at once a patriot, pledging allegiance to the flag, and a racist, denying blacks the right to vote.

Flags inevitably raise issues of national pride and identity. Yukinori Yanagi's World Flag Ant Farm (Fig. 16) is an extraordinarily witty assault on nationalism, even as it stands as a metaphor for the globalization of culture in the last 50 years. For The World Flag Ant Farm, he created a grid of plastic boxes, each filled with colored sand in the pattern of a national flag—representing the nations of the world. Each box was connected to adjacent

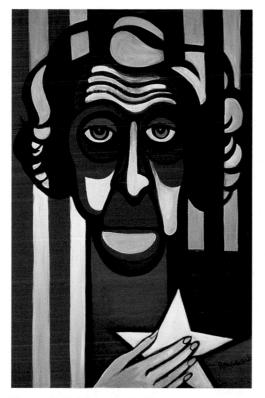

Fig. 15 Faith Ringgold, *God Bless America*, 1964. Oil on canvas, 31 × 19 in. © Faith Ringgold, Inc. 1964

boxes by plastic tubing. Yanagi then introduced ants into the system, which immediately began carrying colored sand between flags, transforming and corrupting the flags' original designs. As each flag's integrity was degraded by these "border crossings," a new "cross-cultural" network of multinational symbols and identities began to establish itself.

Yanagi's work directly addresses the traditional view that Japan is a distinct and isolated culture, a view challenged directly by the influence of China, Korea, and more recently, the United States, on Japanese society. But the work has technological implications as well. "If the travels of the ant show us anything," Yanagi says, "it is that he wanders to resume the task he has been programmed to perform, not to acquire freedom." In this sense, Yanagi's Ant Farm functions like some cumbersomely slow microchip or processor from the early days of computing, a metaphor for what has become the processes of the Internet and the World Wide Web, and the interchange of information they have made possible.

Fig. 16 Yukinori Yanagi, The World Flag Ant Farm, 1990. Ants, colored sand, plastic boxes, and plastic tubes, 170 boxes, each 8 × 12 in. Naoshima Contemporary Art Museum, Kagawa, Japan. Photo: Norihiro Ueno. © Norihiro Ueno/Benesse Art Site Naoshima.

THE **CRITICAL** PROCESS Thinking about Making and Seeing

In this chapter, we have discovered that the world of art is as vast and various as it is not only because different artists in different cultures see and respond to the world in different ways, but also because each of us sees and responds to a given work of art in a different way. Artists are engaged in a creative process. We respond to their work through a process of critical thinking. At the end of each chapter of A World of Art is a section like this one titled The Critical Process, in which, through a series of questions, you are invited to think for yourself about the issues raised in the chapter. In each case, additional insights are provided at the end of the text, in the section titled The Critical Process: Thinking Some More about the Chapter Questions. After you have thought about the questions raised, turn to the back and see if you are headed in the right direction.

Here, Andy Warhol's *Race Riot* (Fig. 17) depicts events of May 1963 in Birmingham, Alabama, when police commissioner Bull Connor employed attack dogs and fire hoses to disperse civil rights demonstrators led by

Reverend Martin Luther King, Jr. The traditional roles of the artist—to record the world; to give visible or tangible form to ideas, philosophies, or feelings; to reveal hidden or universal truths; and to help us see the world in new or innovative ways-are all part of a more general creative impulse that leads, ultimately, to the work of art. Which of these is, in your opinion, the most important for Warhol in creating this work? Did any of the other traditional roles play a part in the process? What do you think Warhol feels about the events (note that the print followed soon after the events themselves)? How does his use of color contribute to his composition? Can you think why there are two red panels, and only one white and one blue? Emotionally, what is the impact of the red panels? In other words, what is the work's psychological impact? What reactions other than your own can you imagine the work generating? These are just a few of the questions raised by Warhol's work, questions to help you initiate the critical process for yourself.

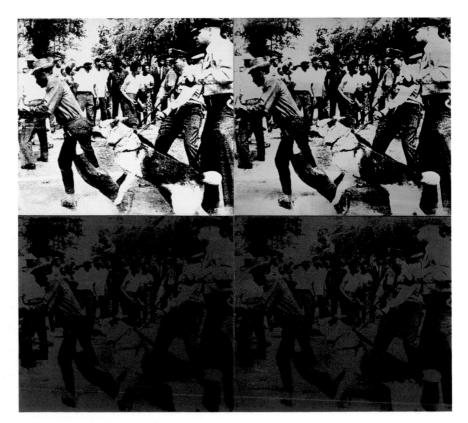

Fig. 17 Andy Warhol, *Race Riot*, 1963.

Acrylic and silkscreen on canvas, four panels, each 20 × 33 in. © 2007 Andy Warhol Foundation for the Visual Arts/Artists Rights Society (ARS), New York.

Developing Visual Literacy

Works in Progress Lorna Simpson's *The Park*

DESCRIBING THE WORLD

Representational, Abstract, and Nonobjective Art Form and Content Conventions and Art Iconography The Critical Process Thinking about Visual Conventions

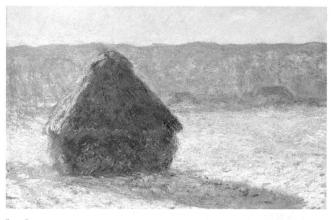

Visual art can be powerfully persuasive, and one of the purposes of this book is to help you to recognize how this is so. Yet it is important for you to understand from the outset that you can neither recognize nor understand—let alone communicate—how visual art affects you without using language. In other words, one of the primary purposes of any art appreciation text is to provide you with a descriptive vocabulary, a set of terms, phrases, concepts, and approaches that will allow you to think critically about visual images. It is not sufficient to say, "I like this or that painting." You need to be able to recognize why you like it, how it communicates to you. This ability is given the name visual literacy.

The fact is, most of us take the visual world for granted. We assume that we understand what we see. Those of us born and raised in the television era are often accused of being nonverbal, passive receivers, like TV monitors themselves. If television—and the mass media generally, from *Time* to MTV—has made us virtually dependent upon visual information, we have not necessarily become visually *literate* in the process. To introduce you to the idea of visual literacy, this chapter will begin by introducing you to the main tools needed for our discussion—the relationship among words, images, and objects in the real world; the idea of representation; and the distinction among form and content in art, conventions in art, and iconography. With these in hand, we will then consider some of the major themes of art in Chapter 3.

WORDS AND IMAGES

The degrees of distance between things in the world and the words and images with which we refer to them is precisely the point of René Magritte's The Treason of Images (Fig. 18). We tend to look at the image of a pipe as if it were really a pipe, but of course it isn't. It is the representation of a pipe. Ceci n'est pas une pipe, the painting tells us: "This is not a pipe." Nor is the word "pipe" the same as an image of it. The word is an abstract set of marks that "represents," in language, both the thing and its image. Language is even further removed from the real world than visual representation. And within language there are different degrees of distance as well. "This," finally, is not a "pipe." These two words are not the same: "This" is a pronoun that could point to anything, and only in this context does it point to a "pipe."

In the West, we tend to confuse words and the things they represent. This is not true in other cultures. For example, in Muslim culture, the removal of the word from what it refers to is seen as a virtue. Traditionally, those who make pictures with human figures in them are labeled "the worst of men," and to possess such a picture is comparable to owning a dog, an animal held in contempt because it is associated with filth. In creating a human likeness, the artist is thought to be competing with the Creator himself, and such *hubris*, or excessive pride, is, of course, a sin. As a result, **calligraphy**—that is, the fine art of handwriting—is the chief form of Islamic art.

The Muslim calligrapher does not so much express himself—in the way that we, individually, express ourselves through our style of writing—as act as a medium through which Allah can express himself in the most beautiful manner possible. Thus all properly pious writing, especially poetry, is sacred. This is the case with the page from the poet Firdawsi's *Shahnamah* (Fig. 19).

Sacred texts are almost always completely abstract designs that have no relation to the world of things. They demand to be considered at least as much for their visual properties as for their literary or spiritual content. Until recent times, in the Muslim world, every book, indeed almost every sustained statement, began with the phrase "In the name of Allah"—the *bismillah*, as it is called—the same phrase that opens the Koran. On this folio page from the *Shahnamah*, the *bismillah* is in the top right-hand corner (Arabic texts read from right to left). To write the *bismillah*

Fig. 18 René Magritte, The Treason of Images, 1929.

Oil on canvas, 21 ¹/₂ × 28 ¹/₂ in. Los Angeles County Museum. © Bridgeman–Giraudon/Art Resource, New York. © 2007 C. Herscovici, Brussels/Artists Rights Society (ARS), New York.

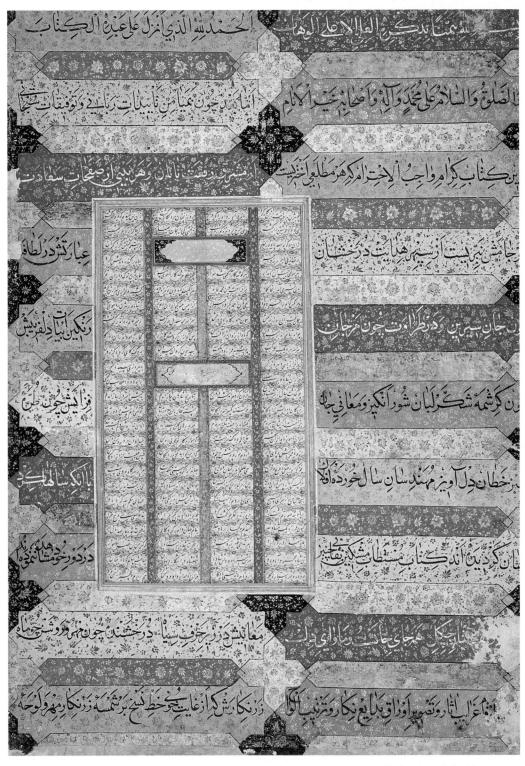

Fig. 19 *Triumphal Entry* (Page from a Manuscript of the "Shahnama of Firdawsi"), Persian, Safavid culture, 1562–1583.

Opaque watercolor, ink, and gold on paper, 18 $^{11}/_{16} \times 13$ in. Francis Bartlett Donation and Picture Fund. 14.692. Courtesy Museum of Fine Arts, Boston. Reproduced with permission. © 2007 Museum of Fine Arts, Boston. All Rights Reserved.

Fig. 20 The visual to the verbal. On the left: C. E. Watkins, *Arbutus Menziesii Pursh*, California, 1861. Albumen print, 14 ¹/₄ × 21 ¹/₄ in. The Museum of Modern Art, New York. Licensed by SCALA/Art Resource, New York. © 2000 Museum of Modern Art, New York.

in as beautiful a form as possible is believed to bring the scribe forgiveness for his sins.

Yet words, however beautifully written, have limitations. If you allow yourself to believe for a moment that the photograph of the tree in Figure 20 represents a "real" tree, and that the drawing in the middle is its "image," the question arises: Should we trust the word "tree" more or less than the image of it? It is no more "real" than the drawing. It is made from a series of pen strokes on paper-not an action radically removed, at least in a physical sense, from the set of gestures used to draw the tree. In fact, the word might seem even more arbitrary and culturally determined than the drawing. Most people would understand what the drawing depicts. Only English speakers understand "tree." In French the word is arbre, in German baum, in Turkish agaç, and in Swahili mti.

The work of photographer Lorna Simpson consistently challenges the relations between words and images (see Works in Progress, pp. 22–23). Consider her photographs of a black female sitting in a chair entitled She (Fig. 21). She is dressed in a brown suit, as if at an interview. Without the title and the italic script label at the top—"female"—the sitter's gender would be in doubt. If the work were called, say, "Interviewee," the sitter's head cut off at the chin, there would be no way to know the gender of the sitter. In fact, Simpson has said that black women in the United States are treated by society as if they are faceless without identity, personality, or individuality. Here, She challenges gender stereotypes, seemingly usurping man's place. It is as if, in the old phrase, *She* is wearing the pants in the family. And even if the words do somewhat diminish the ambiguity of the piece, it remains as open

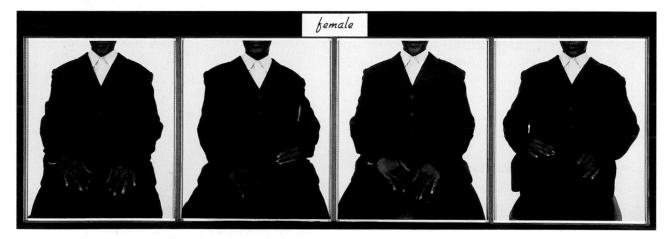

Fig. 21 Lorna Simpson, She, 1992.

Photographs, four dye-diffusion transfers (Polaroids) and plaque, $29'' \times 85 \frac{1}{4}$ in. Reproduced with permission. Ellen Kelleran Gardner Fund, 1992.204a-e. Museum of Fine Arts, Boston. Photo © 2006 Museum of Fine Arts, Boston.

to interpretation as the sitter's hand gestures, which are expressive even if we don't know what precisely they express. The **subject matter** of the work—what the image literally depicts—barely hints at the complexity of its content—what the image means.

Whichever we tend to trust more, the visual or the verbal (and it probably depends upon the context of any given situation), it should nevertheless be clear that words and images need to work together. Each is insufficient in itself to tell the whole "truth." It should be equally clear that any distrust of visual imagery we might feel is, at least in part, a result of the visual's power. When, in Exodus, the worship of "graven images," that is, idols, is forbidden, the assumption is that such images are powerfully attractive, even dangerously seductive. As we have noted, the page of Arab poetry reproduced previously (see Fig. 19) depends for its power at least as much on its visual presence and beauty as it does on what it actually says.

DESCRIBING THE WORLD

In the last section, we explored the topic of visual literacy by considering the relationship between words and images. Words and images are two different systems of describing the world. Words refer to the world in the abstract. Images represent the world, or reproduce its appearance. Traditionally, one of the primary goals of the visual arts has been to capture and portray the way the natural world looks. But, as we all know, some works of art look more like the natural world than others. and some artists are less interested than others in representing the world as it actually appears. As a result, a vocabulary has developed that describes how closely, or not, the image resembles visual reality itself. This basic set of terms is where we need to begin in order to talk or write intelligently about works of art.

Representational, Abstract, and Nonobjective Art

Generally we refer to works of art as either representational, abstract, or nonobjective (or nonrepresentational). The more a work resembles real things in the real world, the more representational, or realistic, it is said to be. You may also encounter the related terms naturalistic, meaning "like nature," and illusionistic, which refers to an image so natural that it creates the illusion of being real. Traditional photography is, in many ways, the most representational medium, because its transcription of what lies before the viewfinder appears to be direct and unmanipulated. The photograph, therefore, seems to capture the immediacy of visual experience. It seems equivalent to what we actually see. It is important to remember, however, that photography captures only what is visible in the camera's viewfinder. As in the Lorna Simpson photographic portraits in She, the photographic image does not necessarily capture the emotional world that lies beneath the surface, or what lies beyond the frame. Photography offers up only a replica of the visual or illuminated world, not the world as a whole.

Representational works of art portray natural objects in recognizable form. Thus, Albert Bierstadt's painting *The Rocky Mountains* (see Fig. 5) is representational, even though the scene it depicts may be imaginary. The sculpture of *Pat* (Fig. 22), is fully representational.

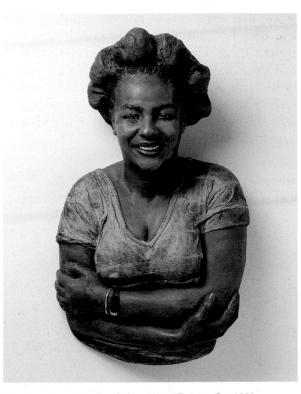

 Fig. 22 John Ahearn and Rigoberto Torres, Pat, 1982.
 Painted cast plaster, 28 ¹/₂ × 16 ¹/₂ × 11 in. Courtesy Alexander and Bonin, New York. Collection Norma and William Roth, Winter Haven, Florida.
 Photo courtesy of Sotheby's

WORKS IN PROGRESS

s a photographer, Lorna Simpson is preoccupied with the question of representation and limitations. All of her works, its of which the multi-panel Necklines (Fig. 23) is a good example, deal with the ways in which words and images function together to make meaning. Simpson presents us with three different photographs of the same woman's neck and the neckline of her dress. Below these images are two panels with four words on each, each word in turn playing on the idea of the neck itself. The sensuality of the photographs is affirmed by words such as "necking" and "neck-ed" (that is, "naked"), while the phrases "neck & neck" and "breakneck" introduce the

possible. Simpson seeks to articulate this tension—the violence that always lies beneath the surface of the black person's world—by bringing words and images together.

A group of large-scale black-and-white serigraphs, or silkscreen prints, on felt, takes up different subject matter but remains committed to investigating the relationship between words and images. Created for the opening of the Sean Kelly Gallery in New York City in October 1995, all of the works but one are multi-panel photographs of landscapes (the one exception is a view of two almost identical hotel rooms). They employ a unique process. Simpson first photographed the scenes. Then she arranged with Jean Noblet, one of the premier serigraph printers in the world, to print them, blown up

idea of speed or running. The question is, what do these two sets of terms have to do with one another? Necklaces and neckties go around the neck. So do nooses at hangings. In fact, "necktie parties" conduct hangings, hangings break necks, and a person runs from a "necktie party" precisely because, instead of wearing a necklace, in being hanged one becomes "neckless."

If this set of ver-

bal associations runs contrary to the sensuality and seeming passivity of Simpson's photographs, it does not run contrary to the social reality faced, throughout American history, by black people in general. The anonymity of Simpson's model serves not only to universalize the situation that her words begin to explore, but also depersonalizes the subject in a way that suggests how such situations become

several large into panels, on felt, a material never before used in the silkscreen printing process. The felt absorbed vast quantities of ink, and each panel had to be printed several times to achieve the correct density of black. Furthermore, each panel had to match the others in the image. In less than two weeks, the entire suite of seven images, consisting of more than 50 panels, was

miraculously printed, just in time for the show.

Each of the images is accompanied by a wall text that, when read, transforms the image. On one side of *The Park* (Fig. 24), for instance, the viewer reads:

Just unpacked a new shiny silver telescope. And we are up high enough for a really good view of all the buildings and

Fig. 23 Lorna Simpson, Necklines, 1989. Three silver prints, two plastic plaques, 68 ½ × 70 in. Courtesy Sean Kelly Gallery, New York.

Lorna Simpson's THE PARK

the park. The living room window seems to be the best spot for it. On the sidewalk below a man watches figures from across the path.

On the other side of the image, a second wall text reads:

It is early evening, the lone sociologist walks through the park, to observe private acts in the men's public bathrooms. . . He decides to adopt the role of voyeur and look out in order to go unnoticed and noticed at the same time. His research takes several years. . . .

These texts effectively involve Simpson's audience in a complex network of voyeurism. The photographer's position is the same as that of the person who has purchased the telescope, and our viewpoint is the same. Equipped with a telescope (or the telescopic lens of

a camera) apparently purchased for viewing the very kind of scene described in the second text, we want to zoom in to see what's going on below.

There is, in fact, a kind of telescopic feel to the work. The image itself is more than $5\frac{1}{2}$ feet square and can be readily taken in from across the room. But to understand it, we need to come in close to read the texts. Close up, the image is too large to see as a whole, and the crisp contrasts of the print as seen from across the room are lost in the soft texture of

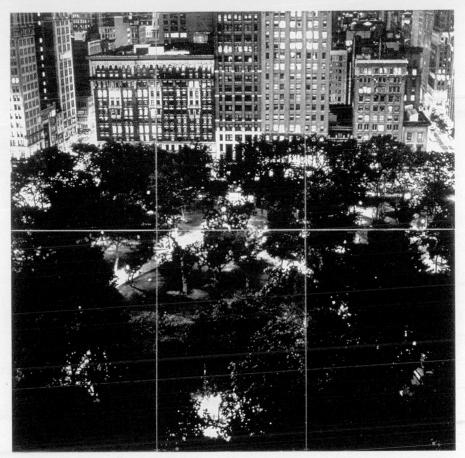

the felt. The felt even seems to absorb light rather than reflect it as most photographic prints do, blurring our vision in the process. As an audience, we zoom in and out, viewing the scene as a whole, and then coming in to read the texts. As we move from the general to the particular, from the panoramic view to the close-up text, the innocuous scene becomes charged with meaning. The reality beneath surface appearances is once again Simpson's theme—the photographer challenging the camera view. The sculpture almost looks as if it is alive, and certainly anyone meeting the real "Pat" would recognize her from this representation of her. In fact, Pat is one of many plaster casts made from life by John Ahearn and Rigoberto Torres, residents of the South Bronx in New York City. In 1980, Ahearn moved to the South Bronx and began to work in collaboration with local resident Torres. Torres had learned the art of plaster casting from his uncle, who had cast plaster statues for churches and cemeteries. Together Ahearn and Torres set out to capture the spirit of a community that was financially impoverished but that possessed real, if unrecognized, dignity. "The key to my work is life-lifecasting," says Ahearn. "The people I cast know that they are as responsible for my work as I am, even more so. The people make my sculptures."

While natural objects remain recognizable in abstract works of art, they are rendered in a stylized or simplified way. Marisol's *Baby Girl* (Fig. 25) is still recognizable as a representation of a little girl, but it is much less realistic than *Pat*. Instead of rendering the human form exactly, Marisol simply draws the human form on the large, barely rounded blocks of wood. As a result, the work seems half sculpture, half drawing.

The less a work resembles real things in the real world, the more **abstract** it is said to be. Abstract art does not try to duplicate the world exactly but instead reduces the world to its essential qualities. It is concerned with the formal qualities of an image (such as line and form and color), or with the emotions that may be expressed through it. For example, Marisol's *Baby Girl* is over 6 feet tall, sitting down. Her exaggerated size lends her the emotional presence of a monster, an all-consuming, all-demanding force far larger than her actual size.

In a group of works known as the *Siluetas* (Fig. 26), done in the 1970s, Cuban-born Ana Mendieta transferred the silhouette of her own body into the landscape. In 1961, following the Communist Revolution of Fidel Castro, Mendieta's parents arranged to have her flown out of Cuba along with thousands of other children in what was known as Operation Peter Pan. For several years after, she lived in a Catholic orphanage in Iowa. "The making of

Fig. 25 Marisol Escobar, *Baby Girl*, 1963. Wood and mixed media, 74 × 35 × 47 in. Albright-Knox Art Gallery, Buffalo, New York. Gift of Seymour H. Knox, 1964. Art © Marisol Escobar/Licensed by VAGA, New York, NY.

my silueta," she explained, "makes the transition between my homeland and my new home. It is a way of reclaiming my roots and becoming one with nature. Although the culture in which I live is part of me, my roots and cultural identity are a result of my Cuban heritage." That heritage, on her mother's side, includes the sixteenth-century Spanish conquest of the Americas. When she created the Silueta pictured here, in Mexico, she stained it with red paint to evoke the oppression, even genocide, endured by the native peoples of the Americas after the conquest. Here the silhouette of the body seems transformed into the imprint of a large, bloody sword on the earth, the head and arms its hilt, the body its blade.

Nonobjective or nonrepresentational works of art do not refer to the natural or objective world at all. Judy Chicago's *Pasadena Lifesavers Red Series* #3 (Fig. 27), one of a series of

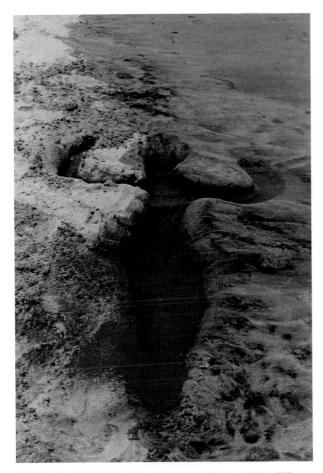

Fig. 26 Ana Mendieta, Silueta Works in Mexico, 1973–1977. Color photograph, 19 ³/₈ × 26 ⁹/₁₆ in. The Museum of Cuntemporary Art, Los Angeles. Purchased with grant provided by The Judith Rothschild Foundation.

15 paintings, would appear to most viewers to be just such a work. It consists of four circular wheels divided into color segments organized around a central core, the lighter segments serving as the corners to a luminous square in the middle of the composition. But for Chicago, they were anything but nonobjective. Like Mendieta's *Siluetas*, they were symbolic of the female body, organized, in Chicago's words, "around a central core, my vagina, that which made me a woman." But when the series was exhibited in 1970, almost no one got the reference. Chicago describes the paintings' reception in her 1975 autobiography, *Through the Flower: My Struggle as a Woman Artist:*

I wanted my being a woman to be visible in the work and had thus decided to change my name from Judy Gerowitz to Judy Chicago as an act identifying myself as an independent woman. . . . My name change was on the wall directly across from the entrance. It said:

Judy Gerowitz hereby divests herself of all names imposed upon her through male social dominance and freely chooses her own name Judy Chicago.

But, even though my position was so visibly stated, male reviewers refused to accept that my work was intimately connected to my femaleness. Rather, they denied that my statement had anything at all to do with my art. Many people interpreted the work in the same way they interpreted my earlier, more neutralized work, as if I were working only with formal issues....

As I look back on this, I realize that many issues were involved in the situation. I had come out of a formalist background and had learned how to neutralize my subject matter. In order to be considered a "serious" artist I had had to suppress my femaleness. . . . Although I was trying to make my images clearer, I was still working in a frame of reference that people had learned to perceive in a particular, non-content-oriented way.

Fig. 27 Judy Chicago, Pasadena Lifesavers Red Series #3, c. 1969–1970.

Sprayed acrylic lacquer on sheet acrylic, 5×5 ft. © 20U/ Estate of Judy Chicago/Artists Rights Society (ARS), NY. Photo © Donald Woodman.

Fig. 28 Kasimir Malevich, *Suprematist Painting, Black Rectangle, Blue Triangle*, 1915. Oil on canvas, 26 ¹/₈ × 22 ¹/₂ in. Stedelijk Museum, Amsterdam. Erich Lessing/Art Resource, New York.

The subject matter of Chicago's *Lifesaver* paintings—so visible to the artist—was invisible to its audience. They took her paintings to be about the relation of forms and colors. The paintings were, instead, about Chicago's life as a woman.

It is not always easy, or even necessary, to make absolute distinctions between the representational, the abstract, and the nonobjective. A given work of art may be more or less representational, more or less abstract. Very often certain elements of a representational painting will be more abstract, or generalized, than other elements. Likewise, works like Judy Chicago's *Pasadena Lifesavers* may appear totally nonobjective until you read more about them. Purely nonobjective art, such as Kasimir Malevich's *Suprematist Painting* (Fig. 28) is concerned only with questions of form, and we turn now to those considerations.

Form and Content

When we speak of a work's form, we mean everything from the materials used to make it, to the way it employs the various formal elements (discussed in Part II), to the ways in which those elements are organized into a composition.

Fig. 29 Claude Monet, Grainstack (Snow Effect), 1891.
 Oil on canvas, 25 ³/₄ × 36 ³/₈ in. Museum of Fine Arts, Boston. Gift of Misses Aimee and Rosamond Lamb in memory of Mr. and Mrs. Horatio A Lamb. 1970.253.
 Photo © 2004 Museum of Fine Arts Boston.

Form is the overall structure of a work of art. Somewhat misleadingly, it is generally opposed to content, which is what the work of art expresses or means. Obviously, the content of nonobjective art is its form. Malevich's painting is really about the relation between the black rectangle, the blue triangle, and the white ground behind them. Though it is a uniform blue, notice that the blue triangle's color seems to be lighter where it is backed by the black rectangle, and darker when seen against the white ground. This phenomenon results from the fact that our perception of the relative lightness or darkness of a color depends upon the context in which we see it, even though the color never actually changes. If you stare for a moment at the line where the triangle crosses from white to black, you will begin to see a vibration. The two parts of the triangle will seem, in fact, to be at different visual depths. Malevich's painting demonstrates how purely formal relationships can transform otherwise static forms into a visually dynamic composition.

Claude Monet uses the same forms in his Grainstack (Fig. 29). In fact, compositionally, this work is almost as simple as Malevich's. That is, the haystack is a triangle set on a rectangle, both set on a rectangular ground. Only the cast shadow adds compositional complexity. Yet Monet's painting has clear content. For nearly three years, from 1888 to 1891, Monet painted the haystacks near his home in Giverny, France, over and over again, in all kinds of weather and in all kinds of light. When these paintings were exhibited in May 1891, the critic Gustave Geffroy summed up their meaning: "These stacks, in this deserted field, are transient objects whose surfaces, like mirrors, catch the mood of the environment. ... Light and shade radiate from them, sun and shadow revolve around them in relentless pursuit; they reflect the dying heat, its last

Fig. 30 Apollo Belvedere (detail), Roman copy after a 4th century BCE. Greek original. Height of entire sculpture 7 ft. 4 in. Vatican Museums, Rome. © Alinari/Art Resource, NY.

Fig. 31 African mask, Sang tribe, Gabon, West Africa. Courtauld Gallery, Courtauld Institute, London.

rays; they are shrouded in mist, soaked with rain, frozen with snow, in harmony with the distant horizon, the earth, the sky." This series of paintings, in other words, attempts to reveal the dynamism of the natural world, the variety of its cyclic change.

In a successful work of art, form and content are inseparable. Consider another two examples of the relation between form and content. To our eyes, the heads in figures 30 and 31 possess radically different formal characteristics and, as a result, differ radically in content. Kenneth Clark compares the two on the second page of his famous book Civilisation: "I don't think there is any doubt that the Apollo embodies a higher state of civilization than the mask. They both represent spirits, messengers from another world-that is to say, from a world of our own imagining. To the Negro imagination it is a world of fear and darkness, ready to inflict horrible punishment for the smallest infringement of a taboo. To the Hellenistic imagination it is a world of light and confidence, in which the gods are like ourselves, only more beautiful, and descend to earth in order to teach men reason and the laws of harmony."

Conventions and Art

Clark is wrong about the African mask. His reading is ethnocentric. That is, it imposes upon the art of another culture the meanings and prejudices of our own. Individual cultures always develop a traditional repertoire of visual images and effects that they tend to understand in a particular way. We call such habitual or generally accepted ways of seeing conventions. Different cultures possess different visual conventions and do not easily understand each other's conventions. It is important to recognize that what we think is expressed in an artwork sometimes results from our own prejudices or mistaken expectations: This is why learning about the art in the context of the culture it reflects is so important to understanding it.

In the case of the African mask, its features are exaggerated at least in part to separate it from the "real" and to underscore its ceremo-

Fig. 32 Leonardo da Vinci, *Five Characters in a Comic Scene*, c. 1490.

Pen and ink, 10 $^{3}\!/_{16} \times 8$ $^{3}\!/_{8}$ in. The Royal Collection. © 2004 Her Majesty Queen Elizabeth II.

Fig. 33 Mask (Bo Nun Amuin), Helmet, African, Baule peoples, Ivory Coast, 19th-20th century. Wood, pigment, egg shell (?), Height 33 ²⁵/₃₂ in. The Metropolitan Museum of Art, The Michael C. Rockefeller Memorial Collection, Gift of Adrian Pascal LaGamma, 1973. (1978.412.664). nial function. Clark is reading it through the eyes of Western civilization, which has referred to the African continent as "darkest" Africa ever since the Europeans first arrived there. The best light in which Clark's reading of the African mask can be seen is to think of it as the manifestation of a traditional Western convention in which the face is considered the outer expression of a psychological reality within. Distortions in the human face indicate or imply distortions or aberrations in the human psyche beneath. This particular convention can be traced back at least as far as Leonardo da Vinci's studies of grotesque heads (Fig. 32). Thus, when Clark sees an African mask, he reads into its features his own preconceptions of the psychic realities-violence, horror, or fright-that might lie beneath its surface.

The properties for which many in the Western world value African masks—the abstractness of their forms and their often horrifying emotional expressiveness—are not necessarily those most valued by their makers. For the Baule carvers of the Yamoussoukio area of the Ivory Coast, the Helmet Mask (Fig. 33) is a pleasing and beautiful object. But it has other conventional meanings as well.

This is the Dye sacred mask, according to one carver cited in Susan Vogel's *Perspectives: Angles on African Art.* "The god is a dance of rejoicing for me. So when I see the mask, my heart is filled with joy. I like it because of the horns and the eyes. The horns curve nicely, and I like the placement of the eyes and ears. In addition, it executes very interesting and graceful dance steps... This is a sacred mask danced in our village. It makes us happy when we see it. There are days when we want to look at it. At that time, we take it out and contemplate it."

The Baule carvers pay attention to formal elements, but the mask is seen as much as part of a process, the dance, as an object. To the Baule eye, the mask projects its performance. It is a vehicle through which the spirit world is made available to humankind. In performance, the wearer of the mask takes on the spirit of the place, and the carver quoted above apparently imagines this as he contemplates it.

If we do not immediately share with the Baule carvers the feelings evoked by the mask, we can be educated to see it in their terms. When we see the mask only through the conventions of

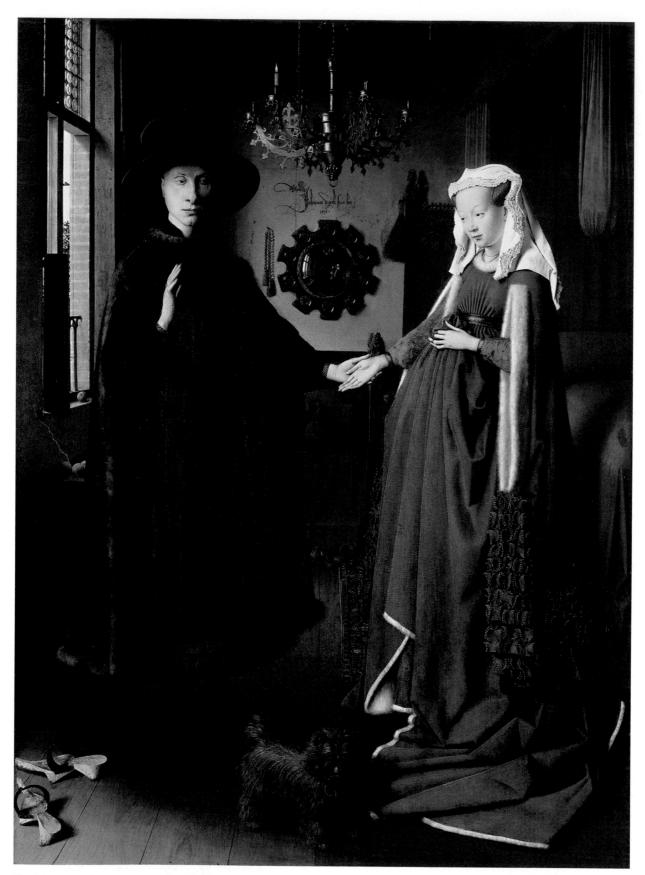

Fig. 34 Jan van Eyck, (1422–1441), "The Portrait of Giovanni Arnolfini and his wife Giovanna Cenami (The Arnolfini Marriage)". Oil on wood. 81.8 × 59.7. © National Gallery, London.

our own culture, then we not only radically alter its meaning and function, but also we implicitly denigrate the African viewpoint, or, at best, refuse to acknowledge it at all.

Iconography

Even within a culture, the meaning of an image may change or be lost over time. When Jan van Eyck painted The Marriage of Giovanni Arnolfini and Giovanna Cenami in 1434 (Fig. 34), its repertoire of visual images was well understood, but today much of its meaning is lost to the average viewer. For example, the bride's green dress, a traditional color for weddings, was meant to suggest her natural fertility. She is not pregnant-her swelling stomach was a convention of female beauty at the time, and her dress is structured in a way to accentuate it. The groom's removal of his shoes is a reference to God's commandment to Moses to take off his shoes when standing on holy ground. A single candle burns in the chandelier above the couple, symbolizing the presence of Christ at the scene. And the dog, as most of us recognize even today, is associated with faithfulness and in this context, particularly, with marital fidelity.

The study or description of such visual images or symbolic systems is called **iconography**. In iconographic images, subject matter is not obvious to any viewer unfamiliar with the symbolic system in use. Every culture has its specific iconographic practices, its own system of images that are understood by the culture at large to mean specific things. But what would Arab culture make of the dog in the van Eyck painting, since in the Muslim world dogs are traditionally viewed as filthy and degraded? From the Muslim point of view, the painting verges on nonsense.

Even to us, viewing van Eyck's work more than 500 years after it was painted, certain elements remain confusing. An argument has recently been made, for instance, that van Eyck is not representing a marriage so much as a betrothal, or engagement. We have assumed for generations that the couple stands in a bridal chamber where, after the ceremony, they will consummate their marriage. It turns out, however, that in the fifteenth century it was commonplace for Flemish homes to be decorated with hung beds with canopies. Called "furniture of estate," they were important status symbols commonly displayed in the principal room of the house as a sign of the owner's prestige and influence. The moment is not unlike that depicted by Shakespeare in Henry V, when the English king proposes to Katherine, the French princess: "Give me your answer; i' faith, do; and so clap hands and a bargain: how say you lady?" Such a touching of the hands was the common sign of a mutual agreement to wed. The painter himself stands in witness to the event. On the back wall, above the mirror, are the words Jan de Evck fuit hic. 1434-"Jan van Eyck was here, 1434" (Fig. 35). We see the backs of Arnolfini and his wife reflected in the mirror, and bevond them, standing more or less in the same

Fig. 35 Jan van Eyck, *The Marriage of Giovanni Arnolfini and Giovanna Cenami* (detail), 1434. Oil on oak panel. National Gallery, London, UK. Bridgeman Art Library.

Fig. 36 Buddha, adorned, seated in meditation on the serpent Mucilinda, c. 1100–1150. Photo: Private Collection/Superstock

place as we do as viewers, two other figures, one a man in a red turban who is probably the artist himself.

Similarly, most of us in the West probably recognize a Buddha when we see one, but most of us do not know that the position of the Buddha's hands carries iconographic significance. Buddhism, which originated in India in the fourth century BCE, is traditionally associated with the worldly existence of Sakyamuni, or Gautama, the Sage of the Sakya clan, who lived and taught around 500 BCE In his thirty-fifth year, Sakyamuni experienced enlightenment under a tree at Gaya (near modern Patna), and he became Buddha or the Enlightened One.

Buddhism spread to China in the third century BCE, and from there into Southeast Asia during the first century CE Long before it reached Japan, by way of Korea in the middle of the fifth century CE, it had developed a more or less consistent iconography, especially related to the representation of Buddha himself. The symbolic hand gestures, or *mudra*, refer both to general states of mind and to specific events in the life of Buddha. The *mudra* best known to Westerners, the hands folded in the seated Buddha's lap, symbolizes meditation (Fig. 36). The snake motif, seen here, illustrates a specific episode from the life of the Buddha in which the serpent-king Mucilinda made a seat out of its coiled body and spread a canopy of seven heads over Buddha to protect him, as he meditated, from a violent storm.

One of the most popular of the *mudra*, especially in East India, Nepal, and Thailand, is the gesture of touching the earth, right hand down over the leg, the left lying in the lap (Fig. 37). Biographically, it represents the moment when Sakyamuni achieved Enlightenment and became Buddha. Challenged by the Evil One, Mara, as he sat meditating at Gaya, Sakyamuni proved his readiness to reach Nirvana, the highest spiritual state, by calling the earth goddess to witness his worthiness with a simple touch of his hand. The gesture symbolizes, then, not only Buddha's absolute serenity, but the state of Enlightenment itself.

A Buddhist audience can read these gestures as readily as we, in the predominantly

Fig. 37 Buddha subduing Mara, Nepal, late 14th century. Gilted copper.

Photo: Christie's Images, London/Bridgeman Art Library, London/Superstock

Fig. 38 Lower nine panels of the center lancet window in the west front of Chartres Cathedral, showing the Nativity, Annunciation of the Shepherds, and the Adoration of the Magi, c. 1150. Chartres Cathedral, France. Giraudon/Art Resource, NY.

Christian West, can read incidents from the story of Christ. Figure 38 shows the lower nine panels of the center window in the west front of Chartres Cathedral in France. This window was made about 1150 and is one of the oldest and finest surviving stained-glass windows in the world. The story can be read like a cartoon strip, beginning at the bottom left and moving right and up, from the Annunciation (the angel Gabriel announcing to Mary that she will bear the Christ Child) through the Nativity, the Annunciation to the Shepherds, and the Adoration of the Magi. The window is usually considered the work of the same artist who was commissioned by the Abbot Suger to make the windows of the relic chapels at Saint-Denis, which portray many of the same incidents. "The pictures in the windows are there," the Abbot explains in his writings, "for the sole purpose of showing simple people, who cannot read the Holy Scriptures, what they must believe." But he understood as well the expressive power of this beautiful glass. It transforms, he said, "that which is material into that which is immaterial." Suger understood that whatever story the pictures in the window tell, whatever iconographic significance they contain, and whatever words they generate, it is, above all, their art that lends them power.

THE **CRITICAL** PROCESS Thinking about Visual Conventions

 \bigvee ery rarely can we find the same event documented from the point of view of two different cultures, but two images, one by John Taylor, a journalist hired by Leslie's Illustrated Gazette (Fig. 39), and the other by the Native American artist Howling Wolf (Fig. 40), son of the Chevenne chief Eagle Head, both depict the October 1867 signing of a peace treaty between the Cheyenne, Arapaho, Kiowa, and Comanche peoples and the United States government at Medicine Lodge Creek, a tributary of the Arkansas River, in Kansas. Taylor's illustration is based on sketches done at the scene, and it appeared soon after the events. Howling Wolf's work, actually one of several depicting the events, was done nearly a decade later, after he was taken east and imprisoned at Fort Marion in St. Augustine, Florida, together with his father and 70 other "ringleaders" of the continuing Native American insurrection in the Southern

Plains. While in prison, Howling Wolf made many drawings such as this one, called "ledger" drawings because they were executed on blank accountants' ledgers.

Even before he was imprisoned, Howling Wolf had actively pursued ledger drawing. As Native Americans were introduced to crayons, ink, and pencils, the ledger drawings supplanted traditional buffalo hide art, but in both the hide paintings and the later ledger drawings, artists depicted the brave accomplishments of their owners. The conventions used by these Native American artists differ greatly from those employed by their Anglo-American counterparts. Which, in your opinion, is the more representational? Which is the more abstract?

Both works possess the same overt content—that is, the peace treaty signing—but how do they differ in form? Both Taylor and Howling Wolf depict the landscape, but how

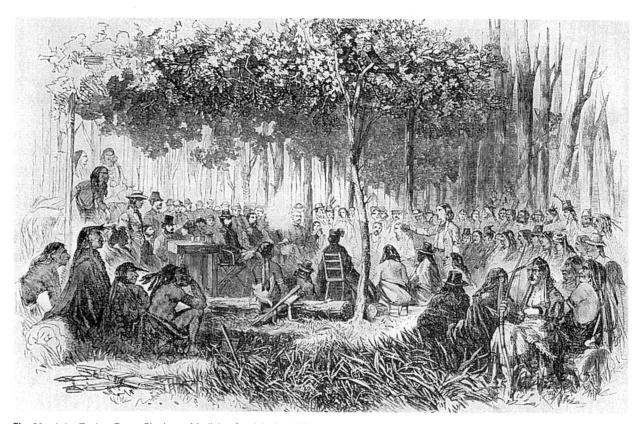

Fig. 39 John Taylor, Treaty Signing at Medicine Creek Lodge, 1867. Drawing for Leslie's Illustrated Gazette, September–December. 1867, as seen in Douglas C. Jones, The Treaty of Medicine Lodge, page xx, Oklahoma University Press, 1966.

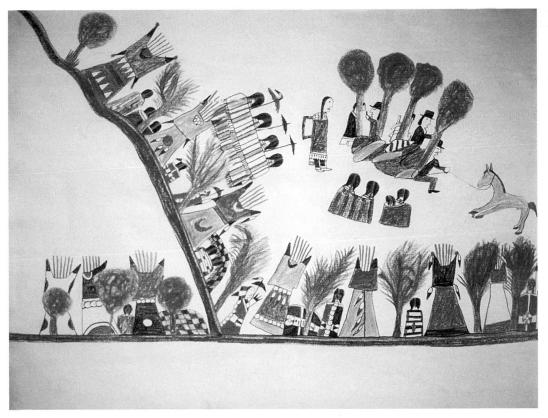

Fig. 40 Howling Wolf, *Treaty Signing at Medicine Creek Lodge*, 1875–1878. Ledger drawing, pencil, crayon, and ink on paper, 8 × 11 in. New York State Library, Albany, New York.

do they differ? Can you determine why Howling Wolf might want to depict the confluence of Medicine Creek and the Arkansas in his drawing? It is as if Howling Wolf portrays the events from above, so that simultaneously we can see tipis, warriors, and women in formal attire, and the grove in which the United States soldiers meet with the Indians. Taylor's view is limited to the grove itself. Does this difference in the way the two artists depict space suggest any greater cultural differences? Taylor's work directs our eyes to the center of the image, while Howling Wolf's does not. Does this suggest anything to you?

Perhaps the greatest difference between the two depictions of the event is the way in which the Native Americans are themselves portrayed. In Howling Wolf's drawing, each figure is identifiable—that is, the tribal affiliations and even the specific identity of each individual are revealed through the iconography of the decorations of his or her dress and tipi. How, in comparison, are the Native Americans portrayed in Taylor's work? In what ways is Taylor's work ethnocentric?

One of the most interesting details in Howling Wolf's version of the events is the inclusion of a large number of women. Almost all of the figures in Howling Wolf's drawing are, in fact, women. They sit with their backs to the viewer, their attention focused on the signing ceremony before them. Their braided hair is decorated with customary red paint in the part. This convention is of special interest. When the Plains warrior committed himself to a woman, he ceremonially painted her hair to convey his affection for and commitment to her. Notice the absence of any women in Taylor's depiction, as opposed to their prominence in Howling Wolf's. What does this suggest to you about the role of women in the two societies?

CHAPTER

THE POWER OF IMAGINATION

THE IDEA OF THE BEAUTIFUL

■ Works in Progress Pablo Picasso's *Les Demoiselles d'Avignon*

> ■ The Critical Process Thinking about the Themes of Art

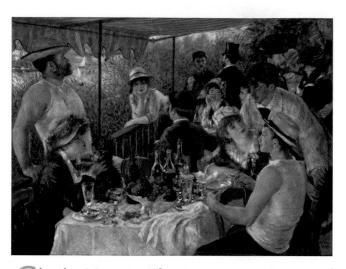

laude Monet's The Regatta at Argenteuil (Fig. 41) is one of the great examples of Impressionism, a mode of painting that dominated late nineteenth-century art in the Western world, especially in France. Impressionism takes its name from its particular way of seeing-not the careful and exact gaze of a painter determined to represent every detail of a scene exactly as it appears, but a quick glance at a more fleeting or transitory scene. The impressionist painter captures the play of light on the surface of the world with a technique noted for its purposeful sketchiness. Impressionists do not paint things so much as their impressions of things. Thus Monet would tell the American painter Lilla Cabot Perry: "When you go out to paint, try to forget what objects you have before you-a tree, a house, a field, or whatever. Merely think, here is a little square of blue, here an oblong of pink, here a streak of yellow, and paint it just as it looks to you, the exact color and shape, until it gives you your own naïve impression of the scene before you."

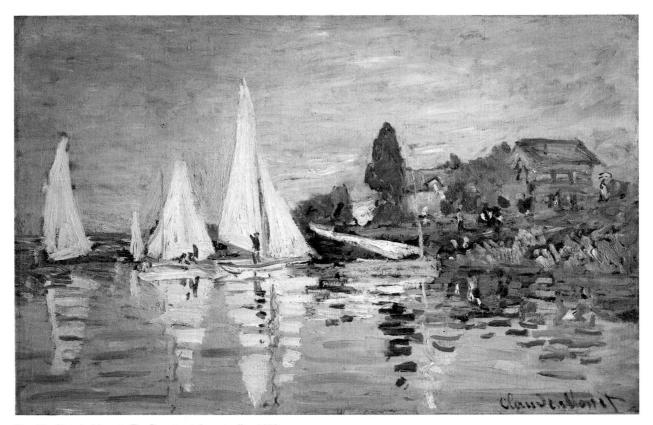

Fig. 41 Claude Monet, *The Regatta at Argenteuil*, c. 1872. Oil on canvas, 19 × 29 ½ in. Musée d'Orsay, Paris. Scala/Art Resource, New York.

Monet's intentions, however, are far more complex than simply capturing his impressions of the scene. His purpose is to question the nature of representation itself. Notice how, in its reflection in the water, the shoreline scene disintegrates into a sketchy series of broad dashes of paint. On the surface of the water, the mast of the green sailboat on the right seems to support a red and green sail, but this "sail" is really the reflection of the red house and cypress tree on the hillside. Monet seems to argue that the relationship between his painting and reality is comparable to the relationship between the surface of the water and the shoreline above. Both of these surfaces-canvas and water-reflect the fleeting quality of sensory experience.

In these terms, it could be said that Monet's theme is the very nature of art, a problem he approaches in three interrelated ways. First, *The Regatta at Argenteuil* embodies the relationship between the artist and the world around him, reflecting both. Second, even while it describes things as they are in the here and now, the painting suggests that through art the everyday world can be transcended, elevated by the artistic imagination to a different order of reality. And art accomplishes this transcendent feat, finally, by making something beautiful out of the ordinary-though, as we will see, the idea of the "beautiful" is more complex than we might at first suppose. In this chapter, we will consider all three of these interrelated ideas as "sub-themes" of the "grand" theme-What is the nature of art?-a question all artists ask themselves almost continually. What is the relationship between artists and the world around them? What is the artistic imagination, and how does it impact our understanding of the world? And what, finally, is this idea we call the "beautiful"?

THE REPRESENTATION OF THE WORLD

It is difficult to say what drives us in the West to imitate the world around us in our art, an impulse that many other cultures do not share. In part, we admire and value the technical virtuosity of artists who are able to translate what they see before their eyes into true likenesses. Interestingly, this value, which dominated the civilization of ancient Greece, for instance, disappeared in Western culture for more than a thousand years after the birth of Christ. But beginning in the Renaissance and culminating in the great encyclopedic cataloguing of the world that characterized the nineteenth century-an era marked by the invention of the greatest imitator of them all, photography-Western art seems to have been driven by a more general cultural quest for an ever more exact and specific knowledge of the world.

The desire to represent the natural world perhaps derives from our sense that our relationship to nature somehow defines us. As a culture, we claim to have "tamed" the wild, even as we know that nature is fully capable, in earthquake and storm, of wreaking havoc upon our works. We seek to protect the fragile ecology of the natural world in parks and wilderness areas, even as we plunder it to provide natural resources for our cities and states.

The tension and conflict between the uncontrollable forces of nature and the civilizing powers of human society dominated American art and literature in the nineteenth century. The "conquest" of the North American continent, particularly its western regions, provided a constant and compelling example of the impasse between nature and civilization. As early as 1834, the American painter Thomas Cole painted this theme in a series of five paintings called, collectively, The Course of Empire (Figs. 42-46). The paintings represent, according to Cole, "the History of a Natural Scene, as well as an Epitome of Man; showing the natural changes of Landscape and those effected by Man in his progress from Barbarism to Civilization-to the state of Luxury-to the vicious state or state of Destruction, etc." In the first painting of the cycle, The Savage State, prehistoric hunters chase a stag, smoke rising from their encampment in the distance. Next comes the Pastoral or Arcadian State, where shepherds tend their flocks while a plowman tills his field to the left. Smoke rises

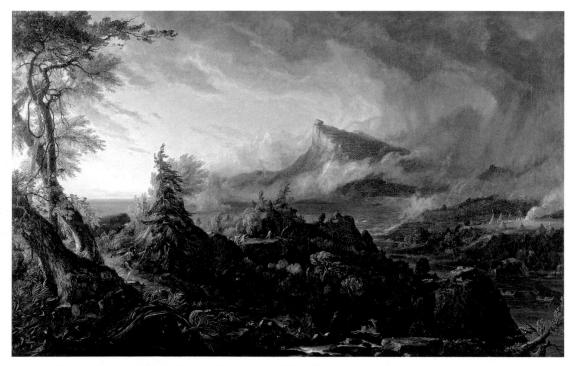

Fig. 42 Thomas Cole, The Course of Empire Savage State, 1834–1836.
 Oil on canvas, 39 ¼ × 63 ¼ in.
 Collection of the New York Historical Society, acc. no. 1858.1, neg. no. 6045.

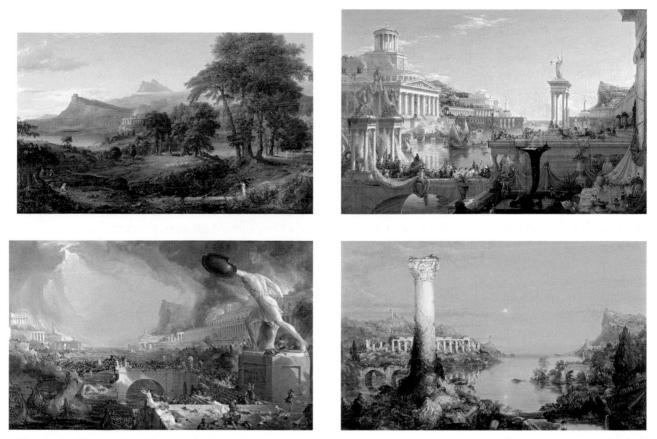

Fig. 43-46Thomas Cole, The Course of Empire, 1834–1836.Top left: The Pastoral or Arcadian State, 1834. Oil on canvas, 39 ¼ × 63 ¼ in.Collection of The New York Historical Society, acc. no. 1858.2, neg. no. 6046.

Top right: *The Consummation of Empire*, 1835–1836 Oil on canvas, 51 $\frac{1}{4} \times 76$ in. Collection of The New York Historical Society, acc. no. 1858.3, neg. no. 6047.

Lower left: *Destruction*, 1836. Oil on canvas, $39 \frac{1}{4} \times 63 \frac{1}{4}$ in. Collection of The New York Historical Society, acc. no. 1858.4, neg. no. 6048.

Lower right: *Desolation*, 1836. Oil on canvas, 39 ¹/₄ × 63 ¹/₄ in. Collection of The New York Historical Society, acc. no. 1858.5, neg. no. 6049.

here from a stone temple in the middle distance. This is the ideal "middle ground," halfway between wild nature and civilization proper, representing an ideal state of balance and harmony. The third painting of the series, The Consummation of Empire, is the largest of the five and was conceived to be surrounded by the other four. Here an emperor, robed in red and standing atop a carriage drawn by an elephant, returns to the city in triumph, but it is a triumph short-lived. In the fourth painting, Destruction, the empire collapses in war. Finally, in Desolation, a scene reminiscent of the state of Greek and Roman ruins as the eighteenth- and nineteenthcentury tourists discovered them in Europe, nature reclaims the landscape.

The five paintings also represent the cycle of the seasons, beginning in spring and ending in autumn. They move, furthermore, from dawn to dusk, civilization reaching its apogee at high noon. The permanence of the natural world is symbolized by the rock-topped mountain that rises above each painting. As opposed to both the passing of time and the fleeting quality of human civilization, the promontory remains constant and enduring.

Cole's cycle rehearses a whole range of relationships between humankind and nature. At its most balanced, in the *Pastoral or Arcadian State*, the relationship resembles the harmonious world of the garden. The garden not only embodies the natural world, it also reflects the sensibilities of its creator. In the Fig. 47 Claude Monet, The Artist's House at Argenteuil, 1873.
Oil on canvas, 23 ⁷/₈ × 29 ¹/₈ in. The Art Institute of Chicago. The Mr. and Mrs. Martin A. Ryerson Memorial Collection, 1933.1153.
Photo © 2002, The Art Institute of Chicago. All rights reserved.

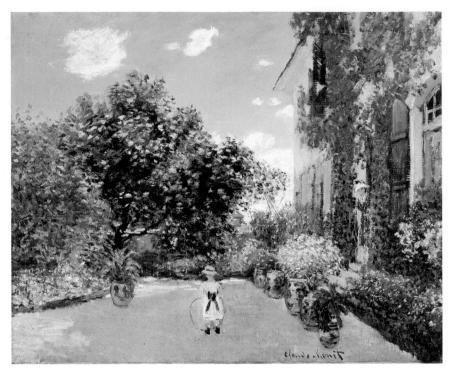

tranquility of his own garden at Argenteuil, which he celebrates in painting after painting in the early 1870s (Fig. 47), Monet was able to find respite from the pressures of urban life. When he moved, in the 1880s, up river to Giverny, site of his famous water lily garden, he removed himself even further from the kind of worldly turmoil he depicted in such paintings as *Le Pont de l'Europe* (Fig. 48). One of a series of paintings of the Saint-Lazare railroad station in Paris, it is strikingly similar in mood to Cole's *Destruction* from the *Course of Empire* cycle.

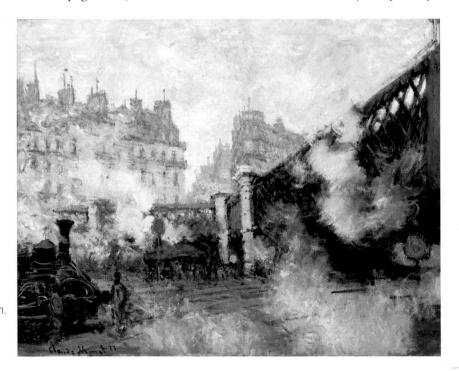

Fig. 48 Claude Monet, Le Pont de l'Europe. Gare Saint-Lazare, 1877. Oil on canvas, 25 ¼ × 31 ⅛ in. Musée Marmottan, Paris, France. Giraudon/Art Resource, New York.

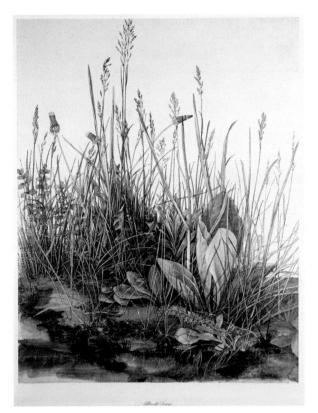

 Fig. 49 Albrecht Dürer, The Great Piece of Turf, 1503.
 Watercolor, 16 ¼ × 12 ⅓ in. Graphische Sammlung Albertina, Vienna.
 © 2004 Nimatallah/Art Besource.

Both paintings reflect not just the reality of modern life, on the one hand, and war, on the other, but also their artists' feelings in the face of such smoke and storm. Both Cole and Monet depict the world as they do in order to tell us something about themselves, something about their own values and beliefs.

It is important to recognize, furthermore, that the transcience of the natural world-not only its constant change from hour to hour, day to day, and season to season, but its very fragility-is answered by the relative permanence of the work of art itself. Nature changes, but the work of art endures, much like the promontory in Cole's Course of Empire paintings. A work such as Albrecht Dürer's The Great Piece of Turf (Fig. 49) documents the fertile density of a summer pasture in a manner that suggests an almost ecological interest in the environment. The work is roughly life-size, and we are able to identify in it not only a number of species-the daisy, dandelion, pantain, cock's foot, yarrow, and speedwell, among others-but also the time and place in which Dürer painted it-these are plants typically found at the edges of Franconian meadows of the German Rhineland in May. Here an ordinary patch of ground, the kind that we would never pause to observe carefully or might even trample down, is revealed to be as visually interesting as a magnificent sunset. Such closeness of observation would lead to the development of the biological sciences. Painting in 1503, Dürer was far in advance of his time-the word "biology" would not enter the English language in its modern sense until around 1819. (Before then, the word meant the study of human life and character.) In the end, however, the painting tells us as much about the artist-his acute interest in observation of the smallest phenomena of nature—as it does about the biological diversity of a German meadow.

We represent the world, then, because we see ourselves reflected there. In nature, we see something of our own interests and habits of mind. In the more than a thousand years between the birth of Christ and the Renaissance, we longed to see something else—God or salvation. We looked, at any rate, not out on the world, but beyond it, to the heavens or the afterlife. Still, there is more to art—and life than the material world in which we find ourselves. There is certainly something greater. Let's call it "imagination."

THE POWER OF IMAGINATION

Anyone who has ever fallen in love has experienced very real feelings that transcend the material reality of the outside world. There are many imaginative spaces that art has traditionally attempted to represent, from our spiritual or religious feelings, to our innermost desires and dreams, to our personal sense of what moves us emotionally. But the paradox is this: To represent the immaterial is to give it material form.

For example, the idea of daring to represent the Christian God has, throughout the history of the Western world, aroused controversy. In seventeenth-century Holland, images of God were banned from Protestant churches. As one contemporary Protestant theologian put it, "The image of God is His Word"—that is, the Bible—and "statues in human form, being an earthen image of

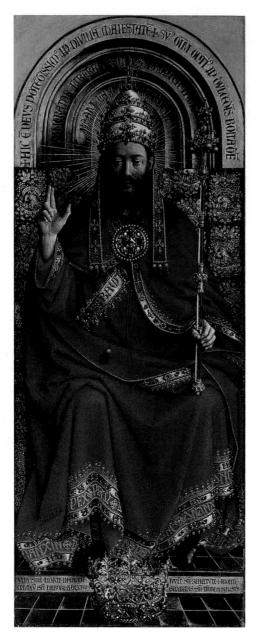

Fig. 50 Jan van Eyck, *God.* Panel from the Ghent Altarpiece, c. 1432. St. Bavo's, Ghent. Scala/Art Resource, New York.

visible, earthborn man [are] far away from the truth." In fact, one of the reasons that Jesus, for Christians the son of God, is so often represented in Western art, is that representing the son, a real person, is far easier than representing the father, a spiritual unknown who can only be imagined.

Nevertheless, artists in all cultures have always tried to depict their gods. It is the power of their imaginations that has allowed them to do so. One of the most successful depictions in Western culture was painted by Jan van Eyck

nearly 600 years ago as part of an altarpiece for the city of Ghent in Flanders (Fig. 50). Van Eyck's God is almost frail, surprisingly young, apparently merciful and kind, and certainly richly adorned. Indeed, in the richness of his vestments, van Eyck's God apparently values worldly things. Van Eyck's painting seems to celebrate a materialism that is the proper right of benevolent kings. Behind God's head, across the top of the throne, are Latin words that, translated into English, read: "This is God, all powerful in his divine majesty; of all the best, by the gentleness of his goodness; the most liberal giver, because of his infinite generosity." God's mercy and love are indicated by the pelicans embroidered on the tapestry behind him, which in Christian tradition symbolize self-sacrificing love, for pelicans were believed to wound themselves in order to feed their young with their own blood if other food was unavailable.

Different cultures represent their gods in entirely different ways. In Hawaiian society, before contact with the West, each man worshipped a specific deity related to his profession. Gods existed for canoemakers, fishermen, and the makers of the Polynesian bark cloth called kapa. Farmers generally worshipped Lono, the rain god, father of waters, and god of thunder and lightning. But Kamehameha I (c. 1758–1819), the Hawaiian king who first consolidated the islands under one rule, worshipped the war god Kukailimoku ("Ku, Snatcher of Islands"). Kamehameha ordered the construction of a sacrificial temple enclosure called a *heiau* near his home and installed images of Kukailimoku in it. A wellpreserved statue of Kukailimoku, from one of Kamehameha's *heiau*, captures the god's ferocity (Fig. 51). His head is disproportionately large because it is the site of his mana. The Pacific Islanders believed that individuals, objects (both works we, in the West, might call art, as well as more ordinary objects), and places are imbued with mana, an invisible but forceful spiritual substance that is the manifestation of the gods on earth. Chiefs, who were believed to be descended from the gods, were thought to be born with considerable quantities of mana, nobility with somewhat less, and commoners with almost none. The mana of a person (or object or place) was protected by

Fig. 51 Kukailimoku, Hawaii, late 18th or early 19th century. Wood, height, 7 ft. 7 in. Gift of W. Howard. © The Trustees of the British Museum.

tapu, a strict state of restriction indicating that an object or person cannot be touched or a place entered. A chief's food, for instance, might be protected by *tapu*. People might increase their *mana* by skillful or courageous acts, or by wearing certain items of dress. This representation of the god Kukailimoku was believed to possess extraordinary *mana*. His nostrils flare menacingly, and his mouth, surrounded by what may be tattoos or scarification, is ferociously open, perhaps in a war cry, suggesting his *tapu*. His headdress is decorated with small, stylized pigs, possibly symbolic of wealth. He conveys the ferocity of Kamehameha I himself, the ferocity required to bring all of the islands of Hawaii under his rule, "snatching" them, as Kukailimoku's name suggests.

Van Eyck's God and the Hawaiian gods are all extremely personal ones. They reflect each artist's imaginative response to the question of who God is and what God might look like. Any act of imagination of this kind is necessarily subjective—that is, it exists in the mind of the artist, or in the artist's culture, not in the world as we know it.

Abstract and nonobjective art have always been open to the charge of being so subjective that they are virtually inaccessible to the average person. This subjectivity is, nevertheless, fundamental to the history of modern art. Picasso's portrait of *Gertrude Stein* (Fig. 52) is a case in point. The painting was begun in the winter of 1905–1906. Stein would visit Picasso's studio nearly every day to pose for the portrait, but Picasso had a terrible time painting her face. Finally, after more than 80 sittings, Picasso, in complete frustration, painted out Stein's head and departed for Spain,

Fig. 52 Pablo Picasso, Gertrude Stein, 1906.
 Oil on canvas, 39 % × 32 in. The Metropolitan Museum of Art, New York. Bequest of Gertrude Stein, 1947 (47.106).
 Photo © 1996 The Metropolitan Museum of Art. © 2003 Estate of Pablo Picasso/Artists Rights Society (ARS), New York.

leaving a great blank in the middle of the canvas. In the late summer he returned, stood before the canvas, and painted Stein's face from memory. When, some months later, Stein's friend Alice B. Toklas told Picasso how much she admired the painting, he thanked her. "Everyone says that she does not look like it," Picasso said, smiling, "but that does not make any difference—she will."

The story could be said to define a trend in Western art that had slowly been transforming painting for nearly 100 years. Painters like Picasso no longer felt compelled to represent the world as it is but instead found themselves free to paint what they felt or imagined it to be. In other words, for Picasso, his own subjective knowledge of Stein was more "real" than what she objectively looked like. This belief in the reality and power of the imagination dominates the history of modern art. In his 1928 book Surrealism and Painting, André Breton, the leader of the French Surrealists, asserted that the mistake of painters "has been to believe that a model could be derived only from the exterior world. . . . [Painters must] either seek a *purely interior model* or cease to exist." Surrealism is a style of art in which the reality of the dream, or the subconscious mind, is seen as more "real" than the surface reality of everyday life. Its reality is a higher reality. The Surrealist Salvador Dali called paintings such as The Persistence of Memory (Fig. 53) "handpainted dream photographs." The limbless

Fig. 53 Salvador Dali, The Persistence of Memory, 1931. Oil on canvas, 9 ½ × 13 in. The Museum of Modern Art. Licensed by Scala/Art Resource, NY. © 1999 Demart Pro Arte®, Geneva/Artists Rights Society (ARS), New York.

figure lying on the ground like a giant slug is actually a self-portrait of the artist, who seems to have moved into a landscape removed from time and mind.

Similarly, because he believed that he was directly presenting the reality of his own imagination on canvas, the Abstract Expressionist painter Robert Motherwell refused to admit that his paintings were abstract, let alone nonobjective-though certainly it is hard to see any recognizable forms in Elegy to the Spanish Republic XXXIV (Fig. 54). Speaking of paintings such as this one, Motherwell wrote in 1955: "I never think of my pictures as 'abstract'.... Nothing can be more concrete to a man than his own felt thought, his own thought feeling. I feel most real to myself in the studio, and resent any description of what transpires there as 'abstract'-which nowadays . . . signifies something remote from reality. From whose reality? And on what level?" The painting's title refers to the Fascist defeat of the democratic Spanish Republican forces by General Franco's forces just before World War II. It marks for Motherwell the terrible death of liberty itself, a reality he was unwilling to think of as being "abstract" in any sense of the word. He thought of the black forms and their lighter background as elemental "protagonists in the struggle between life and death." Nothing, for him, could be more real than that struggle.

The imagination, in sum, is an instrument of transformation. For the artist, it is the means by which the subjective and abstract idea is given concrete reality in the work of art. For many artists, this simple fact—the transformation of idea into image—is beautiful in itself. It is this transformation that makes their work meaningful.

THE IDEA OF THE BEAUTIFUL

If life itself is a fleeting event, our experiences in life are even more so. Art has traditionally concerned itself with capturing these ordinary experiences, especially the more pleasurable ones. This is one reason we all photograph family get-togethers. In painting, such depictions of everyday life are called **genre** paintings. Auguste Renoir's *The Luncheon of the Boating Party* (Fig. 55) depicts an afternoon

Fig. 54 Robert Motherwell, Elegy to the Spanish Republic No. 34, 1953–1954.
 Oil on canvas, 80 × 100 in. Albright-Knox Art Gallery, Buffalo, New York. Gift of Seymour H. Knox, 1957.
 Art © Dedalus Foundation, Inc. Licensed by VAGA, New York, NY.

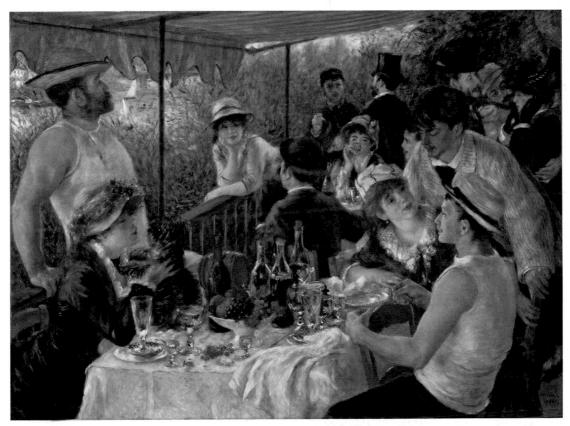

Fig. 55Pierre Auguste Renoir, The Luncheon of the Boating Party, 1880–1881.Oil on canvas, 51 1/4 × 68 1/8 in. The Phillips Collection, Washington, D.C. Acquired 1923.

Fig. 56 Edouard Manet (1832–1883), *"The Asparagus,"* 1880. Musée d'Orsay, Paris, France. Reunion des Musees Nationaux/Art Resource, NY. © 2007 ARS Artists Rights Society, NY

gathering on the terrace of a restaurant near Chatou on the banks of the Seine, north of Paris. So "real" is the scene that we can identify with some certainty many of the people in it. Standing at the left, with his back to the river, is Alphonse Fornaise, son of the restaurant's proprietor. The woman seated below him, about to kiss the little dog, is Renoir's future wife, Aline Charigot. The lushness of Renoir's color, and the almost tangible quality of his impressionist brushwork, lend the painting an almost sensual reality. When the painting was first exhibited in 1882, one critic captured its spirit with particular accuracy: "It is a charming work," he wrote, "full of gaiety and spirit, its wild youth caught in the act, radiant and lively, frolicking at high noon in the sun, laughing at everything, seeing only today and mocking tomorrow. For them eternity is in their glass, in their boat, and in their songs."

The implicit theme of this painting is that the charming people it depicts have transformed ordinary experience into something special, something beautiful. They have turned ordinary life into "the good life." One of the purposes of art is to make everyday objects and events more pleasurable or beautiful, and one of the most extraordinary instances of this in the history of art is Edouard Manet's tiny painting *The Asparagus*, a single spear painted in 1880 (Fig. 56). Manet sent the picture as a gift to Charles Ephrussi, who had purchased another small still life, *Bunch of Asparagus*, paying Manet rather more than the asking price. Accompanying the gift was a note from Manet: "This one was missing from your bunch."

Nothing could be more trivial, but nothing in its triviality more masterfully painted. The asparagus spear sits very near the viewer in the foreground of the painting, at a slight angle to a vast expanse of tabletop extending behind it, almost the same color as the asparagus spear but just a degree grayer. The spear itself is painted with surprising hints of color—both red and green—and with a looseness of brushwork that suggests Manet's sensual engagement with his subject. Even the abbreviated signature, scrawled in the top right of the

Fig. 57 Kane Kwei (Teshi tribe, Ghana, Africa), Coffin Orange, in the Shape of a Cocoa Pod, c. 1970. Polychrome wood, 34 × 105 ½ × 24 in. The Fine Arts Museums of San Francisco. Gift of Vivian Burns, Inc., 74.8.

painting, a completely anti-traditional placement, declares the immediacy of Manet's involvement with his subject matter.

But why such a degree of engagement with so slight a subject? White asparagus is one of the great delicacies of European cuisine. It is grown underground, so as to prevent any chlorophyll from greening the spear, and its season is short, a few weeks in late spring. White asparagus is, in short, a sign of the good life. And this single spear, sitting on the table, evokes all the sensual appetites of Parisian society.

In the West, we are used to approaching everyday objects made in African, Oceanic, Native American, or Asian cultures in museums as "works of art." But in their cultures of origin, such objects might be sacred tools that provide divine insight and inspiration. Or they might serve to define family and community relationships, establishing social order and structure. Or they might document momentous events in the history of a people. Or they might serve a simple utilitarian function, such as a pot to carry water or a spoon to eat with, or, as in the case of the work by Kane Kwei of Ghana (Fig. 57), the object might be a coffin to bury someone in. Trained as a carpenter, Kwei first made a decorative coffin for a dying uncle, who asked him to produce one in the shape of a boat. In Ghana, coffins possess a ritual significance, celebrating a successful life, and Kwei's coffins delighted the community. Soon he was making fish and whale coffins for fishermen, hens with chicks for women with large families, Mercedes Benz coffins for the wealthy, and cash crops for farmers, such as the 8 ½ foot cocoa bean coffin illustrated here. In 1974, an enterprising San Francisco art dealer brought examples of Kwei's work to the United States, and today the artist's large workshop makes coffins for both funerals and the art market.

Another purely practical piece that transcends its functionality is a coconut grater from Micronesia (Fig. 58). To use this tool, one sits on the back of the horse-like form and grates the coconut across the serrated blade on

Fig. 58 Coconut grater. Kapingamarangi, Caroline Islands, 1954. Wood, shell blade attached with coconut sennit. Height, 19 ½ inches. Private collection.

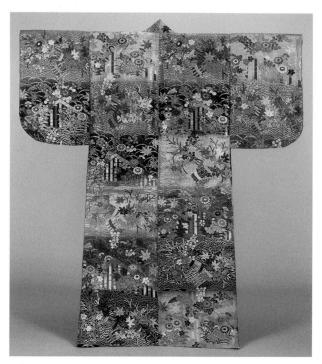

Fig. 59 *Karaori* kimono, Middle Edo Period, Japan, c. 1700. Brocaded silk, length, 60 in. Tokyo National Museum.

the top of the animal's head so that the grated coconut falls into a bowl below. But the practicality of the "tool" is almost irrelevant. Its streamlined form, its almost austere simplicity, is beautiful in its own right.

Perhaps the object upon which cultures lavish their attention most is clothing. Clothing serves many more purposes than just protecting us from the elements: It announces the wearer's taste, self-image, and, perhaps above all, social status. The Karaori kimono illustrated here (Fig. 59) was worn by a male performer who played the part of a woman in Japanese Noh theater. In its sheer beauty, it announced the dignity and status of the actor's character. Made of silk, brocaded with silver and gold, each panel in the robe depicts autumn grasses, flowers, and leaves. Thus the kimono is more an aesthetic object than a functional one-that is, it is conceived to stimulate a sense of beauty in the viewer.

Almost all of us apply, or would like to apply, this aesthetic sense to the places in which we live. We decorate our walls with pictures, choose apartments for their visual appeal, ask architects to design our homes, plant flowers in our gardens, and seek out wellmaintained and pleasant neighborhoods. We want city planners and government officials to work with us to make our living space more appealing.

Public space is particularly susceptible to aesthetic treatments. The great Gothic churches of the late Middle Ages were, like the stained glass that adorned them, conceived to move the congregation's aesthetic, as much as their spiritual, sense. One of the most beautiful of these churches is the tiny chapel of Sainte Chapelle (Fig. 60), in the heart of Paris, near the great Notre Dame Cathedral. Built by the king to house religious relics he had purchased, including the Crown of Thorns and a piece of the original Cross, it was literally conceived as a giant jewel box, its windows sparkling like jewels themselves.

One of the newest standards of aesthetic beauty in public space has become its compatibility with the environment. A building's

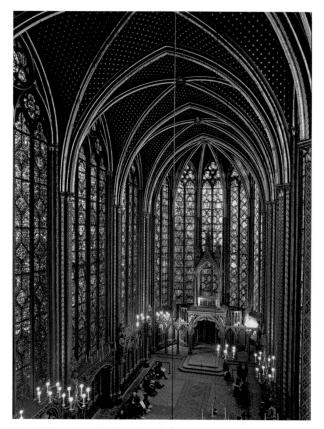

Fig. 60 Interior of Sainte Chapelle, Paris, 1243–1248. © Archim Bednorz, Koln.

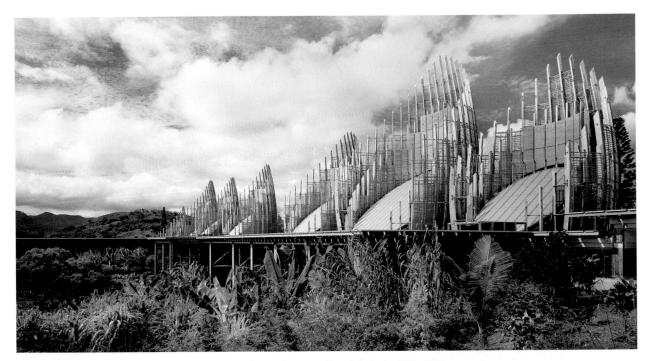

Fig. 61 Renzo Piano, Jean-Marie Tjibaou Cultural Center, Nouméa, New Caledonia, 1991–1998. © Hans Schlupp/architekturphoto.

beauty is measured, in the minds of many, by its self-sufficiency (that is, its lack of reliance on nonsustainable energy sources such as coal), its use of sustainable building materials (the elimination of steel, for instance, since it is a product of iron ore, a nonrenewable resource), and its suitability to the climate and culture in which it is built (a glass tower, however attractive in its own right, would seem out of place rising out of a tropical rainforest). These are the principles of what has come to be known as "green architecture."

The Jean-Marie Tjibaou Cultural Center in Nouméa, New Caledonia, an island in the South Pacific, illustrates these principles (Fig. 61). The architect is Renzo Piano, an Italian, but the principles guiding his design are anything but Western. The Center is named after a leader of the island's indigenous people, the Kanak, and it is dedicated to preserving and transmitting Kanak culture. Piano studied Kanak culture thorougly, and his design blends Kanak tradition with green architectural principles. The buildings are constructed of wood and bamboo, easily renewable resources of the region. Each of the Center's ten pavilions represents a typical Kanak dwelling (in a finished dwelling the vertical staves would rise to meet at the top, and the horizontal elements would weave in and out between the staves, as in basketry). Piano left the dwelling forms unfinished, as if under construction, but to a purpose-they serve as wind scoops, catching breezes off the nearby ocean and directing them down to cool the inner rooms, the roofs of which face south at an angle that allows them to be lit largely by direct daylight. As in a Kanak village, the pavilions are linked with a covered walkway. Piano describes the project as "an expression of the harmonious relationship with the environment that is typical of the local culture. They are curved structures resembling huts, built out of wooden joists and ribs; they are containers of an archaic appearance, whose interiors are equipped with all the possibilities offered by modern technology."

For many people, the main purpose of art is to satisfy our *aesthetic* sense, our desire to see and experience the beautiful. But as Robert Motherwell's representation of "the struggle

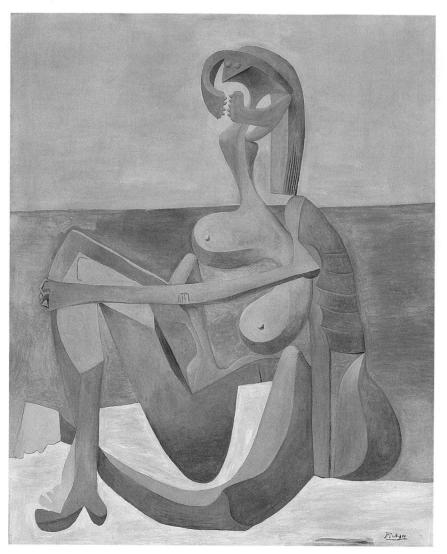

Fig. 62 Pablo Picasso, Seated Bather (La Baigneuse), 1930.
 Oil on canvas, 64 ¹/₄ × 51 in. Mrs. Simon Guggenheim Fund. (82.1950). The Museum of Modern Art, New York, NY, U.S.A.
 Digital Image ©The Museum of Modern Art/Licensed by Scala / Art Resource, NY.
 © 2007 ARS Artists Rights Society, NY.

between life and death" in his *Elegy to the Spanish Republic* demonstrates, (see Fig. 54) art often represents other truths, other realities that seem to have little to do with a purely aesthetic response to the world.

Many of Pablo Picasso's representations of women in the late 1920s and early 1930s are almost demonic in character. Most biographers believe images such as his *Seated Bather by the Sea* (Fig. 62) to be portraits of his wife, the Russian ballerina, Olga Koklova whom he married in 1918. By the late 1920s, their marriage was in shambles, and Picasso portrays her here as a skeletal horror, her back and buttocks almost crustacean in appearance, her horizontal mouth looking like some archaic mandible. Her pose is ironic, inspired by classical representations of the nude, and the sea behind her is as empty as the Mediterranean sky is gray. Picasso means nothing in this painting to be pleasing, except our recognition of his extraordinary ability to invent expressive images of tension. His entire career, since his portrayal of a brothel in his 1907 *Les Demoiselles d'Avignon* (see *Works in Progress*, p. 52), he represented his relation to

Fig. 63 Philippe de Champaigne, *Still Life* or *Vanitas* (tulip, skull, and hour glass). Oil on panel, 11 ¹/₄ × 14 ³/₄ in. Musée de Tessé, Le Mans, France. Photo: Bridgeman–Giraudon/Art Besource, New York.

women as a sort of battlefield between attraction and repulsion. There can be no doubt which side has won the battle in this painting.

From a certain point of view, the experience of such dynamic tension is itself pleasing, and it is the ability of works of art to create and sustain such moments that many people value most about them. That is, many people find such moments *aesthetically* pleasing. The work of art may not itself be beautiful, but it triggers a higher level of thought and awareness in the viewer, and the viewer experiences this intellectual and imaginative stimulus this higher order of thought—as a form of beauty in its own right.

The *vanitas* tradition of still life painting is specifically designed to induce in the spectator a higher order of thought. *Vanitas* is the Latin term for "vanity," and *vanitas* paintings, especially popular in Northern Europe in the seventeenth century, remind us of the vanity, or frivolous quality, of human existence. One ordinarily associates the contemplation of the normal subjects of still life paintings-flowers, food, books, and so on, set on a tabletop-with the enjoyment of the pleasurable things in life. The key element in a vanitas painting, however, is the presence of a human skull among these objects. The skull reminds the viewer that the material world-the world of still life-is fleeting, and that death is the end of all things. Such a reminder is called a momento mori-literally a "reminder of death." In Philippe de Champaigne's Vanitas (Fig. 6.3), the skull reminds us that the other elements in the painting are themselves short-lived. The hourglass embodies the quick passage of time. The cut flower will quickly fade, its petals dropping to the tabletop, its beauty temporary and conditional. Even the light in the room will soon disappear as darkness falls. Nevertheless, the vanitas is not about death, it is about the right way to live. It reminds the viewer that the material world is not as long-lasting as the spiritual, and that spiritual well-being is of greater importance than material wealth.

WORKS IN PROGRESS

ot long after finishing his portrait of Gertrude Stein (see Fig. 52), Picasso began working on a large canvas, nearly eight feet square, that would come to be considered one of the first major paintings of the modern era-and one of the least beautiful-Les Demoiselles d'Avignon (Fig. 66). The title, chosen not by Picasso but by a close friend, literally means "the young ladies of Avignon," but its somewhat tongue-in-cheek reference is specifically to the prostitutes of Avignon Street, the red-light district of Barcelona, Spain, Picasso's hometown. We know a great deal about Picasso's process as he worked on the canvas from late 1906 into the early summer months of 1907, not only because many of his working sketches survive but also because the canvas itself has been submitted to extensive examination, including X-ray analysis. This reveals early versions of certain passages, particularly the figure at the left and the two figures on the right, which lie under the final layers of paint.

An early sketch (Fig. 64) reveals that the painting was originally conceived to include seven figures-five prostitutes, a sailor seated in their midst, and, entering from the left, a medical student carrying a book. Picasso probably had in mind some anecdotal or narrative idea contrasting the dangers and joys of both work and pleasure, but he soon abandoned the male figures. By doing so, he involved the viewer much more fully in the scene. No longer does the curtain open up at the left to allow the medical student to enter. Now the curtain is opened by one of the prostitutes as if she were admitting us, the audience, into the bordello. We are implicated in the scene.

And an extraordinary scene it is. Picasso seems to have willingly abdicated any traditional aesthetic sense of beauty. There is nothing enticing or alluring here. Of all the nudes, the two central ones are the most traditional, and their facial features, particularly their brows and oval eyes, are closely related to Gertrude Stein's in his portrait of her. But their bodies are composed of a series of long lozenge shapes, hard angles, and only a few traditional curves. It is unclear whether the second nude from the left is standing or sitting, or possibly even lying down. (In the early drawing, she is clearly seated.) Picasso seems to have made her position in space intentionally ambiguous.

We know, through X-rays, that all five nudes originally looked like the central two. We also know that sometime after he began painting *Les Demoiselles*, Picasso visited the Trocadero, now the Museum of Man, in Paris, and saw in its collection of African sculpture, particularly African masks, an approach to the representation of the human face that was extraordinarily powerful. As in his portrait of Gertrude Stein, the masks freed him from representing exactly what his subjects looked like and allowed him to represent his *idea* of them instead.

Fig. 64 Pablo Picasso, Medical Student, Sailor, and Five Nudes in a Bordello (study for Les Demoiselles d'Avignon), Paris early 1907.

Charcoal and pastel, 18 $\frac{1}{2} \times 25$ in. Oeffentliche Kunstsammlung, Kupferstichkabinett Basel. Photo: Oeffentliche Kunstsammlung, Martin Buhler. © 2007 Estate of Pablo Picasso/Artists Rights Society (ARS), New York.

Pablo Picasso's LES DEMOISELLES D'AVIGNON

 Fig. 65 Pablo Picasso, Study for Les Demoiselles d'Avignon. Head of the Squatting Demoiselle, 1907. Inv.: MP 539. Gouache and Indian ink on paper, 24 ³/₄ × 18 ⁷/₈ in. Musée Picasso, Paris. Reunion des Musées Nationaux/ Art Resource, NY. © 2007 Estate of Pablo Picasso/Artists Rights Society (ARS), New York.

That idea is clearly ambivalent. Picasso probably saw in these masks something of the same "fear and darkness" that Kenneth Clark would find in them 60 years later in his book Civilisation (see the discussion of the African masks on pages 28, 31). But it is also clear that he found something liberating in them. They freed him from a slavish concern for accurate representation, and they allowed him to create a much more emotionally charged scene than he would have otherwise been able to accomplish. Rather than offering us a single point of view, he offers us many, both literally and figuratively. The painting is about the ambiguity of experience.

Nowhere is this clearer than in the squatting figure in the lower-

right-hand corner of the painting. She seems twisted around on herself in the final version, her back to us, but her head is impossibly turned to face us, her chin resting on her grotesque, clawlike hand. We see her, in other words, from both front and back. (Notice, incidentally, that even the nudes in the sketch possess something of this "double" point of view: Their noses are in profile though they face the viewer.) But this crouching figure is even more complex. An early drawing (Fig. 65) reveals that her face was originally conceived as a headless torso. What would become her hand was originally her arm. What would become her eyes were her breasts. And her mouth would begin as her bellybutton. Here we are witness to the extraordinary freedom of invention that defines all of Picasso's art.

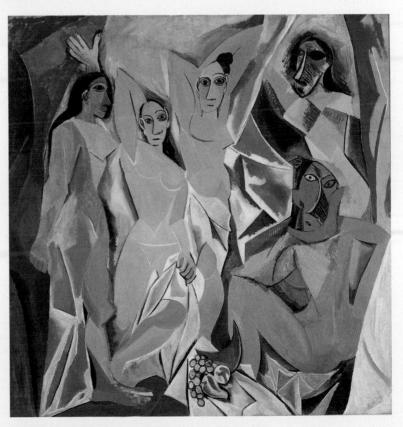

 Fig. 66 Pablo Picasso, Les Demoiselles d'Avignon, 1907.
 Oil on Canvas. 8' × 7'8". Acquired through the Lillie P. Bliss Bequest. The Museum of Modern Art/Licensed by Scala-Art Resource, NY.
 © 2007 Artists Rights Society (ARS), NY.

The central *Crucifixion* panel of Matthias Grünewald's *Isenheim Altarpiece* (Fig. 67) is one of the most tragic and horrifying depictions of Christ on the cross ever painted. Many people cannot bear to look at it. Rigor mortis has set in, Christ's body is torn with wounds and scars, his flesh is a greenish gray, his feet are mangled, and his hands are stiffly contorted in the agony of death. The painting portrays suffering, pure and simple. It causes us to ask some difficult questions. Can the ugly itself ever be art? Can the ugly be made, by the artist, to appear beautiful, and if so, does that cause us to ignore the reality of the situation?

Grünewald painted this altarpiece for a hospital chapel, and it was assumed that pa-

tients would find solace in knowing that Christ had suffered at least as much as they. In this painting, the ugly and horrible are transformed into art, not least of all because, as Christians believe, resurrection and salvation await Christ after his suffering. The line that runs down Christ's right side is, in fact, the edge of a double door that opens to reveal the Annunciation and the Resurrection behind. In the latter, Christ's body has been transformed into a pure, unblemished white, his hair and beard are gold, and his wounds are rubies.

Grünewald's *Crucifixion* shows how beauty can arise out of horror. The horror of the image is countered by the expressive drama of the scene itself. The ancient Greek

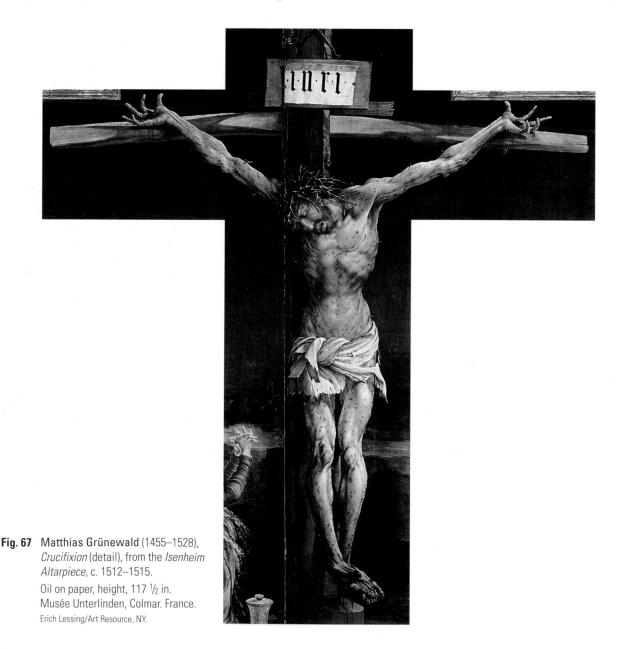

philosopher Socrates, in fact, argued that painters should be exiled from his ideal Republic on just these grounds. To him, the painter's ability to create an emotionally charged (and hence, he believed, illogical and irrational) scene was destructive to a society that should strive, instead, to attain truth, wisdom, and order. But for an artist like Grünewald, it is precisely the disjunction between the horror of what he depicts and the beauty of its implications that makes the work interesting. By making our relation to the painting so problematic, he creates a sense of tension that makes the work dynamic. Our feelings about it are not easily resolved. The painting demands our active response.

THE **CRITICAL** PROCESS Thinking about the Themes of Art

At the time of his death and for long afterward, Robert Mapplethorpe was probably the world's most notorious photographer, known to the general public chiefly for his photographs of sadomasochistic and homoerotic acts. Known as the "X Portfolio," these photographs were the focus of a continuing congressional debate, headed by Senator Jesse Helms of North Carolina, over funding of the National Endowment for the Arts, which par-

tially financed their scheduled exhibition at the Corcoran Gallery in Washington, D.C. the summer after Mapplethorpe's death. Many of these same photographs were seized a year after his death, when they were exhibited at the Cincinnati Arts Center, as police arrested the center's director, Dennis Barrie, for pandering and the use of a minor in pornography.

In the midst of these controversies, the remainder of Mapplethorpe's work was ignored. The "X Portfolio" was meant to be seen, for instance, in conjunction with a "Y Portfolio," a series of still lifes of flowers. Mapplethorpe's many stunningly beautiful flower photographs, such as *Parrot Tulip* (Fig. 68), take on a special poignancy in relation to his other work. In what way is this photograph not merely a still life? In what particular ways does it acknowledge the *vanitas* tradition? You might want to consider more than just the vase and flower. What about the lighting? What does it suggest? How does it compare to Philippe de Champaigne's *Vanitas*? Assuming, as well, that Mapplethorpe does have an interest in erotic, even pornographic, imagery, how does this image reflect or represent that aspect of his mind? What, all told, contributes to the aesthetic beauty of this image? What tensions are created in the collision of erotic and *vanitas* themes?

Fig. 68 Robert Mapplethorpe, Parrot Tulip, 1985. © 1985 The Estate of Robert Mapplethorpe.

Seeing the Value in Art

t the end of Chapter 3, we used Robert Mapplethorpe's Parrot Tulip to suggest the many complex meanings that works of art can have. Mapplethorpe's photography raises key questions about the value of art-not its monetary worth, but its intrinisic value to the individual and to society as a whole. These questions continue to be raised by contemporary art. A case in point is the controversy surrounding the exhibition Sensation: Young British Artists from the Saatchi Collection, which appeared at the Brooklyn Museum of Art October 2, 1999 through January 9, 2000. At the center of the storm was a painting called The Holy Virgin Mary (Fig. 69), by Chris Ofili, a Britishborn artist who was raised a Catholic by parents born in Lagos, Nigeria. The work's background gleams with glitter and dabs of yellow resin, a shimmering mosaic evoking medieval icons that contrasts with the soft, petal-like texture of the Virgin's blue-gray robes. What appears to be black-and-white beadwork turns out to be pushpins. Small cutouts decorate the space-bare bottoms from porn magazines meant to evoke putti,

ART AND ITS RECEPTION

ART, POLITICS, AND PUBLIC SPACE

Three Public Sculptures

The "Other" Public Art

■ Works in Progress Guillermo Gómez-Peña's *Temple of Confessions*

CHAPTER

The Critical Process Thinking about the Value of Art

Fig. 69 Chris Ofili, "The Holy Virgin Mary". 1996.
 Paper collage, oil paint, glitter, polyester, resin, map pins, and elephant dung on linen. 8 × 6 ft. The Saatchi Gallery, London.
 Photo: Diane Bondareff/AP World Wide Photos

the baby angels popular in Renaissance art. But most controversial of all is the incorporation of elephant dung, acquired from the London Zoo, into the work. Two balls of resin-covered dung, with pins stuck in them spelling out the words "Virgin" and "Mary," support the painting, and another ball of dung defines one of the Virgin's breasts.

Cardinal John O'Connor called the show an attack on religion itself. The Catholic League for Religious and Civil Rights said people should picket the museum. New York Mayor Rudolph W. Giuliani threatened to cut off the museum's city subsidy and remove its board if the exhibition was not canceled, calling Ofili's work, along with the work of several other artists, "sick stuff." (Taken to court, the Mayor was forced to back down.) Finally, Dennis Heiner, a 72-year-old Christian who was incensed by Ofili's painting, eluded guards and smeared white paint across the work. For Ofili, the discomfort his work generates is part of the point: His paintings, he says, "are very delicate abstractions, and I wanted to bring their beauty and decorativeness together with the ugliness of shit and make them exist in a twilight zone you know they're there together, but you can't really ever feel comfortable about it." Ofili exists in this same twilight zone, caught between his African heritage and his Catholic upbringing.

The Ofili example demonstrates the many complex factors that go into a judgment of art's value. In the rest of this chapter, we will explore the public nature of art in order to reach some conclusions about how our culture comes to value it.

PRIVATE			PUBLIC
0	0	O	0
artist as	artist as	artist as	artist as
experiencer	reporter	analyst	activist

Fig. 70 Suzanne Lacy, Spectrum of Artists' Roles, from Mapping the Terrain: New Genre Public Art, 1995.

ART AND ITS RECEPTION

In a recent book on public art, artist and activist Suzanne Lacy, whose own art we will consider at the end of this chapter, has provided a chart representing a spectrum of possible roles for the artist, from private to public (Fig. 70). These roles correspond closely to those outlined in Chapter 1. Artists as experiencers desire to give tangible form to their feelings about their world. Artists as reporters represent their world. Artists as analysts look beyond the immediate to reveal hidden or universal truths. And artists as activists help us see the world in new ways. They even expect their work to have an impact on the world. Questions of the *aesthetic*—that is, questions about knowing and appreciating the beautiful-are supplanted by questions of transformation-how artists can affect and change the world to make it a better, more beautiful place.

Lacy's chart is useful because it helps us see that from the extremely private moment when the artist first experiences the world, each of these possible roles is increasingly public in nature. The experiencer has no necessary audience—the experiencer is like a television receiver, taking information in. But the reporter assumes an audience, a public, and so does the analyst. They are both like transmitters, putting information out that they hope will be understood. The activist, finally, puts information out not only to be understood but also to make things happen.

The artist's relation to the public, it should be clear, depends on the public's understanding of what the artist is trying to say. But the history of the public's reception of art abounds in instances of the public's misunderstanding. In 1863, for example, Edouard Manet submitted his painting *Luncheon on the Grass*, more commonly known by its French name, *Déjeuner sur l'herbe* (Fig. 71), to the conservative jury that picked paintings for the annual Salon exhibition in Paris. It was rejected along with many other paintings considered "modern," and the resulting outcry forced Napoleon III to create a Salon des Refusés, an exhibition of works refused by the Salon proper, to let the public judge for itself the individual merits of the rejected works. Even at the Salon des Refusés, however, Manet's painting created a scandal. Some years later, in his novel *The Masterpiece*, Manet's friend Emile Zola wrote a barely fictionalized account of the painting's reception:

It was one long-drawn-out explosion of laughter, rising in intensity to hysteria.... A group of young men on the opposite side of the room were writhing as if their ribs were being tickled. One woman had collapsed on to a bench, her knees pressed tightly together, gasping, struggling to regain her breath.... The ones who did not laugh lost their tempers. . . . It was an outrage and should be stopped, according to elderly gentlemen who brandished their walking sticks in indignation. One very serious individual, as he stalked away in anger, was heard announcing to his wife that he had no use for bad jokes.... It was beginning to look like a riot . . . and as the heat grew more intense faces grew more and more purple.

Though it was not widely recognized at the time, Manet had, in this painting, by no means abandoned tradition completely to depict everyday life in all its sordid detail. *Déjeuner sur l'herbe* was based on a composition by Raphael that Manet knew through an engraving, *The Judgment of Paris*, copied from the original by one of Raphael's students, Marcantonio Raimondi (Fig. 72). The pose of the three main figures in Manet's painting directly copies the pose of the three figures in the lower-right corner of the engraving. However,

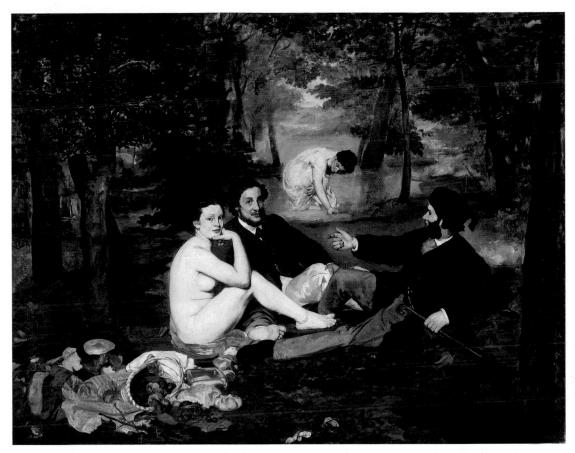

Fig. 71 Edouard Manet, "Luncheon on the Grass (Le Déjeuner sur l'herbe)," 1863.
 Oil on canvas, 7 ft. × 8 ft. 10 in. (2.13 × 2.6 m). Musée d'Orsay, Paris.
 RMN Reunion des Musées Nationaux/Art Resource, NY. © 2007 ARS Artists Rights Society, NY.

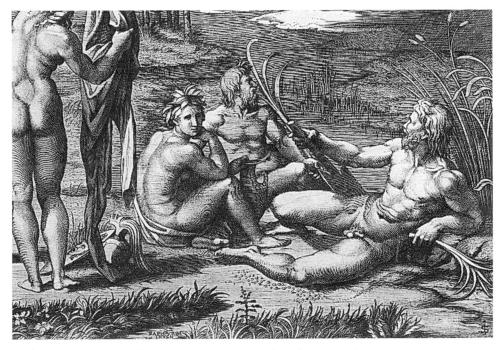

Fig. 72Marcantonio Raimondi, The Judgment of Paris (detail), c. 1488–1530.Engraving, after Raphael. Clipped impression, Plate line 11 5/8 × 17 1/4 in.The Metropolitan Museum of Art, New York. Rugers Fund, 1919 (19.74.1).

if Manet's sources were classical, his treatment was anything but. In fact, what most irritated both critics and the public was the apparently "slipshod" nature of Manet's painting technique. He painted in broad visible strokes. The body of the seated nude in *Déjeuner* was flat. The painting's sense of space was distorted, and the bather in the background and the stream she stands in both seemed about to spill forward into the picnic.

Manet's rejection of traditional painting techniques was intentional. He was drawing attention to his very modernity, to the fact that he was breaking with the past. His manipulation of his traditional sources supported the same intentions. In the words of his contemporary, Karl Marx, Manet was looking "with open eyes upon his conditions of life and true social relations." Raphael had depicted the classical judgment of Paris, the mythological contest in which Paris chose Venus as the most beautiful of the goddesses, a choice that led to

Fig. 73 Marcel Duchamp, "Nude Descending a Staircase, No. 2," 1912.

Oil on canvas, 58 × 35 in. Philadelphia Museum of Art: The Louise and Walter Arensberg Collection. Photo: Graydon Wood, 1994. © 2007 ARS Artists Rights Society, NY. the Trojan War. In his depiction of a decadent picnic in the Bois de Bologne, Manet passed judgment upon a different Paris, the modern city in which he lived. His world had changed. It was less heroic, its ideals less grand.

The public tends to receive innovative artwork with reservation because it usually has little context, historical or otherwise, in which to view it. It is not easy to appreciate, let alone value, what is not understood. When Marcel Duchamp exhibited his Nude Descending a Staircase (Fig. 73) at the Armory Show in New York City in 1913, it was a scandalous success, parodied and ridiculed in the newspapers. Former President Teddy Roosevelt told the papers, to their delight, that the painting reminded him of a Navajo blanket. Others called it "an explosion in a shingle factory," or "a staircase descending a nude." The American Art News held a contest to find the "nude" in the painting. The winning entry declared, "It isn't a lady but only a man."

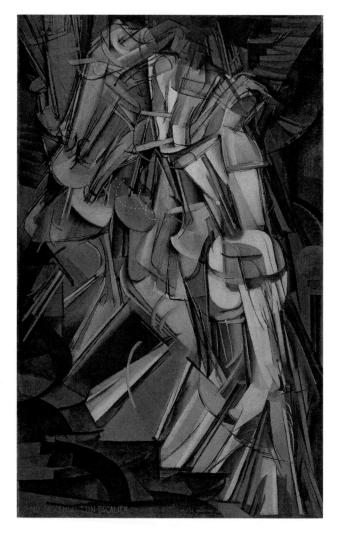

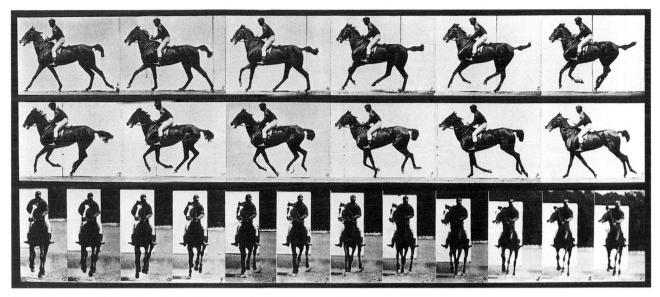

Fig. 74 Eadweard Muybridge, Annie G, Cantering, Saddled, December 1887.
 Collotype print, sheet: 19 × 24 in., image: 7 1/2 × 16 1/8 in. Philadelphia Museum of Art. City of Philadelphia, Trade & Convention Center, Dept. of Commerce, 1962-135-280.

The Armory Show was most Americans' first exposure to modern art, and more than 70,000 people saw it during its New York run. By the time it closed, after also traveling to Boston and Chicago, nearly 300,000 people had seen it. If not many understood the Nude then, today it is easier for us to see what Duchamp was representing. He had read, we know, a book called Movement, published in Paris in 1894, a treatise on human and animal locomotion written by Etienne-Jules Marey, a French physiologist who had long been fascinated with the possibility of breaking down the flow of movement into isolated data that could be analyzed. Marey himself had seen the photographs of a horse trotting, published by Eadweard Muybridge in La Nature in 1878 (Fig. 74). Muybridge had used a trip-wire device in an experiment commissioned by California Governor Leland Stanford to settle a bet about whether there were moments in the stride of a trotting or galloping horse when it was entirely free of the ground. Inspired by Muybridge's photographs, Marey began to use the camera himself, using models dressed in black suits with white points and stripes (Fig. 75), which allowed him to study, in images created out of a rapid succession of photographs, the flow of their motion. These

Fig. 75 Etienne-Jules Marey, Man in Black Suit with White Stripe Down Side of Chronophotograph Motion Experiment, 1883. Musée Marey, Beaune, France. Photo; Jean-Claude Couvol.

Fig. 76 Etienne-Jules Marey, Man Walking in Black Suit with White Stripe Down Sides, 1883. Collection Musée Marey, Beaune, France. Photo: Jean-Claude Couval.

images, called "chronophotographs," literally "photographs of time" (Fig. 76), are startlingly like Duchamp's painting. "In one of Marey's books," Duchamp later explained, "I saw an illustration of how he indicated [movement] . . . with a system of dots delimiting the different movements. . . . That's what gave me the idea for the execution of [the] *Nude*."

Marey, Muybridge, and Duchamp had all embarked, we can now see, on the same path, a path that led to the invention of the motion picture. On December 28, 1895, at the Grand Café on the Boulevard des Capucines in Paris, the Lumière brothers, who knew Marey and his work well, projected motion pictures of a baby being fed its dinner, a gardener being doused by a hose, and a train racing directly at the viewers, causing them to jump from their seats. Duchamp's vision had already been confirmed, but the public had not yet learned to see it.

A more recent example of the same phenomenon, of a public first rejecting and then coming to understand and accept a work of art, is Maya Lin's *Vietnam Memorial* in Washington, D.C. (Fig. 77). Lin's work was selected from a group of more than 1,400 entries in a

Fig. 77 Maya Ying Lin, Vietnam Memorial, Washington, D.C., 1982 Polished black granite, length, 492 ft. Woodfin Camp & Associates:

national competition. At the time her proposal was selected, Lin was 22 years old, a recent graduate of Yale University, where she had majored in architecture.

Many people at first viewed the monument as an insult to the memory of the very soldiers to whom it was supposed to honor. Rather than rise in majesty and dignity above the Washington Mall, like the Washington Monument or the Jefferson Memorial, it descends below earth level in a giant V, more than 200 feet long on each side. It represents nothing in particular, unlike the monument to the planting of the flag on the hill at Iwo Jima, which stands in Arlington National Cemetery, directly across the river. If Lin's memorial commemorates the war dead, it does so only abstractly.

And yet, this anti-monumental monument has become the most visited site in Washington. In part, people recognize that it symbolizes the history of the Vietnam War itself, which began barely perceptibly, like the gentle slope that leads down into the V, then deepened and deepened into crisis, to end in the riveting drama of the American withdrawal from Saigon. Though technically over, the war raged on for years in the nation's psyche, while at the same time a slow and at times almost imperceptible healing process began. To walk up the gentle slope out of the V symbolizes for many this process of healing. The names of the 58,000 men and women who died in Vietnam are chiseled into the wall in the order in which they were killed. You find the name of a loved one or a friend by looking it up in a register. As you descend into the space to find that name, or simply to stare in humility at all the names, the polished black granite reflects your own image back at you, as if to say that your life is what these names fought for.

Like Manet's *Déjeuner* and Duchamp's *Nude*, Lin's piece was misunderstood by the public. But unlike either, it was designed for public space. As we have seen, the public as a whole is a fickle audience, and the fate of art in public places can teach us much about how and why we, as a culture, value art.

ART, POLITICS, AND PUBLIC SPACE

A certain segment of the public has always sought out art in galleries and museums. But as a general rule (except for statues of local heroes mounted on horseback in the public square-of interest mainly to pigeons), the public could ignore art if it wished. In 1967, when Congress first funded the National Endowment for the Arts (NEA), that changed. An Arts in Public Places Program was initiated, quickly followed by state and local programs nationwide that usually required 1 percent of the cost of new public buildings to be dedicated to purchasing art to enhance their public spaces. Where artists had before assumed an interested, self-selected audience, now everyone was potentially their audience. And like it or not, artists were thrust into an activist role-their job, as the NEA defined it, to educate the general public about the value of art.

The Endowment's plan was to expose the nation's communities to "advanced" art, and the Arts in Public Places Program was conceived as a mass-audience art appreciation course. Time and again, throughout its history, it commissioned pieces that the public initially resisted but learned to love. Alexander Calder's La Grand Vitesse (Fig. 78) in Grand Rapids, Michigan, was the first piece commissioned by the Program. The selection committee was a group of four well-known outsiders, including New York painter Adolph Gottlieb and Gordon Smith, director of the Albright-Knox Art Gallery in Buffalo, New York, and three local representatives, giving the edge to the outside experts, who were, it was assumed, more

 Fig. 78 Alexander Calder, La Grand Vitesse, 1969.
 Painted steel plate, 43 × 55 ft. Calder Plaza, Vandenberg Center, Grand Rapids, Michigan.
 © John Corriveau, all rights reserved. © 2007 Estate of Alexander Calder/Artists Rights Society (ARS), New York.

knowledgeable about art matters than their local counterparts. In the case of *La Grand Vitesse*, the public reacted negatively to the long organic curves of Calder's praying mantis-like forms but soon adopted the sculpture as a civic symbol and a source of civic pride. The NEA and its artists were succeeding in teaching the public to value art for art's sake.

Three Public Sculptures

To value art for art's sake is to value it as an aesthetic object, to value the beauty of its forms rather than its functional practicality or its impact on social life. The NEA assumed, however, that teaching people to appreciate art would enhance the social life of the nation. Public art, the Endowment believed, would make everyone's life better by making the places in which we live more beautiful, or at least more interesting. The three public sculptures considered in this section have all tested this hypothesis.

Carl Andre's Stone Field Sculpture (Figs. 79 and 80) was commissioned in 1977 by the Arts in Public Places Program. Designed for a triangular public green at the corner of Gold and Main Streets in downtown Hartford, Connecticut, it offers a particularly clear example of how the community came to appreciate a work of art that it at first regarded as a frivolous waste of tax dollars. The work consists of 36 boulders, ranging in weight from 1,000 pounds to 11 tons, placed in eight rows, beginning with one boulder in the first row and increasing by one boulder in each subsequent row. The largest boulder is situated at the narrowest end of the green, and the row containing the eight smallest boulders is at the other end. The stones themselves are uncut, natural boulders from a sand and gravel pit in nearby Bristol, Connecticut. About a third of them are Connecticut sandstone, the same material used in many Hartford buildings, and the rest are granite, basalt, schist, gneiss, and serpentine.

Figs. 79–80 Carl Andre, Stone Field Sculpture, Hartford, Connecticut, 1977. 36 glacial boulders, 51 × 290 ft. overall. Collection: City of Hartford, Connecticut. Courtesy Paula Cooper Gallery, New York. © Carl Andre/Licensed by VAGA, New York.

Many people in Hartford felt that the work hardly qualified as art. They were doubly incensed that money had been spent on it at a time when the jobless rate was very high. For example, the Republican candidate for mayor at the time called it "another slap in the face for the poor and elderly." Residents in the apartment tower across the street called meetings to discuss having the boulders removed. "There was a lot of real hostility during the installation," Andre told The New Yorker magazine. "People would come up and start screaming at me-really screaming. People from all social and economic classes. I was quite startled by the vehemence." But as people came more and more to understand Andre's intentions-and the issue was constantly before them in the press-they began to change their minds.

In the first place, Andre wanted to create a tranquil space that would parallel, both emotionally and physically, the 300-year-old graveyard of Center Church alongside it. He also wanted to juxtapose human time-Center Church's first minister, appointed in 1633, was the great Puritan preacher Thomas Hooker-with the far vaster scale of geological time embodied in the rocks. He saw the site as facilitating a sort of dialogue between gravestones and quarry stones, as the meeting place of human history and natural time. "What I really hate," he said, "is to see a piece of abstract art in a public space that's nothing more than a disguised man-on-horseback. That just doesn't interest me at all." He thinks of his work, instead, in terms of movement in and around it. "My idea of a piece of sculpture is a road," he has said. "We don't have a single point of view for a road at all, except a moving one, moving along it. Most of my works-certainly the successful ones-have been ones that are in a way causeways-they cause you to make your way along them or around them.... There should be no one place, nor even group of places . . . where you should be." By activating the viewer physically, Andre believes his work will activate the viewer imaginatively. To his way of thinking, this is a better kind of public sculpture, no longer just acsthetically pleasing but also intellectually compelling.

Richard Serra's controversial Tilted Arc (Fig. 81) received an entirely different reception. When it was originally installed in 1981 in Federal Plaza in Lower Manhattan, there was only a minor flurry of negative reaction. However, beginning in March 1985, William Diamond, newly appointed Regional Administrator of the General Services Administration, which had originally commissioned the piece, began an active campaign to have it removed. At the time, nearly everyone believed that the vast majority of people working in the Federal Plaza complex despised the work. In fact, of the approximately 12,000 employees in the complex, only 3,791 signed the petition to have it removed, while nearly as many-3,763-signed a petition to save it. Yet the public perception was that the piece was "a scar on the plaza" and "an arrogant, nosethumbing gesture," in the words of one observer. During the night of March 15, 1989,

Fig. 81 Richard Serra, *Tilted Arc*, 1981. Cor-Ten steel, 12 ft. × 120 ft. × 2 1/2 in. Installed, Federal Plaza, New York City. Destroyed by the U.S. Government, 3/15/89.

© 2007 Richard Serra/Artists Rights Society (ARS), New York.

against the artist's vehement protests and after he had filed a lawsuit to block its removal, the sculpture was dismantled and its parts stored in a Brooklyn warehouse. It has subsequently been destroyed.

From Serra's point of view, Tilted Arc was destroyed when it was removed from Federal Plaza. He had created it specifically for the site, and once removed, it lost its reason for being. In Serra's words: "Site-specific works primarily engender a dialogue with their surroundings.... It is necessary to work in opposition to the constraints of the context, so that the work cannot be read as an affirmation of questionable ideologies and political power." Serra *intended* his work to be confrontational. It was political. He had assumed the role of the artist as analyst. That is, he felt that Americans were divided from their government, and the arc divided the plaza in the same way. Its tilt was ominous-it seemed ready to topple over at any instant. Serra succeeded in guestioning political power probably more dramatically than he ever intended, but he lost the resulting battle. He made his intentions known and understood, and the work was judged as fulfilling those intentions. But those in power judged his intentions negatively, which is hardly surprising, considering that Serra was challenging their very position and authority.

One of the reasons that the public has had difficulty, at least initially, accepting so many of the public art projects that have been funded by both the NEA and percent-for-art programs is that they have not found them to be aesthetically pleasing. The negative reactions to Andre's boulders and Serra's arc are typical. If art must be beautiful, then neither work is evidently art. And yet, as the public learned what each piece meant, many came to value the works, not for their beauty but for their insight, for what they revealed about the places they were in. Serra's work teaches us a further lesson about the value of art. Once public art becomes activist, promoting a specific political or social agenda, there are bound to be segments of the public that disagree with its point of view.

A classic example is Michelangelo's *David* (Fig. 82). Today it is one of the world's most famous sculptures, considered a master-

piece of Renaissance art. But it did not meet with universal approval when it was first displayed in Florence, Italy, in 1504. The sculpture was commissioned three years earlier, when Michelangelo was 26 years old, by the Opera del Duomo ("Works of the Cathedral"), a group founded in the thirteenth century to look after the Florence cathedral and to maintain works of art. It was to be a public piece, designed for outdoor display in the Piazza della Signoria, the plaza where public political meetings took place on a raised platform called the arringhiera (from which the English word "harangue" derives). Its political context, in other words, was clear. It represented David's triumph over the tyrant Goliath and was meant to symbolize Republican Florence-the city's freedom from foreign and papal domination, and from the rule of the Medici family as well.

The *David* was itself, as everyone in the city knew, a sculptural triumph in its own right. It was carved from a giant 16-foot-high block of marble that had been quarried 40 years earlier. Not only was the block riddled with cracks, forcing Michelangelo to bring all his skills to bear, but earlier sculptors, including Leonardo da Vinci, had been offered the problem stone and refused.

When the David was finished, in 1504, it was moved out of the Opera del Duomo at eight in the evening. It took 40 men four days to move it the 600 yards to the Piazza della Signoria. It required another 20 days to raise it onto the arringhiera. The entire time its politics hounded it. Each night, stones were hurled at it by supporters of the Medici, and guards had to be hired to keep watch over it. Inevitably, a second group of citizens objected to its nudity, and before its installation a skirt of copper leaves was prepared to spare the general public any possible offense. The skirt is today long gone. By the time the Medici returned to power in 1512, the David was a revered public shrine, and it remained in place until 1873, when it was replaced by a copy (as reproduced here in order to give the reader a sense of its original context) and moved for protection from a far greater enemy than the Medici-the natural elements themselves. Michelangelo's David suggests another lesson about the value of art. Today, we no longer value the sculpture for its politics but rather for its sheer aesthetic beauty and accomplishment. It teaches us how important aesthetic issues remain, even in the public arena.

The "Other" Public Art

Public art, as these last three examples make clear, has been associated particularly with sculptural works. Whatever social issues or civic pride they may symbolize, however, they are not active agents of change.

Still, there are other fully activist kinds of public art that are designed to have direct impact on our lives. For example, in their 1994 piece *The Cruci-fiction Project* (Fig. 83), performance artists Guillermo Gómez-Peña and Roberto Sifuentes crucified themselves for three hours on 16-foot-high crosses at Rodeo

Fig. 83 Guillermo Gómez-Peña and Roberto Sifuentes, *The Cruci-fiction Project*, 1994. Site-specific performance, Marin headlands, California. Photo: Victor Zaballa. Courtesy Headlands Center for the Arts.

Beach, in front of San Francisco's Golden Gate Bridge (for discussion of two other pieces by Gómez-Peña see *Works in Progress*, p. 68). "The piece was designed for the media," Gómez-Peña explains, "as a symbolic protest against the xenophobic immigration politics of California's governor Pete Wilson." The artists identified themselves as modern-day versions of Dimas and Gestas, the two smalltime thieves who were crucified along with Jesus Christ, and they dressed as Mexican stereotypes: "I was an 'undocumented bandido,' crucified by the INS [Immigration and Naturalization Service]," Gómer Poña recalls, "and Roherto was a generic 'gang member,'

WORKS IN PROGRESS

n his work, Mexican artist and activist Guillermo Gómez-Peña has chosen to address what he considers to be the major political question facing North America-relations between the United States and Mexico. For him. the entire problem is embodied in the idea of the "border." As the border runs from the Gulf of Mexico up the Rio Grande, it has a certain geographical reality, but as it extends west from Texas, across the bottom of New Mexico, Arizona, and California, its arbitrary nature becomes more and more apparent until, when it reaches the Pacific Ocean between San Diego and Tijuana, it begins to seem patently absurd. Gómez-Peña's work dramatizes how the geographical pseudo-"reality" of the border allows us, in the United States, to keep out what we do not want to see. The "border" is a metaphor for the division between ourselves and our neighbors, just as the difference in our national languages, English and Spanish, bars us from understanding one another. Gómez-Peña's work is an ongoing series of what he calls "border crossings," purposeful transgressions of this barrier.

Gómez-Peña asks his audience in the United States to examine its own sense of cultural superiority. He laces all his performances with Spanish in order to underscore to his largely English-speaking audience members that he, the Mexican, is bilingual, and they are not. In one of his most famous pieces, Two Undiscovered Amerindians (Fig. 84), a collaboration with Coco Fusco, he and Fusco dressed as recently discovered, wholly uncivilized "natives" of the fictitious island of Guatinaui in the middle of the Gulf of Mexico. At places such as the Walker Art Center in Minneapolis, Columbus Plaza in Madrid, Spain, and in London, England, they performed, in their own words, "authentic and traditional tasks, such as writing on a laptop computer, watching television, sewing voodoo dolls, and doing exercise." Audience members could pay for "authentic" dances or for Polaroid snapshots. To the artists' astonishment, nearly half of the audience members assumed that they were real, and huge numbers of people didn't find the idea of supposed natives locked in a cage as part of an "art" or "anthropological" exhibit objectionable or even unusual. The project pointed out just how barbaric the assumptions of Western culture can be.

Fig. 84 Guillermo Gómez-Peña and Coco Fusco, Two Undiscovered Amerindians Visit London, May 1992. Site-specific performance, London, England. Photo: Peter Barker.

Guillermo Gómez-Peña's TEMPLE OF CONFESSIONS

Another ongoing performance and installation work is titled The Temple of Contessions (Fig. 85). Gomez-Peña and Roberto Sifuentes exhibit themselves, for five to seven hours a day, inside Plexiglass booths. Sifuentes's arms and face are painted with tattoos, his bloody Tshirt is riddled with bullet holes. He shares his booth with 50 cockroaches, a fourfoot iguana, and what appear to be real weapons and drug paraphernalia. In his own booth, Gómez-Peña sits on a toilet (or wheelchair), dressed as what he calls a "curio shop shaman." Hundreds of souvenirs hang from his chest and waist. He shares his box with live crickets, stuffed animals, tribal musical instruments, and a giant ghetto blaster. A violet neon light

Fig. 85 Guillermo Gómez-Peña and Roberto Sifuentes, *The Temple of Confessions*, 1994. Site-specific performance, Detroit Institute of the Arts, 1994. Photo: Dirk Bakker.

frames the entire altar, and a highly "techno" soundtrack plays constantly.

In front of each booth, there is a church kneeler with a microphone to allow audience members to confess their "intercultural fears and desires." At least a third of all visitors eventually do so. Gómez-Peña describes the effect: "Emotions begin to pour forth from both sides. Some people cry, and in doing so, they make me cry. Some express their sexual desire for me. Others spell their hatred, their contempt, and their fear. . . . The range goes from confessions of extreme violence and racism toward Mexicans and other people of color, to expressions of incommensurable tenderness and solidarity with us. Some confessions are filled with guilt, or with fear of invasion, violence, rape, and disease. Others are fantasies about wanting to be Mexican or Indian, or vice versa: Mexicans and Latinos suffused in self-hatred wanting to be Anglo, Spanish, or 'blond.'" At night, after each performance, Sifuentes and Gómez-Peña listen to tapes of all the confessions of the day. The most revealing ones are edited and incorporated into the installation soundtrack. crucified by the LAPD [Los Angeles Police Department]." Gómez-Peña describes what happened at the performance:

Our audience of over 300 people each received a handout, asking them to "free us from our martydom as a gesture of political commitment." However, we had miscalculated their response. Paralyzed by the melancholia of the image, it took them over three hours to figure out how to get us down. By then, my right shoulder had become dislocated and Roberto had passed out. We were carried to a nearby bonfire and nurtured back to reality, while some people in the crowd rebuked those who were trying to help us, saying, "Let them die!"

Photographs of the event were quickly picked up by the media, and the piece became international news. The image appeared in, among other publications, Der Speigel (Germany), Cambio 16 (Spain), Reforma and La Jornada (Mexico), and various U.S. newspapers. The photos have since reappeared in major news media and art publications as the debates on immigration and arts funding continue to be the focus of the political right.

Another example of this activist direction in art is artist Krzysztof Wodiczko's Homeless Vehicle (Figs. 86 and 87). Wodiczko, who had fled Poland in 1984 and had lived in the United States for only four years, was appalled during the winter of 1987-1988 that an estimated 70,000 people were homeless in New York City alone. While he felt that "the fact that people are compelled to live on the streets is unacceptable," he also proposed to do something about it. Given the failure of the city's shelter system, he asked himself, "What can we do for individuals struggling for selfsufficiency on the streets today?" His solution was a vehicle for the homeless. As ingenious as the vehicle itself is, providing a level of safety and some creature comforts on the streets, Wodiczko's project is also motivated by more traditional issues. He draws attention to what the viewer has failed, or refuses, to see, and thus attempts "to create a bridge of empathy between homeless individuals and observers."

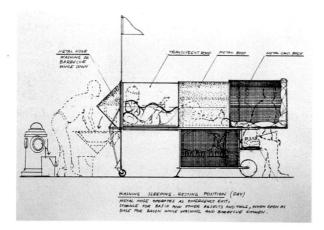

Fig. 86 Krzysztof Wodiczko, *Homeless Vehicle*, 1988. Preliminary drawing showing vehicle in washing, sleeping, and resting position (day). Courtesy of the Artist and Gallery Lelong, New York.

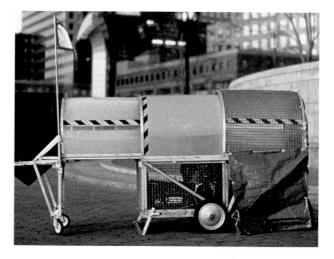

Fig. 87 Krzysztof Wodiczko, Homeless Vehicle in New York City, 1988–1989. Color photograph. Courtesy of the Artist and Gallery Lelong, New York.

THE CRITICAL PROCESS Thinking about the Value of Art

In December 1977, outside the Los Angeles City Hall, Suzanne Lacy and Leslie Labowitz staged a collaborative performance piece entitled In Mourning and in Rage to protest violence against women in America's cities. To ensurc media coverage, the performance was timed to coincide with a Los Angeles city council meeting. Ten women stepped from a hearse wearing veils draped over structures that, headress-like, made each figure seven feet tall. Representing the ten victims of the Hillside Strangler, a serial killer then on the loose in Los Angeles, each of the figures, in turn, addressed the media. They linked the so-called Strangler's crimes to a national climate of violence against women and the sensationalized media coverage that supports it. As Lacy and Labowitz have explained: "The art is in making it compelling; the politics is in making it clear. . . . In Mourning and in Rage took this culture's trivialized images of mourners as old, powerless women and transformed them into commanding seven-foot-tall figures angrily demanding an end to violence against women." To maximize the educational and emotional impact of the event, the perfor-

mance itself was followed up by a number of talk show appearances and activities organized in conjunction with a local rape hot line.

This model for political art represents the end of Lacy's spectrum of possible roles for the artist that opened this chapter. Lacy has continued to pursue this kind of art. One of the most visually spectacular of her works is Whisper, the Waves, the Wind (Fig. 88), a performance tableau in which 154 women over the age of 65 proceeded through an audience of 1,000 and down steep stairs to two beach coves situated back-to-back in La Jolla, California, to sit around white cloth-covered tables and talk about their lives, their relationships, their hopes, and their fears. In the middle of the performance the audience was invited onto the beach to listen close at hand. The piece was motivated by several salient facts: By the year 2020, one of every five people in the United States will be over 65; this population will be predominantly female and single; and today women account for nearly 75 percent of the aged poor. For Lacy, the performance reinforced the strong spiri-

tual and physical beauty of older women. Lacy says, "They reminded me of the place where the ocean meets shoreline. Their bodies were growing older, wrinkled. But what I saw was the rock in them; solid, with the presence of the years washing over them." Although clearly an activist piece of art, how does it reflect the other roles of the artist, as experiencer, reporter, and analyzer? Judging from the photograph of the performance, what aesthetic qualities does it possess that reinforce Lacy's comment on its symbolic nature?

Fig. 88 Suzanne Lacy, Whisper, the Waves, the Wind, 1993–1994. Still photograph of a performance in the Whisper Projects. Courtesy Suzanne Lacy.

THE FORMAL ELEMENTS and THEIR DESIGN Describing the Art You See

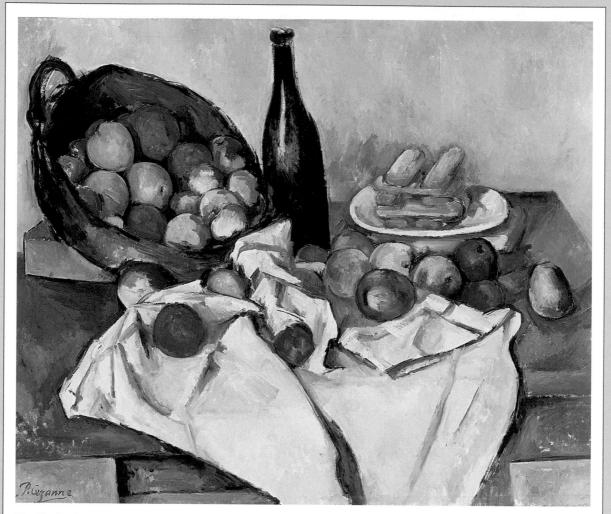

 Fig. 89
 Paul Cézanne, The Basket of Apples, c. 1895.

 Oil on canvas, 21 7/16 × 31 1/2
 in. Helen Birch Bartlett Memorial Collection. 1926.252.

 © The Art Institute of Chicago. All rights reserved.

Line

Paul Cézanne's *The Basket of Apples* (Fig. 89) is a still life, but it is also a complex arrangement of visual elements: lines and shapes, light and color, space, and, despite the fact that it is a "still" life, time. Upon first encountering the painting, most people sense immediately that it is full of what appear to be visual "mistakes." The edges of the table, both front and back, do not line up. The wine bottle is tilted sideways, and the apples appear to be spilling forward, out of the basket, onto the white napkin, which in turn seems to project forward, out of the picture plane. Indeed, looking at this work, one feels compelled to reach out and catch that first apple as it rolls down the napkin's central fold and falls into our space.

However, Cézanne has not made any mistakes at all. Each decision is part of a strategy designed to give back life to the "still life"—which in French is called *nature morte*—"dead nature." He wants to animate the picture plane, to make its space *dynamic* rather than *static*, to engage the imagination of the viewer. He has taken the visual elements of line, space, and texture and has deliberately

VARIETIES OF LINE
Outline and Contour Line

QUALITIES OF LINE

Implied Line

Expressive Line Works in Progress Vincent Van Gogh's *The Sower*

Analytic or Classical Line

Works in Progress Hung Liu's *Three Fujins*

Line and Movement Line and Cultural Convention The Critical Process

Thinking about Line

manipulated them as part of his composition, the way he has chosen to organize the canvas. As we begin to appreciate how the visual elements routinely function—the topic of this and the next four chapters—we will better appreciate how Cézanne manipulates them to achieve the wide variety of effects in this still life.

VARIETIES OF LINE

One of the most fundamental elements of art is line. If you take pencil to paper, you can draw a straight line or a curved one. Straight lines can be vertical, horizontal, or diagonal. Curved lines can be circular or oval (or segments of circles and ovals), or they can be free-form. Lines can abruptly change direction, in an angle or a curve. They seem to possess direction—they can rise or fall, head off to the left or to the right, disappear in the distance. Lines can divide one thing from another, or they can connect things together. They can be thick or thin, long or short, smooth or agitated.

British artist Andy Goldsworthy continually experiments with the varieties of line in sculptural works that are constructed entirely out of natural materials (Figs. 90 and 91). For Goldsworthy, these sculptures explore different qualities of line and the different qualities of the materials with which he is working. The line of flowers follows the geometric fractures in the rock, their fragile yellow bloom set in stark contrast to the dark gray stone, like some pronouncement of impending Spring. The spiral of the icicle surrounds a tree near Goldsworthy's home at Glenmarlin Falls, near Dumfriesshire, Scotland. Created on December 28, 1995, Goldsworthy feels that his curvilinear icicle

is the expression of something of the core of the tree, its spine . . . as if for a moment that spine has shifted and stepped outside the tree, almost as an apparition.

In other words, like Cézanne in his *Basket of Apples*, Goldsworthy seeks to make his line dynamic, not static, to energize the line into an image of becoming.

Mass 1

Fig. 90 Andy Goldsworthy, Yellow Flowers on Rock. 1994. © Andy Goldsworthy, courtesy Galerie Lelong. New York.

Fig. 91 Andy Goldsworthy, Reconstructed Icicles Around a Tree. 1995. © Andy Goldsworthy, courtesy Galerie Lelong. New York.

Outline and Contour Line

Another important feature of line is that it indicates the edge of two- or three-dimensional shapes or forms. This edge can be indicated either directly, by means of an actual **outline**, as in Jaune Quick-to-See Smith's *House* (Fig. 92), or indirectly, as in Henri Gaudier-Brzeska's *Standing Female from the Back* (Fig. 93). In Smith's painting, the Indian teepee is established by an actual black out-

Fig. 92 Jaune Quick-to-See Smith, House, 1995. Acrylic and mixed media on canvas, 6 ft. 8 in. × 5 ft. Courtesy of Jaune Quick-to-See Smith.

line drawn at its edge. By stenciling the word "House" on the image, she reminds her viewers of the difference between her mental image of a house as a Native American artist and our own. Pasted into the painting are a number of purposefully ironic messages: "Remember How Much Easier a Home Came Together When You Didn't Have to Choose Carpet"; "All Sunrooms Are Not Created Equal"; "Some Children Lead a Very Sheltered Life"; "Room for Two"; and, perhaps most tellingly, "'Tis a Gift to Be Simple." Smith's simple outline drawing, in other words, underscores with some real nostalgia the simplicity of a traditional Native American lifestyle that, as Smith well knows, has long since passed.

Unlike Smith, Gaudier-Brzeska has not drawn lines in order to indicate the edges of his figure. Rather, it is as if each line surrounds and establishes a volume. This is perhaps clearest in the lines that establish the model's lower right leg, which do not define a flat shape but rather the fullness and recession of her anatomy. From the point of view of the artist, there are no actual lines in this work, even though, perceptually, they are quite apparent. There are only volumes that make lines *appear* to us as they curve away. We call these **contour lines**.

Implied Line

Another variety of line that depends upon perception is *implied*. We perceive **implied lines** even though they neither exist in or mark the edge of our visual field. We visually "follow," for instance, the line indicated by a pointing finger. If someone nods toward us, we recognize the direction of that nod, the line of communication thus established between us. Movement also creates implied lines, as we saw in

Fig. 93 Henri Gaudier-Brzeska, Female Nude Back View, c. 1912.

Drawing Pen and blue ink on paper, 14 5% × 10 in. Princeton University Art Museum. Bequest of Dan Fellows Platt, Class of 1895. Acc #1948-137. Photo: Bruce M. White.

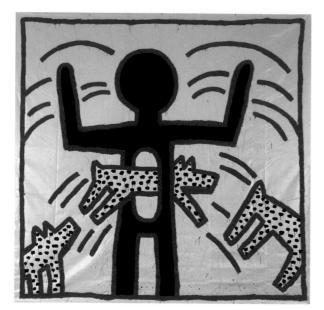

Fig. 94 Keith Haring, Untitled, March 24, 1982. Vinyl ink on vinyl tarp, 12 × 12 ft. © The Estate of Keith Haring.

Chapter 4 in the photographs of Eadweard Muybridge and Etienne-Jules Marey (see Figs. 74-76). In his Untitled drawing (Fig. 94), Keith Haring draws actual lines to indicate the motion of waving hands and jumping dogs. Haring began his career as a graffiti artist in the New York City subways and made his work available to a large audience through a retail outlet called the Pop Shop. Though Haring died of AIDS in 1990, the Pop Shop continued to sell Haring-designed posters, T-shirts, refrigerator magnets, radios, buttons, Swatch watches, and other items until it closed in 2005. The piece reproduced here is typical of Haring's work. Deceptively simple in its outlines, it is not just a "fun" line drawing. It is meant to depict the fatal shooting of John Lennon. Lennon's assassin is only one in an endless line of hyenas, representing a hideous, all-consuming public that believes it has the right to enter into any star's heart and soul.

Many kinetic works—works that move rely on our ability to remember the path that particular elements in the work have followed. Alexander Calder's mobiles, composed of circular and wing-shaped discs that spin around their points of balance on arched cantilevers, are designed to create a sense of virtual volume as space is filled out by implied line. The sequence of photographs of *Dots* and *Dashes* (Fig. 95) clearly reveals how

Fig. 95 Alexander Calder, Sequential view of *Dots and Dashes* in motion, 1959.

Painted sheet metal wire. Lipman Family Foundation. Courtesy of the Whitney Museum of American Art, NY. Photos: Jerry L. Thompson.

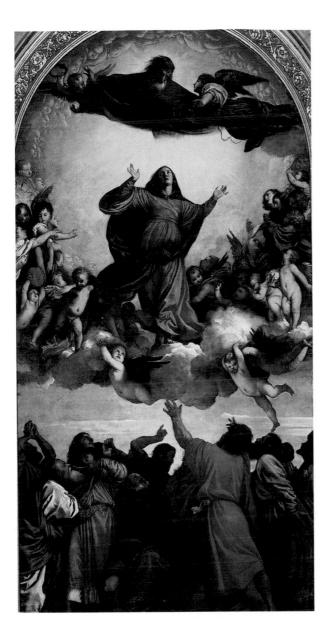

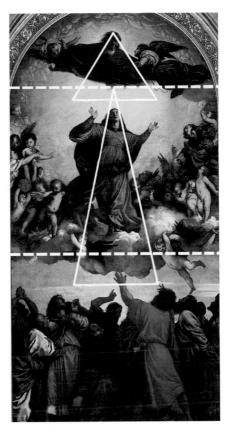

Fig. 96 Titian, Assumption and Consecration of the Virgin, c. 1516–1518.
Oil on wood, 22 1/2 × 11 4/5 ft. Santa Maria Gloriosa dei Frari, Venice.
Scala/Art Resource, New York.

Fig. 97 Line analysis of Titian, Assumption and Consecration of the Virgin, c. 1516–1518.
Oil on wood, 22 1/2 × 11 1/5 ft. Santa Maria Gloriosa dei Frari, Venice.
Scala/Art Resource, New York.

Calder's sculpture changes as it moves. The lines generated here are equivalent, in Calder's mind, to the lines created by a dancer moving through space.

One of the most powerful kinds of implied line is a function of *line of sight*, the direction the figures in a given composition are looking. In his *Assumption and Consecration of the Virgin* (Fig. 96), Titian ties together the three separate horizontal areas of the piece—God the Father above, the Virgin Mary in the middle, and the Apostles below—by implied lines that create simple, interlocking, symmetrical triangles (Fig. 97) that serve to unify the worlds of the divine and the mortal.

QUALITIES OF LINE

Line delineates form and shape by means of outline and contour line. Implied lines also create a sense of movement and direction. But line also possesses certain intellectual, emotional, and expressive qualities.

In a series of six works entitled *Drawing* Lesson, Part I, Line #1, Pat Steir has created

Fig. 98 Pat Steir, Drawing Lesson, Part I, Line #1, 1978. Drypoint with aquatint, from a portfolio of 7 etchings, each 16 × 16 in., edition of 25. Courtesy of Crown Point Press, San Francisco.

what she calls "a dictionary of marks," derived from the ways in which artists whom she admires employ line. Each pair of works represents a particular intellectual, emotional, or expressive quality of line. One pair, of which Figure 98 is an example, refers to the work of Rembrandt, particularly to the kinds of effects Rembrandt achieved in works like The Three Crosses (Fig. 99). The center square of Steir's piece is a sort of "blow-up" of Rembrandt's basic line; the outside frame shows the wide variety of effects achieved by Rembrandt as he draws this line with greater or lesser density. Rembrandt's lines seem to envelop the scene, shrouding it in a darkness that moves in upon the crucified Christ like a curtain closing upon a play or a storm descending upon a landscape. Rembrandt's line-and Steir's toobecomes more charged emotionally as it becomes denser and darker.

A second pair of Steir's "drawing lessons" is even more emotionally charged. In the center of Figure 100 is a dripping line, one of the

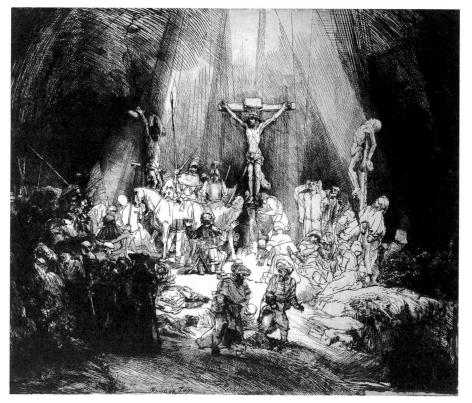

Fig. 99 Rembrandt van Rijn, *The Three Crosses*, 1653. Etching, 15 ¼ × 17 ¾ in. © The British Museum, London.

Fig. 100 Pat Steir, Drawing Lesson, Part I, Line #5, 1978. Sugar lift aquatint with soft ground etching from a portfolio of 7 etchings, each 16 × 16 in., edition of 25. Courtesy of Crown Point Press, San Francisco.

basic "signatures" of contemporary abstract painting. It indicates the presence of the artist's brush in front of the canvas. Surrounding it is a series of gestures evocative of Vincent van Gogh. Of the swirling turmoil of line that makes up *The Starry Night* (Fig. 101), van Gogh would write to his brother Theo, "Is it not emotion, the sincerity of one's feeling for nature, that draws us?" Steir has willingly submitted herself to van Gogh's emotion and style. "Getting into his mark," she says, "is like getting onto a merry-go-round, you can't stop. . . . It's like endless movement."

Expressive Line

Van Gogh's paintings are, for many, some of the most personally expressive in the history of art. When we speak of the expressive use of a formal element, such as line, we mean that it expresses powerful emotions. The **expressive line** of van Gogh is loose and free, so much so that it seems almost out of

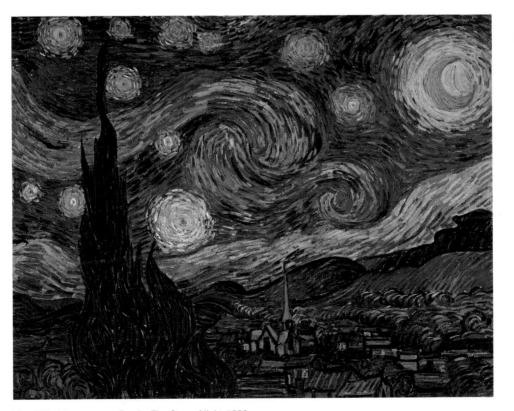

Fig. 101 Vincent van Gogh, The Starry Night, 1889.
 Oil on canvas, 29 × 36 ¼ in. The Museum of Modern Art, New York. Acquired through the Lillie P. Bliss Bequest. (472.1941)
 Digital Image © The Museum of Modern Art/Licensed by Scala/Art Resource, New York.

Texture & Pattern 1

WORKS IN PROGRESS

e know more about the genesis and development of *The Sower* than of almost all of Vincent van Gogh's other paintings, and we can follow the work's progress in some detail. There are four different descriptions of it in his letters, the first on June 17, 1888, in a letter to Austrian painter John Russell (Fig. 102) that includes a preliminary sketch of his idea. "Am working at a Sower," van Gogh writes in the letter, "the great field all violet the sky & sun very yellow. It is a hard subject to treat."

Theard Roolin had a beautiful heav at the Salur. I have been to the seasedes /02 a week and say likely an young thether ayoun Joon - Plat shore Jands - line / yures there straight stylish like Cimabie Am working at a Surger til lui i Turnill the great field all videt the sty sunvery Please remember me very Rendly to mis Rugfell - and in the pf I heartily shake hands. yours very muly Hincent

Fig. 102 Vincent van Gogh, *Letter to John Peter Russell,* April 1888.

Ink on laid paper, 8 × 10 ¼ in. Solomon R. Guggenheim Museum, New York. Thannhauser Collection, Gift, Justin K. Thannhauser, 1978. 78.2514.18.

Photo by Robert E. Mates. © The Solomon R. Guggenheim Foundation, New York.

The difficulties he was facing in the painting were numerous, having particularly to do with a color problem. At sunset, he wrote in a letter to the painter Emile Bernard on the very next day, June 18, Van Gogh was faced with a moment when the "excessive" contrast between the vellow sun and the violet shadows on the field would necessarily "irritate" the beholder's eye. He had to be true to that contrast and yet find a way to soften it. For approximately eight days he worked on the painting. First he tried making the sower's trousers white in an effort to create a place in the painting that would "allow the eye to rest and distract it." That strategy apparently failing, he tried modifying the yellow and violet areas of the painting. On June 26, he wrote to his brother Theo: "Yesterday and today I worked on the sower, which is completely recast. The sky is yellow and green, the ground violet and orange." This plan succeeded (Fig. 103). Each area of the painting now contained color that connected it to the opposite area, green to violet and orange to vellow.

The sower was, for van Gogh, the symbol of his own "longing for the infinite," as he wrote to Bernard, and having finished the painting, he remained, in August, still obsessed with the image. "The idea of the Sower continues to haunt me all the time," he wrote to Theo. In fact, he had begun to think of the finished painting as a study that was itself a preliminary work leading to a drawing (Fig. 104). "Now the harvest, the Garden, the Sower ... are sketches after painted studies. I think all these ideas are good," he wrote to Theo on August 8, "but the painted studies lack clearness of touch. That is [the] reason why I felt it necessary to draw them."

In the drawing, sun, wheat, and the sower himself are enlarged, made more monumental. The house and tree on the left have been eliminated, causing us to focus more on the sower himself, whose stride is now wider and who seems more intent on his task. But it is the clarity of van Gogh's line that is especially

Vincent van Gogh's THE SOWER

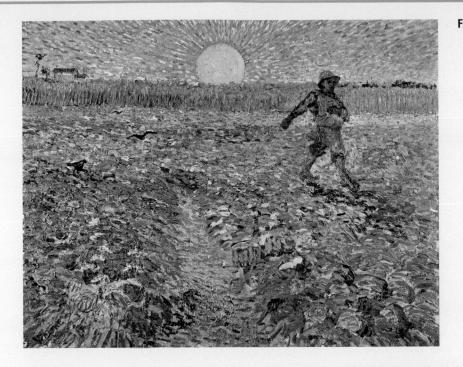

Fig. 103 Vincent van Gogh, *The Sower*, 1888. Oil on canvas, 25 1/4 × 31 3/4 in. Signed, Iower left: Vincent. Collection Kröller-Müller Museum, Otterlo, The

Netherlands.

astonishing. Here we have a sort of anthology of line types: short and long, curved and straight, wide and narrow. Lines of each type seem to group themselves into bundles of five or ten, and each bundle seems to possess its own direction and flow, creating a sense of the tilled field's uneven but regular furrows. It is as if, wanting to represent his longing for the infinite, as it is contained at the moment of the genesis of life, sowing the field, van Gogh himself returns to the most fundamental element in art—line itself.

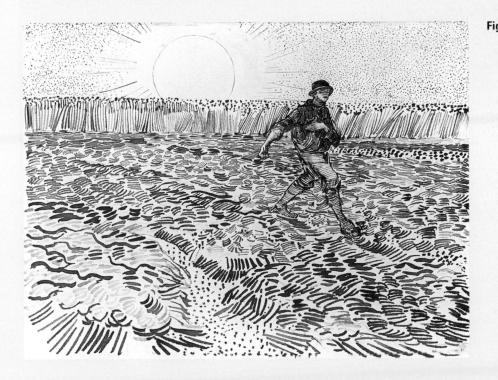

Fig. 104 Vincent van Gogh, *The Sower*, 1888. Drawing. Pencil, reed pen, and brown and black ink on wove paper, 9 5% × 12 1⁄2 in. Amsterdam, Van Gogh Museum, (Vincent van Gogh Foundation). control. It remains, nevertheless, consistent enough that it is recognizably van Gogh's. It has become, in this sense, *autographic*. Like a signature, it identifies the artist himself, his deeply anguished and creative genius (see *Works in Progress*, p. 80).

During the 15 months just before Starry Night was painted, while he was living in the southern French town of Arles, van Gogh produced a truly amazing quantity of work: 200 paintings, more than 100 drawings and watercolors, and roughly 200 letters, mostly written to his brother Theo. Many of these letters help us understand the expressive energies released in this creative outburst. In Starry Night, life and death-the town and the heavens-collide, and they are connected by both the church spire and the swaying cypress, a tree traditionally used to mark graves in southern France and Italy. "My paintings are almost a cry of anguish," van Gogh wrote. On July 27, 1890, a little over a year after The Starry Night was painted, the artist shot himself in the chest. He died two days later at the age of 37.

Analytic or Classical Line

Sol LeWitt, whose work is the source, incidentally, of another pair of Steir's *Drawing Lessons*, employs a line that is equally autographic, recognizably his own, but one that reveals to us a personality very different from van Gogh's (see Figs. 102–104). LeWitt's line is *analytical*, where van Gogh's is expressive. LeWitt's **analytic line** is precise, controlled, mathematically rigorous, logical, and rationally organized, where van Gogh's expressive line is imprecise, emotionally charged, and almost chaotic. One seems a product of the mind, the other of the heart.

A measure of the removal of LeWitt's art from personal expression is that very often LeWitt does not even draw his own lines. The works are usually generated by museum staff according to LeWitt's instructions. Illustrated here is, *Wall Drawing No. 681 C* (Fig. 105), along with two photographs of the staff at the National Gallery of Art installing the work in 1993 (Fig. 106). If a museum "owns" a LeWitt, it does not own the actual wall drawing but

 Fig. 105 Sol LeWitt, Wall Drawing No. 681 C, A wall divided vertically into four equal squares separated and bordered by black bands. Within each square, bands in one of four directions, each with color ink washes superimposed, 1993.
 Colored ink washes, image: 120 × 444 in. The National Gallery of Art, Washington, D.C.
 The Dorothy and Herbert Vogel Collection, Gift of Dorothy Vogel and Herbert Vogel, Trustees. 1993.41.1.

Fig. 106 Installation of *Wall Drawing No. 681 C*, August 25, 1993. National Gallery of Art, Washington, D.C. Photo © Board of Trustees, National Gallery of Art, Washington, D.C.

only the instructions on how to make it. As a result, LeWitt's works are temporary, but they are always resurrectable. Wall Drawing No. 681 C is, in fact, in the collection of the National Gallery of Art-that is to say, the instructions for making it are in the National Gallery's collection-but when it was "borrowed" in 2000 for a Sol LeWitt retrospective exhibition at both the San Francisco Museum of Modern Art and the Whitney Museum of American Art in New York City, the National Gallery lent only its instructions. Since LeWitt often writes his instructions so that the staff executing the drawing must make its own decisions about the placement and arrangement of the lines, the work changes from appearance to appearance.

LeWitt's drawings usually echo the geometry of the room's architecture, lending the work a sense of mathematical precision and regularity. But it is probably the grid, the pattern of vertical and horizontal lines crossing one another to make squares, that most characteristically dominates compositions of this variety. So strong is the grid's sense of orderliness and

Fig. 107 Jasper Johns, Numbers in Color, 1958–1959.
 Encaustic and collage on canvas, 67 × 49 ½ in.
 Albright-Knox Art Gallery, Buffalo, New York. Gift of Seymour H. Knox Jr., 1959.
 © Jasper Johns/Licensed by VAGA, New York. NY.

regularity that it can easily lend a sense of rational organization and logical operations to even the most expressive compositions. Jasper Johns's *Numbers in Color* (Fig. 107) is a case in point. Johns's brushwork—what we call his gesture—is fluid and loose, almost as expressive as van Gogh's, yet the grid here seems to contain and control it, to exercise some sort of rational authority over it. The numbers themselves repeat regularly, and like the alphabet, which arbitrarily organizes random elements into a coherent system, they impose a sense of logic where none necessarily exists.

Analytic line is closely related to what is widely referred to as **classical line**. The word "classical" refers to the Greek art of the fifth century BCE, but by association it has come to refer to any art that is based on logical, rational principles, and that is executed in a

Fig. 108 Jacques Louis David, Study for the Death of Socrates, 1787.

Charcoal heightened in white on gray-brown paper, 20 $\frac{1}{2} \times 17$ in. Musée Bonnat, Bayonne, France. Art Resource, New York.

deliberate, precise manner. Such order is considered by many to be inherently pleasing and beautiful, and thus of the highest aesthetic order. In his Study for the Death of Socrates (Fig. 108), Jacques Louis David portrays Socrates, the father of philosophy, about to drink deadly hemlock after the Greek state convicted him of corrupting his students, the youth of Athens, by his teaching. In this preliminary drawing, David has submitted the figure of Socrates to a mathematical grid that survives into the final painting (Fig. 109). Notice especially the gridwork of stone blocks that form the wall behind the figures. The human body is not constructed of parallels and perpendiculars, of course, but David has rendered it almost as if it is.

The structure and control evident in David's classical line is underscored by comparing it to Eugène Delacroix's much more expressive and romantic *Study for The Death of Sardanapalus* (Fig. 110). (The term **romantic**,

Fig. 109 Jacques Louis David, *The Death of Socrates*, 1787.
 Oil on canvas, 51 × 77 ¼ in. The Metropolitan Museum of Art, New York. Catherine Lorillard Wolfe Collection, Wolfe Fund, 1931 (31.45).
 Photo © 1980 The Metropolitan Museum of Art.

often used to describe nineteenth-century art such as Delacroix's, does not refer just to the expression of love, but also to the expression of all feelings and passions.) The finished painting (Fig. 111) shows Sardanapalus, the last king of the second Assyrian dynasty at the end of the ninth century BCE, who was besieged in his city by an enemy army. He ordered all his horses, dogs, servants, and wives slain before him, and all his belongings destroyed, so that none of his pleasures would survive him when his kingdom was overthrown. The drawing is a study for the lower corner of the bed, with its elephant-head bedpost, and, below it, on the floor, a pile of jewelry and musical instruments. The figure of the nude leaning back against the bed in the finished work, perhaps already dead, can be seen at the right edge of the study. Delacroix's line is quick, imprecise, and fluid. Compared to David's, his final painting seems a flurry of curves, knots, and linear webs. It is emotional, almost violent, while David's painting is calm, in exactly the spirit of Socrates.

Often artists use both expressive and analytic line in the same work. The work of London-born painter Matthew Ritchie is a prime example. Ritchie's project is ambitious and vast. He seeks to represent the entire universe and the structures of knowledge and belief through which we seek to understand it. His work begins with drawings that he scans into a computer. In that environment, he can resize and reshape them, make them

 Fig. 110 Eugène Delacroix, Study for The Death of Sardanapalus, 1827–1828.
 Pen, watercolor, and pencil, 10 1/4 × 12 1/2 in. Cabinet des Dessins, Musée du Louvre, Paris. Cliché des Musées Nationaux, Paris.
 Photo © R.M.N.-SPADEM.

Fig. 111 Eugène Delacroix, "The Death of Sardanapalus". 1827.
Oil on canvas, 12' 11/2" × 16' 27/8" in. (3.69 × 4.95 m). Musée du Louvre, Paris.
Photo RMN Reunion des Musees Nationeaux/Art Resource, NY.

Fig. 112 Matthew Ritchie, *No Sign of the World*, 2004. Oil and marker on canvas, 99 × 154 in. ARG # RM2004–001. Courtesy of Andrea Rosen Gallery, New York.

three-dimesional, take them apart, combine them with other drawings, and otherwise transform them. The drawing is above all linear and charged with a personal symbolism, as he explains:

I use the symbol of the straight line a lot in my drawings and paintings. It usually represents a kind of wound, or a direction. The curved line is like a linking gesture that joins things. But the straight line is usually more like an arrow, or rein, or a kind of rupture. It reminds me of St. Sebastian [the third century BCE Christian martyr who was tied to a tree, shot with arrows, and left for dead]. Whenever you see an arrow or spear in a painting, it's always much more damaging than it is constructive, whereas the looping sort of curved line is much more generous and inclusive. Often, in my drawings and paintings, you'll see figures being pierced by multiple fates that are sort of embodied in the lines. It's like

the lines in your destiny. Who would want a straight-line destiny? It'd be rotten, right?

From the bottom of *No Sign of the World* (Fig. 112), violet staight lines shoot up into a field of what appear to be broken sticks and branches. Above the horizon line, across the sky, looping lines of this same violet color appear to gather these fragments into circular fields of energy. After 9/11, in fact, Ritchie began to make paintings, in his words, "about figures being reassembled and rebuilt inside the people that had survived." It is as if we are at the dawn of creation, at the scene of some original "big bang."

A painting on the same theme, the creation of the universe, but employing an entirely different character of line, is Hung Liu's *Relic 12* (Fig. 113). A Chinese-born painter working today in the United States, Hung Liu's work consistently addresses women's place in both pre- and post-revolutionary China (see *Works in Progress*, p. 88). Here she represents a

Fig. 113 Hung Liu, *Relic 12*, 2005. Oil on canvas and lacquered wood, 66 × 66 in. Courtesy of Nancy Hoffman Gallery, New York.

Chinese courtesan surrounded by symbols from classical Chinese painting, including the circle, or *pi*, the ancient Chinese symbol for the universe, and the butterfly, symbol of change, joy, and love. In front of her, in the red square in the middle of the painting, are Chinese characters representing "female" and "Nu-Wa." Nu-Wa is the Chinese creation goddess. It was she who created the first humans from the yellow earth, after Heaven and Earth had separated. Since molding each figure individually was too tedious a process, she dipped a rope into mud and then swung it about her, covering the earth around her with lumps of mud. The early handmade figurines became the wealthy and the noble; those that arose from the splashes of mud were the poor and the common. Nu-Wa is worshipped as the intermediary between men and women, as the goddess who grants children, and as the inventor of

marriage. Here the soft curves of her figure, and of the butterfly, circles, flowers, and leaves, seem to conspire with the vertical drips of paint that fall softly to the bottom of the canvas like life-giving rain. As opposed to Ritchie's work, in which straight and curved lines contrast with one another, here they seem to work together to create an image of the wholeness and unity of creation.

Line and Movement

Lines also record movement. The patterns and habits of animal and human movement across the landscape are described by paths and roadways. The flow of water from mountaintop to sea follows the lines etched in the landscape by streams and rivers. Shooting stars track shortlived lines across the night sky.

WORKS IN PROGRESS

B orn in Changchun, China, in 1948, the year that Chairman Mao forced the Nationalist Chinese off the mainland to Taiwan, painter Hung Liu lived in China until 1984. Beginning in 1966, during Mao's Cultural Revolution, she worked for four years as a peasant in the fields. Successfully "re-educated" by the working class, she returned to Beijing where she studied, and later taught, painting of a strict Russian Social Realist style—propaganda portraits of

Mao's new society that employed a strict, classical line. But this way of drawing and painting, in its clear linear style, constricted Hung Liu's artistic sensibility. In 1980, she applied for a passport to study painting in the United States, and in 1984 her request was granted. An extraordinarily independent spirit, raised and educated in a society that values social conformity above individual identity, Liu depends as a painter on the interplay between the line she was trained to paint and a new, freer line more closely aligned to Western abstraction but tied to ancient Chinese traditions as well.

During the Cultural Revolution, Liu had

begun photographing peasant families, not for herself, but as gifts for the villagers. She has painted from photographs ever since, particularly archival photographs that she has discovered on research trips back to China in both 1991 and 1993. "I am not copying photographs," she explains. "I release information from them. There's a tiny bit of information there—the photograph was taken in a very short moment, maybe ¼100 or ¼150 of a second—and I look for clues. The clues give me an excuse to do things." In other words, for Liu, to paint from a photograph is to liberate something locked inside it. For example, the disfigured feet of the woman in *Virgin/Vessel* (Fig. 114) are the result of traditional Chinese foot-binding. Unable to walk, even upper-

Fig. 114 Hung Liu, Virgin/Vessel, 1990.
Oil on canvas, broom, 72 × 48 in. Collection of Bernice and Harold Steinbaum.
© Hung Liu. Courtesy Bernice Steinbaum Gallery, Miami, FL.

class women were forced into prostitution after Mao's Revolution confiscated their material possessions and left them without servants to transport them. In the painting, the woman's body has become a sexual vessel, like the one in front of her. She is completely isolated and vulnerable.

Three Fujins (Fig. 115) is also a depiction of women bound by the system in which they live. The Fujins were concubines in the royal court at the end of the nineteenth century. Projecting in front of each of them is an actual birdcage, purchased by Liu in San Francisco's Chinatown, symbolizing the women's spiritual captivity. But even the

excessively unified formality of their pose—its perfect balance, its repetitious rhythms—belies their submission to the rule of tyrannical social forces. The unified composition of the

Hung Liu's THREE FUJINS

photograph upon which this painting is based, the sense that these women have given up themselves—and made themselves up—in order to fit into their proscribed roles, Liu sees as symbolizing "relationships of power, and I want to dissolve them in my paintings."

Speaking of *Three Fujins*, Liu explains how that dissolution takes place, specifically in terms of her use of line: "Contrast is very important. If you don't have contrast, everything just cancels each other thing out. So I draw, very carefully, and then I let the paint drip—two kinds of contrasting line." One is controlled and classical, the line representing power, and the other is free, liberated, romantic. "Linseed oil is very thick," Liu goes on, "it drips very slowly, sometimes overnight. You don't know when you leave what's going to be there in the morning. You hope the best. You plant your seed. You work hard. But for the harvest, you have to wait." The drip, she says, gives her "a sense of liberation, of freedom from what I've been painting. I could never have done this work in China. But the real Chinese tradition—landscape painters, calligraphers—are pretty crazy. My drip is closer to the real Chinese tradition than my training. It's part of me, the deeply rooted traditional Chinese ways."

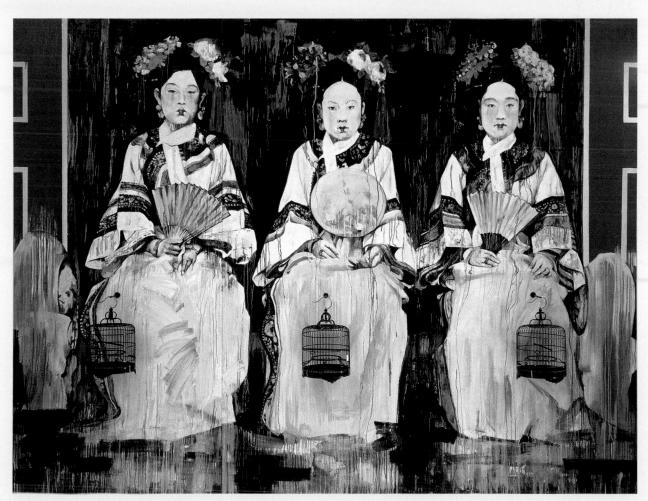

Fig. 115 Hung Liu, Three Fujins, 1995.
 Oil on canvas, bird cages, 96 × 126 × 12 in. Private collection, Washington, D.C.
 Photo: Ben Blackwell. Courtesy of Bernice Steinbaum Gallery, Miami, FL.

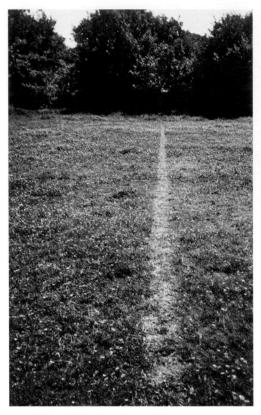

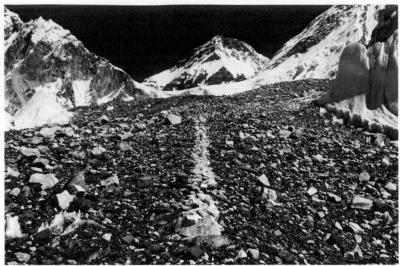

Figs. 116–117 Richard Long, A Line Made by Walking in England, 1967 (left); A Line in the Himalayas, 1975 (right). Photographic documentation. © 2000 Richard Long. Courtesy Haunch of Venison, London.

Since the late 1960s, the British artist Richard Long has been obsessed by the lines made by walking through the world. His first work made by walking is A Line Made by Walking in England (Fig. 116). The line was made in a grass field and led nowhere. It measures, in a sense, the duration of his back-andforth movement through the field, the degree of his obsession to imprint his presence on the landscape. Perhaps, above all, it announced for Long a new way to make sculpture. As he walked though a landscape, he could transform it, by plucking a line of blossoms from a field of daisies, by rearranging stones in the Himalayas (Fig. 117), by placing sticks, dirt, or seaweed in new linear arrangements on the land. "I consider my landscape sculptures," he has explained, "[to] inhabit the rich territory between two ideological positions, namely that of making 'monuments' or conversely, of 'leaving only footprints." In a sense, for all their presence as marks upon the land, they possess an almost disturbing sense of human transcience. They are, as Long has also said, just "one more layer, a mark laid upon the thousands of other layers of human and geographic history." In other words, they "mark time." "Here today, gone tomorrow," they seem to say.

Andy Goldsworthy, whose two line sculptures introduced our discussion of line (see Figs. 90 and 91), is as interested in seeing his works change—even decay—over time as he is in bringing them into being. His works anticipate the future demise, and, in a sense, their demise brings them to full completion, as if they are not finished until they have fulfilled their destiny by disappearing.

An example is a line of hazel leaves sewn together with grass stalks and placed in a pool in a small stream in southern Scotland (Fig. 118). The life of a similar work is recorded in the award-winning documentary film on Goldsworthy's work, *Rivers and Tides: Working with Time*, released in 2001. The piece begins as a spiral resting in a shallow

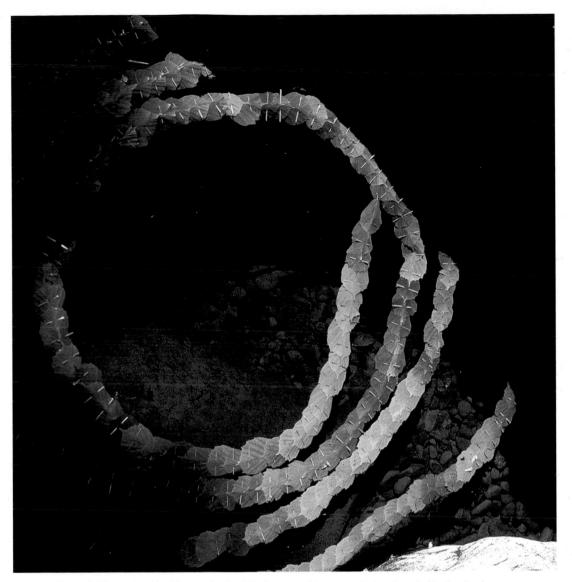

Fig. 118 Andy Goldsworthy, Hazel Leaves (each stitched to next with grass stalks/gently pulled by the river/out of a rock pool/floating downstream/low water), Scaur Water, Dumfriesshire, 5 June 1991. © Andy Goldsworthy, courtesy Galerie Lelong, New York.

pool. Slowly, the current takes hold of its outer end and pulls it downstream. As it unfurls in the pool, a long line of hazel leaves undulates dowstream on the current, forming a line down its center course. Eventually, parts of the hazel green line are caught on rocks and debris. They break apart, caught in this swirl or that, until the piece's journey is over.

Goldsworthy's lines are a metaphor for human life, both the paths of our personal lives and the "time line" of human history. Much less analytic than Long's marks in the landscape, much more fragile and expressive, they nevertheless share with Long's work the sense of transcience and impermanence.

Line and Cultural Convention

Especially in the depiction of human anatomy, certain cultural assumptions have come to be associated with the use of line. Conventionally, classical line is "logical," "rational," and closely identified with the male form. Expressive line is

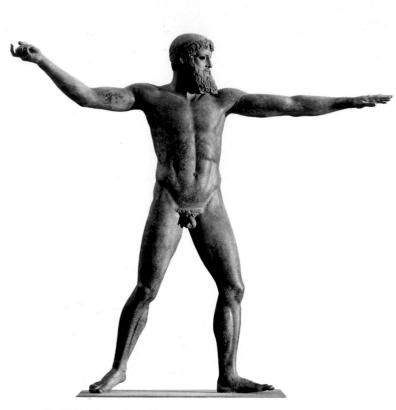

Fig. 119 Zeus, or Poseidon, c. 460 BCE. Bronze, height, 82 in. National Archeological Museum, Athens. Erich Lessing/Art Resource, N.Y.

Fig. 120 Roman copy after Praxiteles, *Aphrodite* of Knidos, 4th century BCE original. Marble, height, 80 in. P. Zigrossi/Vatican Museums, Rome, Italy

less clear, less "logical," more emotional and intuitive, and characteristically identified with the female form. The implications of this convention are worth exploring in some detail.

Compare, for example, the sculptures of the male and female figures in the next two figures. The Greek bronze (Fig. 119), identified by some as Zeus, king of the Greek gods, and by others as Poseidon, Greek god of the sea, has been submitted to very nearly the same mathematical grid as David's *Socrates*. This is especially evident in the definition of the god's chest and stomach muscles, which have been sculpted with great attention to detail, and in the extraordinary horizontality of the outstretched left arm. The severe intensity and powerful muscularity of the male god is far removed from Praxiteles's more spontaneous and casual treatment of the

female figure (Fig. 120). Completed more than 100 years after the Zeus, it renders Aphrodite, the Greek goddess of beauty and love, in very different terms. Every angle of her figure is softened and rounded, so that her body seems to echo the gentle folds of the drapery that she drops over the vase to her left. Her weight is shifted entirely over her right foot, and her hip is thus thrust out to the right, to emphasize the curvilinear structure of her anatomy. Though in fact she is composed using essentially the same mathematical grid as the Zeus, the logic of that grid has been suppressed by the curve.

While conventional representations of the male and female nude carry with them recognizably sexist implications—man as strong and rational, woman as weak and given to emotional outbursts—it should come as no

Fig. 121 Robert Mapplethorpe, *Lisa Lyon*, 1982. © 1982 The Estate of Robert Mapplethorpe.

surprise that these conventions are fundamental to the representation of the human figure in Western art. The biases of our culture are, naturally, reflected in our art, even in the most fundamental of art's formal elements—line.

These conventions have been challenged by many contemporary artists. Robert Mapplethorpe's photograph of Lisa Lyon (Fig. 121), winner of the First World Women's Bodybuilding Championship in Los Angeles in 1979, completely challenges these conventions. She presents herself to the viewer in terms not of Aphrodite but of Zeus. Rather than as a passive object of display, Lyon is portrayed as an active athlete. By presenting herself in this way, Lyon asserts the power of the female and implicitly argues that the female body has been "conditioned" not so much by physical limitations as by culture.

THE CRITICAL PROCESS Thinking about Line

L ine is, in summation, an extremely versa-L tile element. Thick or thin, short or long, straight or curved, line can outline shapes and forms, indicate the contour of a volume, and imply direction and movement. Lines of sight can connect widely separated parts of a composition. Depending on how it is employed, line can seem extremely intellectual and rational or highly expressive and emotional. It is, above all, the artist's most basic tool.

Consider the lines in Jean-Auguste-Dominique Ingres's 1862 painting The *Turkish Bath* (Fig. 122). The whole painting consists of a series of circles within circles, abandoning even the traditional rectangular frame. How do the bodies in Ingres's painting reflect this circular scheme? The painting celebrates the five senses—touch, smell, taste, sound, and sight. How are these reflected in the composition? This is a harem scene, a largely imaginative creation of the Western male imagination, but the presence of the male, especially the presence of the sultan whose harem this would be if he in fact existed, is implied in two ways. First ask yourself where the sultan might phsyically stand in relation to the scene—would he stand where you, the viewer, stand? And then ask yourself what details of the scene also express his power and control.

Fig. 122 Jean-Auguste-Dominique Ingres, *The Turkish Bath*, 1862. Oil on canvas, diameter, 42 ½ in. Musée du Louvre, Paris. Giraudon/Art Resource, NY.

Space

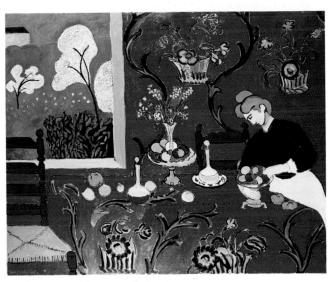

e live in a physical world whose properties are familiar, and together with line, space is one of the most familiar. It is all around us, all the time. We talk about "outer" space-the space outside our world-and "inner" space-the space inside our own minds. We cherish our own "space." We give "space" to people or things that scare us. But in the twenty-first century, space has become a more and more contested issue. Since Einstein, we have come to recognize that the space in which we live is fluid. It takes place in time. We have developed new kinds of space as well-the space of mass media, the Internet, the computer screen, "virtual reality," and cyberspace. All these new kinds of space result, as we shall see, in new media for artists. But first, we need to define some elementary concepts of shape and mass.

THREE-DIMENSIONAL SPACE TWO-DIMENSIONAL SPACE LINEAR PERSPECTIVE SOME OTHER MEANS OF REPRESENTING SPACE DISTORTIONS OF SPACE AND FORESHORTENING

SHAPE AND MASS

MODERN EXPERIMENTS AND NEW DIMENSIONS

The Critical Process Thinking about Space

SHAPE AND MASS

A shape is flat. In mathematical terms, a shape is a two-dimensional *area*, that is, its boundaries can be measured in terms of height and width. A mass, on the other hand, is a solid that occupies a three-dimensional *volume*. It must be measured in terms of height, width, and depth. Though mass also implies density and weight, in the simplest terms, the difference between shape and mass is the difference between a square and a cube, a circle and a sphere.

Donald Sultan's *Lemons*, *May* 16, 1984 (Fig. 123) is an image of three lemons, but it consists of a single yellow shape on a black ground nearly 8 feet square. To create the image, Sultan covered vinyl composite tile with tar. Then he drew the outline of the lemons, scraped out the area inside the outline, filled it with plaster, and painted the plaster area yellow. The shape of the three lemons is created not only by the outline Sultan drew but also by the contrasting colors and textures, black and yellow, tar and plaster.

Martin Puryear's *Self* (Fig. 124) is a sculptural mass standing nearly 6 feet high. Made of wood, it looms out of the floor like a giant basalt outcropping, and it seems to satisfy the other implied meanings of mass—that is, it

Fig. 123 Donald Sultan, Lemons, May 16, 1984, 1984. Latex, tar on vinyl tile over wood, 97 in. × 97 ½ in. Virginia Museum of Fine Arts, Richmond. Gift of the Sydney and Frances Lewis Foundation. Photo: Katherine Wetzel. © 1996 Virginia Museum of Fine Arts.

Fig. 124 Martin Puryear, *Self*, 1978. Polychromed red cedar and mahogany, 69 × 48 × 25 in. Joslyn Art Museum, Omaha.

seems to possess weight and density as well as volume. "It looks as though it might have been created by erosion," Puryear has said, "like a rock worn by sand and weather until the angles are all gone. . . . It's meant to be a visual notion of the self, rather than any particular self—the self as a secret entity, as a secret, hidden place." And in fact, it does not possess the mass it visually announces. It is actually very lightweight, built of thin layers of wood over a hollow core. This hidden, almost secret fragility is the "self" of Puryear's title.

One of the most interesting things about Sultan's *Lemons* is that, though it is completely flat, it implies three-dimensional space. We tend to read the painting from the bottom to the top—the left-hand lemon as closest to us and the top lemon as farthest away—although it is simple enough to imagine any one of the lemons as lying on top of the other two. But the point is that the instant we place any shape on a ground, a sense of space is activated. In Fig. 125, the black vase seems to sit on a white ground. When, conversely, we look at the white as shape and the black as ground,

Fig. 125 Rubin vase.

our perceptual experience of the same space is radically altered. What was the foreground vase becomes the background space, and we see two faces peering at each other. Such **figure-ground reversals** help us recognize how our perceptual experience fundamentally depends on our recognition of the spatial relationships between an object and what lies beside and behind it.

THREE-DIMENSIONAL SPACE

The world that we live in (our homes, our streets, our cities) has been carved out of threedimensional space, that is, a space that possesses height, width, and depth. A building surrounds empty space in such a way as to frame it or outline it. Walls shape the space they contain, and rooms acquire a sense of volume and form. In 1986, architect Gae Aulenti transformed a nineteenth-century Parisian railroad station into the new home for late-nineteenth- and early-twentieth-century art, the now famous Musée d'Orsay (Fig. 126). Aulenti maintained the space defined by the architecture of the original station, with its arched 100-foot ceiling stretching to a length of 150 yards, but across the bottom of this space he carved new cubical and rectilinear gallery rooms. The sculptural quality of these rooms is underscored by the way in which their lines are echoed in the benches and actual sculptures that fill the central walkway through the space. The massive presence of all these new forms stands in marked contrast to the airiness of the original building, but these new spaces also lend the building a sense of monumentality and solidity, a dignity befitting the works of art they contain.

Barbara Hepworth's *Two Figures* (Fig. 127) consists of two standing vertical masses that occupy three-dimensional space in a manner

Fig. 126 Musée d'Orsay, Paris, interior, main floor, Gae Aulenti, architect, 1986.

John Brooks/Musée d'Orsay/Art Resource, NY.

 Fig. 127 Barbara Hepworth, "Two Figures". 1947–1948.
 Elmwood and white paint, 38 × 17 in. Collection Frederick R. Weisman Art Museum, University of Minnesota, Minneapolis.
 Gift of John Rood Sculpture Colloction.

similar to standing human forms. Into each of these figures she has carved **negative shapes** or **negative spaces**, so called because they are empty spaces that acquire a sense of volume and form by means of the outline or frame that surrounds them, like the rooms in the Musée d'Orsay. Hepworth has painted these negative spaces white. Especially in the left-hand figure, the negative shapes suggest anatomical features: The top round indentation suggests a head, the middle hollow a breast, and the bottom hole a belly, with the elmwood wrapping around the figure like a cloak.

The negative space formed by the bowl of the ceremonial spoon of the Dan people native to Liberia and the Ivory Coast (Fig. 128) likewise suggests anatomy. Nearly a foot in length and called the "belly pregnant with rice," the bowl represents the generosity of the most hospitable woman of the clan, who is known as the wunkirle. The wunkirle carries this spoon at festivals, where she dances and sings. As wunkirles from other clans arrive, the festivals become competitions, each woman striving to give away more than the others. Finally, the most generous wunkirle of all is proclaimed, and the men sing in her honor. The spoon represents the power of the imagination to transform an everyday object into a symbolically charged container of social good.

TWO-DIMENSIONAL SPACE

While sculptors and architects define forms out of empty three-dimensional space, painters begin with an empty canvas, a two-dimensional space. **Two-dimensional space** is flat, possessing height and width, but no depth. A sense of depth, of three dimensions, can be achieved only by means of *illusion*.

In Charles Demuth's *Clowns* (Fig. 129), the untouched white ground of the paper—also called the **reserve**—is surrounded by watercolor and pencil so that it seems to stand forward from the paper itself to become the clown and the shirt of the man leaning over backwards. As in the figure–ground reversal discussed at the beginning of this section, we no longer read the drawing's white space as background, but rather as figures dressed in white. The figure–ground reversal creates an illusion. Our eyes read the whiteness as representing the

Fig. 128 Feast-making spoon (Wunkirmian), Liberia/Ivory Coast, Dan, 20th century. Wood and iron, height, 24 1/4 in. The Seattle Art Museum. Gift of Katherine C. White and the Boeing Company, 81.17.204.

> Photo: Paul Macapia. © abm - archives barbier-mueller-studio Ferrazzini-Bouchet, Geneve

 Fig. 129 Charles Demuth, Clowns, 1916.
 Watercolor and pencil on paper, 11 ³/₈ × 8 in. The Metropolitan Museum of Art, New York. Bequest of Charles F. Ikle, 1963 (64.27.6).
 Photo © 1997 The Metropolitan Museum of Art.

elements of the composition, but it is literally the whiteness of the paper that we see.

There are many ways to create the illusion of deep space on the flat surface of the paper or canvas, and most are used simultaneously. For example, we recognize that objects close to us appear larger than objects farther away, creating a change in scale. Objects closer to the viewer overlap and create the illusion of space by covering other objects behind them. Both a change in scale and overlapping inform the creation of the space in Steve DiBenedetto's Deliverance (Fig. 130). A helicopter casts its shadow onto an elaborately decorated radial design below. Another smaller helicopter advances to the left. We naturally read the change in scale to mean that the two are advancing away from the surface of the canvas, which is called the picture plane, into deep space. The whirling propeller

Fig. 130Steve DiBenedetto, Deliverance, 2004.Colored pencil on paper, 30 1/8 × 22 1/2 in. (76 × 57 cm).Courtesy of David Nolan Gallery, New York, Collection of Morris Orden,
New York.

blades of the helicopters dissect the marbleized sky behind them, overlapping it and blocking it from our view. Even though the entire composition is virtually abstract—certainly no landscape is as decorative as the radial design upon which the central helicopter casts its shadow—overlapping and change of scale allow us to read the space created by DiBenedetto.

LINEAR PERSPECTIVE

The overlapping images in DiBenedetto's work evoke certain principles of **perspective**, one of the most convincing means of representing three-dimensional space on a two-dimensional surface. Perspective is a system, known to the Greeks and Romans but not mathematically codified until the Renaissance, that, in simplest terms, allows the picture plane to function as a window through which a specific

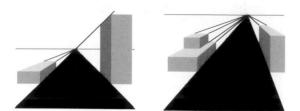

Fig. 131 One-point linear perspective. Left: frontal recession, street level. Right: diagonal recession, elevated position.

scene is presented to the viewer. In one-point linear perspective (Fig. 131), lines are drawn on the picture plane in such a way as to represent parallel lines receding to a single point on the viewer's horizon, called the vanishing point. As the two examples in Fig. 131 make clear, when the vanishing point is directly across from the viewer's vantage point where the viewer is positioned, the recession is said to be frontal. If the vanishing point is to one side or the other, the recession is said to be diagonal.

To judge the effectiveness of linear perspective as a system capable of creating the illusion of real space on a two-dimensional surface, we need only look at an example of a

work painted before linear perspective was fully understood and then compare it to works in which the system is successfully employed. Commissioned in 1308, Duccio's Maestà ("Majesty") Altarpiece was an enormous composition—its central panel alone was 7 feet high and 131/2 feet wide. Many smaller scenes depicting the life of the Virgin and the Life and Passion of Christ appear on both the front and back of the work. In one of these smaller panels, depicting the Annunciation of the Death of the Virgin (Fig. 132), in which the angel Gabriel warns the Virgin of her impending death, Duccio is evidently attempting to grasp the principles of perspective intuitively. At the top, the walls and ceiling beams all converge at a single vanishing point above the Virgin's head. But the moldings at the base of the arches in the doorways recede to a vanishing point at her hands, while the base of the reading stand, the left side of the bench, and the baseboard at the right converge on a point beneath her hands. Other lines converge on no vanishing point at all. Duccio has attempted to create a realistic space in which to place his

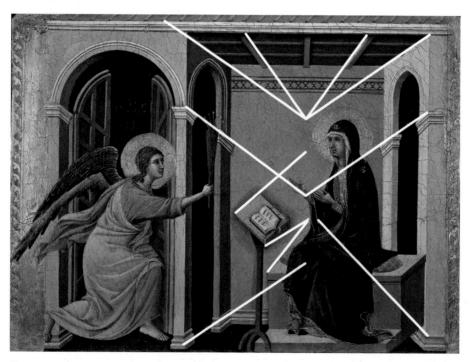

Fig. 132 Duccio, Annunciation of the Death of the Virgin, from the Maestà Altarpiece, 1308–1311. Tempera on panel, 16 % × 21 ¼ in. Museo dell'Opera del Duomo, Siena. Canali Photobank

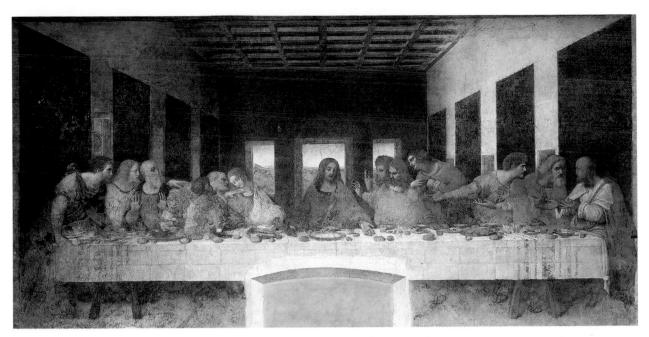

Fig. 133 Leonardo da Vinci, The Last Supper, c. 1495–1498.
 Mural (oil and tempera on plaster), 15 ft. 1 ¼ in. × 28 ft. 10 ½ in. Refectory, Monastery of Santa Maria delle Grazie, Milan.
 Index Ricerca Iconografica. Photo: Ghigo Roli.

figures, but he does not quite succeed. This is especially evident in his treatment of the reading stand and bench. In true perspective, the top and bottom of the reading stand would not be parallel, as they are here, but would converge to a single vanishing point. Similarly, the right side of the bench is splayed out awkwardly to the right and seems to crawl up and into the wall.

By way of contrast, the space of Leonardo da Vinci's famous depiction of *The Last Supper* (Fig. 133) is completely convincing. Leonardo employs a fully frontal one-point perspective system, as the perspective analysis shows (Fig. 134). This system focuses our attention on Christ, since the perspective lines appear almost as rays of light radiating from Christ's head. *The Last Supper* itself is a wall painting created in the refectory—dining hall—of the Monastery of Santa Maria delle Grazie in Milan, Italy. Because the painting's architecture appears to be continuous with the actual architecture of the refectory, it seems as if the world outside the

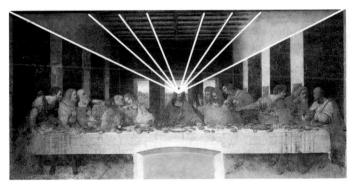

Fig. 134 Leonardo da Vinci, Perspective analysis of *The Last Supper*, c. 1495–1498.
Mural (oil and tempera on plaster), 15 ft. 1 ¹/₈ in. × 28 ft. 10 ¹/₂ in. Refectory, Monastery of Santa Maria delle Grazie, Milan.
Index Ricerca Iconografica. Photo: Ghigo Roli

space of the painting is organized around Christ as well. Everything in the architecture of the painting and the refectory draws our attention to Him. His gaze controls the world.

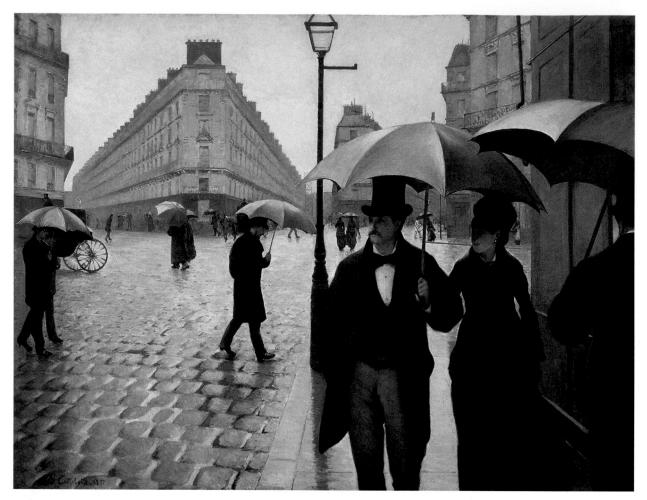

Fig. 135 Gustave Caillebotte, Place de l'Europe on a Rainy Day, 1876–1877.
 Oil on canvas, 83 ¹/₂ × 108 ³/₄ in. The Art Institute of Chicago. Charles H. and Mary F. S. Worcester Collection, 1964.336.
 Photo © 1999 The Art Institute of Chicago. All Rights Reserved.

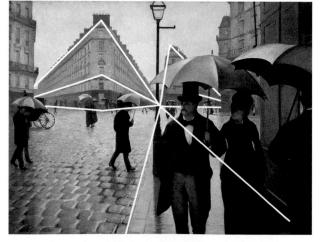

Fig. 136 Gustave Caillebotte, Perspective analysis of *Place de l'Europe on a Rainy Day*, 1876–1877.
Oil on canvas, 83 ½ × 108 ¾ in. The Art Institute of Chicago. Charles H. and Mary F. S. Worcester Collection, 1964.336.
Photo © 1999 The Art Institute of Chicago. All Rights Reserved.

The complex illusion of real space that perspective makes possible is evident in Gustave Caillebotte's Place de l'Europe on a Rainy Day (Fig. 135). Two (and even more) vanishing points organize a complex array of parallel lines emanating from the intersection of the five Paris streets depicted (Fig. 136). More than one vanishing point—that is, twopoint linear perspective (Fig. 137)-help to create a more lively composition, in part because the perspective recedes in several diagonal directions from the viewer, rather than frontally, as in Leonardo's The Last Supper. Caillebotte nevertheless imposes order on this scene by dividing the canvas into four equal rectangles formed by the vertical lamp post and the horizon line.

Comparing two variations on the same theme of Flemish peasants dancing, executed a

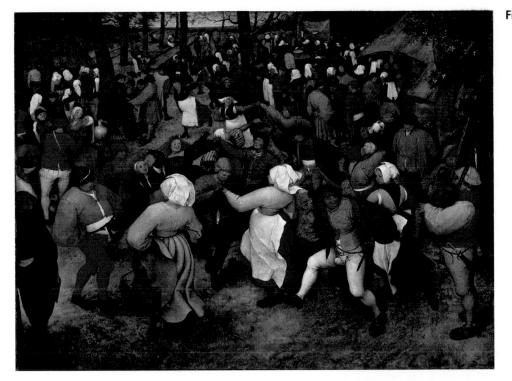

Fig. 138 Pieter Brueghel the Elder, The

Wedding Dance, c. 1566.

Oil on panel, $467/_8 \times 611/_{16}$ in. Detroit Institute of Arts. City of Detroit Purchaso. Photo © 1998 Detroit Institute of Arts, 30.734.

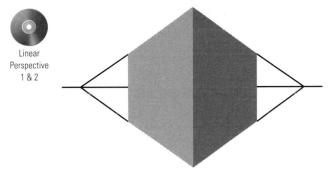

Fig. 137 Two-point linear perspective.

generation apart by the two greatest Flemish painters of their day, reveals the difference in effect created by frontal and diagonal recessions of space. The vanishing point in Pieter Brueghel's 1566 The Wedding Dance (Fig. 138) is on the horizon, directly across from the viewer, though the viewer's position is surprisingly high, as if looking down on the scene from a tree. Despite the confusion of the festivities, the painting is composed of a number of greater and lesser equilateral triangles, each pointing toward the horizon. Not only do the dancing couples raise their arms in triangular gestures, but the entire foreground group also forms a large triangular shape with

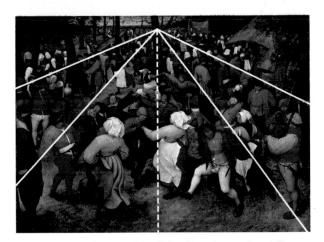

Fig. 139 Pieter Brueghel the Elder, Frontal recession of *The Wedding Dance*, c. 1566.

Oil on panel, 46 $7_8 \times 61 \ ^{1}_{16}$ in. Detroit Institute of Arts. City of Detroit Purchase. Photo © 1998 Detroit Institute of Arts, 30.734.

its apex at the central female figure at the base of the tree, her back arched, her bodice thrust forward, and her head back. Particularly on the left, across the open space between the dance group and the others, the figures are arranged along a diagonal parallel to the foreground group. In a manner appropriate to the theme—marriage and dance—the scene is balanced along its central axis (Fig. 139).

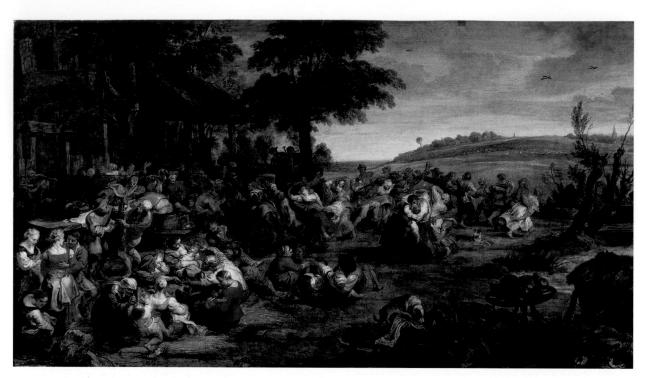

Fig. 140 Peter Paul Rubens, *The Kermis*, c. 1635. Oil on panel, 58 ⁵/₈ × 102 ³/₄ in. Musée du Louvre, Paris. Scala/Art Resource, New York.

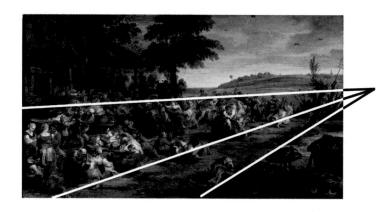

Fig. 141 Peter Paul Rubens, Diagonal recession of *The Kermis*, c. 1635.
Oil on panel, 58 ⁵/₈ × 102 ³/₄ in. Musée du Louvre, Paris.
Scala/Art Resource, New York.

In contrast, in his *The Kermis* (Fig. 140), probably painted in the early 1630s, Peter Paul Rubens positions his vanishing point at the end of a diagonal that disappears somewhere off-canvas to the right of the church steeple in the distance, in the direction that the couple on the far right seems amorously headed (Fig. 141). Here, children drink beer, men brawl, others have passed out, and every male hand seems intent on clutching some unprotected and forbidden part of the female anatomy. Rather than a joyous scene, the painting is ribald, unbalanced, as if teetering with drink itself. Where Brueghel's painting celebrates marriage, and is almost perfectly balanced, Rubens's

work celebrates something less civilized, something closer to raw appetite and pure sexuality, and the painting seems to move to the right, to a space beyond vision. Rubens, it could be said, paints our feelings, and nothing, he suggests, could be less balanced, less rational.

SOME OTHER MEANS OF REPRESENTING SPACE

Linear perspective creates the illusion of three-dimensional space on a two-dimensional surface. Other systems of projecting space, however, are available. These so-called **axonometric projections** (Fig. 142), employed

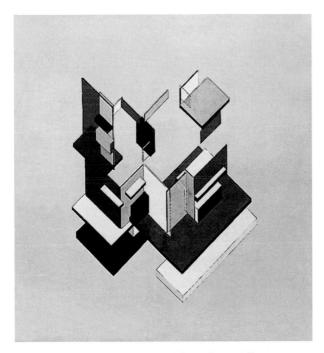

 Fig. 142 Theo van Doesburg and Cornelius van Eesteren, *Color Construction*, Project for a private house, 1923. Gouache and ink on paper, sheet: 22 ½ × 22 ½ in. The Museum of Modern Art, New York. Edgar J. Kaufmann, Jr. Fund. Photo © 1999 The Museum of Modern Art, New York. Licensed by

Scala/Art Resource, New York. © 2003 Artists Rights Society (ARS), New York/ Beeldrecht, Amsterdam.

by architects and engineers, have the advantage of translating space in such a way that the distortions of scale common in linear perspective are eliminated. In axonometric projections, all lines remain parallel rather than receding to a common vanishing point, and all sides of the object are at an angle to the picture plane. There are three types of axonometric projection: isometric, dimetric, and trimetric. In the first, all the measurementsheight, width, and depth-are to the same scale: For instance, each inch might represent one foot. In dimetric projection, two of the measurements maintain the same scale, while the third is reduced, often by half. Figure 142 is an example of dimetric projection, its height employing a smaller scale than its width and depth. In trimetric projection all three measurements use different scales.

Another related type of projection commonly found in Japanese art is **oblique projection**. As in axonometric projection, the sides of the object are parallel, but in this system, one face is parallel to the picture plane as well. The same scale is utilized for height and width, while

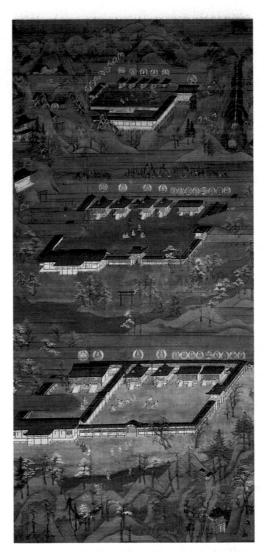

Fig. 143 Kumano Mandala, Kamakura period, c. 1300. Hanging scroll, ink and color on silk, 52 ¼ × 24 ¼ in.
© 2004 The Cleveland Museum of Art. John L. Severance Fund, 1953.16.

depth is reduced. This hanging scroll (Fig. 143) depicts, in oblique perspective, the three sacred Shinto-Buddhist shrines of Kumano, south of Osaka, Japan. The shrines are actually about 80 miles apart: the one at the bottom of the scroll high in the mountains of the Kii Peninsula in a cypress forest, the middle one on the eastern coast of the peninsula, and the top one near a famous waterfall that can be seen to its right. In addition to oblique projection, the artist employs two other devices to give a sense of spatial depth. As is common in traditional perspective, each shrine appears smaller the farther away it is. But spatial depth is also indicated here by positionthe farther away the shrine, the *higher* it is in the composition.

Fig. 144 George Barker, *Sunset—Niagara River (No. 609),* c. 1870–1875. Stereograph. International Museum of Photography at George Eastman House, Rochester, New York.

DISTORTIONS OF SPACE AND FORESHORTENING

The space created by means of linear perspective is closely related to the space created by photography, the medium we accept as representing "real" space with the highest degree of accuracy. The picture drawn in perspective and the photograph both employ a *monocular*, that is, one-eyed, point of view that defines the picture plane as the base of a pyramid, the apex of which is the single lens or eye. Our actual vision, however, is *binocular*. We see with both eyes. If you hold your finger up before your eyes and look at it first with one eye closed and then with the other, you will readily see that the point of view of each eye is different. Under most conditions, the human organism has the capacity to synthesize these differing points of view into a unitary image.

In the nineteenth century, the stereoscope was invented precisely to imitate binocular vision. Two pictures of the same subject, taken from slightly different points of view, were viewed through the stereoscope, one by each eye. The effect of a single picture was produced, with the appearance of depth, or relief, a result of the divergence of the point of view. As George Barker's stereoscope of the Niagara River (Fig. 144) makes clear, the difference between the two points of view is barely discernible if we are looking at relatively distant objects. But if we look at objects that are nearby, as in the stereoscopic view of the Man with Big Shoes (Fig. 145), then the difference is readily apparent.

Fig. 145 Photographer unknown, Man with Big Shoes, c. 1890. Stereograph. Library of Congress.

Fig. 146 Albrecht Dürer, Draftsman Drawing a Reclining Nude, c. 1527.
 Woodcut, second edition, 3 × 8 ½ in. One of 138 woodcuts and diagrams in Underweysung der Messung, mit dem Zirkel und richtscheyt (Teaching of Measurement with Compass and Ruler).
 Photo © Museum of Fine Arts, Boston. Horatio Greenough Curtis Fund.

Painters can make up for such distortions in ways that photographers cannot. If the artist portrayed in Dürer's woodcut (Fig. 146) were to draw exactly what he sees before his eyes, he would end up drawing a figure with knees and lower legs that are too large in relation to her breasts and head. The effect would not be unlike that achieved by the enormous hands that reach toward the viewer in Marcia Gygli King's *Family* (Fig. 147), an image of a

Linear

Perspective 4

Fig. 147 Marcia Gygli King, *The Family*, from *The Culture Series*, 2005. Oil on canvas, 6 ft. 10 in. × 8 ft. 5 in. Courtesy of the artist.

Fig. 148 Andrea Mantegna, *The Dead Christ*, c. 1501. Tempera on canvas, 26 × 30 in. Brera Gallery, Milan. De Agostini Editore Picture Library

medieval family dining on soup and wine in front of a background of wine barrels and flowers. The giant hands of this dysfunctional family are a metaphor for gluttony and excess, reaching out toward the contemporary viewer as if to say, "We are the origin of your own consumer culture. We are the gene pool from which you spring."

Andrea Mantegna was not interested at all in depicting *The Dead Christ* (Fig. 148) with disproportionately large feet. Such a representation would make comic or ridiculous a scene of high seriousness and consequence. It would be indecorous. Thus, Mantegna has employed **foreshortening** in order to represent Christ's body. In foreshortening, the dimensions of the closer extremities are adjusted in order to make up for the distortion created by the point of view.

Fig. 149 Henri Matisse, Harmony in Red (The Red Room), 1908–1909.
 Oil on canvas, 70 ⁷/₈ × 86 ⁵/₈ in. The Hermitage, St. Petersburg.
 © Alinari/Art Resource, New York. © 2007 Succession H Matisse, Paris/Artists Rights Society (ARS), New York.

MODERN EXPERIMENTS AND NEW DIMENSIONS

As we saw in King's painting, modern artists often intentionally violate the rules of perspective to draw the attention of the viewer to elements of the composition other than its *verisimilitude*, or the apparent "truth" of its representation of reality. In other words, the artist seeks to draw attention to the act of imagination that created the painting, not its overt subject matter. In his large painting *Harmony in Red* (Fig. 149), Henri Matisse has almost completely eliminated any sense of three-dimensionality by uniting the different spaces of the painting in one large field of uniform color and design. The wallpaper and the tablecloth are made of the same fabric. Shapes are repeated throughout: The spindles of the chairs and the tops of the decanters echo one another, as do the maid's hair and the white foliage of the large tree outside the window. The tree's trunk repeats the arabesque design on the tablecloth directly below it. Even the window can be read in two ways: It could, in fact, be a window opening to the world outside, or it could be the corner of a painting, a framed canvas lying flat against the wall. In traditional perspective, the picture frame functions as a window. Here the window has been transformed into a frame.

Fig. 150 Paul Cézanne, Mme. Cézanne in a Red Armchair, 1877.
 Oil on canvas, 28 ½ × 22 in. Museum of Fine Arts, Boston. Bequest of Robert Treat Paine 2nd, 44.77.6.
 Photo © 2004 Museum of fine Arts, Boston.

What one notices most of all in Cézanne's *Mme. Cézanne in a Red Armchair* (Fig. 150) is its very lack of spatial depth. Although the arm of the chair seems to project forward on the right, on the left the painting is almost totally flat. The blue flower pattern on the wallpaper seems to float above the spiraled end of the arm, as does the tassel that hangs below it, drawing the wall far forward into the composi-

tion. The line that establishes the bottom of the baseboard on the left seems to ripple on through Mme. Cézanne's dress. But most of all, the assertive vertical stripes of that dress, which appear to rise straight up from her feet parallel to the picture plane, deny Mme. Cézanne her lap. It is almost as if a second, striped vertical plane lies between her and the viewer. By this means Cézanne announces that it is not so

Fig. 151 Terry Winters, Color and Information, 1998. Oil and alkyd resin on canvas, 9 × 12 ft. © Terry Winters, courtesy Matthew Marks Gallery, New York.

much the accurate representation of the figure that interests him as it is the design of the canvas and the activity of painting itself, the play of its pattern and color.

With the advent of the computer age, a new space for art has opened up, one beyond the boundaries of the frame and, moreover, beyond the traditional boundaries of time and matter. It is the space of information, which in Terry Winters's *Color and Information* (Fig. 151) seems to engulf us. The painting is enormous, 9 by 12 feet. It is organized around a central pole that rises just to the left of center. A web of circuitry-like squares circle around this pole, seeming to implode into the center or explode out of it—there is no way to tell. Writing in *Art in America* in 2005, critic Carol Diehl describes her reaction to paintings such as this one:

At any given moment, some or all of the following impressions may suggest themselves and then quickly fade, to be replaced by others: maps, blueprints, urban aerial photographs, steel girders, spiderwebs, X-rays, molecular structures, microscopic slides of protozoa, the wrap and woof of gauzy fabric, tangles or balls of yarn, fishing nets, the interlace of wintry tree branches, magnified crystals, computer readouts or diagrams of the neurological circuits of the brain, perhaps on information overload. That we can never figure out whether what we're looking at depicts something organic or manmade only adds to the enigma.

In fact, the title of this painting refers only to Winters's process, not its enigmatic content. The work began with a series of black-and-white woodcuts generated from small pen-and-ink drawings scanned into a computer so that the blocks could be cut by a laser. Winters wanted to see what would happen if he transformed this digital information into a painting, confounding or amplifying the stark black-and-white constrast of the source images by adding color and

Fig. 152 Mary Flanagan, [collection], 2001-present. Courtesy of Mary Flanagan, www.maryflanagan.com/collection.htm

vastly magnifying their scale. In front of the resulting work, we are suspended between order and chaos, image and abstraction, information and information overload.

Mary Flanagan's [collection] (Fig. 152) is a work that exists in what might be called digital space. The work is an ongoing project that may be downloaded onto any visitor's hard drive from the Web address provided in the caption. Once downloaded, it scours the visitor's hard drive for bits and pieces of data-sentences from emails, graphics, Web-browser cached images, business letters, sound files, operating-system files, and normally hidden materials-and then collects them on a centralized server. It then presents these materials, taken from countless users' hard drives, and creates a moving, three-dimensional and continuously shifting map of this information, floating as if projected on the blackest of night skies.

What the work reveals might be called the subconscious of the Web, or the collective unconscious of the Internet, functioning like some digital dreamwork. It also questions notions of authenticity and authorship in the digital age, breaking the conceptual line separating, for example, a personal email from a Help file, or the space separating "my computer" from yours. In the words of one of the leading experts on the impact of digital technology on modern life, William J. Mitchell, it projects a new kind of space, "unrooted to any definite spot on the surface of the earth, shaped by connectivity and bandwidth constraints rather than by accessibility and land values, largely asynchronous in its operation, and inhabited by disembodied and fragmented subjects who exist as collections of aliases and agents."

THE **CRITICAL** PROCESS Thinking about Space

The history of modern art has often been summarized as the growing refusal of painters to represent three-dimensional space and the resulting emphasis placed on the twodimensional space of the picture plane. While modern art diminished the importance of representing "real" space in order to draw attention to other types of reality, recent developments in video and computer technologies have begun to make it possible to create artificial environments that the viewer experiences as real space. Variously known as cyberspace, hyperspace, or virtual reality, these spaces are becoming increasingly realistic. The viewer "enters" one such space by donning a set of goggles containing two small video monitors, one in front of each eye (Fig. 153). Created in 1993 with a grant from the Art and Virtual Environment Project at the Banff Centre for the Arts in Banff, Canada, Michael Scroggins and Stewart Dickson's Topological Slide (Fig. 154) allows the viewer/ participant to slide down a non-Euclidean mathematical model through a hole that descends hypothetically to infinity. The image sequence reproduced here shows the rider's point of view in one side of the head-mounted display as the rider slides down the virtual space of Topological Slide. The larger, composite image shows the rider standing on the slide's

tilting platform as if immersed in the virtual space of the image.

In this technology, traditional distinctions about the nature of space begin to collapse. As a result, our sense of space is today open to redefinition, a redefinition perhaps as fundamental as that which occurred in the fifteenth century when the laws of linear perspective were finally codified. How would you speak of this space? In what ways is it two-dimensional? In what ways is it three-dimensional? What are the implications of our seeming to move in and through a two-dimensional image? What would you call such new spaces? Electronic space? Four-dimensional space? What possibilities do you see for such spaces?

Fig. 153 Michael Scroggins and Stewart Dickson, *Topological Slide*, 1993. The Banff Centre for the Arts. Photo: Cheryl Bellows/The Banff Centre for the Arts.

Fig. 154 Michael Scroggins and Stewart Dickson, Topological Slide, 1993. Digital images courtesy Michael Scroggins. © 1999 Michael Scroggins.

Light and Color

LIGHT

Atmospheric Perspective Chiaroscuro Hatching and Cross-hatching Works in Progress Mary Cassatt's *In the Loge*

CHAPTER

Value

COLOR

Basic Color Vocabulary Color Schemes Works in Progress Chuck Close's Stanley

Color in Representational Art

■ Works in Progress Sonia Delaunay's *Electric Prism*

Symbolic Use of Color

The Critical Process Thinking about Light and Color

he manipulation of perspective systems is by no means the only way that space is created in art. Light is at least as important to the rendering of space. For instance, light creates shadow, and thus helps to define the contour of a figure or mass. Our experience of color is itself a direct function of light. In 1666, Sir Isaac Newton demonstrated that objects appear to be a certain color because they absorb and reflect different parts of the visible spectrum. In the simplest terms, when light strikes an object that appears blue, the object has absorbed all the colors of the spectrum but wavelengths of blue. If it appears vellow-green-or chartreuse-it has screened out all but yellow and green wavelengths. Color is essential in defining shape and mass. It allows us, for instance, to see a red object against a green one, and thus establish their relation in space. Socalled "color-blind" people (who actually can see colors, just not those that most of us see) cannot detect, for reasons that are not entirely understood, one or both of the numerals in Figure 155. Interestingly, if you were to photocopy this

Fig. 155 Ishihara "Test for Color Deficiency." Courtesy Kanehara & Co., Ltd. Offered exclusively in the USA by Graham-Field Inc., Bay Shore, New York.

pattern of dots, the numerals would not be visible. The machine, like the eye of the colorblind person, reads the light brown and light red dots as if they were the same, and the dark brown and red dots as if they were the same. Because they are unable to see some shapes overlapping others, color-blind people experience spatial relationships differently than the rest of us, but their difficulty helps demonstrate how important color—and, by extension, light—is to our experience of space.

LIGHT

Since natural light helps us to define spatial relationships, it stands to reason that artists are interested in manipulating it. By doing so, they can control our experience of their work. Architects, particularly, must concern themselves with light. Interior spaces demand lighting, either natural or artificial, and our experience of a given space can be deeply affected by the quality of its light.

One of the most dramatically lit spaces in all modern architecture is Le Corbusier's church of Notre-Dame-du-Haut at Ronchamp in Eastern France (Fig. 156). The light is admitted

Fig. 156 Le Corbusier, Notre-Dame-du-Haut at Ronchamp (interior), Ronchamp, France, 1950–1955. Photo Researchers, Inc. © 2003 Artists Rights Society (ARS), New York/ADAGP, Paris/FLC/Photo Resources, Inc.

through narrow stained-glass windows on the exterior southern wall, but as the window boxes expand through the thick wall, the light broadens into wide shafts that possess an unmistakably spiritual quality. The effect is one of extraordinary beauty.

Obviously, not all artists are able to utilize light as fully as architects. But, especially if they are interested in representing the world, they must learn to imitate the effects of light in their work. Before turning to a discussion of color the most complex effect of light—we need to consider some of the more general ways in which the properties of light are utilized in art.

Atmospheric Perspective

For Leonardo da Vinci, representing the effects of light was at least as important as perspective in creating believable space. The effect of the atmosphere on the appearance of elements in a landscape is one of the chief preoccupations of his *Notebooks*, and it is fair to say that Leonardo is responsible for formulating the "rules" of what we call **atmospheric** or **aerial perspective**. Briefly, these rules state that the quality of the atmosphere (the haze and relative humidity) between us and large objects, such as mountains, changes their appearance. Objects farther away from us appear less distinct, often cooler or bluer in color, and the contrast between light and dark is reduced.

Clarity, precision, and contrast between light and dark dominate the foreground elements in Leonardo's *Madonna of the Rocks* (Fig. 157). The Madonna's hand extends over the head of the infant Jesus in an instance of almost perfect perspectival foreshortening. Yet perspective has little to do with the way in which we perceive the distant mountains over

Functions of Light 1

Fig. 157 Leonardo da Vinci, Madonna of the Rocks, c. 1495–1508. Oil on panel, 75 × 47 in. Musée du Louvre, Paris. Scala/Art Resource, New York.

the Madonna's right shoulder. We assume that the rocks in the far distance are the same brown as those nearer to us, yet the atmosphere has changed them, making them appear blue. We know that of these three distant rock formations, the one nearest to us is on the right, and the one farthest away is on the left. Since they are approximately the same size, if they were painted with the same clarity and the same amount of contrast between light and dark, we would be unable to place them spatially. We would see them as a horizontal wall of rock, parallel to the picture plane, rather than as a series of mountains, receding diagonally into space. By the nineteenth century, aerial perspective had come to dominate the thinking of landscape painters. A painting like *Rain*, *Steam*, and Speed—The Great Western Railway (Fig. 158) certainly employs linear perspective: We stare over the River Thames across the Maidenhead Bridge, which was completed for the railway's new Bristol and Exeter line in 1844, the year Turner painted the scene. But the space of this painting does not depend upon linear perspective. Rather, light and atmosphere dominate it, creating a sense of space that in fact overwhelms the painting's linear elements in luminous and intense light. Turner's light is at once so opaque that it

Fig. 158 J. M. W. Turner, Rain, Steam, and Speed—The Great Western Railway, 1844.
 Oil on canvas, 33 ³/₄ × 48 in. Clore Collection, Tate Gallery, London.
 Erich Lessing/Art Resource, New York.

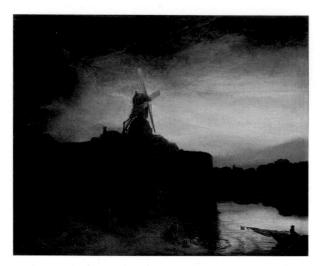

Fig. 159 Rembrandt van Rijn, *The Mill*, 1645–1648.
 Oil on canvas, 34 ¹/₂ × 41 ⁵/₈ in. The National Gallery of Art, Washington, D.C. Widener Collection.
 © 1999 Board of Trustees, National Gallery of Art.

conceals everything behind it and so deep that it seems to stretch beyond the limits of vision. Describing the power of Rembrandt's *The Mill* (Fig. 159) in a lecture delivered in 1811, Turner praised such ambiguity: "Over [the Mill] he has thrown that veil of matchless color, that lucid interval of Morning dawn and dewy light on which the Eye dwells . . . [and he] thinks it a sacrilege to pierce the mystic shell of color in search of form." With linear perspective one might adequately describe physical reality—a building, for instance—but through light one could reveal a greater spiritual reality.

Chiaroscuro

One of the chief tools employed by artists of the Renaissance to render the effects of light is chiaroscuro. In Italian, the word *chiaro* means "light," and the word *oscuro* means "dark." Thus, the word *chiaroscuro* refers to the balance of light and shade in a picture, especially its skillful use by the artist in representing the gradual transition around a curved surface from light to dark. The use of chiaroscuro to represent light falling across a curved or rounded surface is called **modeling**.

In his *Study for La Source* (Fig. 160), Pierre Paul Prud'hon has employed the techniques of chiaroscuro to model his figure. Drawing on blue tinted paper, he has indicated

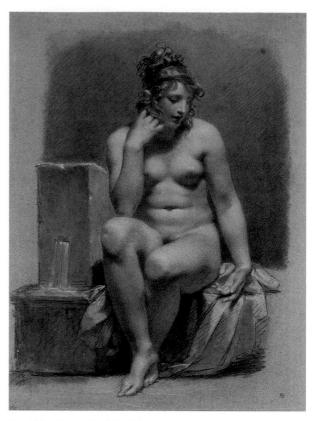

 Fig. 160 Pierre Paul Prud'hon, Study for La Source, c. 1801. Black and white chalk, 21 ³/₄ × 15 ¹/₄ in.
 © Sterling and Francine Clark Art Institute, Williamstown, Massachusetts.

shadow by means of charcoal and has created the impression of light with white chalk. The *reserve*—or the tinted paper upon which the drawing is made—functions as the light area. Thus, Prud'hon leaves all of the normally lit areas of the model's body, as it were, "blank"—they are not drawn upon.

The basic types of shading and light employed in chiaroscuro can be observed in Figure 161. **Highlights**, which directly reflect the light source, are indicated by white, and the various degrees of shadow are noted by darker and darker areas of black. There are three basic areas of shadow: the **penumbra**, which provides the transition to the **umbra**, the core of the shadow, and the **cast shadow**, the darkest area of all. Finally, areas of reflected light, cast indirectly on the table on which the sphere rests, lighten the underside of shadowed surfaces. The effect can be seen on the underside of the model's left thigh in the Prud'hon drawing.

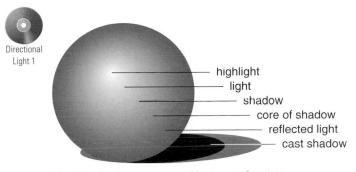

Fig. 161 A sphere represented by means of modeling.

Hatching and Cross-hatching

Other techniques used to model figures include hatching and cross-hatching. Employed especially in ink-drawing and printmaking, where the artist's tools do not readily lend themselves to creating shaded areas, hatching and cross-hatching are linear methods of modeling. Hatching is an area of closely spaced parallel lines, or hatches. The closer the spacing of the lines, the darker the area. If you look closely, you will see that Prud'hon has employed black hatches to deepen the shadows of his Study for La Source. They are especially evident along the figure's left thigh and upper-left arm. A more obvious example of hatching can be seen in The Coiffure (Fig. 162), a drawing by Mary Cassatt, an artist deeply interested in the play of light and dark (see Works in Progress, p. 122). Here parallel lines, of greater or lesser density, define the relative deepness of the shadow in the room. Interestingly, the woman's reflection in the mirror is rendered as untouched white reserve. Hatching

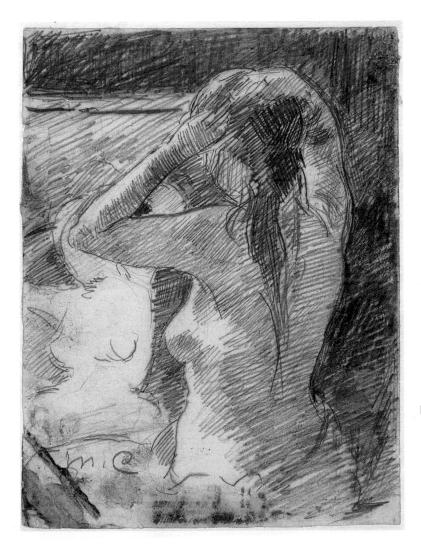

Fig. 162 Mary Cassatt, The Coiffure, c. 1891.

Graphite with traces of green and brown watercolor, approx. 5 $\frac{7}{8} \times 4 \frac{3}{8}$ in. The National Gallery of Art, Washington, D.C. Rosenwald Collection, 1954.12.6. Photo © Board of Trustees, National Gallery of Art, Washington, D.C.

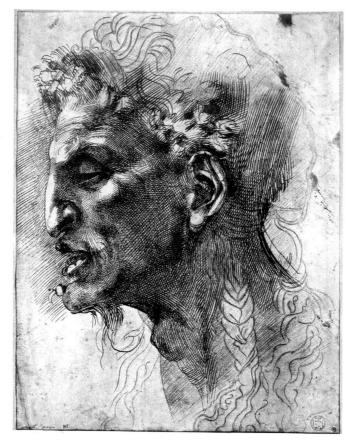

Fig. 163 Michelangelo, Head of a Satyr, c. 1620–1630. Pen and ink over chalk, 10 ⁵/₈ × 7 ⁷/₈ in. Musée du Louvre, Paris. Giraudon/Art Resource, New York.

can also be seen in Michelangelo's Head of a Satyr (Fig. 163), at the top and back of the satyr's head and at the base of his neck. But in Michelangelo's drawing, it is through cross-hatching that the greatest sense of volume and form in space is achieved. In cross-hatching one set of hatches is crossed at an angle by a second, and sometimes a third, set. The denser the lines, the darker the area. The hollows of the satyr's face are tightly cross-hatched. In contrast, the most prominent aspects of the satyr's face, the highlights at the top of his nose and on his cheekbone, are almost completely free of line. Michelangelo employs line to create a sense of volume not unlike that achieved in the sphere modeled in Figure 161.

Value

The gradual shift from light to dark that characterizes both chiaroscuro and atmospheric perspective is illustrated by the gray scale (Fig. 164). The relative level of lightness or

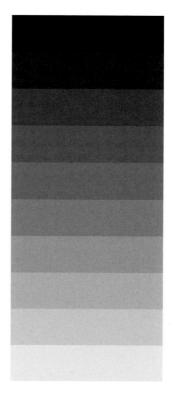

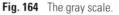

darkness of an area or object is traditionally called its relative value. That is, a given area or object can be said to be darker or lighter in value. Colors, too, change value in similar gradients. Imagine, for example, substituting the lightest blue near the bottom of this scale and the darkest cobalt near its top. The mountains in the back of Leonardo's *Madonna of the Rocks* (see Fig. 157) are depicted in a blue of lighter and lighter value the farther they are away from us.

Likewise, light pink is a lighter value of red, and dark maroon a darker value. In terms of color, whenever white is added to the basic hue, or color, we are dealing with a **tint** of that color. Whenever black is added to the hue, we are dealing with a shade of that color. Thus pink is a tint and maroon a shade of red. Pat Steir's two large paintings, Pink Chrysanthemum (Fig. 165) and Night Chrysanthemum (Fig. 166), are composed of three panels, each of which depicts the same flower in the same light viewed increasingly close-up, left to right. Not only does each panel become more and more abstract as our point of view locuses in on the flower, so that in the last panel we are looking at almost pure gestural line and brushwork, but also the feeling of each panel shifts, depending on its relative value. The light painting becomes increasingly energetic and alive, while the dark one becomes increasingly somber and threatening.

Fig. 165 Pat Steir, "Pink Chrysanthemum," 1984. Oil on canvas, 3 panels, 60 × 60 inches each. Courtesy of the artist and Cheim & Read, New York.

Fig. 166 Pat Steir, "*Night Chrysanthemum*," 1984. Oil on canvas, 3 panels, 60 × 60 incluse each. Courtesv of the artist and Cheim & Read, New York.

WORKS IN PROGRESS

ainted in 1879, the year she first exhibited with the Impressionists, Mary Cassatt's *In the Loge (At the Francais, a Sketch*) (Fig. 168) is a study in the contrast between light and dark,

as becomes evident when we compare the final work to a tiny sketch, a study perhaps made at the scene itself (Fig. 167). In the sketch, Cassatt divides the work diagonally into two broad zones, the top left bathed in light, the lower right dominated by the woman's black dress. As the drawing makes clear, this diagonal design is softened by Cassatt's decision to fit her figure into the architectural curve of the loge itself, so that the line running along the railing, then up the woman's arm, continues around the line created by her hat and its strap in a giant compositional arch. Thus the woman's face falls into the zone of light, highlighted by her single diamond earring, and cradled, as it were, in black.

In the final painting, the strict division between light and dark has been somewhat modified, particularly by the revelation of the woman's neck between the hat's strap and her collar, creating two strong light-and-dark diagonals. A sort of angularity is thus introduced into the painting, emphasizing the horizontal quality of the woman's profile and gaze as she stares out at the other loges through her binoculars, at an angle precisely 90° from our point of view.

Across the way, a gentleman, evidently in the company of another woman, leans forward out of his box to stare through his own binoculars in the direction of the woman in black. He is in the zone of light, and the dramatic division between light and dark defines itself as a division between male and female spaces. But Cassatt's woman, in a bold painterly statement, enters the male world. Both her face and her hand holding the binoculars enter the space of light. Giving up the female role as the passive recipient of his gaze, she becomes as active a spectator as the male across the way.

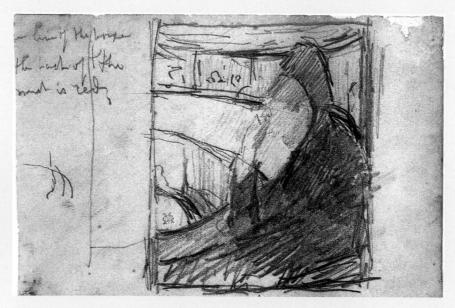

Fig. 167 Mary Cassatt, Study for painting *In the Loge*, 1880.
 Pencil, 4 × 6 in. Museum of Fine Arts, Boston. Gift of Dr. Hans Schaeffer.
 Photo © 2004 Courtesy Museum of Fine Arts, Boston, 55.28.

122 Part 2 Formal Elements and Their Design

Mary Cassatt's IN THE LOGE

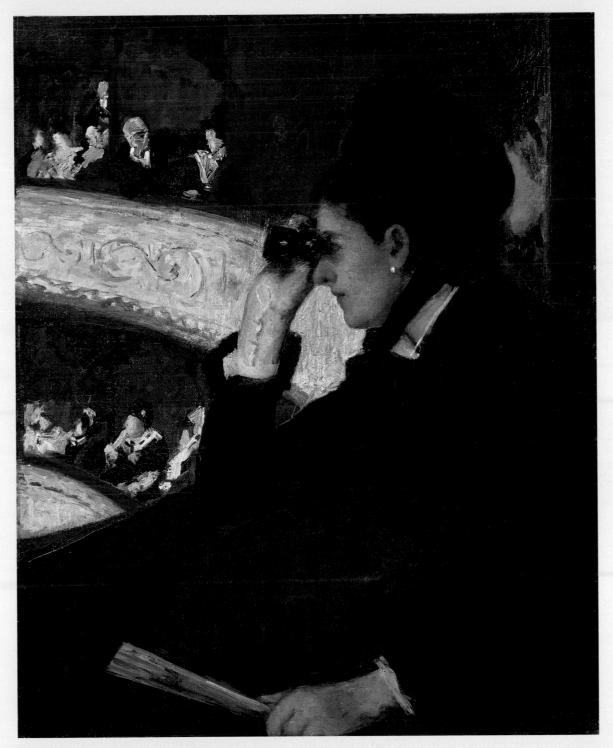

 Fig. 168
 Mary Cassatt, In the Loge (At the Francais, a Sketch), 1879.

 Oil on canvas, 32 × 26 in. Museum of Fine Arts, Boston. The Hayden Collection, 10.35.

 Photo © 2004 Museum of Fine Arts, Boston.

Fig. 169 Artemisia Gentileschi, Judith and Maidservant with the Head of Holofernes, c. 1625.
Oil on canvas, 72 ¹/₂ × 55 ³/₄ in. Detroit Institute of Arts. Gift of Mr. Leslie H. Green, 52.253.
Photo © 1984 Detroit Institute of Arts.

In her Judith and Maidservant with the Head of Holofernes (Fig. 169), Artemisia Gentileschi heightens the drama inherent in the conflict between light and dark, taking the technique of chiaroscuro to a new level. One of the most important painters of her day, Gentileschi utilizes a technique that came to be known as tenebrism, from the Italian tenebroso, meaning murky. Competing against the very deep shadows of the painting are dramatic spots of light. Based on the tale in the book of Judith in the Bible in which the noble Judith seduces the invading general Holofernes and then kills him, thereby saving her people from destruction, the painting is larger than lifesize. Its figures are heroic, illuminated in a strong artificial spotlight, and modeled in both their physical features and the folds of their clothing with a skill that lends them astonishing spatial reality and dimension. Not only does Judith's outstretched hand cast a shadow across her face, suggesting a more powerful, revealing source of light off canvas to the left, it also invokes our silence. Like the light itself, danger lurks just offstage.

If Judith is to escape, even we must remain still. Gentileschi represents a woman of heroic stature in a painting of heroic scale, a painting that dominates, even controls, the viewer.

Light and dark have traditionally had strong symbolic meaning in Western culture. In his painting The Oxbow (Fig. 170), Thomas Cole presents the same themes that dominate his Course of Empire series (see Figs. 42-46) in terms of light and dark. The left side of the painting depicts the wilderness. The two trees at the left have been blasted by lightning. The forest is dense and daunting, and a thunderstorm rolls across the mountainous landscape. This wild scene contrasts dramatically with the civilized valley floor on the right. Here, bathed in serene sunlight, are cultivated fields, hillsides cleared of timber, and farmhouses from whose chimneys rise gentle plumes of smoke. The Connecticut River itself flows in a giant arc that reinforces the pastoral tranquility of the scene.

The painting embodies many of the themes that Cole's contemporaries, the authors Washington Irving and James Fenimore Cooper, expressed in such classics as Irving's *Rip Van Winkle* and Cooper's *Leatherstocking* novels. In 1826, a decade before this painting, Cole himself described a storm in the Catskills, the mountains of Eastern New York and Western Connecticut:

In one of my many mountain rambles I was overtaken by a thunderstorm. . . . As it advanced, huge masses of vapour were seen moving across the deep blue.... The deep gorge below me grew darker, and the general gloom more awful: terrific clouds gathered in their black wings upon the hollow, hushed and closer . . . squadrons of vapour rolled in,-shock succeeded shock,-thunderbolt fell on thunderbolt,-peal followed peal,-waters dashed on every crag from the full sluices of the sky. . . . All at once, a blast, with the voice and temper of a hurricane, swept up through the gulf, and lifted with magical swiftness the whole mass of clouds high into the air. . . . A flood of light burst forth from the west and jeweled the whole broad bosom of the mountain. The birds began to sing, and I saw, in a neighboring dell, the blue smoke curling up quietly from a cottage chimney.

Fig. 170 Thomas Cole, View from Mount Holyoke, Northampton, Massachusetts, after a Thunderstorm—The Oxbow, 1836. Oil on canvas, 51 ½ × 76 in. The Metropolitan Museum of Art, New York. Gift of Mrs. Russell Sage, 1908 (08.228). Photo © 1995 The Metropolitan Museum of Art.

The power of Cole's description rests on the same tension between light and dark as his painting. It is, in fact, as if *The Oxbow* captures the very moment with which his narrative ends. The artist's umbrella juts out across the river from the rock at the right. And just below it, to the left, is Cole himself, now at work at his easel. The furious forces of nature have moved on, and the artist "captures" the scene just as civilization would "tame" the wild.

We have only to think of the Bible, and the first lines of the Book of Genesis, which very openly associates the dark with the bad and the light with the good to understand how thoroughly the tension between light and dark dominates Western thought:

In the beginning God created the heaven and the earth. And the earth was without form, and void; and darkness was upon the face of the deep. And the Spirit of God moved upon the face of the waters. And God said, Let there be light: and there

was light. And God saw the light, that it was good: and God divided the light from the darkness.

In the history of art, this association of light or white with good, and darkness or black with evil was first fully developed in the lateeighteenth- and early-nineteenth-century color theory of the German poet and dramatist Johann Wolfgang von Goethe. For Goethe, colors were not just phenomena to be explained by scientific laws. They also had moral and religious significance, existing halfway between the goodness of pure light and the damnation of pure blackness. In heaven there is only pure light, but the fact that we can experience color—which, according to the laws of optics, depends upon light mixing with darkness promises us at least the hope of salvation.

Since Biblical times Western culture has tended to associate blackness with negative qualities and whiteness with positive ones, and it is understandable that people might take

Fig. 171 Nikolai Buglai, "Race'ing Sideways," 1991. Graphite and ink, 30 in. high × 40 in. wide. Courtesy of the artist.

offense at this association. In "Race" ing Sideways (Fig 171), Nicolai Buglaj has drawn 13 racers, conceived as mannequins in an installation, tied for the lead in a race no one seems intent on winning. From left to right, their skin color changes from white to black, even as their clothing changes from black to white, a double version of the traditional "value" scale. But what "values" are at stake here? The runners are moving forward uniformly, all equally "making progress." But this equality is an illusion. Left to right, our "values" change. They reveal themselves to be governed by questions of race (skin color) and class (clothing color, i.e., "white collar," "blue collar"). And we understand that Buglaj's drawing is a stinging indictment of the lack of progress we have made in race and class relations in this country.

For Buglaj, perceptual illusion replicates cultural illusion.

If for Goethe blackness is not merely the absence of color but the absence of good, for African-Americans blackness is just the opposite. In poet Ted Wilson's words:

Mighty drums echoing the voices of Spirits.... these sounds are rhythmatic The rhythm of vitality, The rhythm of exuberance and the rhythms of Life These are the sounds of blackness Blackness—the presence of all color.

Ben Jones's *Black Face and Arm Unit* (Fig. 172) is in many ways the visual equivalent

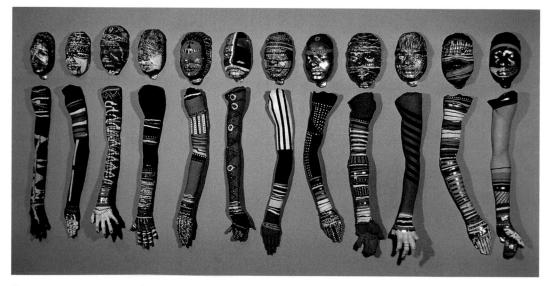

Fig. 172 Ben Jones, Black Face and Arm Unit, 1971. Acrylic on plaster and paint, life-size plaster casts. Courtesy of the artist.

Fig. 173 Head of a King, from Ife, Nigeria, c. 13th century CF.
 Brass, height, 11 ¹¹/₁₆ in. Museum of Ife Antiquities, Ife.
 © 1985 Dirk Bakker, Detroit, Michigan.

of Wilson's poem. Cast lifesize from actual hands and arms, the 12-part piece literally embodies an essential blackness. Adorning this essence is a series of bands, decorations, and scarifications, reminiscent of the facial decorations evident in some of the most ancient African sculpture. The brass head of an oni, or king, illustrated here (Fig. 173), dates from the thirteenth century CE. Holes along the scalp line suggest that hair might once have been attached, and the large holes around the base of the neck suggest that the head may have been attached to a wooden mannequin for ritual occasions. Like Jones's more colorful descendants, the parallel striations of the scarification on the face create a sense of rhythm and exuberance, and it is as if in Jones's arms and faces we hear the voices of this Nigerian spirit.

Another, more contemporary example of Nigerian art, a funeral cloth (Fig. 174) commissioned by a collector in the late 1970s, similarly illustates the limits of white Western assumptions about the meaning of light and dark, black and white. The cloth is the featured element of a shrine, called a *nuvomo*, constructed of bamboo poles to commemo-

Fig. 174 Okun Akpan Abuje, *Nigerian, Funerary shrine cloth, commissioned in the late 1970s.* Cotton, dye 135 ³/₄ × 60 ¹/₄ in. National Museum of African Art/Smithsonian Institution Museum Purchase 84-6-9. Photo: Frank Khoury.

rate the death of a member of Ebie-owo, a Nigerian warriors' association. A deceased elder, wearing a woolen hat, is depicted in the center of this cloth. His eldest daughter, at the left, pours liquor into his glass. The woman on the right wears the hairdo of a mourning widow. She is cooking two dried fish for the funeral feast.

But the dominant colors of the cloth—red, black, and white—are what is most interesting. While in the West we associate black with funerals and mourning, here it signifies life and the ancestral spirits. White, on the other hand, signifies dcath. Though red is the color of blood, it is meant to inspire the warrior's valorous deeds.

COLOR

Both the ambiguity of Goethe's color theory and the example of the Nigerian funeral cloth make clear that, of all the formal elements. color is perhaps the most complex. Not only do different colors mean different things to different people and cultures, but also our individual perception of a given color can change as its relationship to other colors changes. The human eye may be able to distinguish as many as ten million different colors, but we have nowhere near that many words to differentiate among them. Different cultures, furthermore, tend to emphasize different ranges of color. Although apparently able to distinguish visually between green and blue, many cultures do not possess different words for them. The Maoris of New Zealand regularly employ over 100 words for what most of us would simply call

"red." Color is so complex that no one—neither scientists, nor artists, nor theoreticians such as Goethe—has ever fully explained it to everyone's satisfaction.

Because of this complexity, color is also almost infinitely suggestive. When New York City's Museum of Modern Art closed for an extensive redesign and moved to temporary quarters across the river in Queens, it commissioned Chinese-born artist Cai Guo-Qiang to celebrate the move with one of his famous explosion projects. His proposal resulted in *Transient Rainbow* (Fig. 175), a massive fireworks display that extended across the East River, connecting Manhattan and Queens, on the evening of June 29, 2002. For the artist, the rainbow is a sign of hope, renewal and promise. In Chinese mythology, the rainbow is associated with the goddess Nu-Wa (see Fig. 113), who sealed the broken

Fig. 175 Cai Guo-Qiang, Transient Rainbow, 2002.
 1000 3-inch multicolor peonies fitted with computer chips, 300 × 600 feet, duration 15 seconds. Commissioned by Museum of Modern Art, New York.
 Photo: Hiro Ihara, courtesy of the artist. Cai Studio.

Fig. 176 Cai Guo-Qiang, Drawing for Transient Rainbow, 2003 Gunpowder on paper, 198 × 157 in. Museum of Modern Art, New York. Art Licensed by Scala/Art Resource, NY.

sky after a fight among the gods with stones of seven different colors—the colors of the rainbow. Coming after 9/11, the choice of the rainbow image was similarly designed to heal, at least symbolically, the wounded city. Reflected in the water, the arch created by Cai Guo-Qiang's rainbow creates the circular pi, the ancient Chinese symbol for the universe.

Perhaps nothing reflects the transformative power of color more than Cia Guo-Qiang's drawing for *Transient Rainbow*, executed after the event itself (Fig. 176). His medium is, in fact, gunpowder, exploded and burnt onto paper. It forms the same circular image as

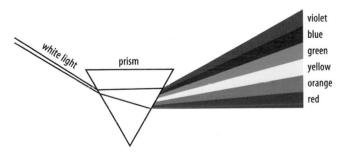

Fig. 177 Colors separated by a prism.

Transient Rainbow, the arc of explosives and its reflection in the East River. But this work is a *memento mori*, a sort of *vanitas* (see Fig. 63), reminding us, even after the celebratory gesture of *Transient Rainbow*, of the fragility and transience of the moment and, by extension, life itself. In black and white, the border between life and death seems a definitive matter. But gunpowder is the trace of the rainbow's explosion, the aftermath of its short but spectacular life. It is, in the end, for Cai Guo-Qiang, the very mark of our memory of the event's great color, the trace of its history, and the indelible imprint on, and its promise for, the future.

Basic Color Vocabulary

As we have said, color is a direct function of light. Sunlight passed through a prism breaks into bands of different colors, in what is known as the **spectrum** (Fig. 177). By reorganizing the visible spectrum into a circle, we have what is recognized as the conventional **color wheel** (Fig. 178). The three **primary colors**—red, yellow, and blue (designated by the number 1 on the color wheel)—are those that, in theory at least, cannot be made by any mixture of the other colors. Each of the **secondary colors**—orange, green, and violet (designated by the number 2)—is a mixture of

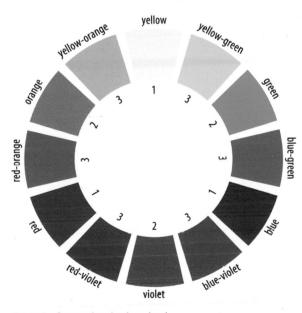

Fig. 178 Convontional color wheel.

Fig. 179 Color mixtures of reflected pigment—subtractive process.

Optical Effects 1 & 3

Fig. 180 Color mixtures of refracted light—additive process.

the two primaries that it lies between. Thus, as we all learn in elementary school, green is made by mixing yellow and blue. The intermediate colors (designated by the number 3) are mixtures of a primary and a neighboring secondary. If we mix the primary yellow with the secondary orange, for instance, the result is yellow-orange.

As we have already noted in our discussion of tint and shade, each primary and secondary color of the visible spectrum is called a hue. Thus all shades and tints of red-from pink to deep maroon—are said to be of the same red hue, though they are different keys of that hue. One of the more complex problems presented to us by color is that the primary and secondary hues change depending upon whether we are dealing with refracted light or reflected pigment. The conventional color wheel illustrated in Fig. 178 demonstrates the relationship among the various hues as reflected pigment. When we mix pigments, we are involved in a subtractive process (Fig. 179). That is, in mixing two primaries, the secondary that results is of a lower key and seems duller than either of the original two primaries, because each given primary absorbs a different range of white light. Thus, when we combine red and yellow, the resulting orange absorbs twice as much light as either of its source primaries taken alone. Theoretically, if we combined all the pigments, we would absorb all light and end up with black, the absence of color altogether.

Refracted light, on the other hand, works in a very different manner. With refracted light, the primary colors are red-orange, green, and blue-violet. The secondaries are yellow, magenta, and cyan. When we mix light, we are involved in an additive process (Fig. 180). That is, if we mix two primaries of colored light, the resulting secondary is higher in key and seems brighter than either primary. Our most common exposure to this process occurs when we watch television. This is especially apparent on a large-screen monitor, where yellow, if viewed close-up, can be seen to result from the overlapping of many red and green dots. In the additive color process, as more and more colors are combined, more and more light is added to the mixture, and the colors that result are brighter than either source taken alone. As Newton discovered, when the total spectrum of refracted light is recombined, white light results.

Color is described first by reference to its hue (red), then to its relative key or value (pink or maroon), and also by its **intensity** or **saturation** (bright pink). Intensity is a function of a color's relative brightness or dullness. One lowers the intensity of a hue by adding to it either gray or the hue opposite it on the color wheel (in the case of red, we would add green). Intensity may also be reduced by adding **medium**—a liquid that makes paint easier to manipulate—to the hue.

There is perhaps no better evidence of the psychological impact that a change in intensity can make than to look at the newly restored frescoes of the Sistine Chapel at the Vatican in Rome, painted by Michelangelo between 1508 and 1512 (Figs. 181 and 182). Restoration was begun in 1980 and has just been completed. The process was relatively simple. A solvent called AB 57, mixed with a fungicide and antibacterial agent, and a cellulose gel so that it would not drip from the ceiling, was painted onto a small section of the fresco with a bristle brush. The AB 57 mixture was allowed to sit for 3 minutes, and then it was removed with a sponge and water, which also removed the grime. The process was repeated in the dirtiest areas. The entire operation was documented in great detail by the Nippon Television Network of Japan, which funded the entire restoration project.

Restorers have discovered that the dull, somber hues always associated with Michelangelo were not the result of his **palette**, that is, the range of colors he preferred to use, but of centuries of accumulated dust, smoke, grease, and varnishes made of animal glue painted

Fig. 181 Michelangelo, *The Creation of Adam* (unrestored), ceiling of the Sistine Chapel, 1508–1512. Fresco. The Vatican, Rome. AKG-Images

Fig. 182 Michelangelo, *The Creation of Adam* (restored), ceiling of the Sistine Chapel, 1508–1512. Fresco. The Valican, Rome. Sistine Chapel/Canali Photobank

Fig. 183 Sanford R. Gifford, October in the Catskills, 1880.
 Oil on canvas, 36 ⁵/₁₆ × 29 ³/₁₆ in. Los Angeles County Museum of Art. Gift of Mr. and Mrs. Charles C. Shoemaker, Mr. and Mrs. J. Douglas Pardee, and Mr. and Mrs. John McGreevey, M77.141.
 Photo © 2002 Museum Associates/LACMA.

over the ceiling by earlier restorers. The colors are in fact much more saturated and intense than anyone had previously supposed. Some experts find them so intense that they seem, beside the golden tones of the unrestored surface, almost garish. As a result, there has been some debate about the merits of the cleaning. But, in the words of one observer: "It's not a controversy. It's culture shock."

Color Schemes

Colors can be employed by painters in different ways to achieve a wide variety of effects. Analogous color schemes are those composed of hues that neighbor each other on the color wheel. Such color schemes are often organized on the basis of color temperature. Most of us respond to the the range from yellow through orange and red as warm, and to the opposite side of the color wheel, from green through violet, as cool. Sanford Gifford's October in the Catskills (Fig. 183) is a decidedly warm painting-just like a sunny fall day. The color scheme consists of yellows, oranges, and reds in varying degrees of intensity and key. Even what appears to be brown in this composition is a result of mixing this spectrum of warm colors. Its warmth is so powerful that even the blue of the sky is barely perceptible through the all-consuming yellow atmosphere. The painting is a study in atmospheric perspective, though it modifies Leonardo's formula somewhat, since the distant hills do not appear "bluer," only softer in hue. Representing the effects of atmosphere was Gifford's chief goal in painting. "The really important matter," he asserted, "is not the natural object itself, but the veil or medium through which we see it."

Just as warm and cool temperatures literally create contrasting physical sensations, when both warm and cool hues occur together in the same work of art they tend to evoke a sense of contrast and tension. Romare Bearden's She-ba (Fig. 184) is dominated by cool blues and greens, but surrounding and accenting these great blocks of color are contrasting areas of red, yellow, and orange. "Sometimes, in order to heighten the character of a painting," Bearden wrote in 1969, just a year before this painting was completed, "I introduce what appears to be a dissonant color where

1&2

Fig. 184 Romare Bearden, She-ba, 1970. Oil on canvas, 48×35 $\frac{7}{8}$ in. Wadsworth Atheneum, Hartford. The Ella Gallup Sumner and Mary Catlin Sumner Collection Fund © Romare Bearden Fund/Licensed by VAGA, New York

the reds, browns, and yellows disrupt the placidity of the blues and greens." Queen of the Arab culture that brought the Muslim religion to Ethiopia, Sheba here imparts a regal serenity to all that surrounds her. It is as if, in her every gesture, she cools the atmosphere, like rain in a time of drought, or shade at an oasis in the desert.

Color schemes composed of hues that lie opposite each other on the color wheel, as opposed to next to each other, are called complementary. Thus, on the traditional color wheel, there are three basic sets of complementary relations: orange/blue, yellow/violet, and red/green. Each intermediate color has its complement as well. When two complements appear in the same composition, especially if they are pure hues, each will appear more intense. If placed next to each other, without mixing, complements seem brighter than if they appear alone. This effect, known as simultaneous contrast, is due to the physiology of the eye. If, for example, you state

Fig. 185 Leon Golub, Mercenaries III, 1980. Acrylic on canvas, 120 × 198 in. Collection of the Eli Broad Family Foundation, Los Angeles. © Leon Golub/Licensed by VAGA, New York.

intensely at the color red for about 30 seconds and then shift your vision to a field of pure white, you will see not red, but a variety of green. Physiologically, the eye supplies an **afterimage** of a given hue in the color of its complement. This effect can be experienced in Leon Golub's *Mercenaries III* (Fig. 185). Based on news photos, Golub's painting attempts, in his words, to "have a sense of the contemporaneity of events. They are poised to be almost physically palpable, a tactile tension of events." The almost neon, electric red and and green of the canvas clash dramatically. The color seems as explosive as the situation Golub depicts.

In his A Sunday on La Grande Jatte (Fig. 186), Georges Seurat has tried to harmonize his complementary colors rather than create a sense of tension with them. With what almost amounts to fanaticism, Seurat painted this giant canvas with thousands of tiny dots, or points, of pure color in a process that came to be known as *pointillism*. Instead of mixing color on the palette or canvas, he believed that the eye of the perceiver would be able to mix colors optically. (Contemporary artist Chuck Close has, in fact, perfected the technique—see Works in Progress, p. 136.) Seurat strongly believed that if he placed complements side by side—particularly orange and blue in the shadowed areas of the painting—that the intensity of the color would be dramatically enhanced. But to his dismay, most viewers found the painting "lusterless" and "murky." This is because there is a rather limited zone in which the viewer does in fact optically mix the pointillist dots. For most viewers, Seurat's painting works from about 6 feet away—closer, and the painting breaks down into abstract dots, farther away, and the colors muddy, turning almost brown.

One of the more vexing issues that the study of color presents is that the traditional color wheel really does not adequately describe true complementary color relations. For instance, the afterimage of red is not really green, but bluegreen. In 1905, Albert Munsell created a color wheel based on five, rather than three, primary hues: yellow, green, blue, violet, and red (Fig. 187). The complement of each of these five is a secondary. Munsell's color wheel accounts for what is, to many eyes, one of the most powerful complementary color schemes, the relation between yellow and blue-violet. The Brazilian feather mask, known as a *Cara Grande*

Fig. 186 Georges Seurat, A Sunday on La Grande Jatte, 1884–1886.
 Oil on canvas, 71 ³/₄ in. × 10 ft. 1 ¹/₄ in. The Art Institute of Chicago. Helen Birch Bartlett Memorial Collection, 1926.224.
 Photo © 2001 The Art Institute of Chicago. All Rights Reserved.

(Fig. 188), illustrates this contrast. The mask is worn during the annual Banana Fiesta in the Amazon Basin; it is almost 3 feet tall. It is made of wood and is covered with pitch to which feathers are attached. The brilliantly colored feathers are not dyed, but are the natural plumage of tropical birds, and the intensity of their color is heightened by the simultaneous contrast between yellow and blue-violet, which is especially apparent at the outer edge of the mask.

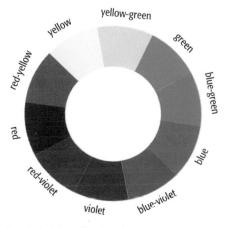

Fig. 187 Munsell color wheel.

Fig. 188 *Cara Grande* feather mask, Tapirapé, Rio Tapirapé, Brazil, c. 1960. Height, 31 in. National Museum of the American

Indian/Smithsonian Institution.

WORKS IN PROGRESS

huck Close's 1981 oil painting Stanley (Fig. 190) might best be described as "layered" pointillism (see Fig. 186). Like all of his paintings, the piece is based on a photograph. Close's working method is to overlay the original photograph with a grid. Then he draws a grid with the same number of squares on a canvas. Close is not so much interested in representing the person whose portrait he is painting as he is in reproducing, as accurately as possible, the completely abstract design that occurs in each square of the photo's grid. In essence, Close's large paintings-Stanley is nearly 8 feet high and 6 feet wide-are made up of thousands of little square paintings, as the detail (Fig. 189) makes clear. Each of these "micro"-paintings is composed as a small target, an arrangement of two, three, or four concentric circles. Viewed up close, it is hard to see anything but the design of each square of the grid. But as the viewer moves farther away, the design of the individual squares of the composition dissolves, and the sitter's features emerge with greater and greater clarity.

In an interview conducted by art critic Lisa Lyons for an essay that appears in the book *Chuck Close*, published by Rizzoli International in 1987, Close describes his working method in *Stanley* at some length, comparing his technique to, of all things, the game of golf:

Golf is the only sport in which you move from the general to the specific. In the beginning when you take your first shot, you can't even see the pin. And in a matter of three or four strokes, you're supposed to be in the cup, a very small, specific place a very long ways away. I thought of the gridded canvas as a golf course, and each square of the grid as a par-four hole. Then just to complicate things and make the game more interesting, I teed off in the opposite direction of

Fig. 189 Chuck Close, *Stanley* (large version), 1980–1981, detail. Oil on canvas, 108 × 84 in. The Solomon R. Guggenheim Museum, New York. Purchased with funds contributed by Mr. and Mrs. Barrie M. Damson, 1981, 81.2839. Photo: David Heald. © The Solomon R. Guggenheim Foundation, New York (FN 2839).

the pin. For example, I knew that the color of the skin was going to be in the orange family, so I started out by putting down a thin wash of blue, green, or purple—something very different from what the final color would be. The second color then had to go miles to alter the first one. So for this big correcting stroke, I chose a hue that moved me into the generic color family I should have been aiming for.

Chuck Close's **STANLEY**

Fig. 190 Chuck Close, *Stanley* (large version), 1980–1981.

Oil on canvas, 104 × 84 in. The Solomon R. Guggenheim Museum, New York. Purchased with funds contributed by Mr. and Mrs. Barrie M. Damson, 1981, 81.2839.

Photo: David Heald. © The Solomon R. Guggenheim Foundation, New York (FN 2839).

Now I had moved into orange, but it was too yellow, so in the middle of that stroke, I put down a gob of red to move into a reddish orange. Then I was at the equivalent of being "on the green" and hopefully quite close to the cup. But the color was still much too bright. So the final stroke was a little dot of blue, the complementary color, which optically mixed with the orange and lowered its intensity, dropping it down to an orangish brown. I was in the cup.

[It was possible] to have a birdie—to come in a stroke early. It was even possible to have an eagle—to come in two [strokes] under par. Of course, it was also equally possible to have a bogie or a double bogie [one or two strokes over par], and even get mired in some aesthetic sandtrap, just making strokes and getting nowhere at all.

Close's "game" with color is exacting and demanding, requiring a knowlege of the optical effects of color mixing that is virtually unparalleled in the history of art. He is able to achieve, in his work, two seemingly contradictory goals at once. On the one hand, his work is fully representational. On the other, it is fully abstract, even nonobjective in its purely formal interest in color. Close has it both ways.

 Fig. 191
 Charles Searles, Filàs for Sale (from the Nigerian Impressions series), 1972.

 Acrylic on canvas, 72 × 50 in. Lent by the Museum of the National Center of Afro-American Artists, Roxbury, Massachusetts.

Artists working with either analogous or complementary color schemes choose to limit the range of their color selection. In his painting Filàs for Sale (Fig. 191), Charles Searles has rejected such a closed or restricted palette in favor of an open palette, in which he employs the entire range of hucs in a wide variety of keys and intensities. Such a painting is polychromatic. The painting depicts a Nigerian marketplace and was inspired by a trip Searles took to Nigeria, Ghana, and Morocco in 1972. "What really hit me," Searles says, "is that the art is in the people. The way the people carried themselves, dressed, decorated their houses became the art to me, like a living art." A pile of *filas*, or brightly patterned skullcaps, occupies the right foreground of this painting. The confusion and turmoil of the crowded marketplace is mirrored in the swirl of the variously colored textile patterns. Each pattern has its own color schemevellow arcs against a set of violet dots, for instance, in the swatch of cloth just above the pile of hats—but all combine to create an almost disorienting sense of movement and activity.

Color in Representational Art

There are four different ways of using color in representational art. The artist can employ local color, represent perceptual color, create an optical mix like Seurat, or simply use color arbitrarily. The green tree and the red brick building in Stuart Davis's *Summer Landscape* (Fig. 192) are examples of **local color**, or the color of objects viewed close-up in even lighting conditions. Local color is the color we "know" an object to be, in the way that we know a banana is yellow or a fire truck is red. But we are also aware that as the effects of light and atmosphere on an object change, we will perceive its color as different. As we know from the example of atmospheric perspective, we actually see a distant

Fig. 192 Stuart Davis, Summer Landscape, 1930.
Oil on canvas, 29 × 42 in.
© Estate of Stuart Davis/Licensed by VAGA, New York.

 Fig. 193 Claude Monet, Grainstack (Sunset), 1891.
 Oil on canvas, 28 ⁷/₈ × 36 ¹/₂ in. Museum of Fine Arts, Boston. Juliana Cheney Edwards Collection, 25.112.
 Photo © 2004 Museum of fine Arts Boston.

pine-covered hill as blue, not green. The Impressionist painters were especially concerned with rendering such perceptual colors. Monet painted his landscapes outdoors, in front of his subject—**plein-air painting** is the technical term, the French word for "open air"—so as to be true to the optical colors of the scene before him. He did not paint a grainstack yellow simply because he knew hay to be yellow. He painted it in the colors that natural light rendered it to his eyes. Thus this *Grainstack* (Fig. 193) is dominated by reds, with afterimages of green flashing throughout.

The Impressionists' attempt to render the effects of light by representing *perceptual reality* is different from Seurat's attempt to reproduce light's effects by means of optical color mixing. Monet mixes color on the canvas. Seurat expects color to mix in your own eye. He put two hues next to each other, creating a third, new hue in the beholder's eye. Early in the twentieth century, the introduction of electric light would create yet another optical color mix, additive in character, that fascinated artists (see *Works in Progress*, p. 142).

The ability of the eye to trick itself—or rather for color to trick the eye—is readily demonstrated in Gerhard Richter's 256 Farben (256 Colors) (Fig. 194). The painting belongs to a series of chromatic charts painted by the artist from the mid-1960s on. His first paintings in the series were enlarged replicas of commercial paint sample cards which, in fact, used the same commercial paints as the sample cards. The arrangement of the colors on the

Fig. 194 Gerhard Richter, 256 Farben (256 Colors), 1974–1984.
 Enamel on canvas, 7 ft. 3 in. × 14 ft. 5 in. Castello di Rivoli Museo d'Arte Contemporanea, Turin, Italy. Long-term Ioan—private collection.
 © Gerhard Richter.

140 Part 2 Formal Elements and Their Design

Fig. 195 Pierre Bonnard, The Terrace at Vernon, c. 1920–1939.
 Oil on canvas, 57 ¹¹/₁₆ × 76 ¹/₂ in. The Metropolitan Museum of Art, New York. Gift of Mrs. Frank Jay Gould, 1968 (68.1).
 Photo © 1980 The Metropolitan Museum of Art. © 2003 Artists Rights Society (ARS), New York/ADAGP, Paris.

squares was done by a random process to obtain a diffuse, undifferentiated overall effect, intentionally stripping color of its emotional value. But, to Richter's delight, the paintings were hardly static. Where the vertical and horizontal white lincs intersect, a gray retinal "pop" appears. If the viewer looks at any given "pop" directly, it disappears, suggesting that it exists to the eye only at the edge of vision, a sort of blur or aura that surrounds color.

Artists sometimes choose to paint things in colors that are not "true" to either their optical or local colors. Bonnard's painting *The Terrace at Vernon* (Fig. 195) is an example of the expressive use of **arbitrary color**. No tree is "really" violet, and yet this large foreground tree is. The woman at the left holds an apple, but the apple is as orange as her dress. Next to

her, a young woman carrying a basket seems almost to disappear into the background, painted, as she is, in almost the same hues as the landscape (or is it a hedge?) behind her. At the right, another young woman in orange reaches above her head, melding into the ground around her. Everything in the composition is sacrificed to Bonnard's interest in the play between warm and cool colors, chiefly orange and violet or blue-violet, which he uses to flatten the composition, so that the fore-, middle-, and backgrounds all seem to coexist in the same space. "The main subject," Bonnard would explain, "is the surface which has its color, its laws, over and above those of the objects." He sacrifices both the local and optical color of things to the arbitrary color scheme of the composition.

WORKS IN PROGRESS

ith husband Robert her Delaunay, whom she married in 1910, Sonia Delaunay-Terk was one of the founders of modern abstract painting. Together in Paris, in the first decades of the twentieth century, they explored what their poet friend, Guillaume Apollinaire, called "the beautiful fruit of light," the colors of the modern world. In the work of both artists, these colors assumed the shape of disks. Robert called these Simultaneous Disks (Fig. 196), and they were based on his own notions about the simultaneous contrast of colors. He sought, in the paintings, to balance complements in giant color wheels. Sonia was less scientific in her approach to the design. Electric streetlights, which were still a relatively new phenomenon, transfixed her. "Robert, our friends and I met at the St. Michel fountain at the bottom of Boulevard Saint-Michel," she would later recall. "The halos of the new electric lights made colors and shades turn and vibrate, as if as yet unidentified objects fell out of the sky around us."

Reacting to this new light, in the summer of 1913, Delaunay began to make what she called

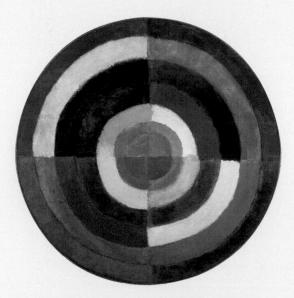

Fig. 196 Robert Delaunay, Premier Disque, 1912. Oil on canvas, 53 in. diameter. Christie's Images Ltd. 1999. © L & M Services B.V. Amsterdam 20030208. "simultaneous dresses" (Fig. 197). Apollinaire described such a dress for the readers of the *Mercure de France*, a Paris newspaper: "A purple dress, wide purple and green belt, and under the jacket, a bodice divided into brightly colored zones, delicate or faded where the following colors are mixed—antique rose, yellow-orange, blue, scarlet, etc., appearing on different materials." Imprinted on a dress, Delaunay's colors became dynamic. They moved as the body moved.

The poet Blaise Cendrars was so inspired by Sonia's color sense that he asked her to illustrate his long prose poem *The Prose of the Transsiberian*. The printed poem, with its illustrations, is 81 ³/₄ inches high, and end to end, its total edition of 150 added up to the height of the Eiffel

Fig. 197 Sonia Delaunay in a simultaneous dress, 1914. Musée National d'Art Moderne, Paris. Collection du Centre Georges Pompidou. © CNAC/MNAM/Dist. Reunion des Musées Nationaux/Art Resource, New York. © L & M Services B.V., Amsterdam 20030208.

Sonia Delaunay's **ELECTRIC PRISM**

Tower. Illustrating the poem, Delaunay experimented with what she called her "simultaneous colors," and her discoveries quickly led to a large painting, *Electric Prism* (Fig. 198). The title of Cendrars's poem, and other phrases, such as the words "Text by Blaise Cendrars," appear in the center left of the painting, like an advertisement in a store window. In *Electric Prism* Delaunay's experiments with color come to fruition. The circular disks and color combinations she had seen in electric light and that her husband had captured in his *Simultaneous Disks*, and the dynamic movement of color and flowing lines that she had designed into her dresses, are unified in this single work. As early as 1906, after her first year of studying art in Paris, she had come to believe, as she put it, that "colors can heighten our sense of ourselves, of our union with the universe." In the colors of *Electric Prism* she believed she had joined herself to the flux and flow, the enegy and dynamism, of modernity itself.

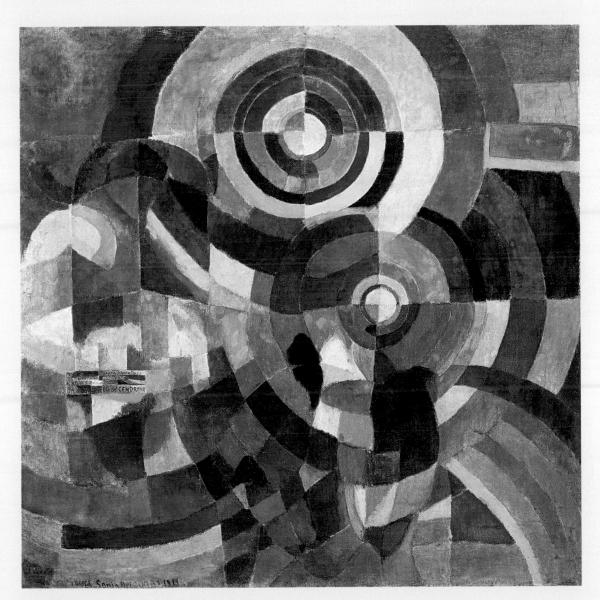

Fig. 198 Sonia Delaunay, Prismes Electriques, 1914. Oil on canvas, 98 3/8 × 98 3/6 in. Musóo National d'Art Moderne, Paris. Cullection du Centre Georges Pompidou. Photo: Phototheque des collections du Mnam/Cci. © Reunion des Musées Nationaux/Art Resource, New York. © L & M Services R V. Amsterdam 20000208.

Symbolic Use of Color

As we have seen in the example of Leon Golub's Mercenaries painting (see Fig. 185), the complementary opposition between red and green symbolizes larger thematic oppositions of the work. To different people in different situations and in different contexts. color symbolizes different things. There is no one meaning for any given color, though in a particular cultural environment, there may be a shared understanding of it. So, for instance, when we see a stop light, we assume that everyone understands that red means "stop" and green means "go." In China, however, this distinction does not exist. In Western culture, in the context of war, red might mean "death" or "blood," or "anger." In the context of Valentine's Day, it means "love." Most Americans, when confronted by the complementary pair of red and green, think first of all of Christmas.

In his painting *The Night Café* (Fig. 199), van Gogh employs red and green to his own expressive ends. In a letter to his brother Theo, written September 8, 1888, he described how the complements work to create a sense of visual tension and emotional imbalance:

In my picture of the Night Café I have tried to express the idea that the café is a place where one can ruin oneself, run mad, or commit a crime. I have tried to express the terrible passions of humanity by means of red and green. . . . Everywhere there is a clash and contrast of the most alien reds and greens. . . So I have tried to express, as it were, the powers of darkness in a low wine-shop, and all this in an atmosphere like a devil's furnace of pale sulphur. . . It is color not locally true from the point of view of the stereoscopic realist, but color to suggest the emotion of an ardent temperament.

Fig. 199 Vincent van Gogh, The Night Café, 1888.
 Oil on canvas, 28 ¹/₂ × 36 ¹/₄ in. Yale University Art Gallery, New Haven. Bequest of Stephen Carlton Clark, B.A., 1903.

While there is a sense of opposition in Wassily Kandinsky's *Black Lines* (Fig. 200) as well, the atmosphere of the painting is nowhere near so ominous. The work is virtually nonobjective, though a hint of landscape can be seen in the upper left where three mountainlike forms rise in front of and above what appears to be a horizon line defined by a lake or an ocean at sunset. The round shapes that dominate the painting seem to burst into flowers. Emerging like pods from the red-orange border at the painting's right, they suffuse the atmosphere with color, as if to overwhelm and dominate the nervous black lines that give the painting its title. Color had specific symbolic meaning for Kandinsky. "Blue," he says, "is the heavenly color." Its opposite is yellow, "the color of the earth." Green is a mixture of the two; as a result, it is "passive and static, and can be compared to the so-called 'bourgeoisie'—selfsatisfied, fat, and healthy." Red, on the other hand, "stimulates and excites the heart." The complementary pair of red and green juxtaposes the passive and the active. "In the open air," he writes, "the harmony of red and green is very charming," recalling for him not the "powers of darkness" that van Gogh witnessed in the pair, but the simplicity and pastoral harmony of an idealized peasant life.

Fig. 200 Wassily Kandinsky, Black Lines (Schwarze Linien), December 1913.
 Oil on canvas, 51 × 51 ⁵/₈ in. Solomon R. Guggenheim Muscum, New York. Gift, Solomon R. Guggenheim, 1937, 37.241.
 Photo: David Heald, © The Solomon R. Guggenheim Foundation, New York/© 2007 Artists Rights Society (ARS), New York/ADAGP Paris

THE CRITICAL PROCESS Thinking about Light and Color

In this chapter, we have witnessed how artists I use the properties of light to help us define spatial relationships in atmospheric perspective, to define volume by means of chiaroscuro and other modeling techniques such as crosshatching, and to manipulate key or value in order to create a range of moods. We have seen how the contrast between light and dark can be an effective expressive tool, and how in different cultures light and dark mean different things. And we have paid detailed attention to the properties of light that result in color. Color is an extraordinarily versatile tool for the artist, allowing for an almost limitless range of color schemes. In representing the world, artists can utilize color's local effects, its perceptual qualities, the way in which it mixes optically in the viewer's eye. Or, forsaking fidelity to the world, artists can use it arbitrarily, seeking other effects. Finally, color can be employed, like the contrast between light and dark, to symbolize many different things, depending on the artist's sensibility and intentions.

In what ways does British artist Tony Cragg's Newton's Tones/New Stones (Fig. 201) remind us, finally, that color is a function of light? Cragg was in fact trained as a scientist and turned to art in order to create works that demonstrate the complexities of the modern world in straightforward, even simple terms that the average person on the street can understand. In this sense his theme is the natural world and how best to represent it. But if we think of Cragg's piece as a prism, what else besides natural light appears to have passed through it? Cragg gathered all of this material on a Sussex, England, beach. Given this, what do you make of Cragg's title? What are the "new stones" he speaks of? Can you usefully think of these in terms of the power of the artistic imagination to transform everyday objects? What are "Newton's tones"? Does color serve a symbolic function here? Is it good? Is it evil? Or is the science of color indifferent? Think of the discussion of aesthetic beauty in Chapter 3. What is the nature of the aesthetic in this work?

Fig. 201 Tony Cragg, Newton's Tones/New Stones, 1982. Plastic floor construction, 197 × 72 in. Courtesy Marian Goodman Gallery, New York. Photo: Ed Owen, Washington, D.C.

Other Formal Elements

TEXTURE

Actual Texture Visual Texture

PATTERN

TIME AND MOTION

■ Works in Progress Jackson Pollock's *Number 29, 1950*

The Critical Process Thinking about the Formal Elements o this point, we have discussed some of the most important of the formal elements—line, space, light, and color—but several other elements employed by artists can contribute significantly to an effective work of art. **Texture** refers to the surface quality of a work. **Pattern** is a repetitive motif or design. And **time** and **motion** can be introduced into a work of art in a variety of ways. A work can *suggest* the passing of time by telling a story, for instance, in a sequence of panels or actions. It can create the *illusion* of movement, optically, before the eye. Or the work can *actually* move, as Alexander Calder's mobiles do (see Figure 95), or as video and film do.

TEXTURE

Texture is the word we use to describe the work of art's ability to call forth certain tactile sensations and feelings. It may seem rough or smooth, as coarse as sandpaper or as fine as powder. If it seems slimy, like a slug, it may repel us. If it seems as soft as fur, it may make us want to touch it. In fact, most of us are compelled to touch what we see. It is one of the ways we come to understand our world. That's why signs in museums and galleries saying "Please Do Not Touch" are so necessary: If, for example, every visitor to the Vatican in Rome had touched the marble body of Christ in Michelangelo's Pietà (Fig. 202), the rounded, sculptural forms would have been reduced to utter flatness long ago.

Actual Texture

Marble is one of the most tactile of all artistic mediums. Confronted with Michelangelo's almost uncanny ability to transform marble into lifelike form, we are virtually compelled to reach out and confirm that Christ's dead body is made of hard, cold stone and not the real, yielding flesh that the grieving Mary seems to hold in her arms. Even the wound on his side, which Mary almost touches with her own hand, seems real. The drapery seems soft, falling in gentle folds. The visual experience of this work defies what we know is materially true. Beyond its emotional content, part of the power of this work derives from the stone's

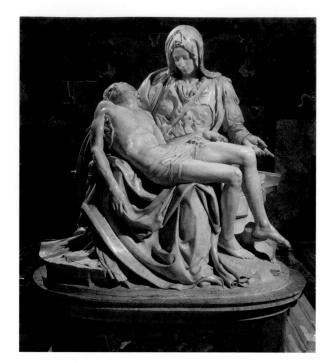

Fig. 202 Michelangelo, *Pietà*, 1501. Marble, height, 6 ft. 8 ½ in. Vatican, Rome. Canali Photobank

extraordinary texture, from Michelangelo's ability to make stone come to life.

Another actual texture that we often encounter in art is paint applied in a thick, heavy manner. Each brushstroke is not only evident but also seems to have a "body" of its own. This textural effect is called **impasto**. Frank Auerbach is known for the expressive impasto of his native *London from Primrose Hill* near his studio in Mornington Crescent (Fig. 203).

Fig. 203 Frank Auerbach (1931–), "View from Primrose Hill". 1962. Oil on Composition Board, 122.0 × 152.4 cm. National Gallery of Australia, Canberra. NGA 1978.979. Purchased 1978. Courtesy of the Artist/Marlborough Fine Arts, London. The view here is looking southeast, over the walking paths that crisscross the park, toward the London skyline, its steeples, towers, and chimneys rising in the top third of the composition. Such paintings take months, even years of work, as Auerbach reworks the surface with layer upon layer of paint, letting the paint dry for several weeks and then coming back to paint over the surface again and again. The resulting impasto, so thick that it is almost sculptural, virtually frees the work from its content—the view itself—revealing instead the artist's obsessive emotional reaction to it.

In Manuel Neri's bronze sculpture from the *Mujer Pegada Series* (Fig. 204), the actual texture of the bronze is both smooth, where it implies the texture of skin on the figure's thigh, for instance, and rough, where it indicates the "unfinished" quality of the work. It is as if Neri can only begin to capture the whole woman who is his subject, as she emerges half-realized from the sheet of bronze. Our sense of the transitory nature of the image, its fleeting quality, is underscored by the enamel paint that Neri has applied in broad, loosely gestural strokes to the bronze. This paint adds yet another texture to the piece, the texture of the brushstroke. This brushstroke helps, in turn, to emphasize the work's two-dimensional quality. It is as if Neri's three-dimensional sculpture is attempting to escape the two-dimensional space of the wall, to escape, that is, the space of painting.

Fig. 204 Manuel Neri, *Mujer Pegada Series No. 2*, 1985–1986. Bronze with oil-based enamel, 70 × 56 × 11 in. Courtesy Charles Cowles Gallery, New York. Photo: M. Lee Fatheree.

Fig. 205 Max Ernst, Europe After the Rain, 1940–1942.
 Oil on canvas, 21 %₁₆ × 58 %₁₆ in. Wadsworth Atheneum, Hartford. The Ella Gallup Sumner and Mary Catlin Sumner Collection Fund.
 © 2007 Artists Rights Society (ARS), New York/ADAGP, Paris.

Visual Texture

Visual texture appears to be actual but is not. Like the representation of three-dimensional space on a two-dimensional surface, a visual texture is an illusion. If we were to touch the painting *Europe After the Rain* (Fig. 205), it would feel primarily smooth, despite the fact that it seems to possess all sorts of actual surface texture, bumps and hollows of funguslike growth.

The painting is by Max Ernst, the inventor of a technique called *frottage*, from the French word *frotter*, "to rub." By putting a sheet of paper over textured surfaces, especially floorboards and other wooden surfaces, and then rubbing a soft pencil across the paper, he was able to create a wide variety of textural effects. He would then arrange these textures into visions of surrealistic "forests" and fantastic landscapes.

William Garnett's stunning aerial view of strip farms stretching across an eroding landscape (Fig. 206) is a study in visual texture. The plowed strips of earth contrast dramatically with the strips that have been left fallow. And the predictable, geometric textures of the farmed landscape also contrast with the irregular veins and valleys of the unfarmed and eroded landscape in the photograph's upper left.

The evocation of visual textures is, in fact, one of the primary tools of the photographer.

When light falls across actual textures, especially *raking* light, or light that illuminates the surface from an oblique angle, the resulting patterns of light and shadow emphasize the texture of the surface. In this way, the Garnett photograph reveals the most subtle details of the land surface. But remember, the photograph itself is smooth and flat, and its textures are therefore *visual*. The textures of its subject, revealed by the light, are *actual* ones.

Fig. 206 William A. Garnett, Erosion and Strip Farms, 1951. Gelatin-silver print, 15 %16 × 19 ½ in. Museum of Modern Art, New York. Licensed by Scala/Art Resource, New York. © 1999 Museum of Modern Art.

PATTERN

The textures of the landscape in Garnett's photograph reveal themselves as a pattern of light and dark stripes. Any formal element that repeats itself in a composition—line, shape, mass, color, or texture—creates a recognizable pattern.

In its systematic and repetitive use of the same motif or design, pattern is an especially important *decorative* tool. Throughout history, decorative patterns have been applied to utilitarian objects in order to make them more pleasing to the eye. Early manuscripts, for instance, such as the page reproduced here from the eighthcentury *Lindisfarne Gospels* (Fig. 207), were *illuminated*, or elaborately decorated with drawings, paintings, and large capital letters, to beautify the sacred text. This page represents the ways in which Christian imagery—the cross and earlier pre-Christian pagan motifs came together in the early Christian era in the British Isles. The simple design of the traditional Celtic cross, found across Ireland, is almost lost in the checkerboard pattern and the interlace of fighting beasts with spiraling tails, extended necks, and clawing legs that borders the page. These beasts are examples of the pagan *animal style*, which consists of intricate, ribbonlike traceries of line that suggest wild and fantastic beasts. The animal style was used not only in England but also in Scandinavia, Germany, and France.

Because decorative pattern is associated with the beautifying of utilitarian objects in the crafts, with folk art, and with "women's work" such as quilt-making, it had not been held in the highest esteem among artists. But since the early 1980s, as the value of "women's work" has been rethought, and as the traditional "folk" arts of other cultures have come to

Fig. 207 Cross page from the *Lindisfarme Gospels*, c. 700 13 ¹/₂ × 9 ¹/₄ in. British Library/Bridgeman Art Library.

Fig. 208 Miriam Schapiro, *Night Shade*, 1986. Acrylic and fabric collage on canvas, 48 × 96 in. Private collection, New York. Photo: Gamma One Conversions. Courtesy of the artist.

be appreciated by the Western art world, its importance in art has been reassessed by many.

Of all the artists working with pattern and decoration, Miriam Schapiro has perhaps done the most to legitimate pattern's important place in the arts. Schapiro creates what she calls "femmages," a bilingual pun, contracting the French words femme and hommage, "homage to woman," and the English words "female" and "image." "I wanted to explore and express," Schapiro explains, "a part of my life which I had always dismissed-my homemaking, my nesting." In her monumental multimedia work Night Shade (Fig. 208), Schapiro has chosen an explicitly feminine image, the fan that fashionable women, in earlier days, used to cool themselves. Partially painted and partially sewn out of fabric, it intentionally brings to mind the kinds of domestic handiwork traditionally assigned to women as well as the life of leisure of the aristocratic lady.

TIME AND MOTION

Pattern's repetitive quality creates a sense of linear and directional movement. Anyone who has ever stared at a wallpaper pattern, trying to determine where and how it begins to repeat itself, knows how the eye will follow a pattern. Nevertheless, one of the most traditional distinctions made between the *plastic arts*—painting and sculpture—and the written arts, such as music and literature, is that the former are *spatial* and the latter *temporal* media. That is, we experience a painting or sculpture all at once; the work of art is before us in its totality at all times. But we experience music and literature over time, in a linear way; a temporal work possesses a clear beginning, middle, and end.

While there is a certain truth to this distinction, time plays a greater role in the plastic arts than such a formulation might suggest. Even in the case where the depiction of a given event implies that we are witness to a photographic "frozen moment," an instant of time taken from a larger sequence of events, the single image may be understood as part of a larger *narrative* sequence: a story.

Consider, for instance, Bernini's sculpture of *David* (Fig. 209). As opposed to Michelangelo's *David* (see Fig. 82), who rests, fully self-contained, at some indeterminate time before going into battle, Bernini's figure is caught in the midst of action, coiled and ready to launch his

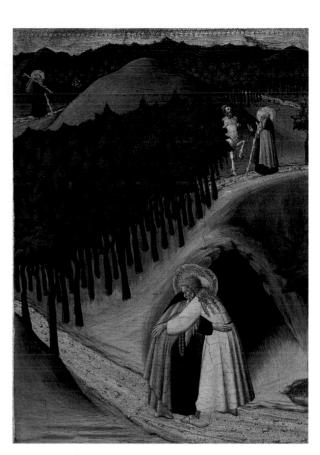

Fig. 210 Sassetta, and workshop of Sassetta, *The Meeting of Saint Anthony and Saint Paul*, c. 1440.
 Tempera on panel, 18 ³/₄ × 13 ⁵/₈ in. National Gallery of Art, Washington, D C,
 Samuel H. Kress Collection. © 2002 Board of Trustees, National Gallery of Art.

Fig. 209 Gianlorenzo Bernini, *David*, 1623. Marble, lifesize. Galleria Borghese, Rome. Canali PhotoBank, Milan/SuperStock.

stone at the giant Goliath. In a sense, Bernini's sculpture is "incomplete." The figure of Goliath is implied, as is the imminent flight of David's stone across the implicit landscape that lies between the two of them. As viewers, we find ourselves in the middle of this same scene, in a space that is much larger than the sculpture itself. We intuitively back away from David's sling. We follow his eyes toward the absent giant. We are engaged in David's energy, and in his story.

A work of art can also, in and of itself, invite us to experience it in a linear or temporal way. *The Meeting of Saint Anthony and Saint Paul* (Fig. 210), for example, depicts Saint Anthony at three different points as he travels down a winding road, away from the city in the distant background and toward his meeting with the hermit, Saint Paul. First, he enters a wood, then he confronts a centaur, and finally he meets Saint Paul. The road here represents Saint Anthony's movement through space and time.

Likewise, we naturally "read" Pat Steir's *Chrysanthemum* paintings (see Figs. 165 and 166) from left to right, in linear progression. While each of Monet's *Grainstack* paintings (see Figs. 29 and 193) can be appreciated as a wholly unified totality, each can also be seen as part of a larger whole, a time sequence. Viewed in a series, they are not so much "frozen moments" removed from time as they are *about* time itself, the ways in which our sense of place changes over time.

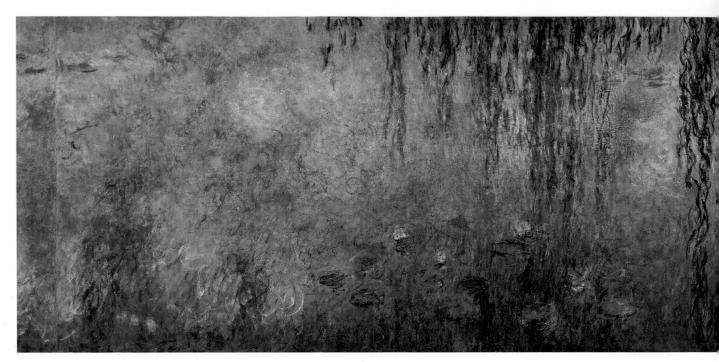

Fig. 211a Claude Monet, *Waterlillies, Morning: Willows* (central section), 1916–1926. Triptych, each panel 80 × 170 in. Musée de l'Orangerie, Paris. Giraudon/Art Resource, New York.

To appreciate large-scale works of art, it may be necessary to move around and view them from all sides, or to see them from a number of vantage points—to view them over time. Monet's famous paintings of his lily pond at Giverny, which were installed in the Orangerie in Paris in 1927, are also designed to compel the viewer to move (Figs. 211a and b). They encircle the room, and to be in the midst of this work is to find oneself suddenly in the middle of a world that has been curiously turned inside out: The work is painted from the shoreline, but the viewer seems to be surrounded by water, as if the room were an island in the middle of the pond itself. The paintings cannot be seen all at once. There is always a part of the work behind you. There is no focal point, no sense of unified perspective. In fact, the series of paintings seems to organize itself around and through the viewer's own acts of perception and movement.

According to Georges Clemenceau, the French statesman who was Monet's close friend and who arranged for the giant paintings to hang in the Orangerie, the paintings could be understood not just as a simple representation of the natural world, but also as a representation of a complex scientific fact, the phenomenon of "Brownian motion." First described by the Scottish scientist Robert Brown in 1827, Brownian motion is a result of the physical movement of minute particles of solid matter suspended in fluid. Any sufficiently small particle of matter suspended in water will be buffeted by the molecules of the liquid and driven at random throughout it. Standing in the midst of Monet's panorama, the viewer's eve is likewise driven randomly through the space of the paintings. The viewer is encircled by them, and there is no place for the eye to rest, an effect that Jackson Pollock would achieve later in the century in the monumental "drip" paintings he executed on the floor of his studio (see Works in Progress, p. 156).

Some artworks are created precisely to give us the illusion of movement. In **optical painting**, or "Op Art" as it is more popularly known, the physical characteristics of certain formal elements—line and color particularly—are subtly manipulated to stimulate the nervous system into thinking it perceives movement. Bridget Riley's *Drift 2* (Fig. 212) is a large canvas that seems to wave and roll before our eyes even though it is stretched taut across its support. One of Riley's earliest paintings was an attempt to find a visual equivalent to heat. She had been

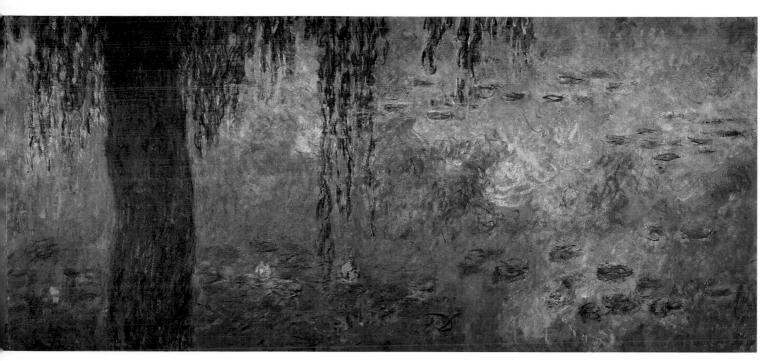

Fig. 211b Claude Monet, Waterlillies, Morning: Willows (right side), 1916–1926. Triptych, each panel 80 × 170 in. Musée de l'Orangerie, Paris. Giraudon/Art Resource, New York.

crossing a wide plain in Italy: "The heat off the plain was quite incredible—it shattered the topographical structure of it and set up violent color vibrations.... The important thing was

to bring about an equivalent shimmering sensation on the canvas." In *Drift 2*, we encounter not heat, but wave action, as though we were, visually, out at sea.

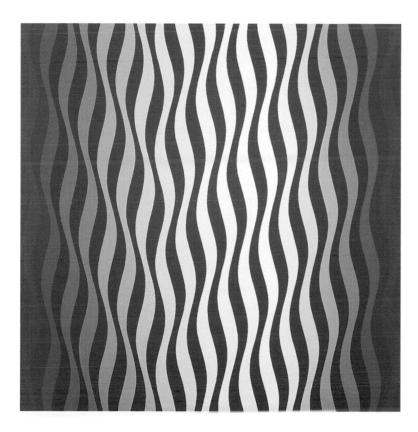

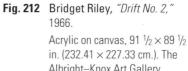

Albright–Knox Art Gallery, Buffalo, NY. Gift of Seymour H Knox, Jr., 1967. © Bridge Riley. All Rights Reserved. Courtesy Karsten Schubert, London

WORKS IN PROGRESS

hile not as large as Monet's paintings at the Orangerie, Jackson Pollock's works are still large enough to engulf the viewer. The eye travels in what one critic has called "galactic" space, following first one line, then another, unable to locate itself or to complete its visual circuit through the web of paint. Work such as this has been labeled "Action Painting," not only because it prompts the viewer to become actively engaged with it, but also because the lines that trace themselves out across the sweep of the painting seem to chart the path of Pollock's own motions as he stood over it. The drips and sweeps of paint record his action as a painter and document it, a fact captured by Hans Namuth in October of 1950 in a famous series of photographs

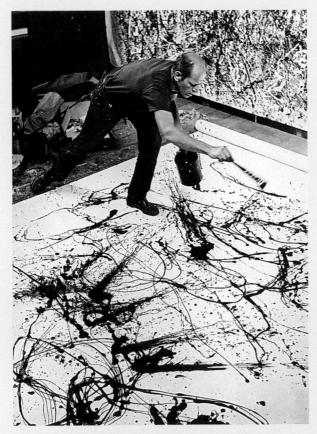

Fig. 213 Jackson Pollock painting Autumn Rhythm, 1950. Center for Creative Photography, Tucson. Photo: Hans Namuth. © 2001 Pollock-Krasner Foundation/Artists Rights Society (ARS), New York.

(Fig. 213) of Pollock at work on the painting *Autumn Rhythm*, and then in two films, one shot in black-and-white and the other in color. The second of these was shot from below through a sheet of glass on which Pollock was painting (Fig. 214), vividly capturing the motion embodied in Pollock's work. The resulting work, *No. 29, 1950* (Fig. 215), was completed over the course of five autumn weekends, with Namuth filming the entire event. After a false start on the painting, which Pollock wiped out in front of the camera, he created a collage web of paint, containing pebbles, shells, sand, sections of wire mesh, marbles, and pieces of colored plastic.

Namuth's photographs and films teach us much about Pollock's working method. Pollock longed to be completely involved in the process of painting. He wanted to become wholly absorbed in the work. As he had written in a short article called "My Painting," published in 1947, "When I am *in* my painting, I'm not aware of what I'm doing . . . the painting has a life of its own. I try to let it come through. It is only when I lose contact with the painting that the result is a mess. Otherwise there is pure harmony, an easy give and take, and the painting comes out well."

Fig. 214 Jackson Pollock painting on glass, 1951. Still from a color film by Hans Namuth and Paul Falkenberg. Courtesy Hans Namuth Ltd.

Jackson Pollock's NO. 29, 1950

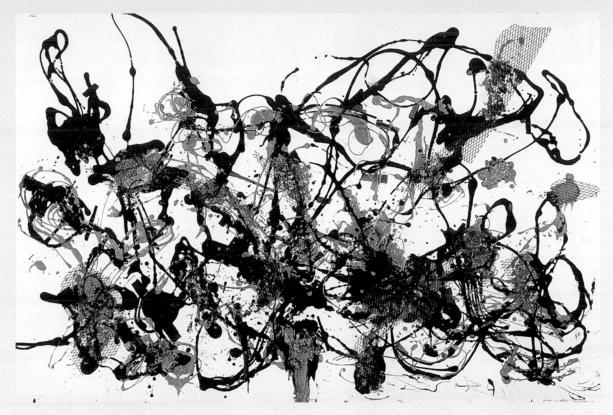

Fig. 215 Jackson Pollock, No. 29, 1950, 1950. Oil on convos, expanded steel, string, glass, and pebbles on glass, 48 × 72 in. National Gallery of Canada, Ottawa. Purchased 1968.

© 2007 Pollock-Krasner Foundation/Artists Rights Society (ARS), New York.

In Namuth's photographs and films, we witness Pollock's absorption in the work. We see the immediacy of his gesture as he flings paint, moving around the work, the paint tracing his path. He worked on the floor, in fact, in order to heighten his sense of being in the work. "I usually paint on the floor," he says in Namuth's film. "I feel more at home, more at ease in a big area, having a canvas on the floor, I feel nearer, more a part of a painting. This way I can walk around it, work from all four sides and be in the painting." We also see in Namuth's images something of the speed with which Pollock worked. According to Namuth, when Pollock was painting, "his movements, slow at first, gradually became faster and more dancelike." In fact, the tracerics of line on the canvas are like choreographies, complex charts

of a dancer's movement. In Pollock's words, the paintings are

energy and motion made visiblememories arrested in space.

Namuth was disturbed by the lack of sharpness and the blurred character in some of his photographs, and he did not show them to Pollock. "It was not until years later," Namuth admitted, "that I understood how exciting these photographs really were." At the time, though, his inability to capture all of Pollock's movement led him to the idea of making a film. "Pollock's method of painting suggested a moving picture," he would recall, "the dance around the canvas, the continuous movment, the drama."

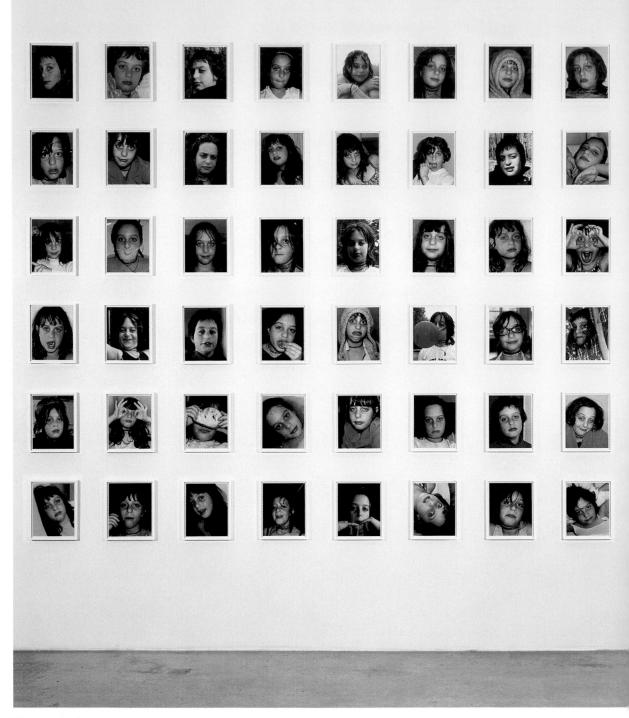

Fig. 216a Roni Horn, This is Me, This is You, 1997–2000.
96 C-prints (installed on two walls with 48 images on each wall), 13 × 10 ³/₄ in. each; overall size of each panel approx. 11 × 9 ft.
Photo: Bill Jacobson/Matthew Marks Gallery, New York. Copyright Hauser & Wirth Zurich London.

Of all the arts, those that employ cameras are probably most naturally concerned with questions of time and motion. Time and motion are the very conditions of their media. Consider Roni Horn's photographic installation *This is Me, This is You* (Fig. 216). Over the course of four years, from 1997 to 2000, Horn photographed her niece, Georgia, in a series of photographic pairs, each shot taken about two or three seconds apart. The final

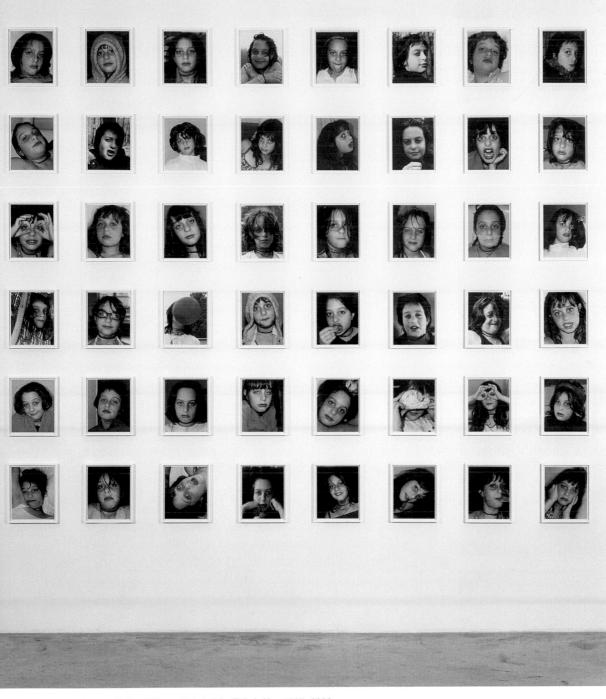

Fig. 216b Roni Horn, *This is Me, This is You*, 1997–2000.
96 C-prints (installed on two walls with 48 images on each wall), 13 × 10 ³/₄ in. each; overall size of each panel approx. 11 × 9 ft.

Photo: Bill Jacobson/Matthew Marks Gallery, New York. Copyright Hauser & Wirth Zurich London.

work consists of two walls, either opposite one another or in separate rooms, with 48 images on each wall. One of each pair is placed in the same location on each wall. The result is a work that both records a moment to-moment shift in identity in each pair, and a more long-term sense of a young girl's coming of age. "I really just recorded her in action," Horn recounts, "a girl becoming a woman, trying on identities."

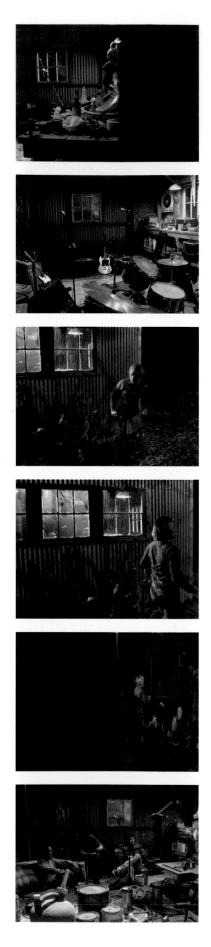

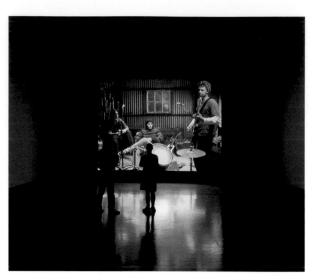

Figs. 217 and 218 Teresa Hubbard and Alexander Birchler, Detached Building, 2001.

High-definition video with sound transferred to DVD, 5 min. 38 sec. loop.

Installation photo by Stefan Rohner, courtesy of the artists and Tanya Bonaker Gallery, New York. Stills courtesy of the artists and Tanya Bonaker Gallery, New York.

The title of the piece is a metaphor for this period of shifting identities in a girl's life. Georgia explains: "We would send each other postcards with two animals, or two people, or two objects on them, and we would write 'This is Me' and point to one, and 'This is You.'" But it also points to the viewer, whose experience of the work, moving back and forth from wall to wall or from room to room, reiterates the complex relationship between time and motion. identity and change, that is in fact the very fabric of the work itself. "This is Me, Georgia," the work seems to say, but in your recognition of the many faces Georgia puts on-her clothes and costumes, jewelry and make-upthis is also you, the viewer, the face of your own shifting self.

Video artists Teresa Hubbard and Alexander Birchler think of their videos as "long photographs" to which they have added sound, thus extending the space of the image beyond the frame. In *Detached Building* (Figs. 217 and 218), the camera dollies in one seamless movement around the inside of a tin shed converted into a workshop and rehearsal space, moving to the sound of chirping crickets over a cluttered workbench, a guitar, a chair, a sofa, a drumset, and a power drill, then passing without interruption through the

160 Part 2 *The Formal Elements and Their Design*

shed's wall into the neglected garden behind it. A young woman enters the garden, picks up stones, and throws them at a nearby house. A window can be heard breaking, and a dog begins to bark. The camera passes back into the interior of the shed, where three young men are now sitting around the room, while a fourth plays a continuous riff on a bass guitar. The camera sweeps around the room again and then passes back outside. The young woman has disappeared. Only the chirping of crickets and the muted sound of the bass guitar can be heard. The camera passes back through the wall, sweeps around the room again, and moves back outside to a view of the guitar player within. The video plays on a

continuous 5-minute, 38-second loop, and so, at this point, the camera returns to the empty workshop, and the entire sequence repeats itself. What, the viewer wonders, is the connection between the two scenarios, the boys inside, the girl outside? No plot evidently connects them, only a series of oppositions: interior and exterior, light and dark, male and female, the group and the individual. The movement of the camera across the boundary of the wall suggests a disruption not only of space but of time. In looped video works such as this one, viewers can enter the installation at any point, leave at any point. and construct any narrative they want out of what they see.

THE **CRITICAL** PROCESS Thinking about the Formal Elements

Bill Viola's video installation Room for St. John of the Cross (Figs. 219 and 220) creates a structure of opposition similar to Hubbard and Birchler's Detached Building and involves the viewer in a manner comparable to Horn's *This is Me*, *This is You*. The work consists of a small television monitor that shows a color image of a snow-covered mountain.

Fig. 219 Bill Viola, "Room for St. John of the Cross," 1983 Video/sound installation. Photo: Kira Porov/SQUIDDS & NUNNS.

Fig. 220 Bill Viola, "Room for St. John of the Cross," 1983. (Detail) Video/sound installation. Collection: Museum of Contemporary Art, Los Angeles. Photo: Kira Perov/SQUIDDS & NUNNS. Barely audible is a voice reading St. John's poetry. The videotape consists of a single "shot." The camera never moves. The only visible movement is wind blowing through the trees and bushes.

This cubicle is like the cell of the Spanish mystic and poet St. John of the Cross, who was imprisoned in 1577 for nine months in a windowless cell too small to allow him to stand upright. In this cell, he wrote most of the poems for which he is known, poems in which he often flies out of captivity, over the city walls and across the mountains. The image on the small monitor is the landscape that St. John remembers. On the large screen, behind the cubicle, Viola has projected a black-and-white video image of snow-covered mountains, shot with an unstable hand-held camera. These mountains move in wild, breathless flights, image after image filing by in an uneven, rapid rhythm, like the imagination escaping imprisonment on the loud roaring wind that fills the room, making the voice reading in the cubicle even harder to hear.

As we ourselves move in this installation and we must move in order to view the piece we experience many of the formal elements of art all at once. How does the architecture of the cell contrast with the image on the large screen? What conflicting senses of space does Viola employ? How is the play between light and dark, black-and-white and color imagery, exploited? How does time affect your experience of the piece? These are the raw materials of art, the formal elements, playing upon one another in real time. Viola has set them in motion together, in a single composition.

The Principles of Design

BALANCE Symmetrical Balance

Asymmetrical Balance Radial Balance

EMPHASIS AND FOCAL POINT

Works in Progress Diego Velázquez's *Las Meninas*

SCALE AND PROPORTION

Works in Progress Judith F. Baca's *La Memoria de Nuestra Tierra*

REPETITION AND RHYTHM UNITY AND VARIETY

The Critical Process Thinking about the Principles of Design

he word *design* is both a verb and a noun. Thus design is both a process and a product. To design something, the process is to organize the various aspects of a work of art—line, space, light and color, texture, pattern, time and motion, the formal elements that we have studied in the last four chapters—into a totality, a unified whole. We are able to see in that totality something we call its "design"—that is, the product. And we can recognize in the finished product the process of its organization and composition.

The principles of design are usually discussed in terms of the qualities of balance, emphasis, proportion and scale, rhythm and repetition, and unity and variety. For the sake of clarity, we must discuss these qualities one by one, but artists unite them. For example, Leonardo's famous *Illustration of Proportions of the Human Figure* (Fig. 221) embodies them all. The figure is perfectly balanced and symmetrical. The very center of the composition is the figure's bellybutton, a focal point that represents the source of life itself, the

Fig. 221 Leonardo DaVinci (1452–1519), "Study of Human Proportion: The Vitruvian Man", ca. 1492, pen and ink drawing. Photo credit: Cameraphoto Arte, Venice / Art Resource, NY, Academia, Venice, Italy

fetus's connection by the umbilical cord to its mother's womb. Each of the figure's limbs appears twice, once to fit in the square, symbol of the finite, earthly world, and once to fit in the circle, symbol of the heavenly world, the infinite and the universal. Thus, the various aspects of existence—mind and matter, the material and the transcendental—are unified by the design into a coherent whole.

By way of contrast, architect Frank Gehry's 1977–78 redesign of his house in Santa Monica, California (Figs. 222 and 223), seems anything but unified. He surrounded the original structure with an outer shell constructed of plywood, concrete blocks, corrugated metal, and chain-link fence. The result shocked and bewildered his neighbors. They could not understand what principles of design had guided the architect in both his choice of materials and their construction. To many, it seemed that he had destroyed a perfectly good house, and in the process destroyed the neighborhood.

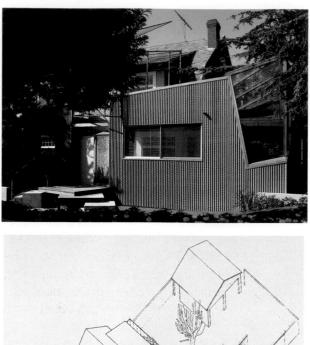

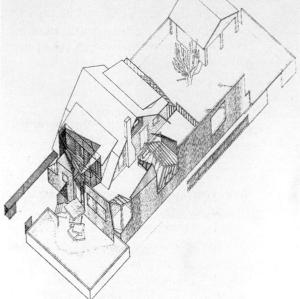

Figs. 222 and 223 Frank Gehry, Gehry house, 1977–1978, and axonometric drawing. Photo: Tim Street-Porter.

Certain principles of design did, of course, guide Gehry, and looking closely at the house, we can begin to guess what they are. He apparently values common, everyday materials. It was important to him to establish a sense of discontinuity between the original house and its addition; they were not meant to blend into a harmonious, unified whole. Most of all, the house is different from its neighbors. It does not fit in—willfully, almost gleefully so.

Leonardo's illustration is a remarkable example of the "rules" of proportion, yet the inventiveness and originality of Gehry's work teaches us, from the outset, that the "rules" guiding the creative process are, perhaps, made to be broken. In fact, the very idea of creativity implies a certain willingness on the part of the artist to go beyond the norm, to extend the rules, and to discover new principles around which artistic expression can organize itself. As we have seen, artists can easily create visual interest by purposefully breaking with conventions such as the traditional rules of perspective; likewise, any artist can stimulate our interest by purposefully manipulating the principles of design.

In the remainder of this chapter, we discuss the way artists combine the formal elements with classical design principles to create inventive, original work. Once we have seen how the formal elements and their design come together, we will be ready to survey the various materials, or media, that artists employ to make their art.

BALANCE

If you have ever skied in a heavy fog, unable to distinguish between the white of the atmosphere and the white of the snow, the mountain dropping away beneath your feet, you will know that you quickly lose your balance. Your sense of balance is something you maintain by means of your powers of sight, and this is perhaps why most of us value balance when we look at works of art. Instability is threatening. It makes us uncomfortable.

We need to see the space around us in order to distribute our actual weight evenly over our feet. If our weight is evenly distributed, we are able to stay balanced. In sculpture and architecture, actual weight, or the physical weight of materials in pounds, comes into play, but all art deals with visual weight, the apparent "heaviness" or "lightness" of the shapes and forms arranged in the composition. When both sides of a composition have the same visual weight, they are balanced. Artists achieve visual balance in compositions by one of three means—symmetrical balance, asymmetrical balance, or radial balance.

Symmetrical Balance

If you were to draw a line down the middle of your body, each side of it would be, more or less, a mirror reflection of the other. When children make "angels" in the snow, they are creating, almost instinctively, symmetrical representations of themselves that recall Leonardo's *Illustration of Proportions*. When each side is exactly the same, we have **absolute symmetry**. But even when it is not, as is true of most human bodies, where there are minor discrepancies between one side and the other, the overall effect is still one of symmetry, what we call **bilateral symmetry**. The two sides seem to line up.

A clear example of bilateral symmetry can be seen in Jan Vermeer's Woman Holding a Balance (Fig. 224). If you look closely at the scales you will see they are not symmetrical the left is larger than the right—but they are perfectly balanced. The woman is evidently in the process of weighing her jewelry, which is scattered on the table before her, but she seems to be distracted, as if the scales themselves have evoked other thoughts. It appears, in fact, that the scales are empty. Since scales are the traditional symbol of justice, and since behind her on the wall is a painting of

 Fig. 224 Jan Vermeer, Woman Holding a Balance, c. 1664.
 Oil on canvas, 15 ⁷/₈ × 14 in., framed: 24 ³/₄ × 23 × 3 in.
 Widener Collection, National Gallery of Art, Washinqton, D. C.
 Image © 2003 Board of Trustees, National Gallery of Art. Photo: Bob Grove.

Fig. 225 Enguerrand Quarton, *Coronation of the Virgin*, 1453–1454. Panel painting, 72 × 86 ⁵/₈ in. Musée de l'Hospice, Villeneuve-lès-Avignon. Giraudon/Art Resource, New York.

The Last Judgment, when Christ judges the worth of all souls for entry into heaven, perhaps she is weighing nothing less than the worth of her own life. Her peaceful gaze suggests, at least, her contentment.

One of the dominant images of symmetry in Western art is the crucifix, which is, in itself, a construction of absolute symmetry. In Enguerrand Quarton's remarkable *Coronation of the Virgin* (Fig. 225), the crucifix at the lower center of the composition is a comparatively small detail in the overall composition. Nevertheless, its *cruciform* shape dominates the whole, and all the formal elements in the work are organized around it. Thus God, the Father, and Jesus, the Son, flank Mary in almost perfect symmetry, identical in their major features (though the robes of each fall a little differently). On earth below, the two centers of the Christian faith flank the cross, Rome on the left and Jerusalem on the right. And at the very bottom of the painting, below ground level, Purgatory, on the left, out of which an angel assists a newly redeemed soul, balances Hell on the right. Each element balances out another, depicting a unified theological universe.

Asymmetrical Balance

The Coronation of the Virgin is symmetrically balanced. Compositions that have two apparently balanced halves that are not mirror images of one another are said to be **asymmetrically** balanced. That is, though the two sides of the composition do not match, they seem to possess the same visual weight. Visual weight refers to the apparent lightness or heaviness of the visual elements on each side of the composition. In Vermeer's painting (see Fig. 224), the scales themselves are symmetrically balanced, but the composition as a whole is asymmetrically balanced. This is because the light falling on the woman, which is massed near the center right of the composition, visually balances the great dark mass of the left side of the painting.

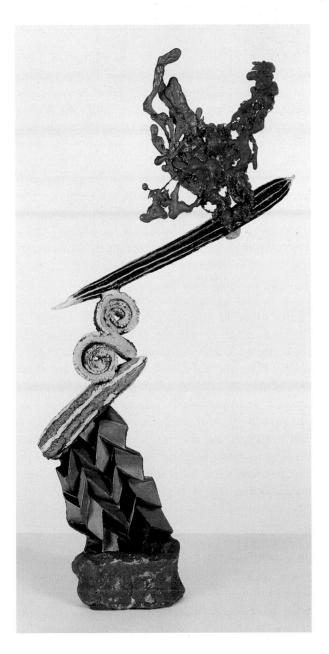

We intuitively know that Nancy Graves's Zeeg (Fig. 226) is balanced-otherwise it would topple over-but this bronze sculpture consisting, from the bottom up, of billows, a squash, what appears to be a sweetroll, an English cucumber, and finally two large Abstract Expressionist drips is completely asymmetrical. Compare it, for instance, to the symmetrical balance of a cruciform construction, or to the asymmetrical balance of Michelangelo's Pietà (see Fig. 202). Neither side of Michelangelo's sculpture is a mirror image of the other, but the entire composition is achieved in a perfectly balanced equilateral triangle. Graves does not fit her composition into any such geometrical scheme. Rather, she relies on your seeing the large Abstract Expressionist drips at the top of the sculpture as rising, not falling. They appear to defy gravity and thus put no downward pressure on the cucumber. In fact, they appear to be holding the end of the cucumber up. But despite the sculpture's apparent balance, Graves has depended on actual weight to balance it. She has heavily weighted the bottom left of the sculpture so that the lighter upper thrust of the cucumber and its attendant drips do not fall to the right.

The change in actual weight that allows three-dimensional sculpture to achieve equilibrium has a number of visual equivalents in twodimensional terms. You probably remember from childhood what happened when an older and larger child got on the other end of the seesaw. Up you shot, like a catapult. In order to right the balance, the larger child had to move toward the fulcrum of the seesaw, giving your smaller self more leverage and allowing the plank

Fig. 226 Nancy Graves, Zeeg (Spill Series) 1983. Bronze with polychrome patina, 24 $\frac{1}{2} \times 14 \times 11$ in. Private collection. Courtesy Knoedler & Company, New York.

© Nancy Graves Foundation/Licensed by VAGA, New York.

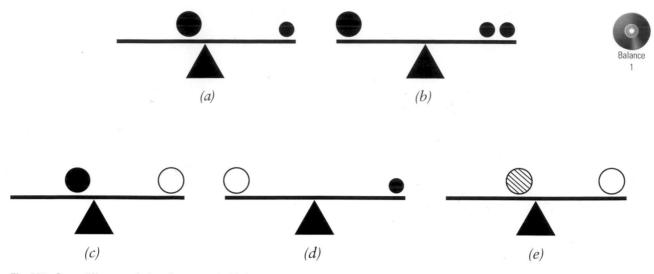

Fig. 227 Some different varieties of asymmetrical balance.

to balance. The illustrations (Fig. 227) show, in visual terms, some of the ways this balance can be attained (in a work of art, the center axis of the work is equivalent to the fulcrum):

(a) A large area closer to the fulcrum is balanced by a smaller area farther away. We instinctively see something large as heavier than something small.

(b) Two small areas balance one large area. We see the combined weight of the two small areas as equivalent to the larger mass.

(c) A dark area closer to the fulcrum is balanced by a light area of the same size farther away. We instinctively see light-colored areas as light in weight, and dark-colored areas as dense and heavy.

(d) A large light area is balanced by a small dark one. Because it appears to weigh less, the light area can be far larger than the dark one that balances it.

(e) A textured area closer to the fulcrum is balanced by a smooth, even area farther away. Visually, textured surfaces appear heavier than smooth ones because texture lends the shape an appearance of added density—it seems "thicker" or more substantial.

These are only a few of the possible ways in which works might appear balanced. There are, however, no "laws" or "rules" about how to go about visually balancing a work of art. Artists generally trust their own eyes. When a work looks balanced, it is balanced.

Childe Hassam's Boston Common at Twi*light* (Fig. 228) is a good example of asymmetrical balance functioning in yet another way. The central axis around which this painting is balanced is not in the middle, but to the left. The setting is a snowy sidewalk on Tremont Street at dusk, as the gaslights are coming on. A fashionably dressed woman and her daughters are feeding birds at the edge of the Boston Common. The left side of this painting is much heavier than the right. The dark bulk of the buildings along Tremont Street, along with the horse-drawn carriages and streetcars and the darkly clad crowd walking down the sidewalk, contrast with the expanse of white snow that stretches to the right, an empty space broken only by the dark trunks of the trees rising to the sky. The tension between the serenity of the Common and the bustle of the street, between light and dark-even as night comes on and daylight fades-reinforces our sense of asymmetrical balance. If we were to imagine a fulcrum beneath the painting that would balance the composition, it would in effect divide the street from the Common, dark from light, exactly, as it turns out, below the vanishing point established by the buildings, the street, and the lines of the trees extending down the park. Instinctively, we place ourselves at this fulcrum.

As Hassam's painting suggests, formal balance (or lack of it) can contribute to a work of art's emotional or psychological impact. Ida Applebroog's *Emetic Fields* (Fig. 229) is one of a number of works from a series of paintings called *Nostrums*. A nostrum is medicine (in

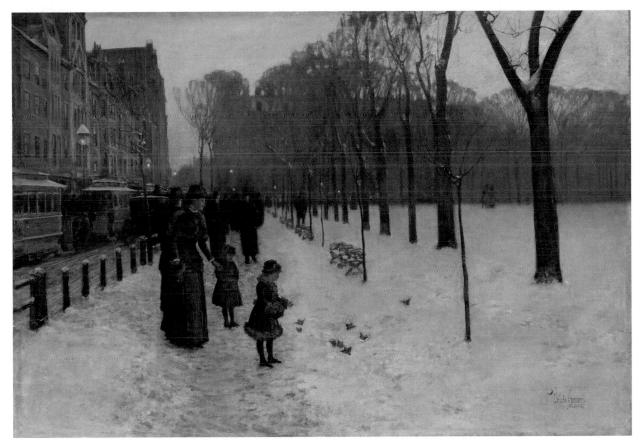

Fig. 228 Childe Hassam, Boston Common at Twilight, 1885–1886.
 Oil on canvas, 42 × 60 in. Museum of Fine Arts, Boston. Gift of Miss Maud E. Appleton, 1931. 31.952.
 Photo © 2004 Museum of Fine Arts, Boston. All right reserved.

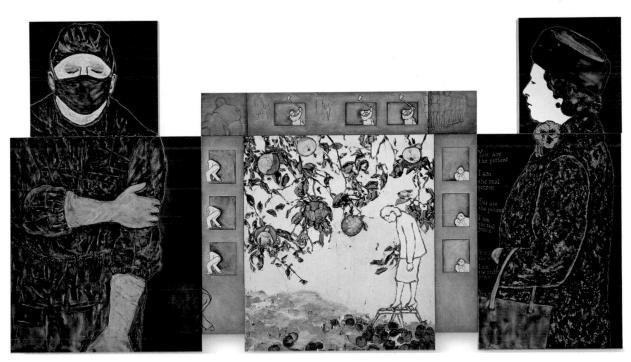

 Fig. 229
 Ida Applebroog, Emetic Fields, 1989.

 Oil on canvas, 8 panels, 102 × 204 ½ in. Collection of the Whitney Museum of American Art, New York.

 Courtesy Ronald Feldman Fine Arts, New York.

this case an emetic, designed to induce vomiting) recommended by its preparer but usually without scientific proof of effectiveness. It is also the Latin word for "ours." These works represent, in other words, the trust we mistakingly place in those who purport to cure us. *Emetic Fields* is by and large symmetrical in its composition, consisting of a central grouping of four panels dominated by the color orange, flanked by a pair of two panel images dominated by the color green. These outer panels are representations of a surgeon and Queen Elizabeth. Applebroog explains:

I love Queen Elizabeth. . . . Here's this woman called "Queen"—she gives that little wave—and she has no power whatsoever. In Emetic Fields, there is the figure of Queen Elizabeth and there is the figure of a surgeon. And that all goes back to my own sense of how power works. Queen Elizabeth, to me, is the epitome of how power works. Not too well. . . .

And it's the idea of how power works—male over female, parents over children, governments over people, doctors over patients—that operates continously [in my work].

The symmetry of the painting suggests, in other words, a certain "balance of power" exercised by the two figures who purport to cure our physical and social ills-the surgeon and the Queen. These two, in turn, dominate the figures in the painting's central panels. In the largest of these, a woman stands above a pile of rotten fruit, her shoes attached to platforms, effectively impeding her ability to move. Hanging from the tree above her is other fruit, some of which contains images of other people, presumably about to rot on the branch themselves. Surrounding her are other images—a couple embracing, a lineup of girls apparently dressed for gym class, a man swinging an ax, a mother and child, a male figure carrying another who is seems wounded, and a figure bending down to pick up a stone, as if, David-like, he is about to bring down the Goliath surgeon whose space he crosses into at the bottom left. Finally, the psychological imbalance suggested in the relation of the outer panels to the inner is underscored by the words that are repeated down the panel in front of Queen Elizabeth: "You are the patient. I am the real person."

Radial Balance

A final type of balance is radial balance, in which everything *radiates* outward from a central point. The large, dominating, and round stained-glass window above the south portal of Chartres Cathedral in France (Fig. 230) is a perfect example. Called a rose window because of its dominant color and its flowerlike structure, it represents the Last Judgment. At its center is Jesus, surrounded by the symbols of Matthew, Mark, Luke, and John, the writers of the Gospels, and of angels and seraphim. The Apostles, depicted in pairs, surround these, and on the outer ring are scenes from the Book of Revelations. In other words, the entire New Testament of the Bible emanates from Jesus in the center.

Perhaps because radial balance is so familiar in nature—from the petals of a flower to the rays of the sun—it commonly possesses, as at Chartres, spiritual and religious significance, a characteristic parodied by John Feodorov in his *Animal Spirit Channeling Device for the Contemporary Shaman* (Fig. 231). Feodorov, who is part Navajo and part Euro-American, often uses kitschy objects, such as this children's toy that imitates the sounds of various farm animals, to

Fig. 230 Rose window, south transept. *Chartres Cathedral*, c. 1215. Chartres, France. Erich Lessing/Art Resource, N.Y.

Fig. 231 John Feodorov, Animal Spirit Channeling Device for the Contemporary Shaman, 1997. Mixed media, 15 × 12 × 3 in. Photo by the Artist. Courtesy of the Artist.

create "updated" ritual objects. In Native American cultures, animals are powerful totem symbols demanding fear and respect. Furthermore, the number 12 has deep ritual significance to the Navajo. By adding the word "spirit" to each of the 12 animals names on this toy, he implies that the recorded voice created by pulling on the tab at the bottom right is now imbued with a newfound spiritual power.

EMPHASIS AND FOCAL POINT

Artists employ *emphasis* in order to draw the viewer's attention to one area of the work. We refer to this area as the **focal point** of the composition. The focal point of a radially balanced composition is obvious. The center of the rose window in the south transcept of Chartres Cathedral (see Fig. 230) is its focal point, and fittingly an enthroned Christ occupies that spot. The focal point of Quarton's *Coronation of the Virgin* (see Fig. 225) is Mary, who is also, not coincidentally, the object of everyone's attention.

One important way that emphasis can be established is through the manipulation of light and color. Figure 232 uses a complementary color scheme to focus our attention. The work was painted in the court of the French king Louis XVI by Anna Vallayer-Coster, a female member of the Académie Royale, the official organization of French painters (though it is important to note that after Vallayer-Coster was elected to the Académie in 1770, membership by women was limited to four, perhaps because the male-dominated Académie felt threatened by women's success). By painting everything else in the composition a shade of green, Vallayer-Coster focuses our attention on the delicious red lobster in the foreground. Lush in its brushwork, and with a sense of luminosity that we can almost feel, the painting celebrates Vallaver-Coster's skill as a painter, her ability to control both color and light. In essence-and the double meaning is intentional-the painting is an exercise in "good taste."

Fig. 232 Anna Vallayer-Coster, Still Life with Lobster, 1781.
 Oil on canvas, 27 ³/₄ × 35 ¹/₄ in. Toledo Museum of Art, Toledo, Ohio. Purchased with funds from the Libbey Endowment, Gift of Edward Drummond Libbey.

Fig. 233 Georges de LaTour (1593–1652). "Joseph the Carpenter". c. 1645. Oil on canvas. 18 1/2 × 25 1/2 in. Photo: Gerard Blot. Musee du Louvre/RMN Reunion des Musees Nationaux, France. SCALA/Art Resource, NY

When it functions like a stage spotlight, as in Artemisia Gentileschi's *Judith and Maidservant with the Head of Holofernes* (see Fig. 169), light can cause us to focus our attention on things other than the ostensible subject matter of the work. The light in Georges de La Tour's *Joseph the Carpenter* (Fig. 233) draws our attention away from the painting's titular subject, Joseph, the father of Jesus, and to the brightly lit visage of Christ himself. The candlelight here is comparable to the Divine Light, casting an ethereal glow across the young boy's face.

Similarly, Anselm Kiefer's *Parsifal I* (Fig. 234) draws our attention to the brightly lit crib set under the window of the artist's attic studio in a rural schoolhouse in Odenwald, a forested region of Southern Germany. First in a series of four paintings that illustrates Richard Wagner's last opera and its source in a thirteenth-century romance by Wolfram von Eschenbach, both of which are based on the legend of the Holy Grail, the painting represents the young hero Parsifal's innocent and sheltered childhood. Although his mother tried to protect him from knowlege of

chivalric warfare, Parsifal would grow up to become a knight. His ultimate task was to recover, from the magician Klingsor, the so-called Spear of Destiny-the very spear, legend had it, that a Roman centurion had thrust into the side of Christ on the cross-so that peace could be restored to the kingdom of the Grail. This is one of the earliest paintings in which Kiefer reflects upon and critiques the myths and chauvinism that eventually propelled the German Third Reich into power, in this case Hitler's own obsession with owning the Spear of Destiny, housed in the Hapsburg Treasure House in Vienna. When Hitler was 21 years old, a Treasure House guide had told him that whoever possessed the spear would hold the destiny of the world in his hands. Hitler would eventually invade Vienna and take possession of the relic. The painting thus embodies the ambivalence felt by Kiefer and his generation toward the excessive arrogance of German nationalism and its impact on history. Its focal point, reflecting across the floor as if across time,

Fig. 234 Anselm Kiefer (1945–) "Parsifal I". 1973. Oil on paper. 127 ⁷/₈ × 86 ¹/₂ in. Tate Gallery, London, Great Britain. Purchased 1982. T0340. Photo: Tate Gallery, London, Great Britain. Art Resource, NY.

Fig. 235 Anselm Kiefer, "Les

Reines de France". 1995. Emulsion, acrylic, sunflower seeds, photographs, woodcut, gold leaf, and cardboard (mosaic) on canvas. Three panels, overall $220 \frac{1}{2} \times 290 \frac{1}{2}$ in. $(560 \times 737.9 \text{ cm}).$ Anonymous gift, 1997. Solomon R. Guggenheim 97.4558.

is a moment of innocence, the longing for a German past before war took a terrible toll on German consciousness.

Finally, it is possible, as the earlier example of Pollock's No. 29 (see Fig. 215) indicates, to make a work of art that is afocal—that is, not merely a work in which no single point of the composition demands our attention any more or less than any other, but also one in which the eve can find no place to rest. Diego Velázquez's Las Meninas is such a work (see Works in Progress, p. 174). So is Kiefer's Les Reines de France (The Queens of France) (Fig. 235). In 1991, the year of Germany's reunification, Kiefer left Germany to travel the world, finally settling in the South of France. This is one of a series of paintings dedicated to French female royalty. Here the queens-from Catherine de' Medici (see Fig. 682) to Eleanor of Aquitaine to Marie-Antoinette, the wife of Louis XVI when the French Revolution overthrew the monarchy in 1889. Their faces and identities are half-buried in Kiefer's deep impasto of paint and gold leaf, at once implying their historical likeness, their complicity in the fiscal irresponsibility of the monarchy (which, of course, eventually led to revolution), and their growing irrelevance to modern memory.

As in Gerhard Richter's 256 Farben (see Fig. 194), Larry Poons's Orange Crush (Fig. 236) becomes afocal because the viewer's

eye is continually distracted from its point of vision. If you stare for a while at the dots in the painting and then transfer your attention quickly to the more solid orange area that surrounds them, dots of an even more intense orange will appear. Your vision seems to want to float aimlessly through the space of this painting, focusing on nothing at all.

WORKS IN PROGRESS

n his masterpiece Las Meninas (The Maids of Honor) (Fig. 239), Diego Velázquez creates competing points of emphasis. The scene is the Spanish court of King Philip IV. The most obvious focal point of the composition is the young princess, the infanta Margarita, who is emphasized by her position in the center of the painting, by the light that shines brilliantly on her alone, and by the implied lines created by the gazes of the two maids of honor who bracket her. But the figures outside this central group, that of the dwarf on the right, who is also a maid of honor, and the painter on the left (a self-portrait of Velázquez), gaze away from the infanta. In fact, they seem to be looking at us, and so too is the infanta herself. The focal point of their attention, in other words, lies outside the picture plane. In fact, they are looking at a spot that appears to be occupied by the couple reflected in the mirror at the opposite end of the room, over the infanta's shoulder (Fig. 240)-a couple that turns out to be King Philip IV and Queen Mariana, recognizable from the two portrait busts

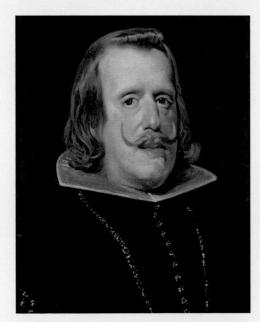

Fig. 237 Diego Velázquez, Philip IV, King of Spain, 1652–1653. Oil on canvas, 17 $\frac{1}{2} \times 14 \frac{3}{4}$ in.

> Kunsthistorisches Museum, Vienna. © Erich Lessing/Art Resource, New York.

painted by Velázquez at about the same time as *Las Meninas* (Figs. 237 and 238). It seems likely that they are the subject of the painting that Velázquez depicts himself as painting, since they are in the position that would be occupied normally by persons sitting for a portrait. The *infanta* Margarita and her maids of honor have come, it would seem, to watch the royal couple have their portrait painted by the great Velázquez. And Velázquez has turned the tables on everyone—the focal point of *Las Meninas* is not the focal point of what he is painting.

Or perhaps the king and queen have entered the room to see their daughter, the *infanta*, being painted by Velázquez, who is viewing the entire room, including himself, in a mirror. Or perhaps the image on the far wall is not a mirror at all, but a painting, a double portrait. It has, in fact, been suggested that both of the single portraits illustrated here are studies for just such a double portrait (which, if it ever existed, is now lost). Or, even more likely, since their positions in the mirror—he looking to his right, she looking to her left—are mirror images of their actual portraits, perhaps this is a mirror reflecting not the king and queen but their

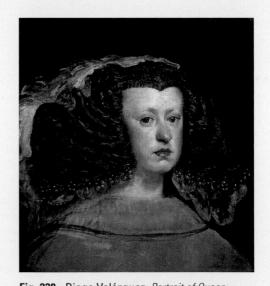

 Fig. 238 Diego Velázquez, Portrait of Queen Mariana, c. 1656.
 Oil on canvas, 18 ³/₈ × 17 ¹/₈ in. Meadows Museum, Southern Methodist University, Dallas. Alger H. Meadows Collection.

78.01.

Diego Velázquez's LAS MENINAS

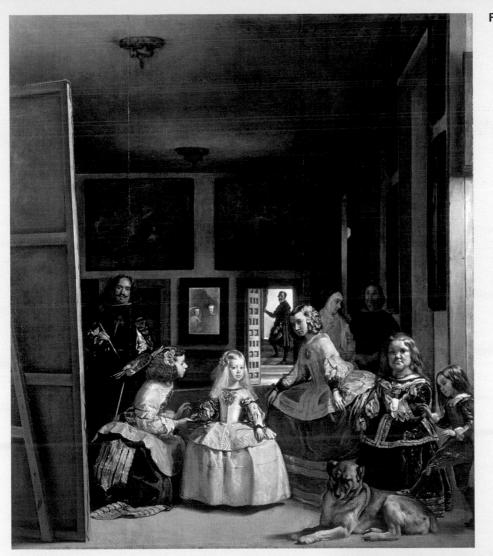

Fig. 239 Diego Velázquez, Las Meninas (The Maids of Honor), 1656.

> Oil on canvas, 10 ft. ¾ in. × 9 ft. ¾ in. Museo del Prado, Madrid. Derechus reservados © Museo Nacional Del Prado – Madrid

double portrait, which hangs on the wall (behind us) and which the *infanta* has come to admire.

Whatever the case, Velázquez's painting depicts an actual work in progress. We do not know, we can never know, what work he is in the midst of making—a portrait of the king and queen, or *Las Meninas*, or some other work but it is the working process he describes. And fundamental to that process, it would appear, is his interaction with the royal family itself, who are not merely his patrons, but the very measure of the nobility of his art.

> Fig. 240 Diego Velázquez, Las Meninas, 1656, detail. Museo del Prado, Madrid. © Erich Lessing/Art Resource, New York.

SCALE AND PROPORTION

Scale is the word we use to describe the dimensions of an art object in relation to the original object that it depicts or in relation to the objects around it. Thus we speak of a miniature as a "small-scale" portrait, or of a big mural as a "large-scale" work. Scale is an issue that is important when you read a textbook such as this. You must always remember that the reproductions you look at do not usually give you much sense of the actual size of the work. The scale is by no means consistent throughout. That is, a relatively small painting might be reproduced on a full page, and a very large painting on a half page. In order to make the artwork fit on the book page we must-however unintentionally-manipulate its scale.

In both Do-Ho Suh's *Public Figures* (Fig. 241) and Claes Oldenburg's *Spoonbridge* and Cherry (Fig. 242), the artists have intentionally manipulated the scale of the object depicted. In Do-Ho Suh's case, the scale of the people carrying the sculptural pediment has been diminished in relation to the pediment itself, which is purposefully lacking the expected statue of a public hero standing on top of it.

 Fig. 241 Do-Ho Suh, Public Figures, 1998–1999.
 Installation view at Metrotech Center Commons, Brooklyn, New York. Fiberglass/resin, steel pipes, pipe fittings, 10 × 7 × 9 ft.
 Courtesy of the artist and Lehmann Maupin Gallery, New York.

"Let's say if there's one statue at the plaza of a hero, who helped or protected our country," Do-Ho Suh explains, "there are hundreds of thousands of individuals who helped him and worked with him, and there's no recognition for them. So in my sculpture, Public Figures, I had around six hundred small figures, twelve inches high, six different shapes, both male and female, of different ethnicities"-the "little people" behind the heroic gesture. Oldenburg's Spoonbridge and Cherry, in contrast, is gigantic in scale. It is an intentional exaggeration that parodies the idea of garden sculpture even as it wryly comments on art as the "maraschino cherry" of culture, the useless and artificial topping on the cultural sundae.

Proportion refers to the relationship between the parts of an object and the whole, or to the relationship between an object and its surroundings. Thus the internal proportions of each of these objects are accurate. However, each of these objects is "out of proportion" in relationship to its environment. When something is disproportionate to its surroundings, its scale is either too large or too small.

John Singer Sargent's *The Daughters of Edward Darley Boit* (Fig. 243) has a certain "Alice in Wonderland" feel to it. It is as if the young ladies depicted here had each swal-

Fig. 242 Claes Oldenburg and Coosje van Bruggen *Spoonbridge and Cherry,* 1988.

Stainless steel and aluminum painted with polyurethane enamel, 29 ft. 6 in. × 51 ft. 6 in. × 13 ft. 6 in. Collection Walker Art Center, Minneapolis. Gift of Frederick R. Weisman in honor of his parents, William and Mary Weisman, 1988.

© Claes Oldenburg and Coosje van Brugen.

Fig. 243 John Singer Sargent, The Daughters of Edward Darley Boit, 1882.
 Oil on canvas, 87 ³/₈ × 87 ⁵/₈ in. Museum of Fine Arts, Boston. Gift of Mary Louisa Boit, Julia Overing Boit, Jane Hubbard Boit, and Florence D. Boit in memory of their father, Edward Darley Boit. 19 124.
 Photo © 2004 Museum of Fine Arts, Boston.

lowed a piece of cookie and suddenly shrunk to a size smaller than a Chinese vase. The scale of the vases appears to be too large. They are out of proportion with the room. The painting, executed in 1882 in the Boit family's Paris apartment, is not merely a group portrait, but a stunning psychological study, granting us access into the complicated reality of these young girls' lives. Writing about it in *Harper's Magazine*, Sargent's contemporary, the novelist Henry James, found in this depiction of privileged children the same mysterious depth that he tried to convey in his own fiction"the sense," he called it, "of assimilated secrets." The older girls are farther back in space than the youngest child, in the darkness rather than the light, as if their psychological world were becoming increasingly private as they become more mature. The giant vases that loom over them, especially in combination with the bright red gash of the screen at the right, function like parental hands, at once threatening and caressing, but dominating their social world at every turn.

Artists also manipulate scale by the way they depict the relative size of objects. As we

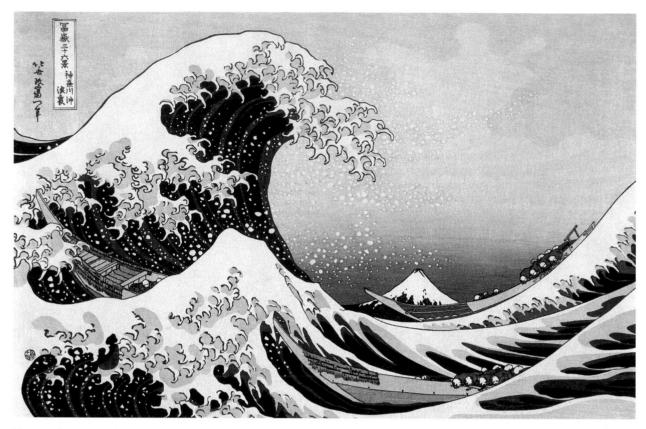

Fig. 244 Hokusai, "The Great Wave off Kanagawa", from the series "Thirty-Six Views of Mount Fuji". 1823–1829.
Color woodcut, 10 ft. × 15 in.
© Historical Picture Archive/CORBIS

know from our study of perspective, one of the most important ways to represent recessional space is to depict a thing closer to us as larger than a thing the same size farther away. This change in scale helps us to measure visually the space in the scene before us. When a mountain fills a small percentage of the space of a painting, we know that it lies somewhere in the distance. We judge its actual size relative to other elements in the painting and our sense of the average real mountain's size.

Because everybody in Japan knows just how large Mount Fuji is, many of Hokusai's various views of the mountain take advantage of this knowledge and, by manipulating scale, play with the viewer's expectations. His most famous view of the mountain, Figure 244, is a case in point. In the foreground, two boats descend into a trough beneath a great crashing wave that hangs over the scene like a giant, menacing claw. In the distance, Fuji rises above the horizon, framed in a vortex of wave and foam. Hokusai has echoed its shape in the foremost wave of the composition. While the wave is visually larger than the distant mountain, our sense of scale causes us to diminish its importance. The wave will imminently collapse, yet Fuji will remain. For the Japanese, Fuji symbolizes not only the everlasting, but Japan itself, and the print juxtaposes the perils of the moment with the enduring life of the nation.

In the work of political activist artists like Felix Gonzalez-Torres, shifts in scale are designed to draw attention to the magnitude of global socio-political crises. In 1991, as part of an exhibition at the Museum of Modern Art in New York, Gonzalez-Torres installed 24 billboards across New York City with an image of an empty, unmade bed (Fig. 245). The image evoked feelings of emptiness, loss, loneliness, and, ultimately, death. Its scale was designed, above all, to bring awareness to the broader community of the enormity of the AIDS epidemic, not only the amount of people affected by it, but also the personal and private cost that it had inflicted on both the city's gay community, and its heterosexual population. By bringing to light and making large

Fig. 245 Felix Gonzalez-Torres, Untitled, 1991. Billboard, overall dimensions vary with installation. Courtesy of Andrea Rosen Gallery, New York, and Museum of Modern Art, New York. © The Felix Gonzalez-Torres Foundation. what was otherwise hidden, as muralist Judith F. Baca does in her work (see Works in *Progress*, p. 180), Gonzalez-Torres meant to heighten New York's awareness of the problem that he himself faced. He would die of AIDS in 1996, at the age of 38.

By manipulating proportion, artists can create disturbing effects. Picasso's Woman with Stiletto (Death of Marat) (Fig. 246) depicts one of the most famous moments in French history, when Charlotte Corday assassinated the revolutionary hero Jean-Paul Marat in his bath. Every element in Picasso's painting is grotesquely disproportionate. Marat lies in his tub with a tiny head and tiny left arm in which he holds a pen. His right arm is somewhat larger; in it he holds the letter that Corday wrote in order to gain entrance to his house. His right leg is swollen to gigantic size. Corday stretches out above him like a praying mantis, her giant mouth opened as if to consume the minuscule Marat, her stiletto, the size of a sewing needle, piercing his heart, her lower body hugely distorted. Blood falls in a rush to the floor, and its red becomes, behind Marat's gigantic foot, part and parcel of the tricolor, the flag of the French Revolution. By radically distorting the normal proportions of the human body, Picasso is able to dramatize the horror of this scene convincingly.

Fig. 246 Pablo Picasso, Woman with Stiletto (Death of Marat), 1931.
Oil on canvas, 18 ¼ × 24 in. Musée Picasso, Paris. Clichés des Musée Nationaux-Paris
© R.M.N. © 2007 Estate of Pablo Picasso/Artists Rights Society (ARS), New York.

WORKS IN PROGRESS

n 1933, Mexican artist David Alfaro Siqueiros painted a mural, America Tropical, on Olvera Street, the historic center of Chicano and Mexican culture in Los Angeles. It was quickly painted over by city fathers, who objected to its portrayal of the plight of Mexicans and Chicanos in California. Currently under restoration with funds provided by the Getty Foundation, the mural depicts a mestizo shooting at an American eagle and a crucified Chicano, one of the inspirations for Guillermo Gómez-Peña's Cruci-fiction Project (see Fig. 83). Siqueiros's mural, and the work of the other great Mexican muralists of the twentieth century, Diego Rivera and Clemente Orozco-Los Tres Grandes, as they are known-has also inspired activist artist Judy Baca, who has dedicated her career to "giving voice" to the marginalized communities of California, empowering people through art.

In 1996, at the University of Southern California in Los Angeles, Baca was commissioned to create a mural (Fig. 248) for the student center, designed to embody the Chicano presence on campus and to symbolize the long struggle of USC's Chicano community to gain acknowledgment at the university. The project illustrates her working method. She begins with a group effort, gathering interested students together to research the historical events that took place around the site. This "excavation of the land," as she calls it, is the foundation for the collaborative venture to follow. Layers of information and historical data in the form of photographs, newspaper clippings, and old letters are gathered by students. Like layers of paint, the information is blended to become the imagery of the art-an imagery that will express, Baca hopes, the truth of the place where the work will be housed. She then creates a drawing (Fig. 247) based on the students' research, and the drawing is transferred to the wall.

Fig. 247 Judith F. Baca, La Memoria de Nuestra Tierra, 1996.
 Preliminary drawing, Acrylic on canvas, 9 × 23 ft. USC Student Topping Center.
 © 1997 Judith F. Baca. Courtesy of the artist.

Judith F. Baca's LA MEMORIA DE NUESTRA TIERRA

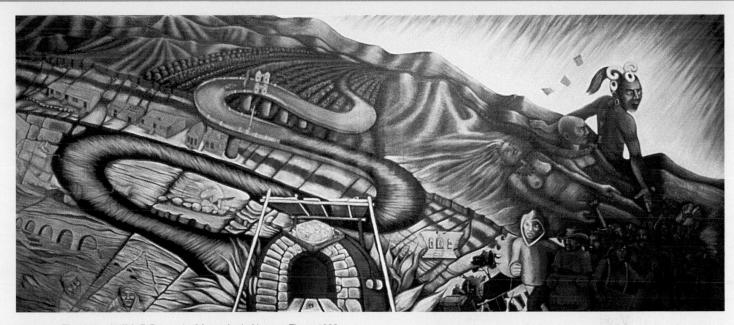

Fig. 248 Judith F. Baca, *La Memoria de Nuestra Tierra*, 1996. Acrylic on canvas, 9 × 23 ft. USC Student Topping Center. © 1997 Judith F. Baca. Courtesy of the artist.

The USC mural was conceived as a history of the Chicano community in Los Angeles, from the earliest houses in Senora town, to East Los Angeles, to Chavez Ravine. Like the mural by Siqueiros, it included a lynching, a tiny ³/4-inch image of an actual historical event, which the president of the University found "absolutely unacceptable," causing work on the project to come to a stop. It was subsequently removed, a compromise that allowed Baca to complete the rest of the mural as she had originally planned. Scale is everywhere an issue in Baca's mural. The mural is, in the first place, a "large-scale" work, dominating the room it occupies. In the process of its creation, the piece changes scale as well, from drawing to wall, from the intimate view to the public space. Most interesting of all is the relative "scale" of the hanging man. The image was itself very small, but it became emotionally large in scale—absolutely unacceptable, Baca agreed, but not as an image, as a fact.

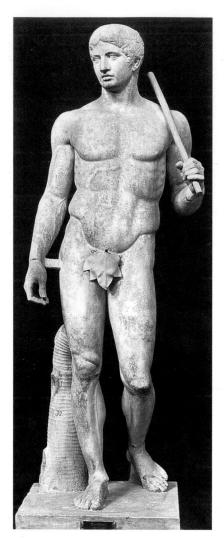

Fig. 249 Polykleitos, "Doryphoros, 450 BCE. Marble, Roman copy after lost bronze original, height, 84 in. National Museum, Naples. Scala / Art Resource, NY.

When the proportions of a figure seem normal, on the other hand, the representation is more likely to seem harmonious and balanced. The classical Greeks, in fact, believed that beauty itself was a function of proper proportion. In terms of the human body, these perfect proportions were determined by the sculptor Polykleitos, who not only described them in a now-lost text called the **canon** (from the Greek *kanon*, or "rule") but who also executed a sculpture to embody them. This is the *Doryphoros*, or "spear carrier," the original of which is also lost, although numerous copies survive (Fig. 249). The perfection of this figure is based on the fact that each part of the body is a common fraction of the figure's total height. According to the *Canon*, the height of the head ought to be one-eighth and the breadth of the shoulders one-fourth of the total height of the body.

This sense of mathematical harmony was utilized by the Greeks in their architecture as well. The proportions of the facade of the Parthenon, constructed in the fifth century BCE on the top of the Acropolis in Athens (Fig. 250), are based on the so-called golden section: The width of the building is 1.618 times the height. In terms of proportions, the height is to the width as 1 is to 1.618, or in less precise terms, approximately a ratio of 5:8. Plato regarded this proportion as the key to understanding the cosmos, and many years later, in the thirteenth century CE, the mathematician Leonardo Fibonacci discovered that this ratio is part of an infinite sequence (1, 2, 3, 5, 8, 13, 21, 34, 55, 89, etc.) in which each number is the sum of the two numbers before it, and each pair of numbers is a ratio that, as the numbers increase, more and more closely approximates 1:1.618. That the Parthenon should be constructed according to this proportion is hardly accidental. It is a temple to Athena, not only the protectress of Athens but also the goddess of wisdom, and the Golden Section represents to the ancient Greeks not merely beauty, but the ultimate wisdom of the universe.

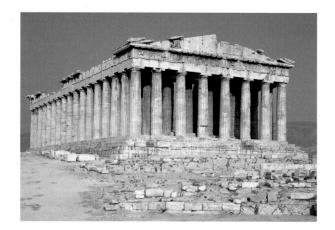

Fig. 250 Parthenon, 447–438 BCE. Pentelic marble, 111 × 237 ft. at base. Athens, Greece. D.A. Harissiadis, Athens. Studio Kontos/Photostock.

REPETITION AND RHYTHM

Repetition often implies monotony. If we see the same thing over and over again, it tends to get boring. Nevertheless, when the same or like elements-shapes, colors, or a regular pattern of any kind-are repeated over and over again in a composition, a certain visual rhythm will result. In Jacob Lawrence's Barber Shop (Fig. 251), this rhythm is established through the repetition of both shapes and colors. One pattern is based on the diamond-shaped figures sitting in the barber chairs, each of which is covered with a different-colored apron: one lavender and white, one red, and one black and green. The color and pattern of the left-hand patron's apron is echoed in the shirts of the two barbers on the right, while the pattern of the right-hand patron's apron is repeated in the

vest of the barber on the left. Hands, shoulders, feet-all work into the triangulated format of the design. "The painting," Lawrence explained in 1979, "is one of the many works . . . executed out of my experience . . . my everyday visual encounters." It is meant to capture the rhythm of life in Harlem, where Lawrence grew up in the 1930s. "It was inevitable," he says, "that the barber shop with its daily gathering of Harlemites, its clippers, mirror, razors, the overall pattern and the many conversations that took place there . . . was to become the subject of many of my paintings. Even now, in my imagination, whenever I relive my early years in the Harlem community, the barber shop, in both form and content . . . is one of the scenes that I still see and remember."

As we all know from listening to music, and as Lawrence's painting demonstrates,

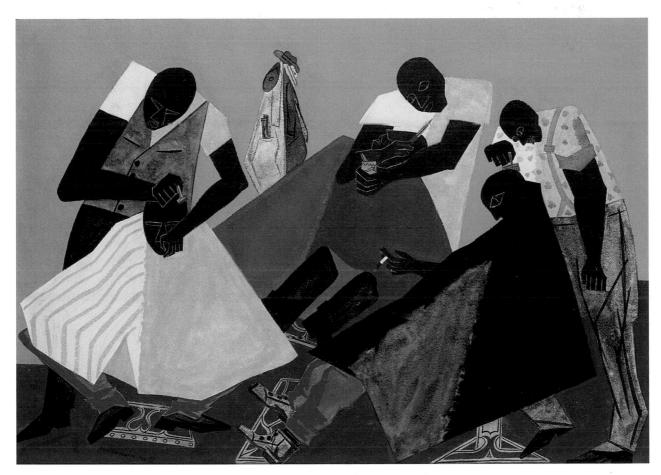

Fig. 251 Jacob Lawrence (American, 1917–2000), "Barber Shop," © 1946. Gouache on paper, 21 ¼ × 29 ¾ in. (53.6 × 74.6 cm). The Toledo Museum of Art, Toledo, Ohio. Purchased with funds from the Libbey Endowment, Gift of Edward Drummond Libbey. Artwork copyright 2003 Gwendolyn Knight Lawrence, courtesy of the Jacob and Gwendolyn Lawrence Foundation. © 2007 Gwendolyn Knight Lawrence / Artists Rights Society (ARS). New York.

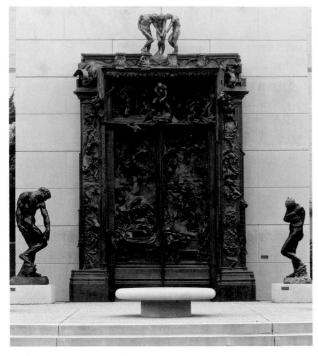

Fig. 252 Auguste Rodin, *Gates of Hell with Adam and Eve*, 1880–1917. Bronze, 25 × 158 × 33 in. Stanford University Museum of Art. Photo: Frank Wing.

repetition is not necessarily boring. The Gates of Hell (Fig. 252), by Auguste Rodin, was conceived in 1880 as the entry for the Museum of Decorative Arts in Paris, which was never built. The work is based on the Inferno section of Dante's Divine Comedy and is filled with nearly 200 figures who swirl in hellfire, reaching out as if continually striving to escape the surface of the door. Rodin's famous Thinker sits atop the door panels, looking down as if in contemplation of man's fate, and to each side of the door, in its original conception, stand Adam and Eve. At the very top of the door is a group of three figures, the Three Shades, guardians of the dark inferno beneath.

What is startling is that the *Three Shades* are not different, but, in fact, all the same (Fig. 253). Rodin cast his Shade three times and arranged the three casts in the format of a

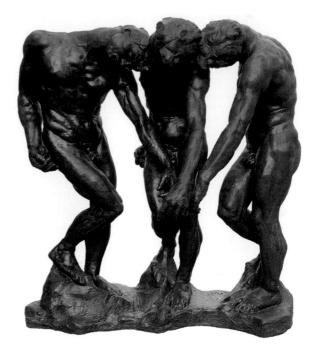

semicircle. (As with *The Thinker* and many other figures on the *Gates*, he also exhibited them as a separate, independent sculpture.) Though each figure is identical, thus arranged, and viewed from different sides, each appears to be a unique and different figure. Furthermore, in the *Gates*, the posture of the figure of Adam, in front and to the left, echoes that of the *Shades* above. This formal repetition, and the downward pull that unites all four figures, implies that Adam is not merely the father of us all, but, in his sin, the very man who has brought us to the Gates of Hell.

In Laylah Ali's most famous and longestrunning series of paintings, depicting the brown-skinned and gender-neutral Greenheads (Fig. 254), repetition plays a crucial role. Her figures are the archetypal "Other," a sort of amalgam of extraterrestrial Martians with their green heads and the dark-skinned denizens of the Third World. In the image reproduced here, three almost identical but masked Greenheads are being hung in front of an unmasked fourth victim. The hanged Greenheads hold in their hands the amputated

Fig. 254 Laylah Ali, *Untitled*, 2000. Gouache on paper, 13 × 19 in. Courtesy 303 Gallery, New York.

leg and arm, as well as the belt (for Ali, belts connote power) of the figure awaiting his or her fate. As Ali says, "The repetition is what I think is so striking. It's not like one thing happens and you say, 'Wow! That was just so terrible,' and it will never happen again. You know it will happen again." The horror of her images, in other words, resides exactly in their repetition.

UNITY AND VARIETY

Repetition and rhythm are employed by artists in order to unify the different elements of their works. In *Barber Shop* (see Fig. 251), Jacob Lawrence gives the painting a sense of coherence by repeating shapes and color patterns. Each of the principles of design that we have discussed leads to this idea of organization, the sense that we are looking at a unified whole—balanced, focused, and so on. Even Lawrence's figures, with their strange, clumsy hands, their oversimplified features, and their oddly extended legs and feet, are *uniform* throughout. Such consistency lends the picture its feeling of being complete.

It is as if, in Barber Shop, Lawrence is painting the idea of community itself, bringing together the diversity of the Harlem streets through the unifying patterns of his art. In fact, if everything were the same, in art as in life, there would be no need for us to discuss the concept of "unity." But things are not the same. The visual world is made up of different lines, forms, colors, textures-the various visual elements themselves-and they must be made to work together. Still, Rodin's Three Shades atop the Gates of Hell (see Fig. 253) teaches us an important lesson. Even when each element of a composition is identical, it is variety-in this case, the fact that our point of view changes with each of the Shades-that sustains our interest. In general, unity and variety must coexist in a work of art. The artist must strike a balance between the two.

Fig. 255 James Lavadour, The Seven Valleys and the Five Valleys, 1988.
 Oil on canvas, 54 × 96 in. Collection of Ida Cole.
 Courtesy of the artist and PDX, Portland, Oregon.

James Lavadour's *The Seven Valleys and the Five Valleys* (Fig. 255) is a stylistically unified composition of 12 landscape views, but each of the views is quite different from the others. Lavadour's paintings constantly negotiate the boundaries betweeen realism and abstraction. Close up, they seem to dissolve into a scraped, dripped, and brushed abstract surface, but seen from a distance, they become expansive landscape views, capturing the light and weather of the Pacific Northwest plateau country where Lavadour lives. Viewing a painting such as this is like viewing a series of Monet grainstacks, all rolled into one.

Fig. 256 Jean-Michel Basquiat, Untitled, 1984.

Acrylic, silkscreen, and oilstick on canvas, 88 × 77 in. © 2007 Estate of Jean-Michel Basquiat/Artists

Rights Society (ARS), New York/ADAGP, Paris.

By way of contrast, this untitled painting by Jean-Michel Basquiat (Fig. 256) seems purposefully to avoid any sense of unity. Basquiat was the middle-class son of a Brooklyn accountant who, at age 20, moved from painting graffiti on

Fig. 257 Las Vegas, Nevada. Steve Vidler/SuperStock, Inc.

walls throughout Manhattan to painting and drawing on large canvases. His loose, expressionist brushwork is painted over a body of scrawled notations, the content of which is willfully arbitrary. On the one hand, we sense Basquiat's alienation from his community in the work, in the contorted masks that grin menacingly out of the space of the composition and in the very crudeness of his style, a purposeful affront to traditional notions of artistic "quality." But on the other hand, Basquiat's painting is distinguished by the sheer energy and exuberance of his style, the vitality of his color, and the sense of freedom that his brushwork sccms to embody. If Basquiat was himself alienated from an art world that had granted him instant success, he also always seemed to have fun with it, spoofing its high seriousness and mocking, particularly, its preoccupation with money and fame.

It is this sense of disjunction, the sense that the parts can never form a unified whole, that we have come to identify with what is commonly called **Postmodernism**. The discontinuity between the old and the new that marks Frank Gehry's house (See Figs. 222 and 223), discussed at the beginning of this chapter, is an example of this postmodern sensibility, a sensibility defined particularly well by another architect, Robert Venturi, in his important 1972 book, Learning from Las Vegas. For Venturi, the collision of styles, signs, and symbols that marks the American "strip," especially the Las Vegas strip (Fig. 257), could be seen in light of a new sort of unity. "Disorder," Venturi writes, "[is] an order we cannot see The commercial strip with the urban sprawl . . . [is an order that] includes; it includes at all levels, from the mixture of seemingly incongruous land uses to the mixture of seemingly incongruous advertising media plus a system of neoorganic . . . restaurant motifs in Walnut Formica." The strip declares that anything can be put next to anything else. While traditional art has tended to exclude things that it deemed unartful, postmodern art lets everything in. In this sense, it is democratic. It could even be said to achieve a unity larger than the comparatively elitist art of high culture could ever imagine.

Elizabeth Murray's shaped canvas Just in Time (Fig. 258) is, at first glance, a two-panel abstract construction of rhythmic curves, oddly and not quite evenly, cut in half. But on second glance, it announces its postmodernity. For the construction is also an ordinary tea cup, with a pink cloud of steam rising above its rim. In a move that calls to mind Claes Oldenburg's Spoonbridge and Cherry (see Fig. 242), the scale of this cup-it is nearly nine feet highmonumentalizes the banal, domestic subject matter. Animal forms seem to arise out of the design-a rabbit on the left, an animated, Disney-like, laughing teacup in profile on the right. The title recalls pop lyrics-"Just in time, I found you just in time." Yet it remains an abstract painting, interesting as painting and as

design. It is even, for Murray, deeply serious. She defines the significance of the break down the middle of the painting by citing a stanza from W. H. Auden's poem, "As I walked out one evening":

The glacier knocks in the cupboard, The desert sighs in the bed, And the crack in the tea-cup opens A lane to the land of the dead.

Who knows what meanings are rising up out of this crack in the cup, this structural gap. Murray's painting is at once an ordinary teacup and an image rich in possible meanings, stylistically coherent and physically fragmented. The endless play of unity and variety is what it's about.

Fig. 258 Elizabeth Murray, Just in Time, 1981.

Oil on canvas in two sections, 106×97 in. Philadelphia Museum of Art. Purchased: The Eadward and Althea Budd Fund, the Adele Haas Turner and Beatrice Pastorius Fund, and funds contributed by Marion Stroud and Lorine E. Vogt. 1981-1994-1a,b.

THE **CRITICAL** PROCESS Thinking about the Principles of Design

By way of concluding this part of the book, let's consider how the various elements and principles inform a particular work, Monet's The Railroad Bridge, Argenteuil (Fig. 259). Line comes into play here in any number of ways. How would you describe Monet's use of line? Is it classical or expressive? Two strong diagonals-the near bank and the bridge itselfcross the picture. What architectural element depicted in the picture echoes this structure? Now note the two opposing directional lines in the painting-the train's and the boat's. In fact, the boat is apparently tacking against a strong wind that blows from right to left, as the smoke coming from the train's engine indicates. Where else in the painting is this sense of opposition apparent? Consider the relationships of light to dark in the composition and the complementary color scheme of orange and blue that is especially utilized in the reflections and in the smoke above. Can you detect opposing and contradictory senses of symmetry and asymmetry? What about opposing focal points?

What appears at first to be a simple landscape view, upon analysis reveals itself to be a much more complicated painting. In the same way, what at first appears to be a cloud becomes, rather disturbingly, a cloud of smoke. Out of the dense growth of the near bank, a train emerges. Monet seems intent on describing what larger issues here? We know that when Monet painted it, the railroad bridge at Argenteuil was a new bridge. How does this painting capture the dawn of a new world, a world of opposition and contradiction that in many ways mirrors the tensions in Thomas Cole's Course of Empire series (see Figs. 42-46)? Can you make a case that almost every formal element and principle of design at work in the painting supports this reading?

Fig. 259Claude Monet, The Railroad Bridge, Argenteuil, 1874.Oil on canvas, 21 4/5 × 29 2/5 in. The John G. Johnson Collection, Philadelphia Museum of Art. J#1050.

THE FINE ARTS MEDIA Learning How Art Is Made

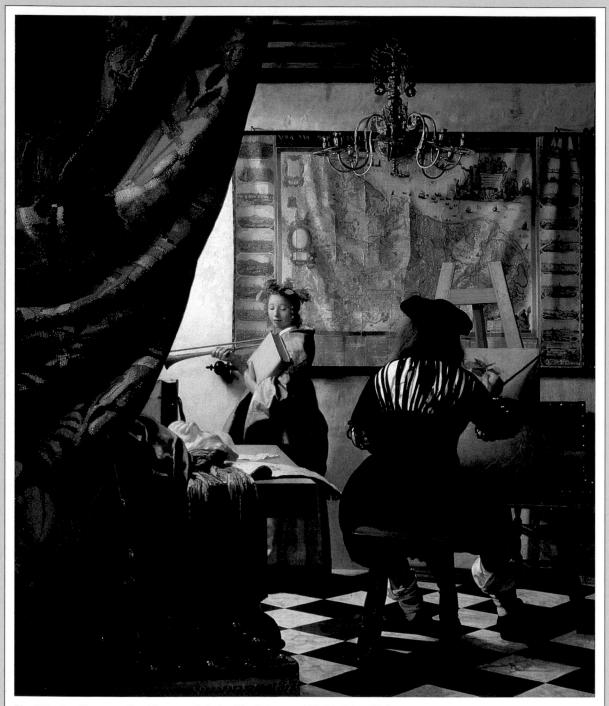

Fig. 260 Jan Vermeer, The Allegory of Painting (The Painter and His Model as Klio), 1665–1666.
 Oil on canvas, 48 × 40 in. Kunsthistorisches Museum, Vienna, Austria. Cat. 395, Inv. 9128.
 Photo © Erich Lessing. Art Resource, New York.

Drawing

n Jan Vermeer's *The Allegory of Painting* (Fig. 260), a stunning variety of media are depicted. The artist, his back to us, is shown painting his model's crown, but the careful observer can detect, in the lower half of the canvas, the white chalk lines of his preliminary drawing. A tapestry has been pulled back at the left, and a beautifully crafted chandelier hangs from the ceiling. A map on the back wall illustrates the art of cartography. The model herself is posed above a sculpted mask, which lies on the table below her gaze. As the muse of history, she holds a book in one hand, representing writing and literature, and a trumpet, representing music, in the other hand.

Each of the materials in Vermeer's work painting, drawing, sculpture, tapestry, even the book and the trumpet—represents what we call a **medium.** The history of the various media used to create art is, in essence, the history of the various **technologies** that artists have employed. These technologies have helped artists both to achieve their desired effects more readily and to discover new modes of creation and expression. A technology,

DRAWING AS AN ART

DRAWING MATERIALS

■ Works in Progress Raphael's *Alba Madonna*

Dry Media

■ Works in Progress Beverly Buchanan's *Shackworks*

> Liquid Media Innovative Drawing Media The Critical Process Thinking about Drawing

literally, is the "word" or "discourse" (from the Greek *logos*) about a "techne" (from the Greek word for art, which in turn comes from the Greek verb *tekein*, "to make, prepare, or fabricate"). A medium is, in this sense, a *techne*, a means of making art.

In Part III we will study all of the various media, but we turn our attention first to drawing, perhaps the most basic medium of all. Drawing has many purposes, but chief among them is preliminary study. Through drawing, artists can experiment with different approaches to their compositions. They illustrate, for themselves, what they are going to do. And, in fact, illustration is another important purpose of drawing. Before the advent of the camera, illustration was the primary way that we recorded history, and today it provides visual interpretations of written texts, particularly in children's books. Finally, because it is so direct, recording the path of the artist's hand directly on paper, artists also find drawing to be a ready-made means of self-expression. It is as if, in the act of drawing, the soul or spirit of the artist finds its way to paper.

DRAWING AS AN ART

The young man in this picture (Fig. 261) seems to be doing the most ordinary thing in the world—drawing. We think of drawing as an everyday activity that everyone, both artists and ordinary people, does all the time. You doodle on a pad; you throw away the marked-up sheet and start again with a fresh one. Artists often make dozens of sketches before deciding on the composition of a major work. But people have not always been able or willing to casually toss out marked-up paper and begin again. Before the late fifteenth century, paper was costly.

Look closely at Figure 261. The young man is sketching on a wooden tablet that he would sand clean after each drawing. The artist who drew him at work, however, worked in pen and ink on rare, expensive paper. This work thus represents a transition point in Western art the point at which artists began to draw on paper before they committed their ideas to canvas or plaster.

Until the late fifteenth century, drawing was generally considered a student medium. Copying a master's work was the means by which a

Fig. 261 Workshop of Pollaiuolo (?), Youth Drawing, late 15th century.
Pen and ink with wash on paper, 7 ⁵/₈ × 4 ¹/₂ in.
© The Trustees of the British Museum

student learned the higher art of painting. Thus, in 1493, the Italian religious zealot Savonarola outlined the ideal relationship between student and master: "What does the pupil look for in the master? I'll tell you. The master draws from his mind an image which his hands trace on paper and it carries the imprint of his idea. The pupil studies the drawing, and tries to imitate it. Little by little, in this way, he appropriates the style of his master. That is how all natural things, and all creatures, have derived from the divine intellect." Savonarola thus describes drawing as both the banal, everyday business of beginners and also as equal in its creativity to God's handiwork in nature. For Savonarola, the master's idea is comparable to "divine intellect."

The master is to the student as God is to humanity. Drawing is, furthermore, autographic: It bears the master's imprint, his style.

By the end of the fifteenth century, then, drawing had come into its own. It was seen as embodying, perhaps more clearly than even the finished work, the artist's personality and creative genius. As one watched an artist's ideas develop through a series of preparatory sketches, it became possible to speak knowingly about the creative process itself. By the time Giorgio Vasari wrote his famous Lives of the Painters in 1550, the tendency was to see in drawing the foundation of Renaissance painting itself. Vasari had one of the largest collections of fifteenthcentury-or so-called quattrocento-drawings ever assembled, and he wrote as if these drawings were a dictionary of the styles of the artists who had come before him.

In the Lives Vasari recalls how, in 1501, crowds rushed to see Leonardo's Madonna and Child with St. Anne and Infant St. John the Baptist, a cartoon (from the Italian cartone, meaning "paper") or drawing done to scale for a painting or a fresco. "The work not only won the astonished admiration of all the artists," Vasari reported, "but when finished for two days it attracted to the room where it was exhibited a crowd of men and women, young and old, who flocked there, as if they were attending a great festival, to gaze in amazement at the marvels he had created." Though this cartoon apparently does not survive, we can get some notion of it from the later cartoon illustrated here (Fig. 262). Vasari's account, at any rate, is the earliest recorded example we have of the public actually admiring a drawing.

Fig. 262 Leonardo da Vinci, Madonna and Child with St. Anne and Infant St. John the Baptist, c. 1505–1507. National Gallery, I ondon Art Resource, New York.

The two works shown here illustrate why drawing merits serious consideration as an art form in its own right and why Leonardo's drawings would so influence younger artists such as Raphael (see Works in Progress, p. 196). In Leonardo's Study for a Sleeve (Fig. 263), witness the extraordinary fluidity and spontaneity of the master's line. In contrast to the stillness of the resting arm (the hand, which is comparatively crude, was probably added later), the drapery is depicted as if it were a whirlpool or vortex. The directness of the medium, the ability of the artist's hand to move quickly over paper, allows Leonardo to bring out this turbulence. Through the intensity of his line, Leonardo imparts a degree of emotional complexity to the sitter. which is revealed in the part as well as in the whole. But the drawing also reveals the movements of the artist's own mind. It is as if the still sitter were at odds with the turbulence of the

artist's imagination, an imagination that will not hold still whatever its object of contemplation.

Movement, in fact, fascinated Leonardo. And nothing obsessed him more than the movement of water, in particular the swirling forms of the Deluge (Fig. 264), which he celebrated in a series of 16 drawings depicting the great flood that would come at the end of the world. It is as if, even in this sleeve, we are witness to the artist's fantastic preoccupation with the destructive forces of nature. We can see this preoccupation also in his famous notebooks, where he instructs the painter on how to represent a storm:

O what fearful noises were heard throughout the dark air as it was pounded by the discharged bolts of thunder and lightning that violently shot through it to strike whatever opposed their course. O how many you might have seen covering their ears with their hands in abhorrence at the uproar. . . O how much weeping and wailing! O how many terrified beings hurled themselves from the rocks! Let there be shown huge branches of great oaks weighed down with men and borne through the air by the impetuous winds. . . You might see herds of horses, oxen, goats and sheep, already encircled by the waters and left marooned on the

Fig. 263 Leonardo da Vinci, Study for a Sleeve, c. 1510–1513. Pen, lampblack, and chalk, 3 ⅓ × 6 ¾ in. The Royal Collection. © 2004 Her Majesty Queen Elizabeth II.

Fig. 264 Leonardo da Vinci, *Hurricane over Horsemen and Trees*, c. 1518. Pen and ink over black chalk, 10 1/4 × 16 1/8 in. The Royal Collection. © 2003 Her Majesty Queen Elizabeth II.

high peaks of the mountains. Now they ... huddled together with those in the middle clambering on top of the others, and all scuffling fiercely amongst themselves. . . . The air was darkened by the heavy rain that, driven aslant by the crosswinds and wafted up and down through the air, resembled nothing other than dust, differing only in that this inundation was streaked through by the lines drops of water make as they fall.

Because we can see in the earlier drawing of the sleeve a fascination with swirling line that erupts in the later drawings of the Deluge, we feel we know something important not only about Leonardo's technique but also about what drove his imagination. More than any other reason, this was why, in the sixteenth century, drawings began to be preserved by artists and, simultaneously, collected by connoisseurs, experts on and appreciators of fine art.

DRAWING MATERIALS

Just as the different fine arts media produce different kinds of images, different drawing materials produce different effects as well. Drawing materials are generally divided into two categories-dry media and liquid media. The dry media-metalpoint, chalk, charcoal, graphite, and pastel-consist of coloring agents-or pigments-that are sometimes ground or mixed with substances that hold the pigment together, called binders. Binders, however, are not necessary if the natural pigment for instance, charcoal made from vine wood heated in a hot kiln until only the carbon charcoal remains—can be applied directly to the surface of the work. In liquid media, pigments are suspended in liquid binders, like the ink in Leonardo's drawing of the hurricane. The liquid ink flows much more easily onto Leonardo's surface than the dry chalk below it.

WORKS IN PROGRESS

n a series of studies for The Alba Madonna (Fig. 267), the great Renaissance draughtsman Raphael demonstrates many of the ways that artists utilize drawings to plan a final work. It is as if Raphael, in these sketches, had been instructed by Leonardo himself. We do know, in fact, that when Raphael arrived in Florence in 1504, he was stunned by the freedom of movement and invention that he discovered in Leonardo's drawings. "Sketch subjects quickly," Leonardo admonished his students. "Rough out the arrangement of the limbs of your figures and first attend to the movements appropriate to the mental state of the creatures that make up your picture rather than to the beauty and perfection of their parts."

In the studies illustrated here, Raphael worked on both sides of a single sheet of paper (Figs. 265 and 266). On one side he has drawn a male model from life and posed him as the Madonna. In the sweeping cross-hatching below the figure in the sketch, one can already sense the circular format of the final painting, as these lines rise and turn up the arm and shoulder and around to the model's head. Inside this curve is another, rising from the knee bent under the model up across his chest to his neck and face.

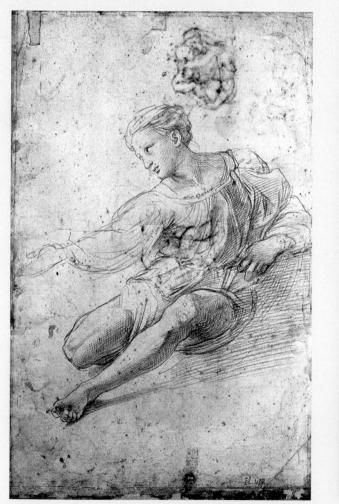

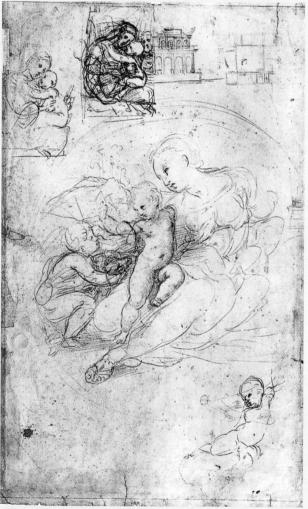

 Figs. 265 and 266
 Raphael, Studies for The Alba Madonna (recto and verso), c. 1511.

 Left: red chalk; right: red chalk and pen and ink, both 16 ½ × 10 ¼ in. Musée des Beaux Arts, Lille, France.

 RMN (left); Giraudon/Art Resource, New York (right).

Raphael's ALBA MADONNA

Even the folds of the drapery under his extended arm echo this curvilinear structure.

On the other side of the paper, all the figures present in the final composition are included. The major difference between this and the final painting is that the infant St. John offers up a bowl of fruit in the drawing and Christ does not yet carry a cross in his hand. But the circular format of the final painting is fully realized in this drawing. A hastily drawn circular frame encircles the group (outside this frame, above it, are first ideas for yet another Madonna and Child, and below it, in the bottom-right corner, an early version of the Christ figure for this one). The speed and fluency of this drawing's execution is readily apparent, and if the complex facial expressions of the final painting are not yet indicated here, the emotional tenor of the body language is. The postures are both tense and relaxed. Christ seems to move away from St. John even as he turns toward him. Mary reaches out, possibly to comfort the young saint, but equally possibly to hold him at bay. Raphael has done precisely as Leonardo directed, attending to the precise movements and gestures that will indicate the mental states of his subjects in the final painting.

Fig. 267 Raphael, *The Alba Madonna*, c. 1510.
Oil on panel transferred to canvas, diameter 37 ¼ in.; framed: 54 × 53 ½ in. National Gallery of Art, Washington, D.C. Andrew W. Mellon Collection.
© 1999 Board of Trustees, National Gallery of Art. Photo: José A. Naranjo.

Dry Media

Metalpoint One of the most common tools used in drawing in late fifteenth- and early sixteenth-century Italy was **metalpoint**. A *stylus* (point) made of gold, silver, or some other metal is applied to a sheet of paper prepared with a mixture of powdered bones (or lead white) and gumwater (when the stylus was silver, as it often

was, the medium was called **silverpoint**). Sometimes pigments other than white were added to this preparation in order to color the paper. When the metalpoint is applied to this ground, a chemical reaction results, and line is produced.

Rogier van der Weyden's Saint Luke Drawing the Virgin and Child (Fig. 268) actually depicts St. Luke drawing with metalpoint on

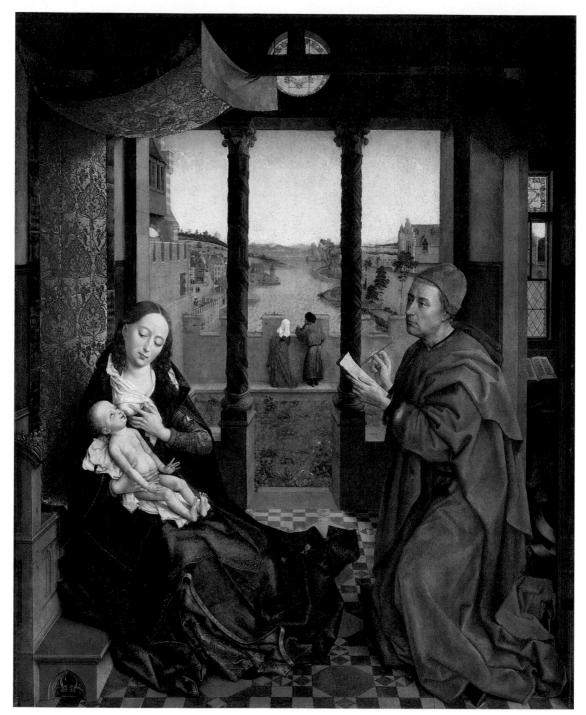

Fig. 268Rogier van der Weyden, Saint Luke Drawing the Virgin and Child, c. 1435.Oil on panel, 54 1/8 × 43 3/8 in. Museum of Fine Arts, Boston, Gift of Mr. and Mrs. Henry Lee Higginson. 93.153.

parchment. The figure of St. Luke is believed to be a self-portrait of van der Weyden himself. Probably executed for the chapel of the Painters Guild in Brussels, of which van der Weyden was the head, the painting is, then, a compendium of the artist's craft, and represents the entire process of making a painting, from drawing to finished product. The painting, incidentally, is indebted to Jan van Eyck's *The Madonna of Chancellor Rolin* (see Fig. 339), which was painted six years earlier. Van der Weyden's painting reverses van Eyck's composition; its format is more vertical than van Eyck's, and it is considerably simpler in its details.

A metalpoint line, which is pale gray, is very delicate and cannot be widened by increasing pressure upon the point. To make a thicker line, the artist must switch to a thicker point. Often, the same stylus would have a fine point on one end and a blunt one on the other, as does St. Luke's in the van der Weyden painting. Since a line cannot be erased without resurfacing the paper, drawing with metalpoint requires extreme patience and skill. Raphael's metalpoint drawing of Saint Paul Rending His Garments (Fig. 269) shows this skill. Shadow is rendered here by means of careful hatching. At the same time, a sense of movement and energy is evoked not only by the directional force of these parallels, but also by the freedom of Raphael's outline, the looseness of the gesture even in this most demanding of formats. The highlights in the drawing are known as heightening, and they are created by applying an opaque white to the design after the metalpoint lines have been drawn.

Chalk and Charcoal Metalpoint is a mode of drawing that is chiefly concerned with **delineation**—that is, with a descriptive representation of the thing, seen through an outline or contour drawing. Effects of light and shadow are essentially "added" to the finished drawing by means of hatching or heightening. With the softer media of chalk and charcoal, however, it is much easier to give a sense of the *volumetric*—that is, of three-dimensional form—through modulations of light and dark. While some degree of hatching is visible in Fra Bartolommeo's *Study for a Prophet Seen*

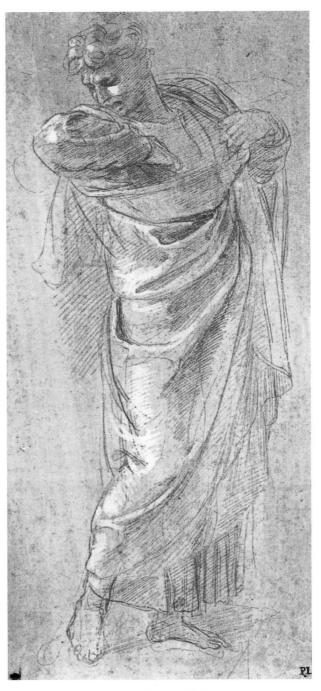

Fig. 269 Raphael, Saint Paul Rending His Garments. c. 1514–1515.

Metalpoint heightened with white gouache on lilac-gray prepared paper, 9 $^{1}/_{16} \times 4$ $^{1}/_{16}$ in. The J. Paul Getty Museum, Los Angeles. 84.GG.919. © The J. Paul Getty Museum.

Fig. 270 Fra Bartolommeo, Study for a Prophet Seen from the Front, 1499–1500.
Black chalk, heightened with white chalk, on brown prepared paper, 11 5% × 8 5% in. Museum Boimans Van Beuningen, Rotterdam, The Netherlands.

from the Front (Fig. 270), the primary impression is not one of linearity or two-dimensionality. Instead, the artist uses *chiaroscuro* to realize the three-dimensional form of the figure in space (see Chapter 7).

By the middle of the sixteenth century, artists used natural chalks, derived from red ocher hematite, white soapstone, and black carbonaceous shale, which were fitted into holders and shaved to a point. With these chalks, it became possible to realize gradual transitions from light to dark, either by adjusting the pressure of one's hand or by merging individual strokes by gently rubbing over a given area with a finger, cloth, or eraser. Charcoal sticks are made from burnt wood, and the best are made from hardwood, especially vines. They can be either hard or soft, sharpened to so precise a point that they draw like a pencil, or held on their sides and dragged in large bold gestures across the surface of the paper.

In her charcoal drawing of a *Banana Flower* (Fig. 271), Georgia O'Keeffe achieves a sense of volume and space comparable to that realized by means of chalk. Though she is noted for her stunning oil paintings of flowers, this is a rare example in her work of a colorless flower composition. O'Keeffe's interest here is in creating three-dimensional space with a minimum of means, and the result is a study in light and dark in many ways comparable to a black-and-white photograph.

Because of its tendency to smudge easily, charcoal was not widely used during the Renaissance except in **sinopie**, tracings of the outlines of compositions drawn on the wall before the painting of frescoes. Such *sinopie* have come to light only recently, as the plaster supports for frescoes have been removed for conservation purposes. Drawing with both charcoal and chalk requires a paper with *tooth*—a rough surface to which the media can adhere. Today, charcoal drawings can be kept from smudging by spraying synthetic resin **fixatives** over the finished work.

In the hands of modern artists, charcoal has become one of the more popular drawing media, in large part because of its expressive directness and immediacy. In her Self-Portrait, Drawing (Fig. 272), Käthe Kollwitz has revealed the extraordinary expressive capabilities of charcoal as a medium. Much of the figure was realized by dragging the stick up and down in sharp angular gestures along her arm from her chest to her hand. It is as if this line, which mediates between the two much more carefully rendered areas of hand and face, embodies the dynamics of her work. This area of raw drawing literally connects her mind to her hand, her intellectual and spiritual capacity to her technical facility. It embodies the power of the imagination. She seems to hold the very piece of charcoal that has made this mark sideways between her fingers. She has rubbed so hard, and with such fury, that it has almost disappeared.

Graphite Graphite, a soft form of carbon similar to coal, was discovered in 1564 in Borrowdale, England. As good black chalk became more and more difficult to obtain, the lead

Fig. 271 Georgia O'Keeffe, Banana Flower, 1933.

Charcoal and black chalk on paper, $21 \frac{3}{4} \times 14 \frac{3}{4}$ in. Museum of Modern Art, New York. Given anonymously (by exchange).

Photo © 1999 Museum of Modern Art. Licensed by Scala/Art Resource, New York. © 2007 The Georgia O'Keeffe Foundation/Artists Rights Society (ARS), New York.

pencil—graphite enclosed in a cylinder of soft wood—increasingly became one of the most common of all drawing tools. It became even more popular during the Napoleonic Wars early in the nineteenth century. Then, because supplies of English graphite were cut off from the continent, the Frenchman Nicholas-Jacques Conté invented, at the request of Napoleon himself, a substitute for imported pencils that became known as the **Conté crayon** (not to be confused with the so-called Conté crayons marketed today, which are made with chalk). Conté substituted clay for some of the graphite. This technology was quickly adapted to the making of pencils

Fig. 272 Käthe Kollwitz, Self-Portrait, Drawing, 1933.
 Charcoal on brown laid Ingres paper (Nagel 1972 1240), 18 ³/₄ × 25 in. National Gallery of Art, Washington, D. C. Rosenwald Collection.
 © 1999 Board of Trustees, National Gallery of Art. 1943.3.5217. © 2003 Artists Rights Society (ARS), New York/VG Bild-Kunst, Bonn.

Fig. 273 Georges Pierre Seurat, *Café Concert*, c. 1887–1888. Conté crayon with white heightening on Ingres paper, 12×9 ¹/₄ in. Museum of Art, Rhode Island School of Design, Providence. Gift of Mrs. Murray S. Danforth. Photo: Erik Gould.

generally. Thus the relative hardness of the pencil could be controlled—the less graphite, the harder the pencil—and a greater range of lights (hard pencils) and darks (soft pencils, employing more graphite) became available.

Georges Seurat's Conté crayon study (Fig. 273) indicates the powerful range of tonal effects afforded by the new medium. As Seurat presses harder, in the lower areas of the composition depicting the shadows of the orchestra pit, the coarsely textured paper is filled by the crayon. Above, pressing less firmly, Seurat creates a sense of light dancing on the surface of the stage. Where he has not drawn on the surface at all—across the stage and on the singer's dress—the glare of the white paper is almost as intense as light itself.

Vija Celmins's *Untitled (Ocean)* (Fig. 274) is an example of a highly developed photorealist graphite drawing. A little larger than a sheet of legal paper, the drawing is an extraordinarily detailed rendering of ocean waves seen from the Venice Pier in Venice, California. This is one of

Fig. 274 Vija Celmins, Untitled (Ocean) (Venice, California), 1970. Pencil on paper, 14 1/8 × 18 7/8 in. Museum of Modern Art, New York. Mrs. Florence M. Schoenborn Fund. Licensed by Scala/Art Resource, New York. Photo © 2000 Museum of Modern Art.

a long series of drawings based on small $3\frac{1}{2} \times 5$ -inch photographs. Celmins used a pencil of differing hardness for each drawing in the series, exploring the range of possibilities offered by the medium.

Graphite drawings can be erased, and erasure itself can become an important element in the composition. In 1953, a young Robert Rauschenberg, just at the beginning of his career, was thinking about the possibility of making an entire drawing by erasing. He told Willem de Kooning, a generation older than himself and an established abstract expressionist painter, about his musings. "I'd been trying with my own drawings, and it didn't work, because that was only 50 percent of what I wanted to get. I had to start with something that was 100 percent art, which mine might not be; but his work was definitely art." De Kooning reluctantly agreed to give Rauschenberg a drawing to erase. "It was a drawing done partly with a hard line, and also with grease pencil, and ink, and heavy crayon. It took me a month, and about forty erasers, to do it." The result is not easy to reproduce. It is a white sheet of paper with a faint shadow of its original gestures barely visible on it.

Larry Rivers's full figure of Willem de Kooning (Fig. 275) is a more traditional homage of a younger artist to his mentor, but it too is concerned with erasure. Rivers has described the process and the rationale behind it: I tend to erase it, erase it, erase it, keep trying, erase, keep trying, erase, and finally . . . well, let the observer make up more than I can represent This drawing is in the tradition of those kinds of work in which the history of the work became part of the quality of the work. De Kooning's work is full of that. His whole genre is that. His work is all about sweeping away, putting in . . . struggle, struggle, struggle and poof—masterpiece!

What Rivers says about de Kooning's work is evident if we consider one of the master's own drawings (Fig. 276), itself a study for a famous series of paintings of women, executed between 1950 and 1953. One can see that the drawing has been erased, smudged out, and drawn over. Part of the comic effect of the drawing is the result of the fact that the proportions of the woman are odd, her breasts too big, her eyelashes huge, her head too small for the torso. In fact, this work probably began as two separate drawings—de Kooning cut the head off another drawing and pasted it to the top of this one—putting in and sweeping away, as Rivers described his process.

Fig. 275 Larry Rivers, Willem de Kooning, 1961.
 Pencil on paper, 10 ³/₄ × 10 in. The Detroit Institute of Arts. Founders Society Purchase, Director's Discretionary Fund. 64.63.
 Photo © 1993 The Detroit Institute of Arts/© Larry Rivers Estate/

Photo © 1993 The Detroit Institute of Arts/© Larry Rivers Estate/ Licensed by VAGA, New York.

 Fig. 276 Willem de Kooning, Seated Woman, 1952.
 Pastel and pencil on cut and pasted paper, 12 × 9 ½ in. Museum of Modern Art, New York. The Lauder Foundation Fund.

Licensed by Scala/Art Resource, New York. Photo © 1996 Museum of Modern Art © 2007 The Willem de Kooning Foundation/Artists Rights Society (ARS), New York.

Pastel

The color in de Kooning's drawing is the result of pastel, which is essentially a chalk medium with colored pigment and a nongreasy binder added to it. Pastels come in sticks the dimension of an index finger and are labeled soft, medium, and hard, depending on how much binder is incorporated into the medium-the more binder, the harder the stick. Since the pigment is, in effect, diluted by increased quantities of binder, the harder the stick, the less intense its color. This is why we tend to associate the word "pastel" with pale, light colors. Although the harder sticks are much easier to use than the softer ones, some of the more interesting effects of the medium can only be achieved with the more intense colors of the softer sticks. The lack of binder in pastels makes them extremely fragile. Before the final drawing is fixed, the marks created by the chalky powder can literally fall off the paper, despite the fact that, since the middle of the eighteenth century, special ribbed and

textured papers have been made that help hold the medium to the surface.

Of all artists who have ever used pastel, perhaps Edgar Degas was the most proficient and inventive. He was probably attracted to the medium because it was more direct than painting, and its unfinished quality seemed particularly well-suited to his artistic goal of capturing the reality of the contemporary scene. According to George Moore, a friend of Degas's who began his career as a painter in Paris but gave it up to become an essavist and novelist. Degas's intention in works such as After the Bath, Woman Drying Herself (Fig. 277) was to show "a human figure preoccupied with herself-a cat who licks herself; hitherto, the nude has always been represented in poses which presuppose an audience, but these women of mine are honest and simple folk, unconcerned by any other interests than those involved in their physical condition. . . . It is as if you looked through a keyhole." It is disturbing that Degas is so comfortable in his position as voyeur, and, if Moore is right about Degas' intentions that he assumes that his model possesses little or no intelligence. The comparison of his model to a cat is demeaning. But Degas is also to be admired for giving up the academic studio pose.

And Degas's use of his medium is equally unconventional, incorporating into the "finished" work both improvised gesture and a loose, sketchlike drawing. Degas invented a new way to use pastel, building up the pigments in successive layers. Normally, this would not have been possible because the powdery chalks of the medium would not hold to the surface. But Degas worked with a fixative, the formula for which has been lost, that allowed him to build up layers of pastel without affecting the intensity of their color. Laid on the surface in hatches, these successive layers create an optical mixture of color that shimmers before the eyes in a virtually abstract design.

Fig. 277 Edgar Degas, After the Bath, Woman Drying Herself, c. 1889–1890.
Pastel on paper, 26 ⁵/₈ × 22 ³/₄ in. Courtauld Institute Galleries, London.

Fig. 278 Mary Cassatt, Young Mother, Daughter, and Son, 1913. Pastel on paper, 43 ¼ × 33 ¼ in. Memorial Art Gallery of the University of Rochester. Marion Stratten Gould Fund.

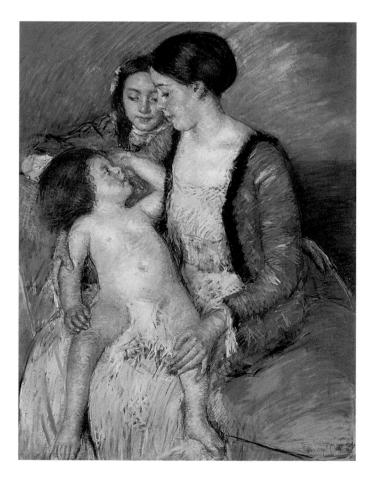

The American painter Mary Cassatt met Degas in Paris in 1877, and he became her artistic mentor. Known for her pictures of mothers and children, Cassatt learned to use the pastel medium with an even greater freedom and looseness than Degas. In this drawing of Young Mother, Daughter, and Son (Fig. 278), one of Cassatt's last works, the gestures of her pastel line again and again exceed the boundaries of the forms that contain them, and loosely drawn, arbitrary blue strokes extend across almost every element of the composition.

The owner of this work, Mrs. H. O. Havemeyer, Cassatt's oldest and best friend, saw in works such as this one an almost virtuoso display of "strong line, great freedom of technique and a supreme mastery of color." When Mrs. Havemeyer organized a benefit exhibition of Cassatt's and Degas's works in New York in 1915, its proceeds to be donated to the cause of woman's suffrage, she included works such as this one because Cassatt's freedom of line was, to her, the very symbol of the strength of women and their equality to men. Seen beside the works by Degas, it would be evident that the pupil had equaled, and in many ways surpassed, the achievement of Degas himself.

Oil Stick

Oil sticks are oil paint manufactured with enough wax for the paint to be molded into stick form. They allow the painter to draw directly onto a surface without brushes, palettes, paint tubes, or solvents. They are related to the pastel oil sticks used by artists such as Beverly Buchanan (see Works in Progress, p. 206). But unlike pastel oil sticks, which are too soft to build up densely on a surface, oil stick drawings can be deeply impastoed. Richard Serra's Clifton Chenier (Fig. 279) is one of a series of similar oil stick works called Rounds, which celebrate the masters of American jazz, including Al Green, Billie Holiday, Brownie McGhee, and John Coltrane. Chenier was a Louisiana accordianist, born in 1925, and he was often considered the most influential musician in zydeco history. The drawing is so dramatically built up that it approaches being sculpture on paper, its circular form playing off against its square format, its depth of surface against its two-dimensional shape. As in the other Rounds as well, the density of the surface is meant to suggest the density of sound exploding out of the history of American music.

Fig. 279 Richard Serra, *Clifton Chenier*, 1997.

From the series *Rounds.* Oil stick on paper, 5 $\frac{1}{2} \times 59 \frac{3}{4}$ in. Whitney Museum of American Art, New York. Purchase, with funds from the Painting and Scupture Committee. Photo and Digital Image © Whitney Mucoum of American Art. 98.4.2

WORKS IN PROGRESS

Pastels are an extremely fragile medium, but they can be combined with oil to make pastel oil sticks that not only flow more easily onto the surface of the drawing but also adhere to the surface more readily. Pastel oil stick drawings are central to the art of Beverly Buchanan, whose work is about the makeshift shacks that dot the Southern landscape near her home in Athens, Georgia.

Beginning in the early 1980s, Buchanan started photographing these shacks, an enterprise she has carried on ever since (Fig. 280). "At some point," she says, "I had to realize that for me the structure was related to the people who built it. I would look at shacks and the ones that attracted me always had something a little different or odd about them. This evolved into my having to deal with [the fact that] I'm making portraits of a family or person."

Buchanan soon began to make drawings and sculptural models of the shacks. Each of these models tells a story. This legend, for instance, accompanies the sculpture of *Richard's Home* (Fig. 281):

Some of Richard's friends had already moved north, to freedom, when he got on the bus to New York. Richard had been "free" for fifteen years and homeless now for seven After eight years as a fore-

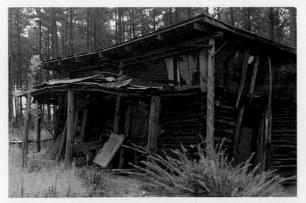

Fig. 280 Beverly Buchanan, *Ms. Mary Lou Furcron's House, deserted,* 1989. Ektacolor print, 16 × 20 in. Courtesy Steinbaum Krauss Gallery, New York.

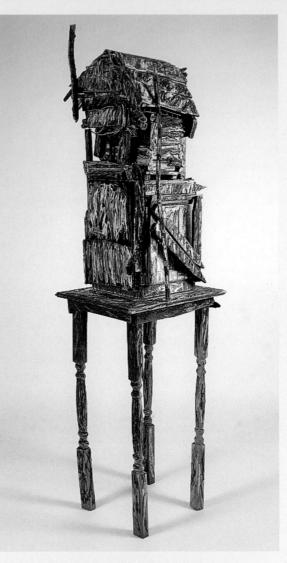

Fig. 281 Beverly Buchanan, Richard's Home, 1993.
 Wood, oil crayon, and mixed media, 78 × 16 × 21 in.
 Courtesy Steinbaum Krauss Gallery, New York. Collection of Bernice and Harold Steinbaum. Photo: Adam Reich.

man, he was "let go." He never imagined it would be so hard and cruel to look for something else. Selling his blood barely fed him. At night, dreams took him back to a childhood of good food, hard work, and his Grandmother's yard of flowers and pinestraw and wood. Late one night, his cardboard house collapsed during a heavy rain. Looking down at a soggy heap, he heard a voice, like thunder, roar this message through his brains, RICHARD GO HOME!

Beverly Buchanan's SHACKWORKS

 Fig. 282
 Beverly Buchanan, Monroe County House with Yellow Datura, 1994.

 Oil pastel on paper, 60 × 79 in.
 Courtesy Steinbaum Krauss Gallery, New York. Collection of Bernice and Harold Steinbaum. Photo: Adam Reich.

Buchanan's sculpture does not represent the collapsed cardboard house in the North, but Richard's new home in the South. It is not just a ramshackle symbol of poverty. Rather, in its improvisational design, in its builder's determination to use whatever materials are available, to make something of nothing, as it were, the shack is a testament to the energy and spirit of its creator. More than just testifying to Richard's will to survive, his shack underscores his creative and aesthetic genius.

Buchanan's paste oil stick drawings such as *Monroe County House with Yellow Datura* (Fig. 282) are embodiments of this same energy and spirit. In their use of expressive line and color, they are almost abstract, especially in the fields of color that surround the shacks. Their distinctive scribble-like marks are based on the handwriting of Walter Buchanan, Beverly Buchanan's great-uncle and the man who raised her. Late in his life he suffered a series of strokes, and before he died he started writing letters to family members that he considered very important. "Some of the words were legible," Buchanan explains, "and some were in this kind of script that I later tried to imitate What I thought about in his scribbling was an interior image. It took me a long time to absorb that And I can also see the relation of his markings to sea grasses, the tall grasses, the marsh grasses that I paint." The pastel oil stick is the perfect tool for this line, the seemingly untutored rawness of its application mirroring the haphazard construction of the shacks. And it results in images of great beauty, as beautiful as the shacks themselves.

Liquid Media

Pen and Ink During the Renaissance, after the invention of paper, most drawings were made with iron-gall ink, which was made from a mixture of iron salts and an acid obtained from the nutgall, a swelling on an oak tree caused by disease. The characteristic brown color of most Renaissance pen and ink drawings results from the fact that this ink, though black at application, browns with age.

The quill pen used by most Renaissance artists, which was most often made from a goose or swan feather, allows for far greater variation in line and texture than is possible with a metalpoint stylus or even with a pencil. As we can see in this drawing by Elisabetta Sirani (Fig. 283), one of the leading artists in Bologna during the seventeenth century, the line can be thickened or thinned, depending on the artist's manipulation of the flexible quill and the absorbency of the paper (the more absorbent the paper, the more freely the ink will flow through its fibers). Diluted to a greater or lesser degree, ink also provides her with a more fluid and expressive means to render light and

shadow than the elaborate and tedious hatching that was necessary when using stylus or chalk. Drawing with pen and ink is fast and expressive. Sirani, in fact, displayed such speed and facility in her compositions that, in a story that most women will find familiar, she was forced to work in public in order to demonstrate that her work was her own and not done by a man.

In this example from Jean Dubuffet's series of drawings Corps de Dame (Fig. 284) ("corps" means both a group of women and the bodies of women), the whorl of line, which ranges from the finest hairline to strokes nearly a halfinch thick, defines a female form, her two small arms raised as if to ward off the violent gestures of the artist's pen itself. Though many see Dubuffet's work as misogynistic-the product of someone who hates women-it can also be read as an attack on academic figure drawing, the pursuit of formal perfection and beauty that has been used traditionally to justify drawing from the nude. Dubuffet does not so much render form as flatten it, and in a gesture that insists on the modern artist's liberation from traditional techniques and values, his use of pen and ink threatens to transform drawing into scribbling, conscious draftsmanship into automatism, that is, unconscious and random automatic marking. In this, his work is very close to surrealist experiments designed to make contact with the unconscious mind.

 Fig. 283 Elisabetta Sirani The Holy Family with a Kneeling Monastic Saint, c. 1660.
 Pen and brown ink, black chalk, on paper, 10 ³/₈ × 7 ³/₈ in. Private collection.
 Photo courtesy of Christie's, New York.

 Fig. 284
 Jean Dubuffet, Corps de Dame, June–December 1950.

 Pen, reed pen, and ink, 10 5% × 8 3% in. Museum of Modern Art, New York The Jean and Lester Avnet Collection.

 Licensed by Scala/Art Resource, New York. Photo © 2000 Museum of Modern Art © 2007 Artists Rights Society (ARS), New York/ADAGP, Paris.

Fig. 285 Giovanni Battista Tiepolo, The Adoration of the Magi, c. 1740s.
 Pen and brown wash over graphite sketch, 11 ³/₅ × 8 ¹/₅ in. Iris & B. Gerald Cantor Center for Visual Arts at Stanford University. Mortimer C. Leventritt Fund.1950.392.

Wash and Brush When ink is diluted with water and applied by brush in broad, flat areas, the result is called a wash. Tiepolo's Adoration of the Magi (Fig. 285) is essentially three layers deep. Over a preliminary graphite sketch is a pen and ink drawing, and over both, Tiepolo has laid a brown wash. The wash serves two purposes here: It helps to define volume and form by adding shadow, but it also creates a visual pattern of alternating light and dark elements that helps to make the drawing much more dynamic than it would otherwise be. As we move from right to left across the scene, deeper and deeper into its space, this alternating pattern leads us to a central moment of light, which seems to flood from the upper right, falling on the infant Jesus himself.

Many artists prefer to draw with a brush. It affords them a sense of immediacy and spontaneity, as Rembrandt's brush drawing of *A Sleeping Woman* (Fig. 286) makes clear. The work seems so spontaneous, so quick and impetuous, that one can imagine Rembrandt drawing the scene quickly, so as not to wake the woman. And the drawing possesses an equally powerful sense of intimacy. It is as if

Fig. 286 Rembrandt van Rijn, *A Sleeping Woman*, c. 1660–1669. Brush drawing in brown ink and wash, 9 ⁵⁄₀ × 8 in. The British Museum, London. Marburg/Art Resource, New York. the ability to draw this fast is the result of knowing very well who it is one draws.

Drawing with a brush is a technique with a long tradition in the East, perhaps because the brush is used there as a writing instrument. Chinese calligraphy requires that each line in a written character begin very thinly, then broaden in the middle and taper again to a point. The soft brushtip allows calligraphers to control the width of their lines. Thus, in the same gesture, a line can move from broad and sweeping to fragile and narrow, and back again. Such ribbons of line are extremely expressive. In his depiction of the Tang poet Li Bo (Fig. 287), Liang Kai juxtaposes the quick strokes of diluted ink that form the robe with the fine, detailed brushwork of his face. This opposition contrasts the fleeting materiality of

Fig. 287 Liang Kai, *The Poet Li Bo Walking and Chanting a Poem, Southern Song Dynasty*, c. 1200. Hanging scroll, ink on paper, 31 ⅔4 × 11 7/₈ in. Tokyo National Museum, Japan the poet's body—as insubstantial as his chant, which drifts away on the wind—with the enduring permanence of his poetry.

Innovative Drawing Media

Drawing is by its nature an exploratory medium. It invites experiment. Taking up a sheet of heavy prepainted paper, Henri Matisse was often inspired, beginning in the early 1940s, to cut out a shape in the paper with a pair of wide-open scissors, using them like a knife to carve through the paper. "Scissors," he says, "can acquire more feeling for line than pencil or charcoal." Sketching with the scissors, Matisse discovered what he considered to be the essence of a form. Cut-outs, in fact, dominated Matisse's artistic production from 1951 until his death in 1954. In this *Venus* (Fig. 288), the figure of the goddess is revealed in the negative space of the composition. It is as if the goddess of love—and hence love itself—were immaterial. In the blue positive space to the right we discover the profile of a man, as if love springs, fleetingly, from his very breath.

One of the great drawing innovators of the day is South African artist William Kentridge, who employs his drawings to create animated films. These films are built up from single drawings in charcoal and pastel on paper that are successively altered through erasure, additions, and re-drawings that are photographed at each stage of evolution. Instead of being constructed, as in normal animation, out of hundreds of separate drawings, Kentridge's films are made of hundreds of photographs of drawings in process. Drawing over a week's time might add up to around 40 seconds of animation.

The process of erasure, and the smudged layering that results, is for Kentridge a kind of

Fig. 288 Henri Matisse, Venus, 1952.

Paper collage on canvas, 39 $\frac{7}{8} \times 30$ $\frac{1}{8}$ in. National Gallery of Art, Washington, D.C. Ailsa Mellon Bruce Fund.

© 1999 Board of Trustees, National Gallery of Art. © 2007 Succession H. Matisse, Paris/Artists Rights Society (ARS) New York. metaphor for memory, and it is memory that concerns Kentridge, especially the memory of apartheid in South Africa and by extension the memory of the forces that mark the history of modernity as a whole. The films chronicle the rise and fall of a white Johannesburg businessman, Soho Eckstein. Always dressed in a pin-striped suit, Soho buys land and then mines it, extracting the resources and riches of the land and creating an empire based upon his own exploitation of miners and landscape. He is emotionally the very embodiment of the industrial infrastructure he has helped to create—dark, somber, virtually dehumanized. Over time, as the films have followed his career, he has come to understand the high price that he and his country have paid for his actions.

Reproduced here are four drawings from the seventh film in the Soho Eckstein cycle, WEIGH-ING . . . and WANTING (Fig. 289). The first is an image of Soho's brain as he passes through a magnetic resonance imaging (MRI) apparatus. It reveals a line of workers heading into the mines. Next, we see the ore in the mine itself imaged in his skull. The scanned brain is then transformed into a rock, which Soho comes across on his evening walk and embraces. Inside it, he can hear his own memories, as if fossilized within the stone.

Fig. 289 William Kentridge, Four drawings from WEIGHING. . . and WANTING, 1997–1998. Charcoal, pastel on paper, from left to right, 24 ⁵/₈ × 30 ³/₄ in., 24 ⁵/₈ × 30 ³/₄ in., 47 ¹/₄ ×, 63 in., and 47 ¹/₄ × 63 in. Courtesy Marion Goodman Gallery, New York. © Goodman Gallery 2006. All rights reserved.

THE **CRITICAL** PROCESS Thinking about Drawing

As we have seen, drawing is one of the most basic and one of the most direct of all media. Initially, drawing was not considered an art in its own right, but only a tool for teaching and preliminary study. By the late Renaissance, it was generally acknowledged that drawing possessed a vitality and immediacy that revealed significant details about the artist's personality and style. Today, drawing is an increasingly popular medium, especially in Japan, where *anime*, a type of animation often employing computer-assisted techniques, and *manga*, comic books or graphic novels, dominate the popular market.

In many ways indebted to Japanese *anime* is Theresa Duncan and Jeremy Blake's 39-minute animated video *The History of Glamour* (Fig. 290). Prior to its release, Duncan had produced a popular line of CD-ROM games for girls. Collaborating with digital animator Jeremy Blake, Duncan created a hybrid pseudo-"rockumentary" that explores the nature of American celebrity, featuring music by Kathi Wilcox of the feminist rock band Bikini Kill and Brendan Canty of Fugazi. Its heroine, the teen singer-songwriter Charles Valentine, from the fictional backwater farm town of Antler, Ohio, storms Manhattan intent on achieving fame and fortune. But the lyrics of her songs increasingly reflect the emptiness of the cult of celebrity: "I got a call from a magazine yesterday, I think it was called *Interview*. I said, 'Thursday is out, but how about never? Is never good for you?"" In the end, Charles becomes a reclusive writer, chucking "glamour for grammar."

Why is drawing a particularly appropriate medium in which to narrate this tale? What advantages does drawing have over performances by live actors? Traditionally, drawing was thought to reveal significant aspects of the artist's personality. This brand of drawing seems, rather, to reflect the artist's culture. How so? And why, given the narrative, of *The History of Glamour*, does this seem appropriate?

Fig. 290 Theresa Duncan and Jeremy Blake, still from *"The History of Glamour"*, 1998. Video, color, sound, 39 minutes. Courtesy Theresa Duncan and Jeremy Blake / Valentine Media.

Printmaking

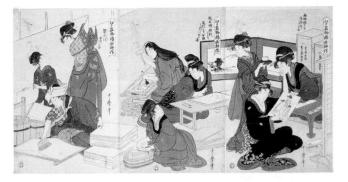

RELIEF PROCESSES

Woodcut

Works in Progress Utamaro's Studio

> Wood Engraving Linocut

INTAGLIO PROCESSES

Engraving Etching

■ Works in Progress Albrecht Dürer's *Adam and Eve*

> Drypoint Mezzotint and Aquatint

LITHOGRAPHY

Works in Progress June Wayne's *Knockout*

SILKSCREEN PRINTING

MONOTYPES

The Critical Process Thinking about Printmaking he medium of printmaking originated in the West very soon after the appearance of the first book printed with movable type, the Gutenberg Bible (1450–1456). At first, printmaking was used almost exclusively as a mode of illustration for books. In post-medieval Western culture, prints not only served to codify and regularize scientific knowledge, which depends on the dissemination of exact reproductions, but they were fundamental to the creation of our shared visual culture.

This illustration for *The Nuremberg Chronicle* (Fig. 291, see p. 216) was published in 1493 by one of the first professional book publishers in history, Anton Koberger. Appearing in two editions, one in black and white, and another much more costly edition with hand-colored illustrations, *The Nuremberg Chronicle* was intended as a history of the world. A bestseller in its day, it contained more than 1,800 pictures, though only 654 different blocks were employed. Forty-four images of men and women were repeated 226 times to represent different famous historical characters, and depictions of many different cities utilized the same woodcut.

Fig. 291Hartmann Schedel, The Nuremberg Chronicle: View of Venice, 1493.Woodcut, illustration size approx. 10 × 20 in. The Metropolitan Museum of Art, New York. Rogers Fund, 1921. 21.36.145.

For centuries, prints were primarily used in books, but since the nineteenth century, and increasingly since World War II, the art world has witnessed what might well be called an explosion of prints. The reasons for this are many. For one thing, the fact that prints exist in multiple numbers seems to many artists absolutely in keeping with an era of mass production and distribution. The print allows the contemporary artist, in an age increasingly dominated by the mass media and mechanical modes of reproduction, such as photography, to investigate the meaning of mechanically reproduced imagery. An even more important reason is that the unique work of art—a painting or a sculpture-has become, during the twentieth century, too expensive for the average collector, and the size of the purchasing public has, as a consequence, diminished considerably. Far less expensive than unique paintings, prints are an avenue through which artists can more readily reach a wider audience.

A print is defined as a single impression, or example, of a multiple edition of impressions, made on paper from the same matrix, the master image on the working surface. As collectors have come to value prints more and more highly, the somewhat confusing concept of the original print has come into being. How, one wonders, can an image that exists in multiple be considered "original"? By and large, an original print consists of an image that the artist alone has created, and that has been printed by the artist or under the artist's supervision. Since the late nineteenth century, artists have signed and numbered each impression—for example, the number 3/35 at the bottom of a print means that this is the third impression in an edition of 35. Often the artist reserves a small number of additional **proofs**—trial impressions made before the final edition is run—for personal use. These are usually designated "AP," meaning "artist's proof." After the edition is made, the original plate is destroyed or canceled by incising lines across it. This is done to protect the collector against a misrepresentation about the number of prints in a given edition.

Today, prints provide many people with aesthetic pleasure. There are five basic processes of printmaking—relief, intaglio, lithography, silkscreen, and monotype—and we will consider them all in this chapter.

RELIEF PROCESSES

The term relief refers to any printmaking process in which the image to be printed is raised off the background in reverse. Common rubber stamps utilize the relief process. If you have a stamp with your name on it, you will know that the letters of your name are raised off it in reverse. You press the letters into an ink pad, and then to paper, and your name is printed right side up. All relief processes rely on this basic principle.

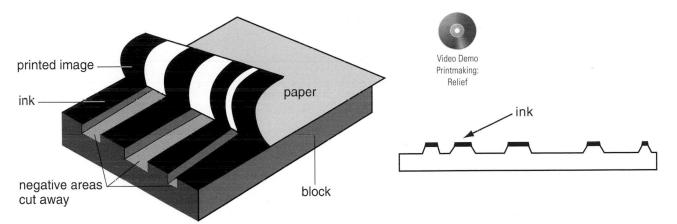

Fig. 292 Relief-printing technique.

Woodcut

The earliest prints, such as the illustrations for *The Nuremberg Chronicle*, were woodcuts. A design is drawn on the surface of a wood block, and the parts that are to print white are cut or gouged away, usually with a knife. This process leaves the areas that are to be black elevated. A black line is created, for instance, by cutting away the block on each side of it. This elevated surface is then rolled with a relatively viscous ink, thick and sticky enough that it will not flow into the hollows (Fig. 292). Paper is then rolled through a press directly against this inked and raised surface.

The woodcut print offers the artist a means of achieving great contrast between light and dark, and as a result, dramatic emotional effects. In the twentieth century, the expressive potential of the medium was recognized, particularly by the German Expressionists. In Emile Nolde's *Prophet* (Fig. 293), we do not merely sense the pain and anguish of the prophet's life, the burden that prophesy entails, but we feel the portrait emerging out of the very gouges Nolde's knife made in the block.

European artists became particularly interested in the woodblock process in the nineteenth century through their introduction to the Japanese woodblock print. Woodblock printing had essentially died as an art form in Europe as early as the Renaissance, but not long after Commodore Matthew C. Perry's arrival in Japan in July 1853, ending 215 years of isolation from the rest of the world, Japanese prints flooded the European market, and they were received with enthusiasm. Part of their attraction was their exotic subject matter, but artists were also intrigued by the range of color in the prints, their subtle and economical use of line, and their novel use of pictorial space.

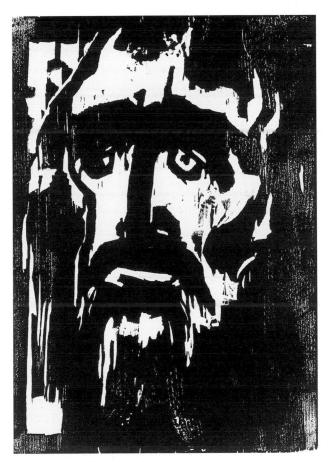

Fig. 293 Emile Nolde, Prophet, 1912.

Woodcut (Schiefler/Mosel 1966 [W] 110 only), image: 12 $\frac{5}{8} \times 8 \frac{7}{8}$ in.; sheet: 15 $\frac{3}{4} \times 13 \frac{5}{16}$ in. National Gallery of Art, Washington, D.C. Rosenwald Collection. © 1999 Board of Trustees, National Gallery of Art. 1943.3.6698. Courtesy Stiftung Seebull, Ada and Emil Nolde.

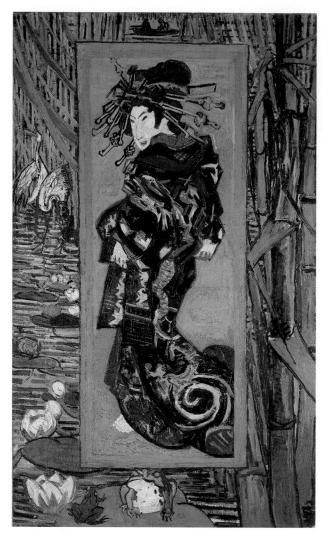

Fig. 294 Vincent van Gogh, Japonaiserie: The Courtesan (after Kesai Eisen), 1887.
 Oil on canvas, 41 ³/₈ × 24 in. Van Gogh Museum, Amsterdam (Vincent van Gogh Foundation).

Impressionist artists such as Edouard Manet, Edgar Degas, and Mary Cassatt were particularly influenced by Japanese prints. But the artist most enthusiastic about Japanese prints was Vincent van Gogh. He owned prints by the hundreds, and on numerous occasions he copied them directly. Japonaiserie: The Courtesan (after Kesai Eisen) (Fig. 294) is an example. The central figure in the painting is copied from a print by Kesai Eisen that van Gogh saw on the cover of a special Japanese issue of Paris Illustré published in May 1886 (Fig. 295). All the other elements of the painting are derived from other Japanese prints, except perhaps the boat at the very top, which appears Western in conception. The frogs were copied from Yoshimaro's New Book of Insects, and both the cranes and the bamboo stalks are derived from prints by Hokusai, whose Great Wave Off Kanagawa we saw in Chapter 9 (see Fig. 244). Van Gogh's intentions in combining all these elements become clear when we recognize that the central figure is a courtesan (her tortoiseshell hair ornaments signify her pro-

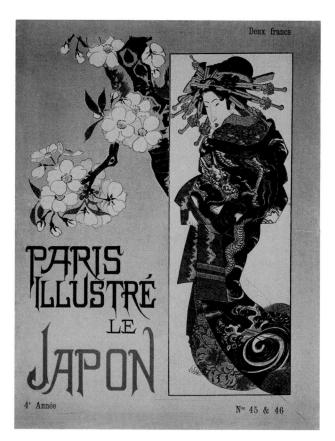

Fig. 295 "Le Japon," cover of *Paris Illustré*, May 1886. Van Gogh Museum, Amsterdam (Vincent van Gogh Foundation).

Fig. 296 Kitagawa Utamaro, Shaving a Boy's Head, c. 1795. Color woodblock print, 15 ¼ × 10 ¼ in. The Minneapolis Institute of Arts. Bequest of Richard P. Gale. 74.1.153.

Fig. 297 Mary Cassatt, *The Bath*, 1890–1891.
Drypoint and aquatint on laid paper, plate: 12 ½ × 9 ¼ in.; sheet: 17 ¾ 6 × 12 in. National Gallery of Art, Washington, D.C. Rosenwald Collection.
Photograph © Board of Trustees, National Gallery of Art, Washington, D C Photo: Dean Beasom

fession), and that the words grue (crane) and grenouille (frog) were common Parisian words for prostitutes. Van Gogh explained his interest in Japanese prints in a letter written in September 1888: "Whatever one says," he wrote, "I admire the most popular Japan ese prints, colored in flat areas, and for the same reasons that I admire Rubens and Veronese. I am absolutely certain that this is no primitive art."

Of all the Impressionists, perhaps the American Mary Cassatt, who exhibited with the group beginning in 1867, was most taken with the Japanese tradition. She was especially impressed with its interest in the intimate world of women, the daily routines of domestic existence. She consciously imitated works like Utamaro's *Shaving a Boy's Head* (Fig. 296) (see *Works in Progress*, p. 220). Cassatt's *Bath* (Fig. 297), one of ten prints inspired by an April 1890 exhibition of Japan ese woodblocks at the École des Beaux-Arts in Paris, exploits the same contrasts between printed textiles and bare skin, between colored fabric and the absence of color in space. Her whole composition is made up of flatly silhouetted shapes against a bare ground, the whole devoid of the traditional shading and tonal variations that create the illusion of depth in Western art.

WORKS IN PROGRESS

ost Japanese prints are examples of what is called *ukiyo-e*, or "pictures of the transient world of everyday life." Inspired in the late seventeenth century by a Chinese manual on the art of painting entitled *The Mustard-Seed Garden*, which contained many woodcuts in both color and black and white, *ukiyo-e* prints were commonplace in Japan by the middle of the eighteenth century. Between 1743 and 1765, Japanese artists developed their distinctive method for color printing from multiple blocks.

The subject matter of these prints is usually concerned with the pleasures of contemporary life-hairdos and wardrobes, daily rituals such as bathing, theatrical entertainments, life in the Tokyo brothels, and so on, in endless combination. Utamaro's depiction of The Fickle Type, from his series Ten Physiognomies of Women (Fig. 298), embodies the sensuality of the world that the ukiyo-e print so often reveals. Hokusai's views of the eternal Mount Fuji in The Great Wave Off Kanagawa (see Fig. 244), which we have already studied in connection with their play with questions of scale, were probably conceived as commentaries on the self-indulgence of the genre of ukiyo-e as a whole. The mountain-and, by extension, the values it stood for, the traditional values of the nation itself-is depicted in these works as transcending the fleeting pleasures of daily life.

Traditionally, the creation of a Japanese print was a team effort, and the publisher, the designer (such as Utamaro), the carver, and the printer were all considered essentially equal in the creative process. The head of the project was the publisher, who often conceived of the ideas for the prints, financing individual works or series of works that the public would, in his estimation, be likely to buy. Utamaro's depiction of his studio in a publisher's establishment (Fig. 299) is a *mitate*, or fanciful picture. Each of the workers in the studio is a pretty girl—hence, the print's status as a

mitate-and they are engaged, according to the caption on the print, in "making the famous Edo [present day Tokyo] color prints." Utamaro depicts himself at the right, dressed in women's clothing and holding a finished print. His publisher, also dressed as a woman, looks on from behind his desk. On the left of the triptych is a depiction of workers preparing paper. They are sizing it-that is, brushing the surface with an astringent crystalline substance called alum that reduces the absorbency of the paper so that ink will not run along its fibers-then hanging the sized prints to dry. The paper was traditionally made from the inside of the bark of the mulberry tree mixed with bamboo fiber, and, after sizing, it was kept damp for six hours before printing.

Fig. 298 Kitagawa Utamaro, *The Fickle Type*, from the series *Ten Physiognomies of Women*, c. 1793. Woodcut, 14×9 7/8 in. Art Resource, New York.

Utamaro's STUDIO

Fig. 299 Kitagawa Utamaro, Utamaro's Studio, Eshi . . . dosa-hiki (the three primary steps in producing a print from drawing to glazing), c. 1790. From the series *Edo meibutsu nishiki-e kosaku*, Oban triptych. Ink and color on paper, 24 ³/₄ × 9 ⁵/₈ in. Published by Tsuruya Kiemon. The Art Institute of Chicago. Clarence Buckingham Collection. 1939.2141.
 Photo © 1999. The Art Institute of Chicago. All rights reserved.

In the middle section of the print, the block is actually prepared. In the foreground, a worker sharpens her chisel on a stone. Behind her is a stack of blocks with brush drawings made by Utamaro stuck face down on them with a weak rice-starch dissolved in water. The woman seated at the desk in the middle rubs the back of the drawing to remove several layers of fiber. She then saturates what remains with oil until it becomes transparent. At this point, the original drawing looks as if it were drawn on the block. Next the workers carve the block, and we can see here large white areas being chiseled out of the block by the woman seated in the back. Black-and-white prints of this design are made and then returned to the artist, who indicates the colors for the prints, one color to a sheet. The cutter then carves each sheet on a separate block. The final print is, in essence, an accumulation of the individually colored blocks, requiring a separate printing for each color.

Wood Engraving

By the late nineteenth century, woodcut illustration had reached a level of extraordinary refinement. Illustrators commonly employed a method known as **wood engraving**. Wood engraving is a "white-line" technique in which the fine, narrow grooves cut into the block do not hold ink. The grainy end of a section of wood—comparable to the rough end of a 4×4 —is utilized instead of the smooth side of a board, as it is in woodcut proper. The end grain can be cut in any direction without splintering, and thus extremely delicate modeling can be achieved by means of careful hatching in any direction.

The wood engraving in Figure 300 was copied by a professional wood engraver from an original sketch, executed on the

Fig. 300 Noon-Day Rest in Marble Canyon, from Exploration of the Colorado River of the West by J. W. Powell, 1875.
 Plate 25 opposite page 75. Wood engraving after an original sketch by Thomas Moran, 6 ½ × 4 ⅔ in.
 Courtesy Colorado Historical Society. 978.06/P871eS.

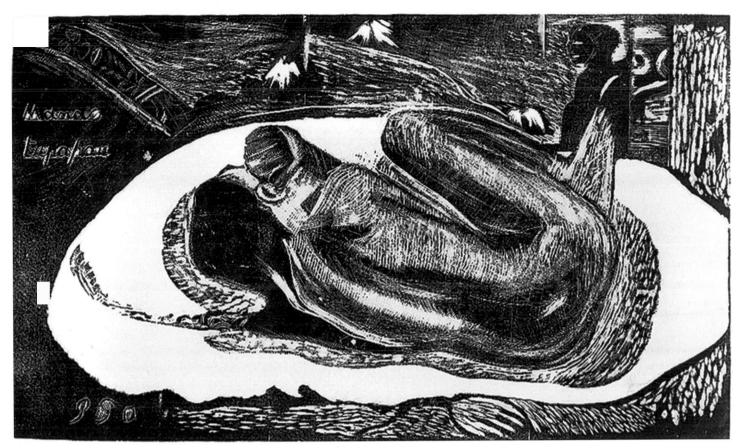

Fig. 301 Paul Gauguin, Watched by the Spirit of the Dead (Manao Tupapau), c. 1891–1893.
 Woodcut, printed in black on endgrain boxwood, composition: 8 1/16 × 14 in. Museum of Modern Art, New York. Lillie P. Bliss Collection.
 Licensed by Scala/Art Resource, New York. Photo © 1999 Museum of Modern Art.

site, by American painter Thomas Moran (his signature mark, in the lower-left corner, is an "M" crossed by a "T" with an arrow pointing downward). It was used to illustrate Captain J. W. Powell's 1875 *Exploration of the Colorado River of the West*, a narrative of the first exploration of the Colorado River canyon from Green River, in Wyoming, to the lower end of the Grand Canyon. The wood engravings of Moran's work—together with a number of paintings executed by him from the same sketches—were America's first views of the great western canyonlands.

The French artist Paul Gauguin detested the detailed effects achievable in wood engraving. He felt they made the print look more like a photograph than a woodcut. He considered his own wood engravings interesting because, he said, they "recall the primitive era."

Gauguin gave up the detailed linear representation achieved by expert cutting, and opted instead to compose with broad, bold, purposely coarse gestures. Whereas in a traditional woodcut the surface of the block would be cut away, leaving black line on a predominantly white surface, Gauguin chose to leave large areas of surface uncut so that they would print in black. In a purposefully unrefined example of the wood engraver's method, he would scratch raggedly across this black surface to reveal form by means of white line on black. Every detail of Gauguin's print, Watched by the Spirit of the Dead (Fig. 301), reveals the presence of the artist at workpoking, gouging, slicing, scraping, and scratching into the block.

Fig. 302 Pablo Picasso, Luncheon on the Grass, after Edouard Manet, 1962. Linoleum cut, one block printed in black, green, red, violet, blue, and yellow; Arches paper, edition: 50; sheet: 24 ³/₈ × 29 ⁵/₈ in; image: 20 ⁷/₈ × 25 ¹/₄ in. Metropolitan Museum of Art, New York. The Mr. and Mrs. Charles Kramer Collection, Gift of Mr. and Mrs. Charles Kramer, 1979. 1979.620.50.

Photo © 1983 The Metropolitan Museum of Art/ © 2003 Estate of Pablo Picasso/Artists Rights Society (ARS), New York.

Linocut

Color can also be added to a print by creating a series of different blocks, one for each different color, each of which is aligned with the others in a process known as registration. In 1959, Picasso, working with linoleum instead of wood, simplified the process. This linocut, as it is called, is made from one linoleum block. After each successive stage of carving is completed, the block is printed. An all-yellow run of the print in Figure 302 was first made from an uncarved block. Picasso then cut into the linoleum, hollowing out the areas that appear yellow on the print so that they would not print again. Then he printed in blue. The blue area was then hollowed out, the plate reprinted again, in violet, and so on, through red, green, and finally black.

INTAGLIO PROCESSES

Relief processes rely on a *raised* surface for printing. With the **intaglio** process, on the other hand, the areas to be printed are *below* the surface of the plate. *Intaglio* is the Italian word for "engraving," and the method itself was derived from engraving techniques practiced by gold-smiths and armorers in the Middle Ages. One of its earliest masters was Albrecht Dürer, himself the son of a goldsmith (see *Works in Progress*, p. 226). In general, intaglio refers to any process in which the cut or incised lines on the plate are filled with ink (Figs. 303 and 304).

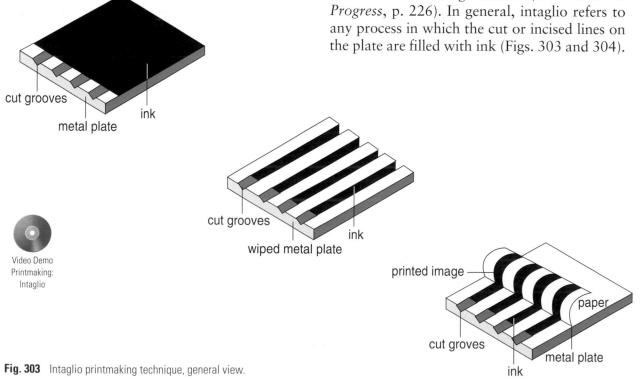

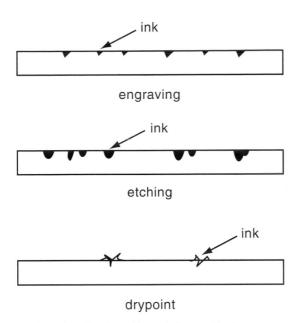

Fig. 304 Intaglio printmaking techniques, side views.

The surface of the plate is wiped clean, and a sheet of dampened paper is pressed into the plate with a very powerful roller so that the paper picks up the ink in the depressed grooves. Since the paper is essentially pushed into the plate in order to be inked, a subtle but detectable elevation of the lines that results is always evident in the final print. Modeling and shading are achieved in the same way as in drawing, by hatching, cross-hatching, and often **stippling**—where, instead of lines, dots are employed in greater and greater density the deeper and darker the shadow.

Engraving

Engraving is accomplished by pushing a small V-shaped metal rod, called a **burin**, across a metal plate, usually of copper or zinc, forcing the metal up in slivers in front of the line. These slivers are then removed from the plate with a hard metal scraper. Depending on the size of the burin used and the force with which it is applied to the plate, the results can range from almost microscopically fine lines to ones so broad and coarse that they can be felt with a fingertip.

Line engravings were commonly used to illustrate books and reproduce works of art in the era before the invention of photography, and for many years after. We know, for instance, Raphael's painting The Judgment of Paris only through Marcantonio Raimondi's engraving after the original (see Fig. 72). Illustrated here is an engraving done on a steel plate (steel was capable of producing many more copies than either copper or zinc) of J. M. W. Turner's painting Snow Storm: Steamboat off a Harbor's Mouth (Fig. 305). The anonymous engraver captures the play of light and dark in the original by using a great variety of lines of differing width, length, and density.

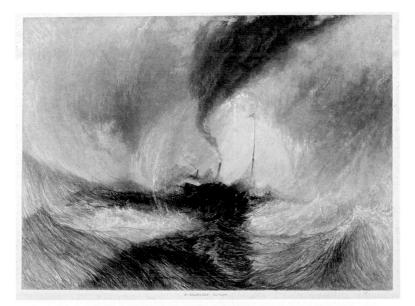

Fig. 305 After J. M. W. Turner, Snow Storm: Steamboat off a Harbor's Mouth (1842), 1891. Engraving on steel. © The Trustees of the British Museum

WORKS IN PROGRESS

O ne of the greatest of the early masters of the intaglio process was Albrecht Dürer. Trained in Nuremberg from 1486 to 1490, he was the godson of Anton Koberger, publisher of *The Nuremberg Chronicle*. As an apprentice in the studio of Michael Wolgemut, who was responsible for many of the major designs in the *Chronicle*, Dürer may, in fact, have carved several of the book's woodcuts. By the end of the century, at any rate, Dürer was recognized as the preeminent woodcut artist of the day, and he had mastered the art of engraving as well.

Dürer's engraving of *Adam and Eve* (Fig. 308) is one of his finest. It is also the first of his works to be "signed" with the artist's characteristic tablet, including his Latinized name and the date of composition, here tied to

a bough of the tree above Adam's right shoulder. Two of Dürer's trial proofs (Figs. 306 and 307) survive, providing us the opportunity to consider the progress of Dürer's print. The artist pulled each of these states, or stages in the process, so that he could consider how well his incised lines would hold ink and transfer it to paper, as well as to see the actual image, since on the plate it is reversed. In the white areas of both states we can see how Dürer outlined his entire composition with lightly incised lines. In the first state, all of the background has been incised, except for the area behind Eve's left shoulder. Adam himself is barely realized. Dürer has only just begun to define his leg with hatching and cross-hatching. In the second state, Adam's entire lower body and the ground around his left foot have been realized. Notice how hatching and cross-hatching create a sense of real volume in Adam's figure.

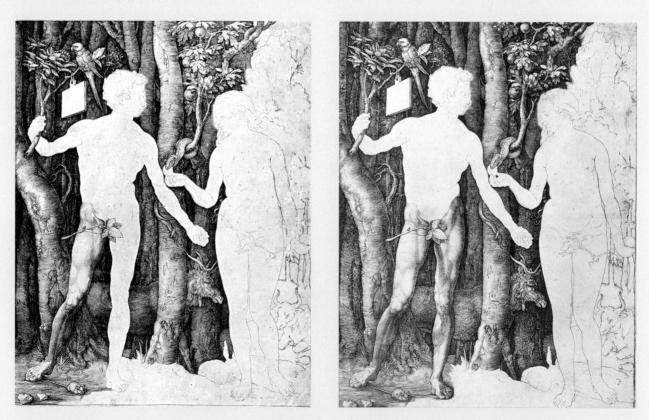

Figs. 306 and 307 Albrecht Dürer, *Adam and Eve*, First State and Second State, 1504. Engravings, each $9\frac{7}{8} \times 7\frac{5}{8}$ in. Graphische Sannlung, Albertina, Wien.

Albrecht Dürer's **ADAM AND EVE**

The print is rich in iconographical meaning. The cat at Eve's feet—a symbol of deceit, and perhaps sexuality as well—suggests not only Eve's feline character but, as it prepares to pounce on the mouse at Adam's feet, Adam's susceptibility to the female's wiles. The parrot perched over the sign is the embodiment of both wisdom and language. It contrasts with the evil snake that Eve is feeding. Spatially, then, the parrot and its attributes are associated with Adam, the snake and its characteristics with Eve. An early sixteenth-century audience would have immediately understood that the four animals on the right were intended to represent the four *humors*, the four bodily fluids thought to make up the human constitution. The elk represents melancholy (black bile), the cat, anger and cruelty (yellow bile), the rabbit, sensuality (blood), and the ox, sluggishness or laziness (phlegm). The engraving technique makes it possible for Dürer to realize this wealth of detail.

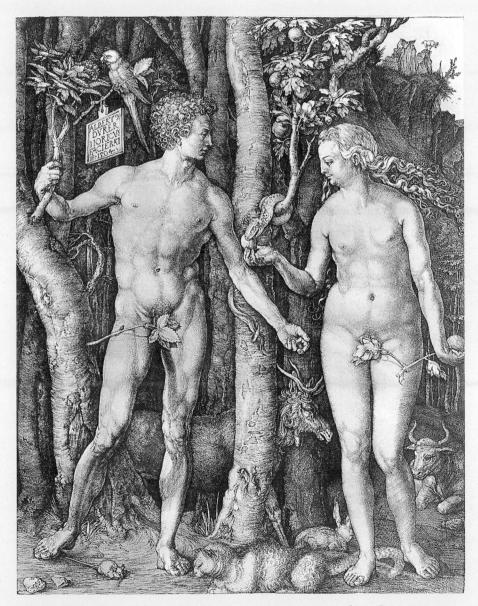

Fig. 308 Albrecht Dürer, *Adam and Eve*, Fourth State, 1504. Engraving, 9 $\frac{7}{10} \times 7$ $\frac{5}{10}$ in. Metropolitan Museum of Art, New York. Fletcher Fund, 1919. 19.73.1.

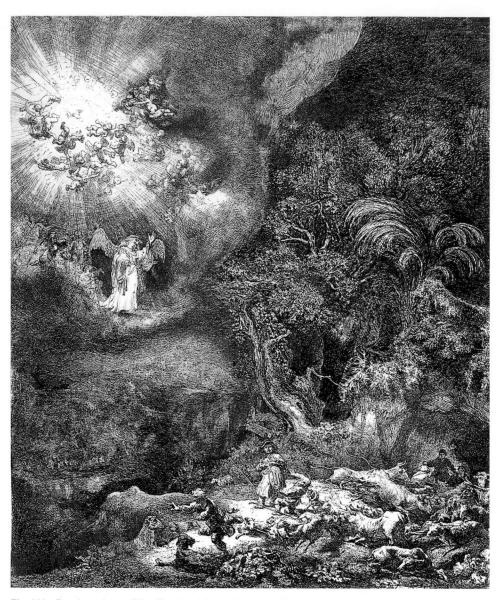

Fig. 309 Rembrandt van Rijn, *The Angel Appearing to the Shepherds*, 1634. Etching, $10 \frac{1}{4} \times 8 \frac{1}{2}$ in. Rijksmuseum, Amsterdam.

Etching

Etching is a much more fluid and free process than engraving and is capable of capturing something of the same sense of immediacy as the sketch. As a result, master draughtsmen, such as Rembrandt, readily took to the medium. It satisfied their love for spontaneity of line. Yet the medium also requires the utmost calculation and planning, an ability to manipulate chemicals that verges, especially in Rembrandt's greatest etchings, on wizardry, and a certain willingness to risk losing everything in order to achieve the desired effect. Creating an etching is a twofold process, consisting of a drawing stage and an etching stage. The metal plate is first coated with an acid-resistant substance called a **ground**, and this ground is drawn upon. If a hard ground is chosen, then an etching needle is required to break through the ground and expose the plate. Hard grounds are employed for finely detailed linear work. Soft grounds, made of tallow or petroleum jelly, can also be utilized, and virtually any tool, including the artist's finger, can be used to expose the plate. The traditional softground technique is often called *crayon* or *pencil manner* because the final product so closely resembles crayon and pencil drawing. In this technique, a thin sheet of paper is placed on top of the ground and is drawn on with a soft pencil or crayon. When the paper is removed, it lifts the ground where the drawing instrument was pressed into the paper.

Whichever kind of ground is employed, the drawn plate is then set in an acid bath, and those areas that have been drawn are eaten into, or etched, by the acid. The undrawn areas of the plate are, of course, unaffected by the acid. The longer the exposed plate is left in the bath, and the stronger the solution, the greater the width and depth of the etched line. The strength of individual lines or areas can be controlled by removing the plate from the bath and stopping out a section by applying a varnish or another coat of ground over the etched surface. The plate is then resubmerged into the bath. The stoppedout lines will be lighter than those that are again exposed to the acid. When the plate is ready for printing, the ground is removed with solvent, and the print is made in the intaglio method.

Rembrandt's The Angel Appearing to the Shepherds (Fig. 309) is one of the most fully realized etchings ever printed, pushing the medium to its very limits. For this print, Rembrandt altered the usual etching process. Fascinated by the play of light and dark, he wanted to create the feeling that the angel, and the light associated with her, was emerging out of the darkness. Normally, in etching, the background is white, since it is unetched and there are no lines on it to hold ink. Here Rembrandt wanted a black background, and he worked first on the darkest areas of the composition, creating an intricately cross-hatched landscape of ever-deepening shadow. Only the white areas bathed in the angel's light remained undrawn. At this point, the plate was placed in acid and bitten as deeply as possible. Finally, the angel and the frightened shepherds in the foreground were worked up in a more traditional manner of etched line on a largely white ground. It is as if, at this crucial moment of the New Testament, when the angel announces the birth of Jesus, Rembrandt reenacts, in his manipulation of light and dark, the opening scenes of the Old Testament-God's pronouncement in Genesis, "Let there be light."

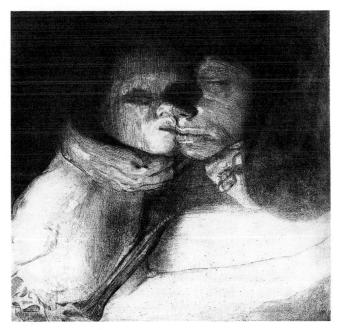

Modern Art/© 2007 Artists Rights Society (ARS), New York/VG Bild-Kunst, Bonn.

The dynamic play between dark and light achieved by Rembrandt would be used to great expressive effect in the work of the German artist Käthe Kollwitz. Kollwitz, renowned for the quality of her graphic work, chose as her artistic subject matter the poor and downtrodden, especially mothers and children. Deliberately avoiding the use of color in her work, she preferred the sense of emotional conflict and opposition that could be realized in black and white.

In 1914, at the beginning of World War I, Kollwitz's son Peter was killed. The drama of the battle between the life-giving mother and the forces of death that we witness in *Death*, *Woman and Child* (Fig. 310) painfully foreshadows her own tragedy. It is hard to say just whose hand is reaching around the child's throat—the mother's or death's. What is clear, however, is that, in the dark and deeply inked shadow created where the mother presses her child's forehead hard against her own face, is expressed a depth of feeling and compassion virtually unsurpassed in the history of art.

Fig. 311 Mary Cassatt, *The Map (The Lesson),* 1890.
 Drypoint, 6 ³/₁₆ × 9 ³/₁₆ in. The Art Institute of Chicago.
 Joseph Brooks Fair Collection. 1933.537.
 Photo © 1999 The Art Institute of Chicago. All rights reserved.

Drypoint

A third form of intaglio printing is known as **drypoint**. The drypoint line is scratched into the copper plate with a metal point that is pulled across the surface, not pushed as in engraving. A ridge of metal, called a **burr**, is pushed up along each side of the line, giving a rich, velvety, soft texture to the print when inked, as is evident in Mary Cassatt's *The Map* (Fig. 311). The softness of line generated by the drypoint process is especially appealing. Because this burr quickly wears off in the printing process, it is rare to find a drypoint edition of more than 25 numbers, and the earliest numbers in the edition are often the finest.

Mezzotint and Aquatint

Two other intaglio techniques should be mentioned—mezzotint and aquatint. Mezzotint is, in effect, a negative process. That is, the plate is first ground all over using a sharp, curved tool called a **rocker**, leaving a burr over the entire surface that, if inked, would result in a solid black print. The surface is then lightened by scraping away the burr to a greater or lesser degree. One of the earliest practitioners of the mezzotint process was Prince Rupert, son of Elizabeth Stuart of the British royal family and Frederick V of Germany, who learned the process from its inventor in 1654. Rupert is credited, in fact, with the invention of the rocking tool used to darken the plate. His *Standard*

Fig. 312 Prince Rupert, The Standard Bearer, 1658. Mezzotint, 11 × 11 ⁷/₈ in. Metropolitan Museum of Art, New York. Harris Brisbane Dick Fund, 1933. 32.52.32.

Bearer (Fig. 312) reveals the deep blacks from which the image has been scraped.

Like mezzotint, **aquatint** relies for its effect not on line but on tonal areas of light and dark. Invented in France in the 1760s, the method involves coating the surface of the plate with a porous ground through which acid can penetrate. Usually consisting of particles of resin or powder, the ground is dusted onto the plate, then set in place by heating it until it melts. The acid bites around each particle into the surface of the plate, creating a sandpaperlike texture. The denser the resin, the lighter the tone of the resulting surface. Line is often added later, usually by means of etching or drypoint.

Jane Dickson's *Stairwell* (Fig. 313) is a pure aquatint, printed in three colors, in which the roughness of the method's surface serves to underscore the emotional turmoil and psychological isolation embodied in her subject matter. "I'm interested," Dickson says, "in the ominous underside of contemporary culture that lurks as an ever present possibility in our lives . . . I aim to portray psychological states that everyone experiences." In looking at this

print, one can almost feel the acid biting into the plate, as if the process itself is a metaphor for the pain and isolation of the figure leaning forlornly over the bannister.

LITHOGRAPHY

Lithography—meaning, literally, "stone writing"—is the chief planographic printmaking process, meaning that the printing surface is flat. There is no raised or depressed surface on the plate to hold ink. Rather, the method depends on the fact that grease and water don't mix.

The process was discovered accidentally by a young German playwright named Alois Senefelder in the 1790s in Munich. Unsuccessful in his occupation, Senefelder was determined to

Fig. 313 Jane Dickson, Stairwell, 1984.

Aquatint on Rives BFK paper, $35 \frac{3}{4} \times 22 \frac{3}{4}$ in. Mount Holyoke College Art Museum, South Hadley, Massachusetts. The Henry Rox Memorial Fund for the Acquisition of Works by Contemporary Women Artists.

reduce the cost of publishing his plays by writing them backwards on a copper plate in a wax and soap ground and then etching the text. But with only one good piece of copper to his name, he knew he needed to practice writing backwards on less expensive material, and he chose a smooth piece of Kelheim limestone, the material used to line the Munich streets and abundantly available. As he was practicing one day, his laundry woman arrived to pick up his clothes and, with no paper or ink on the premises, he jotted down what she had taken on the prepared limestone slab. It dawned on him to bathe the stone with nitric acid and water, and when he did so, he found that the acid had etched the stone and left his writing raised in relief above its surface.

Recognizing the commercial potential of his invention, he abandoned playwrighting to perfect the process. By 1798, he had discovered that if he drew directly on the stone with a greasy crayon, and then treated the entire stone with nitric acid, water, and gum arabic (a very tough substance obtained from the acacia tree that attracts and holds water), then ink would stick to the grease drawing but not to the treated and dampened stone. He also discovered that the acid and gum arabic solution did not actually *etch* the limestone. As a result, the same stone could be used again and again. The essential processes of lithography had been invented.

Possibly because it is so direct a process, actually a kind of drawing on stone, lithography has been the favorite printmaking medium of nineteenth- and twentieth-century artists. The Fig. 314 Edouard Manet (French, 1832–1883), *"The Races (Les Courses),"* 1865. Lithograph, (Harris 1970 41. only) Rosenwald Collection, © 1999 Board of Trustees, National Gallery of Art, Washington, D.C. 1943.3.9084 (B-11151). Photo by Dean Beasom. © 2007 ARS Artists Rights Society, NY

Printmaking; Lithography

gestural freedom it offers the artist, the sense of spontaneity and immediacy that can be captured in its line, is readily apparent in Edouard Manet's *The Races* (Fig. 314). More than a simple sketch of the event, the print is almost abstract, a whirl of motion and line that captures the furious pace of the race itself.

In the hands of Honoré Daumier, who turned to lithography to depict actual current events, the feeling of immediacy that the lithograph could inspire was most fully realized. From the early 1830s until his death in 1872, Daumier was employed by the French press as an illustrator and political caricaturist. Recognized as the greatest lithographer of his day, Daumier did some of his finest work in the 1830s for the monthly publication L'Association Mensuelle, each issue of which contained an original lithograph. His famous print Rue Transnonain (Fig. 315) is direct reportage of the outrages committed by government troops during an insurrection in the Parisian workers' quarters. He illustrates what happened in a building at 12 rue Transnonain on the night of April 15, 1834, when police, responding to a sniper's bullet that had killed one of their number and had appeared to originate from the building, revenged their colleague's death by slaughtering everyone inside. The father of a family, who had evidently been sleeping, lies dead by his bed, his child crushed beneath him, his dead wife to his right and an elder parent to his left. The foreshortening of the scene draws us into the lithograph's visual space, making the horror of the scene all the more real.

While lithography flourished as a medium throughout the twentieth century, it has enjoyed a marked increase in popularity since the late 1950s. In 1957 Tatyana Grosman established Universal Limited Art Editions (ULAE) in West Islip, New York. Three years later, June Wayne founded the Tamarind Lithography Workshop in Los Angeles with a grant from the Ford Foundation (see Works in Progress, p. 234, for examples of Wayne's own lithography). While Grosman's primary motivation was to make available to the best artists a quality printmaking environment, one of Wayne's main purposes was to train the printers themselves. Due to her influence, workshops sprang up across the country, including Gemini G.E.L. in Los Angeles, Tyler Graphics in Mount Kisco, New York, Landfall Press in Chicago, Cirrus Editions in Los Angeles, and Derrière l'Etoile in New York City. In 1987, an exhibition of prints by women artists that was inspired by Nancy Campbell's founding of the Mount Holyoke College Printmaking Workshop in 1984 was held at the Mount Holyoke College Art Museum. Elaine de Kooning was the first resident artist at this workshop, and the series of prints she created there, one of which is reproduced here (Fig. 316), was inspired by the prehistoric cave drawings at Lascaux, France (see Chapter 18, "The Ancient World").

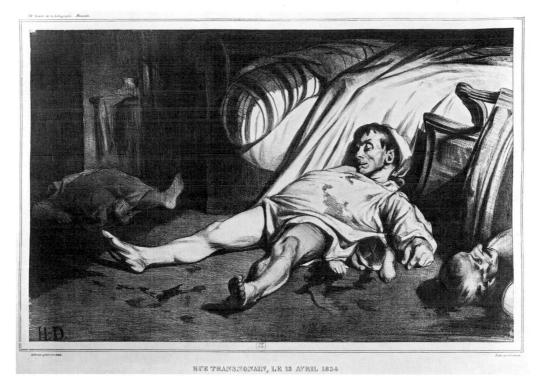

Fig. 315 Daumier, Honoré (1808–1879). "Rue Transnonain, 15 Avril 1834. A murdered family".
 28.5 × 44.1 cm. Inv. A 1970–67. Kupferstichkabinet, Staatliche Kunstsammlungen, Dresden, Germany Erich Lessing/Art Resource, NY

Fig. 316 Elaine de Kooning, Lascaux #4, 1984.

Lithograph on Arches paper, sheet: 15 \times 21 in. Mount Holyoke College Art Museum, South Hadley, Massachusetts. Gift of the Mount Holyoke College Printmaking Workshop. Printed by John Hutcheson at Mount Holyoke College.

WORKS IN PROGRESS

ne of the great innovators of the lithographic process in last 50 years has been the June Wayne, founder of the Tamarind Lithography Workshop. She founded the workshop because lithography was, in 1960, on the verge of extinction, like "the great white whooping crane," she says. "In all the world there were only 36 cranes left, and in the United States there were no master printers able to work with the creative spectrum of our artists. The artist-lithographers, like the cranes, needed a protected environment and a concerned public so that, once rescued from extinction, they could make a go of it on their own." By 1970, Wayne felt that lithography had been saved, and she arranged for Tamarind to move to the University of New Mexico, where it remains, training master printers and bringing artists to Albuquerque to work with them.

Fig. 317June Wayne, Stellar Roil, Stellar Winds 5, 1978.Lithograph, image: 11 × 9 ¼ in.; paper: 18 ¾ × 14 ¾ in.© June Wayne/Licensed by VAGA, New York. Courtesy of the artist.

Wayne still lives and works in the original Tamarind Avenue studio in Los Angeles. "Every day," she says, "I push lithography and it reveals something new." With Edward Hamilton, who was trained at Tamarind and who was her personal printer for 14 years, beginning in 1974, Wayne has continually discovered new processes. She is inspired by the energy made visible in Leonardo da Vinci's Deluge drawings (see Fig. 264), and she is equally inspired by modern science and space exploration-in her own words, by "the ineffably beautiful but hostile wilderness of astrophysical space." She regularly visits the observatory at Mount Palomar above Los Angeles, she is acquainted with leading physicists and astronauts, and she routinely reviews the images returned to earth by unmanned space probes. In 1975, experimenting with zinc plates and liquid tusche, she discovered that the two oxidized when combined and that the resultant textures created patterns reminiscent of skin, clusters of nebulae, magnetic fields, solar flares, or astral winds. In prints such as Stellar Roil (Fig. 317) and Wind Veil (Fig. 318), she felt that she was harnessing in the lithographic process the same primordial energies that drive the universe.

A long-time feminist, who sponsored the famous "Joan of Art" seminars in the 1970s, designed to help women understand their professional possibilities, Wayne has turned her attention, in her 1996 print Knockout (Fig. 319), to a scientific discovery with implications about sexual politics. In November 1995, The New York Times reported that scientists had discovered that a brain chemical, nitric oxide, which plays a significant role in human strokes, also controls aggressive and sexual behavior in male mice. Experiments in mice had indicated that by blocking the enzyme responsible for producing nitric oxide, incidence of stroke can be reduced by 70 percent. But in the course of experiments on so-called "knockout" mice, from whom the gene responsible for the enzyme had been genetically eliminated, scien-

June Wayne's KNOCKOUT

tists found that the male mice would fight until the dominant one in any cage would kill the others. Furthermore, paired with females, the male mice were violently ardent. "They would keep trying to mount the female no matter how much she screamed," according to the *Times*. It would appear, then, that nitric oxide curbs aggressive and sexual appetites, and it also appears that this function is sex-specific. Female mice lacking the same gene show no significant change in behavior.

It is, of course, dangerous to extrapolate human behavior from the behavior of rodents, but from a feminist point of view, the implications of this discovery are enormous. The study suggests that male violence may in fact be genetically coded. *Knockout* is, in this sense, a feminist print, and Wayne's choice of a printer underscores this—Judith Solodkin of Solo Impression, Inc. in New York, the first woman trained at Tamarind to become a master printer.

Knockout is an explosion of light, its deep black inks accentuating the whiteness of the paper, the shattered white bands piercing the darkness like screams of horror. At the bot-

Fig. 318 June Wayne, Wind Veil, Stellar Winds 3, 1978. Lithograph, image: 11 ⅓ × 9 ⅔ in.; paper: 18⅔ × 14⅔ in. © June Wayne/Licensed by VAGA, New York. Courtesy of the artist.

tom, three crouching spectators look on as a giant mouse, perhaps a product of genetic engineering, attacks a human victim.

Fig. 319 June Wayne, Knockout, 1996. Lithograph, image: 28 ¼ × 35 ¾ in.; paper: bleed. © June Wayne/Licensed by VAGA, New York. Courtesy of the artist.

Fig. 320 Robert Rauschenberg, Accident, 1963. Lithograph on paper, 41 × 29 in. Collection of The Corcoran Gallery of Art. Gift of the Women's Committee. © Robert Rauschenberg/Licensed by VAGA, New York.

The medium of lithography allows de Kooning to use to best advantage the broad painterly gesture that she developed as an Abstract Expressionist painter in the 1950s and 1960s. In these prints she develops a remarkable tension between what might be called "the present tense" of her gesture, the sense that we can feel the very motion of her hand, and the "past tense" of her chosen image, the timelessness and permanence of the drawings at Lascaux.

Robert Rauschenberg's *Accident* (Fig. 320), printed at Universal Limited Art Editions in 1963, represents the spirit of innovation and experiment found in so much contemporary printmaking. At first, Rauschenberg, a postabstract expressionist painter who included everyday materials and objects in his canvases, was reluctant to undertake printmaking. "Drawing on rocks," as he put it, seemed to him archaic. But Grosman was insistent that he try his hand at making lithographs at her West Islip studio. "Tatyana called me so often that I figured the only way I could stop her was to go out there," Rauschenberg says. He experimented with pressing all manner of materials down on the stone in order to see if they contained enough natural oil to leave an imprint that would hold ink. He dipped zinc cuts of old newspaper photos in **tusche**—a greasing liquid, which also comes in a hardened, crayonlike form, made of wax, tallow, soap, shellac, and lampblack, and which is the best material for drawing on a lithographic stone. *Accident* was created with these tusche-dipped zinc cuts.

As the first printing began, the stone broke under the press, and Rauschenberg was forced to prepare a new version of the piece on a second stone. Only a few proofs of this second state had been pulled when it, too, broke, an almost unprecedented series of catastrophes. It turned out that a small piece of cardboard lodged under the press's roller was causing uneven pressure to be applied to the stones. Rauschenberg was undaunted. He dipped the broken chips of the second stone in tusche, set the two large pieces back on the press, and lay the chips beneath them. Then, with great difficulty, his printer, Robert Blackburn, printed the edition of 29 plus artist's proofs. *Accident* was awarded the grand prize at the Fifth International Print Exhibition in Ljubljana, Yugoslavia, in 1963. Says Grosman: "Bob is always bringing something new, some new discovery" to the printmaking process.

SILKSCREEN PRINTING

Silkscreens are more formally known as serigraphs, from the Greek graphos, "to write," and the Latin seri, "silk." Unlike other printmaking media, no expensive, heavy machinery is needed to make a serigraph, though, as in the case of printing Lorna Simpson's The Park (see Fig. 24), elaborate serigraphy studios such as Jean Noblet's in New York do exist. The principles used are essentially the same as those required for stenciling, where a shape is cut out of a piece of material and that shape is reproduced over and over on other surfaces by spreading ink or paint over the cutout. In serigraphy proper, shapes are not actually cut out. Rather, the fabric-silk, or more commonly today, nylon and polyesteris stretched tightly on a frame, and a stencil is made by painting a substance such as glue across the fabric in the areas where the artist does not want ink to pass through to the paper. Alternately, special films can be cut out and stuck to the fabric, or tusche can be utilized. This last method allows the artist a freedom of drawing that is close to the lithographic process. The areas that are left uncovered are those that will print. Silkscreen inks are very thick, so that they will not run beneath the edge of the cutout, and must be pushed through the open areas of the fabric with the blade of a tool called a squeegee.

Serigraphy is the newest form of printmaking, though related stencil techniques were employed in textile printing in China and Japan as early as 550 CE. Until the 1960s, serigraphy

 Fig. 321 Claes Oldenburg, Design for a Colossal Clothespin Compared to Brancusi's Kiss, 1972.
 Silkscreen, 21 1/2 × 13 7/8 in. Philadelphia Museum of Art. From the Friends of the Philadelphia Museum of Art.

was used primarily in commercial printing, especially by the advertising industry. In fact, the word "serigraphy" was coined in 1935 by the curator of the Philadelphia Museum of Fine Arts in order to differentiate the work of artists using the silkscreen in creative ways from that of their commercially oriented counterparts.

In the 1960s, serigraphy became an especially popular medium for **Pop artists**. Claes Oldenburg's *Design for a Colossal Clothespin Compared to Brancusi's Kiss* (Fig. 321) takes advantage of the fact that photographs can be transferred directly to the screen. The print compares his own giant clothespin to Brancusi's famous sculpture *The Kiss*, not merely to underscore their formal similarity—and it is striking—but, with tongue in cheek, to lend his own design the status of Brancusi's modern masterpiece. The print not only celebrates, with intentional irony, the commonplace and our culture's ability to monumentalize virtually anything, but also makes fun of art criticism's tendency to regard art in formal terms alone, the logic that might lead one to see the Brancusi and the clothespin in the same light.

MONOTYPES

There is one last kind of printmaking for us to consider, one that has much in common with painting and drawing. However, **monotypes** are generally classified as a kind of printmaking because they utilize both a plate and a press in the making of the image. Unlike other prints, however, a monotype is a unique image. Once it is printed, it can never be printed again.

In monotypes, the artist forms an image on a plate with printer's ink or paints, and the image is transferred to paper under pressure, usually by means of an etching press. Part of the difficulty and challenge of the process is that if a top layer of paint is applied over a bottom layer of paint on the plate, when printed, the original bottom layer will be the top layer and vice versa. Thus the foreground elements of a composition must be painted first on the plate, and the background elements over them. The process requires considerable planning.

Native American artist Fritz Scholder is a master of the medium. Scholder often works in series. Whenever he lifts a full impression of an image, a "ghost" of the original remains on the plate. He then reworks that ghost, revising and renewing it to make a new image. Since each print is itself a surprise—the artist never knows until the image is printed just what the work will look like—and since each print leaves a "ghost" that will spur him to new discoveries, the process is one of perpetual discovery and renewal. His *Dream Horse* monotypes, of which Figure 322 is an exam-

Fig. 322 Fritz Scholder, Dream Horse G, 1986. Monotype, 30 × 22 in. Courtesy of the artist. ple, are symbolic of this process. The artist figuratively "rides" the horse, and its image, on his continuing imaginative journey.

Scholder's process is, in another sense, a summation of the possibilities of printmaking as a whole. As new techniques have been invented—from the relief processes to those of intaglio, to lithography, silkscreen printing, and the monotype—the artist's imagination has been freed to discover new means of representation and expression. The variety of visual effects achievable in printmaking is virtually unlimited.

THE CRITICAL PROCESS Thinking about Printmaking

L ike Claes Oldenburg, Andy Warhol is a Pop L artist who recognized in silkscreen printing possibilities not only for making images but for commenting on American culture in general. In his many silkscreen images of Marilyn Monroe, almost all made within three or four years of her death in 1962, he depicted her in garish, conflicting colors (Fig. 323). Twenty years later, he created a series of silkscreen prints, commissioned by New York art dealer Ronald Feldman, of endangered species. What do the Marilyn silkscreens and the images like Silverspot (Fig. 324) from the endangered species series have in common? Think of Marilyn as both a person and a Hollywood image. What does it mean to be an "image"? How, in the case of the endangered species, might existing as an "image" be more useful than not? Consider the quality of color in both silkscreens. How does color affect the meaning of both works? Why do you think that Warhol resorts to such garish, bright coloration? Finally, how do both images suggest that Warhol was something of a social critic intent on challenging the values of mainstream America?

Fig. 323 Andy Warhol (American 1928–1987), "Marilyn Monroe". Serigraph. 1967. 37 ½ × 37 ½ in. Robert Gale Doyon Fund and Harold F. Bishop Fund purchase. Chazen Museum of Art, University of Wisconsin–Madison. © 2005 Andy Warhol Foundation for the Visual Arts/Artists Rights Society (ARS), New York ™ 2002 Marilyn Monroe LLC under license authorized by CMG Worldwide Inc., Indianapolls, Indiana 46256 USA www.MarilynMonroe.com

Fig. 324 Andy Warhol, *San Francisco Silverspot*, from the *Endangered Species* series, 1983. Screenprint, 38 × 38 in.

Courtesy Ronald Feldman Fine Arts, New York. Photo: Dr. James Dee. © 2007 The Andy Warhol Foundation for the Visual Arts, Inc./Artists Rights Society (ARS). New York.

Painting

____ arly in the fifteenth century, a figure known as

ENCAUSTIC

FRESCO

Works in Progress Michelangelo's *Libyan Sybil*

TEMPERA

OIL PAINTING

■ Works in Progress Milton Resnick's *U* + *Me*

WATERCOLOR

GOUACHE

SYNTHETIC MEDIA

MIXED MEDIA

■ Works in Progress Hannah Höch's *Cut with the Kitchen Knife*

> The Critical Process Thinking about Painting

- La Pittura—literally, "the picture"—began to appear in Italian art (Fig. 325). As art historian Mary D. Garrard has noted, the emergence of the figure of La Pittura, the personification of painting, could be said to announce the cultural arrival of painting as an art. In the Middle Ages, painting was never included among the liberal arts-those areas of knowledge that were thought to develop general intellectual capacity-which included rhetoric, arithmetic, geometry, astrology, and music. While the liberal arts were understood to involve inspiration and creative invention, painting was considered merely a mechanical skill, involving, at most, the ability to copy. The emergence of La Pittura announced that painting was finally something more than mere copywork, that it was an intellectual pursuit equal to the other liberal arts, all of which had been given similar personification early in the Middle Ages.

Fig. 325 Giorgio Vasari, *The Art of Painting*, 1542. Fresco of the vault of the Main Room, Arezzo, Casa Vasari. Canali Photobank, Capriolo, Italy.

In her Self-Portrait as the Allegory of Painting (Fig. 326), Artemisia Gentileschi presents herself as both a real person and as the personification of La Pittura. Iconographically speaking, Gentileschi may be recognized as La Pittura by virtue of the pendant around her neck that symbolizes imitation. And, Gentileschi can imitate the appearance of things very wellshe presents us with a portrait of herself as she really looks. Still, in Renaissance terms, imitation means more than simply copying appearances: It is the representation of nature as seen by and through the artist's imagination. On the one hand, Gentileschi's multicolored garment alludes to her craft and skill as a copyist-she can imitate the effects of color-but on the other hand, her unruly hair stands for the imaginative frenzy of the artist's temperament. Thus, in this painting, she portrays herself both as a real woman and as an idealized personification of artistic genius, possessing all the intellectual authority and dignity of a Leonardo or a Michelangelo. Though in her time it was commonplace to think of women as intellectually inferior to men-"women have long dresses and short intellects" was a popular saying-here

Fig. 326 Artemisia Gentileschi, Self-Portrait as the Allegory of Painting, 1630.
Oil on canvas, 35 ¹/₄ × 29 in. The Royal Collection.
© 2007 Her Majesty Queen Elizabeth II. Photo: C. Cooper Ltd.

Gentileschi transforms painting from mere copywork, and, in the process, transforms her own possibilities as a creative person.

Nevertheless, from the earliest times, one of the major concerns of Western painting has been representing the appearance of things in the natural world. There is a famous story told by the historian Pliny about a contest between the Greek painters Parrhasius and Zeuxis as to who could make the most realistic image:

Zeuxis produced a picture of grapes so dexterously represented that birds began to fly down to eat from the painted vine. Whereupon Parrhasius designed so lifelike a picture of a curtain that Zeuxis, proud of the verdict of the birds, requested that the curtain should now be drawn back and the picture displayed. When he realized his mistake, with a modesty that did him honor, he yielded up the palm, saying that whereas he had managed to deceive only birds, Parrhasius had deceived an artist.

Fig. 327 Cimabue, *Madonna Enthroned*, c. 1280. Tempera on panel, 12 ft. 7 ¹/₂ in. × 7 ft. 4 in. Galleria degli Uffizi, Florence. Cimabue (Cenni di Pepi)/Index Ricerca Iconografica

This tradition, which views the painter's task as rivaling the truth of nature, has survived to the present day.

In the late Middle Ages, Dante wrote in the Purgatory section of his *Divine Comedy* about the painters Cimabue and Giotto: "Once, Cimabue was thought to hold the field/In painting; now it is Giotto's turn." If we compare altarpieces by both artists (Figs. 327 and 328), Giotto's painted just 30 years after Cimabue's, we can readily see that Giotto's is the more "realistic." However, this is not the realism to which we have since grown accustomed in, for instance, photography. For one thing, Giotto's Madonna and Child are far larger than the angels, raising all sorts of problems of scale. To early Renaissance eyes, however, Giotto's painting was a significant "advance" over the work of Cimabue. It is possible, for instance, to feel the volume of the Madonna's knee in Giotto's altarpiece, to sense actual bodies beneath the draperies that clothe his models. The neck of Cimabue's Madonna is a flat surface, while the neck of Giotto's Madonna is modeled and curves round beneath her cape. Cimabue's Madonna is chinless, her nose almost rendered in profile; the face of Giotto's Virgin is far more sculptural, as if real bones lie beneath her skin.

By this measure, the more faithful to nature a painting is, the more accurately it represents the real world, the greater is its aesthetic value. However, there are many types and styles of painting for which truth to nature is not of paramount importance. Think of modern abstract art. Even during the Renaissance, the concept of imitation, or **mimesis**, involved the creation of representations that transcended mere appearance, that implied the sacred or spiritual essence of things. This is the truth Gentileschi sought to reveal.

In other words, painting, even when it is fully representational, can outstrip physical reality and leave it behind. It need not simply point at what it represents. Painting can suggest at least as much, and probably more, than it portrays. Another way to say this is that painting can be understood in terms of its connotation as well as its denotation. What a painting denotes is clearly before us: Both Cimabue and Giotto have painted a Madonna and Child surrounded by angels. But what these paintings connote is something else. To a thirteenth- or fourteenth-century Italian audience, both altarpieces would have been understood as depicting the ideal of love that lies between mother and childand, by extension, the greater love of God for mankind. The meaning, then, of these altarpieces exists on many levels. And although the relative realism of Giotto's painting is what secures its place in art history, its *didactic* function—that is, its ability to teach, to elevate the mind, in this case, to the contemplation of salvation-was at least as important to its original audience. Its truth to nature was, in fact, probably inspired by

Giotto's desire to make an image with which its audience could readily identify.

In this chapter, we will consider the art of painting. We will pay particular attention to how its various media developed in response to artists' desires to imitate reality and express themselves more fluently. But before we begin our discussion of these various painting media, we should be familiar with a number of terms that all the media share and that are crucial to understanding how paintings are made.

From prehistoric times to the present day, the painting process has remained basically the same. As in drawing, artists use pigments, or powdered colors, suspended in a medium or binder that holds the particles of pigment together. The binder protects the pigment from changes and serves as an adhesive to anchor the pigment to the support, or the surface on which the artist paintsa wall, a panel of wood, a sheet of paper, or a canvas. Different binders have different characteristics. Some dry more quickly than others. Some create an almost transparent paint, while others are opaque—that is, they cannot be seen through. The same pigment used in different binders will look different because of the varying degrees of each binder's transparency.

Since most supports are too absorbent to allow the easy application of paint, artists often *prime* (pre-treat) a support with a paintlike material called a **ground**. Grounds also make the support surface smoother or more uniform in texture. Many grounds, especially white grounds, increase the brightness of the final picture.

Finally, artists use a solvent or vehicle, a thinner that enables the paint to flow more readily and that also cleans brushes. All waterbased paints use water for a vehicle. Other types of paints require a different thinner turpentine in the case of oil-based paint.

Each painting medium has unique characteristics and has flourished at particular historical moments. Though many media have been largely abandoned as new media have been discovered—media that allow the artist to create a more believable image or that are simply easier to use—almost all media continue to be used to some extent, and older

Fig. 328 Giotto, Madonna and Child Enthroned, c. 1310. Tempera on panel, 10 ft. 8 in. × 6 ft. 8 ¼ in. Galleria degli Uffizi, Florence.

media, such as encaustic and fresco, sometimes find fresh uses in the hands of contemporary artists.

ENCAUSTIC

Encaustic, made by combining pigment with a binder of hot wax, is one of the oldest painting media. It was widely used in Classical Greece, most famously by Polygnotus, but very few paintings from that period survive. (The contest between Zeuxis and Parrhasius was probably conducted in encaustic.) The Hellenistic Greeks used it as well.

Most of the surviving encaustic paintings come from Faiyum in Egypt, which, in the second century CE, was a thriving Roman province about 60 miles south of present-day Cairo. The Faiyum paintings are funeral portraits, which were attached to the mummy

Fig. 329 Mummy Portrait of a Man, Faiyum, Egypt, c. 160–170 cE. Encaustic on wood, 14 × 18 in. Albright-Knox Art Gallery, Buffalo, New York, Charles Clifton Fund, 1938

cases of the deceased, and they are the only indication we have of the painting techniques used by the Greeks. A transplanted Greek artist may, in fact, have been responsible for *Mummy Portrait of a Man* (Fig. 329), though we cannot be sure.

What is clear, though, is the artist's remarkable skill with the brush. The encaustic medium is a demanding one, requiring the painter to work quickly so that the wax will stay liquid. Looking at *Mummy Portrait of a Man*, we notice that while the neck and shoulders have been rendered with simplified forms, which gives them a sense of strength that is almost tangible, the face has been painted in a very naturalistic and sensitive way. The wide, expressive eyes and the delicate modeling of the cheeks make us feel that we are looking at a "real" person, which was clearly the artist's intention. The extraordinary luminosity of the encaustic medium has led to its revival in recent years. Of all contemporary artists working in the medium, no one has perfected its use more than Jasper Johns, whose encaustic *Three Flags* (see Fig. 13) we saw in Chapter 1.

FRESCO

Wall painting was practiced by the ancient Egyptians, Greeks, and Romans, as well as by Italian painters of the Renaissance. The preferred medium was **fresco**, in which pigment is mixed with limewater (a solution containing calcium hydroxide, or slaked lime) and then applied to a lime plaster wall that is either still wet or hardened and dry. If the paint is applied to a wet wall, the process is called *buon fresco* (Italian for "good" or "true fresco"), and if it is applied to a dry wall, it is called *fresco secco*,

Fig. 330 Still Life with Eggs and Thrushes, Villa of Julia Felix, Pompeii, before 79 CE. Fresco, 35 × 48 in. National Museum, Naples. Scala/Art Besource, New York

or "dry fresco." In buon fresco, the wet plaster absorbs the wet pigment, and the painting literally becomes part of the wall. The artist must work quickly, plastering only as much wall as can be painted before the plaster dries, but the advantage of the process is that it is extremely durable. In fresco secco, on the other hand, the pigment is combined with binders such as egg volk, oil, or wax and applied separately, at virtually any pace the artist desires. As a result, the artist can render an object with extraordinary care and meticulousness. The disadvantage of the fresco secco technique is that moisture can creep in between the plaster and the paint, causing the paint to flake off the wall. This is what happened to Leonardo da Vinci's Last Supper in Milan (see Fig. 133), which has peeled away to such a tragic degree that the image has almost disappeared, though it is today being carefully restored.

In the eightcenth century, many frescoes were discovered at Pompeii and nearby Herculaneum, where they had been buried under volcanic ash since the eruption of Mt. Vesuvius in 79 CE. A series of still-life paintings was unearthed in 1755–1757 that proved so popular in France that they led to the renewed popularity of the still-life genre. This *Still Life with Eggs and Thrushes* (Fig. 330), from the Villa of Julia Felix, is particularly notable, especially the realism of the dish of eggs, which seems to hang over the edge of the painting and push forward into our space. The fact that all the objects in the still life have been painted lifesize adds to the work's sense of realism.

This goal of creating the illusion of reality dominates fresco painting from the early Renaissance in the fourteenth century through the Baroque period of the late seventeenth century. It is as if painting at the scale of the wall invites, even demands, the creation of "real" space. In one of the great sets of frescoes of the early Renaissance, painted by Giotto in the Arena Chapel in Padua, Italy, this realist impulse is especially apparent.

The Arena Chapel was specially designed, possibly by Giotto himself, to house frescoes, and it contains 38 individual scenes that tell the stories of the lives of the Virgin and Christ. In the Lamentation (Fig. 331), the two crouching figures with their backs to us extend into our space in a manner similar to the bowl of eggs in the Roman fresco. Here, the result is to involve us in the sorrow of the scene. As the hand of the leftmost figure cradles Christ's head, it is almost as if the hand were our own. One of the more remarkable aspects of this fresco. however, is the placement of its focal point-Christ's face-in the lower-left-hand corner of the composition, at the base of the diagonal formed by the stone ledge. Just as the angels in the sky seem to be plummeting toward the fallen Christ, the tall figure on the right leans forward in a sweeping gesture of grief that mimics the angels' descending flight.

The fresco artists' interest in illusionism culminated in Michelangelo's frescoes for the Sistine Chapel (see Works in Progress, p. 248) and in the Baroque ceiling designs of the late seventeenth century. Among the most remarkable of these is The Glorification of Saint Ignatius (Fig. 332), which Fra Andrea Pozzo painted for the church of Sant' Ignazio in Rome. Standing in the nave, or central portion of the church, and looking upward, the congregation had the illusion that the roof of the church had been removed, revealing the glories of Heaven. A master of perspective, about which he wrote an influential treatise, Pozzo realized his effects by extending the architecture in paint one story above the actual windows in the vault. Saint Ignatius, the founder of the Jesuit order, is shown being transported on a cloud toward the waiting Christ. The foreshortening of the many figures, becoming ever smaller in size as they rise toward the center of the ceiling, greatly adds to the realistic, yet awe-inspiring, effect.

Fig. 331 Giotto, Lamentation, c. 1305. Fresco, approx. 70 × 78 in. Arena Chapel, Padua, Italy. Chapel, Padua/Canali Photobank

Fig. 332 Fra Andrea Pozzo, *The Glorification of Saint Ignatius*, 1691–1694. Ceiling fresco. Nave of Sant' Ignazio, Rome. Scala/Art Resource, New York.

WORKS IN PROGRESS

n May 10, 1506, Michelangelo received an advance payment from Pope Julius II to undertake the task of frescoing the ceiling of the Sistine Chapel at the Vatican in Rome. By the end of July, a scaffolding had been erected. By September 1508, Michelangelo was painting, and for the next four and one-half years, he worked almost without interruption on the project.

According to Michelangelo's later recounting of events, Julius had originally envisioned a design in which the central part of the ceiling would be filled with "ornaments according to custom" (apparently a field of geometric ornaments) surrounded by the 12 apostles in the 12 spandrels. Michelangelo protested, assuring Julius that it would be "a poor design" since the apostles were themselves "poor too." Apparently convinced, the pope then freed Michelangelo to paint anything he liked. Instead of the apostles, Michelangelo created a scheme of 12 Old Testament prophets alternating with 12 sibyls, or women of classical antiquity said to possess prophetic powers. The center of the ceiling would be filled with nine scenes from Genesis.

As the scaffolding was erected, specially designed by the artist so that he could walk around and paint from a standing position, Michelangelo set to work preparing hundreds of drawings for the ceiling. These drawings were then transferred to full-size cartoons, which would be laid up against the moist surface of the fresco as it was prepared, their outlines traced through with a stylus. None of these cartoons, and surprisingly few of Michelangelo's drawings, have survived.

One of the greatest, and most revealing, of the surviving drawings is a study for *The Libyan Sibyl* (Fig. 333). Each of the sibyls holds a book of prophecy—though not Christian figures, they prophesy the revelation of the New Testament in the events of the Old Testament that they surround. *The Libyan Sibyl* (Fig. 334) is the last sibyl that Michelangelo would paint. She is positioned next to the *Separation of Light from Darkness*, the last of the central panels, which is directly over the altarpiece. The Libyan Sibyl herself turns to close her book and place it on the desk behind her. Even as she does so, she steps down from her throne, creating a stunning opposition of directional forces, an exaggerated, almost spiral *contrapposto*. She abandons her book of prophecy as she turns to participate in the celebration of the Eucharist on the altar below.

The severity of this downward twisting motion obviously came late in Michelangelo's work on the figure. In the drawing, the sibyl's hands are balanced evenly, across an almost horizontal plane. But the idea of dropping the

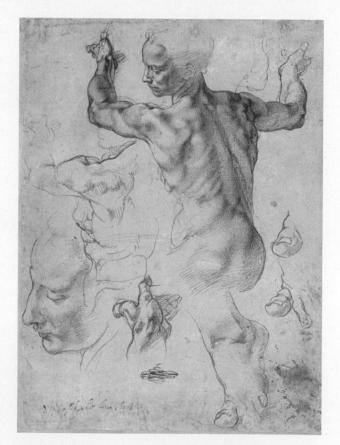

Fig. 333 Michelangelo Buonarroti, Study for the Libyan Sibyl, c. 1510. Red chalk on paper, 11 $\frac{3}{8} \times 8^{-7}/_{16}$ in. Metropolitan

Museum of Art, New York. Purchase, Joseph Pulitzer Bequest, 1924 (24.197.2). Photo © 1995 Metropolitan Museum of Art.

Michelangelo's LIBYAN SIBYL

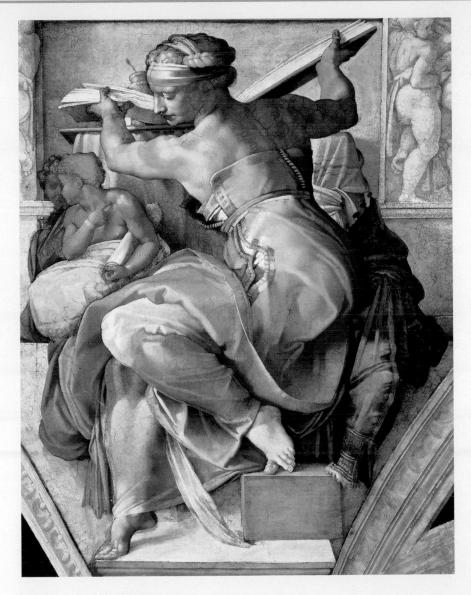

Fig. 334 Michelangelo Buonarroti, *The Libyan Sibyl*, 1511–1512. Fresco, detail of the Sistine Ceiling, Sistine Chapel, Vatican City. A. Bracchetti/P. Zigrossi/IKONA

left hand, in order to emphasize more emphatically the sibyl's downward movement, came almost immediately, for just below her left arm is a second variation, in which the upper arm drops perceptively downward and the left hand is parallel to the face instead of the forehead, matching the positions of the final painting. In the drawing, the sibyl is nude, and apparently Michelangelo's model is male, his musculature more closely defined than in the final painting. Furthermore, in the drawing, the model's face is redone to the lower left, her lips made fuller and feminized, the severity of the original model's brow and check softened. The magnificently foreshortened left hand is redone in larger scale, as if in preparation for the cartoon, and so is the lower-left foot. There are, in fact, working upward from the bottom of the drawing, three versions of the big toe, and, again, the second and third are closer to the final painted version than the first, more fully realized foot, the second toe splaying more radically backward, again to emphasize downward pressure and movement. It is upon this foot that, in the final painting, Michelangelo directs our attention, illuminating it like no other portion of the figure, the fulcrum upon which the sibyl turns from her pagan past to the Christian present.

A revival of fresco painting occurred in Mexico in the 1920s, when the new revolutionary Mexican government decided to support a public mural project that would teach and inform citizens about revolutionary history. Diego Rivera's *Sugar Cane* (Fig. 335), one of eight portable murals created especially for a 1931 exhibition at the Museum of Modern Art, replicates an actual mural at the Palace of Cortez in Cuernavaca, Mexico. It depicts, on the one hand, the suppression of the working class by landowners, and on the other, the nobility of the suppressed workers.

TEMPERA

Until the end of the Middle Ages, most paintings were done in **tempera**, a medium made by combining water, pigment, and some gummy material, usually egg yolk. The paint was meticulously applied with the point of a fine red sable brush. Colors could not readily be blended, and, as a result, effects of *chiaroscuro* were accomplished by means of careful and gradual hatching. In order to use tempera, the painting surface, often a wood panel, had to be prepared with a very smooth ground, not unlike the smooth plaster wall prepared for *buon fresco*. Gesso, made from glue and plaster of Paris or chalk, is the most common ground, and like wet plaster, it is fully absorbent, combining with the tempera paint to create an extremely durable and softly glowing surface unmatched by any other medium.

Sandro Botticelli's *Primavera* (Fig. 336), painted for a chamber next to the bedroom of his patron Lorenzo di Pierfrancesco de'Medici, is one of the greatest tempera paintings ever made. As a result of its restoration in 1978, we know a good deal about how it was painted. The support consists of eight poplar panels, arranged vertically and fastened by two horizontal strips of spruce. This support was covered with a gesso ground that hid the seams between the panels. Botticelli next outlined the trees and his human figures on the gesso and then painted the sky, laying blue tempera directly on the ground. The figures and trees

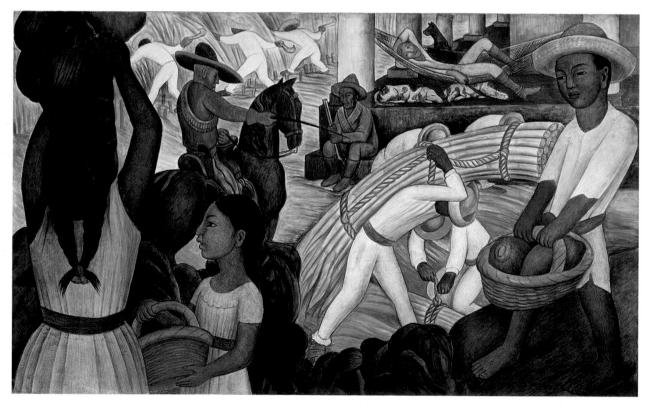

Fig. 335 José Diego Maria Rivera, Sugar Cane, 1931.
 Fresco, 57 1/8 × 94 1/8 in. Philadelphia Museum of Art. Gift of Mr. and Mrs. Herbert Cameron Morris, 1943–1946.
 © Banco de Mexico Diego Rivera and Frida Kahlo Museums Trust. Av. Cinco de Mayo No. 2, Col. Centro, Del. Cuauhtemoc 06059, Mexico, D.F. Reproduction authorized by the Instituto Nacional de Bellas Artes y Literatura.

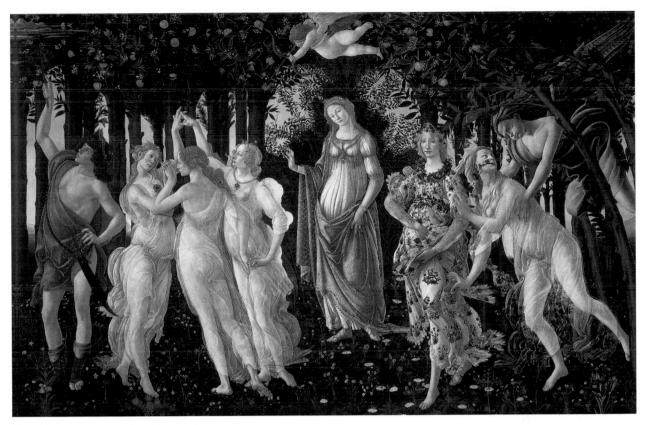

Fig. 336 Sandro Botticelli, "Primavera". c. 1482. Panel. 6 ft. 8 in. × 10 ft. 4 in. (2 × 3.1 m). Uffizi Gallery, Florence.

were painted on an undercoat—white for the figures, black for the trees. The transparency of the drapery was achieved by layering thin yellow washes of transparent medium over the white undercoat. As many as 30 coats of color, transparent or opaque depending on the relative light or shadow of the area being painted, were required to create each figure.

The kind of detail the artist is able to achieve using egg tempera is readily apparent in Braids (Fig. 337) by Andrew Wyeth, one of the few contemporary artists to work almost exclusively in the medium. Wyeth's brushwork is so fine that each strand of hair escaping from his model's braids seems caught individually in the light. In fact, the most obvious effect that Wyeth achieves with the medium is that of light. Wyeth's figures often seem posed in the most intense late-afternoon sun. The intensity is achieved by Wyeth setting his palette of warm colors against a deep black background. Thus, the inherently glowing surface of the tempera medium seems to glow even more acutely.

Fig. 337 Andrew Wyeth, Braids, 1979.
Egg tempera on canvas, 16 1/2 × 20 1/2 in. Private collection.
© AM Art, Inc. Photo courtesy of Ann Kendall Richards, Inc., New York.

Fig. 338 The Master of Flémall (probably Robert Campin), The Annunciation, (The Mérode Altarpiece) c. 1425–1430.
 Oil on wood, triptych, central panel: 25 ¼ × 24 ⅔ in.; each wing: 25 ⅔ × 10 ⅔ in. Metropolitan Museum of Art, New York. The Cloisters Collection, 1956 (56.70).
 Photo © 1996 Metropolitan Museum of Art.

OIL PAINTING

Oil paint is a far more versatile medium than tempera. It can be blended on the painting surface to create a continuous scale of tones and hues, many of which, especially darker shades, were not possible before oil paint's invention. As a result, the painter who uses oils can render the most subtle changes in light and achieve the most realistic three-dimensional effects, rivaling sculpture in this regard. Thinned with turpentine, oil paint can become almost transparent. Used directly from the tube, with no thinner at all, it can be molded and shaped to create threedimensional surfaces, a technique referred to as impasto. Perhaps most important, because its binder is linseed oil, oil painting is slow to dry. Whereas with other painting media, artists had to work quickly, with oil they could rework their images almost endlessly.

Though the ancient Romans had used oil paint to decorate furniture, the medium was first used in painting in Flanders in the early fifteenth century. The so-called Master of Flémalle, probably the artist Robert Campin, was among the first to recognize the realistic effects that could be achieved with the new medium. In *The Mérode Altarpiece* (Fig. 338), the Annunciation of the Virgin takes place in a fully realized Flemish domestic interior. The scene is not idealized. In the right-hand panel, Joseph the carpenter works as a real fifteenthcentury carpenter might have. Shown kneeling outside the door in the left-hand panel are the donors, the couple who commissioned the altarpiece, dressed in fashionable fifteenthcentury clothing.

The Master of Flémalle's contemporary, Jan van Eyck, developed oil painting even further. Van Eyck was particularly skilled both at realizing the effects of atmospheric perspective and at rendering the visible world in the utmost detail. What fascinates the viewer about a painting like The Madonna of Chancellor Rolin (Fig. 339) is at least as much what can be seen out of the window-from the garden to the distant mountains-as what is seen in the figures of the chancellor and the Virgin and Child who occupy the foreground. Our interest, like that of the two figures who lean over the wall beyond the garden, is drawn from the interior scene to the world beyond, almost as if we were being drawn away from the representation of an ideal world in art and into the representation of a real one.

Fig. 339 Jan van Eyck, *The Madonna of Chancellor Rolin*, c. 1433–1434.
Oil on panel, 26 × 24 ³/₄ in. Musée du Louvre, Paris.
© Scala/Art Resource, New York.

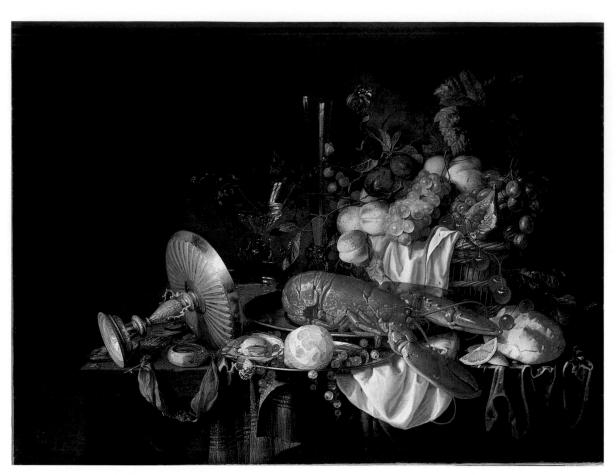

Fig. 340 Jan de Heem, Still Life with Lobster, late 1640s.
 Oil on canvas, 25 ¹/₈ × 33 ¹/₄ in. Toledo Museum of Art, Toledo, Ohio. Purchased with funds from the Libbey Endowment.
 Gift of Edward Drummond Libbey.

In 1608, the Netherlands freed itself from Spanish rule and became, by virtue of its almost total dominance of world trade, the wealthiest nation in the world. By that time, artists had become extremely skillful at using the medium of oil paint to represent these material riches. One critic has called the Dutch preoccupation with still life "a dialogue between the newly affluent society and its material possessions." In a painting such as Jan de Heem's Still Life with Lobster (Fig. 340), we are witness to the remains of a most extravagant meal, most of which has been left uneaten. This luxuriant and conspicuous display of wealth is deliberate. Southern fruit in a cold climate is a luxury, and the peeled lemon, otherwise untouched, is a sign of almost wanton consumption. And though we might want to read into this image our own sense of its decadence, for de Heem the painting was more a celebration, an invitation to share, at least visually and thus imaginatively, in its world. The feast on the table was a feast for the eyes.

The ability to create such a sense of tactile reality is a virtue of oil painting that makes the medium particularly suitable to the celebration of material things. By **glazing** the surface of the painting with thin films of transparent color, the artist creates a sense of luminous materiality. Light penetrates this glaze, bounces off the opaque underpainting beneath, and is reflected back up through the glaze. Painted objects thus seem to reflect light as if they were real, and the play of light through the painted surfaces gives them a sense of tangible presence.

The more real a painting appears to be, the more it is said to be an example of **trompe** l'oeil, a French phrase meaning "deceit of the eye." It is precisely painting's ability to deceive the eye, to substitute itself for reality, that is the subject of Gerhard Richter's oil painting *Betty* (Fig. 341). At first glance the painting seems so realistic that we might mistake it for a photograph. But of course a photograph is

Fig. 341 Gerhard Richter, Betty, 1988.
Oil on canvas, 40 ¼ × 28 ½ in. St. Louis Art Museum, St. Louis, MO. Funds given by Mr. & Mrs. R. Crosby Kemper Jr., through the Crosby Kemper Foundation, The Arther & Helen Baer Charitable Foundation, Mr. & Mrs. Van-Lear Black III, Anabeth Calkins & John Weil, Mr. & Mrs. Gary Wolff, the Honorable & Mrs. Thomas F. Eagleton; Museum Purchase, Dr. & Mrs. Harold J. Joseph, and Mrs. Edward Mallinckrodt, by exchange.

no more or less real than an oil painting. Furthermore, this painting of "Betty"—actually Richter's daughter—is not a "likeness." She turns her head away from us, in fact, concealing her "likeness." In this painting the complex interchange between art and reality that painting embodies is fully highlighted. If painting is, after all, a mental construction, an artificial reality and not reality itself, are not mental constructions as real as anything else?

If oil painting exists in the mind and for the mind, it need not necessarily reflect the world outside it. Virtually since its inception, oil painting's *expressive* potential has also been recognized. Much more than in fresco, where the artist's gesture was lost in the plaster, and much more than in tempera, where the artist was forced to use brushes so small that gestural freedom was absorbed by the scale of the image, oil paint could record and trace the artist's presence before the canvas. In the swirls and dashes of paint that make up Susan Rothenberg's Biker (Fig. 342), we can detect a cyclist charging straight at us through a puddle or a stream, water splashing up from the bike's tires. A windswept tree reaches into the painting from the right, like a claw ready to bring the biker down. The biker himself seems disembodied. All we can see of him is his head and his right arm, which reaches up to his brow as if to shade his eyes. Rothenberg's paint seems to want to capture the image and, at the same time, reject it. It is as if the artist's hand, caught in the act of painting a figure, rejects reality (representation) and insists on abstraction. We feel, in other words, that Rothenberg has been moved by something she has seen, but that she can express it only through the expressive agitation of her brushwork and the glimmering beauty of her color. As in Kathë Kollwitz's Self-Portrait (Fig. 272), the power of the artist's imagination is embodied in the artist's gesture.

Fig. 342Susan Rothenberg, Biker, 1985.Oil on canvas, 74 × 69 ½ in. Museum of Modern Art,
New York. Fractional gift of Paine Webber Group, Inc.,
1986.

© 2007 Susan Rothenberg /Artists Rights Society (ARS), New York.

Fig. 343 Pat Passlof, Dancing Shoes, 1998.
 Oil on linen, 80 × 132 in.
 Courtesy of the artist and Elizabeth Harris Gallery, New York.

While Rothenberg begins with the thing seen, Pat Passlof begins with abstraction. Her painting Dancing Shoes (Fig. 343), like many of her larger paintings, began with leftover paint from a smaller work, which she distributed in odd amounts over the surface of the 11-foot canvas. The painting developed as a predominantly yellow field that threatened, even with its syncopation of darker, loosely rectangular medium-yellow shapes, to flatten out. In response to these yellow shapes, Passlof added sap green blocks of color, so dark that they read as black. These immediately animated the surface, creating an uneven choreography of short leaps and intervals across the painting's surface that at first glance seems to fit into a grid but reveals itself to be much freer, the space between elements lengthening itself out across the canvas with a greater and greater sense of abandon.

Many of Passlof's attitudes about painting were developed working with New York painters such as Willem de Kooning, whom she first met when she attended Black Mountain College in North Carolina in 1948 and who, soon after, introduced her to her husband, Milton Resnick (see Works in Progress, p. 258). At the time, de Kooning was in the process of creating a more and more abstract art. In paintings like Door to the River (Fig. 344), there is no reference to visual reality at all. De Kooning has described the subject matter of this painting, and others like it, as a mixture of raw sensations: "landscapes and highways and sensations of that, outside the city-with the feeling of going to the city or coming from it." What we feel here, especially, is energy, the energy of the city translated into the energy of painting itself.

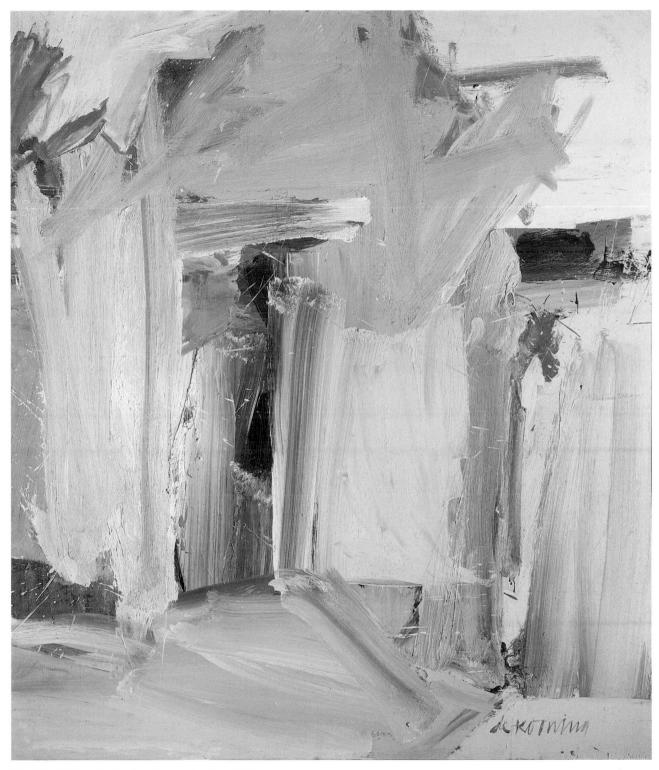

Fig. 344 Willem de Kooning, Door to the River, 1960. Oil on canvas, 80 × 70 in. Whitney Museum of American Art, New York. Purchased with funds from the Friends of the Whitney Museum of American Art (60.63).

WORKS IN PROGRESS

July 25, 1995, Abstract n **Expressionist painter Milton** Resnick began five new large paintings. They would sum up, he hoped, what he had learned over the years as a painter. He had left home in his late teens to become an artist and lived through the heyday of Abstract Expressionist painting in New York, where, as one of the leaders of what would come to be known as the New York School, he had worked with Willem de Kooning, Jackson Pollock, and Franz Kline. He had continued to work up to the present, longer than any of his contemporaries. These new paintings would take Resnick full circle, back to his beginnings and forward again into the present. And it was, in fact, beginnings that would lend the new paintings their theme-Genesis, the first book of the Bible, Adam and Eve, the Garden of Eden, the Tree of the Knowledge of Good and Evil, and the serpent, Satan. Pat Passlof, Resnick's wife and fellow painter, suggested that the figures in the new work had a more general significance as well, that they were "you and me." The name stuck, though modified to U + Me, because, Resnick says, "it's easier to write."

On July 25, Resnick painted on all five canvases in his Eldridge Street studio in Chinatown, a two-story brick-walled space with large windows that had been, in the first decades of the twentieth century, a Jewish synagogue. It is Resnick practice to begin painting without a plan and without preliminary drawings-with nothing but a brushmark and a feeling about where he's going. "This feeling doesn't have to be physical," he says, "but it has to be as if I come at you and you're frightened. That's the feeling. It's like if you have a glass and there's something in it and it's a kind of funny color. And someone says, 'Drink it.' And you say, 'What's in it?' And they say, 'Drink it or else!' And so you have to drink it. So that's the feeling. I'm going to drink something, and I don't know what's going to happen to me."

Pictured on these pages is one of the U + Me paintings at three different stages in its development—two studio photographs taken on each of the first two days, July 25 and July 26 (Fig. 345), and the finished painting as it appeared in February 1996 in an exhibition of the new U + Me paintings at the Robert Miller Gallery in New York (Fig. 346).

Fig. 345 Milton Resnick's *U* + *Me* in progress. Left: July 25, 1995, right: July 26, 1995.

Milton Resnick's **U** + **ME**

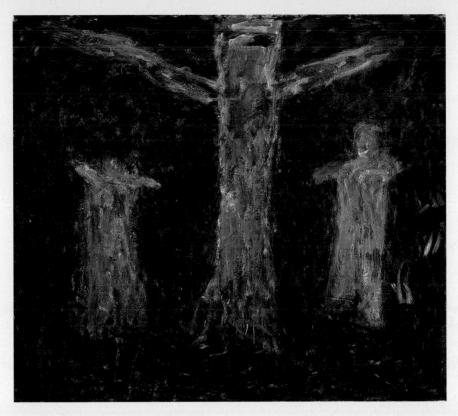

Fig. 346 Milton Resnick, U + Me, 1995.
Oil on canvas, 93 ¹/₄ × 104 ¹/₂ in.
© Milton Resnick. Courtesy Robert Miller Gallery, New York

In the first stages of the painting there are two figures, the one on the right kicking forward to meet the other, who seems to be striding forward in greeting. The major difference in the work from day one to day two is color. The exuberant red and yellow of the first brushstrokes is suppressed in an overall brownish-green over-painting. The figures are smaller and darker, the gestural marks appear denser, and the surface begins to have a much more layered feel.

The final painting, in fact, is a culmination of layer upon layer of paint being added to the work over the course of several months, each revealing itself at different points across the canvas. For instance, the second day's brownish-green layer can be seen in the final work above the top of the tree, and rich dapples of differently colored layers appear throughout the dark layer of paint of the ground behind the figures and tree.

If the final work seems dramatically different from its beginnings, that is not least of all because Resnick has added a tree. "I put it in the middle," he says, "because that's the most difficult place"-difficult because the tree makes the painting so symmetrical and balanced that it risks losing any sense of tension or energy. But Resnick's tree also has symbolic resonance, prefiguring the cross. By looking forward to the crucifixion from the Garden of Eden, Resnick changes the image. The figures have changed as well, giving up their sense of physical motion. "The figures have to have a vitality but not be in motion," Resnick says. "They have to be animated with some force. . .with some energy. That's what the paint is doing. Paint has the energy."

From de Kooning, Passlof learned to appreciate, in de Kooning's words, "a leap of space," a sense of discontinuity or displacement between elements in a composition that creates surprise, excitement, and even a degree of existential trembling, as if we are about, at each moment, to step into the void. It is, perhaps, this leap that *Dancing Shoes* so successfully exploits, as each "step" or block in the composition stands in surprising relation to the next, not as an impossible "next move," but not in the rhythm of a natural pace either. It is as if, in looking at the painting, we can hear the syncopation of its jazz beat.

WATERCOLOR

Of all the painting media, watercolor is potentially one of the most expressive. The ancient Egyptians used it to illustrate papyrus scrolls, and it was employed intermittently by other artists down through the centuries, notably by Albrecht Dürer and Peter Paul Rubens. But it was not until artists began to exploit the expressive potential of painting, rather than pursue purely representational ends, that the characteristics of the watercolor medium were fully explored.

Watercolor paintings are made by applying pigments suspended in a solution of water and gum arabic to dampened paper. Working quickly, it is possible to achieve gestural effects that are very close to those possible with brush and ink, and many people think of watercolor as a form of drawing. Historically, it has often been used and as a sketching tool. Certainly, as a medium, watercolor can possess all of the spontaneity of a high-quality sketch.

Depending on the absorbency of the paper and the amount of watercolor on the brush, the paint spreads along the fibers of the paper when it is applied. Thin solutions of pigment and binder have the appearance of soft, transparent washes, while dense solutions can become almost opaque. The play between the transparent and the opaque qualities of the medium is central to Winslow Homer's *A Wall, Nassau* (Fig. 347). Both the wall and the sky behind it

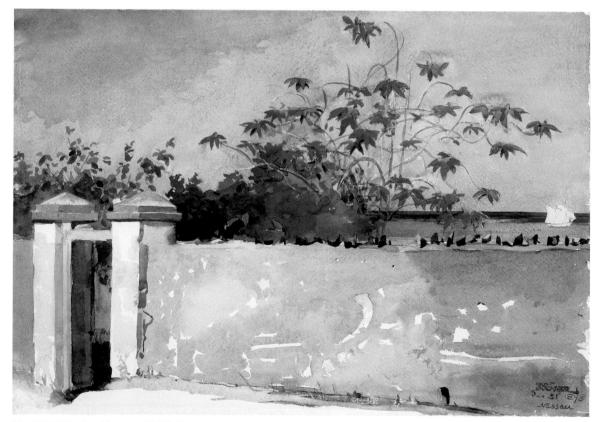

Fig. 347 Winslow Homer, A Wall, Nassau, 1898.
 Watercolor and pencil on paper, 14 ³/₄ × 21 ¹/₂ in. Metropolitan Museum of Art, New York. Amelia B. Lazarus Fund, 1910 (10.228.90).
 Photo © 1995 Metropolitan Museum of Art.

are transparent washes, and the textural ribbons and spots of white on the coral limestone wall are actually unpainted paper. Between these two light bands of color lies the densely painted foliage of the garden and, to the right, the sea, which becomes a deeper and deeper blue as it stretches toward the horizon. A white sailboat heads out to sea on the right. Almost everything of visual interest in this painting takes place between the sky above and the wall below. Even the red leaves of the giant poinsettia plant that is the painting's focal point turn down toward this middle ground. Pointing up from the top of the wall, framing this middle area from below, is something far more ominous-dark, almost black shards of broken glass. Suddenly, the painting is transformed. No longer just a pretty view of a garden, it begins to speak of privacy and intrusion, and of the divided social world of the Bahamas at the turn of the century, the islands given over to tourism and its associated wealth at the expense of the local black population. The wall holds back those outside it from the beauty and luxury within, separating them from the freedom offered, for instance, by the boat as it sails away.

It is worth comparing Homer's watercolor style with that of a more contempoary watercolorist, Laurie Reid. Reid began her career working in a traditional vein, painting representational watercolor still lifes. But over the years she became increasingly interested in the ways in which watercolor reacts with paper. She was interested, she says, in "how the fruit, when it bruises, was similar to the way pigment settles in on paper. . . . I started investigating the way the paper acts. Eventually the imagery just dropped away." *Ruby Dew (Pink Melon Joy)* (Fig. 348) consists of a single curve, or necklace, of watercolor droplets that

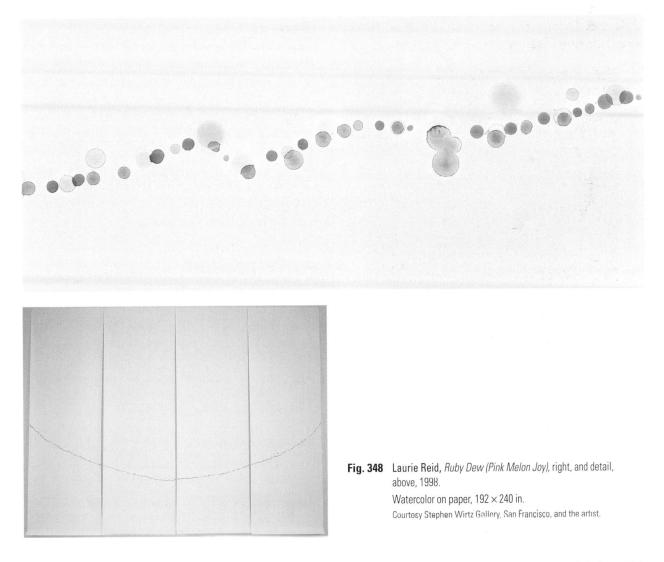

extends across four giant pieces of paper that hang vertically. Unanchored at the bottom, the fall of the paper echoes the curved fall of the watercolor necklace-a visual manifestation of gravity that echoes the fall of the watercolor droplet from brush to ground, even as it evokes, in deliberate understatement, the drips of a Jackson Pollock oil painting (see Figs. 213–215). The subtitle of Reid's work, *Pink Melon Joy*, is the name of a short work by modernist writer Gertrude Stein, one of her more metaphorically erotic pieces. It suggests that these "dew"-like droplets are meant to possess a certain sensuality, like water dripping from someone's mouth as he or she eats a honeydew melon, as well as the sensuality of watercolor as a medium in its own right.

The expressive potential of watercolor is fully realized in Georg Baselitz's *Untitled* (Fig. 349). At first glance, the painting seems to

Fig. 349 Georg Baselitz, Untitled, 1981.

Watercolor and chalk pastel on white paper, $23 \frac{3}{4} \times 16 \frac{3}{4}$ in. Courtesy of The Fogg Art Museum, Harvard University Art Museums, Cambridge, Massachusetts. Acquired through the Deknatel Purchase Fund.

Photo © President and Fellows of Harvard College, Harvard University, 1982.2.

be an almost totally abstract sunset landscape, representing perhaps a lake, at the left, emptying into a distant sea. Baselitz's title, however, indicates that our temptation to read this image figuratively is probably a mistake. When we realize that, viewed upside down, this is not a landscape, but the image of a man eating a drumstick or singing into a microphone, we begin to understand that Baselitz wishes us to value his painting as painting, subject matter aside. For Baselitz, painting reveals the mind, not the world, an idea realized in his transformation of the representational into the abstract.

GOUACHE

Derived from the Italian word guazzo, meaning "puddle," gouache is essentially watercolor mixed with Chinese white chalk. The medium is opaque, and, while gouache colors display a light-reflecting brilliance, it is difficult to blend brushstrokes of gouache together. Thus, the medium lends itself to the creation of large, flat, colored forms. It is this abstract quality that attracted Jacob Lawrence to it. Everything in the painting You can buy bootleg whiskey for twenty-five cents a quart (Fig. 350) tips forward. This not only creates a sense of disorienting and drunken imbalance, but also emphasizes the flat twodimensional quality of the painting's space. Lawrence's dramatically intense complementary colors blare like the jazz we can almost hear coming from the radio.

SYNTHETIC MEDIA

Because of its slow-drying characteristics and the preparation necessary to ready the painting surface, oil painting lacks the sense of immediacy so readily apparent in more direct media like drawing or watercolor. For the same reasons, the medium is not particularly suitable for painting out-of-doors, where one is continually exposed to the elements.

The first artists to experiment with synthetic media were a group of Mexican painters, led by David Alfaro Siqueiros, whose goal was to create large-scale revolutionary mural art. Painting outdoors, where their celebrations of the struggles of the working class could easily be seen, Siqueiros, Diego Rivera, and José

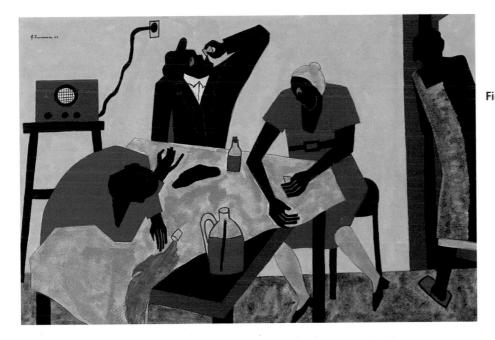

Fig. 350 Jacoblawrence, You can buy bootleg whiskey for twenty-five cents a quart, from the Harlem Series, 1942-1943. Gouache on paper, 15 1/2 × 22 1/2 in. Portland Art Museum, Portland, Oregon. Helen Thurston Ayer Fund. Artwork. © 2003 Gwendolyn Knight Lawrence, courtesy of the Jacob and Gwendolyn Lawrence Foundation. © 2007 Gwendolyn Knight Lawrence / Artists Rights Society (ARS), New York.

Clemente Orozco—Los Tres Grandes, as they are known—worked first in fresco and then in oil paint, but the sun, rain, and humidity of Mexico quickly ruined their efforts. In 1937, Siqueiros organized a workshop in New York, closer to the chemical industry, expressly to develop and experiment with new synthetic paints. One of the first media used at the workshop was pyroxylin, commonly known as Duco, a lacquer developed as an automobile paint. Housed in the Union Housing Project at Tlatelco since 1964, *Cuauhtémoc against the Myth* (Fig. 351) depicts the story of the Aztec hero who shattered the myth of the conquering Spanish army's invulnerability to attack. Meant as a commentary on the

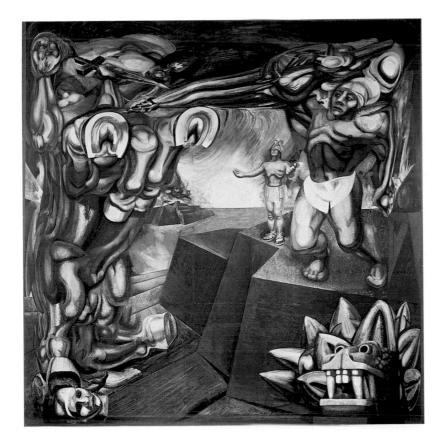

Fig. 351 David Alfaro Siqueiros, "Cuauhtémoc against the Myth,"

1944. Mural, pyroxylin on celotex and plywood, 1,000 sq. ft. Teepan Union Housing Project, Tlatelco, Mexico.

Photo by Bob Schalkwiji/AMI/INAH/CNCA. Art Resource, NY. Reproduction authorized by the Instituto Nacional de Bellas Artes y Literatura. © 2007 ARS Artists Rights Society, NY. vulnerability of the Nazi army as well, the mural was painted on a 1,000-square-foot panel instead of a wall in order to withstand damage from earthquakes.

In the early 1950s, Helen Frankenthaler gave up the gestural qualities of the brush loaded with oil paint and began to stain raw, unprimed canvas with greatly thinned oil pigments, soaking color into the surface in what has been called an art of "stain-gesture." Her technique soon attracted a number of painters who were themselves experimenting with Magna, a paint made from acrylic resins-materials used to make plastic-mixed with turpentine. Staining canvas with oil created a messy, brownish "halo" around each stain or puddle of paint, but the painters realized that the "halo" disappeared when they stained canvas with Magna, the paint and canvas really becoming one.

At almost exactly this time, researchers in both Mexico and the United States discovered a way to mix acrylic resins with water, and by 1956, water-based acrylic paints were on the market. These media were inorganic and, as a result, much better suited to staining raw canvas than turpentine or oil-based media, since no chemical interaction could take place that might threaten the life of the painting.

Inevitably, Frankenthaler gave up staining her canvases with oil and moved to acrylic in 1963. With this medium, she was able to create such intensely atmospheric paintings as *Flood* (Fig. 352). Working on the floor and pouring paint directly on the canvas, the artist was able to make the painting seem spontaneous, even though it is quite large. "A really good picture," Frankenthaler says, "looks as if it's happened at once. . . . It looks as if it were born in a minute."

Fig. 352 Helen Frankenthaler, *Flood*, 1967.
 Synthetic polymer on canvas, 124 × 140 in. Whitney Museum of American Art, New York.
 Purchased with funds from the Friends of the Whitney Museum of American Art, 68.12.

The usefulness of acrylic for outdoor mural painting was immediately apparent. Once dried, the acrylic surface was relatively immune to the vicissitudes of weather. Judith F. Baca, whose mural for the University of Southern California student center we considered in Chapter 9, put the medium to use in 1976 for The Great Wall of Los Angeles, a mural that would be more than a mile long. It is located in the Tujunga Wash of the Los Angeles River, which had been entirely concreted over by developers as Los Angeles grew. The river, as a result, seemed to Baca "a giant scar across the land which served to further divide an already divided city." She thought of her mural, which depicts the history of the indigenous peoples, immigrant minorities, and women of the area from prehistory to the present, as a healing gesture: "Just as young Chicanos tattoo battle scars on their bodies, Great Wall of Los Angeles is a tattoo on a scar where the river once ran." Illustrated here (Fig. 353) is a 13-foot-high section depicting the intersection of four major freeways in the middle of East Los Angeles, the traditional center of Chicano life in the city, freeways that divided the community and weakened it. To the right, for instance, a Mexican woman protests the building of Dodger Stadium, which displaced the traditional Mexican community in Chavez Ravine.

Baca worked on the *Great Wall* project more as a director and facilitator than as a painter. Nearly 400 inner-city youth, many of them recruited through the juvenile justice system from rival gangs, did the actual painting and design. They represented, in real terms, the divided city itself. "The thing about muralism," Baca says, "is that collaboration is a requirement. . . .[The] focus is cooperation."

MIXED MEDIA

All of the painting media we have so far considered can be combined with other media, from drawing to fiber and wood, as well as found objects, to make a new work of art. In the twentieth century, in particular, artists purposefully and increasingly combined various media. The result is **mixed media** work. The motives for working with mixed media are many, but the primary formal one is that mixed media violate the integrity of painting as a medium. They do this by introducing into the space of painting materials from the everyday world.

Fig. 353 Judith F. Baca, The Great Wall of Los Angeles, detail, Division of the Barrios and Chavez Ravine, 1976–continuing. Mural, height 13 ft. (whole mural more than 1 mile long). Tujunga Wash, Los Angeles. Photo © SPARC, Venice, California.

Collage

The two-dimensional space of the canvas was first challenged by Pablo Picasso and his close associate Georges Braque when they began to utilize collage in their work. **Collage** is the process of pasting or gluing fragments of printed matter, fabric, natural material—anything that is relatively flat—onto the two-dimensional surface of a canvas or panel. Collage creates, in essence, a low-relief assemblage.

A good example of collage is one created soon after Picasso and Braque began using the new technique by their colleague Juan Gris. Although no one would mistake *The Table* (Fig. 354) painting for an accurate rendering of reality, it is designed to raise the question of just what, in art, is "real" and what is "false" by bringing elements from the real world into the space of the painting. The woodgrain of the tabletop is both woodgrain-printed wallpaper and paper with the woodgrain drawn on it by hand. Thus it is both "false" wood and "real"

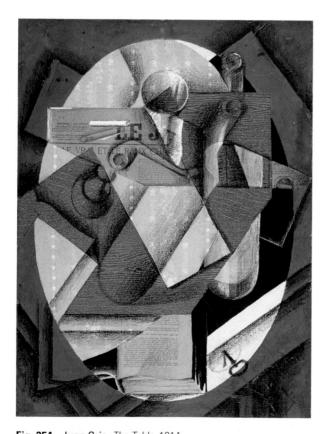

Fig. 354 Juan Gris, *The Table*, 1914.
 Colored papers, printed matter, charcoal on paper mounted in canvas, 23 ¹/₂ × 17 ¹/₂ in. © Philadelphia Museum of Art. A. E. Gallatin Collection.
 Photo: Lynn Rosenthal, 1993. © 2007 Juan Gris/Artists Rights Society (ARS), New York.

wallpaper, as well as "real" drawing. The fragment of the newspaper headline—its a "real" piece of newspaper, incidentally—reads "*Le Vrai et le Faux*" ("The True and the False"). A novel lies open at the base of the table. Is it any less "real" as a novel just because it is a work of fiction? The key in the table drawer offers us a witty insight into the complexity of the work, for in French the word for "key," clé, also means "problem." In this painting the problematic interchange between art and reality that painting embodies is fully highlighted. If painting is, after all, a mental construction, an artificial reality, not reality itself, are not mental constructions as real as anything else?

Because it brings "reality" into the space of painting, collage offers artists a direct means of commenting on the social or political environment in which they work (for an example of a Nazi-era political collage, see *Works in Progress*, p. 268). The African-American artist Romare Bearden was inspired particularly by the African-American writer Ralph Ellison's 1952 novel *Invisible Man*. One of Ellison's narrator's most vital realizations is that he must assert, above all else, his blackness, not hide from it. He must not allow himself to be absorbed into white society. "Must I strive toward colorlessness?" he asks.

But seriously, and without snobbery, think of what the world would lose if that should happen. America is woven of many strands; I would recognize them and let it so remain... Our fate is to become one, and yet many—this is not prophecy, but description.

There could be no better description of Bearden's collages. Bearden had worked for two decades in an almost entirely abstract vein, but, inspired by Ellison, in the early 1960s he began to tear images out of *Ebony*, *Look*, and *Life* magazines and assemble them into depictions of the black experience. *The Dove* (Fig. 355)—so named for the white dove that is perched over the central door, a symbol of peace and harmony—combines forms of shifting scale and different orders of fragmentation, so that, for instance, a giant cigarette extends from the hand of the dandy, sporting a cap, at the right, or the giant fingers of a woman's

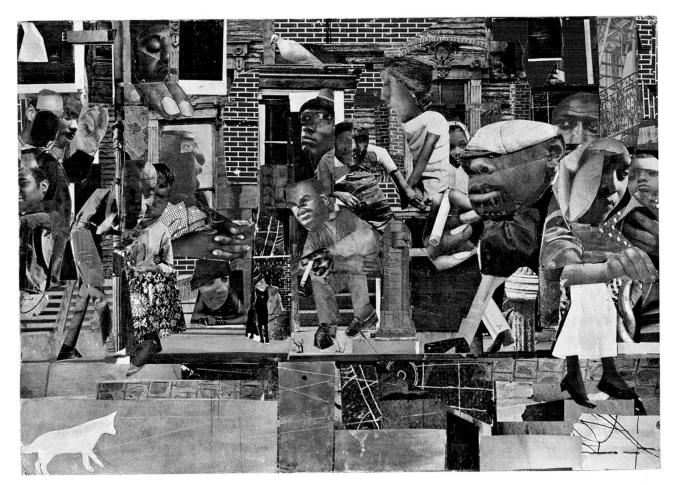

Fig. 355 Rumane Bearden, *The Dove*, 1964.
 Cut-and-pasted paper, gouache, pencil, and colored pencil on cardboard, 13 ³/₈ × 18 ³/₄ in. Museum of Modern Art, New York.
 Blanchette Rockefeller Fund.
 © Romare Bearden Foundation/VAGA, New York.

hand reach over the windowsill at the top left. The resulting effect is almost kaleidoscopic, an urban panorama of a conservatively dressed older generation and hipper, younger people gathered into a scene nearly bursting with energy—the "one, and yet many." As Ellison wrote of Bearden's art in 1968:

Bearden's meaning is identical with his method. His combination of technique is in itself eloquent of the sharp hreaks, leaps of consciousness, distortions, paradoxes, reversals, telescoping of time and surreal blending of styles, values, hopes, and dreams which characterize much of American history. Mixed media, in other words, provide Bearden with the means to bring the diverse elements of urban African-American lilfe into a formally unified, yet still distinctly fragmented, whole.

Painting toward Sculpture

One of the most important results of mixed media has been to extend what might be called "the space of art." If this space was once defined by the picture frame—if art was once understood as something that was contained within that boundary and hung on a wall—that definition of space was extended in the hands of mixed-media artists, out of the two-dimensional and into the three-dimensional space.

WORKS IN PROGRESS

iven collage's inclusiveness, it is hardly surprising that it is among the most political of mediums. In Germany, after World War I, as the forces that would lead to the rise of Hitler's Nazi party began to assert themselves, a number of artists in Berlin, among them Hannah Höch, began to protest the growing nationalism of the country in their art. Reacting to the dehumanizing speed, technology, industrialization, and consumerism of the modern age, they saw in collage, and in its more representational cousin, photomontage-or collage constructed of photographic fragments-the possibility of reflecting the kaleidoscopic pace, complexity, and fragmentation of everyday life. Höch was particularly friendly with Raoul Hausmann, whose colleague Richard Hulsenbeck had met a group of so-called Dada artists in Zurich, Switzerland, in 1916. The anarchic behavior of these "anti-artists" had impressed both men, and with Höch and others they inaugerated a series of Dada evenings in Berlin, the first such event occuring on April 12, 1918. Hulsenbeck read a manifesto, others read sound or noise poetry, and all were accompanied by drums, instruments, and audience noise. On June 20, 1920, they opened a Dada Fair in a three-room apartment covered from floor to ceiling with a chaotic display of photomontages, Dada periodicals, drawings, and assemblages, one of which has been described as looking like "the aftermath of an accident between a trolley car and a newspaper kiosk." On one wall was Hannah Höch's photomontage Cut with the Kitchen Knife Dada through the Last Weimar Beer Belly Cultural Epoch of Germany (Fig. 357).

We are able to identify many of the figures in Höch's work with the help of a preparatory drawing (Fig. 356). The top right-hand corner is occupied by the forces of repression. The recently deposed emperor Wilhelm II, with two wrestlers forming his mustache, gazes out below the words "Die anti-dadistische Bewegung," or "the anti-Dada movement," the leader of what Höch calls in her title "the Wiemar beer belly." On Wilhelm's shoulder rests an exotic dancer with the head of General Field Marshall Friedrich von Hindenburg. Below them are other generals and, behind Wilhelm, a photograph of people waiting in line at a Berlin employment office.

The upper-left focuses on Albert Einstein, out of whose brain Dada slogans seem to burst, as if the Theory of Relativity, overturning traditional physics as it did, was a proto-Dada event. In the very center of the collage is a headless dancer, and above her floats the

Fig. 356 Hannah Höch, Study for Collage "Cut with the Kitchen Knife Dada through the Last Weimar Beer Belly Cultural Epoch of Germany," 1919.

Ballpoint pen sketch on white board, 10 $\frac{5}{8} \times 8 \frac{5}{8}$ in. Staatliche Museen zu Berlin, Preussischer Kulturbesitz Nationalgalerie/NG 57/61

Photo: Jorg P. Anders, Berlin. Bildarchiv Preussischer Kulturbesitz/Art Resource, NY. © 2007 Artists Rights Society (ARS), New York/VG Bild-Kunst, Bonn.

Hannah Höch's CUT WITH THE KITCHEN KNIFE

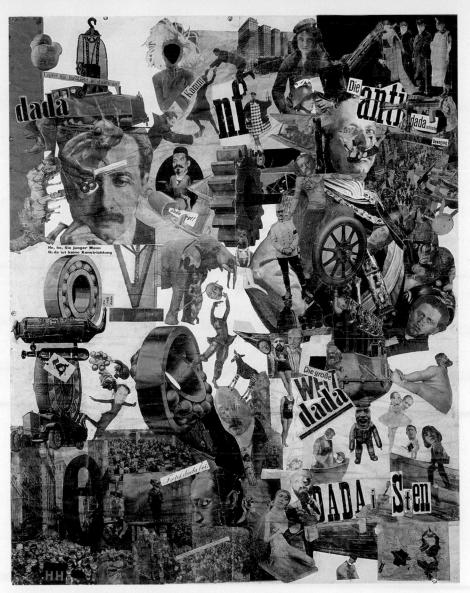

 Fig. 357 Hannah Höch, Cut with the Kitchen Knife Dada through the Last Weimar Beer Belly Cultural Epoch of Germany, 1919.
 Collage, 44 ⁷/₈ × 35 ⁷/₁₆ in. Staatliche Museen zu Berlin, Preussischer Kulturbesitz Nationalgalerie/NG57/61.
 Photo: Jorg P. Anders, Berlin. Bildarchiv Preussischer Kulturbesitz/Art Resource, NY. © 2007 Artists Rights Society (ARS), New York/VG Bild-Kunst, Bonn.

head of printmaker Kathë Kollwitz. To the right of her are the words "Die grossse Welt dada," and then, further down, "Dadaisten," "the great dada World," and "Dadaists." Directly above these words are Lenin, whose head tops a figure dressed in hearts, and Karl Marx, whose head seems to emanate from a machine. Raoul Hausmann stands just below in a diver's suit. A tiny picture of Höch herself is situated at the bottom right, partially on the map of Europe that depicts the progress of women's enfranchisement. To the left a figure stands above the crowd shouting "Tretet Dada bei"—"Join Dada."

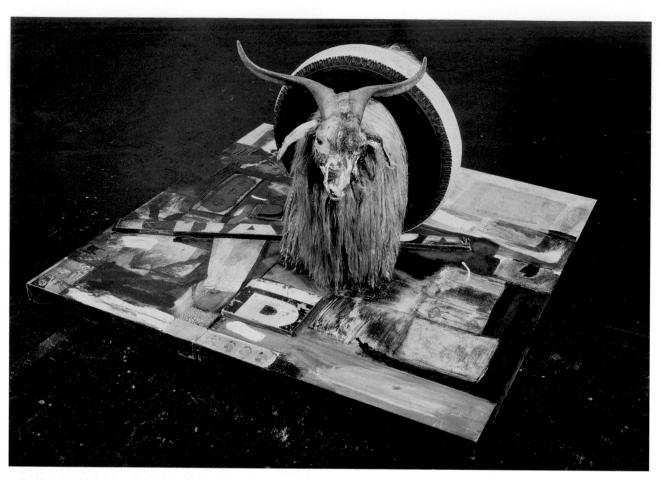

Fig. 358 Robert Rauschenberg, Monogram, 1955–1959.
 Freestanding combine: oil, fabric, wood, on canvas and wood, rubber heel, tennis ball, metal plaque, hardware, stuffed Angora goat, rubber tire, mounted on four wheels, 42 × 63 ¹/₄ × 64 ¹/₂ in.
 © Robert Rauschenberg/Licensed by VAGA, New York.

This movement is nowhere more forcefully stated than in the work of Robert Rauschenberg. Rauschenberg's work literally moves "off the wall"—the title of Calvin Tomkins's biography of the artist. There is probably no better example of this than *Monogram* (Fig. 358), a combine-painting, or high-relief collage, that Rauschenberg worked on over a five-year period from 1955 to 1959.

The composer John Cage once defined Rauschenberg's combine-paintings as "a situation involving multiplicity." They are a kind of collage, but more lenient than other collages about what they will admit into their space. They will, in fact, admit anything, because unity is not something they are particularly interested in. They bring together objects of diverse and various kinds and simply allow them to coexist beside one another in the same space. In Rauschenberg's words, "A pair of socks is no less suitable to make a painting with than wood, nails, turpentine, oil and fabric." Nor, apparently, is a stuffed Angora goat.

Rauschenberg discovered the goat in a second-hand office-furniture store in Manhattan. The problem it presented, as Tomkins has explained, was how "to make the animal look as if it belonged in a painting." In its earliest recorded state (Fig. 359) the goat is mounted on a ledge in profile in the top half of a sixfoot painting. It peers over the edge of the painting and casts a shadow on the wall. Compared to later states of the work, the goat is integrated into the two-dimensional surface, or as integrated as an object of its size could be.

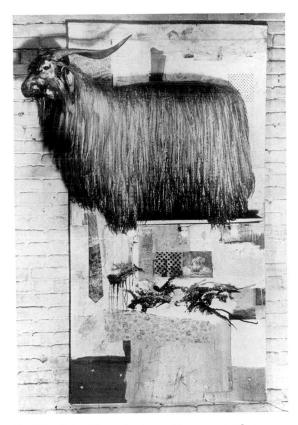

Fig. 359 Robert Rauschenberg, Monogram, 1st State. © Robert Rauschenberg/Licensed by VAGA, New York. Photo: Harry Shunk.

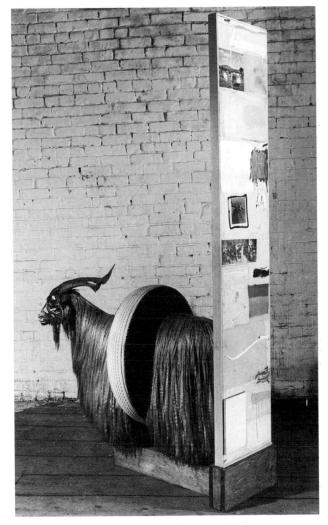

Fig. 360 Robert Rauschenberg, *Monogram*, 2nd State. © Robert Rauschenberg/Licensed by VAGA, New York. Photo: Rudolph Burckhardt.

In the second state (Fig. 360), Rauschenberg brings the goat off its perch and sets it on a platform in front of another combine-painting, this one nearly 10 feet high. Now it seems about to walk forward into our space, dragging the painting behind it. Rauschenberg has also placed an automobile tire around the goat's midsection. This tirc underscores its volume, its three-dimensionality.

But Rauschenberg was not happy with this design either. Finally, he put the combinepainting flat on the floor, creating what he called a "pasture" for the goat. Here Rauschenberg manages to accomplish what seems logically impossible: The goat is at once fully contained within the boundaries of the picture frame and totally liberated from the wall. Painting has become sculpture.

THE CRITICAL PROCESS Thinking about Painting

In this chapter, we have considered all of the painting media-encaustic, fresco, tempera, oil paint, watercolor, gouache, acrylic paints, and mixed media-and we have discussed not only how these media are used but also why artists have favored them. One of the most important factors in the development of new painting media has always been the desire of artists to represent the world more and more faithfully. But representation is not the only goal of painting. If we recall Artemisia Gentileschi's Self-Portrait at the beginning of this chapter, she is not simply representing the way she looks but also the way she feels. In her hands, paint becomes an expressive tool. Some painting media-oil paint, watercolor, and acrylics—are better suited to expressive ends than others because they are more fluid or can be manipulated more easily. But the possibilities of painting are as vast as the human imagination itself. In painting, anything is possible.

And, as we have seen in the last section of this chapter, the possibilities of painting media can be extended even further when they are combined with other media. The art of Fred Tomaselli is a case in point. Tomaselli began producing mixed-media works in the late 1980s that combine pills (over-the-counter medicines, prescription pharmaceuticals, and street drugs), leaves (including marijuana leaves), insects, butterflies, and various cutout elements, including floral designs, representations of animals, and body parts. The resulting images constitute for Tomaselli a kind of cartography-he sees them as "maps" describing his place in the world. Airborne Event (Fig. 361) might well be considered an image of a psychedelic high. But Tomaselli, born in the late 1950s, is well-aware of the high price first hippie and then punk cultures have paid for their hallucinogenic indulgences. Another way to read this painting is as a critique of

what has been called "the jewel-like nature of a pill." That is, Tomaselli's work might also be considered an essay on the toxic nature of beauty or "airborne events" such as disease or disaster. How does it suggest that the world it depicts is as artificial as it is visionary? In order to answer these questions, it might be useful to compare Tomaselli's mixed-media work to Fra Andrea Pozzo's *Glorification of Saint Ignatius* (see Fig. 332).

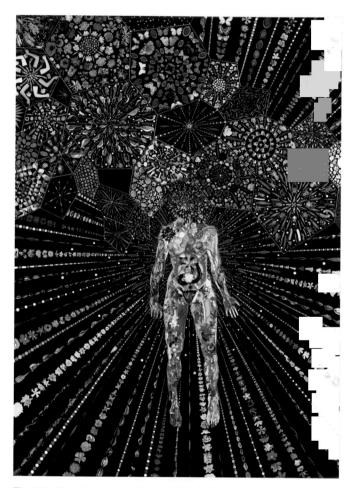

 Fig. 361
 Fred Tomaselli, Airborne Event, 2003.

 Mixed media, acrylic, and resin on wood, 84 × 60 × 1 ½ in.

 Courtesy of James Cohan, Gallery, New York.

The Camera Arts

PHOTOGRAPHY

Early History Form and Content Color Photography New Technologies: Digital Photography

FILM

The Popular Cinema

VIDEO

■ Works in Progress Bill Viola's *The Greeting*

COMPUTER- AND INTERNET-BASED ART MEDIA

The Critical Process Thinking about the Camera Arts

hus far in Part III we have discussed the twodimensional media of drawing, printmaking, and painting. Now we turn to the last of the twodimensional media, the camera arts, which also allow the artist to explore the fourth dimension—time.

The images that come from still, motion-picture, and video cameras are, first and foremost, informational. Cameras record the world around us, and the history of the camera is a history of technologies that record our world with ever-increasing sophistication and expertise. Photography began with still images, then added motion. To the silent moving image was added sound. To the "talkie" was added color. And film developed in its audience a taste for "live" action, a taste satisfied by live television transmission, video images that allow us to view anything happening in the world as it happens. The history of the camera arts is thus a history of increasing immediacy and verisimilitude, or semblance to the truth. In this chapter, we will survey that history, starting with still photography, moving to film, and, finally, to video. Our focus will be on these media as works of art.

Fig. 362 Walker Evans, Roadside Store between Tuscaloosa and Greensboro, Alabama, 1936. Library of Congress. Photo: Walker Evans.

PHOTOGRAPHY

Like collage, photography is, potentially at least, an inclusive rather than an exclusive medium. You can photograph anything you can see. According to artist Robert Rauschenberg, whose combine-paintings we studied in the last chapter (see Fig. 358), "The world is essentially a storehouse of visual information. Creation is the process of assemblage. The photograph is a process of instant assemblage, instant collage." Walker Evans's photograph *Roadside Store between Tuscaloosa and Greensboro*,

Alabama (Fig. 362) is an example of just such "instant collage." Evans's mission as a photographer was to capture every aspect of American visual reality, and his work has been called a "photographic equivalent to the Sears, Roebuck catalog of the day." But the urge to make such instant visual assemblages-to capture a moment in time-is as old as the desire to represent the world accurately. We begin our discussion of photography by considering the development of the technology itself, and then we will consider the fundamental aesthetic problem photography faces-the tension between form and content, the tension between the way a photograph is formally organized as a composition and what it expresses or means.

Early History

The word *camera* is the Latin word for "room." And, in fact, by the sixteenth century, a darkened room, called a *camera obscura*, was routinely used by artists to copy nature accurately. The scientific principle employed is essentially the same as that used by the camera today. A small hole on the side of a light-tight room admits a ray of light that projects a scene, upside down, directly across from the hole onto a semitransparent white scrim. The *camera obscura* depicted here (Fig. 363) is a double one, with images entering the room from both sides. It is also portable, allowing the artist to set up in front of any subject matter.

But working with the *camera obscura* was a tedious proposition, even after small portable dark boxes came into use. The major drawback of the *camera obscura* was that while it could capture the image, it could not preserve

Fig. 363 Unidentified Photographer, *Camera Obscura*. Engraving. George Eastman House, Rochester, New York.

Fig. 364 William Henry Fox Talbot, *Mimosoidea Suchas, Acacia*, c. 1839. Photogenic drawing, Fox Talbot Collection, National Museum of Photography, London.

Film & Television/Science & Society Picture Library.

it. In 1839, that problem was solved, simultaneously in England and France, and the public was introduced to a new way of representing the world.

In England, William Henry Fox Talbot presented a process for fixing negative images on paper coated with light-sensitive chemicals, a process that he called **photogenic drawing** (Fig. 364). In France, a different process, which yielded a positive image on a polished metal plate, was named the **daguerreotype** (Fig. 365), after one of its two inventors, Louis Jacques Mandé Daguerre (Joseph Nicéphore Niépce had died in 1833, leaving Daguerre to perfect the process and garner the laurels). Public reaction was wildly enthusiastic, and the French and English press faithfully reported every development in the greatest detail.

Fig. 365 Louis Jacques Mandé Daguerre, *Le Boulevard du Temple*, 1839 Daguerreotype. Bayerisches National Museum, Munich.

Fig. 366 Richard Beard, *Maria Edgeworth*, 1841. Daguerreotype, 2 ¹/₈ × 1 ³/₄ in. Courtesy of the National Portrait Gallery, London.

When he saw his first daguerreotype, the French painter Paul Delaroche is reported to have exclaimed, "From now on, painting is dead!" Delaroche may have overreacted, but he nevertheless understood the potential of the new medium of photography to usurp painting's historical role of representing the world. In fact, photographic portraiture quickly became a successful industry. As early as 1841, a daguerreotype portrait could be had in Paris for 15 francs. That same year in London, Richard Beard opened the first British portrait studio, bringing a true sense of showmanship to the process. One of his first customers, the novelist Maria Edgeworth (Fig. 366), described having her portrait done at Beard's in a breathless letter dated May 25, 1841: "It is a wonderful mysterious operation. You are taken from one room into another upstairs and down and you see various people whispering and hear them in neighboring passages and rooms unseen and the whole apparatus and stool on a high platform under a glass dome casting a snapdragon blue light making all look like spectres and the men in black gliding about...."

In the face of such a "miracle," the art of portrait painting underwent a rapid decline. Of the 1,278 paintings exhibited at the Royal Academy in London in 1830, more than 300 were miniatures, the most popular form of the portrait; in 1870, only 33 miniatures were exhibited. In 1849 alone, 100,000 daguerreotype portraits were sold in Paris. Not only had photography replaced painting as the preferred medium for portraiture, it had democratized the genre as well, making portraits available not only to the wealthy, but also to the middle class, and even, with some sacrifice, to the working class.

The daguerreotype itself had some real disadvantages as a medium, however. In the first place, it required considerable time to prepare, expose, and develop the plate. Iodine was vaporized on a copper sheet to create light-sensitive silver iodide. The plate then had to be kept in total darkness until the camera lens was opened to expose it. At the time Daguerre first made the process public in 1839, imprinting an image on the plate took from 8 to 10 minutes in bright summer light. His own view of the Boulevard du Temple (see Fig. 365) was exposed for so long that none of the people in the street, moving about their business, has left any impression on the plate, save for one solitary figure at the lower left, who is having his shoes shined. By 1841, the discovery of so-called chemical "accelerators" had made it possible to expose the plate for only 1 minute, but a sitter could not move in that time for fear of blurring the image. The plate was finally developed by suspending it face down in heated mercury, which deposited a white film over the exposed areas. The unexposed silver iodide was dissolved with salt. The plate then had to be rinsed and dried with the utmost care.

An even greater drawback of the daguerreotype was that it could not be reproduced. Utilizing paper instead of a metal plate, Fox Talbot's photogenic process made multiple prints a possibility. Talbot quickly learned that he could reverse the negative image of the photogenic drawings by placing sheets of sensitized paper over them and exposing both again to sunlight. Talbot also discovered that sensitized paper, exposed for even a few seconds, held a *latent* image that could be brought out and developed

Fig. 367 William Henry Fox Talbot, *The Open Door*, 1843. Calotype. Fox Talbot Collection, National Museum of Photography, London. Film & Television/Science & Society Picture Library.

by dipping the paper in gallic acid. This calotype process is the basis of modern photography.

In 1843, Talbot made a picture, which he called The Open Door (Fig. 367), that convinced him that the calotype could not only document the world as we know it, but also become a work of art in its own right. When he published this calotype in his book The Pencil of Nature, the first book of photographs ever produced, he captioned it as follows: "A painter's eye will often be arrested where ordinary people scc nothing remarkable. A casual gleam of sunshine, or a shadow thrown across his path, a time-withered oak, or a moss-covered stone may awaken a train of thoughts and feelings, and picturesque imaginings." For Talbot, at least, painters and photographers saw the world as one.

In 1850, the English sculptor Frederick Archer introduced a new wet-plate collodion photographic process that was almost universally adopted within five years. In a darkened room, he poured liquid collodion—made of pyroxyline dissolved in alcohol or other —over a glass plate bathed in a solution of silver nitrate. The plate had to be prepared, exposed, and developed all within 15 minutes and while still wet. The process was cumbersome, but the exposure time was short and the rewards were quickly realized. On her 49th birthday, in 1864, Julia Margaret Cameron, the wife of a high-placed British civil servant and friend to many of the most famous people of her day,

Fig. 368 Julia Margaret Cameron, Portrait of Thomas Carlyle, 1863. Silver print, 10 × 8 in. The Royal Photographic Society, London. Science and Society Picture Library.

was given a camera and collodion-processing equipment by her daughter and son-in-law. "It may amuse you, Mother, to photograph," the accompanying note said.

Cameron set up a studio in a chicken coop at her home on the Isle of Wright, and over the course of the next 10 years convinced almost everyone she knew to pose for her, among them the greatest men of British art, literature, and science. She often blurred their features slightly, believing this technique drew attention away from mere physical appearance and revealed more of her sitter's inner character. Commenting on her photographs of famous men like Thomas Carlyle (Fig. 368), she wrote, "When I have had such men before my camera, my whole soul has endeavored to do its duty towards them in recording faithfully the great ness of the inner man as well as the features of the outer man. The photograph thus taken has been almost the embodiment of a prayer."

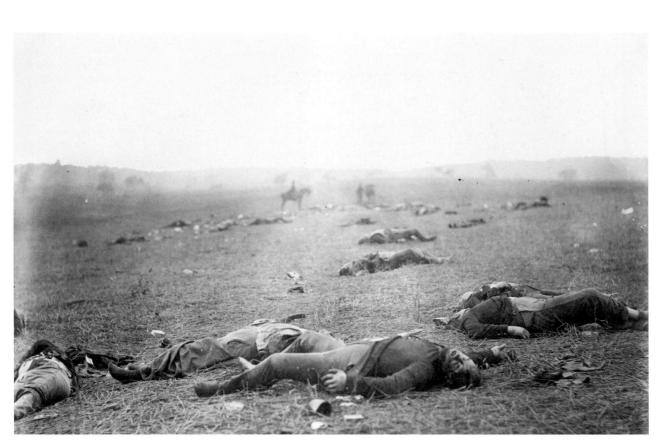

Fig. 369 Timothy O'Sullivan, *Harvest of Death, Gettysburg, Pa.,* 1863. Collodion print. Courtesy of the Library of Congress.

More than anything else, the ability of the portrait photographer to expose, as it were, the "soul" of the sitter led the French government to give photography the legal status of art as early as 1862. But from the beginning, photography served a *documentary* function as well-it recorded and preserved important events. At the outbreak of the American Civil War, in 1861, Matthew Brady spent the entirety of his considerable fortune to outfit a band of photographers to document the war. When Brady insisted that he owned the copyright for every photograph made by anyone in his employ, whether or not it was made on the job, several of his best photographers quit, among them Timothy O'Sullivan (Fig. 369). One of the first great photojournalists, O'Sullivan is reported to have photographed calmly during the most horrendous bombardments, twice having his camera hit by shell fragments.

After the war, O'Sullivan packed his photography wagon, laden with glass plates, chemicals, and cameras, and joined Clarence King's Survey of the Fortieth Parallel in order to document a landscape few Americans had ever seen: the rugged, sometimes barren terrain stretching along the Fortieth Parallel between Denver, Colorado and Virginia City, Nevada. Hired to record the geological variety of the region, O'Sullivan quickly realized that on the two-dimensional surface of the photograph, the landscape yielded sometimes stunningly beautiful formal plays of line and texture. In his view of the Green River Canyon (Fig. 370), brush dots the landscape in small, isolated flecks that create an almost dimensionless space, especially on the right. A geological upthrust, through which the river has apparently cut its way, sweeps up from the left, ending abruptly at the picture's center, almost reminding us of the broad brushwork of an Abstract Expressionist canvas.

Form and Content

It might be said that every photograph is an abstraction, a simplification of reality that substitutes two-dimensional for three-dimensional space, an instant of perception for the seamless continuity of time, and, in black-and-white

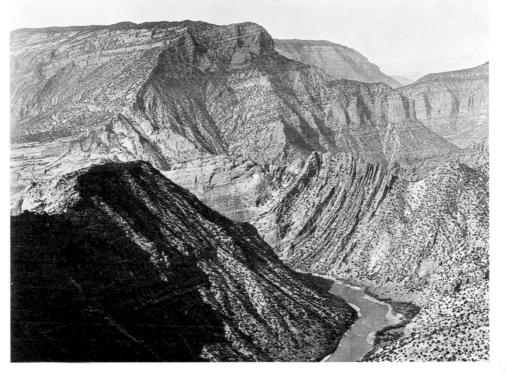

Fig. 370 Timothy O'Sullivan, *Green River (Colorado)*, c. 1868. Collodion print, 8 × 10 in. Library of Congress.

work at least, the gray scale for color. By cmphasizing formal elements over representational concerns, as O'Sullivan seems to have done in his picture of the Green River Canyon, the artist further underscores this abstract side of the medium. One of the greatest sources of photography's hold on the popular imagination lies in this ability to aestheticize the everyday to reveal as beautiful that which we normally take for granted. In his photograph From the Shelton, New York (Fig. 371), Alfred Stieglitz has transformed the three-dimensional space of the picture into a two-dimensional design of large, flat, black-and-white shapes. By heightening the contrast between light and dark, and almost completely eliminating middle-register grays, Stieglitz de-emphasizes the literal content of his photograph and creates, instead, what he called "an affirmation of light. . . . Each thing that arouses me is perhaps but a variation on the theme of how black and white maintain a living equilibrium."

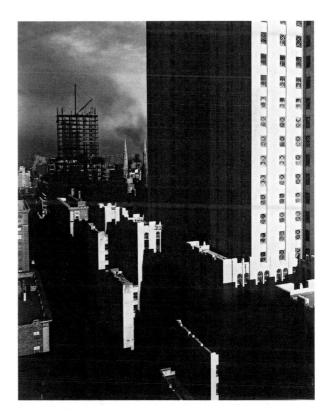

Fig. 371 Alfred Stieglitz, From the Shelton, New York, 1931.
 Gelatin silver print, 9 %₁₆ × 7 %₁₆ in. National Gallery of Λrt.
 © 1999 National Gallery of Art, Washington, D.C. Alfred Stieglitz Collection.

Fig. 373 John Paul Filo, Kent State—Girl Screaming over Dead Body, May 4, 1970. John Paul Filo/Getty Images, Inc.

Fig. 372 Charles Sheeler, *Criss-Crossed Conveyors—Ford Plant*, 1927. Gelatin silver print, 10 × 8 in. Museum of Fine Arts, Boston. The Lane Collection

The geometric beauty of Stieglitz's work deeply influenced Charles Sheeler, who was hired by Henry Ford to photograph the new Ford factory at River Rouge in the late 1920s (Fig. 372). Sheeler's precise task was to aestheticize Ford's plant. His photographs, which were immediately recognized for their artistic merit and subsequently exhibited around the world, were designed to celebrate industry. They revealed, in the smokestacks, conveyors, and iron latticework of the factory, a grandeur and proportion not unlike that of the great Gothic cathedrals of Europe.

Even when the intention is not to aestheticize the subject, as is often true in photojournalism, the power of the photograph will come from its ability to focus our attention on that from which we would normally avert our eyes. Kent State University photography student John Paul Filo's famous photograph of a young girl screaming in despair as she kneels over one of the four students killed by the Ohio National Guard on May 4, 1970, as students protested President Richard Nixon's invasion of Cambodia (Fig. 373), was reproduced on the front pages of newspapers around the world. Its impact lies in its sheer matter-of-factness. With its unrelenting insistence on what might be called the "truth factor" of the photographic image—"Could this really happen here?" it seemed to ask—it galvanized the anti-war movement. The photograph became, like Abraham Zapruder's film of John F. Kennedy's assassination or the television coverage of Jack Ruby shooting Lee Harvey Oswald, an icon of the political and moral ambiguity of the age.

Both Sheeler and Filo's photographs depend on much more sophisticated photographic equipment and film than was available to early practitioners like O'Sullivan. Since the day in 1888 when Kodak introduced the hand-held camera, the technological advances have been staggering. But technological advances have not effaced the medium's primary concern with the tension and distance between form and content—between the photographic object, which exists out of time in aesthetic space, and the real event, the content, which takes place in both historical time and actual space.

In some photographs, the content completely overcomes the photograph's formal composition. When newspapers published Filo's photograph, for instance, many airbrushed out of the photograph the stake that seems to emerge out of the young woman's head, believing that it diminished the political force of the image. Anti-war activists had also quickly reacted to reports that American soldiers, the men of Charlie Company, had slaughtered men, women, and children in the Vietnam village of My Lai on March 16, 1968. More than a year later, in November 1969, as the army was investigating Charlie Company's platoon leader, First Lieutenant William L. Calley, Jr., photographs taken at My Lai by army photographer Ron Haeberle appeared in the Cleveland Plain Dealer. Four days later, in an interview with Mike Wallace on CBS-TV, Paul Meadlo, who had been at My Lai, reported that Lieutenant Calley had rounded up 40 or 45 villagers and ordered them shot. "Men, women, and children?" Wallace asked. "Men, women, and children," Meadlo answered. "And babies?" "And babies." The transcript of the interview was published the next day in The New York Times, accompanied by the photograph. Quickly, artists protesting the war added Meadlo's response to Wallace to the image (Fig. 374), printed a poster, and distributed it around the world. In this case, the text's content does not merely gloss the image, but rather heightens its power.

Still, very often the power of a photographic image can be attributed most directly to its formal composition. Talking about the ways in which he arrives at the photographic image, Henri Cartier-Bresson has described the relationship between form and content in the following terms:

We must place ourselves and our camera in the right relationship with the subject, and it is in fitting the latter into the frame of the viewfinder that the problems of composition begin. This recognition, in real life, of a rhythm of surfaces, lines, and values is for me the essence of photography. . . . We compose almost at the moment of pressing the shutter. . . . Sometimes one remains motionless, waiting for something to happen; sometimes the situation is resolved and there is nothing to photograph. If something should happen, you remain alert, wait a bit, then shoot and go off with the sensation of having got something. Later you can amuse yourself by tracing out on the photo the geometrical pattern, or spatial relationships, realizing that, by releasing the shutter at that precise instant, you had instinctively selected an exact geometrical harmony, and that without this the photograph would have been lifeless.

Fig. 374 Ron Haeberle, Peter Brandt, and the Art Workers' Coalition, *Q. And Babies? A. And Babies*, 1970. Muscum of Modern Art, New York Gift of the Benefit for the Attica Defense Fund. Photo © The Muscum of Modern Art/Licensed by Scala/Art Besource, NY.

Fig. 375 Henri Cartier-Bresson, Athens, 1953. Magnum Photos, Inc.

Thus, in looking at this photograph (Fig. 375), we can imagine Cartier-Bresson walking down a street in Athens, Greece, one day in 1953, and coming across the second-story balcony with its references to the classical past. Despite the doorways behind the balcony, the second story appears to be a mere facade. Cartier-Bresson stops, studies the scene, waits, and then spies two women walking up the street in his direction. They pass beneath the two female forms on the balcony above, and, at precisely that instant, he releases the shutter. Cartier-Bresson called this "the decisive moment." Later, in the studio, the parallels and harmonies between street and balcony, antiquity and the present moment, youth and age, white marble and black dresses, stasis and change-all captured in this photograph—become apparent to him, and he prints the image.

These same conflicts between the ideal and the real animate Margaret Bourke-White's *At the Time of the Louisville Flood* (Fig. 376). Far less subtle than Cartier-Bresson's image, Bourke-White juxtaposes the dream of white America against the reality of black American lives. The dream is a flat, painted surface, the idealized space of the advertising billboard. In front of it, real people wait, indifferent in their hunger.

Fig. 376 Margaret Bourke-White,

"At the Time of the Louisville Flood," 1937. Black and white photograph, *Life* magazine. © Getty Images/Time Life Pictures

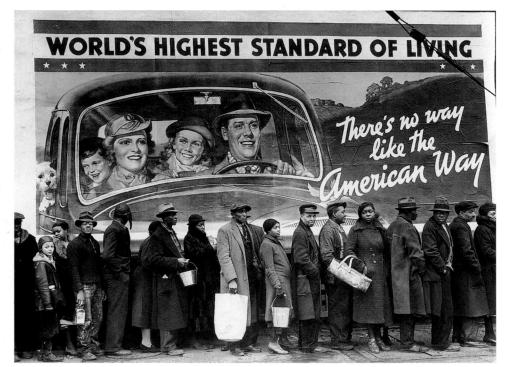

Bourke-White shot the scene in January 1937, on assignment for *Life* magazine. The Ohio River had flooded, inundating Louisville, Kentucky, and killing or injuring more than 900 people. Bourke-White flew into the city on the last flight before the airfield was flooded out. She hitchhiked on rowboats that were delivering food packages and searching for survivors. She shot photos of the churning river from a raft. *Life* ran *At the Time of the Louisville Flood* as its lead in a story featuring Bourke-White's photographs.

Life magazine, which started publication in November 1936, was conceived as a photojournalistic enterprise—heavy on pictures, light on words—and it became one of the primary outlets for American photography for the next 30 years. According to Bourke-White, it taught photographers an important lesson: "Pictures can be beautiful, but must tell facts too." Photographs have to balance form and content. But whatever *Life*'s emphasis on content, the magazine still provided an enormous opportunity for creative work. "I could almost feel the horizon widening and the great rush of wind sweeping in," Bourke-White wrote of the magazine's arrival on the scene. "This was the kind of magazine that could be anything we chose to make it . . . everything we could bring to bear would be swallowed up in every piece of work we did."

Color Photography

In color photography, the formal tensions of black-and-white photography are not necessarily lost. Early in his career Joel Meyerowitz worked mostly in black and white, but in the mid-1970s, in a continuing series of photographs taken at Cape Cod, in Massachusetts, he started to work in color. He often takes advantage of dynamic color contrasts, especially complementary color schemes that create much of the same kind of tension that we discover in black-and-white work. In *Porch, Provincetown* (Fig. 377), the deep blue sky, lit up by a bolt of lightning, contrasts dramatically with the hot orange

Fig. 377 Joel Meyerowitz, Porch, Provincetown, 1977. (Lightning bolt, C/L Plate 7.) Courtesy of Joel Meyerowitz.

electric light emanating from the interior of the house. Here we have a perfect example of what Cartier-Bresson described as "the decisive moment." By releasing the shutter at this precise instant, Meyerwitz not only captures the contrasting colors of the scene, but he also underscores the tension between the peacefulness of the porch and the wildness of the night in the contrast between the geometry of the house and the jagged line of the lightning bolt itself.

New Technologies: Digital Photography

We tend to forget today that color photography was itself a new technology introduced to the public at large in the 1950s and 60s. The rise of color photography in the 1960s coincides with the growing popularity of color television. On February 17, 1961, when NBC first aired all of its programs in color, only 1 percent of American homes possessed color sets. By 1969, 33 percent of American homes had color TVs, and today they command almost 100 percent of the market. The advent of the Polaroid camera and film, and inexpensive color processing for Kodak film, both contributed to a growing cultural taste for color images.

In the last few years, digital technologies have been introduced into the world of photography, rendering film obsolete and transforming photography into a highly manipulable medium. German photographer Andreas Gursky utilizes digital technologies to present his vision of a world dominated by high-tech industries who view the marketplace as the ultimate "image." By creating photographs as large as 16 feet wide, Gursky immerses us in this corporate vision, a literal panorama of commerce. In 99 Cent (Fig. 378), he saturates our view with a wild field of undeniably attractive color. As literally "full" as the image is, emotionally-and spiritually-it remains empty, a view into our own human isolation. Digitally, Gursky has eliminated all atmospheric perspective, and he has no doubt emphasized the color saturation of the scene, but if the scene is technically "inauthentic," the viewer must ask just how "authentic" anything in the world of "99 cent" shopping really is.

Fig. 378 Andreas Gursky, 99 Cent, 1999.

Cibachrome print mounted on Plexiglass in artist's frame, 81 1/2 × 132 5/8 in. The Broad Art Foundation, Santa Monica, California. © 2007 Andreas Gursky/Artist Rights Society (ARS) New York /VG Bild-Kunst, Bonn.

FILM

As we saw in Chapter. 4, almost as soon as photography was invented, people sought to extend its capacities to capture motion. Eadweard Muybridge captured the locomotion of animals (see Fig. 74) and Etienne-Jules Marey the locomotion of human beings (see Fig. 75) in sequences of rapidly exposed photos. It was, in fact, the formal revelations of film that first attracted artists to it. As forms and shapes repeated themselves in time across the motion picture screen, the medium seemed to invite the exploration of rhythm and repetition as principles of design. In his 1924 film *Ballet Mécanique* (Fig. 379), the Cubist

Fig. 379 Fernand Léger, Ballet Mécanique, 1924.
 Courtesy The Humanities Film Collection, Center for the Humanities, Oregon State University.
 (© 2007 Artists Rights Society (ARG), New York/ADAGP, Paris.

painter Fernand Léger chose to study a number of different images—smiling lips, wine bottles, metal discs, working mechanisms, and pure shapes such as circles, squares, and triangles. By repeating the same image again and again at separate points in the film, Léger was able to create a visual rhythm that, to his mind, embodied the beauty—the ballet—of machines and machine manufacture in the modern world.

Assembling a film, the process of editing, is a sort of linear collage, as Léger plainly shows. Although the movies may seem true to life, as if they were occurring in real time and space, this effect is only an illusion accomplished by means of editing. Editing is the process of arranging the sequences of a film after it has been shot in its entirety. It is perhaps not coincidental that as film began to come into its own in the second decade of the twentieth century, collage, constructed by cutting and pasting together a variety of fragments, was itself invented.

The first great master of editing was D. W. Griffith who, in *The Birth of a Nation* (Fig. 380), essentially invented the standard vocabulary of filmmaking. Griffith sought to create visual variety in the film by alternating between and among a repertoire of **shots**, each one a continuous sequence of film frames. A **full shot** shows the actor from head to toe, a **medium shot** from the waist up, a **close-up** the head and shoulders, and an **extreme close-up** a portion of the face. The image of the battle

Fig. 380 D. W. Griffith, battle scene from "The Birth of a Nation," 1915. The Museum of Modern Art/Film Stills Archive.

Courtesy of the Library of Congress

Fig. 381 Sergei Eisenstein, four stills from Battleship Potemkin, 1925. Goskino. Courtesy of The Kobal Collection.

scene reproduced here is a long shot, a shot that takes in a wide expanse and many characters at once. Griffith makes use of another of his techniques in this shot as well—the edge of the film is blurred and rounded in order to focus the attention of the viewer on the scene in the center. This is called an **iris shot**.

Related to the long shot is the pan, a name given to the panoramic vista, in which the camera moves across the scene from one side to the other. Griffith also invented the traveling shot, in which the camera moves back to front or front to back. In editing, Griffith combined these various shots in order to tell his story. Two of his more famous editing techniques are cross-cutting and flashbacks. The flashback, in which the editor cuts to narrative episodes that are supposed to have taken place before the start of the film, is now standard in film practice, but it was an entirely original idea when Griffith first utilized it. Cross-cutting is an editing technique meant to create high drama. The editor moves back and forth between two separate events such as someone in jeopardy and the hero fighting his way to the rescue—in ever shorter sequences, the rhythm of shots eventually becoming furiously paced. Griffith borrowed these techniques of fiction writing to tell a visual story in film.

One of the other great innovators of film editing was the Russian filmmaker Sergei Eisenstein. Eisenstein did his greatest work in Bolshevik Russia after the 1917 revolution, in a newly

formed state whose leader, Vladimir Lenin, had said, "Of all the arts, for us the cinema is the most important." In this atmosphere, Eisenstein created what he considered a revolutionary new use of the medium. Rather than concentrating on narrative sequencing, he sought to create a shock in his film that would ideally lead the audience to perception and knowledge. He called his technique montage-the sequencing of widely disparate images to create a fast-paced, multifaceted image. In the famous "Odessa Steps Sequence" of his 1925 film Battleship Potemkin, four frames of which are reproduced here (Fig. 381), Eisenstein utilized 155 separate shots in 4 minutes and 20 seconds of film, an astonishing rate of 1.6 seconds per shot. The movie is based on the story of an unsuccessful uprising against the Russian monarchy in 1905, and the sequence depicts the moment when the crowd pours into the port city of Odessa's harbor to welcome the liberated ship Potemkin. Behind them, at the top of the steps leading down to the pier, soldiers appear, firing on the crowd. In the scene, the soldiers fire, a mother lifts her dead child to face the soldiers. women weep, and a baby carriage careens down the steps. Eisenstein's "image" is all of these shots combined and more. "The strength of montage resides in this," he wrote, "that it involves the creative process-the emotions and mind of the spectator . . . assemble the image."

The thrust of Eisenstein's work is to emphasize action and emotion through enhanced time sequencing. Just the opposite effect is created

Fig. 382 Janet Leigh. Scene still from *Psycho 1960*. Directed and produced by Alfred Hitchcock. Picture Desk Inc./Kobal Collection.

by Douglas Gordon in his 1993 24 Hour Psycho (Fig. 382). Gordon's work is an extreme slow motion video projection of Alfred Hitchcock's 1960 classic film *Psycho*. As opposed to the standard 24 frames per second, Gordon projects the film at 2 frames per second, extending the playing time of the movie to a full 24 hours. Hitchcock's original in fact utilizes many of Eisenstein's time sequencings to create a film of uncanny tension. But Gordon's version so slows Hitchcock's pace that each action is extended, sometimes excruciatingly so—as in the famous shower scene. To view either film is to understand the idea of *duration* in terms one might have never before experienced.

The Popular Cinema

However interesting Gordon's 24 Hour Psycho might be on an intellectual level, and however much it might transform our experience of and appreciation for Hitchcock's film, it is not the kind of movie that most audiences would appreciate. Audiences expect a narrative, or story, to unfold, characters with whom they can identify, and action that thrills their imaginations. In short, they want to be entertained. After World War I, American movies dominated the screens of the world like no other mass media in history, precisely because they entertained audiences so completely. And the name of the town where these entertainments were made became synonymous with the industry itself—Hollywood.

The major players in Hollywood were Fox and Paramount, the two largest film companies, followed by Universal and Metro-Goldwyn-Mayer (M-G-M). With the introduction of sound into the motion picture business in 1926, Warner Brothers came to the forefront as well. In addition, a few well-known actors, notably Douglas Fairbanks, Mary Pickford, and Charlie Chaplin, maintained control over the financing and distribution of their own work by forming their own company, United Artists. Their ability to do so, despite the power of the other major film companies, is testimony to the power of the **star** in Hollywood.

The greatest of these stars was Charlie Chaplin who, in his famous role of the tramp, managed to merge humor with a deeply sympathetic character who could pull the heartstrings of audiences everywhere. In *The Gold Rush*, an 80 minute film made in 1925, much of it filmed on location near Lake Tahoe in the Sierra Nevada mountains of Califonia, he portrayed the abyssmal conditions faced by miners working in the Klondike gold fields during the Alaska gold rush of 1898. One scene in this movie is particularly poignant—and astonishingly funny: together with a fellow prospector, Big Jim, a starving Charlie cooks and eats, with relish and delight, his old leather shoe (Fig. 383).

Fig. 383 Charlie Chaplin in *The Gold Rush*, 1925. United Artists. Everett Collection.

The Gold Rush is a silent film, but a year after it was made, Warner Brothers and Fox were busy installing speakers and amplification systems in theaters as they perfected competing sound-on-film technologies. On October 6, 1927, the first words of synchronous speech uttered by a performer in a feature film were spoken by Al Jolson in *The Jazz Singer*: "Wait a minute. Wait a minute. You ain't heard nothing yet." By 1930, the conversion to sound was complete.

For the next decade, the movie industry produced films in a wide variety of genres, or narrative types-comedies, romantic dramas, war films, horror films, gangster films, and musicals. By 1939, Hollywood had reached a zenith. Some of the greatest films of all time date from that year, including the classic western Stagecoach, starring John Wayne, Gone with the Wind, starring Vivien Leigh and Clark Gable, and Mr. Smith Goes to Washington, starring Jimmy Stewart. But perhaps the greatest event of the year was the arrival of 24-year-old Orson Welles in Hollywood. Welles had made a name for himself in 1938 when a Halloweennight radio broadcast of H. G. Wells's novel War of the Worlds convinced many listeners that Martians had invaded New Jersey. Gathering the most talented people in Hollywood around him, he produced, directed, wrote, and starred in Citizen Kane, the story of a media baron modeled loosely on newspaper publisher William Randolph Hearst. Released in 1941 to rave reviews, the film utilized every known trick of the filmmaker's trade, with high-angle and low-angle shots (Fig. 384), a wide variety of editing effects, including dissolves between scenes, and a narrative technique, fragmented and consisting of different points of view, unique to film at the time. All combined to make a work of remarkable total effect that still stands as one of the greatest achievements of American popular cinema.

The year 1939 also marked the emergence of color as a major force in the motion picture business. The first successful full-length Technicolor film had been *The Black Pirate*, starring Douglas Fairbanks, released in 1926, but color was considered an unnecessary ornament, and audiences were indifferent to it. However, audiences reacted differently to the release of *Gone with the Wind*, with its

Fig. 384 *CITIZEN KANE*, © 1941 The Kobal Collection/RKO. Warner Brothers Motion Picture Titles.

4 hours of color production. And when, in *The Wizard of Oz* (Fig. 385), Dorothy arrives in a full-color Oz, having been carried off by a tornado from a black-and-white Kansas, the magical transformation of color became stunningly evident.

Fig. 385 *"The Wizard of Oz,"* © 1939 The Kobal Collection/MGM. Warner Brothers Motion Picture Titles.

Fig. 386 Five stills from "The Sorcerer's Approntice" in *Fantasia*, 1940. © Disney Enterprises, Inc.

Meanwhile, Walt Disney had begun to create feature-length animated films in full color. The first was Snow White and the Seven Dwarfs, in 1937, which was followed, in 1940, by both Pinocchio and Fantasia. Animation, which means "bringing to life," was suggested to filmmakers from the earliest days of the industry when it became evident that film itself was a series of "stills" animated by their movement in sequence. Obviously, one could draw these stills as well as photograph them. But in order for motion to appear seamless, and not jerky, literally thousands of drawings need to be executed for each film, up to 24 per second of film time. "The Sorcerer's Apprentice" section of Fantasia (Fig. 386) was conceived as a vehicle to reinvigorate the stock Disney cartoon character of Mickey Mouse. Donning the sorcerer's cap, Mickey commands a broom to do all his work for him, and the Disney animators soon multiplied and accelerated the broom's every move into a virtual army of whirling dervishes. As a film, Fantasia is itself an experiment in animation, an anthology of human fantasy freed of the constraints of reality, somewhat more successful than the experiment of the sorcerer's apprentice.

In the years after World War II, the idea of film as a potential art form resurfaced, especially in Europe. Fostered in large part by international film festivals, particularly in Venice and Cannes, this new "art cinema" brought directors to the fore, seeing themselves as the auteurs, or "authors," of their works. Chief among these was the Italian director Federico Fellini, whose film about the decadent lifestyle of 1960s Rome, *La Dolce Vita*, earned him an international reputation. Close on his heels was the Swedish director Ingmar Bergman and the French "New Wave" directors Jean-Luc Godard and Alain Resnais.

By the end of the 1960s, Hollywood had lost its hold on the film industry, and most films had become international productions. But, a decade later, Hollywood had regained control of the medium when, in 1977, George Lucas's *Star Wars* swept onto the scene. In many ways an anthology of stunning special effects, the movie had made over \$200 million even before its highly successful twentieth-anniversary re-release in 1997, and it inaugurated an era of "blockbuster" Hollywood attractions, including *E.T.*, *Titanic*, *The Lord of the Rings* trilogy, and the *Harry Potter* series.

VIDEO

One of the primary difficulties faced by artists who wish to explore film as a medium is the sheer expense of using it. The more sophisticated a film is in terms of its camera work, lighting, sound equipment, editing techniques, and special effects, the more expensive it is to produce. With the introduction in 1965 of the relatively inexpensive hand-held video camera, the Sony Portapak, artists were suddenly able to explore the implications of seeing in time. Video is not only cheaper than film but it is also more immediate-that is, what is seen on the recorder is simultaneously seen on the monitor. While video art tends to exploit this immediacy, commercial television tends to hide it, by attempting to make videotaped images look like film.

Nam June Paik was one of the first people in New York to buy a Portapak. Since the late 1950s, he has been making video installations, exploring the limits and defining characteristics of the medium. His *TV Buddha* (Fig. 387), for example, perpetually contemplating itself on the screen, is a self-contained version of Warhol's exercises in filmic duration. The work is deliberately and playfully ambiguous. It includes an inanimate stone sculpture shown "live" on TV. It is both peacefully meditative and mind-numbingly boring, simultaneously an image of complete wholeness and absolute emptiness. It represents, in short, the best and worst of TV.

The playfulness that Paik employs in *TV Buddha* is equally evident in the wordplay that underlies his *TV Bra for Living Sculpture* (Fig. 388), a literal realization of the "boob tube." The piece is a collaborative work, executed with the avant-garde musician Charlotte Moorman. Soon after Paik's arrival in New York in 1964, he was introduced to Moorman by the composer Karl-

Fig. 387 Nam June Paik, *TV Buddha*, 1974–1982. Mixed media, 55 × 115 × 36 in. Photo: Peter Moore. © Estate of Peter Moore/Licensed by VAGA, New York

Fig. 388 Nam June Paik, *TV Bra for Living Sculpture*, 1969. Performance by Charlotte Moorman with television sets and cello. Photo: Peter Moore. © The Estate of Peter Moore/Licensed by VAGA, New York

heinz Stockhausen. Moorman wanted to perform a Stockhausen piece called Originale, but the composer would grant permission only if it was done with the assistance of Paik, who had performed the work many times. Paik's role was to cover his entire head with shaving cream, sprinkle it with rice, plunge his head into a bucket of cold water, and then accompany Moorman's cello on the piano as if nothing strange had occurred. So began a long collaboration. Like all of Paik's works, TV Bra's humor masks a serious intent. For Paik and Moorman, it was an attempt "to humanize the technology . . . and also stimulate viewers . . . to look for new, imaginative, and humanistic ways of using our technology." TV Bra, in other words, is an attempt to rescue the boob tube from mindlessness.

The clichéd mindlessness of commercial television has been hilariously investigated in a vast number of short videos by William Wegman. In one, called *Deodorant*, the artist simply sprays an entire can of deodorant under one armpit while he extols its virtues. The video, which is about the same length as a normal television commercial, is an exercise in consumerism run amok. In *Rage and Depression* (Fig. 389), Wegman sits smiling at the camera as he speaks the following monologue:

I had these terrible fits of rage and depression all the time. It just got worse and worse and worse. Finally my parents had me committed. They tried all kinds of therapy. Finally they settled on shock. The doctors brought me into this room in a straight jacket because I still had this terrible, terrible temper. I was just the meanest cuss you could imagine, and when they put this cold, metal electrode, or whatever it was, to my chest, I started to giggle and then when they shocked me, it froze on my face into this smile, and even though I'm still incredibly depressed—everyone thinks I'm happy. I don't know what I'm going to do.

Wegman completely undermines the authority of visual experience here. What our eyes see is an illusion. He implies that we can never trust what we see, just as we should not trust television's objectivity as a medium.

As forms of art, film and video are not the same as the movies and television. Film and video art seek to do more than merely entertain. They seek to discover new possibilities in

Fig. 389 William Wegman, Still from *Rage and Depression, Reel 3*, 1972–1973. Video, approx. 1 min. Courtesy of the artist.

their mediums, to transcend, in fact, the limitations inherent in producing work for the corporate film industry and the commercial networks. Photography, too, has its commercial and journalistic side. It is an inherently informational medium, but it transcends that limitation—its ability to record the facts—by presenting its content in a formally beautiful or interesting way. Obviously, there are great commercial and journalistic photographs just as there are great commercial films and even television shows. But what separates the art of photography, film, and video from mainstream production is the *aesthetic* sense. When a photograph or a film or a video triggers a higher level of thought and awareness in the viewer, when it stimulates the imagination, then it is a work of art.

At the end of Chapter 8, we discussed a video installation by Bill Viola to sum up the ways in which all the formal elements come into play (see Figs. 219 and 220). (One of the video installations he created as the American representative to the Venice Biennale in 1995 is the subject of the *Works in Progress* on p. 294.) Another of his installations,

Stations (Fig. 390), consists of five video projections focusing on the human body submerged in water. Five cloth screens, three of which are visible in this reproduction, are suspended from the ceiling of a large, dark open space. Polished granite slabs lie flat on the floor underneath each screen. The projections of the floating bodies are upside down, causing their reflections on the polished granite below to appear rightside up. Underwater sounds can be heard near each screen. The images slowly drift out of the frame and then, suddenly, plunge into the water. Water, for Viola, is a kind of tangible space. In it, the body's relation to space becomes clear. The piece strips away the viewer's sense of gravity. Nothing is what it seems here. The reflecting pools are granite, up becomes down, to fall is to rise. The installation positions us somewhere between the dream state, our memory of birth, and the soul's flight from the body after death.

Iranian-born but U.S.-educated video artist Shirin Neshat's work concerns itself with what might best be called the soul of the Middle East. *Passage* (Fig. 391), commissioned

Fig. 390 Bill Viola, *Stations*, 1994.

Video/sound installation. Commissioned by the Bohen Foundation for the inaugural opening of the American Center, Paris. © Bill Viola Studio. Photo: Charles Duprat.

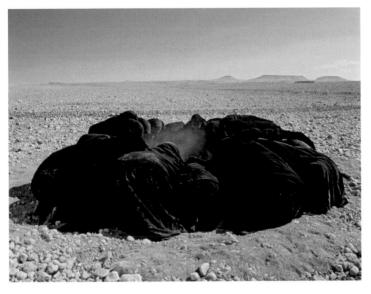

by composer Philip Glass in 2001, was inspired by televised images of violence and mourning in Palestine, specifically clashes between stone-throwing Palestinians and Israeli soldiers, and the sight of Palestinian bodies held aloft in funeral processions. Sound is fundamental to the aesthetic power of the work, and Glass's orchestration rhythmically underscores the ritualized movements of the funerary procession of men. The men carry a shrouded corpse across the sand dunes and down a beach. Chador-covered women, in a small circular group, dig a grave with their hands. As the funerary procession approaches the grave site-the linear column of men meeting the circular huddle of women-a fire seems to emerge from a pile of stones on which a young girl has been placing twigs. The fire surrounds both men and women as if to enforce the idea that their mourning and tragedy is part and parcel of the elemental forces of nature that surround them-earth, water, air, and fire. The child looks on, perhaps the very embodiment of the future.

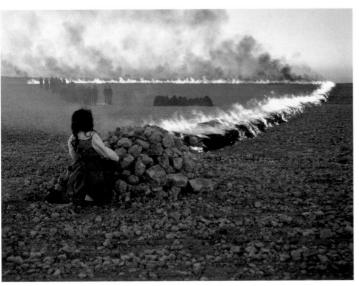

Fig. 391 Shirin Neshat, "Passage, 2001".

One of three stills. Color video installation with sound, 00:11:40, dimensions vary with installation. Edition 5/6. Solomon R. Guggenheim Museum, New York, Purchased with funds contributed by the International Director's Council and Executive Committee Members. 2001.71.

WORKS IN PROGRESS

hen video artist Bill Viola first saw a reproduction of Jacopo Pontormo's 1528 painting The Visitation (Fig. 393), he knew that he had to do something with it. Asked to be the American representative at the 1995 Venice Biennale, perhaps the oldest and most prestigious international arts festival, he decided to see if he could create a piece based on Pontormo's painting for the exhibition. He intended to convert the entire United States Pavilion into a series of five independent video installations, which he called, as a whole, "Buried Secrets." By "buried secrets" he meant to refer to our emotions, which have for too long lain hidden within us. "Emotions," he says, "are precisely the missing key that has thrown things out of balance, and the restoration to their right place as one of the higher orders of the mind of a human being cannot happen fast enough."

What fascinated Viola about Pontormo's painting was, first of all, the scene itself. Two women meet each other in the street. They embrace as two other women look on. An instantaneous knowledge and understanding seems to pass between their eyes. The visit, as told in the Bible by Luke (I:36-56), is of the Virgin Mary to Elizabeth. Mary has just been told by the angel Gabriel: "You shall conceive and bear a son, and you shall give him the name Jesus," the moment of the Annunciation. In Pontormo's painting, the two women, one just pregnant with Jesus, the other six months pregnant, after a lifetime of barrenness, with the child who would grow to be John the Baptist, share each other's joy. For Viola, looking at this work, it is their shared intimacy-that moment of contact in which the nature of their relationship is permanently changed-that most fascinated him. Here was the instant when we leave the isolation of ourselves and enter into social relations with others. Viola decided that he wanted to re-create this encounter, to try to capture in media such as film

or video—media that can depict the passing of time—the emotions buried in the moment of the greeting itself.

In order to re-create the work, Viola turned his attention to other aspects of the composition. He was particularly interested in how the piece depicted space. There seemed to him to be a clear tension between the deep space of the street behind the women and the space occupied by the women themselves. He made a series of sketches of the hypothetical street behind the women (Fig. 392); then, working with a set designer, re-created it. The steep, odd perspective of the buildings had to fit into a 20-foot-deep sound stage. He discovered that if he filled the foreground with four women, as in the Pontormo painting, much of the background would be lost. Furthermore, the fourth woman in the painting presented dramatic difficulties. Removed from the main group as she is, there was really little for her to do in a re-creation of the scene involving live action.

Fig. 392 Bill Viola, sketch for *The Greeting Set*, 1995. Courtesy of Bill Viola Studio.

Bill Viola's THE GREETING

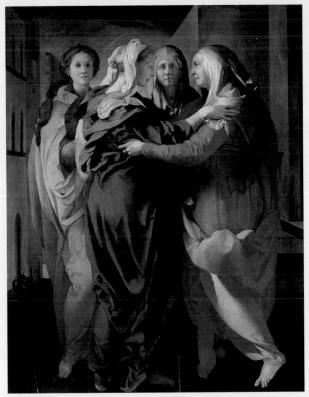

Fig. 393 Jacopo da Pontormo, The Visitation, 1528.
Oil on canvas, 79 ½ × 61 ⅔ in. Pieve di S. Michele, Carmignano, Italy.
© Canali Photobank, Capriolo, Italy.

A costume designer was hired; actors auditioned, were cast, and then rehearsed. On Monday, April 3, 1995, on a sound stage in Culver City, California, Viola shot *The Greeting*. He had earlier decided to shoot the piece on film, not video, because he wanted to capture every nuance of the moment. On an earlier project, he had utilized a special high-speed 35-millimeter camera that was capable of shooting an entire roll of film in about 45 seconds at a rate of 300 frames per second. The camera was exactly what he needed for this project. The finished film would run for more than 10 minutes. The action it would record would last for 45 seconds.

"I never felt more like a painter," Viola says of the piece. "It was like I was moving color around, but on film." For 10 slow-motion minutes, the camera never shifts its point of view. Two women stand talking on a street, and a third enters from the left to greet them. An embrace follows (Fig. 394).

Viola knew, as soon as he saw the unedited film, that he had what he wanted, but questions still remained. How large should he show the piece? On a table monitor, or larger than lifesize, projected on a wall? He could not decide at first, but at the last minute he determined that he would project it. On the day of the Venice Biennale opening, he saw it in its completed state for the first time, and for the first time since filming it, he saw it with the other key element in video-sound. It seemed complete as it never had before. Gusts of wind echo through the scene. Then the woman in red leans across to the other and whispers, "Can you help me? I need to talk with you right away." Joy rises to their faces. Their emotions surface. The wind lifts their dresses, and they are transformed.

Fig. 394 Bill Viola, *"The Greeting,"* 1995. Video/sound installation. Commissioner, Marilyn Zeitlin. Arizona State University Art Museum, Tempe, Arizona. © Bill Viola Studio. Photo: Kira Perov.

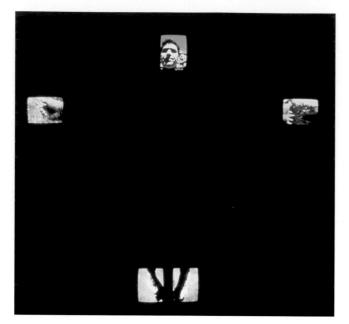

In his video installation Crux (Figs. 395 and 396), made in the mid-1980s, Gary Hill transforms the traditional imagery of the Crucifixion. The installation consists of five television monitors mounted on a wall in the shape of a cross. Hill shot the piece on a deserted island in the middle of the Hudson River in New York. Attached to his body were five video cameras, one on each shin facing his feet, one braced in front of his face and pointed directly back at him, and one on each arm aimed at his hands, which he extended out from his body. On his back, he carried all the necessary recording equipment and power packs. The cameras recorded his barefooted trek across the island, through the woods and an abandoned armory, to the river's edge. The 26-minute journey captures all the agony and pain of Christ's original ascent of Golgotha, as he carried his own cross to the top of the hill where he was crucified. But all we see of Hill's walk are his two bruised and stumbling feet, his two hands groping for balance, and his exhausted face. The body that connects them is absent, a giant blank spot on the gallery wall. This absence not only suggests the disappearance of Christ's body after the

Fig. 396 Gary Hill, *Crux*, 1983–1987. Five-channel video/sound installation. Five color monitors, five-channel synchronizer, three amplifiers, five speakers, five laser disk players, and five laser disks. Production shot at Bannerman's Island by Ulam Curjel. Courtesy Donald Young Gallery, Chicago.

Resurrection, but it is also the "crux" of the title. A "crux" is a cross, but it is also a vital or decisive point ("the crux of the matter"), or something that torments by its puzzling nature. By eliminating his body, Hill has discovered a metaphor for the soul—that puzzling energy that is spiritually present but physically absent.

COMPUTER- AND INTERNET-BASED ART MEDIA

If the image on a computer monitor is literally two-dimensional, the screenspace occupied by the image is, increasingly, theatrical, interactive, and time-based. In his groundbreaking study of the global digital network, *E-topia* (MIT Press, 1999), William J. Mitchell, Dean of the School of Architecture and Planning at the Massachusetts Institute of Technology, puts it this way:

In the early days of PCs, you just saw scrolling text through the rectangular aperture [of your personal computer], and the theatrical roots of the configuration were obscured. . . . [But] with the emergence of the PC, the growth of networks, and ongoing advances in display technology, countless millions of glowing glass rectangles scattered through the world have served to construct an increasingly intricate interweaving of cyberspace and architecture... As static tesserae were to the Romans, active pixels are to us. Signs and labels are becoming dynamic, text is jumping off the page into three-dimensional space, murals are being set in motion, and the immaterial is blending seamlessly with the material.

Architecture is no longer simply the play of masses in light. It now embraces the play of digital information in space.

It is hardly coincidental that artists have leapt into this domain. One important innovator in the field is John F. Simon, Jr., who creates computer programs, each of which quickly generates a wealth of images. For his 1997 project, Every Icon, he created a Java applet, a small program that automatically downloads from the Internet and runs on a computer's hard drive. It generates every possible combination of blackand-white squares in a grid of 32×32 , or a total of 1,024 squares, beginning with all white squares and ending with all black. On an average home computer, it would take several hundred trillion years for the process to conclude, which is Simon's way of "making you think about a very, very long time." Inspired by the instruction- and rule-based work of artists like Sol LeWitt (see Fig. 105), Simon automates and accelerates their processes with digital technologies. His Internet-based work, Unfolding Object (Fig. 397), was originally a blank square visible on a Web page. As visitors from across the globe encounter the square, it unfolds, new facets branching off the original shape, generating lines and shapes according to rules built into the program. For example, each leaf of this "book" that has been turned four times in the past is marked with four vertical lines; a horizontal line, meanwhile, stands for 10 such unfoldings. Simon means for Unfolding Object to place the beholder in a communal, if virtual, space.

Another Internet artist who is interested in the possibilities resulting from the global digital network is Mark Napier. For Napier, the Internet represents a new, borderless landscape

Fig. 397 John F. Simon, Jr., Unfolding Object, 2002. Interactive networked code: Java applet with server database and servlets, dimensions variable. Solomon R. Guggenheim Museum, New York. 2002.16. © 2004 John F. Simon, Jr.

occupied by people from various geographical regions and ideologies. Its flag, then, must be as versatile and multiplicitous as its inhabitants. Napier's Internet project *net.flag* (Fig. 398), accessible at netflag.guggenheim.org, changes constantly in something of an online version of Yukinori Yanagi's *World Flag Ant Farm* (see Fig. 16), only now Yanagi's ants have been supplanted by people making selections from menus of familiar flag motifs: stars, fields of color, bold patterns, insignia, and stripes. As viewers add their contributions to the palimpsest, the cumulative identity of the flag

Fig. 398 Mark Napier, net.flag, 2002. Interactive networked code: Java applet with server database, dimensions variable. Solomon R. Guggenheim Museum, New York. 2002.17. © Courtesy of the artist. changes as one country's insignia or symbols temporarily overlap those of another. Emblems of national identity lose their immutability and become malleable sources for the ever-changing flag of the Internet. The visitor to net.flag can easily change the flag to reflect his or her own nationalist, political, apolitcal, or territorial agenda. In the example shown here, the white stripes of the United States flag are replaced with the green of Islam, suggesting a new relationship between a superpower and a world religion that is as frightening to some as it is amusing to others.

Jon Ippolito, an associate curator at the Guggenheim Museum, explains: "In a world

where global trade, facilitated by telecommunications and e-commerce, has blurred national borders, nationalism in general had seemed increasingly to be losing its relevance—until September 11, 2001. In the months following the attacks, nationalistic fervor increasingly gave way to the realization that isolated sovereignty was untenable in a global economy. What happens to an emblem of solitary statehood when that state's internal affairs become entangled with geopolitical commitments? How can the notion of a flag reflect the new reality rather than pining for a nostalgic sovereignty that no longer exists? *net.flag* is one answer to those questions."

THE **CRITICAL** PROCESS Thinking About the Camera Arts

Jeff Wall's *A Sudden Gust of Wind* (Fig. 400) is a large, backlit photographic image modeled on a nineteenth-century Japanese print by

Hokusai, Shunshuu Ejiri (Fig. 399), from the series Thirty-Six Views of Mount Fuji, which also includes The Great Wave of Kanagawa

Fig. 399 Sakino Hokusai, Shunshuu Ejiri, from the series Thirty-Six Views of Mount Fuji, 1831. Color woodblock, 30 ¹/₂ × 46 ft. The Japan Ukiyo-e Museum, Matsumoto City, Japan.

Fig. 400 Jeff Wall, A Sudden Gust of Wind (After Hokusai), 1993.
 Fluorescent light and display case 90 ³/₁₆ × 148 ⁷/₁₆ in.
 Tate Gallery, London.
 Art Resource, New York.

(see Fig. 244). Wall's interest lies, at least in part, in the transformations contemporary culture has worked on traditional media. Thus his billboard-like photograph creates a scene radically different from the original. What sorts of transformations can you describe? Consider, first of all, the content of Wall's piece. What does it mean that businessmen inhabit the scene rather than Japanese in traditional dress? How has the plain at Ejiri-considered one of the most beautiful locations in all of Japan-been translated by Wall? And though Hokusai indicates Mount Fuji with a simple line drawing, why has Wall eliminated the mountain altogether? (Remember, Fuji is, for the Japanese, a national symbol, and it is virtually held in spiritual reverence.)

But perhaps the greatest transformation of all is from the print to the photograph. Wall's format, in fact, is meant to invoke cinema, and the scene is anything but the result of some chance photographic encounter. Wall employed professional actors, staged the scene carefully, and shot it over the course of nearly five months. The final image, in fact, consists of 50 separate pieces of film spliced together through digital technology to create a completely artificial but absolutely realistic scene. For Wall, photography has become "the perfect synthetic technology," as conducive to the creation of propaganda as art. What is cinematic about this piece? What does this say about the nature of film as a medium-not only photographic film but motion picture film? Where does "truth" lie? Can we-indeed, should we-trust what we see? If we can so easily create "believeable" imagery, what are the possibilities for belief itself? And, perhaps most important of all, why must we, engaged in the critical process, consider not just the image itself, but also the way the image is made, the artistic process?

Sculpture

ll of the media we have considered thus fardrawing, printmaking, painting, and the camera arts-are generally considered two-dimensional media. In this chapter, we turn to a discussion of the three-dimensional media and their relation to the space we ourselves occupy. Sculpture, the chief of these media, is one of the oldest and most enduring of all the arts. All the types of sculpture we will study in this chapter-carving, modeling, casting, construction and assemblage, installation art, earthworks, and even performance art-employ two basic processes: They are either subtractive or additive in nature. In subtractive processes, the sculptor begins with a mass of material larger than the finished work and removes material, or subtracts from that mass until the work achieves its finished form. Carving is a subtractive process. In additive processes, the sculptor builds the work, adding material as the work proceeds. Modeling, construction, and assemblage are additive processes. Casting, in which material in a liquid state is poured into a mold and allowed to harden, has additive aspects, but, as we

CARVING

Works In Progress Jim Sardonis's *Reverence*

MODELING

CASTING

ASSEMBLAGE

■ Works in Progress Eva Hesse's *Contingent*

INSTALLATION

EARTHWORKS

PERFORMANCE ART

■ Works in Progress Goat Island's *How Dear to Me the Hour When* Daylight Dies

> ■ The Critical Process Thinking about Sculpture

shall see, it is in many ways a process of its own. Earthworks often utilize both additive and subtractive processes. Installations and performance art are essentially additive, transforming a given space by addition of new elements, including the live human body.

In addition to these processes, there are three basic ways in which we experience sculpture in three-dimensional space—as relief, in the round, and as an environment. If you recall the process for making woodblock prints, which is described in Chapter 11, you will quickly understand that the raised portion of a woodblock plate stands out in relief against the background. The woodblock plate is, in essence, a carved relief sculpture, a sculpture that has three-dimensional depth but is meant to be seen from only one side.

Among the great masters of relief sculpture were the Egyptians, who often decorated the walls of their temples and burial complexes with intricate raised relief sculpture, most of which was originally painted. One of

the best preserved of these is the so-called "White Chapel," built by Senwosret I in about 1930 BCE at Karnak, Thebes, near the modern city of Luxor in the Nile River Valley. Like many great archeological finds, it has survived, paradoxically, because it was destroyed. In this case, 550 years after its construction, King Amenhotep III dismantled it and used it as filling material for a monumental gateway for his own temple at Karnak. Archeologists have thus been able to reconstruct it almost whole. The scene depicted (Fig. 401) is a traditional one, showing Senwosret I in the company of two Egyptian dieties and surrounded by hieroglyphs, the pictorial Egyptian writing system. On the left is Amun, the chief god of Thebes, recognizable by the two plumes that form his headdress and by his erect penis. In the middle, leading Senwosret, is Atum, the creator god. By holding the hieroglyph ankh (a sort of cross with a rounded top) to Senwosret I's nose, he symbolically grants him life.

Fig. 401 Senwosret I led by Atum to Amun-Re, from the White Chapel at Karnak, Thebes, c. 1930 BCE. Limestone, raised relief, height, 13 ft. 6 in. Scala/Art Resource, New York.

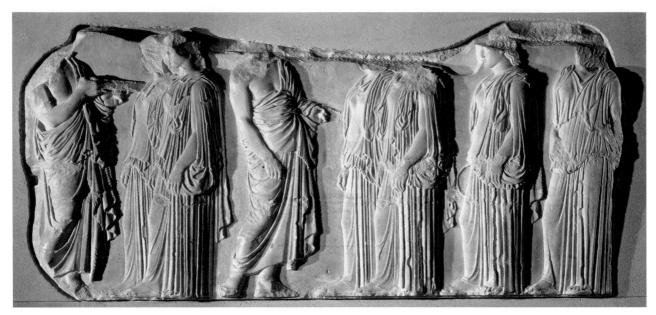

Fig. 402 Maidens and Stewards, fragment of the *Panathenaic Procession,* from the east frieze of the Parthenon, Acropolis, Athens, 447–438 BCE. Marble, height, approx. 43 in. Musée du Louvre, Paris. Marburg/Art Resource, New York.

Like the Egyptians, the Greeks used the sculptural art of relief as a means of decoration and to embellish the beauty of their great architectural achievements. Forms and figures carved in relief are spoken of as done in either low relief or high relief. (Some people prefer the French terms, bas-relief and haut-relief.) The very shallow depth of the Egyptian raised reliefs is characteristic of low relief, though technically any sculpture that extends from the plane behind it less than 180 degrees is considered low relief. High-relief sculptures project forward from their base by at least half their depth, and often several elements will be fully in the round. Thus, even though it possesses much greater depth than the Evgyptian raised relief at Karnak, the fragment from the frieze, or sculptural band, on the Parthenon called the Maidens and Stewards (Fig. 402) projects only a little distance from the background, and no sculptural element is detached entirely from it. It is thus still considered low relief. By contrast, Atlas Bringing Herakles the Golden Apples (Fig. 403), from the Temple of Zeus at Olympia, is an example of high relief. Here, the figures project from the background at least half their circumference, and other elements, like the left arm of Atlas, the righthand figure, float free.

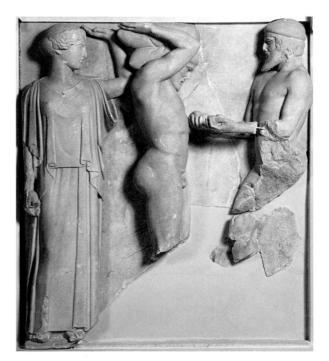

Fig. 403 Atlas Bringing Herakles the Golden Apples, from the Temple of Zeus, Olympia, c. 470–456 BCE. Marble, height, 63 in. Archaeological Museum, Olympia. Alinari/Art Resource, New York.

Of the two, the relief from the Temple of Zeus is the simpler and more direct in carving style. It depicts the moment in the story of Herakles when the giant Atlas returns from the Hesperides with the Golden Apples of immortality. In Atlas's absence, Herakles had assumed the giant's normal task of holding up the heavens on his back, assisted by a pillow that rests upon his shoulders. In the relief, his protectress, Athena, the goddess of wisdom, helps Herakles to support the weight of the sky so that he can exchange places with Atlas. The frontality of Athena's body is countered by the pure profile of her face, a profile repeated in the positioning of both Herakles and Atlas. Compared to the Egyptian relief sculpture at Karnak, where the head and legs are in profile, and the body squarely frontal, the frieze from Olympia seems highly naturalistic. Still, the composition of this relief is dominated by right angles, and, as a result, it is stiff and rigid, as if the urge to naturalism, realized, for instance, in the figure of Herakles, is as burdened by tradition as Herakles is himself weighed down.

The naturalism of the Parthenon frieze is much more fully developed. Figures overlap one another and are shown in three-quarter view, making the space seem far more natural and even deeper than that at Olympia, though it is, in fact, much shallower. The figures themselves seem almost to move in slow procession, and the garments they wear reveal real flesh and limbs beneath them. The carving of this drapery invites a play of light and shadow that further activates the surface, increasing the sense of movement.

Perhaps because the human figure has traditionally been one of the chief subjects of sculpture, movement is one of the defining characteristics of the medium. Even in relief sculptures it is as if the figures want to escape the confines of their base. Sculpture in-theround literally demands movement. It is meant to be seen from all sides, and the viewer must move around it. Giovanni da Bologna's The Rape of the Sabine Women (Fig. 404) is impossible to represent in a single photograph. Its figures rise in a spiral, and the sculpture changes dramatically as the viewer walks around it and experiences it from each side. It is in part the horror of the scene that lends the sculpture its power, for as it draws us around it, in order to see more of what is happening, it involves us both physically and emotionally in the scene it depicts.

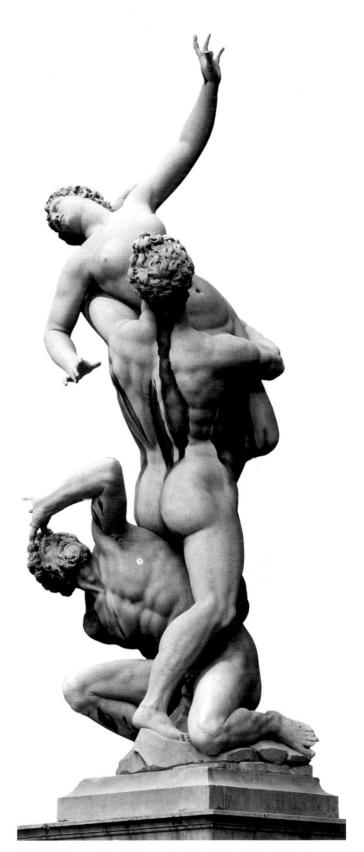

Fig. 404 Giovanni da Bologna, *The Rape of the Sabine Women*, completed 1583. Marble, height, 13 ft. 6 in. Loggia dei Lanzi, Florence. Alimat/Art Resource, New York.

Figs. 405 and 406 David Smith, Blackburn: Song of an Irish Blacksmith, frontal view at left; profile view at right, 1949–1950. Steel and bronze, 46 ¼ × 49 ¾ × 24 in. Wilhelm Lehmbruck Museum, Duisburg, Germany.
© Estate of David Smith/Licensed by VAGA. New York.

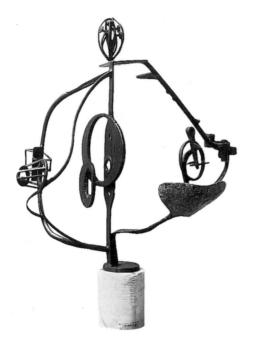

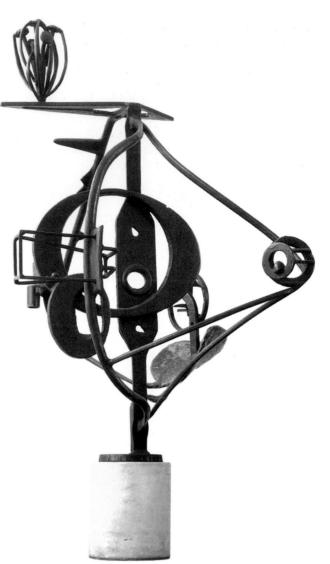

Looked at from different points of view, David Smith's *Blackburn: Song of an Irish Blacksmith* (Figs. 405 and 406) appears to be two entirely different works of art. The frontal view is airy and open, the work seeming to float in space like a series of notes and chords, while the profile view reveals the sculpture as densely compacted, a confusing jumble of forms from which two seem to want to escape, one at the top left, the other on the extreme right. The frontal view is almost symmetrical, the profile view radically asymmetrical.

The viewer is even more engaged in the other sculptural media we will discuss in this chapter—environments. An **environment** is a sculptural space into which you can physically enter either indoors, where it is generally referred to as an **installation**, or out-of-doors, where its most common form is that of the **earthwork**. With these terms in mind—relief sculpture, sculpture in-the-round, and environments—we can now turn to the specific methods of making sculpture.

CARVING

Carving is a subtractive process in which the material being carved is chipped, gouged, or hammered away from an inert, raw block of material. Wood and stone are the two most common carving materials. Both materials present problems for the artist to solve. Sculptors who work in wood must pay attention to the wood's grain, since wood will only split in the direction it grew. To work "against the grain" is to risk destroying the block. Sculptors who work in stone must take into account the different characteristics of each type of stone. Sandstone is gritty and coarse, marble soft and crystalline, granite dense and hard. Each must be dealt with differently. For Michelangelo, each stone held within it the secret of what it might become as a sculpture. "The best artist," he wrote, "has no concept which some single marble does not enclose within its mass. . . .

Fig. 407 Michelangelo, *Atlas' Slave*, c. 1513–1520. Marble, 9 ft. 2 in. Accademia, Florence. Nimotolloh/Art Resource, New York.

Taking away . . . brings out a living figure in alpine and hard stone, which . . . grows the more as the stone is chipped away." But carving is so difficult that even Michelangelo often failed to realize his concept. In his "*Atlas*" *Slave* (Fig. 407), he has given up. The block of stone resists Michelangelo's desire to transform it, as if refusing to release the figure it holds enslaved within it. Yet, arguably, the power of Michelangelo's imagination lies in his willingness to leave the figure unrealized. Atlas, condemned to bearing the weight of the world on his shoulders forever as punishment for challenging the Greek gods, is literally held captive in the stone.

Nativity (Fig. 408), by the Taos, New Mexico-born Hispanic sculptor Patrocinio Barela, is carved out of the aromatic juniper tree that grows across the arid landscape of the Southwest. Barela's forms are clearly dependent on the original shape of the juniper itself. The lines of his figures, verging on abstraction, follow the natural contours of the wood and its grain. The group of animals at the far left, for instance, are supported by a natural fork in the branch that is incorporated into the sculpture. The human figures in Barela's work are closely related to *santos*, images of the saints. Those who carve *santos* are known as *santeros*. Both have been

Fig. 408 Patrocinio Barela, *Nativity*, c. 1966. Juniper wood, height of tallest figure, 33 in. Private collection.

Fig. 409 King Menkaure (Mycerinus) and His Queen, Khamerenebty II. Egyptian, Old Kingdom, Dynasty 4, reign of Menkaure.

> c. 2490–2472 BCE. Giza, Menkaure Valley Temple. Greywacke. $56 \times 22 \frac{1}{2} \times 21 \frac{3}{4}$ in. Reproduced with permission. © 2006 Museum of Fine Arts, Boston. Harvard University-Boston Museum of Fine Arts. All Rights Reserved.

an important part of Southwestern Hispanic culture since the seventeenth century, serving to give concrete identity to the abstractions of Catholic religious doctrine. By choosing to work in local wood, Barela ties the local world of the everyday to the universal realm of religion, uniting material and spiritual reality.

This desire to unify the material and the spiritual worlds has been a goal of sculpture from the earliest times. In Egypt, for example, stone funerary figures (Fig. 409) were carved to bear the ka, or individual spirit, of the deceased into the eternity of the afterlife. The permanence of the stone was felt to guarantee the ka's immortality. (For a contemporary sculptor's use on the idea of stone's permanence see *Works in Progress*, on p. 308). For the ancient Greeks, only the gods were immortal. What tied the world of the gods to the world of humanity was beauty itself, and the most beautiful thing of all was the perfectly proportioned, usually athletic, male form.

Egyptian sculpture was known to the Greeks as early as the seventh century BCE, and Greek sculpture is indebted to it, but the Greeks quickly evolved a much more realistic, or naturalistic, style. In other words, compared with the rigidity of the Egyptian figures, this Kouros, or youth (Fig. 410), is both more at ease and more lifelike. Despite the fact that his feet have been lost, we can see that the weight of his body is on his left leg, allowing his right leg to relax completely. This youth, then, begins to move-we see him shift his weight to his left foot to take a step in one of the earliest examples of the principle of ponderation, or weight shift. The sculpture begins to be animated, to portray not just the figure but also its movement. It is as if the stone has begun to come to life. Furthermore, the Kouros is much more anatomically correct

Fig. 410 Kouros (also known as the Kritios Boy), c. 480 BCE. Marble, height, 36 in. Acropolis Museum, Athens. (Inv. no. 698.)

Fig. 411 Praxiteles, *Hermes and Dionysos*, c. 330 BCE. Marble, height, 7 ft. 1 in. National Archeological Museum, Athens. Scala/Art Besource, New York.

than his Egyptian forebear. In fact, by the fifth century BCE, the practice of medicine had established itself as a respected field of study in Greece, and anatomical investigations were commonplace. At the time that the *Kouros* was sculpted, the body was an object of empirical study, and its parts were understood to be unified in a single, flowing harmony.

This flowing harmony was further developed by Praxiteles, without doubt the most famous sculptor of his day. In works such as *Hermes and Dionysos* (Fig. 411), he shifted the weight of the body even more dynamically, so that Hermes's weight falls on his right foot, raising his right hip. This shift in weight is countered by a turn of the shoulders, so that the figure stands in a sort of S-curve. Known as **contrapposto**, or counter-balance, this pose became a favorite in the Renaissance, as artists strove to achieve greater and greater naturalistic effects.

Such naturalism is perhaps nowhere more fully realized in Greek sculpture than in the grouping *Three Goddesses* (Fig. 412), from the east pediment, or triangular roof gable, of the Parthenon. Though actually freestanding when seen from the ground, as it is displayed today in the British Museum, with the wall of the pedi ment behind them, the goddesses—commonly believed to be Aphrodite, the goddess of beauty, her mother Dione, and Hestia, the goddess of the

Fig. 412 Three Goddesses, from the east pediment of the Parthenon, Acropolis, Athens, c. 438–432 BCE. Marble, over-lifesize, British Museum, London. © The British Museum.

WORKS IN PROGRESS

tone is a symbol of permanence, and of all stones, black granite is one of the hardest and most durable. Thus, in 1988, when sculptor Jim Sardonis chose the stone out of which to carve his tribute to the whale, Reverence (Fig. 414), black granite seemed the most suitable medium. Not only was its color close to that of the whales themselves, but also the permanence of the stone stood in stark contrast to the species' threatened survival. Sardonis wanted the work to have a positive impact. He wanted it to help raise the national consciousness about the plight of the whale, and he wanted to use the piece to help raise funds for both the Environmental Law Foundation and the National Wildlife Federation, organizations that both actively engaged in wildlife conservation efforts.

The idea for the sculpture first came to Sardonis in a dream—two whale tales rising out of the sea. When he woke he saw the sculpture as rising out of the land, as if the land were an imaginary ocean surface. And, surprisingly, whales were not unknown to the area of New England where Sardonis worked. In 1849, while constructing the first railroad between Rutland and Burlington, Vermont, workers unearthed a mysterious set of bones near the town of Charlotte. Buried nearly 10 feet below the surface in a thick blue clay, they were ultimately determined to be the bones of a "beluga" or "white" whale, an animal that inhabits arctic and subarctic marine waters. Because Charlotte is far inland (more than 150 miles from the nearest ocean), early naturalists were at a loss to explain the bones of a marine whale buried beneath the fields of rural Vermont. But the Charlotte whale was preserved in the sediments of the Champlain Sea, an arm of the ocean that extended into the Champlain Valley for 2,500 years following the retreat of the glaciers 12,500 years ago.

Sculptures of the size that Sardonis envisioned are not easily realized without financial backing. A local developer, who envisioned the piece installed at the entrance of a planned motel and conference center, supported the idea, and Sardonis was able to begin. The piece would require more space, and more complicated equipment, than Sardonis had available in his own studio, so he arranged to work at Granite Importers, an operation in Barre, Vermont, that could move stones weighing 22 and 14 tons, respectively, and that possessed diamond saws as large as 11 feet for cutting the stones.

Sardonis recognized that it would be easier to carve each tail in two pieces, a tall vertical piece and the horizontal flukes, so he began by

Fig. 413 Jim Sardonis's *Reverence* in progress, 1988–1989. Photos courtesy of the artist.

Jim Sardonis's **REVERENCE**

having each of the two stones cut in half by the 11-foot saw. Large saws roughed out the shapes, and then Sardonis began to work on the four individual pieces by hand (see Fig. 413). As a mass, such granite is extremely hard, but in thin slabs, it is relatively easy to break away. The sculptor's technique is to saw the stone, in a series of parallel cuts, down to within two to six inches of the final form, then break each piece out with a hammer. This "cut-and-break" method results in an extremely rough approximation of the final piece that is subsequently realized by means of smaller saws and grinders.

When the pieces were finally assembled, they seemed even larger to Sardonis than he had imagined. But as forms, they were just what he wanted: As a pair, they suggest a relationship that extends beyond themselves to the rest of us. The name of the piece, *Reverence*, suggests a respect for nature that is tinged with awe, not only for the largest mammals on the planet, but also for the responsibility we all share to protect all nature. The whale, as the largest creature, becomes a symbol for all species and for the fragility and interconnection of all life on earth.

The project had taken almost a year, and by midsummer 1989, the site at the prospective conference center was being prepared. Though the pair of forms were installed, when funding for the conference center fell through, they were moved to a new site, just south of Burlington, Vermont, on Interstate 89, where they overlook the Champlain Valley.

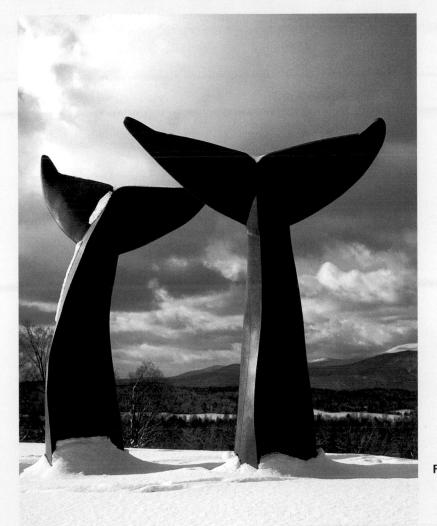

Fig. 414 Jim Sardonis, *Reverence*, 1989. Beside Interstate 89, south of Burlington, Vermont. Photo courtesy of the artist. © 1989 Jim Sardonis.

hearth—would have looked as if they had been carved in high relief. As daylight shifted across the surface of their bodies, it is easy to imagine the goddesses seeming to move beneath the swirling, clinging, almost transparent folds of cloth, as if brought to life by light itself.

MODELING

When you pick up a handful of clay, you almost instinctively know what to do with it. You smack it with your hand, pull it, squeeze it, bend it, pinch it between your fingers, roll it, slice it with a knife, and shape it. Then you grab another handful, repeat the process, and add it to the first, building a form piece by piece. These are the basic gestures of the additive process of modeling, in which a pliant substance, usually clay, is molded.

Clay, a natural material found worldwide, has been used by artists to make everything from pots to sculptures since the earliest times. Its appeal is largely due to its capacity to be molded into forms that retain their shape. Once formed, the durability of the material can be ensured by **firing** it—that is, baking it at temperatures normally ranging between 1200 and 2700 degrees Fahrenheit in a **kiln**, or oven, designed especially for the process. This causes it to become hard and waterproof. We call all works made of clay **ceramics**.

Video Demo Sculpture: Modeling

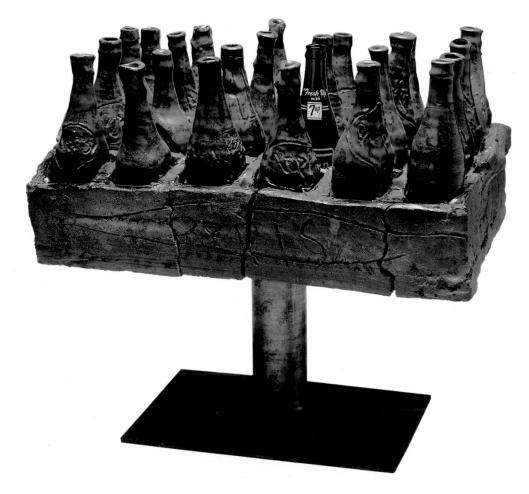

Fig. 415 Robert Arneson, Case of Bottles, 1964.

Glazed ceramic (stoneware) and glass, 10 $\frac{1}{2} \times 22 \times 15$ in. Santa Barbara Museum of Art. Gift of Mr. and Mrs. Stanley Sheinbaum.

© Estate of Robert Arneson/Licensed by VAGA, New York. Courtesy of George Adams Gallery, New York.

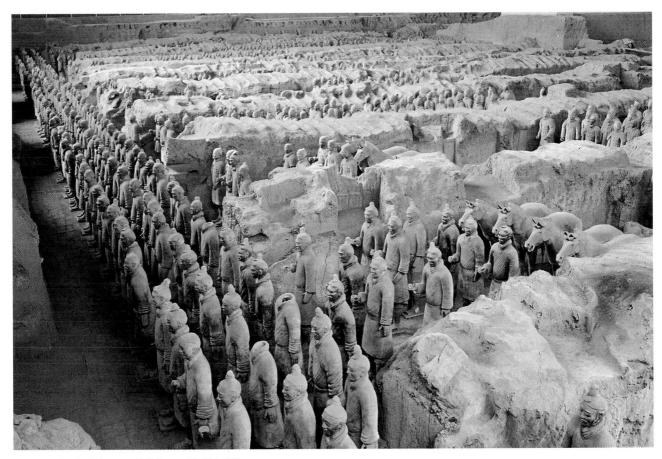

Fig. 416 Tomb of Emperor Shih Huang Ti, 221–206 BCE. Painted ceramic figures, lifesize National Geographic Image Collection.

Robert Arneson's *Case of Bottles* (Fig. 415) is a ceramic sculpture. The rough handmade quality of Arneson's work, a quality that clay lends itself to especially well, contrasts dramatically with his subject matter, mass-produced consumer products. He underscores this contrast by including in the case of Pepsi a single real 7-Up bottle. He has even allowed the work to crack by firing it too quickly. The piece stands in stark defiance to the assembly line.

Throughout history, the Chinese have made extraordinary ceramic works, including the finest porcelains of fine, pure white clay. We tacitly acknowledge their expertise when we refer to our own "best" dinner plates as "china." But the most massive display of the Chinese mastery of ceramic art was discovered in 1974 by well diggers who accidentally drilled into the tomb of Shih Huang Ti, the first emperor of China (Fig. 416). In 221 BCE, Shih Huang Ti united the country under one rule and imposed order, establishing a single code of law and requiring the use of a single language. Under his rule, the Great Wall was built, and construction of his tomb required a force of more than 700,000 men. Shih was buried near the central Chinese city of Xian, or Ch-in (the origin of the name China), and his tomb contained more than 6,000 lifesize, and extraordinarily lifelike, ceramic figures of soldiers and horses, immortal bodyguards for the emperor. More recently, clerks, scribes, and other court figures have been discovered, as well as a set of magnificent bronze horses and chariots. Compared to Arneson's rough work, the figures created by the ancient Chinese masters are incredibly refined, but between the two of them we can see how versatile clay is as a material.

CASTING

Casting is an invention of the Bronze Age (beginning approximately 2500 BCE), when it was first utilized to make various utensils by simply pouring liquid bronze into open-faced molds. The technology is not much more complicated than that of a gelatin mold. You pour gelatin into the mold and let it harden. When you remove the Jello, it is shaped like the inside of the mold. Small figures made of bronze are similarly produced by making a simple mold of an original modeled form, filling the mold with bronze, and then breaking the mold away.

As the example of gelatin demonstrates, bronze is not the only material that can be cast. In the kingdom of Benin, located in southern Nigeria, on the coastal plain west of the Niger River, brass casting reached a level of extraordinary accomplishment as early as the late fourteenth century. Brass, which is a compound composed of copper and zinc, is similar to bronze but contains less copper and is yellower in color. When, after 1475, the people of Benin began to trade with the Portuguese for copper and brass, an explosion of brass casting occurred. Shown in Figure 417 is a brass head of an Oba dating from the eighteenth century. The Oba is the king of a dynasty. When an Oba dies, one of the first duties of the new Oba is to establish an altar commemorating his father and to decorate it with newly cast brass heads. The heads are not portraits. Rather, they are generalized images that emphasize the king's coral-bead crown and high bead collar, the symbols of his authority. The head has a special significance in Benin ritual. According to British anthropologist R.E. Bradbury, the head "symbolizes life and behavior in this world, the capacity to or-

 Fig. 417 African, Nigeria, Edo, Court of Benin, Head of an Oba, 18th century.
 Brass and iron, height, 13 ¹/₈ in. Metropolitan Museum of

Art, New York. Gift of Mr. and Mrs. Klaus G. Perls, 1991 (1991.17.2). Photo © 1991 Metropolitan Museum of Art. ganize one's actions in such a way as to survive and prosper. It is one's Head that 'leads one through life.' . . . On a man's Head depends not only his own wellbeing but that of his wives and children. . . At the state level, the welfare of the people as a whole depends on the Oba's Head which is the object of worship at the main event of the state ritual year."

The Oba head is an example of one of the most enduring, and one of the most complicated, processes for casting metal. The lostwax method, also known as cire-perdue, was perfected by the Greeks if not actually invented by them. Because metal is both expensive and heavy, a technique had to be developed to create hollow images rather than solid ones. The diagram in Figure 418 schematizes the process in simplified terms.

In the lost-wax method, the sculpture is first modeled in some soft, pliable material, such as clay, wax, or plaster in a putty state. This model looks just like the finished sculpture, but, of course, the material of which it is composed is nowhere near as durable as metal. As the process proceeds, this core is at least the-

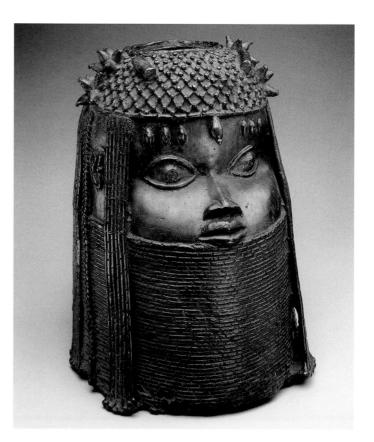

Video Demo: Sculpture: Casting

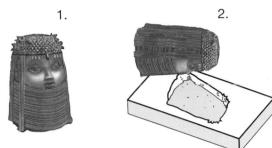

4.

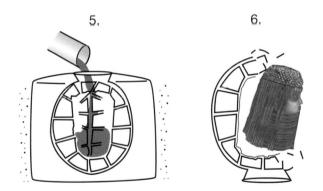

Fig. 418The Lost-Wax Casting Process

A positive model (1), often created with clay, is used to make a negative mold (2). The mold is coated with wax, the wax shell is filled with a cool fireclay, and the mold is removed (3). Metal rods, to hold the shell in place, and wax rods, to vent the mold, are then added (4). The whole is placed in sand, and the wax is burned out (5). Molten bronze is poured in where the wax used to be. When the bronze has hardened, the whole is removed from the sand, and the rods and vents are removed (6). oretically disposable, though many sculptors, including Auguste Rodin (see Fig. 253), have habitually retained these cores for possible re-casting.

A mold is then made of the model (today, synthetic rubber is most commonly used to make this mold), and when it is removed, we are left with a *negative* impression of the original—in other words, something like a gelatin mold of the object. Molten wax is then poured or brushed into this impression to the same thickness desired for the final sculpture-about an eighth of an inch. The space inside this wax lining is filled with an investment-a mixture of water, plaster, and powder made from ground-up pottery. The mold is then removed, and we are left with a wax casting, identical to the original model, that is filled with the investment material. Rods of wax are then applied to the wax casting: they stick out from it like giant hairs. They will carry off melted wax during baking and will eventually provide channels through which the molten bronze will be poured. The sculpture now consists of a thin layer of wax supported by the investment. Sometimes bronze pins are driven through the wax into the investment in order to hold investment, casting, and channels in place.

This wax cast, with its wax channels, is ready to be covered with another outer mold of investment. When this outer mold cures, it is then baked in a kiln at a temperature of 1500 degrees Fahrenheit, with the wax replica inside it. The wax rods melt, providing channels for the rest of the wax to run out as well—hence the term *lost-wax*. A thin space where the wax once was now lies empty between the inner core and the outer mold, the separation maintained by the bronze pins.

Molten bronze is poured into the *casting* gate, an opening in the top of the mold, filling the cavity where the wax once was. Hence, many people refer to casting as a **replacement** method—bronze replaces wax. When the bronze has cooled, the mold and the investment are removed, and we are left with a bronze replica of the wax form complete with the latticework of rods. The rods are cut from the bronze cast, and the surface is smoothed and finished.

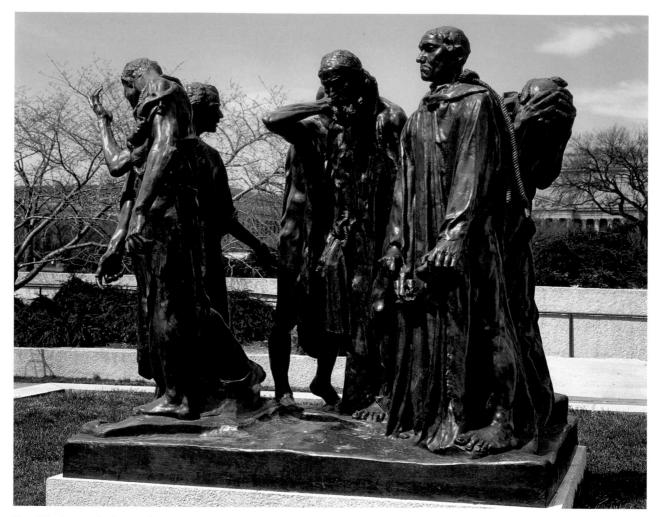

Fig. 419 August Rodin, The Burghers of Calais, 1884–1885.
 Bronze, 79 ³/₈ × 80 ⁷/₈ in. Hirshhorn Museum and Sculpture Garden, Smithsonian Institution, Washington, D.C. Gift of Joseph H. Hirshhorn, 1966. 66.4340. Photo: Lee Stalsworth.

Large pieces such as Auguste Rodin's Burghers of Calais (Fig. 419) must be cast in several pieces and then welded together. Bronze is so soft and malleable that the individual pieces can easily be joined in either of two ways: pounded together with a hammer, the procedure used in Greek times, or welded, the more usual procedure today. Finally, the shell is reassembled to form a perfect hollow replica of the original model. Rodin's sculpture was commissioned by the city of Calais to commemorate six of its leading citizens (or burghers) who, during the Hundred Years' War in 1347, agreed to sacrifice themselves and free the city of seige by the English by turning themselves over to the enemy for execution. Rodin depicts them,

dressed in sackcloth with rope halters, about to give themselves up to the English. Each is caught up in his own thoughts-they are, alternately, angry, resentful, resigned, distraught, and fearful. Their hands and feet are purposefully elongated, exaggerating their pathos. Rodin felt that the hand was capable of expressing the full range of human emotion. In this work, the hands give, they suffer, they hold at bay, they turn inward. The piece, all told, is a remarkable example of sculpture in-the-round, an assemblage of individual fragments that the viewer can only experience by walking around the whole and taking in each element from a different point of view. As it turns out, the story has a happy ending. The English king's queen, upon see-

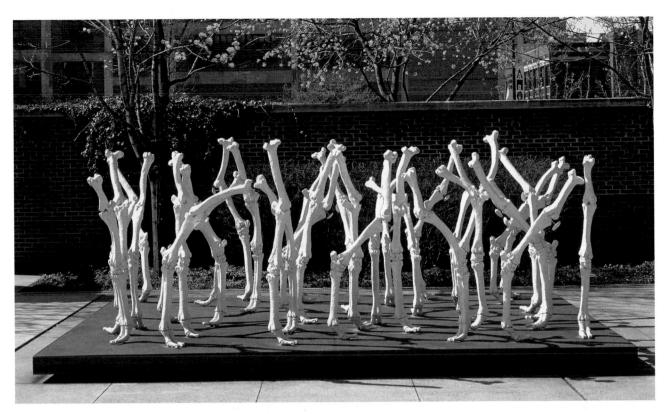

Fig. 420 Nancy Graves, Variability and Repetition of Similar Forms, II, 1979.
 Bronze with white pigmented wax patina on Cor-Ten steel base, 6 × 12 × 16 ft. Akron Art Museum. Mary S. and Louis S. Myers Foundation, the Firestone Foundation, National Endowment for the Arts, and the Museum Acquisition Fund.
 Photo: Richard Haire.

ing the courage of the burghers, implored her husband to have mercy on them, and he agreed. Still, Rodin depicts them as they trudge toward what they believe will be their final destiny.

In her Variability and Repetition of Similar Forms, II (Fig. 420), Nancy Graves pays homage to Rodin's Burghers. The work consists of 36 leg bones, modeled after lifesize camel bones and arranged across a large, flat base. Each leg appears unique, but, in fact, each is derived from three or four models, which Graves refashioned in a variety of ways and covered with a white-wax patina—that is, a chemical compound applied to the bronze by the artist that forms a film or encrustation on the surface after exposure to the elements.

A decade before this work was completed, in 1969, Graves had exhibited lifesize, fully representational camels made of wood, steel, burlap, polyurethane, animal skin, wax, acrylic, oil paint, and fiberglass at the Whitney Museum of American Art-the first oneperson show ever given to a woman artist at the Whitney. A year later, in 1970, Graves made a film entitled Izy Boukir in Morocco, an examination of the interrelationships of line and form produced by the movements of a caravan of closely grouped camels. Variability and Repetition of Similar Forms is based on what Graves learned about the movement of camels while making her film. "Why camels?," Graves was once asked. "Because they shouldn't exist," she replied. "They have flesh on their hoofs, four stomachs, a dislocated jaw. Yet with all of the illogical form the camel still functions. And though they may be amusing, they are still wonderful to watch." They are, in other words, like Rodin's Burghers of Calais, animals seemingly at the very edge of extinction that somehow, heroically, manage to survive, even thrive.

ASSEMBLAGE

Many of the same thematic concerns that we saw in Michelangelo's "Atlas" Slave (see Fig. 407) are at work in David Hammons's Spade with Chains (Fig. 421). Both works specifically address the issue of enslavement. By means of assemblage-creating a sculpture by compiling objects taken from the environment—Hammons has combined "found" materials, a common spade and a set of chains, into a face that recalls an African mask. The piece represents a wealth of transformations. Just as Michelangelo could see in the raw block of stone the figure within, Hammons can see, in the most common materials of everyday life, the figures of his world. This transformation of common materials into art is a defining characteristic of assemblage. As a process, assemblage evokes the myth of the phoenix, the bird that, consumed by fire, is reborn out of its own ashes. That rebirth, or rejuvenation, is also expressed at a cultural level in Hammons's work. The transformation of the materials of slave labor-the spade and the chain-into a mask is an affirmation of the American slave's African heritage. The richness of this transformation is embodied in the double meaning of the word "spade"-at once a racist epithet and the appropriate name of the object in question. But faced with this image, it is no longer possible, in the words of a common cliché, to "call a spade a spade." The piece literally liberates us from that simple and reductive possibility.

To the degree that they are composed of separately cast pieces later welded together, works like Rodin's Burghers of Calais (see Fig. 419) and Graves's Variability and Repetition of Similar Forms, II (see Fig. 420), might themselves seem to be assemblages. But it is better to think of them as constructionsworks in which the artist forms all of the parts that are put together rather than finding the parts in the world. On the other hand, Damien Hirst's Mother and Child Divided (Fig. 422) is an eerie, even disturbing collection of elements from the real world intentionally designed to create a psychological instability in the viewer. The central theme of Hirst's work has been an exploration of mortality, realized especially effectively in the

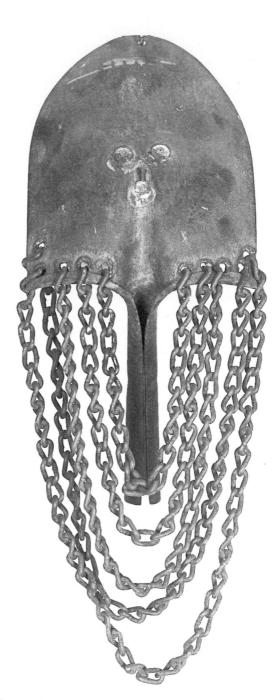

Fig. 421 David Hammons, *Spade with Chains*, 1973. Spade, chains, 24 × 10 × 5 in. Courtesy Jack Tilton Gallery, New York. Photo: Dawoud Bey.

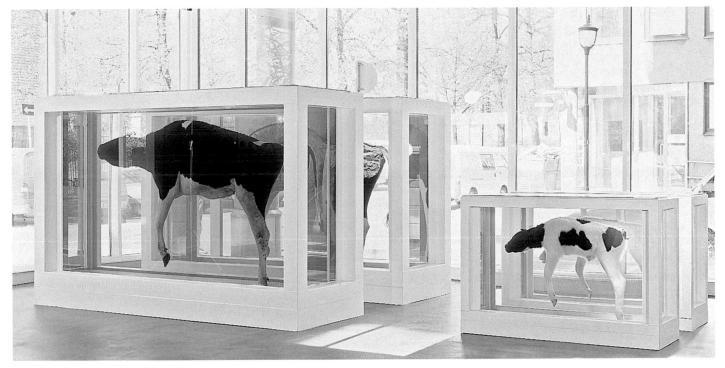

Fig. 422 Damien Hirst, Mother and Child Divided, 1993.

BeySteel, GRP composites, glass, silicone sealants, cow, calf, formaldehyde solution, 2 boxes, 74 $\frac{3}{4} \times 126$ $\frac{3}{4} \times 43$ in. and 40 $\frac{3}{8} \times 66$ $\frac{1}{2} \times 24$ $\frac{5}{8}$ in, respectively. The Astrup Fearnley Museum of Modern Art, Oslo, Norway. © Damien Hirst/ Science, Ltd. Photo: Tore H. Royneland, Oslo.

Natural History series, in which dead animals are presented in a manner derived from displays at museums of natural history. Mother and Child Divided presents two adult cows and two calves suspended in formaldehyde in four separate boxes. They are actual cadavers, the bodies of animals that died naturally because of complications during pregnancy and birth. The work plays off the viewers' initial revulsion at confronting animal bodies, mother forever separated from calf not only by death but by the isolation of each body in its individual case, and the almost stunning beauty of Hirst's display, with its miminal jewel-box-like casing. But the ironies of the work soon become apparent. The animals float angelically, as if freed from the forces of gravity and life. Preserved in formaldehyde, they deny the very transience of life. It is as if, thus capturing them seemingly permanently in the mode of the natural history muscum, as if for analysis and experiment, examination

and classification, we deny them the last right of passage, the passage into eternity. They are, perhaps more than anything else, an image of purgatory, of some "hanging" state between life and death. And, inevitably, Hirst's work suggests that this is a fundamental condition of art itself.

Robert Gober's sculptural assemblages evolve from fragments of our everyday domestic lives that are juxtaposed with one another to create haunting objects that seem to exist halfway between reality and the fitful nightmare of a dreamscape. Gober repeatedly returns to the same fundamental repertoire of objects—body parts (made of plaster and beeswax for skin), particularly lower legs, usually graced with actual body hair, shoes, and socks; storm drains; pipes; doors; children's furniture; and, his most ubiquitous image, a common domestic sink. His work, in cssence, docs not include, as the saying goes, "everything but the kitchen sink," it includes

 Fig. 423
 Robert Gober, Untitled, 1999.

 Plaster, beeswax, human hair, cotton,
 leather, aluminum, and enamel. 33 1/2

 × 40 × 24 in. Philadelphia Museum
 of Art. Gift (by exchange)

 of Mrs. Arthur Barnwell.
 Photo: Graydon Wood. © 2007 ARS Artists

 Rights Society, NY.
 Society, NY.

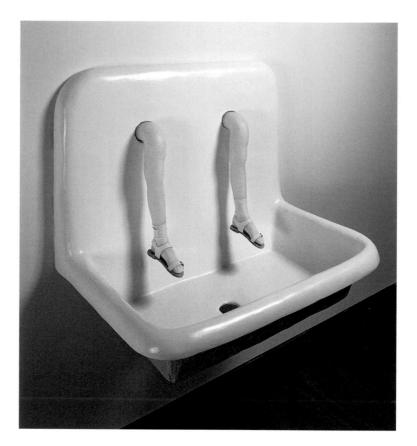

everything *and* the kitchen sink. *Untitled* (Fig. 423) is, in this sense, standard Gober fare. But despite the repetition of certain objects across the body of his work, each new sculpture seems entirely fresh.

Part of the power of Gober's works is that their meaning is open-ended, even as they continually evoke a wide range of American clichés. Like Lorna Simpson, whose work we encountered in Chapter 2 (see Figs. 23 and 24), Gober's objects invite multiple interpretations, none of which can ever take priority over any of the others. Consider, for instance, a sink. A sink is, first of all, a place for cleansing, its white enamel sparkling in a kind of hygenic purity. But this one is nonfunctional, its drain leading nowhere-a sort of "sinkhole." While looking at it, the viewer begins to get a "sinking" feeling that there is more to this image than might have been apparent at first. Of course, the two legs suspended over the basin instead of water spigots has suggested this to even the unthoughtful viewer all along.

They are, evidently, the legs of a young girl. Although not visible in a photograph, they are covered with a light dusting of actual human hair. Oddly enough, they are both left feet, suggesting adolescent awkwardness (a person who can't dance is said to have "two left feet"). More to the point, hanging over the sink, they evoke something akin to bathroom humor even as they seem to suggest the psychological mire of some vaguely sexual dread.

An example of an assemblage with more spiritual overtones is Clyde Connell's *Swamp Ritual* (Fig. 424), fabricated of parts from rusted-out tractors and machines, discarded building materials and logs, and papier-mâché made from the classified sections of the *Shreveport Journal and Times*. The use of papier-mâché developed out of Connell's desire to find a material capable of binding the wooden and iron elements of her work. By soaking the newsprint in hot water until its ink began to turn it a uniform gray, and then mixing it with Elmer's Glue, Connell was able to create a claylike material possessing, when dry, the texture of wasps' nests or rough gray stone.

Connell developed her method of working very slowly, over the course of about a decade, beginning in 1959 when, at age 58, she moved to a small cabin on Lake Bistineau, 17 miles southeast of Shreveport, Louisiana. She was totally isolated. "Nobody is going to look at these sculptures," she thought. "Nobody was coming here. It was just for me because I

wanted to do it. . . . I said to myself, 'I'm just going to start to make sculpture because I think it would be great if there were sculptures here under the trees.' "

In the late 1960s, Connell, by then in her late sixties, discovered the work of another assembler of nontraditional materials, the much younger artist Eva Hesse, who died at age 34 in 1970 (see Works in Progress on p. 320). Hesse's work is marked by its use of the most outlandish materials-rope, latex, rubberized cheesecloth, fiberglass, and cheap synthetic fabrics-which she used in strangely appealing, even elegant, assemblages. Connell particularly admired Hesse's desire to make art in the face of all odds. She sensed in Hesse's work an almost obstinate insistence on being: "No matter what it was," she said about Hesse's work, "it looked like it had life in it." Connell wanted to capture this sense of life-what she calls Hesse's "deep quality"-in her own sculpture. In Swamp Ritual, the middle of Connell's figure is hollowed out, creating a cavity filled with stones. Rather than thinking of this space in sexual terms-as a womb, for instance-it is, in Connell's words, a "ritual space" in which she might deposit small objects from nature. "I began to think about putting things in there, of having a gathering place, not for mementos but for things you wanted to save. The ritual place is an inner sanctuary. . . . Everybody has this interior space."

Fig. 424 Clyde Connell, *Swamp Ritual*, 1972. Mixed media, 81 × 24 × 22 in. Tyler Museum of Art, Tyler, Texas. A gift from the Atlantic Richfield Company.

WORKS IN PROGRESS

etween September 1965 and her death in May 1970, Eva Hesse completed more than 70 sculptural works. Contingent (Fig. 427) is one of the last four pieces she made. For most of the last two years of her life she was ill, suffering from the effects of a brain tumor that was not diagnosed until April 1969. Clyde Connell's admiration for her work is partly a response to Hesse's heroic insistence on making art in the face of her illness and, to use Connell's word, infusing it with "life." But it is also a result of Hesse's feminist sensibilities, for Hesse was a feminist long before the Women's Movement of the early 1970s. "A woman is side-tracked by all her feminine roles," she wrote in 1965. "She's at a disadvantage from the beginning. . . . She

Fig. 425 Eva Hesse, Study for Contingent, 1969.
 Pencil on paper, 8 ¹/₄ × 11 in. Private collection.
 © Estate of Eva Hesse. Courtesy of Barry Rosen, New York. Courtesy Hauser Wirth, Zurich London. Photo: Afira Hagihara.

also lacks the conviction that she has the 'right' to achievement. . . [But] we want to achieve something meaningful and to feel our involvements make of us valuable thinking persons." *Contingent* embodies Hesse's personal strength.

Hesse's first ideas for the piece took the form of drawing (Fig. 425). "I always did drawings," Hesse said, "but they were always separate from the sculpture. . . . They were just sketches. . . . [A drawing] is just a quickie to develop it in the process rather than working out a whole model in small and following it—that doesn't interest me." In the drawing, it appears as if Hesse initially conceived of the piece as hanging against the wall, but by the time she was fabricating it, she had turned it sideways, as her "test piece" (Fig. 426) shows.

 Fig. 426
 Eva Hesse, Test Piece for Contingent, 1969.

 Latex over cheesecloth, 144 × 44 in. Naomi Spector and Stephen Antonakos Private Collection.

 © Estate of Eva Hesse. Courtesy of The Robert Miller Gallery, New York.

Eva Hesse's **CONTINGENT**

The final work consists of eight cheesecloth and fiberglass sheets that catch light in different ways, producing different colors, an effect almost impossible to capture in a photograph. The sheets seem at once to hang ponderously and to float effortlessly away. Hesse's catalogue statement for the first exhibition of the piece at Finch College in the fall of 1969 speaks eloquently of her thinking about the work:

Began somewhere in November-December, 1968. Worked. Collapsed April 6, 1969. I have been very ill. Statement. Resuming work on piece, have one complete from back then.... Piece is in many parts. Each in itself is a complete statement.... textures, coarse, rough, changing. see through, not see through, consistent, inconsistent. they are tight and formal but very ethereal. sensitive. fragile. . . . not painting, not sculpture. it's there though.... non, nothing, everything, but of another kind, vision, sort.... I have learned anything is possible. I know that. that vision or concept will come through total risk. freedom, discipline. I will do it.

Fig. 427 Eva Hesse Contingent, 1969.
 Reinforced fiberglass and latex over cheesecloth, height of each of 8 units, 114–118 in.; width of each of 8 units, 36–48 in. National Gallery of Australia, Canberra.
 © Estate of Eva Hesse. Courtesy The Robert Miller Gallery, New York.

INSTALLATION

Obviously, the introduction of any work of art into a given space changes it. But installation art does this radically by introducing sculptural and other materials into a space in order to transform our experience of it. Installations can be site specific—that is, designed for a particular space—or, like Sol LeWitt's instructions for installing his drawings (see Fig. 105), they can be modified to fit into any number of spaces.

At first glance, Kara Walker's installations, such as *Insurrection!* (Our Tools Were Rudimentary, Yet We Pressed On) (Figs. 428 and 429), seem almost doggedly unsculptural. Her primary tool, after all, is the silhouette, a form of art that originated in the courts of Europe in the early eighteenth century. It takes its name from the Finance Minister of France, Etienne de Silhouette, an ardent silhouette artist who in the 1750s and 60s was also mercilessly taxing the French people. Peasants, in fact, took to wearing only black in protest: "We are dressing a la Silhouette," so the saying went. "We are shadows, too poor to wear color. We are Silhouettes!"

Walker's silhouette works reflect the political context of the medium's origins, except that she has translated it to the master-slave relationship in the nineteenth-century antebellum South. In fact, throughout the nineteenth century, silhouette artists traveled across the United States catering especially to the wealthy, Southern plantation owners chief among them. In *Insurrection!*, a series of grisly scenes unfold across three walls. On the back wall, a plantation owner propositions a naked slave who hides from him behind a tree. A woman with a tiny baby on her head escapes a lynching. In the corner, on the right wall, in a scene barely visible in Fig. 428, but reproduced in its entirety in Fig. 429, slaves disembowel a plantation owner with a soup ladle, as another readies to strike him with a frying pan, and another, at the right, raises her fist in defiance.

But what really transforms this installation into a sculptural piece are light projections from the ceiling that throw light onto the walls. These projections are not only metaphoric—as viewers project their own fears and desires onto other bodies—but they also activate the space by projecting the viewers' shadows onto the walls so that they themselves become implicated in the scene.

Many installations incorporate film and video in a sculptural or architectural setting. Eleanor Antin's 1995 *Minetta Lane—A Ghost Story* consists of a re-creation of three buildings on an actual street in New York City's Greenwich Village that runs for two blocks between MacDougal Street and Sixth Avenue

Figs. 428 and 429 Kara Walker, Insurrection! (Our Tools Were Rudimentary, Yet We Pressed On), installation views, 2000. Cut paper silhouettes and light projections, site-specific dimensions. Solomon R. Guggenheim Museum, New York. Purchased with funds contributed by the International Director's Council and Executive Committee Members. 2000. Photo: Ellen Labenski. © Solomon R. Guggenheim Museum, New York.

 Figs. 430, 431 and 432
 Eleanor Antin, Minetta Lane—A Ghost Story, 1995.

 Mixed media installation. Installation view (top left), two video projections (top right and bottom right).

 Top right: Actors Amy McKenna and Joshua Coleman.

 Dottom right: Artist's window with Miriam (the Ghost).

 Courtesy the artist and Bonald Feldman Fine Arts. New York.

(Fig. 430). In the late 1940s and early 1950s, it was the site of a low-rent artists' community, and Antin seeks to recreate the bohemian scene of that lost world. For the installation, Antin prepared three narrative films, transferred them onto video disc, and backprojected them onto tenement windows of the reconstructed lane. The viewer, passing through the scene, thus voyeristically sees in each window what transpires inside. In one window (Fig. 431), a pair of lovers sport in a kitchen tub. In a second (Fig. 432), an Abstract Expressionist painter is at work. And in a third, an old man tucks in his family of caged birds for the night. These characters are the ghosts of a past time, but their world is inhabited by another ghost. A little girl, who is apparently invisible to those in the scene but clearly visible to us, paints a giant "X" across the artist's canvas and destroys the relationship of the lovers in the tub. She represents a

destructive force that, in Antin's view, is present in all of us. The little girl is to the film's characters as they are to us. For the artist, the lovers, and the old man represent the parts of us that we have lost—like our very youth. They represent ideas about art, sexuality, and life, that, despite our nostalgia for them, no longer pertain.

Artist James Turrell has been studying the psychological and physiological effects of light for almost his entire career. It has been said of him that he manipulated light as a sculptor would clay. Turrell's most famous work is probably his ongoing project at Roden Crater, a remote cinder volcanic crater on the western edge of Arizona's Painted Desert purchased by Turrell in 1977. The site will serve, when it is completed, as a naked-eye observatory for the observation of celestial phenomena. There Turrell is literally sculpting the earth, leveling the crater rim, for instance, so that when the

Fig. 433 James Turrell, A Frontal Passage, 1994 Fluorescent light. 12 ft. 10 in. × 22 ft. 6 in. × 34 ft. Robert and Meryl Meltzer, Michael and Judy Ovitz, and Mr. and Mrs. Gifford Phillips Funds. (185.1994). The Museum of Modern Art, New York, USA. The Museum of Modern Art/Licensed by Scala/Art Resource, New York.

sky is viewed from the bottom of the crater, it will seem to the eye to form a dome.

A Frontal Passage (Fig. 433) is such a piece, part of a larger series of works called Wedgework which he began in the late 1960s. The viewer approaches the work through a blackened hallway, which lets out into a chamber barely illuminated on one side by reddish fluorescent lights. The lights seem to cut, like a scrim, at a diagonal across the room, slicing it in two. But this is pure illusion, a "spatial manipulation," according to Turrell. As one's eyes adjust to the darkness, the diagonal's substance begins to come into question. Is it somehow projected across the room? Is it a wall? Is it just light? Is there in fact anything there at all? The viewer feels absorbed into a dense, hazelike atmosphere in which boundaries and the definition of surrounding space seem to be

thoroughly dissolved. As the viewer's sense of walls and boundaries, defined space, disappears, the space seems to become limitless, like standing on earth at the threshold, a "frontal passage," into the heavens.

The illusory space created by *A Frontal Passage* is related to a visual field called a "Ganzfeld," German for "total field." Comparable to a whiteout in a blinding snowstorm, Ganzfelds are visual phenomena where depth, surface, color, and brightness all register as a homogenous whole. If one were to walk into such a space, all sense of up and down would likely disappear, causing one at least to teeter and fall, and often creating a sense of nausea or vertigo. With such effects, Turrell's works bring the viewer into a state of almost hyper-self-consciousness and awareness, as if one can see oneself seeing.

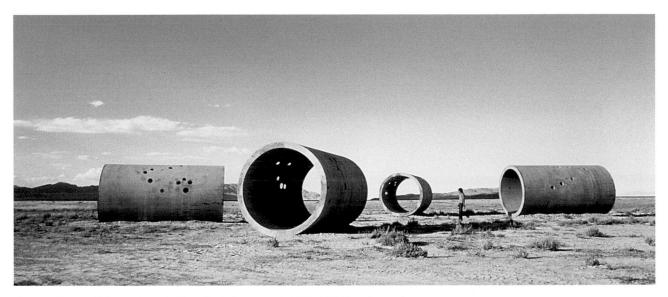

Fig. 434 Nancy Holt, Sun Tunnels, Great Basin Desert, Utah, 1973–1976 (four showing). Four tunnels, each 18 ft. long × 9 ft. 4 in. in diameter; each axis 86 ft. long. © Nancy Holt/Licensed by VAGA, New York. Courtesy John Weber Gallery, New York.

EARTHWORKS

The larger a work, the more our visual experience of it depends on multiple points of view. Since the late 1960s, one of the focuses of modern sculpture has been the creation of large-scale out-of-doors environments, generally referred to as earthworks. Robert Smithson's *Spiral Jetty* (see Fig. 8 and 11) is a classic example of the medium. James Turrell's Roden Crater project, which we just discussed, is one of the most ambitious.

Nancy Holt's Sun Tunnels (Figs. 434 and 435) consists of four 22-ton concrete tunnels aligned with the rising and setting of the sun during the summer and winter solstices. The holes cut into the walls of the tunnels and duplicate the arrangement of the stars in four constellations-Draco, Perseus, Columba, and Capricorn-and the size of each hole is relative to the magnitude of each star. The work is designed to be experienced on site, imparting to viewers a sense of their own relation to the cosmos. "Only 10 miles south of Sun Tunnels," Holt writes, "are the Bonneville Salt Flats, one of the few areas in the world where you can actually see the curvature of the earth. Being part of that kind of landscape ... evokes a sense of being on this planet, rotating in space, in universal time."

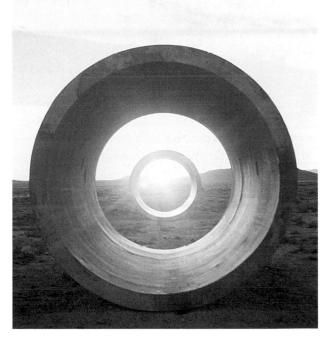

 Fig. 435 Nancy Holt, Sun Tunnels, Great Basin Desert, Utah, 1973–1976. (one front view).
 Four tunnels, each 18 ft. long × 9 ft. 4 in. in diameter; each axis 86 ft. long.
 © Nancy Holt/Licensed by VAGA, New York. Courtesy John Weber Gallery, New York.

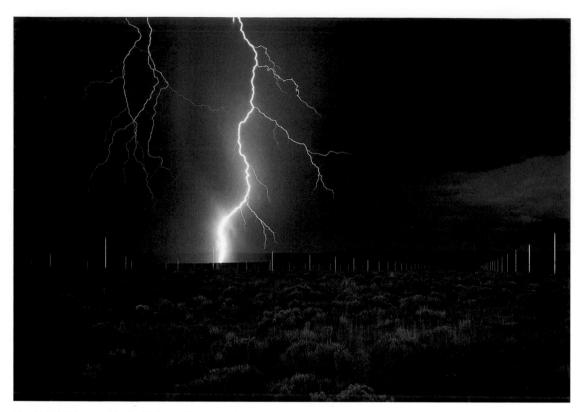

Fig. 436 Walter de Maria, *Lightning Field*, near Quemado, New Mexico, 1977. Stainless-steel poles, average height 20 ft. 7 in.; overall dimensions 5,280 × 3,300 ft. © Dia Center for the Arts. Photo: John Cliett. All reproduction rights reserved.

In an isolated region near the remote town of Quemado, New Mexico, Walter de Maria has created an environment entitled *Lightning Field* (Fig. 436). Consisting of 400 steel poles laid out in a grid over nearly one square mile of desert, the work is activated between 3 and 30 times a year by thunderstorms that cross the region. At these times, lightning jumps from pole to pole across the grid in a stunning display of pyrotechnics, but the site is equally compelling even in the clearest weather.

Visitors to the *Lightning Field* are met in Quemado and driven to the site, where they are left alone for one or two nights in a comfortable cabin at its edge. De Maria wants visitors to his environment to experience the space in relative isolation and silence, to view it over a number of hours, to see the stainless-steel poles change as the light and weather change, to move in and out of the grid at their leisure. He wants them to experience the infinite, to have some sense, posed in the vastness around them, of limitless freedom and time without end.

When artists manipulate the landscape at the scale of De Maria, it becomes clear that

their work has much in common with landscape design in general, from golf courses to parks to landfills. Indeed, part of the power of their work consists in the relationship they establish and the tension they embody between the natural world and civilization. A series of interventions conceived by sculptor Karen McCoy for Stone Quarry Hill Art Park in Cazenovia, New York, including the grid made of arrowhead leaf plants in a small pond, illustrated here (Figs. 437 and 438), underscores this. The work was guided by a concern for land use and was designed to respond to the concerns of local citizens who felt their rural habitat was fast becoming victim to the development and expansion of nearby Syracuse, New York. Thus McCoy's grid purposefully evokes the orderly and regimented forces of civilization, from the fence rows of early white settlers to the street plans of modern suburban developers, but it represents these forces benignly. The softness and fragility of the grid's flowers, rising delicately from the quiet pond, seem to argue that the acts of man can work at one with nature, rather than in opposition to it.

 Figs. 437 and 438
 Karen McCoy, Considering Mother's Mantle, Project for Stone Quarry Hill Art Park, Cazenovia, New York, 1992.

 View of gridded pond made by transplanting arrowhead leaf plants, 40 × 50 ft. Detall (right).

 Photos courtesy of the artist.

PERFORMANCE ART

If installations are works created to fill an interior architectural space and earthworks to occupy exterior spaces, both are activated by the presence of human beings in the space. It should come as no surprise that artists would in turn come to concern themselves with the live human activity that goes on in space. Many even conceived of themselves, or other people in their works, as something akin to live sculptures. We call such works performance art.

One of the innovators of performance art was Allan Kaprow, who, in the late 1950s, "invented" what he called **Happenings**, which he defined as "assemblages of events performed or perceived in more than one time and place. . . A Happening . . . is art but seems closer to life." It was, in fact, the work of Jackson Pollock that inspired Kaprow to invent the form. The inclusiveness of paintings containing whatever he chose to drop into them, not only paint but nails, tacks, buttons, a key, coins, cigarettes, and matches, gave Kaprow the freedom to bring everything, including the activity of real people acting in real time, into the space of art. "Pollock," Kaprow wrote in 1958, "left us at the point where we must become preoccupied with and even dazzled by the space and objects of our everyday life, either our bodies, clothes, rooms, or, if need be, the vastness of Forty-Second Street. . . . Objects of every sort are materials for the new art: paint, chairs, food, electric and neon signs, smoke, water, old socks, a dog, movies, a thousand other things will be discovered by the present generation of artists.... The young artist of today need no longer say, 'I am a painter,' or 'a poet' or 'a dancer.' He is simply an 'artist.' All of life will be open to him."

Fig. 439 Allan Kaprow, Household, 1964. Licking jam off a car hood, near Ithaca, New York. Sol Goldberg/Cornell University Photography.

Fig. 440 Joseph Beuys, I Like America and America Likes Me, 1974. Courtesy Ronald Feldman Fine Arts, New York. Photo © Caroline Tisdall. © 2007 Artists Rights Society (ARS), New York/VG Bild-Kunst, Bonn.

In the Happening Household (Fig. 439), there were no spectators, only participants, and the event was choreographed in advance by Kaprow. The site was a dump near Cornell University in Ithaca, New York. At 11 AM on the day of the Happening, the men who were participating built a wooden tower of trash, while the women built a nest of saplings and string. A smoking, wrecked car was towed onto the site, and the men covered it with strawberry jam. The women, who had been screeching inside the nest, came out to the car and licked the jam as the men destroyed their nest. Then the men returned to the wreck, and slapping white bread over it, began to eat the jam themselves. As the men ate, the women destroyed their tower. Eventually, as the men took sledgehammers to the wreck and set it on fire, the animosity between the two groups began to wane. Everyone gathered and watched until the car was burned up, and then left quietly. What this Happening means, precisely, is not entirely clear, but it does draw attention to the violence of relations between men and women in our society and the frightening way in which violence can draw us together as well as drive us apart.

One of the most interesting and powerful performance artists was Joseph Beuys, who died in 1985. Beuys created what he preferred to call "actions." These were designed to reveal what he believed to be the real function of art-teaching people to be creative so that, through their creativity, they might change contemporary society. As he put it, "The key to changing things is to unlock the creativity in every man. When each man is creative, beyond right and left political parties, he can revolutionize time." Beuys's aims may have been didactic, but they were, nevertheless, almost always expressed in hauntingly poetic and moving images. In 1974, Beuys performed at the René Block Gallery in Manhattan a three-day piece entitled I Like America and America Likes Me (Fig. 440). He had refused to visit the United States until it pulled out of Vietnam, and this performance not only celebrated his first visit to the country but addressed the still unhealed wounds of the Vietnam War, which had so divided the American people. When Beuys arrived at Kennedy International Airport, he was met by medical attendants, wrapped in gray felt, and driven by ambulance to the gallery, where, lying on a stretcher, he was placed behind a chain-link fence to live for three days and nights with a live coyote.

The coyote was comparable to the Native American in Beuys's eyes, a mammal subject to the same type of attack and persecution. For Beuys, the settling (or, rather, conquest) of the American West was a product of the same imperialist mentality that had led to the Vietnam War. The felt fabric in which Beuys wrapped himself is his most characteristic medium. It refers to his own rescue by Tartar tribesmen in the Crimea during World War II. After Beuys's plane crashed in a driving snowstorm, the Tartars restored him to health by covering his body with fat and wrapping him in felt. Thus wrapped in felt, Beuys introduced himself as an agent of healing into the symbolic world of the threatened coyote.

Man and coyote quickly developed a sort of mutual respect, mostly ignoring one another. About 30 times over the course of the three days, however, Beuys would imitate the coyote's every movement for a period of one or two hours, so that the two moved in a strangely harmonious "dance" through the gallery space. Often, when Beuys moved into a corner to smoke, the coyote would join him. For many viewers, Beuys's performance symbolized the possibilities for radically different "types" to coexist in the same space.

The physical "presence" of the artist in the artwork suggests that the body is itself one of the primary mediums of performance art (consider the work of the Chicago-based performance group Goat Island in the Works in *Progress* on p. 330). The performance team of Marina Abramovíc and Uwe Lavsiepen (known as Ulay) made this especially clear in works such as Imponderabilia, performed in 1977 at a gallery in Milan, Italy (Fig. 441). They stood less than a foot apart, naked and facing each other, in the main entrance to the gallery so that people entering the space had to choose which body-male or female-to face as they squeezed between them. A hidden camera filmed each member of the public as he or she passed through the "living door," and their "passage" was then projected on the gallery wall. Choosing which body to face, rub against, and literally feel, forced each viewer to confront their own attitudes and feelings about sexuality and gender. Abramovíc and Ulay's bodies composed the material substance of the work and so did the bodies of the audience members, who suddenly found themselves part of the artwork itself-at least they did for 90 minutes, until the police stopped the performance.

Fig. 441 Marina Abramovíc and Ulay, *Imponderabilia*, Performance at the Galleria Communale d'Arte Moderna, Bologna, Italy, 1977.

Photo: Giovanna dal Magro, courtesy of the artists, and Sean Kelly Gallery New York. © 2007 Artists Rights Society (ARS), New York/VG Bild-Kunst, Bonn.

WORKS IN PROGRESS

G oat Island's work is collaborative in nature. The group's four performers, and its director, Lin Hixson, all contribute to the writing, choreography, and conceptual aspects of each work. Founded in 1987, the group has to date created five performance events, the last of which is *How Dear to Me the Hour When Daylight Dies*, which premiered in Glasgow, Scotland, in May 1996, and then subsequently toured across Scotland and England.

In each piece, the troupe focuses on five major concerns: (1) they try to establish a conceptual and spatial relationship with the audience by treating the performance space, for instance, as a parade ground or a sporting arena; (2) they utilize movement in a way that is demanding to the point of exhaustion; (3) they incorporate personal, political, and social issues into the work directly through spoken text; (4) they stage their performances in nontheatrical spaces within the community, such as gyms or street sites; and (5) they seek to create striking visual images that encapsulate their thematic concerns.

The subject matter of their works is always eclectic, an assemblage of visual images, ideas, texts, physical movements, and music that often have only the most poetic connection to each other. How Dear to Me the Hour When Daylight Dies began with Goat Island's desire to share an intense group experience. To that end, in July 1994, the troupe traveled to Ireland to participate in the massive Croagh Patrick pilgrimage, a grueling four-hour climb up a mountain on the western seacoast near Westport, County Mayo, to a tiny church at the summit, where St. Patrick spent 40 days and 40 nights exorcising the snakes from Ireland. Eleven days before the pilgrimage, on July 20, the father of Greg and Timothy Mc-Cain, two members of the troupe who have subsequently moved on to other endeavors, died in Indianapolis. The elder McCain had seen every Goat Island piece, some of them three times. The pilgrimage thus became not only an act of faith and penance, but one of mourning.

How Dear to Me opens with the troup performing a sequence of hand gestures, silently, 30 times, that evokes for them the memory of Mr. McCain (Fig. 442). The mini-

Figs. 442 and 443 Goat Island, *How Dear to Me the Hour When Daylight Dies*, 1995–1996. Images from video documentation of work in progress, January 20, 1996. Courtesy Goat Island.

Goat Island's **HOW DEAR TO ME THE HOUR WHEN DAYLIGHT DIES**

Fig. 444 Goat Island, *How Dear to Me the Hour When Daylight Dies*, 1995–1996. Image from video documentation of work in progress, January 20, 1996. Courtesy Goat Island.

mal exertion of these gestures contrasts dramatically with the intense physicality of the pilgrimage. But both actions, the hand movements and the pilgrimage, are acts of memory. And memory is, in turn, the focus of the next set of images in the performance.

Matthew Goulish plays the part of Mr. Memory, a sort of traveling sideshow character who claimed to commit to memory 50 new facts a day and who could answer virtually any question posed to him by an audience. After he answers a series of questions, the troupe breaks into a long dance number (Fig. 443). As all four perform this arduous and complex dance in absolute synchronous movement, it becomes clear that it is, at once, another version of the pilgrimage-the same physical exercise performed year after year, again and again-and an exercise in collaborative and communal memory, as each member of the troupe remembers just what movement comes next in the dance sequence.

After the dance, Mr. Memory is asked, "Who was the first woman to fly across the Atlantic Ocean?" The answer is Amelia Earhart, and, at that, Karen Christopher dons a flying cap and becomes Amelia Earhart herself. The mystery surrounding Earhart's death in the South Pacific in World War II is evoked, the mystery of her death is symbolic of the mystery of all death. In Figure 444 we witness the transformation of Christopher from her Earhart character into Mike Walker, "the world's fattest man," who in 1971 weighed 1,187 pounds. This transformation was necessitated by the discovery, during rehearsals, that Christopher was diabetic and would, as a result, need to eat during the course of each performance. The image of the three men carrying her emphasizes not only her weight but the gravity of her situation.

Many more images and ideas collide in the course of this one-and-one-half-hour performance, too many to outline here, but this overview provides a sense of the remarkable energy, power, and inventiveness of Goat Island's collaborative and open-ended process.

Working on her own, Abramovíc has continued to explore a similar terrain, what she calls "the space in-betweeen, like airports, or hotel rooms, waiting rooms, or lobbies . . . all the spaces where you are not actually at home"—not least of all the space between her and Ulay in her earlier work. She feels that we are most vulnerable in such spaces, and vulnerability, for her, means that "we are completely alive." The House with the Ocean View (Fig. 445) was performed November 15-26, 2002, at the Sean Kelly Gallery in New York. Abramovíc lived in three rooms, situated 6 feet above the gallery floor, a toilet and shower in one, a chair and table in another, and clothes and a mattress in the third. The three rooms were connected to the floor by three ladders with butcher's knives for rungs. For 12 days she did not eat, read, write, or speak. She drank water, relieved herself, and sang and hummed as she chose. She slept in the gallery every night, and during the day the public was invited to participate in what she called an "energy dialogue" with the artist. What lay "in-between" the artist and her audience were those ladders. She could stare across at her audience, and her audience back at her, feelings could even be transmitted, but the space "in-between" could not be bridged except at unthinkable risk. At once a metaphor for geopolitical daily domestic realities, the work is a sobering realization of our separation from one another, and a call for us to exert the energy necessary to change.

In post-Mao China, Chinese artists have felt freer than ever before to state their opposition to the government, seeking change on a more practical level than Abramovíc, perhaps, but change nonetheless. In 1997, for instance, performance artist Zhang Huan invited people who had lost their jobs in the government's relentless modernization of Chinese industry to stand in a pond (Fig. 446), raising the level of the water, thereby asserting their presence even as they ideally, but unrealistically, might raise the government's consciousness as well. As a politcal act, Zhang Huan acknowledged that raising the water in the pond one meter higher was "an action of no avail." But as an act of human poetry-the human mass serving as a metaphor for the Chinese masses-it verges on the profound.

Fig. 445 Marina Abramovíc, *The House with the Ocean View— Nov. 22 9:54 am*, 2002. Living installation, November 15–26, 2002.

Courtesy of the Artist and Sean Kelly Gallery, New York. Used with permission. 2006. Photo: Steven P. Harris, New York.

 Fig. 446 Zhang Huan, To Raise the Water Level in a Fish Pond, August 15, 1997.
 Performance documentation (middle distance detail), Nanmofang Fishpond, Beijing, China. C-Print on Fuji archival, 60 × 90 in.
 Courtesy Max Protetch Gallery. Photo by Robyn Beck.

THE **CRITICAL** PROCESS Thinking about Sculpture

E leanor Antin's *The Artist's Studio* (Fig. 447) E is a single image from a photographic sequence entitled *The Last Days of Pompeii*, shot by Antin over the course of several months in the summer of 2001. It was completed just weeks before the events of 9/11, a fact that makes its operative metaphor, the analogy between the fate of a great colonial power like Rome and that of the United States, even more poignant and pronounced. Here Antin recreates the studio of a Roman artist, working unawares of the awful eruption of Vesuvius that will imminently destroy him, in the visual vocabulary of contemporary soft-core pornography.

How does this photograph incorporate almost every variety of sculptural medium dealt with in this chapter—from sculpture in relief to performance art? In what ways does this image both portray and employ subtractive and additive processes? What connection can you develop between carving the human figure and performance art?

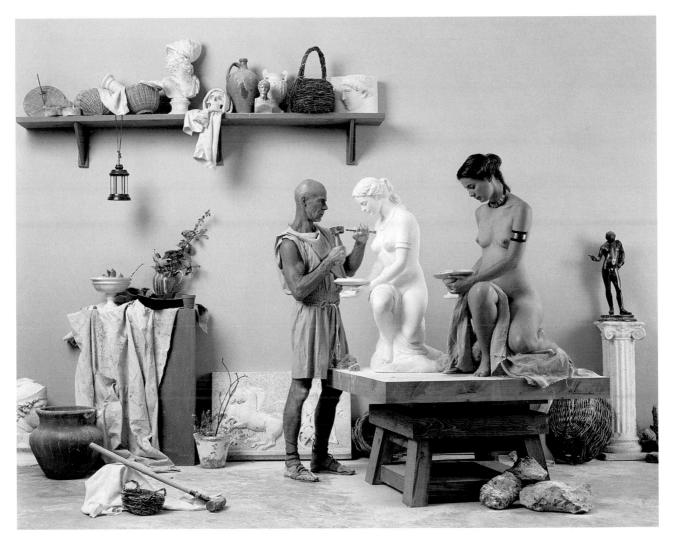

 Fig. 447 Eleanor Antin, The Artist's Studio from The Last Days of Pompeii, 2001. Chromogenic print, 46 ⁵/₆ × 58 ⁵/₈ in., edition of 6. Courtesy of the artist and Ronald Feldman Gallery, New York.

Other Three-Dimensional Media

www e begin this chapter with a discussion of the many so-called "craft" media—ceramics, glass, fiber, metal, and wood in particular—which have traditionally been distinguished from the fine arts because they are employed to make functional objects, from the utensils with which we eat to the clothes we wear. In the hands of an artist, however, these media can be employed to make objects that are not only of great beauty but that also must be appreciated as sculptures in their own right.

THE CRAFTS AS FINE ART

CERAMICS

■ Works in Progress Peter Voulkos's X-Neck

GLASS

■ Works in Progress Fred Wilson's *Mining the Museum*

FIBER

METAL

WOOD

■ The Critical Process Thinking about Other Three-Dimensional Media

THE CRAFTS AS FINE ART

The line between the arts and the crafts is a fine one. Craft refers to expert handiwork, or work done by hand. And yet artists are expert with their hands. How is it that we don't call their work "craft" as well? Indeed, many artists would feel insulted if you complimented their work as being "craftful." These artists feel that a craft must be functional. That is, a craft object is something that can be used to satisfy our everyday needs. But the distinction between craft and artwork is not that clear-cut. Perhaps the only meaningful distinction we can draw between art and craft is this: If a work is primarily made to be used, it is craft, but if it is primarily made to be seen, it is art. However, the artist's intention may be irrelevant. If you buy an object because you enjoy looking at it, then whatever its usefulness, it is, for you at least, a work of art.

Historically, the distinction between the crafts and fine arts can be traced back to the beginnings of the industrial revolution, when, on May 1, 1759, in Staffordshire, England, a 28-year-old man by the name of Josiah Wedgwood opened his own pottery manufacturing plant. With extraordinary foresight, Wedgwood chose to make two very different kinds of pottery: one he called "ornamental ware" (Fig. 448), the other "useful ware" (Fig. 449). The first consisted of elegant handmade luxury items, the work of highly skilled craftsmen. The second were described in his catalogue as "a species of earthenware for the table, quite new in appearance . . . manufactured with ease and expedition, and conse-

Fig. 448 Josiah Wedgwood, Apotheosis of Homer Vase, 1786. Blue, Jasper ware, height, 18 in Courtesy of the Wedgwood Museum Trust Limited, Barlaston, Staffordshire, England.

quently cheap." This new earthcnware was made by machine. Until this moment, almost everything people used was handmade, and thus unique. With the advent of machine mass-manufacturing, the look of the world changed forever.

Fig. 449 Wedgwood Queen's Ware kitchen ware, c. 1850. Courtesy of the Wedgwood Museum Trust Limited, Barlaston. Staffordshire. England. Wedgwood depended upon his "useful" ware to support his business. His creamcolored earthenware (dubbed "Queen's Ware" because the English royal family quickly became interested in it) was made by casting liquid clay in molds instead of by throwing individual pieces and shaping them by hand. Designs were chosen from a pattern book and printed by mechanical means directly on the pottery. Because Wedgwood could massproduce his earthenware both quickly and efficiently, a reliable, quality tableware was made available to the middle-class markets of Europe and America.

But his ornamental ware he considered artwork. Like the artist, producers of ornamental ware had a hands-on relation to the objects they made. Wedgwood's ornamental ware is aesthetic in its intention and was meant to be received as an object of fine art. In contrast, his useful ware was meant to be used daily, on the table. Another way of putting this is to say that the word "ornamental" serves, in Wedgwood's usage, to remove the object from the ordinary, to separate it from the "useful," and to lend it the status of art.

Fig. 450 Josiah Wedgwood, copy of *Portland Vase*, c. 1790. Black Jasper ware, height, 10 in. Courtesy of the Wedgwood Museum Trust Limited, Barlaston, Staffordshire, England.

Although the Wedgwood factory has continued to produce various kinds of ornamental ware, Wedgwood's copy of the Portland Vase (Fig. 450) was his crowning achievement. The original, made around 25 BCE in Rome, is a cameo deep blue (virtually black) glass vase that the Dowager Duchess of Portland purchased in 1784 for her private museum. The duchess died within a year of her purchase, and her entire estate was auctioned off, but the vase stayed in the family when the third Duke of Portland bought it in June 1786. It was subsequently lent to Wedgwood so that he might copy it, and he contracted to sell a number of these copies to a group of "gentlemen" subscribers.

It took Wedgwood four years to reproduce the vase successfully. He was able to match the deep blue-black of the original, but the ornamental ware for which he is best known is generally of a much lighter blue, as pictured on the previous page. Some 50 numbered and unnumbered first-edition copies of the Portland vase survive, and the factory has continued to produce editions over the years, most recently in 1980 for the 250th anniversary of Josiah's birth.

CERAMICS

As we saw in the previous chapter, ceramics are objects that are formed out of clay and then hardened by firing, or baking in a very hot oven, called a kiln. Ceramic objects are generally either flat and relief-like (think of a plate or a square of tile), or hollow, like cast sculpture (think of a pitcher). Unlike metal casts, the hollowness of ceramic objects is not a requirement of weight or cost as much as it is of utility (ceramic objects are made to hold things), and of the firing process itself. Solid clay pieces tend to hold moisture deep inside, where it cannot easily evaporate, and during firing, as this moisture becomes superheated, it can cause the object to explode. In order to make hollow ceramic objects, a number of techniques have been developed.

Most ceramic objects are created by one of three means—*slab construction*, *coiling*, or *throwing* on a potter's wheel. Pieces made by any one of these techniques are then painted with a **glaze**—a material that turns glassy when heated—and fired.

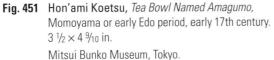

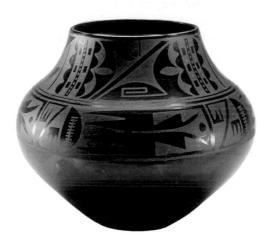

Fig. 452 María Montoya and Julian Martinez (San Ildefonso Pueblo, Native American, ca. 1887–1980; 1879–1943). *"Jar"*. c. 1939.

Blackware, 11 $^{1}\!/_{8} \times$ 13 in. (dia.). The National Museum of Women in the Arts, Washington, DC. Gift of Wallace and Wilhelmina Holladay.

Koetsu's Tea Bowl Named Amagumo (rain clouds) (Fig. 451) is an example of slab construction. Clay is rolled out flat, rather like a pie crust, and then shaped by hand. The tea bowl has a special place in the Japanese tea ceremony, the Way of the Tea. In small tea rooms specifically designed for the purpose and often decorated with calligraphy on hanging scrolls or screens, the guest was invited to leave the concerns of the daily world behind and enter a timeless world of ease. harmony, and mutual respect. Koetsu was an accomplished tea master. At each tea ceremony, the master would assemble a variety of different objects and utensils used to make tea, together with a collection of painting and calligraphy. Through this ensemble the master expressed his artistic sensibility, a sensibility shared with his guest, so that guest and host collaborated to make the ceremony itself a work of art.

This tea bowl, shaped perfectly to fit the hand, was made in the early seventeenth century at one of the "Six Ancient Kilns," the traditional centers of wood-fired ceramics in Japan. These early kilns, known as *anagama*, were narrow underground tunnels, dug out following the contour of a hillside. The pit was filled with pottery, and heat moved through the tunnel from the firebox at the lower end to the chimney at the upper end. The firing would take an average of seven days, during which time temperatures would reach 2500 degrees Fahrenheit. The coloration that distinguished these pieces results from wood ash in the kiln melting and fusing into glass on the pottery. The simplicity of these wood-fired pieces appealed to the devotee of the tea ceremony, and often tea masters such as Koetsu named their pieces after the accidental effects of coloration achieved in firing. The most prized effect is a scorch, or koge, when the firing has oxidized the natural glass glaze completely, leaving only a gray-black area. Such a koge forms the "rain clouds" on Koetsu's tea bowl.

María Martinez's black jar (Fig. 452) is an example of a second technique often used in ceramic construction, **coiling**, in which the clay is rolled out in long, rope-like strands that are coiled on top of each other and then smoothed. This pot is a specific example of a technique developed by María and her husband Julián in about 1919. The red clay pot is smothered in a dung-fueled bonfire during firing and then painted with black-on-black designs.

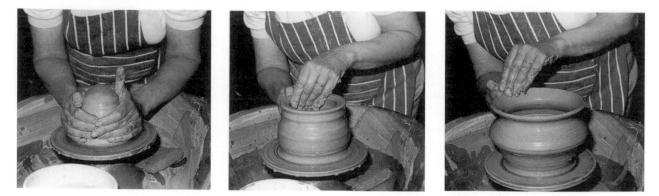

Fig. 453 Pottery Wheel-Throwing, from Craft and Art of Clay. Courtesy of Lawrence King Publishing Ltd.

Native American cultures relied on coiling techniques, whereas peoples of most other parts of the world used the potter's wheel. Egyptian potters employed a wheel by about 4000 BCE, and their basic invention has remained in use ever since. The ancient Greeks became particularly skillful with the process. The potter's wheel is a flat disk attached to a flywheel below it, which is kicked by the potter (or, in modern times, driven by electricity) to make the upper disk turn. A slab of clay, from which air pockets have been removed by slamming it against a hard surface, is centered on the wheel (Fig. 453). As the slab turns, the potter pinches the clay between fingers and thumb, sometimes using both hands at once, and pulls it upward in a round, symmetrical shape, making it wider or narrower as the form demands and shaping both the inside and outside simultaneously. The most skilled potters apply even pressure on all sides of the pot as it is thrown. The Greek amphora, or two-handled vase, known as Revelers (Fig. 454), is a thrown pot designed to store provisions such as wine, oil, or honey. An inscription on its bottom taunts the maker's chief competitor-"Euphronios never did anything like it," it reads-indicating the growing selfconsciousness of the Greek artist, the sense that he was producing not just a useful object but a thing of beauty.

There are three basic types of ceramics. Earthenware, made of porous clay and fired at low temperatures, must be glazed if it is to hold liquid. Stoneware is impermeable to water because it is fired at high temperatures, and it is commonly used for dinnerware today. Finally, porcelain, fired at the highest

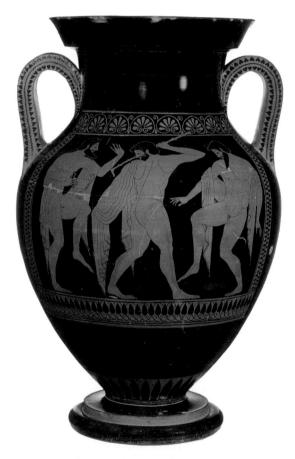

Fig. 454 Euthymides, *Revelers*, found in a tomb at Vulci, made in Athens, c. 510–500 BCE. Height, approx. 24 in. Museum Antiker Kleinkunst, Munich. Staatliche Antikensammulungen, Munich, Germany.

Fig. 455 Plate, Ming Dynasty, late 16th–early 17th century, *Kraakporselein*, probably from the Ching-te Chen kilns. Porcelain, painted in underglaze blue, diameter, 14 ¼ in. Metropolitan Museum of Art, New York. Rogers Fund, 1916 (16.13).

Photo © 1980 The Metropolitan Museum of Art.

temperatures of all, is a smooth-textured clay that becomes virtually translucent and extremely glossy in finish during firing. The first true porcelain was made in China during the T'ang Dynasty (618–906 CE). By the time of the Ming Dynasty (1368-1644), the official kilns at Chingtehchen had become a huge industrial center, producing ceramics for export. Just as the Greek artist painted his revelers on the red-orange amphora, Chinese artists painted elaborate designs onto the glazed surface of the porcelain. Originally, Islam was the primary market for the distinctive blue-and-white patterns of Ming porcelain (Fig. 455), but as trade with Europe increased, so too did Europe's demand for Ming design.

The export trade flourished even after the Manchus overran China in 1644, establishing the Ch'ing Dynasty, which lasted into the twentieth century. This had a profound effect on Chinese design. The Chingtehchen potters quickly began to make two grades of ware, one for export, and a finer "Chinese taste" ware for internal, royal use. They also became dedicated to satisfying European taste. As a result, consistency and standardization of product were of chief concern.

One of the more beautiful Ch'ing Dynasty porcelains is this remarkable *famille verte* vase (Fig. 456), so-called because the palette of enamel paints used is marked by several distinctive shades of green. Here birds, rocks, and flowers create a sense of the vibrancy of nature itself.

By the end of the eighteenth century, huge workshops dominated the Chinese porcelain industry, and by the middle of the nineteenth century, the demands of mass-production for trade throughout China, led to the same lack of creative vitality so common in Western mass-manufacturing.

In the hands of contemporary artists such as Betty Woodman, the boundary between art and craft virtually disappears. "It makes good

Fig. 456 Vase, Ch'ing Dynasty, Kangxi period, late 17th–early 18th century. Vase decorated with birds among flowering branches. Porcelain painted in overglaze *Famille verte* enamels and gilt, height, 18 in. Mctropolitan Museum of Art, New York. Bequest of John D. Rockefeller, Jr., 1960 (61.200.66). Photo © 1986 Metropolitan Museum of Art.

Chapter 15 Other Three-Dimensional Media 339

sense to use clay for pots, vases, pitchers, and platters," Woodman says, "but I like to have things both ways. I make things that could be functional, but I really want them to be considered works of art." In fact, vessels of some kind or another dominate her work, but they are vessels of unique character. They might take the form of a pillow, or of a human or animal body. Sometimes they are shaped like flowers, baskets, or cups. "The container is a universal symbol," she says, "it holds and pours all fluids, stores foods, and contains everything from our final remains to flowers." In one of the more humorous manifestations of the form, Woodman produced a vessel in the form of a tortilla, wrapped to contain the stuffings of a burrito. Floral Vase and Shadow (Fig. 457) underscores the painterly side of Woodman's art (for an even more painterly use of ceramics, see the Works in Progress on Peter Voulkos, p. 342). The amphora-like vase, with its handles of brushstroke-like ribbons, is realized in green, yellow, and black glazes. It casts a ceramic

Fig. 457 Betty Woodman, Floral Vase and Shadow, 1983. Glazed ceramic. Courtesy of Max Protetch.

orange shadow onto the wall behind it. Here Woodman's play with the contrast between two- and three-dimensional realizations of the vase echoes the play of her works between utility and art.

For many years, in the United States especially, crafts were strongly associated with women's work-decorative design of a more or less domestic bent. In the mid-1970s, the Holly Solomon Gallery in New York City's SoHo neighborhood (meaning "south of Houston Street") became the focus of a Pattern and Decoration movement that sought to elevate the so-called "minor arts" of crafts to the level of "high art." Miriam Schapiro's fabric fans, which we saw in Chapter 8 (see Figure 207), are a manifestation of this movement. Joyce Kozloff's ceramic tile murals (Fig. 458) are another. This example, commissioned by the city of Pasadena in 1990, its floral designs erupting from their trellis-like background, celebrates Pasadena as the "City of Roses." Before turning to tile, Kozloff had executed paintings based on tile designs. But she began using actual decorative tile in her work when, between 1979 and 1985, she was commissioned to design ceramic tile mosaics for subway and train stations in Wilmington, Delaware; Buffalo, New York; Philadelphia; Pennsylvania; Cambridge, Massachusetts; and for the international terminal of San Francisco International Airport. Among the sources of her designs are Native American pottery, Moroccan ceramics, and Viennese Art Nouveau architectural ornamentation.

GLASS

Since ancient times, glassware was made either by forming the hot liquid glass, made principally of silica, or sand, on a core or by casting it in a mold. The invention of glassblowing techniques late in the first century BCE so revolutionized the process that, in the Roman world, glassmaking quickly became a major industry. To blow glass, the artist dips the end of a pipe into molten glass and then blows through the pipe to produce a bubble. While it is still hot, the bubble is shaped and cut.

Fig. 458 Joyce Kozloff, *Plaza Las Fuentes*, Pasadena, California, 1990. Glazed ceramic tiles; sculpture, Michael Lucero; landscape architect, Lawrence Halprin. Photo: Tom Vinetz. DC Moore Gallery, New York. Courtesy of the artist.

This glass bowl (Fig. 459) was probably made near Rome in the second half of the first century CE, before glassblowing took hold. It is made of opaque chips of colored glass. These chips expanded and elongated in the oven as they were heated over a core ceramic form. As the glass chips melted, they fused together and fell downward over the form, creating a decorative patchwork of dripping blobs and splotches. By the time this vase was made, demand for glass was so great that many craftsmen had moved from the Middle East to Italy to be near the expanding European markets.

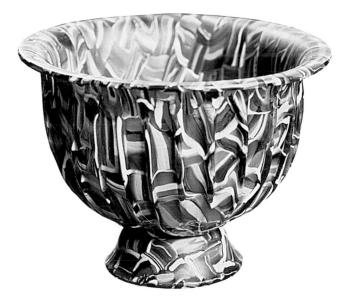

Fig. 459 Mosaic glass bowl, fused and slumped, Roman, 25 BCE–50 CE. Height, 4 ½ in. Victoria and Albert Museum, London. Art Hesource. New York.

WORKS IN PROGRESS

n 1976, a young American ceramic artist by the name of Peter Callas built the first traditional Japanese anagama, or wood-burning kiln, in the United States in Piermont, New York. Three years later, California artist Peter Voulkos was regularly firing his work in Callas's kiln. Voulkos's work is particularly suited to the wood-firing process, in which the artist must give up control of his work and resign himself to the accidental effects that result from submitting the work to a heat of 2500 degrees Fahrenheit over the course of a seven-day firing. His "stacks," giant bottlelike pyramids of clay that average about 250 pounds, are so named because Voulkos literally stacks clay cylinders one on top of the other to create his form. Before they are quite dry, he gouges them, draws on them with various tools, and drags through the clay in giant sweeps across the form's surface. Then he fires it in the anagama. Anything can happen in the firing. Depending on such factors as how the pieces in the kiln are stacked, the direction of the flame, where ash is deposited on the surface of the work, how a section near a flame might or might not melt, and undetectable irregularities in the clay itself, each stack will turn out differently. The Japanese call this a "controlled accident." For Voulkos, it is the source of excitement in the work, "the expectancy of the unknown" that is fundamental to the process.

This interest in the possibilities of the accidental evidences itself in other ways in Voulkos's work. In many of his works, including both the untitled monotype reproduced here (Fig. 460) and the *X-Neck* stack (Fig. 462), a ragged "x" seems to be the focus of the piece. The "x" is, of course, a standard signature for those who cannot write, the signature of an absolute novice in the art of calligraphy. As was pointed out in the catalogue to Voulkos's 1995 retrospective exhibition, the "x" is also a reference to the Zen practice of *shoshin*, which means "beginner's mind." It is Voulkos's way of keeping in touch with what the Zen master Shunryu Suzuki describes as "the limitless potential of original mind, which is rich and sufficient within itself. For in the beginner's mind there are many possibilities; in the expert's mind there are few."

The form of the stacks of clay, however, is not accidental. It is a direct reference to the pyramid form, not only to the pyramids of ancient Egypt, but also those of ancient Mexican Aztec and Mayan cultures. For Voulkos, the pyramid represents the mystery of the unknown. In utilizing this form, Voulkos makes contact between the ancient and the modern, between himself and the forces that have

 Fig. 460 Peter Voulkos, Untitled, 1988.
 Monotype, 50 × 35 in. Collection of Deborah Scripps, San Francisco.
 Photo: Schopplein Studio, Berkeley, California. © Peter Voulkos.

Peter Voulkos's X-NECK

 Fig. 461 Peter Voulkos, Pyramid of the Amphora, 1985.
 Paper collage with pushpins, 52 × 37 in. Collection of Bruce C. and Monica Reeves, Alameda, California.
 Photo: Schopplein Studio, Berkeley, California. © Peter Voulkos.

Fig. 462 Peter Voulkos, X-Neck, 1990. Woodfired stoneware stack, height, 34 ½ in. × diameter, 21 in. Private collection. Photo: Schopplein Studio, Berkeley, California. © 1997 Peter Voulkos.

driven the human race for centuries. His collage, *Pyramid of the Amphora* (Fig. 461), has the stepped sides of a Mexican pyramid. On such structures, men and women were once sacrificed to the gods, their heads cut off, their hearts cut out. Red blood seems to flow across Voulkos's work. Even the tears in the paper and the pins pushed into the surface reflect this violence, and Voulkos's own manner of working with clay, the almost primitive violence of his approach to the material, is underscored by the collage. His stacks make contact with the most elemental of emotions, our most intense, but human, feelings. Today, the Pilchuck Glass School in Washington State is one of the leading centers of glassblowing in the world, surpassed only by the traditional glassblowing industry of Venice, Italy. Dale Chihuly, one of Pilchuck's cofounders, has been instrumental in transforming the medium from its utilitarian purposes into more sculptural ends. In his "basket" series, Chihuly is interested in the

interplay of line and space, in creating a web of interlaced line and transparent form. These works are not "baskets" per se, but rather sculpted containers that hold other sculpted forms within them. Inspired by having seen a group of Indian baskets in a museum storage room sagging under its own weight, works such as *Alabaster Basket Set with Oxblood Wraps* (Fig. 463) sag, bulge, push against, and

 Fig. 463
 Dale Chihuly, Alabaster Basket Set with Oxblood Lip Wraps, October. 1991.

 Glass, 18 × 27 × 21 in.
 Courtesy of Dale Chihuly. Photo: Claire Garoutte.

flow into one another as if still in their liquid state. Chihuly's work demonstrates another quality of glass—the way it is animated by light. At once reflective and transparent, the surface is dynamic, constantly transformed, as both the light and the viewer's point of view changes.

Chihuly's floating and hanging glass works are extraordinary installation pieces designed to animate large interior spaces such as the rotunda, or main entrance, of the Victoria and Albert Museum in London (Fig. 464). Over 30 feet high, it was commissioned by the museum after the rotunda dome was reinforced to both inaugurate the ongoing modernization of the museum's facilities and underscore the museum's commitment to modern design. Lit by spotlights, the piece vibrates with what the artist calls "ice blue" and "spring green" lights, and the inspiration, as with so much of his work, is at once the sea, especially the waters of Puget Sound near his boyhood home in Tacoma, Washington, and flowers, which thrived in his mother's garden when he was a child. For Chihuly, the distinction between art and craft is irrelevant. "I don't really care if they call it art of craft," he says, "it really doesn't make any difference to me, but I do like the fact that people want to see it." In fact, Chihuly has been instrumental in establishing glass as a viable art medium, even inspiring the construction of a new Museum of Glass in his native Tacoma that opened to the public in 2002.

Fred Wilson is an artist and curator who has spent much of his career looking at and thinking about the arts and crafts of American society. He is especially adept at sifting through existing museum collections, reorga nizing some objects and bringing others out of storage, in order to create commentaries on the history of American racism and the socialpolitical realities of the American museum system (see the Works in Progress, p. 348, for an exhibit he created from the collections of the Maryland Historical Society). In 2001, Wilson began working with glass as he prepared to be the American representative at the 2003 Venice Biennale. Given Venice's preeminence as a glass manufacturing city, glass

Fig. 464 Dale Chihuly, Rotunda Chandelier (Victoria and Albert Chandelier). Glass, 1999. 27 × 12 × 12 ft. Photo: Victoria & Albert Museum, London / Art Resource, NY.

seemed a natural choice, and he hired the famcd glassworkers on the island of Murano to create the pieces that he designed. But it was a difficult medium for him to work with. With glass, he says, "it's hard to make anything that has a lot of meaning—or where the meaning is at least as strong as the beauty of the material. Infusing meaning is what I'm really interested in."

Wilson chose to work with black glass, because black as a color is so obviously a metaphor for African-Americans, but also because it refers to the long history of black Africans in Venice, epitomized in Western consciousness by Shakespeare's Othello: The Moor of Venice. Inspired by the watery canals and lagoons of Venice, he shaped the glass so that it appeared to be liquid—ink, oil, tar. In Drip Drop Plop (Fig. 465), what appear to be glass tears descend the wall to form puddles of black liquid on the floor. Some of the tears and puddles have eyes: "Because of 1930s cartoons that were recycled in my childhood in the 1960s, these cartoon eyes on a black object represent African-Americans in a very derogatory way. . . . So I sort of view them as black tears." But the glass tears suggest other things as well—the degradation of the environment, for one, as they fall off the wall like a spill from an oil tanker. They also take on the appearance of sperm, suggesting an almost masturbatory ineffectuality. All these meanings are at least partially at work, and they underscore the ways in which art and craft differ. Art, in essence, goes far beyond mere utility. It provokes thought, and it produces meaning.

In the hands of painter Gregory Grenon, glass takes on yet another aspect. Grennon paints on glass—not canvas or board. But he doesn't use glass as the support or ground for his work; rather, he paints on the back of it, so that the image can only be viewed through the glass. For smaller pieces, Grenon uses real glass, but for larger ones, such as *It's That Woman in*

Fig. 465 Fred Wilson, *Drip Drop Plop*, 2001. Glass, approximately 99 × 72 × 62 in. Photo: Ellen Labenski, courtesy PaceWildenstein, New York. © Fred Wilson, courtesy PaceWildenstein, New York.

Fig. 466Gregory Grenon, It's That Woman in the Red Dress Again, 1994.Oil on plexiglass, 62 × 60 in. Courtesy of the artist. The Laura Russo Gallery, Portland, Oregon.
Photo: Bill Bachhuber.

the Red Dress Again (Fig. 466), which is over 5×5 feet in dimension, he uses the much lighter plexiglass, a transparent acrylic resin that shares many of the same characteristics as glass. Viewing Grenon's paintings through glass imparts a transparency and luminosity not normally seen in painting (the effect is not readily visible in reproduction). It is as if the work is backlit, almost as if a Renaissance painter added so many layers of glazing (see Chapter 12) to his canvas that there appeared to be a sheet of glass on its surface.

Grenon's work consists almost exclusively of portraits of women (although he also paints baseball players—a personal passion). Paintings like *It's That Woman in the Red Dress Again* are part of a larger project to document the social realities of women in contemporary society. "I want to feel the pain of being a woman," Grenon says. "I want to feel the freedom or lack of freedom of being a woman. . . . My paintings are me talking through women, speaking up for women."

WORKS IN PROGRESS

red Wilson is a contemporary museum curator who has transformed the problem of exhibition design by exposing the cultural, political, and socioeconomic assumptions that underlie the modern museum space. Traditionally, museums have tried to create coherent, even homogeneous, spaces in which to view exhibitions. The "white room" effect is one such design principle-that is, the walls of the space are uniform and white so as not to detract from the work on the walls. Even when more elaborate design ideas come into play-for instance, when an architectural setting is re-created in order to reconstruct the original era or setting of the works on display-the principle of an intellectually coherent space, one that helps the viewer to understand and contextualize the work, predominates.

Wilson believes that this traditional curatorial stance has caused most museums to "bury" or ignore works that do not fit easily into the dominant "story" that the museum tells. In 1992, The Contemporary, a museum exhibiting in temporary spaces in Baltimore, Maryland, arranged for Wilson to install an exhibition at the Maryland Historical Society. Wilson saw it as an opportunity to reinterpret the Historical Society's collection and present a larger story about Maryland history than the museum was used to telling.

Wilson begins all of his projects with a research phase—in this case, into the history of Baltimore and the people who lived there. "When I go into a project," he says, "I'm not looking to bring something to it. I'm responding more than anything else. You can still get a very personal emotional response from a situation or an individual who lived a hundred years ago. It's connecting over time that I'm responding to." In the archives and collections of the museum, Wilson was able to discover a wealth of material that the museum had never exhibited, not least of all because it related to a part of Maryland history that embarrassed and even shamed many viewers—the reality of slavery. Wilson brought these materials to light by juxtaposing them with elements of the collection that viewers were used to seeing.

Behind a "punt gun" ostensibly used for hunting game birds on Chesapeake Bay, Wilson placed reward notices for runaway slaves. A document discovered in the archives, an inventory of the estate of one Nicholas Carroll (Fig. 467), lists all his slaves and animals together with their estimated value. What jars the contemporary reader is the fact that least valuable of all, valued at a mere dollar, is the "negro woman Hannah seventy-three years of age." Even the "old Mule called Coby" is worth five times as much. In the middle of a display of silver repoussé objects made by Maryland craftsmen in the early 1800s (Fig. 469), Wilson

Maves	
One mego boy Daniel Hundy aged eighten years	6.00
One negro woman Sophy forty eight years of age	150 -
On mengro woman Ann thirty eight years of age	150 -
One negro woman Margaus thirty two years of age	300 -
On myro girl Sophy today years of age	350 -
One negro gert two years of age	150 -
One negro woman Hannah seventy three years of age	1
Conservation of old a gen	60
One young .	80 -
One young black bull	35 -
One black low called Blass	25 -
Thus calves	15 00
One brindle low called Smut	15 -
One Red low called Suck	16 -
Come Red Cow - Salt	20 -
One Med low . Bilz	
One Hed leow called therey	15
One bay mare . Magippa	22
One bay hore . Andustry	100 -
	100 -
One pair of Mulie . Dogy and this	201 4
One old Hube , Koby	500
One Mare . Same	40 00
Swenty eight sheep	56 .
One gray colt one spar old	30 00

Fig. 467 Nicholas Carroll Estate Inventory, MS 2634, c. 1812. Manuscripts Division, Maryland Historical Society Library. Maryland Historical Society, Baltimore, Maryland.

Fred Wilson's MINING THE MUSEUM

placed a set of iron slave shackles, underscoring the fact that Maryland's luxury economy was built on slavery. Similarly, in a display of Maryland cabinetmaking, he placed a whipping post (Fig. 468) that was used until 1938 in front of the Baltimore city jail, and that the museum had ignored for years, storing it with its collection of fine antique cabinets.

Wilson was equally struck by what was missing from the museum's collection. While the museum possessed marble busts of Henry Clay, Napoleon Bonaparte, and Andrew Jackson, none of whom had any particular impact on Maryland history, it possessed no busts of three great black Marylanders—Harriet Tubman, Frederick Douglass, and the astronomer and mathematician Benjamin Banneker. Thus, at the entrance to the museum, across from the three marble busts in the museum's collection, he placed three empty pedestals, each identified with the name of its "missing" subject.

"Objects," Wilson says, "speak to me." As an artist, curator, and exhibition designer, Wilson translates what these objects say to him for all of us to hear. "I am trying to root out . . . denial," he says. "Museums are afraid of what they will bring to the surface and how people will feel about issues that are long buried. They keep it buried, as if it doesn't exist, as though people aren't feeling these things anyway, instead of opening that sore and cleaning it out so it can heal."

Figs. 468 and 469 Mining the Museum, Installation details, Fred Wilson, artist/curator. Top: Whipping Post and Chairs for Cabinetmaking, 1820–1960. Left: Silver Vessels and Slave Shackles for Metalwork. Photos: Jeff D. Goldman. © Contemporary Museum, Baltimore

FIBER

We do not usually think of fiber as a threedimensional medium. However, fiber arts are traditionally used to fill three-dimensional space, in the way that a carpet fills a room or that clothing drapes across a body. In the Middle Ages, tapestry hangings such as *The Unicorn in Captivity* (Fig. 470) were hung on the stone walls of huge mansions and castles to soften and warm the stone. Fiber is an extraordinarily textural medium, and, as a result, it has recently become an increasingly favored medium for sculpture.

But all fiber arts, sculptural or not, trace their origins back to **weaving**, a technique for constructing fabrics by means of interlacing horizontal and vertical threads. The vertical threads—called the **warp**—are held taut on a

Fig. 470 The Hunt of the Unicorn, VII: The Unicorn in Captivity, Franco-Flemish, 16th century, c. 1500. Silk and wool, silver and silver-gilt threads, 12 ft. 1 in. × 8 ft. 3 in.
© Metropolitan Museum of Art, New York, The Cloisters Collection, Gift of John D. Rockefeller, Jr. 1937 (37.80.6). Photo © 1993 Metropolitan Museum of Art.

loom or frame, and the horizontal threads the weft or woof—are woven loosely over and under the warp. A tapestry is a special kind of weaving in which the weft yarns are of several colors and the weaver manipulates the colors to make an intricate design.

In embroidery, a second traditional fiber art, the design is made by needlework. From the early eighteenth century onward, the town of Chamba was one of the centers of the art of embroidery in India. It was known, particularly, for its *rumals*, embroidered muslin textiles that were used as wrappings for gifts (Fig. 471). If an offering was to be made at a temple, or if gifts were to be exchanged between families of a bride and groom, an embroidered *rumal* was always used as a wrapping.

The composition of the Chamba rumals is consistent. A floral border encloses a dense series of images, first drawn in charcoal and then embroidered, on a plain white muslin background. For a wedding gift, as in the rumal illustrated here, the designs might depict the wedding itself. The designs were double-darned, so that an identical scene appeared on both sides of the cloth. Because of its location in the foothills and mountains of the Himalayas, offering relief from the heat of the Indian plains, the region around Chamba was a favorite summer retreat for British colonists, and its embroidery arts became very popular in nineteenth-century England.

Fig. 471 Embroidered *rumal*, late 18th century. Muslin and colored silks. V & A Images/Victoria and Albert Museum.

 Fig. 472 Anni Albers, Wall Hanging, 1926.
 Silk (two-ply weave), 72 × 48 in. The Busch-Reisinger Museum, Harvard University Art Museums, Cambridge, Massachusetts. Association Fund.
 Photo: Michael Nedzweski. © President and Fellows of Harvard College, Harvard University. BR48.132.
 © 2007 the Josef and Anni Albers Foundation/Artists

Rights Society (ARS), New York.

One of the most important textile designers of the nineteenth century was Anni Albers. The wall hanging in Figure 472 was done on a 12-harness loom, each harness capable of supporting a 4-inch band of weaving. Consequently, Albers designed a 48-inch-wide grid composed of 12 of the 4-inch-wide units. Each unit is a vertical rectangle, variable only in its patterning, which is either solid or striped. The striped rectangles are themselves divided into units of 12 alternating stripes. Occasional cubes are formed when two rectangles of the same pattern appear side by side.

Anni Albers regarded such geometric play as rooted in nature. Inspired by reading *The Metamorphosis of Plants*, by Johann Wolfgang von Goethe, the eighteenth-century German poet and philosopher, she was fascinated by the way a simple basic pattern could generate, in nature, infinite variety. There is, in the design here, no apparent pattern in the occurrence of solid or striped rectangles or in the colors employed in them. This variability of particular detail within an overall geometric scheme is, from Albers's point of view, as natural and as inevitable as the repetition itself.

In 2003, the Museum of Fine Arts, Houston, organized an exhibit of quilts made by the women from the isolated community of Gee's Bend, Alabama. It surprised the American art world by revealing an indigenous grassroots approach to textile design that rivaled in every way the inventiveness of more sophisticated avant-garde artists like Albers. Consisting of 60 quilts by 42 women spanning four generations, the quilts reveal a genius for color and geometry. Jessie T. Pettway's Bars and String-Pieced Columns (Fig. 473) verges back and forth between its highly structured threecolumn organization, and the almost giddy sense of imbalance created by the rise and fall of the horizontal bars of color between the solid red bars. The women themselves were stunned by the attention the art world

 $\begin{array}{l} \mbox{Cotton, 95 \times 76 in. Provided by the Tinwood Alliance} \\ \mbox{(www.tinwoodmedia.com)}. \\ \mbox{Photo: Steve Pitking/Pitking Studios © 2003. Collection, Atlanta.} \end{array}$

suddenly bestowed on them. "We never thought that our quilts was artwork; we never heard about a quilt hanging on a wall in a museum," quilter Arlonzia Pettway says. "Everybody went to talking about our quilts and everybody wanted to meet us and see us and that's what happened." But however practical the quilts were designed to be, heaped on beds to keep their families warm, their artistry could hardly be denied. It was as if, working together, the women of Gee's Bend had forged a unique abstract style of their own.

In the early 1970s, Faith Ringgold, whose earlier painting we saw in Chapter 1 (see Fig. 15), began to paint on soft fabrics and frame her images with deocrative quilted borders made by her mother. After her mother's

death in 1981, Ringgold created the quilt borders herself, and she began writing an autobiography, published in 1995 as We Flew Over the Bridge: The Memoirs of Faith, which she incoporated into her painting/quilts. Tar Beach (Fig. 474) is one of these. "Tar Beach" refers to the roof of the apartment building where Ringgold's family would sleep on hot summer nights when she was growing up. The fictional narrator of this story is an eightyear-old girl named Cassie, shown lying on a quilt (within the quilt) with her brother at the lower right while her parents sit at a nearby table playing cards. A second Cassie flies over the George Washington Bridge at the top of the painting, a manifestation of the child's dreams. In the accompanying story, she imagines she can fly, taking the bridge for her own,

Fig. 474 Faith Ringgold, Tar Beach (Part I from the Woman on a Bridge series), 1988.
 Acrylic on canvas bordered with printed, painted, quilted, and pieced cloth, 74 ⁵/₈ × 68 ¹/₂ in. Solomon R. Guggenheim Museum, New York.
 Photo © Faith Ringgold.

Fig. 475 Mike Kelley, More Love Hours Than Can Ever Be Repaid and The Wages of Sin. 1987.
Stuffed fabric toys and afghans on canvas with dried corn; wax candles on wood and metal base, 90 x 119 ¼ × 5 in. Purchase, with funds from the Painting and Sculpture Committee. Collection of the Whitney Museum of American Art, New York. © Courtesy of the artist and Metro Pictures.

claiming a union building for her father (half black, half Indian, he had helped to build it, but owing to his race, could not join the union himself) and an ice cream factory for her mother, who deserved to eat "ice cream every night for dessert." The painting is a parable of the African-American experience, portraying at once the hopes and aspirations of their community even as it embodies the stark reality of their lives.

In the late 1980s, Mike Kelley began to assemble afghans and crocheted dolls from the bins of thrift stores and arrange them into sometimes shocking scenarios designed to challenge their apparent innocence. More Love Hours Than Can Ever Be Repaid (Fig. 475) is the first work created in this way. Stitched together on a large sheet of unstretched canvas, the dolls evoke, formally, a kind of all-over color abstraction, but, more thematically, a moving image of unrequited love, a pile of objects rejected to the trash bin without, apparently, even a hint of remorse. In a drawing study for the work, Kelley writes: "Harvest of love/ After the fall Love crop/ Time of plenty/ End of harvest/ Love's labour lost/ Undigested corn/ French & Indian Wars/ Fertilized furrows/ Compost heap of love/ Nimble fingers/ Busy guts." Thus, he has hung the piece at each corner with a few ears of Indian corn. The analogy between Indians and dolls suggests that both are throwawaysand, by extension, so are love and friendship-sacrificed to Western society. In Kelley's words, "All I can really do now is work with this dominant culture and flay it, rip it apart, reconfigure it, expose it. Because popular culture is really invisible. People are really visually illiterate. They learn to read in school, but they don't learn to decode images. They're not taught to look at films and recognize them as things that are put together. . . . They don't say, 'Oh yeah, somebody made that, somebody cut that.' They don't think about visual things that way. So visual culture just surrounds them, but people are oblivious to it."

It was in the hands of Magdalena Abakanowicz in this century, that fiber became a tool of serious artistic expression, freed of any associations with utilitarian crafts. In the early 1970s, using traditional fiber materials such as burlap and string, Abakanowicz began to make forms based on the human anatomy (Fig. 476). She presses these fibers into a plaster mold, creating a

Fig. 476 Magdalena Abakanowicz, *Backs in Landscape*, 1978–1981.

Eighty sculptures of burlap and resin molded from plaster casts, over-lifesize. Marlborough Gallery, New York. Photo © 1982 Dirk Bakker, Detroit, Michigan. series of multiples that, though generally uniform, are strikingly different piece to piece, the materials lending each figure an individual identity.

As Anni Albers's work also demonstrates, pattern and repetition have always played an important role in textile design. Abakanowicz brings new meaning to the traditional functions of repetitive pattern. These forms, all bent over in prayer, or perhaps pain, speak to our condition as humans, our spiritual emptiness—these are hollow forms—and our mass anxiety.

The textile wrappings also remind us of the traditional function of clothing-to protect us from the elements. Here, huddled against the sun and rain, each figure is shrouded in a wrap that seems at once clothing and bandage. It is as if the figures are wounded, cold, impoverished, homeless-the universal condition. As Abakanowicz reminds us, "It is from fiber that all living organisms are built-the tissues of plants, and ourselves. Our nerves, our genetic code, the canals of our veins, our muscles. We are fibrous structures. Our heart is surrounded by the coronary plexus, the plexus of most vital threads. Handling fiber, we handle mystery. . . . When the biology of our body breaks down, the skin has to be cut so as to give access to the inside, later it has to be sewn, like fabric. Fabric is our covering and our attire. Made with our hands, it is a record of our souls."

This too is the subject for artist Yinka Shonibare. Like Chris Ofili (see Fig. 69), Shonibare was born in England to Nigerian parents, but unlike Ofili he was raised in Nigeria before returning to art school in London. In the mid-1990s, he began making works out of the colorful printed fabrics that are worn throughout West Africa (Fig. 477), all of which are created by English and Dutch designers, manufactured in Europe, then exported to Africa, where they are in turn remarketed in the West as authentic African design. In this sense, the fabrics are the very record of Shonibare's soul, traveling back and forth, from continent to continent. "By making hybrid clothes," Shonibare explains, "I collapse the idea of a European dichotomy against an African one. There is no way you can work out where the opposites are. There is no way you can work out the precise nationality of my dresses, because they do not have one. And there is no way you can work out

Fig. 477 Yinka Shonibare, Victorian Couple, 1999. Wax printed cotton textile, left approx. $60 \times 36 \times 36$ in; right approx. $60 \times 24 \times 24$ in. Courtesy of the Artist, Stephen Friedman Gallery, London, and James Cohan Gallery, New York.

the precise economic status of the people who would've worn those dresses because the economic status and the class status are confused in these objects." In fact, the era of these costumes is even drawn into question. The bustle on the woman's dress is distinctly nineteenth century, while the man's entire wardrobe seems distinctly out of the 1960s American hippie movement, especially given the decorative effect of the trumpets on his trouser legs.

METAL

Perhaps the most durable of all craft media is metal, and, as a result, it has been employed for centuries to make vessels for food and drink, tools for agriculture and building, and weapons for war. We have discussed traditional metal-casting techniques in Chapter 14, but it is worth remembering that Chinese artisans had developed a sophisticated bronzecasting technique as early as the 16th century BCE, many centuries before the advent of the lost-wax technique in the West. The Chinese

Fig. 478 Griffin bracelet, from the Oxus treasure, c. 500–400 BCE. Gold and stones, diameter, 5 in. British Museum, London. The Bridgeman Art Library.

apparently constructed two-piece "sandwich" molds that did not require wax to hold the two sides apart. For an example, see Chapter 18, "The Ancient World," Figure 593.

Over the years, metals, especially gold and silver, have been most lavishly used in the creation of jewelry. The Persian griffin bracelet pictured here (Fig. 478) was discovered in 1877 as part of the Oxus Treasure, named after the river in Soviet Central Asia where it was found. The griffin is a mythological beast, half eagle, half lion, that symbolized vigilance and courage and was believed by the Persians to guard the gold of India, and the story associated with the discovery of this bracelet is indeed one of heroism and courage. Originally sold to Muslim merchants, the Oxus treasure was soon stolen by bandits, who were intent on dividing the loot evenly by melting it down. Captain F. C. Burton, a British officer in Pakistan, heard of the robbery, rescued the treasure, and returned it to the merchants, asking only that he be given one of two griffin bracelets as his reward. He subsequently donated it to the Victoria and Albert Museum while its companion piece, illustrated here eventually found its way to the British Museum. Considered one of the most beautiful works of jewelry ever made, the bracelet was originally inlaid with colored stones. The minute detail of the griffins—especially the feathers on wings and necks, as well as the clawed feet—must have suggested, inlaid with stone, the finest Asian silk drapery.

The Oxus treasure was almost surely a royal horde, and throughout history, the most elaborate metal designs have always been commissioned by royalty. In 1539, Benvenuto Cellini designed a saltcellar (Fig. 479) for Francis I of France. Made of gold and enamel, it is actually a functional salt and pepper shaker. Salt is represented by the male figure, Neptune, god of the sea, and hence overlord of the sea's salt. Pepper is the provenance of Earth, represented by the female figure. Along the base of the saltcellar is a complex array of allegorical figures depicting the four seasons and the four parts of the day, embodying both seasonal festivities and the daily meal schedule. In his Autobiography, Cellini described the work as follows:

I first laid down an oval framework and upon this ground, wishing to suggest the interminglement of land and ocean, I modeled two figures, one considerably taller than a palm in height, which were seated with their legs interlaced, suggesting those lengthier branches of the sea which run up into the continents. The sea was a man, and in his hand I placed a ship, elaborately wrought in all its details, and well adapted

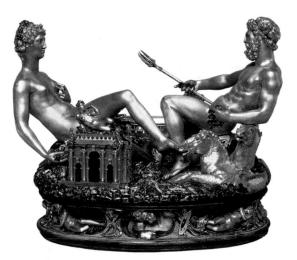

 Fig. 479 Benvenuto Cellini, Saliera (saltcollar), Noptune (sea), and Tollus (earth), 1540–1543.
 Gold, nielo work, and ebony base, height, 10 ¼ in.
 Kunsthistorisches Museum, Vienna, Austria

to hold a quantity of salt. Beneath him I grouped the four sea-horses, and in his right hand he held his trident. The earth I fashioned like a woman, with all the beauty of form, the grace, and charm of which my art was capable. She had a richly decorated temple firmly based upon the ground at one side; and here her hand rested. This I intended to receive the pepper. In her other hand I put a cornucopia, overflowing with all the natural treasures I could think of. Below the goddess, on the part which represented earth, I collected the fairest animals that haunt our globe. In the quarter presided over by the deity of ocean, I fashioned such choice kinds of fishes and shells as could be properly displayed in that small space.

While Cellini apparently later changed the positions of the hands and what they were holding, the description, which must have been written some 20 years after the fact, is accurate. When a Vatican cardinal saw the model, he told

 $\begin{array}{lll} \mbox{Fig. 480} & \mbox{Susan Ewing, Inner Circle Teapot, 1991.} \\ & \mbox{925 silver, 24K vermeil, 9 $^3\!\!/_4 \times 10 $^1\!\!/_4 \times 8 $^1\!\!/_2$ in.} \\ & \mbox{Courtesy of the artist. Photo: Carl Potteiger.} \end{array}$

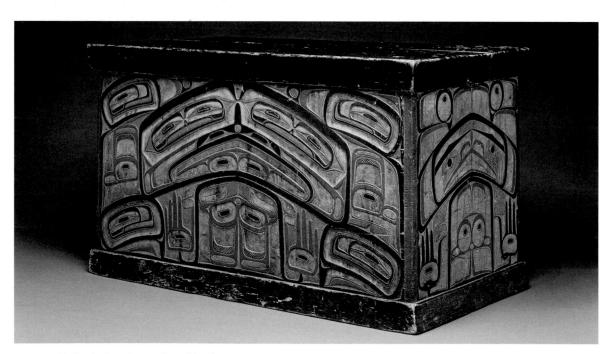

Fig. 481 Heiltsuk, Bent-Corner Chest (Kook), c. 1860.
 Yellow and red cedar, and paint, 21 ¹/₄ × 35 ³/₄ × 20 ¹/₂ in. The Seattle Art Museum. Gift of John H. Hauberg and John and Grace Putnam.
 Photo: Paul Macapia.

Cellini: "Unless you make it for the King, to whom I mean to take you, I do not think that you will make it for another man alive."

A more contemporary example of metalwork at its finest is Susan Ewing's *Inner Circle Teapot* (Fig. 480). Ewing works out the ideas for such pieces by bending and turning everyday materials such as cardboard, common tubing, and the like until she has found a form that seems pleasing. Here she evokes a kind of terrestrial globe orbited by the teapot's handle and spout. The pattern on the teapot is created through a technique known as vermeil, pronounced "vair-may," in which a microscopically thin layer of gold is plated to the finished silver form.

WOOD

Because it is so easy to carve, and because it is so widely available, artisans have favored wood as a medium throughout history. Yet, because it is organic material, wood is also extremely fragile, and few wood artifacts survive from ancient cultures.

Of all woods, cedar, native to the Northwest American coast, is a particular favorite of Native American artists in that region because of its relative impermeability to weather, its rcsistance to insect attack, and its protective, aromatic odor. Chests such as this Heiltsuk example (Fig. 481) were designed to contain family heirlooms and clan regalia and were opened only on ceremonial occasions. Often such a chest also served as the ceremonial seat of the clan leader, who sat upon it, literally supported by his heritage.

Wood has also been a favorite, even preferred, material for making furniture, and in the hands of accomplished artists, a piece of furniture can be transformed into a work of art in its own right. Spanish architect Antoni Gaudí thought that the furniture decorating a house should be integrated with the house itself. His elaborate, organic architectural designs thus demanded organic furniture design. This chair (Fig. 482), designed for the Casa Calvet in Barcelona, is at once animal and vegetable, its legs and arms projecting forward as if it is stalking prey, while the whole takes on the aspect of a giant mushroom.

Fig. 482 Antoni Gaudí, *Oak Armchair for the Casa Calvet,* 1904. Museo Gaudi, Barcelona, Spain. The Bridgeman Art Library.

But it is the impracticability of the most practical of wooden forms, a ladder, that animates Martin Puryear's Ladder for Booker T. Washington (Fig. 483). "The work was really about using the sapling, using the tree," Puryear has explained. "And making a work that had a kind of artificial perspective, a forced perspective, an exaggerated perspective that made it appear to recede into space faster than in fact it does. That really was what the work was about for me, this kind of artificial perspective." To make the piece, Puryear actually split a 36-foot-long ash so that each side of the ladder is almost exactly the same. The title, which Puryear arrived at after finishing the piece, refers to the African-American political leader and educator who at the turn of the century worked to improve racial harmony in the United States. Washington saw the process as long and slow, one whose end always seemed far away. Puryear's ladder reflects that point of view, although in its forced perspective it suggests that Washington's goal might have been nearer than it appeared.

Fig. 483 Martin Puryear, Ladder for Booker T. Washington, 1996.

 $423 \times 22 \frac{3}{4}$ (narrowing to $1 \frac{1}{4}$ at top) $\times 3$ in. Wood (ash and maple). Installation view at the Modern Art Museum of Fort Worth, Texas. Collection of the Modern Art Museum of Fort Worth, Gift of Ruth Carter Stevenson, by Exchange. McKee Gallery, NY.

THE **CRITICAL** PROCESS Thinking about Other Three-Dimensional Media

As a medium, sculpture is, by and large, more active than painting. We passively stand before a painting. But we walk around sculpture—or through it, in the case of earthworks—and it changes with our point of view. Even when we consider sculpture in relief, it is as if the scenes depicted in it are trying to emerge or escape from the confines of twodimensionality. And crafts, when appropriated to artistic ends rather than purely utilitarian ones, offer up the same sculptural experience as any other three-dimensional form.

One of the great myths that helps us to understand the power of sculpture is the story of Pygmalion. According to legend, Pygmalion fell in love with a statue of Venus that he himself

had carved. When he prayed that he might have a wife as beautiful as the image he had created. to his amazement the statue came to life as his wife, Galatea. The story embodies the "liveliness" of all three-dimensional media, their tendency to move off the wall and actively engage us, not just imaginatively but physically as well. By modeling, carving, casting, and assembling, we create objects that enter our world, share our space, even confront us. When we work with clay, glass, fiber, wood, or metal, we may make things that we can physically use, or we may not, but we do make things that enter the three-dimensional space of our lives. Sculptural forms have the uncanny ability to come to life like Galatea herself.

Consider Ann Hamilton's installation 'a round' (Fig. 484). Hamilton conceives of projects that relate directly to their site. 'a round' was commissioned by a contemporary art space in Toronto called the Power Plant, a former storage area on the docks. It consisted of 1,200 human-shaped cotton bags-wrestling dummies-cut and sewn industrially, filled, manually, with sawdust, and piled around the walls, suggesting the transformation of the human into the commodity. The floor was covered with canvas, like a boxing ring, and at the top of two massive pillars, also covered in canvas, were two mechanized leather punching bags that periodically burst into motion, disrupting the silence (hence the work's title). Between them, an extraordinary length of white yarn was stretched in a wide horizontal band, which, during the course of the installation, was gradually unraveled by a seated woman knitting a white shawl in isolation in the middle of the room.

What is sculptural about this space? What about the work is related to the so-called craft

media? What is more performance oriented? What about the space could be described as masculine? What about it could be defined as feminine? It should help you to know that Hamilton was trained, as an undergraduate, in textile design, and as a graduate student, in sculpture. "Cloth," Hamilton has said, "like human skin, is a membrane that divides an interior from an exterior. It both reveals and conceals. . . . In its making, individual threads of warp are crossed successively by individual threads of weft. Thus cloth is an accumulation of many gestures of crossing." What "crossings" can you detect in the work? Can you say how, for instance, the ritualized activity of sewing, or so-called "piece work," relate to the ritualized violence of sport? (Remember the saying "what goes around comes around.") Or what about the tension between "live" and mechanized activity? How does the wall of "dummies" function as a sort of skin in its own right? These are just a few of the questions that this mysterious, but evocative, installation provokes.

Fig. 484 Ann Hamilton, "Untitled (Water/Neck)". 1988, published 1993. Color-toned image on LCD screen. 20 Minutes. Henry Art Gallery, Gift of William and Ruth True. 97.201. Power Plant, Toronto, Canada. May 7–September 6, 1993. Courtesy: Sean Kelly Gallery, New York. Photo: Cheryl O'Brien.

THE VISUAL ARTS IN EVERYDAY LIFE Recognizing the Art of Design

Fig. 485 Philip Johnson and John Burgee, College of Architecture, University of Houston, 1983–1985. Photo: Richard Payne, FAIA.

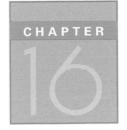

Architecture

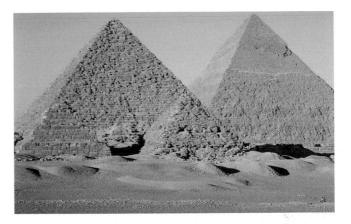

he building that houses the College of Architecture at the University of Houston (Fig. 485), designed by architects Philip Johnson and John Burgee, is a sort of history of Western architecture from the Greeks to the present. Resting on its top is a Greek temple. The main building below is reminiscent of Italian country villas of the Renaissance. The entire building was inspired by an eighteenth-century plan for a House of Education designed by Claude-Nicolas Ledoux (Fig. 486) for a proposed utopian community at Chaux, France, that never came into being. And the building itself is distinctly postmodern in spirit—it

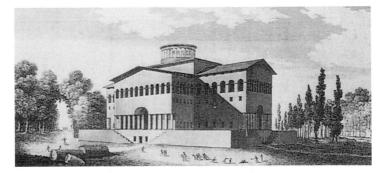

Fig. 486 Claude-Nicolas Ledoux, House of Education, 1773–1779. Courtesy of The Library of Congress.

TOPOGRAPHY

TECHNOLOGY Load-Bearing Construction Post-and-Lintel Arches and Domes Cast-Iron Construction Frame Construction Steel-and-Reinforced-Concrete Construction Works in Progress Frank Lloyd Wright's Fallingwater

COMMUNITY LIFE

Works in Progress Mierle Laderman Ukeles's Fresh Kills Landfill Project

The Critical Process Thinking about Architecture

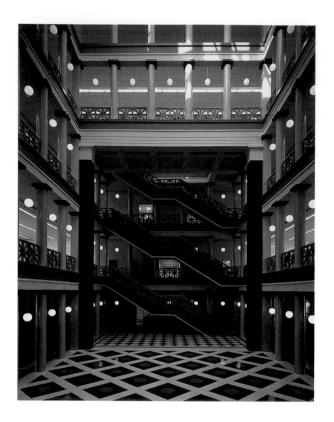

revels in a sense of discontinuity between its parts. One has the feeling that the Greek temple fits on the building's roof about as well as a maraschino cherry would on a scoop of potato salad.

In this chapter, we will consider how our built environment has developed-how we have traveled, in effect, from Greek temples and Anasazi cliff dwellings to skyscrapers and postmodernist designs. We will see that the "look" of our buildings and our communities depends on two different factors and their interrelation-topography, or the distinct landscape characteristics of the local site, and technology, the materials and methods available to a given culture. Johnson and Burgee's design for the College of Architecture at the University of Houston takes advantage of many of the technologies developed over the centuries, but at first glance, it seems to ignore the local topography altogether. However, when we consider its interior (Fig. 487), we can see that the cool atrium space that lies under the colonnade on the roof offers a respite from the hot Texas sun. The site has had a considerable influence on the design. Thus the key to understanding and appreciat-

Fig. 487 Philip Johnson and John Burgee, College of Architecture, University of Houston, interior, 1983–1985. Photo: Richard Payne, FAIA.

ing architecture always involves both technology and topography. We will consider topography first.

TOPOGRAPHY

The built environment reflects the natural world and the conception of the people who inhabit it of their place within the natural scheme of things. A building's form might echo the world around it, or it might contrast with it—but, in each case, the choices builders make reveal their attitudes toward the world around them.

The architecture of the vast majority of early civilizations was designed to imitate natural forms. The significance of the pyramids of Egypt (Fig. 488) is the subject of much debate, but their form may well derive from the image of the god Re, who in ancient Egypt was symbolized by the rays of the sun descending to earth. A text in one pyramid reads: "I have trodden these rays as ramps under my feet." As one approached the mammoth pyramids, covered in limestone to reflect the light of the sun, the eye was carried skyward to Re, the Sun itself, who was, in the desert, the central fact of

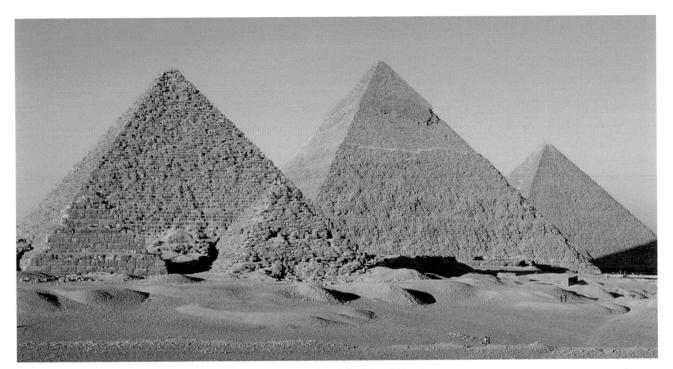

Fig. 488 Pyramids of Menkaure (c. 2470 BCE), Khafre (c. 2500 BCE.), and Khufu (c. 2530 BCE).
 Original height of Pyramid of Khufu 480 ft., length of each side at base 755 ft.
 Photo © Dallas and John Heaton. Corbis, NY. All rights reserved.

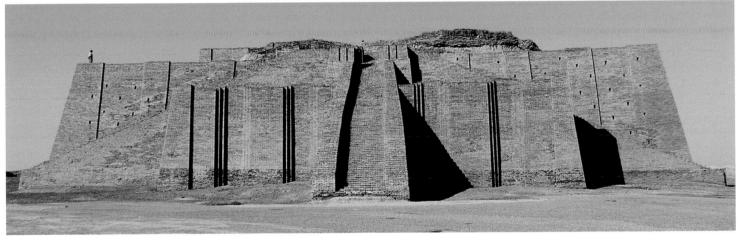

Fig. 489 Ziggurat, Ur, c. 2100 BCE. Fired brick over mudbrick core, 210 × 150 ft. at base. Corbis/Bettman.

life. In contrast, the pyramidlike structures of Mesopotamia, known as ziggurats (Fig. 489), are flatter and wider than their Egyptian counterparts, as if imitating the shape of the foothills that lead up to the mountains. The Sumerians believed that the mountaintops were not only the source of precious water, but also the dwelling place of the gods. The ziggurat was constructed as an artificial mountain in which a god could reside.

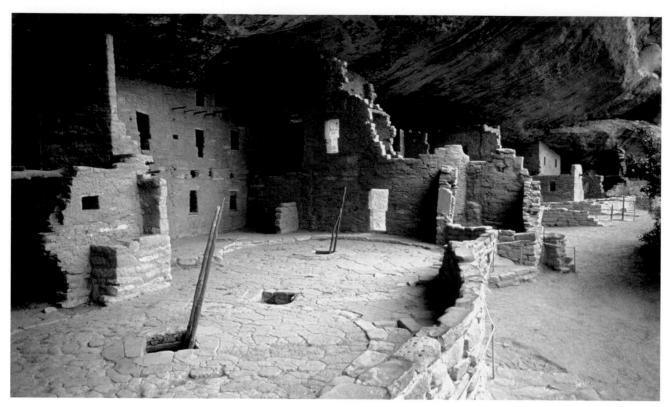

Fig. 490 Mesa Verde, *Spruce Tree House*, c. 1200–1300 cE. Courtyard formed by restoration of the roofs over two underground kivas. Photo: John Deeks/Photo Researchers, Inc.

The Anasazi cliff dwelling known as Spruce Tree House (Fig. 490), at Mesa Verde National Park in southwestern Colorado, reflects a similar relation between humans and nature. The Anasazi lived in these cliffside caves for hundreds, perhaps thousands, of years. The cave not only provided security, but also to live there was to be closer to the people's origin and, therefore, to the source of their strength. For unknown reasons, the Anasazi abandoned their cliff dwellings in about 1300 CE. One possible cause was a severe drought that lasted from 1276 to 1299. It is also possible that disease, a shortened growing season, or warfare with Apache and Shoshone tribes caused the Anasazi to leave the highland mesas and migrate south into Arizona and New Mexico.

At the heart of the Anasazi culture was the kiva, a round, covered hole in the center of the communal plaza in which all ceremonial life took place. The roofs of two underground kivas on the north end of the ruin have been restored. They are constructed of horizontally laid logs built up to form a dome with an ac-

Fig. 491 Cribbed roof construction of a kiva. After a National Park Service pamphlet.

cess hole (Fig. 491). The people utilized these roofs as a common area. Down below, in the enclosed kiva floor, was a *sipapu*, a small, round hole symbolic of the Anasazi creation myth, which told of the emergence of the Anasazi's ancestors from the depths of the earth. In the parched Southwestern desert country it is equally true that water, like life itself, also seeps out of small fissures in the earth. Thus, it is as if the entire Anasazi community, and everything necessary to its survival, emerges from mother earth.

TECHNOLOGY

The structure of the kiva's roof represents a technological innovation of the Anasazi culture. Thus, while it responds directly to the topography of the place, it also reflects the *technology* available to the builder. The basic technological challenge faced by architecture is to construct upright walls and put a roof over the empty space they enclose. Walls may employ one of two basic structural systems: the **shell system**, in which one basic material provides both the structural support and the outside covering of the building, and the **skeleton-and-skin system**, which consists of a basic interior frame, the skeleton, that supports the more fragile outer covering, the skin.

In a building that is several stories tall, the walls or frame of the lower floors must also support the weight of the upper floors. The ability of a given building material to support weight is thus a determining factor in how high the building can be. The walls or frame also support the roof. The span between the elements of the supporting structure-between, for instance, stone walls, columns, or steel beams-is determined by the tensile strength of the roof material. Tensile strength is the ability of a building material to span horizontal distances without support and without buckling in the middle. The greater the tensile strength of a material, the wider its potential span. Almost all technological advances in the history of architecture depend on either the invention of new ways to distribute weight or the discovery of new materials with greater tensile strength. We begin our survey with the most basic technology and move forward to the most advanced.

Load-Bearing Construction

The simplest method of making a building is to make the walls load-bearing-make the walls themselves bear the weight of the roof. One does this by piling and stacking any material-stones, bricks, mud and straw-right up to roof level. Many load-bearing structures, such as the pyramids or the ziggurats we have already seen, are solid almost all the way through, with only small open chambers inside them. Though the Anasazi cliff dwelling contains more livable space than a pyramid or a ziggurat, it too is a load-bearing construction. The kiva is built of adobe bricks-bricks made of dried clay-piled on top of one another, and the roof is built of wood. The complex roof of the kiva spans a greater circumference than would be possible with just wood, and it supports the weight of the community in the plaza above. This is achieved by the downward pressure exerted on the wooden beams by the stones and fill on top of them above the outside wall, which counters the tendency of the roof to buckle.

Post-and-Lintel

The walls surrounding the Lion Gate at Mycenae in Greece (Fig. 492) are load-bearing

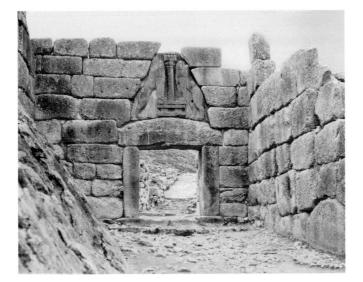

Fig. 492 The Lion Gate, Mycenae, Greece, 1250 BCE. Studio Kontos Photostock.

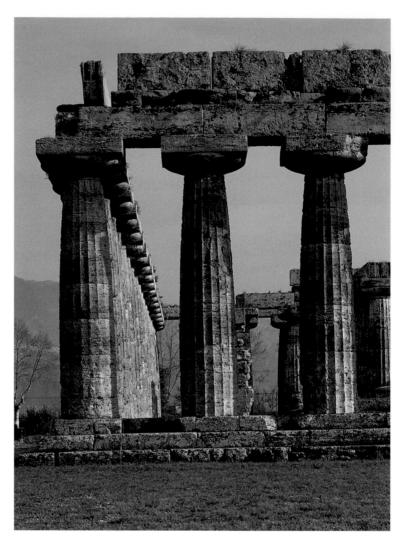

Fig. 493 Corner of the First Temple of Hera, Paestum, Italy, c. 550 BCE. Canali Photobank.

construction. But the gate itself represents another form of construction, post-and-lintel. **Post-and-lintel construction** consists of a horizontal beam supported at each end by a vertical post or a wall. In essence, the downward force of the horizontal bridge holds the vertical posts in an upright position, and, conversely, the posts support the stone above in a give-and-take of directional force and balance. So large are the stones used to build this gate—both the length of the lintel and the total height of the post-and-lintel structure are roughly 13 feet—that later Greeks believed it could only have been built by the mythological race of one-eyed giants, the Cyclops. Post-and-lintel construction is fundamental to all Greek architecture. As can be seen in the First Temple of Hera, at Paestum, Italy (Fig. 493), the columns, or posts, supporting the structure were placed relatively close together. This was done for a practical reason: If stone lintels, especially of marble, were required to span too great a distance, they were likely to crack and eventually collapse. Each of the columns in the temple is made of several pieces of stone, called *drums*. Grooves carved in the stone, called *fluting*, run the length of the column and unite the individual drums into a single unit. Each column tapers dramatically toward the top and slightly toward the

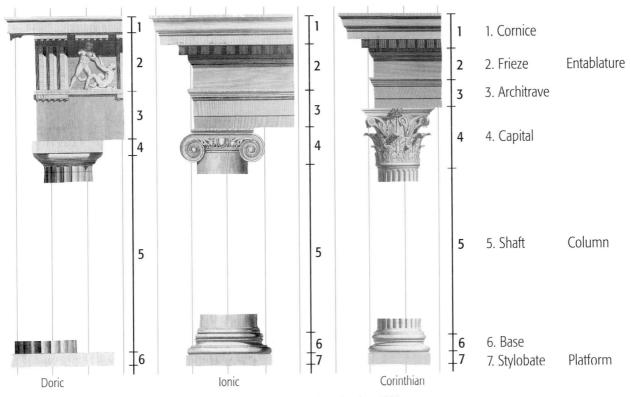

Fig. 494 The Greek orders, from James Stuart, The Antiquities of Athens, London, 1794. Courtesy of The Library of Congress.

bottom, an architectural feature known as entasis. Entasis deceives the cyc and makes the column look absolutely vertical. It also gives the column a sense of almost human musculature and strength. The columns suggest the bodies of human beings, holding up the roof like miniature versions of the giant Atlas, who carried the world on his shoulders.

The values of the Greek city-state were embodied in its temples. The temple was usually situated on an elevated site above the city an *acropolis*, from *akros*, meaning "top," of the *polis*, "city"—and was conceived as the center of civic life. Its colonnade, or row of columns set at regular intervals around the building and supporting the base of the roof, was constructed according to the rules of geometry and embodied cultural values of equality and proportion. So consistent were the Greeks in developing a generalized architectural type for their temples that it is possible to speak of them in terms of three distinct architectural types—the Doric, the Ionic, and the Corinthian, the last of which was rarely used by the Greeks themselves but later became the standard order in Roman architecture (Fig. 494). In ancient times, the heavier Doric order was considered masculine, and the more graceful Ionic order feminine. It is true that the Ionic order is slimmer and much lighter in feeling than the Doric.

The vertical design, or elevation, of the Greek temple is composed of three elementsthe platform, the column, and the entablature. The relationship among these three units is referred to as its order. The Doric, the earliest and plainest of the three, is utilized in the temple at Paestum. The Ionic is later, more elaborate, and organic, while the Corinthian is more organic and decorative still. The elevation of each order begins with a platform, the stylobate. The column in the Doric order consists of two parts, the shaft and the capital, to which both the Ionic and Corinthian orders add a base. The orders are most quickly distinguished by their capitals. The Doric capital is plain, marked only by a subtle outward curve. The Ionic capital is much

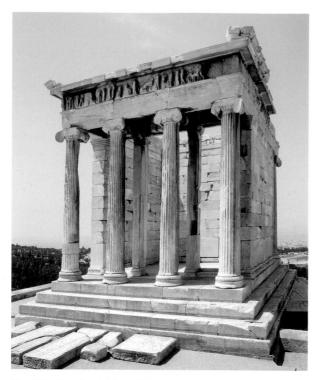

Fig. 495 Temple of Athena Nike, Acropolis, Athens, 427–424 BCE. Studio Kontos Photostock.

more elaborate and is distinguished by its scroll. The temple of Athena Nike (Fig. 495) is the oldest Ionic temple on the Acropolis in Athens. The Corinthian capital is decorated with stylized acanthus leaves. The entablature consists of three parts, the **architrave**, or weight-bearing and weight-distributing element, the decorated **frieze**, and the **cornice**.

Arches and Domes

The geometrical order of the Greek temple suggests a conscious desire to control the natural world. So strong was this impulse that Greek

Fig. 496 Arch.

architecture seems defiant in its belief that the intellect is superior to the irrational forces of nature. We can read this same impulse in Roman architecture-the will to dominate the site. Though the Romans made considerable use of colonnades-rows of columns-they also perfected the use of the arch (Fig. 496), an innovation that revolutionized the built environment. The Romans recognized that the arch would allow them to make structures with a much larger span than was possible with postand-lintel construction. Made of wedge-shaped stones, called voussoirs, each cut to fit into the semicircular form, an arch is not stable until the keystone, the stone at the very top, has been put into place. At this point, equal pressure is exerted by each stone on its neighbors, and the scaffolding that is necessary to support the arch while it is under construction can be removed. The arch supports itself, with the weight of the whole transferred downward to the posts. A series of arches could be made to span a wide canyon with relative ease. One of the most successful Roman structures is the

Fig. 497 Pont du Gard, near Nîmes, France. Late 1st century BCE. Danita Delimont Photography.

Fig. 498 Barrel vault (top) and groined vault (bottom) construction.

Pont du Gard (Fig. 497), an aqueduct used to carry water from the distant hills to the Roman compound in Nîmes, France. Still intact today, it is an engineering feat remarkable not only for its durability, but also, like most examples of Roman architecture, for its incredible size.

With the development of the barrel vault, or tunnel vault (Fig. 498 top), which is essentially an extension in depth of the single arch by lining up one arch behind another, the Romans were able to create large, uninterrupted interior spaces. The strength of the vaulting structure of the Roman Colosseum (Figs. 499 and 500) allowed more than 50,000 spectators to be seated in it. The Colosseum is an example of an amphitheater (literally meaning a "double theater"), in which two semicircular theaters are brought face to face, a building type invented by the Romans to accommodate large crowds. Built for gladiatorial games and other "sporting" events, including mock naval battles and fights to the death between humans and animals, the Colosseum is constructed both with barrel vaults and with groined vaults (Fig. 498, bottom), the latter created when two barrel vaults are made to meet at right angles. These vaults were made possible by the Roman invention of concrete. The Romans discovered that if they added volcanic aggregate, such as that found near Naples and Pompeii, to the concrete mixture, it would both set faster and be stronger. The Colosseum is constructed of these concrete blocks, held together by metal cramps and dowels. They were originally covered with stone and elaborate stucco decorations.

Fig. 499 *The Colosseum* (aerial view), Rome, 72–80 CE. Publi Aer Foto.

Fig. 500 Barrel-vaulted gallery, ground floor of the Colosseum, Rome. Scala/Art Resource, New York.

Fig. 501 Interior, *Pantheon*, 117–125 CE. Alamy Images Royalty Free. Photo: Hemera Technologies.

The Romans were also the first to perfect the dome, which takes the shape of a hemisphere, sometimes defined as a continuous arch rotated 360 degrees on its axis. Conceived as a temple to celebrate all their gods, the Roman Pantheon (Fig. 501)-from the Greek words pan ("every") and theos ("god")-consists of a 142-foot-high dome set on a cylindrical wall 140 feet in diameter. Every interior dimension appears equal and proportionate, even as its scale overwhelms the viewer. The dome is concrete, which was poured in sections over a huge mold supported by a complex scaffolding. Over 20 feet thick where it meets the walls-a point called the springing—the dome thins to only 6 feet at the circular opening, 30 feet in diameter, at the dome's top. Through this oculus (Latin for "eye"), the building's only source of illumination, worshipers could make contact with the

heavens. As the sun shone through it, casting a round spotlight into the interior, it seemed as if the eye of Jupiter, king of the gods, shone upon the Pantheon walls. Seen from the street (Fig. 502), where it was originally approached between parallel colonnades that culminated in a podium now lost to the rise of the area's street level, its interior space could only be intuited. Instead, the viewer was confronted by a portico composed of eight mammoth Corinthian columns made of polished granite rising to a pediment some 121 feet wide.

Even though their use of concrete had been forgotten, the architectural inventions of the Romans provided the basis for building construction in the Western world for nearly 2,000 years. The idealism, even mysticism, of the Pantheon's vast interior space, with its evocation of the symbolic presence of Jupiter, found its way into churches as the Christian religion came to dominate the West. Large congregations could gather beneath the high barrel vaults of churches, which were constructed on Roman architectural principles. Vault construction in stone was employed especially in Romanesque architecture—so called because it utilized so many Roman methods and architec-

Fig. 502 Exterior, *Pantheon*, 117–125 cE. Canali Photobank.

Fig. 503 Interior view of nave, St. Sernin, Toulouse, France, c. 1080-1120. Alamy images.

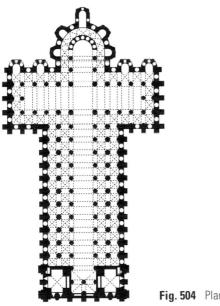

Fig. 504 Plan, St. Sernin.

tural forms. The barrel vault at St. Sernin, in Toulouse, France (Fig. 503), is a magnificent example of Romanesque architecture. The plan of this church is one of great symmetry and geometric simplicity (Fig. 504). It reflects the Romanesque preference for rational order and logical development. Every measurement is based on the central square at the crossing, where the two transepts, or side wings, cross the length of the nave, the central aisle of the church used by the congregation, and the apse, the semicircular projection at the end of the church that is topped by a Roman half-dome. Each square in the aisles, for instance, is onequarter the size of the crossing square. Each transept extends two full squares from the center. The tower that rises over the crossing, incidentally, was completed in later times and is taller than it was originally intended to be.

The immense interior space of the great Gothic cathedrals, which arose throughout Europe beginning in about 1150 CE, culminates this direction in architecture. A building such as the Pantheon, with a 30-foot hole in its roof, was simply impractical in the severe climates of northern Europe. As if in response to the dark and dreary climate outside, the interior of the Gothic cathedral rises to an incredible height, lit by stained-glass windows that transform a dull day with a warm and richly radiant light. The enormous interior space of Amiens Cathedral (Fig. 505), with an interior height of 142 feet and a total interior surface of more than 26,000 square feet, leaves any viewer in awe. At the center of the nave is a complex maze, laid down in 1288, praising the three master masons who built the

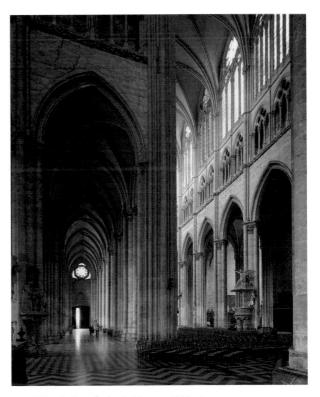

Fig. 505 Amiens Cathedral, begun 1220. Photo © Achim Bednorz, Kohn.

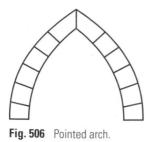

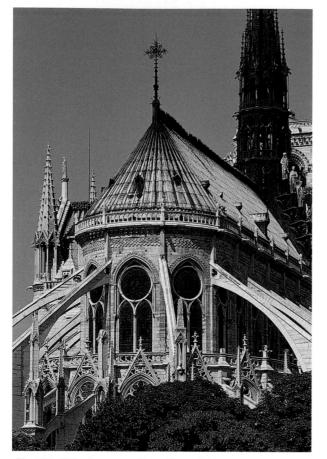

Fig. 508 Flying buttress.

Fig. 507 Flying buttresses, Notre-Dame, Paris. Jim Bryson/Photo Researchers, Inc.

complex, Robert de Luzarches, and Thomas and Renaud de Cormont, who succeeded in creating the largest Gothic cathedral ever built in Northern Europe.

The great height of the Gothic cathedral's interior space is achieved by means of a system of pointed, rather than round, arches. The height of a rounded arch is determined by its width, but the height of a **pointed arch** (Fig. 506) can readily be extended by straightening the curve of the sides upward to a point, the weight descending much more directly down the wall. By utilizing the pointed arch in a scheme of groined vaults, the almost ethereal space of the Gothic cathedral, soaring upward as if toward God, is realized.

All arches tend to spread outward, creating a risk of collapse, and, early on, the Romans learned to support the sides of the arch to counteract this *lateral thrust*. In the great French cathedrals, the support was provided by building a series of arches on the outside whose thrusts would counteract the outward force of the interior arches. Extending inward from a series of columns or *piers*, these **flying buttresses** (Figs. 507 and 508), so named because they lend to the massive stone architecture a sense of lightness and flight, are an aesthetic response to a practical problem. Together with

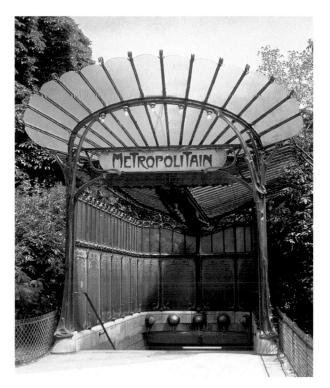

Fig. 509 Hector Guimard, Paris Métro entrance, 1900. H. Roger-Viollet, Paris. Getty Images, Inc. Liaison.

the stunning height of the nave allowed by the pointed arch, the flying buttresses reveal the desire of the builder to elevate the cathedral above the humdrum daily life in the medieval world. The cathedral became a symbol not only of the divine, but also of the human ability to exceed, in art and in imagination, our own limitations and circumstances.

Cast-Iron Construction

Until the nineteenth century, the history of architecture was determined by innovations in the ways the same materials—mostly stone could be employed. In the nineteenth century, iron, a material that had been known for thousands of years, but never employed in architecture, absolutely transformed the built environment. Wrought iron, which Hector Guimard used to construct his entrance for the Paris Métro (Fig. 509) in 1900, was soft and flexible, and, when heated, it could be easily turned and twisted into the plantlike forms evident in Guimard's structure. But engineers discovered that, by adding carbon to iron,

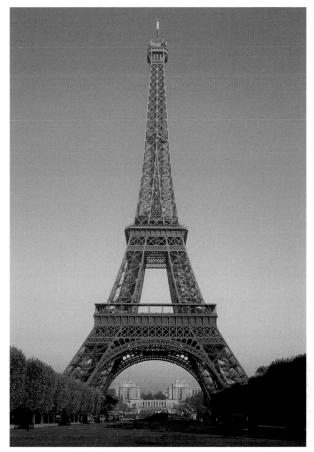

Fig. 510 Gustave Eiffel, *Eiffel Tower*, 1887–1889. Seen from Champs de Mars. Height of tower, 1,051 ft. Alain Evrard/Globe Press. Photo Researchers, Inc.

they could create a much more rigid and strong material—cast iron. The French engineer Gustave Eiffel used cast iron in his new *lattice-beam* construction technique, which produces structures of the maximum rigidity with the minimum weight by exploiting the way in which girders can be used to brace one another in three dimensions.

The most influential result was the Eiffel Tower (Fig. 510), designed as a monument to industry and the centerpiece of the international Paris Exposition of 1889. Nearly 1,000 feet high, and at that time by far the tallest structure in the world, the Tower posed a particular problem—how to build a structure of such a height, yet one that could resist the wind. Eiffel's solution was simple but brilliant: Construct a skeleton, an open lattice-beam framework that would allow the wind to pass through it. Though it served for many years as a radio tower—on July 1, 1913, the first signal transmitted around the world was broadcast from its top, inaugurating the global electronic network-the tower was essentially useless, nothing more than a monument. Many Parisians hated it at first, feeling that it was a blight on the skyline, but by the early years of the twentieth century it had become the symbol of Paris itself, probably the most famous structure in the world. Newspapers jokingly held contests to "clothe" it. But most important, it demonstrated the possibility of building to very great height without load-bearing walls. The tower gave birth to the skeletonand-skin system of building. And the idea of designing "clothes" to cover such a structure soon became a reality.

Frame Construction

The role of iron and steel in changing the course of architecture in the nineteenth century cannot be underestimated—and we will consider steel in even more detail in a moment but two more humble technological innovations had almost as significant an impact, determining the look of our built environment down to the present day. The mass production of the common nail, together with improved methods and standardization in the process of milling lumber, led to a revolution in home building techniques.

Lumber cannot easily support structures of great height, but it is perfect for domestic architecture. In 1833, in Chicago, the common wood-frame construction (Fig. 511), a

Fig. 511 Wood-frame construction.

true skeleton-and-skin building method, was introduced. Sometimes called balloon-frame construction, because early skeptics believed houses built in this manner would explode like balloons, the method is both inexpensive and relatively easy. A framework skeleton of, generally, 2×4 -inch beams, is nailed together. Windows and doors are placed in the wall using basic post-and-lintel design principles, and the whole is sheathed with planks, clapboard, shingles, or any other suitable material. The roof is somewhat more complex, but as early as the construction of Old St. Peter's Basilica in Rome in the fourth century CE (Fig. 512), the basic principles were in use. The walls of St. Peter's were composed of columns and arches made of stone and brick, but the roof was wood. And notice the angled beams supporting the roof over the aisles. These are elementary forms of the truss, prefabricated versions of which most home builders today use for the roofs of their houses. One of the most rigid structural forms in architecture, the truss (Fig. 513) is a triangular framework that, because of its rigidity, can span much wider areas than a single wooden beam.

Fig. 512 Model of Old St. Peter's Basilica, Rome, c. 333–390.

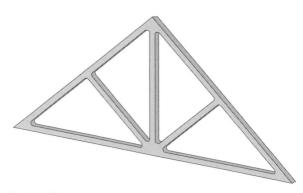

Fig. 514 Christian Gladu, *The Birch*, The Bungalow Company, North Town Woods, Bainbridge Island, Washington, 1998. Photo courtesy of The Bungalow Company.

This form of building is, of course, the foundation of American domestic architecture. Early in the twentieth century, it formed the basis of a widespread "bungalow" style of architecture, which has enjoyed a revival in the last decade (Fig. 514). It became popular when furniture designer Gustav Stickley began publishing bungalow designs in his magazine The Craftsman. From the beginning, the bungalow was conceived as a form of domestic architecture available to everyone. Like Stickley's furniture, which he thought of as "made" for bungalows, it was democratic. It embodied, from Stickley's point of view, "that plainness which is beauty." The hand-hewn local materials-stone and shingles-employed in the construction tied the home to its natural environment. And so did its porches, which tied the interior to the world outside, and which, with their sturdy, wide-set pillars, bespoke functional solidity. By the late 1920s, as many as 100,000 stock plans had been sold by both national architectural companies and local lumber and building firms, and, across America, bungalows popped up everywhere. In the popular imagination, the word "bungalow" was synonymous with "quality."

Steel-and-Reinforced-Concrete Construction

It was in Chicago that frame construction began, and it was Chicago that most impressed C. R. Ashbee, a representative of the British National Trust, when he visited America in 1900: "Chicago is the only American city I have seen where something absolutely distinctive in the aesthetic handling of material has been evolved out of the Industrial system." A young architect named Frank Lloyd Wright impressed him most, but it was Wright's mentor, Louis Sullivan, who was perhaps most responsible for the sense of vitality that Ashbee was responding to.

In 1870, fire had destroyed much of downtown Chicago, providing a unique opportunity for architects to rebuild virtually the entire core of the city. For Sullivan, the foremost problem that the modern architect had to address was how the building

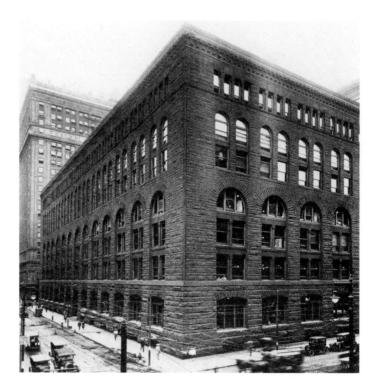

Fig. 515 Henry Hobson Richardson, Marshall Field Wholesale Store, Chicago, 1885–1887. Courtesy of the Library of Congress.

might transcend the "sinister" urban conditions out of which, of necessity, it had to rise. Most urban buildings were massive in appearance. Henry Hobson Richardson's Marshall Field Wholesale Store (Fig. 515), built after the fire, is a good example. Although Richardson employed a skeletal iron framework within the building to support its interior structure, its thick walls carried their own weight, just as stone walls had for centuries. Richardson's genius lay in his ability to lighten this facade by means of the three- and two-story window arcades running from the second through the sixth floors. But from Sullivan's point of view, the building still appeared to squat upon the city block rather than rise up out of the street to transcend its environment.

For Sullivan, the answer lay in the development of steel construction techniques, combined with what he called "a system of ornament." A fireproof steel skeletal frame, suggested by wood-frame construction, freed the wall of load-bearing necessity and opened it both to ornament and to large numbers of exterior windows. The horizontality of Richardson's building was replaced by a vertical emphasis as the building's exterior lines echoed the upward sweep of the steel skeleton. As a result, the exterior of the tall building no longer seemed massive; rather, it might rise with an almost organic lightness into the skies.

The building's real identity depended on the ornamentation that could now be freely distributed across its facade. Ornament was, according to Sullivan, "spirit." The inorganic, rigid, and geometric lines of the steel frame would flow, through the ornamental detail that covered it, into "graceful curves," and angularities would "disappear in a mystical blending of surface." Thus, at the top of Sullivan's Bayard Building (Fig. 516)—a New York, rather than a Chicago, building—the vertical columns that rise between the windows blossom in an explosion of floral decoration.

Such ornamentation might seem to contradict completely the dictum for which Sullivan is most famous—"Form follows function." If the function of the urban building is to provide a well-lighted and ventilated place in which to work, then the steel-frame structure and the abundance of windows on the building's facade make sense. But what about the ornamentation? How does it follow from the structure's function? Isn't it simply an example of purposeless excess?

Down through the twentieth century, Sullivan's original meaning has largely been for-

Fig. 516 Louis H. Sullivan, Bayard (Condict) Building, New York, 1897–1808. Schles/Art Resource, New York.

gotten. He was not promoting a notion of design akin to the sense of practical utility that can be discovered in, for instance, a Model T Ford. For Sullivan, "The function of all functions is the Infinite Creative Spirit," and this spirit could be revealed in the rhythm of growth and decay that we find in nature. Thus the elaborate, organic forms that cover his buildings were intended to evoke the Infinite. For Sullivan, the primary function of a building was to elevate the spirit of those who worked in it.

Almost all of Sullivan's ornamental exuberance seems to have disappeared in the architecture of Frank Lloyd Wright, whom many consider the first truly modern architect. But from 1888 to 1893, Wright worked as chief draftsman in Sullivan's Chicago firm, and Sullivan's belief in the unity of design and nature can still be understood as instrumental to Wright's work. In an article written for the *Architectural Record* in 1908, Wright empha-

Fig. 517 Frank Lloyd Wright, *Robie House*, exterior, Chicago, 1909. Photo: Ezra Stoller. © Esto. All rights reserved. Esto Photographics, Inc..

sized that "a sense of the organic is indispensable to an architect," and as early as the 1890s, he was routinely "translating" the natural and the organic into what he called "the terms of building stone."

The ultimate expression of Wright's intentions is the so-called Prairie House, the most notable example of which is the Robie House in Chicago, designed in 1906 and built in 1909 (Fig. 517). Although the house is contemporary in feeling—with its wide overhanging roof extending out into space, its fluid, open interiors, and its rigidly geometric lines—it was, from Wright's point of view, purely "organic" in conception.

Wright spoke of the Prairie House as "of" the land, not "on" it, and the horizontal sweep of the roof and the open interior space reflect the flat expanses of the Midwestern prairie landscape. Alternatively, in a different environment, a house might reflect the cliffs of a Pennsylvania ravine (see Works in Progress, on p. 378.) The cantilever, a horizontal form supported on one end and jutting out into space on the other, was made possible by newly invented steel-and-reinforced-concrete construction techniques. Under a cantilevered roof, one could be simultaneously outside and protected. The roof thus ties together the interior space of the house and the natural world outside. Furthermore, the house itself was built of materials-brick, stone, and wood, especially oak-native to its surroundings.

WORKS IN PROGRESS

allingwater (Fig. 519), Frank Lloyd Wright's name for the house he designed for Edgar and Lillian Kaufmann in 1935, is arguably the most famous modern house in the world. Edgar Kaufmann was owner of Kaufmann's Store in Pittsburgh, the largest ready-made men's clothing store in the country, and his son had begun to study with Wright in 1934. In November of that year, Wright first visited the site. There are no known design drawings until the following September. Writing a few years before about his own design process, Wright stated that the architect should "conceive the building in the imagination, not on paper but in the mind, thoroughly-before touching paper. Let it live there-gradually taking more definite form before committing it to the draughting board. When the thing lives for you, start to plan it with tools. Not before. . . . It is best to cultivate the imagination

to construct and complete the building before working on it with T-square and triangle."

The first drawings were done in two hours when Kaufmann made a surprise call to Wright and told him he was in the neighborhood and would like to see something. Using a different colored pencil for each of the house's three floors on the site plan, Wright completed not only a floor plan, but a north-south crosssection and a view of the exterior from across the stream (Fig. 518). The drawings were remarkably close to the final house.

Wright thought of the house as entirely consistent with his earlier Prairie Houses. It was, like them, wedded to its site, only the site was markedly different. The reinforced concrete cantilevers mirrored the natural cliffs of the hillside down and over which the stream, Bear Run, cascades. By the end of 1935, Wright had opened a quarry on the site to extract local stone for the house's construction.

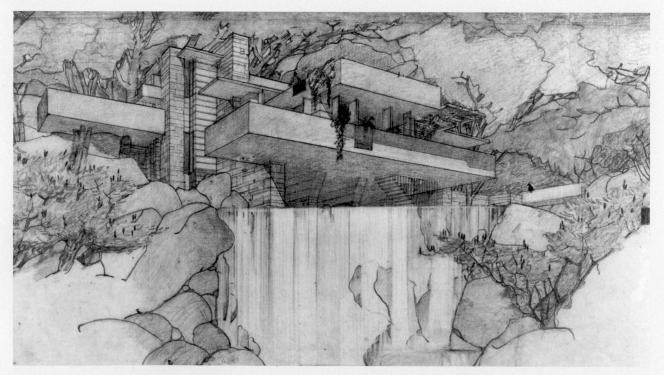

Fig. 518 Frank Lloyd Wright, drawing for *Fallingwater*, Kaufmann House, Bear Run, Pennsylvania, 1936. 15³/₈ × 27 ¹/₄ in. The Frank Lloyd Wright Archives. Frank Lloyd Wright drawings are copyright © 1959, 1994, 1997, 2004 The Frank Lloyd Wright Foundation, Scottsdale, Arizona.

Frank Lloyd Wright's FALLINGWATER

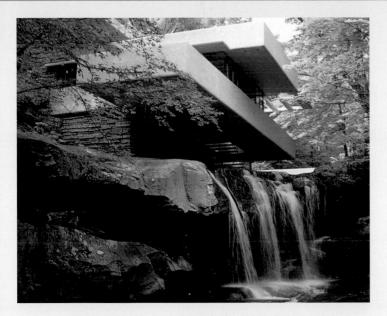

Fig. 519 Frank Lloyd Wright (1867–1959). *Fallingwater*, seen from below. Fallingwater House, Bear Run, Pennsylvania, U. S. A. Western Pennsylvania Conservancy/Art Resource, NY. Frank Lloyd Wright Estate © 2007 ARS Artists Rights Society, NY.

Fig. 520 Frank Lloyd Wright, Fallingwater Scaffolding, from the Fallingwater Collection at the Avery Architectural and Fine Arts Library, Columbia University, New York. © 2005 Frank Lloyd Wright Foundation, Scottsdale, AZ/Artists Rights Society (ARS), New York. Meanwhile, the radical style of the house had made Kaufmann nervous. He hired engineers to review Wright's plan, and they were doubtful that reinforced concrete could sustain the 18-foot cantilevers that Wright proposed. When Kaufmann sent the engineers' reports to Wright, Wright told him to return the plans to him "since he did not deserve the house." Kaufmann apologized for his lack of faith, and work on the house proceeded.

Still, the contractor and engineer didn't trust Wright's plans for reinforcing the concrete for the cantilevers, and before the first slab was poured, they put in nearly twice as much steel as Wright had called for. As a result, the main cantilever droops to this day. Wright was incensed that no one trusted his calculations. After the first slab was set, but still heavily braced with wooden framing (Fig. 520), Wright walked under the house and kicked a number of the wooden braces out.

The house, finally, is in complete harmony with its site. "I came to see a building," Wright wrote in 1936, as the house was nearing completion, "primarily... as a broad shelter in the open, related to vista; vista without and vista within. You may see in these various feelings, all taking the same direction, that I was born an American, child of the ground and of space."

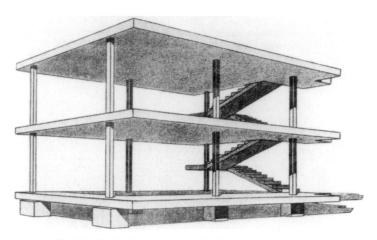

Fig. 521 Le Corbusier, Perspective drawing for Domino Housing Project, 1914. French Embassy.

The architectural innovations of Wright's teacher, Louis Sullivan, led directly to the skyscraper. It is the sheer strength of steel that makes the modern skyscraper a reality. Structures with stone walls require thicker walls on the ground floor as they rise higher. A 16-story building, for instance, would require groundfloor walls approximately 6 feet thick. But the steel cage, connected by concrete floors, themselves reinforced with steel bars, overcomes this necessity. The simplicity of the resulting structure can be seen clearly in French architect Le Corbusier's 1914 drawing for the Domino Housing Project (Fig. 521). The design is almost infinitely expandable, both sideways and upward. Any combination of windows and walls can be hung on the frame. Internal divisions can be freely designed in an endless variety of ways, or, indeed, the space can be left entirely open. Even the stairwell can be moved to any location within the structural frame.

In 1932, Alfred H. Barr, Jr., a young curator at the Museum of Modern Art in New York City, who would later become one of the most influential historians of modern art. identified Le Corbusier as one of the founders of a new "International Style." In an exhibition on "Modern Architecture," Barr wrote: "Slender steel posts and beams, and concrete reinforced by steel have made possible structures of skeletonlike strength and lightness. The modern architect working in the new style conceives of his building . . . as a skeleton enclosed by a thin light shell. He thinks in terms of volume-of space enclosed by planes and surfaces—as opposed to mass and solidity. This principle of volume leads him to make his walls seem thin flat surfaces by eliminating moldings and by making his windows and doors flush with the surface."

Taking advantage of the strength of concrete-and-steel construction, Le Corbusier lifted his houses on stilts (Fig. 522), thus creating, out of the heaviest of materials, a sense of lightness, even flight. The entire structure is composed of primary forms (that is, rectangles, circles, and so on). Writing in his first book, *Towards a New Architecture*, translated into English in 1925, Le Corbusier put it this way: "Primary forms are beautiful forms because they can be clearly appreciated."

For Barr, Ludvig Miës van der Rohe was the other great innovator of the International Style. His German Pavilion for the 1929 International Exposition in Barcelona (Fig. 523) was considered by Barr to be one of the

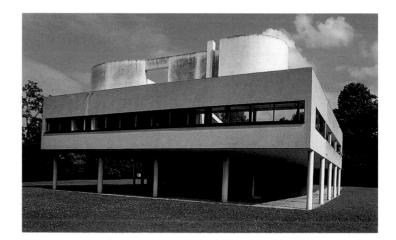

Fig. 522 Le Corbusier and Jeanneret, Villa Savoye, Poissy-sur-Seine, France, 1928–1930. © Anthony Scibilia Solidus. Art Resource, New York. © 2007 Artist Rights Society (ARS), New York/ADAGP, Paris/FLC.

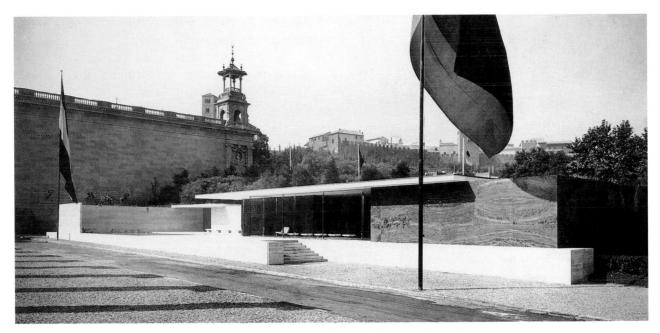

Fig. 523 Ludvig Miës van der Rohe, *German Pavilion, International Exposition,* Barcelona, Spain, 1928–1929. Photo courtesy of Miës van der Rohe Archive, Museum of Modern Art, New York. Licensed by Scala/Art Resource, New York. © 2007 Artists Rights Society (ARS), New York. VG Bild-Kunst, Bonn.

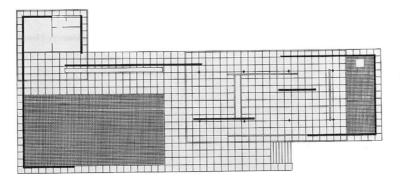

Fig. 524 Ludvig Miës van der Rohe, *German Pavilion, International Exposition*, Barcelona, Spain. Floor plan, final scheme. Made for publication, 1929. Ink, pencil on paper, 22 ¹/₂ × 38 ¹/₂ in. The Miës van der Rohe Archive, Museum of Modern Art, New York. Gift of the architect.

Licensed by Scala/Art Resource, New York. © 1999 Museum of Modern Art, New York/© 2007 Artists Rights Society (ARS), New York. VG Bild-Kunst, Bonn.

most important buildings of the day. As the floor plan (Fig. 524) makes clear, Miës wanted most of all to open the space of architecture. The bands of marble walls and sheets of glass held between stainless steel poles extend back from the entry steps under a daringly cantilevered roof. The back wall encloses, but only barely, a large pool, visible in the lower left of the floor plan, that reflects both building and sky. As a result, as the visitor climbs the short set of stairs approaching the pavilion, the entire structure seems to shimmer in light. Built to showcase the German marble industry, the perfectly proportioned and immaculate building shines like a jewel.

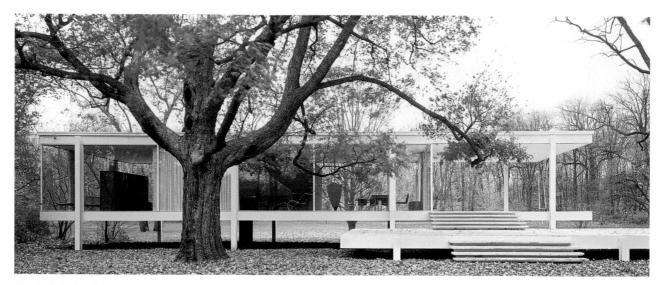

Fig. 525 Ludvig Miës van der Rohe, Farnsworth House, Fox River, Plano, Illinois, 1950. © 2007 Artists Rights Society (ARS), New York/VG Bild-Kunst, Bonn.

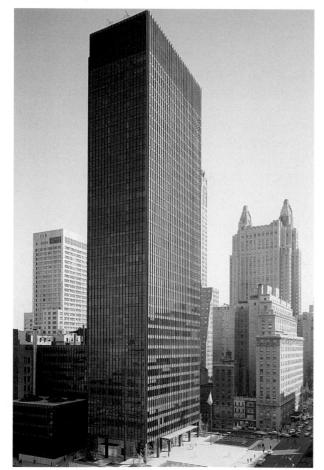

Fig. 526 Miës van der Rohe and Philip Johnson, Seagram Building, New York City, 1958. Photo: Ezra Stoller. © Esto. All rights reserved. Esto Photographics, Inc. © 2007 Artists Rights Society (ARS), New York/ VG Bild-Kunst, Bonn.

and Philip Johnson, *Seagram* ity, 1958. must stagger

Miës's Farnsworth House (Fig. 525), which was built in 1950, likewise opens itself to its surroundings. At once an homage to Le Corbusier's Villa Savoye and a reincarnation of the architect's own German Pavilion, the house is virtually transparent—both opening itself out into the environment and inviting it in.

But the culmination of Le Corbusier's steel-and-reinforced-concrete Domino plan is the so-called International Style skyscraper, the most notable of which is the Seagram Building in New York City (Fig. 526), a collaboration between Miës van der Rohe and Philip Johnson. Johnson is the architect whose design for the College of Architecture at the University of Houston opened this chapter and who, in 1932, had written the foreword to Barr's "Modern Architecture" catalogue. The International Style is marked by its austere geometric simplicity, and the design solution presented by the Seagram Building is extremely elegant. The exposed structural I-beams (that is, steel beams that seen in cross-section look like the capital letter "I") are finished in bronze to match the amber-tinted glass sheath. At the base, these exterior beams drop, unsheathed, to the courtyard, creating an open-air steel colonnade around a recessed glass lobby. New York law requires that buildings must conform to a "setback" restriction: Buildings that at ground level occupy an entire site must stagger-step inward as they rise in order to avoid "walling-in" the city's inhabitants.

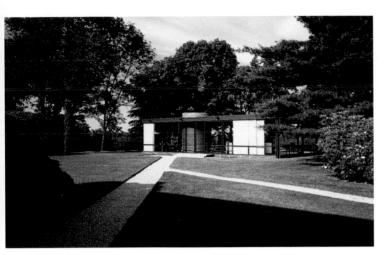

Fig. 527 Philip Johnson, *Glass House*, New Canaan, Connecticut, 1949. Photo: Ezra Stoller. © Esto. All rights reserved. Esto Photographics, Inc.

But the Seagram Building occupies less than one-half its site, and as a result, it is free to rise vertically out of the plaza at its base. At night, the lighted windows activate the building's exterior, and by day, the surface of the opaque glass reflects the changing world around the building.

Johnson's collaboration with Miës on the Seagram Building indicates his admiration for the older architect, but perhaps his greatest homage to Miës is his own home, built in 1949 in New Canaan, Connecticut (Fig. 527). Johnson's goal, and the goal of the International Style, was to speak a language of beauty so universal that it would, inevitably, appeal to all. The house defines this language as the language of simple primary forms in harmony with their surroundings. The glass block rises directly out of the surrounding space and opens, through its glass walls, into it. Except for the central round brick cylinder containing toilet and bath, the practical side of living in a transparent glass house has been almost entirely ignored. It is a pure aesthetic statement, meant to be considered only as a thing of beauty. In Johnson's own words, "If the business of getting the house to run well takes precedence over your artistic invention the result won't be architecture at all: merely an assemblage of useful parts."

Rejecting the International Style's emphasis on primary geometric forms, the architecture of Eero Saarinen demonstrates how steel and reinforced concrete construction can be utilized in other ways. One of his most successful buildings is the TWA Terminal at Kennedy International Airport in New York (Fig. 528), designed in 1956 and completed after his death in 1961. It is defined by a contrast between the openness provided by the broad expanses of window and the sculptural mass of the reinforced concrete walls and roof. What results is a constant play of light and shadow throughout the space. The exterior-two huge concrete wings that appear to hover above the runways—is a symbolic rendering of flight.

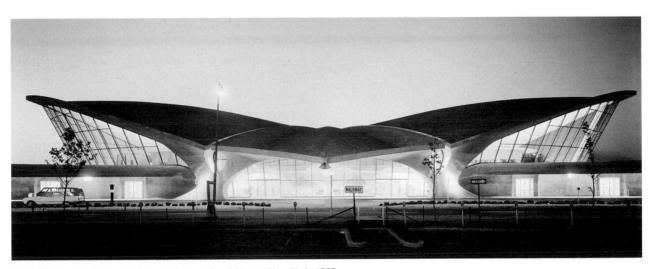

Fig. 528 Eero Saarinen, Kennedy International Airport, New York, 1962. Photo: Ezra Stoller. © Esto. All rights reserved. Esto Photographics, Inc.

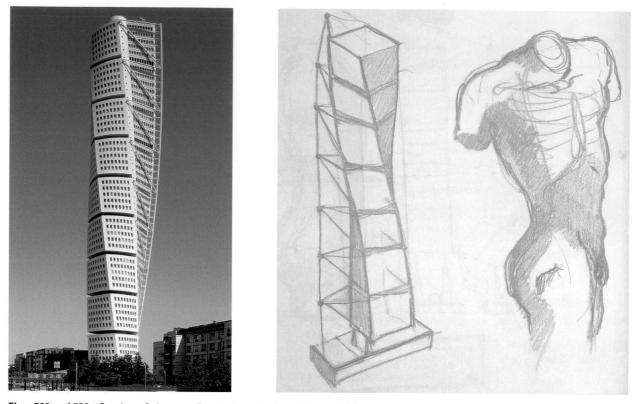

Figs. 529 and 530 Santiago Calatrava, *Turning Torso Residential Tower*, Malmø, Sweden, 2005, and drawing, © 2000. Photo: Courtesy of Barbara Burg, Oliver Schuh/Palladium Photodesign. Drawing: © Santiago Calatrava.

Increasingly, contemporary architecture has largely become a question of creating distinctive buildings that stand out in the vast sameness of the "world metropolis," the vast interconnected fabric of places where people "do business," and among which they "travel," the hubs (all served by airports) of today's mobile society. It is also a question of creating buildings of distinction—contemporary architecture is highly competitive. Most major commissions are competitions, and most cities compete for the best, most distinctive architects.

One of the most successful architects in these international competitions has been Spaniard Santiago Calatrava. Known especially for the dynamic curves of his buildings and bridges, his commissions include the Athens Olympics Sports Complex (2001–2004), the extraordinary Tenerife Opera House (2003), and the equally extraordinary Turning Torso residential tower in Malmø, Sweden (Fig. 529). Based on the model of a twisting body (Fig. 530), it consists of nine cubes, twisting 90 degrees from bottom to top, and rising to a rooftop observation deck with vistas across the Øresund strait to Copenhagen. At 54 stories, it is the tallest building in Sweden.

The Asian city is particularly intriguing to postmodern architects because, much more than the American city, where, by and large, people don't live where they work, Asian cities possess a much greater "mix" of functions and scales, tall buildings that rise in the midst of jumbled smaller structures that seem to change rapidly almost from one day to the next. One of the most intriguing new projects in Asia is the work of the Rotterdam-based Office for Metropolitan Architecture (OMA), headed by Rem Koolhaas. Since 1995, Koolhaas has been a professor at Harvard University, where he is leading a series of research projects for Harvard's "Project on the City," a student-based research group whose recent projects include a study of five cities in the Pearl River Delta of China, and "Shopping," an analysis of the role of retail consumption in the contemporary city. His OMA firm's most recent work includes the new Museum of Modern Art in New York, the new Seattle Public Library (now under construction), and Central China Television's headquarters (Fig. 531), to be completed

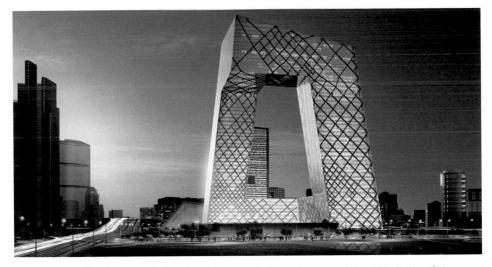

Fig. 531 Rem Koolhaas, OMA, New Headquarters, Central Chinese Television CCTV, Beijing, China, competition drawing, 2002.

Photo courtesy of the Office for Metropolitan Architecture, The Netherlands. OMA/Ole Scheeren and Rem Koolhaas.

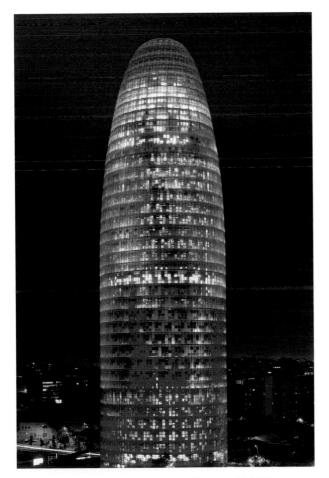

Fig. 532 Jean Nouvel/Ateliers, Jean Nouvel with b720 Arquitectos, *Iorre Agbar*, Barcelona, 2005. Lighting design by Yann Kersalé Photo © Roland Halbe.

for the Beijing Olympics in 2008. Although 750-feet high, the CCTV tower is, in OMA's words, "a continuous loop of horizontal and vertical sections that establish an urban site rather than point to the sky."

Probably no country in the world, however, has defined itself more as a center of international architectural experimentation than Spain. Drawing on the talents of architects from around the world, it has capitalized on the momentum generated by the 1992 Olympics in Barcelona, which required a massive building effort, and the excitement generated by Frank Gehry's Guggenheim Museum in Bilbao (see Fig. 752), completed in 1997. Jean Nouvel's Torre Agbar (Fig. 532), completed in 2005 in Barcelona, is just one example of the new innovative architecture that is erupting across the country. Thirty-one stories high, the bullet-shaped building is the centerpiece of a new commercial district planned by the city. The reinforced-concrete structure, crowned by a glass-and-steel dome, has a multicolored facade of aluminum panels, behind glass louvers, in 25 different colors. There are 4,400 windows and 56,619 transparent and translucent glass plates. The louvers are tilted at different angles calculated to deflect the direct sunlight. At night, 4,500 yellow, blue, pink, and red lights, placed over the facade, illuminate the entire tower.

COMMUNITY LIFE

However lovely we find the Seagram Building, the uniformity of its grid-like facade, in the hands of less-skillful architects, came to represent, for many, the impersonality and anonymity of urban life. The skyscraper became, by the 1960s, the embodiment of conformity and mediocrity in the modern world. Rather than a symbol of community, it became a symbol of human anonymity and loneliness.

Nevertheless, the idea of community remains a driving impulse in American architecture and design. Richard Meier's Atheneum (Fig. 533), in New Harmony, Indiana, is a tribute to this spirit. New Harmony is the site of two of America's great utopian communities. The first, Harmonie on the Wabash (1814–1824), was founded by the Harmony Society, a group of Separatists from the German Lutheran Church. In 1825, Robert Owen, Welsh-born industrialist and social philosopher, bought their Indiana town and the surrounding lands for his own utopian experiment. Owen's ambition was to create a more perfect society through free education and the abolition of social classes and personal wealth. World-renowned scientists and educators settled in New Harmony. With the help of William Maclure, the Scottish geologist and businessman, they introduced vocational education, kindergarten, and other educational reforms.

Meier's Atheneum serves as the Visitors Center and introduction to historic New Harmony. It is a building oriented, on the one hand, to the orderly grid of New Harmony itself, and, on the other, to the Wabash River, which swings at an angle to the city. Thus, the angular wall that the visitor sees on first approaching the building points to the river, and the uncontrollable forces of nature. The glass walls and the vistas they provide serve to connect the visitor to the surrounding landscape. But overall, the building's formal structure recalls Le Corbusier's Villa Savoye (see Fig. 522) and the International Style as a whole. It is this tension between man and nature upon which all "harmony" depends.

Since the middle of the nineteenth century, there have been numerous attempts to incorpo-

Fig. 533 Richard Meier, Atheneum, New Harmony, Indiana, 1979. Digital imaging project. Photo © Mary Ann Sullivan, sullivanm@bluffton.edu.

Fig. 534 Frederick Law Olmsted and Calvert Vaux, *Central Park*, aerial view, New York City, 1857–1887. Steve Proehl

rate the natural world into the urban context. New York's Central Park (Fig. 534), designed by Frederick Law Olmsted and Calvert Vaux after the city of New York acquired the 840acre tract of land in 1856, is an attempt to put city-dwelling humans back in touch with their roots in nature. Olmsted developed a system of paths, fields, and wooded areas modeled after the eighteenth-century gardens of English country estates. These estate gardens *appeared* wholly natural, but they were in actuality extremely artificial, with man-made lakes, carcfully planted forests, landscaped meadows, meandering paths, and fake Greek ruins.

Olmsted favored a park similarly conceived, with, in his words, "gracefully curved lines, generous spaces, and the absence of sharp corners, the idea being to suggest and imply leisure, contemplativeness and happy tranquility." In such places, the rational eighteenthcentury mind had sought refuge from the trials of daily life. Likewise, in Central Park, Olmsted imagined the city dweller cscaping the rush of urban life. "At every center of commerce," he wrote, "more and more business tends to come under each roof, and, in the progress of building, walls are carried higher and higher, and deeper and deeper, so that now 'vertical railways' [elevators] are coming in vogue." For Olmsted, both the city itself and neoclassical Greek and Roman architectural features in the English garden offer geometries—emblems of reason and practicality—to which the "gracefully curved" lines of the park and garden stand in counterpoint.

So successful was Olmsted's plan for Central Park that he was subsequently commissioned to design many other parks, including South Park in Chicago and the parkway system of the City of Boston, Mont Royal in Montreal, and the grounds at Stanford University and the University of California at Berkeley. But he perhaps showed the most foresight in his belief that the growing density of the city demanded the growth of what would later become known as the *suburb*, a residential community lying outside but within commuting distance of the city. "When

Fig. 535 Olmsted, Vaux & Co., landscape architects, General plan of Riverside, Illinois, 1869.

Frances Loeb Library, Graduate School of Design, Harvard University.

not engaged in business," Olmsted wrote, "[the worker] has no occasion to be near his working place, but demands arrangements of a wholly different character. Families require to settle in certain localities which minister to their social and other wants, and yet are not willing to accept the conditions of town-life ... but demand as much of the luxuries of free air. space and abundant vegetation as, without loss of town-privileges, they can be enabled to secure." As early as 1869, Olmsted laid out a general plan for the city of Riverside, Illinois, one of the first suburbs of Chicago (Fig. 535), which was situated along the Des Plaines River. The plan incorporated the railroad as the principle form of transportation into the city. Olmsted strived to create a communal spirit by subdividing the site into small "village" areas linked by drives and walks, all situated near common areas that were intended to have "the character of informal village greens, commons and playgrounds."

Together with Forest Hills in New York, Llewellyn Park in New Jersey, and Lake Forest, also outside of Chicago, Olmsted's design for Riverside set the standard for suburban development in America. The pace of that development was steady but slow until the 1920s, when suburbia exploded. During that decade, the suburbs grew twice as fast as the central cities. Beverly Hills in Los Angeles grew by 2,500 percent, and Shaker Heights outside of Cleveland by 1,000 percent. The Great Depression and World War II slowed growth temporarily, but, by 1950, the suburbs were growing at a rate 10 times that of the cities. Between 1950 and 1960, American cities grew by 6 million people or 11.6 percent. In that same decade, the suburban population grew by 19 million, a rate of 45.6 percent. And, for the first time, some cities actually began to lose population: The populations of both Boston and St. Louis declined by 13 percent.

There were two great consequences of this suburban emigration: first, the development of the highway system, aided as well by the rise of the automobile as the primary means of transportation, and second, the collapse of the financial base of the urban center itself. As early as 1930, there were 800,000 automobiles in Los Angeles—two for every five people—and the city quite consciously decided not to spend public monies on mass transit but to support instead a giant freeway system (Fig. 536). The freeways essentially overlaid the rectilinear grid of the city's streets with continuous, streamlined ribbons of highway. Similarly, in 1940, Pennsylvania opened a turnpike that ran the

Fig. 536 Los Angeles Freeway Interchange. Photo courtesy of California Division of Highways, Sacramento.

length of the state. Public enthusiasm was enormous, and traffic volume far exceeded expectations. That same year, the first stretches of the Pasadena Freeway opened. Today it is estimated that roads and parking spaces for cars occupy between 60 and 70 percent of the total land area of Los Angeles.

However, not only automobiles but also money-the wealth of the middle class-drove down these highways, out of the core city and into the burgeoning suburbs. The cities were faced with discouraging and destructive urban decline. Most discouraging of all was the demise of the infrastructure, the systems that deliver services to people-water supply and waste removal, energy, transportation, and communications. The infrastructure is what determines the quality of city life. Artists such as Leonardo da Vinci have always been concerned with the quality of life, and, as a result, with the infrastructure. Da Vinci's plan for a canal on the Arno River (Fig. 537), which anticipates the route followed by the modern autostrada, or freeway, would have given the city of Florence access to the sea. If we think about many of the works of art we have studied in this chapter, we can recognize that they were initially conceived as part of the infrastructure of their communities. For example, the Pont du Gard (see Fig. 497) is a water supply aqueduct. The Paris Métro and the suspension bridges

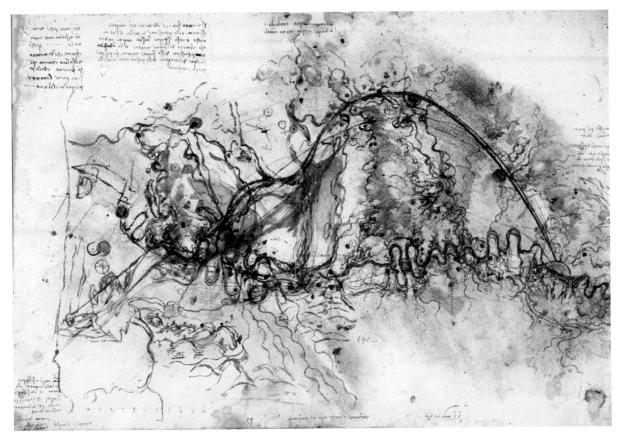

Fig. 537 Leonardo da Vinci, Map of the River Arno and Proposed Canal, c. 1503–1504.
 Pcn and ink over black chalk with washes, pricked for transfer, 13 ³/₁₆ × 19 in. The Royal Collection.
 © 2003 Her Majesty Queen Elizabeth II. Photo: EZM.

WORKS IN PROGRESS

aintenance has been one of the major themes of Mierle Ukeles's multidisciplinary art. Her seminal 1969 Manifesto for Maintenance Art announced her belief that art can reveal, even transform, the discontinuity between society's promise of freedom for all and the unequal effects arising from our need to survive. Survival, she argues, has for too long led to gender, class, and race-based disenfranchisements. If earth is to be our "common home," these inequities must be addressed. Her own personal situation fueled her thinking: "I am an artist. I am a woman. I am a wife. (Random order)," she wrote. "I do a hell of a lot of washing, cleaning, cooking, renewing, supporting, preserving, etc. Also (up to now separately) I 'do' Art. Now I will simply do these maintenance things, and flush them up to consciousness, exhibit them, as Art."

In the first place, Ukeles wanted to challenge the notion of service work—i.e., "women's work"—and make it public. In her 1973 piece *Wash*, she scrubbed the sidewalk in front of A. I. R. Gallery in Soho, New York, on her hands and knees, with a bucket of water, soap, and rags. In taking personal responsibility for maintaining the "cleanliness" of the area for five hours, she immediately wiped out any tracks made by those innocently passing by, following them, rag in hand, erasing their footsteps right up to the point of brushing the backs of their heels. The often-unstated power-based "social contract" of maintenance was made visible.

The city, she realized, was the ideal site for investigating the idea of maintenance. Maintenance of the city's infrastructure is an invisible process that is absolutely vital, and bringing the invisible to light is one of the artist's primary roles. For her *I Make Maintenance Art One Hour Every Day*, a 1976 project for a branch of the Whitney Museum of American Art located in New York's Chemical Bank Building, Ukeles invited the 300-person maintenance staff in the building, most of whom work invisibly at night, to designate one hour of their normal activities on the job as art, while she inhabited the building for seven weeks documenting their selections and exhibiting them daily.

Soon after, Ukeles became the unsalaried artist-in-residence for the New York City Department of Sanitation. In New York, the collection, transportation, and disposal of waste occurs 24 hours a day, every day of the year but Christmas. Her first piece was *Touch*

Fig. 538 Mierle Laderman Ukeles, Fresh Kills Landfill, daily operation. Courtesy Ronald Feldman Fine Arts, Inc., New York.

Mierle Laderman Ukeles's FRESH KILLS LANDFILL PROJECT

Sanitation, a performance artwork in which, after one and one-half year's preparatory research, she spent 11 months creating a physical portrait of New York City as "a living entity" by facing and shaking the hand of each of the Department's 8,500 employees, saying, "Thank you for keeping New York City alive," and walking thousands of city miles with them. She spent four more years creating an exhibition documenting this journey.

Her most ambitious project for the Department is as Artist of the Fresh Kills Landfill on Staten Island (Figs. 538 and 539), an ongoing collaboration in redesign, begun in 1977, with no end in sight. Landfills, she points out, are the city's largest remaining open spaces, and

the Fresh Kills Landfill, at 3,000 acres, is the largest in the United States. She was designated to be part of a team that was to remediate, reshape, transform, and recapture the landfill as healed public space after its closure in 2001. But the events of history intervened in 2002, when Fresh Kills reopened as the repository for the bulk of the material recovered from the World Trade Center disaster of 9/11.

One area of her mega-project is based on re-envisioning the four images of earth that have vielded four traditions of creation. In each, the earth is imaged as female, often as seen by males. Earth as ancient mother, seen in sacred earth mounds, forever nourishes us and sustains us, producing in us an attitude of reverence and devotion. Earth as virgin is, as seen in early American landscape painting as a virtually uninhabited boundless territory, is, she says, "forever fresh and young . . . available for the taking, producing in us (males) lust and acquisitiveness." Earth as wife is "enticingly wild and equally kempt . . . thoroughly domesticated because adequately husbanded." For her, the perfect image of earth as wife is the artificial

Fig. 539 Mierle Laderman Ukeles, Fresh Kills Landfill, aerial view. Courtesy Ronald Feldman Fine Arts, Inc., New York.

wilderness of English landscape and Olmsted. Finally, there is the earth as old sick whore, once free and bountiful and endlessly available, then wasted, used up, dumped, and abandoned. To treat the earth as whore is to pretend that "one has no responsibility for one's actions." In Ukeles's plan for Fresh Kills Landfill, she asks, "Can we utilize the beauty of reverence, devotion, awe, craft, science, technology, and love that yielded the first three traditions while eliminating what has been essentially the obsession with domination and control that comes inevitably when one sex has rapacious power over the other, a power that pollutes all four traditions? Or can we simply un-gender our image of earth, so that we can re-invent our entire relationship, to create a new open interdependency in a more free and equal way?" After 9/11, these questions resonate even more powerfully than before.

made possible by steel eased the difficulty of transportation in their communities. Public buildings such as temples, churches, and cathedrals provide places for people to congregate.f Even skyscrapers are integral parts of the urban infrastructure, providing centralized places for people to work. As the infrastructure collapses, businesses close down, industries relocate, the built environment deteriorates rapidly, and even social upheaval can follow. To this day, downtown Detroit has never recovered from the 1967 riots and the subsequent loss of jobs in the auto industry in the mid-1970s. Block after block of buildings that once housed thriving businesses lie decayed and unused.

Perhaps one of the most devastating assaults on a city's infrastructure occurred on September 11, 2001, when terrorists brought down the twin towers of the World Trade Center in New York City. A suitable site for collecting and sorting through the debris was a crucial factor (see *Works in Progress* on p. 390) Almost immediately after the tragedy, plans were put in place to rebuild the site at Ground Zero, highlighted by an architectural competition. Problems of urban planning were paramount. Transportation issues involving the city's street and subway systems vied with retail and office commercial interests for consideration. But all designs had to address the heavy weight of the site's symbolic significance—the memory of the World Trade Center itself and the people who had worked there.

After months of competition, the plan submitted by architect Daniel Libeskind was selected as the governing "design concept" for the site (Figs. 540 and 541). Libeskind proposed leaving the exposed slurry wall of concrete that formed the foundation of the original twin towers in view as part of a central "memorial park" at the site, to be designed in an international competition. He proposed a "wedge of light" that each year on September 11th between the hours of 8:46 AM, when the first airplane hit, and 10:28 AM, when the second tower collapsed, the sun will shine without shadow, "in perpetual tribute to altruism and courage." Libeskind also suggested the inclusion of a Park of Heroes, with markings in the pavement that

Fig. 540 Studio Daniel Libeskind, *Skyline View, World Trade Center Plan*, 2002. © Studio Daniel Libeskind, courtesy Studio Daniel Libeskind.

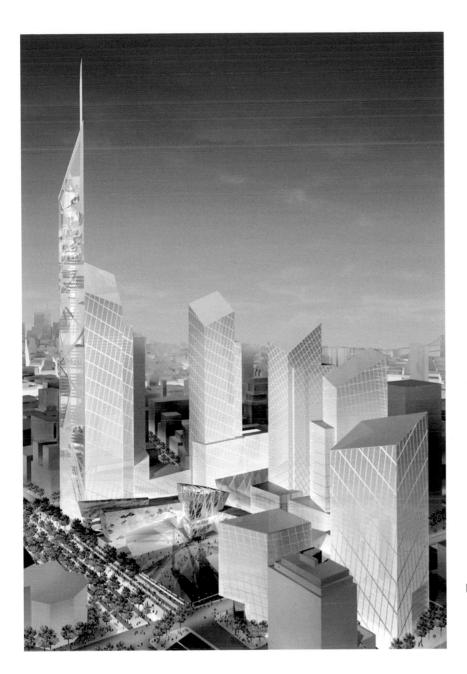

Fig. 541 Studio Daniel Libeskind, Wedge of Light, World Trade Center Plan, 2002. © Archimation. Courtesy Studio Daniel Libeskind.

would contain the names of various fire and rescue companies that responded to the attacks, each name set on a direct axis between the center of Ground Zero and the rescue company's home. Above all this would rise a tower 1,776 feet high, its height referring to the year of American independence and making it the tallest structure in the world. The tower would restore "the spiritual peak to the city." Cascading down the length of this tower, built on a 70story office building, would be the Gardens of the World, meant as "an affirmation of life."

As things have transpired since Libeskind won the competition to design the master plan for Ground Zero, he has actually designed almost none of the buildings for the site itself. Although Libeskind determined where the streets, the memorial, the towers, and the cultural buildings would go, Santiago Calatrava is the architect of the new transit station at the site, Michael Arad has designed the memorial (which differs significantly from Libeskind's original plan), and David Childs and the firm of Skidmore, Owings & Merrill, in a somewhat uneasy collaboration with Libeskind, have been largely responsible for designing the Freedom Tower. How the entire complex will turn out remains to be seen.

THE CRITICAL PROCESS Thinking about Architecture

G oing into the last days of the competition, G the Libeskind design was a decided underdog to one created by THINK design, a collaborative team headed by Rafael Viñoly, with Frederic Schwartz of New York, Shigeru Ban of Tokyo, and the New York landscape architect Ken Smith (Fig. 542). They proposed a World Cultural Center for the site, consisting of a pair of latticework towers, more than 1,600 feet high, set around the footprints of the original twin towers, which they evoked, and containing a 9/11 Memorial and Museum, a Con- ference Center, and a Performing Arts Center. The Museum element, especially, was sculptural in form.

The *New York Times* architecture critic Herbert Muschamp called the Libeskind proposal "an astonishingly tasteless idea," while praising the THINK plan as "a soaring affirmation of American values." The *New York Post*, meanwhile, labeled the Libeskind proposal a "grotesque, anti-urban, anti-commercial eyesore." The Lower Manhattan Development Corporation (LMDC), in charge of choosing the winning design, favored THINK's plan, voting to select it on February 25, 2003, but the next day, after the two competing plans were presented to New York Governor George Pataki and Mayor Michael Bloomberg, the decision was reversed.

There is much to be said for both plans they represent, after all, what most people considered the two best of the many excellent plans submitted to the LMDC. It is fair to say that the final decision was influenced by political factors that we cannot take into account here. But that aside, why do you suppose that THINK's plan was favored by so many? What do you imagine led to its ultimate rejection? What do you see as the particular virtues of Libeskind's design? What are its drawbacks?

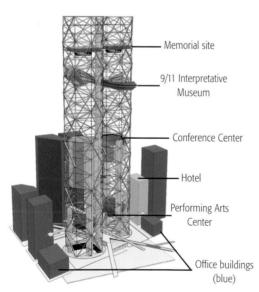

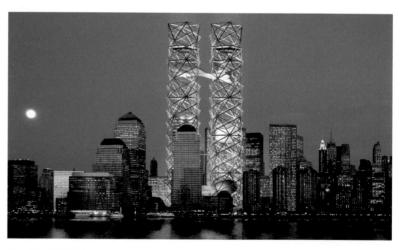

Fig. 542 THINK design, Plan for a *World Cultural Center at the Site of the World Trade Center*, New York, 2002–2003. Courtesy THINK Team, Rafael Vinoly Architects.

Design

D uring the 1920s in the United States, many people who had once described themselves as involved in the graphic arts, the industrial arts, the craft arts, or the arts allied to architecture even architects themselves—began to be referred to as designers. They were seen as serving industry. They could take any object or product—a shoe, a chair, a book, a poster, an automobile, or a building—and make it appealing, and thereby persuade the public to buy it or a client to build it. In fact, design is so intimately tied to industry that its origins as a profession can be traced back only to the beginnings of the industrial age, where it originated largely in opposition to mass production.

THE ARTS AND CRAFTS MOVEMENT ART NOUVEAU ART DECO THE AVANT-GARDES THE BAUHAUS STREAMLINING THE FORTIES AND FIFTIES CONTEMPORARY DESIGN The Critical Process Thinking about Design

THE ARTS AND CRAFTS MOVEMENT

During the first half of the nineteenth century, as mass production became more and more the norm in England, the quality and aesthetic value of mass-produced goods declined. In order to demonstrate to the English the sorry state of modern design in their country, Henry Cole, a British civil servant who was himself a designer, organized the Great Exposition of 1851. The industrial production on exhibit showed, once and for all, just how bad the situation was. Almost everyone agreed with the assessment of Owen Jones: "We have no principles, no unity; the architect, the upholsterer, the weaver, the calico-painter, and the potter, run each their independent course; each struggles fruitlessly, each produces in art novelty without beauty, or beauty without intelligence."

The building that housed the exhibition in Hyde Park was an altogether different proposition. A totally new type of building, which became known as the Crystal Palace (Fig. 543), was designed by Joseph Paxton, who had once served as gardener to the Duke of Devonshire and had no formal training as an architect. Constructed of more than 900,000 square feet of glass set in prefabricated wood and cast iron, it was three stories tall and measured 1,848 by 408 feet. It required only nine months to build, and it hailed in a new age in construction. As one architect wrote at the time, "From such beginnings what glories may be in reserve. . . . We may trust ourselves to dream, but we dare not predict."

Not everyone agreed. A. W. N. Pugin, who had collaborated on the new Gothic-style Houses of Parliament, called the Crystal Palace a "glass monster," and the essayist and reformer John Ruskin, who likewise had championed a return to a preindustrial Gothic style in his book The Stones of Venice, called it a "cucumber frame." Under their influence, William Morris, a poet, artist, and ardent socialist, dedicated himself to the renewal of English design through the renewal of medieval craft traditions. In his own words: "At this time, the revival of Gothic architecture was making great progress in England. . . . I threw myself into these movements with all my heart; got a friend [Philip Webb] to build me a house very medieval in spirit . . . and set myself to decorating it." Built of traditional red brick, the house was called the Red House (Fig. 544), and nothing could be further in style from the Crystal Palace. Where the latter reveals itself to be the product of manufacture-engineered out of prefabricated, factory-made parts and assembled, with minimal cost, by unspecialized workers in a matter of a few months-the former is a purposefully rural, even archaic building that rejects the industrial spirit of Paxton's Palace. It signaled, Morris hoped, a return to craft traditions in which workers were intimately tied, from start to finish, to the design and manufacture of their products.

Morris longed to return to a hand-made craft tradition for two related reasons. He felt that the mass-manufacturing process alienated

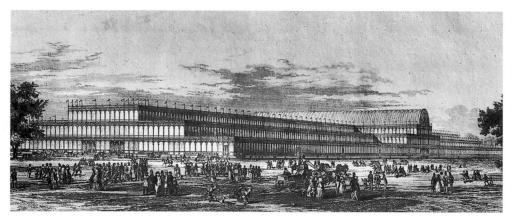

Fig. 543 Joseph Paxton, *Crystal Palace*, Great Exposition, London, 1851. 1,848 × 408 ft. Photo © Marburg/Art Resource, New York.

396 Part 4 The Visual Arts in Everyday Life

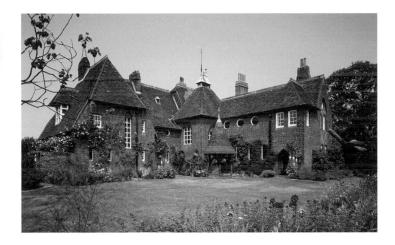

workers from their labor, and he also missed the quality of hand-made items. Industrial laborers had no stake in what they made, and thus no pride in their work. The result, he felt, was both shoddy workmanship and unhappy workers.

As a result of the experience of building the Red House and attempting to furnish it with objects of a medieval, hand-crafted nature, a project that was frustrated at every turn, Morris decided to take matters into his own hands. In 1861 he founded the firm that would become Morris and Company. It was dedicated "to undertake any species of decoration, mural or otherwise, from pictures, properly so-called, down to the consideration of the smallest work susceptible of art beauty." To this end, the company was soon producing stained glass, painted tiles, furniture, embroidery, table glass, metalwork, chintzes, wallpaper, woven hangings, tapestries, and carpets.

In his designs, Morris constantly emphasized two principles: simplicity and utility. However, it is difficult, at first glance, to see "simplicity" in work such as *The Woodpecker* (Fig. 545). For Morris, however, the natural and organic were by definition simple. Thus the pattern possesses, in Morris's words, a "logical sequence of form, this *growth* looks as if it could not have been otherwise." Anything, according to Morris, "is beautiful if it is in accord with nature . . . I must have," he said, "unmistakable suggestions of gardens and fields, and strange trees, boughs, and tendrils."

Morris's desire for simplicity—"simplicity of life," as he put it, "begetting simplicity of taste"—soon led him to create what he called "workaday furniture," the best examples of

Fig. 544 Philip Webb, *The Red House*, Bexley Heath, UK, 1859. Photo: Charlotte Wood.

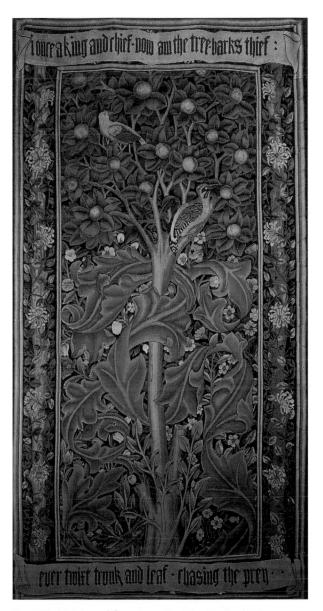

Fig. 545 Morris and Company, *The Woodpecker*, 1885. Wool tapestry designed by Morris. William Morris Gallery, Walthamstow, England.

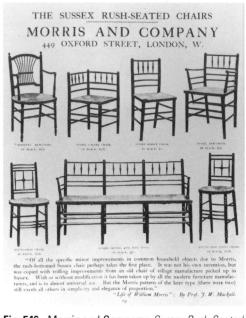

Fig. 546 Morris and Company, Sussex Rush-Seated Chairs. Fitzwilliam Museum, Cambridge, England. Exhibition catalogue Fitzwilliam Museum, Cambridge University Press, 1980, pl. 49

which are the company's line of Sussex rushseated chairs (Fig. 546). Such furniture was meant to be "simple to the last degree" and to appeal to the common man. As Wedgwood had done 100 years earlier (see Chapter 15), Morris quickly came to distinguish this "workaday" furniture from his more costly "state furniture," for which, he wrote, "we need not spare ornament . . . but [may] make them as elaborate and elegant as we can with carving or inlaying or paintings; these are the blossoms of the art of furniture." A sofa designed by Morris's friend, the painter Dante Gabriel Rossetti, and displayed by Morris and Company at the International Exhibition of

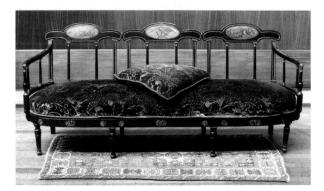

Fig. 547 Dante Gabriel Rossetti, Sofa, 1862. Wood, upholstered in velvet, width, 74 1/8 in. Fitzwilliam Museum, Cambridge, England.

1862 (Fig. 547), is the "state" version of the Sussex settee. Covered in rich, dark green velvet, each of the three panels in the back contains a personification of Love, hand painted by Rossetti. As Morris's colleague Walter Crane put it: "The great advantage . . . of the Morrisian method is that it leads itself to either simplicity or splendor. You might be almost plain enough to please Thoreau, with a rush bottomed chair, piece of matting, and oaken trestle-table; or you might have gold and luster gleaming from the side-board, and jeweled light in your windows, and walls hung with rich arras tapestry."

Perhaps nothing more underscores Morris's aesthetic taste than his work as bookmaker and typographer at the Kelmscott Press, which he founded in 1888. His edition of Chaucer's works (Fig. 548) is a direct expression of his belief in the values and practices of the Middle Ages. Morris commissioned hand-made, wiremolded, linen paper similar to that used in

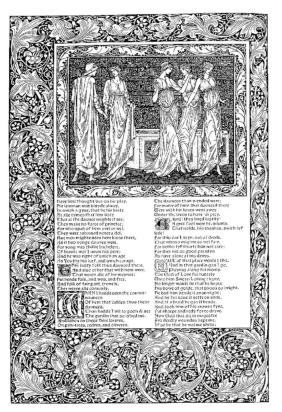

Fig. 548 William Morris (design) and Edward Burne-Jones (illustration), Page opening Geoffrey Chaucer, *The Works of Geoffrey Chaucer Newly Augmented*, Kelmscott Press, 1896.

Edition of 425 copies on paper, sheet 16 3 /₄ × 11 1 /₂ in. Designed by William Morris (CT36648). Victoria & Albert Museum, London. Art Resource, NY.

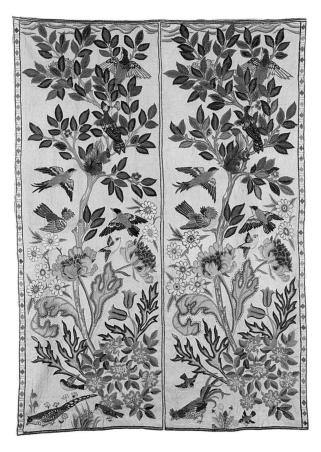

fifteenth-century Bologna. He designed a font, appropriately called Chaucer, which was based on Gothic script. In order to make it more legible, he widened most letterforms, increased the differences between similar characters, and made curved characters rounder. "Books should be beautiful," he argued, "by force of mere typography." But he stopped at nothing to make the Chaucer beautiful in every detail. He set his type by hand, insisting upon a standard spacing between letters, words, and lines. He positioned material on the page in the manner of medieval bookmakers, designed 14 large borders, 18 different frames for the illustrations, and 26 large initial words for the text. Finally, he commissioned 87 illustrations from the English painter Sir Edward Burne-Jones. The book, he felt, should be like architecture, every detail-paper, ink, type, spacing, margins, illustrations, and ornament-all working together as a single design unit.

By the 1870s, embroidered wall hangings were among the most popular items produced by Morris and Company. At first, Morris's wife, Jane, headed a large group of women, some of whom worked for the company full-time and others who worked more occasionally. In 1885, Fig. 549 May Morris, Bed hangings, 1916.
 Wool crewel on linen, cotton lined, 76 ³/₄ × 54 in.
 Cranbrook Art Museum, Bloomfield Hills, Michigan. Gift of George G. Booth and Ellen Scripps Booth.
 Photo: R. H. Hensleigh. Accession number CAM 1955.402.

his daughter May, then 23 years old, took over management of the embroidery section. For a quarter of a century, until about 1910, May Morris trained many women in the art of embroidery at her Hammersmith Terrace workshops, and many designs attributed to her father after 1885 are actually her own (apparently, she thought it important, at least from a commercial point of view, to give her father the credit).

In 1916, May Morris designed bed hangings for a lady's bedroom, "in which elaboration and luxury have been purposefully avoided" (Fig. 549). Shown at the Arts and Crafts Exhibition in London in the same year, the embroidery work was done by May Morris, the teacher Mary Newill, and Newill's students at the Birmingham School of Art. The fact that most of the women who worked for Morris and Company were relegated to the embroidery division demonstrates the rigidity of sex roles in English society at the turn of the century. Nevertheless, May Morris, a successful businesswoman, author, and lecturer, was an important role model for the women of her day. In 1907, she helped found the Women's Guild of Art, the purpose of which was to provide a "centre and a bond for the women who were doing decorative work and all the various crafts."

William Morris claimed that his chief purpose as a designer was to elevate the circumstances of the common man. "Every man's house will be fair and decent," he wrote, "all the works of man that we live amongst will be in harmony with nature . . . and every man will have his share of the best." But common people were in no position to afford the elegant creations of Morris and Company. Unlike Wedgwood (see Chapter 15), whose common, "useful" ware made the most money for the firm, it was the more expensive productions-the state furniture, tapestries, and embroideries-that kept Morris and Company financially afloat. Inevitably, Morris was forced to confront the inescapable conclusion that to hand-craft an object made it prohibitively expensive. With resignation and

Fig. 550 Gustav Stickley, Settee (for the Craftsman Workshops), 1909.

Oak and leather, back: $38 \times 71^{7}/_{16} \times 22$ in.; seat: 19×62 in. The Art Institute of Chicago. Gift of Mr. and Mrs. John J. Evans, Jr., 1971.748. Photo © 1999 The Art Institute of Chicago. All rights reserved.

probably no small regret, he came to accept the necessity of mass-manufacture.

In the United States, Gustav Stickley's magazine The Craftsman, first published in 1901 in Syracuse, New York, was the most important supporter of the Arts and Crafts tradition. The magazine's self-proclaimed mission was "to promote and to extend the principles established by [William] Morris," and its first issue was dedicated exclusively to Morris. Likewise, the inaugural issue of House Beautiful magazine, published in Chicago in 1896, included articles on Morris and the English Arts and Crafts movement. Stickley, recognizing the expense of Morris's hand-crafted furniture and the philosophical dilemma that Morris faced in continuing to make it, accepted the necessity of machine-manufacturing his own work. Massive in appearance, lacking ornamentation, its aesthetic appeal depended, instead, on the beauty of its wood, usually oak (Fig. 550).

By the turn of the century, architect Frank Lloyd Wright was also deeply involved in furniture design. Like Morris before him, Wright felt compelled to design furniture for the interiors of his Prairie Houses that matched the design of the building as a whole (see Fig. 517). Though geometric, his designs were rooted in nature. In the ornamental detail Wright designed for William C. Gannett's book *The House Beautiful*, published in Boston in 1897, Wright literally transformed the organic lines of his own photograph of some wildflowers into a geometric design dominated by straight lines and rectangular patterns (Figs. 551 and 552). "It is

Figs. 551 and 552 Frank Lloyd Wright, left: photo of wildflowers; right: ornamental detail. Both in William C. Gannett, *The House Beautiful*, Boston 1896–1897. The Frank Lloyd Wright Archives, Scottsdale, AZ.

quite impossible," Wright wrote, "to consider the building as one thing, its furnishings another and its setting and environment still another. The Spirit in which these buildings are conceived sees these all together at work as one thing." The table lamp designed for the Lawrence Dana House in Springfield, Illinois (Fig. 553) is meant to reflect the dominant decorative feature of the house-a geometric rendering of the sumac plant that is found abun- dantly in the neighboring Illinois countryside, chosen because the site of the house itself was particularly lacking in vegetation. Given a very large budget, Wright designed 450 glass panels and 200 light fixtures for the house that are variations on the basic sumac theme. Each piece is unique and individually crafted.

Among them, the furniture designs of Morris, Stickley, and Wright point out the basic issues that design faced in the twentieth century. The first dilemma, to which we have been paying particular attention, was whether the product should be hand-crafted or mass-manufactured. But formal issues have arisen as well. If we compare Wright's designs to Morris's, we can see that

Fig. 553 Frank Lloyd Wright, Table lamp, Susan Lawrence Dana House, 1903.

Bronze, leaded glass. Photo: Douglas Carr. Courtesy The Dana-Thomas House, The Illinois Historic Preservation Agency.

O 2005 Frank Lloyd Wright Foundation, Scottsdale, AZ /Artists Rights Society (ARS), New York.

they use line completely differently. Even though both find the source of their forms in nature, Wright's forms are rectilinear and geometric, Morris's curvilinear and organic. Both believed in "simplicity," but the word meant different things to the two men. Morris, as we have seen, equated simplicity with the natural. Wright, on the other hand, designed furniture for his houses because, he said, "simple things . . . were nowhere at hand. A piece of wood without a moulding was an anomaly, plain fabrics were nowhere to be found in stock." To Wright, simplicity meant plainness. The history of design continually confronts the choice between the geometric and the organic. The major design movement at the turn of the century, Art Nouveau, chose the latter.

ART NOUVEAU

The day after Christmas in 1895, a shop opened in Paris named the Galeries de l'Art Nouveau. It was operated by one S. Bing, whose first name was Siegfried, though art history has almost universally referred to him as Samuel, perpetuating a mistake made in his obituary in 1905. Bing's new gallery was a success, and in 1900, at the International Exposition in Paris, he opened his own pavilion, Art Nouveau Bing. By the time the Exposition ended, the name **Art Nouveau** had come to designate not merely the work he displayed but a decorative arts movement of international dimension.

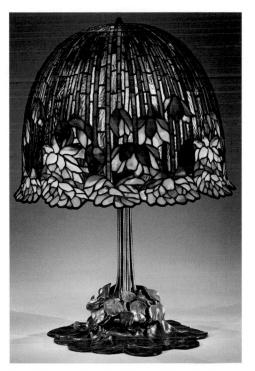

 Fig. 554 Louis Comfort Tiffany, Tiffany Studios, Water-lily table lamp, c. 1904–1915.
 Leaded Favrile glass and bronze, height, 26 ½ in. Metropolitan Museum of Art, New York. Gift of Hugh J. Grant, 1974 (1974.214.15ab).
 Photo © 1984 Metropolitan Museum of Art.

Bing had visited the United States in 1894. The result was a short book titled Artistic Culture in America, in which he praised America's architecture, painting, and sculpture, but most of all its arts and crafts. The American who fascinated him most was the glassmaker Louis Comfort Tiffany, son of the founder of the famous New York jewelry firm Tiffany and Co. The younger Tiffany's work inspired Bing to create his new design movement, and Bing contracted with the American to produce a series of stained-glass windows designed by such French artists as Henri de Toulouse-Lautrec and Pierre Bonnard. Because oil lamps were at that very moment being replaced by electric lights-Thomas Edison had startled the French public with his demonstration of electricity at the 1889 International Exhibition-Bing placed considerable emphasis on new, modern modes of lighting. From his point of view, a new light and a new art went hand in hand. And Tiffany's stained-glass lamps (Fig. 554), backlit by electric light, brought a completely new sense of vibrant color to interior space.

Fig. 555 Louis Comfort Tiffany, *Tiffany Glass & Decorating Co.* (1893–1902), Corona, New York, Peacock Vase, c. 1893–1896.

Favrile glass, height, 41 $\frac{1}{6}$ in.; width, 11 $\frac{1}{2}$ in. Metropolitan Museum of Art, New York. Gift of H. O. Havemeyer, 1896 (96.17.10). Photo © 1987 Metropolitan Museum of Art.

Even more than his stained glass, Bing admired Tiffany's iridescent Favrile glassware, which was named after the obsolete English word for hand-made, "fabrile." The distinctive feature of this type of glassware is that nothing of the design is painted, etched, or burned into the surface. Instead, every detail is built up by the craftsperson out of what Tiffany liked to call "genuine glass." In the vase illustrated in Fig. 555, we can see many of the design characteristics most often associated with Art Nouveau, from the wavelike line of the peacock feathers to the self-conscious asymmetry of the whole. In fact, the formal vocabulary of Art Nouveau could be said to consist of young saplings and shoots, willow trees, buds, vines-anything organic and undulating, including snakes and, especially, women's hair. The Dutch artist Jan Toorop's advertising poster for a peanut-based salad oil

(Fig. 556) flattens the long, spiraling hair of the two women preparing salad into a pattern very like the elaborate wrought-iron grillwork also characteristic of Art Nouveau design. Writing about Bing's installation at the 1900 Universal Exposition, one writer described Art Nouveau's use of line this way: "[In] the encounter of the two lines . . . the ornamenting art is born—an indescribable curving and whirling ornament, which laces and winds itself with almost convulsive energy across the surface of the [design]!"

Yet, for many, Art Nouveau seemed excessively subjective and personal, especially for public forms such as architecture. In Vienna, particularly, where Art Nouveau had flourished under the banner of the *Jugendstil*—

Fig. 556 Jan Toorop, Poster for *Delftsche Slaolie* (Salad Oil), 1894. Dutch advertisement poster. Scala/Art Resource, New York.

Fig. 557 Josef Hoffman, Palais Stoclet, Brussels, 1905–1911. Photo © Archim Bednorz, Koln.

Fig. 558 Gustav Klimt, Fulfillment (Stoclet Frieze), c. 1905–1909. Tempera version of the original mosaic. Osterreichische Galerie, Vienna. Bridgeman Art Library.

literally, "the style of youth"-the curvilinear and organic qualities of Art Nouveau gave way to symmetry and simple geometry. Consider, for instance, the Palais Stoclet in Brussels (Fig. 557), designed by the Viennese architect Josef Hoffman. The exterior is starkly white and geometrical, and quite plain. But the interior is luxurious. Hoffman ringed the walls of the dining room, for instance, in marble inlaid with mosaics of glass and semiprecious stones including onyx and malachite designed by the Viennese painter Gustav Klimt (Fig. 558). The theme of the mosaics was openly sexual. Here, the journey of life's fulfillment is reached in the embrace of male and female. For Hoffman, the interior of the house was private space, a place where fantasy and emotion could have free reign. Through the example of buildings like the Palais Stoclet, Art Nouveau became associated with an interior world of aristocratic wealth, refinement, and even emotional abandon, but it was also a style that realized the necessity of presenting, in its exteriors, a public face of order, simplicity, and control. In other words, the type of geometric and rectilinear design practiced by Frank Lloyd Wright began to find favor, and by the Exposition Internationale des Arts Décoratifs et Industriels Modernes—the International Exposition of Modern Decorative and Industrial Arts-in Paris in 1925, it held sway.

ART DECO

The Exposition Internationale des Arts Décoratifs et Industriels Modernes was planned as early as 1907, during the height of Art Nouveau, but logistical problems—especially the outbreak of World War I—postponed it for almost 20 years. A very influential event, the exposition was the most extensive international showcase of the style of design then called *Art Moderne* and, since 1968, better known as **Art Deco**.

Not only did individual designers build their own exhibition spaces, but all of the great French department stores, as well as the leading French manufacturers, built lavish pavilions as well. Throughout, the emphasis was on a particularly French sense of fashionable luxury. There was no evidence anywhere of the practical side of design-no concern with either utility or function. The cabinet designed by the French furniture company Süe et Mare (Fig. 559) is typical of the most elaborate form of the Art Deco style featured at the 1925 exposition. Made of ebony, the preferred wood of Art Deco designers because it was extremely rare and, therefore, expensive, and inlaid with mother-of-pearl, abalone, and silver, the cabinet is extraordinarily opulent. This richness of materials, together with the slightly asymmetrical and organic floral design of the cabinet door, link the piece to the earlier style of Art Nouveau.

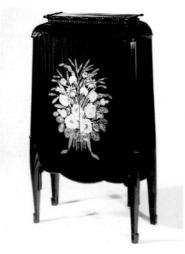

Fig. 559 Louis Süe and Andre Mare, Cabinet, 1927.
 Ebony, mother-of-pearl, silver, height, 61 ⁷/₈; width, 35 ³/₈; depth, 15 ³/₄ in. Virginia Museum of Fine Arts, Richmond. Gift of Sydney and Frances Lewis Foundation.
 Photo: Katherine Wetel. © Virginia Museum of Fine Arts.

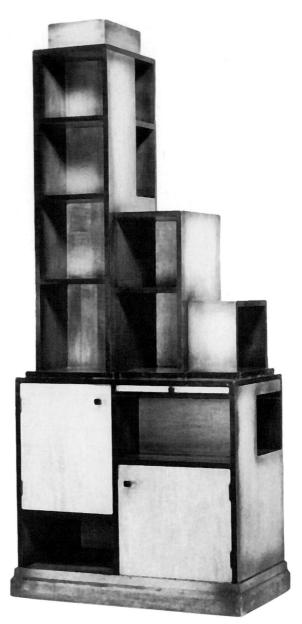

Fig. 560 Paul T. Frankl, *Skyscraper Bookcase*, 1925–1930. Maple wood and Bakelite, height, 79 % in.; width, 34 % in.; depth, 18 % in. The Metropolitan Museum of Art, New York. Purchase: Theodore R. Gamble, Jr. Gift in honor of his mother, Mrs. Theodore Robert Gamble, 1982 (1982.30ab).

But there was another type of Art Deco that, while equally interested in surface decoration, preferred more up-to-date materials chrome, steel, and Bakelite plastic—and sought to give expression to everyday "*moderne*" life. *The Skyscraper Bookcase* by the American designer Paul T. Frankl (Fig. 560), made of maple wood and Bakelite, is all sharp angles that rise into the air, like the brand-new skyscrapers that were beginning to dominate America's urban landscape.

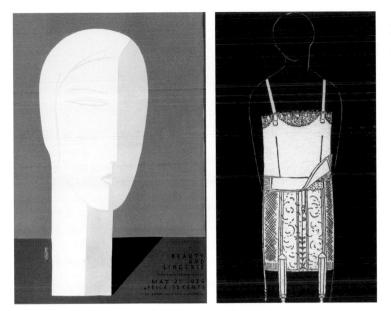

Fig. 561 (left) Edouardo Garcia Benito, Vogue, May 25, 1929 cover.

© Vogue, Condé Nast Publications, Inc.

Fig. 562 (right) Unidentified illustrator, Corset, *Vogue*, October 25, 1924. © Vogue/Condé Nast Publications, Inc.

This movement toward the geometric is perhaps the defining characteristic of Art Deco. Even the leading fashion magazines of the day reflect this in their covers and layouts. In Edouardo Benito's Vogue magazine cover (Fig. 561), we can see an impulse toward simplicity and rectilinearity comparable to Frankl's bookcase. The world of fashion embraced the new geometric look. During the 1920s, the boyish silhouette became increasingly fashionable. The curves of the female body were suppressed (Fig. 562), and the waistline disappeared in tubular, "barrel"-line skirts. Even long, wavy hair, one of the defining features of Art Nouveau style, was abandoned, and the schoolboyish "Eton crop" became the hairstyle of the day.

THE AVANT-GARDES

At the 1925 Paris Exposition, one designer's pavilion stood apart from all the rest, not because it was better than the others, but because it was so different. As early as 1920, a French architect by the name of Le Corbusier had written in his new magazine *L'Esprit Nouveau* (The New Spirit) that "decorative art, as op-

posed to the machine phenomenon is the final twitch of the old manual modes; a dying thing." He proposed a "*Pavillon de l'Esprit Nouveau*" (Pavilion of the New Spirit) for the exposition that would contain "only standard things created by industry in factories and mass-produced; objects truly of the style of today."

To Le Corbusier, to make expensive, handcrafted objects, such as the cabinet by Süe et Mare (see Fig. 559), amounted to making antiques in a contemporary world. From his point of view, the other designers at the 1925 exposition were out of step with the times. The modern world was dominated by the machine, and though designers had shown disgust for machine-manufacture ever since the time of Morris and Company, they did so at the risk of living forever in the past. "The house," Le Corbusier declared, "is a machine for living."

Le Corbusier's "new spirit" horrified the exposition's organizers, and, accordingly, they gave him a parcel of ground for his pavilion between two wings of the Grand Palais, with a tree, which could not be removed, growing right in the middle of it. Undaunted, Le Corbusier built right around the tree, cutting a hole in the roof to accommodate it (Fig. 563). The pavilion was built of concrete, steel, and glass, and its walls were plain white. So distressed were Exposition officials that they ordered a high fence to be built completely around the site

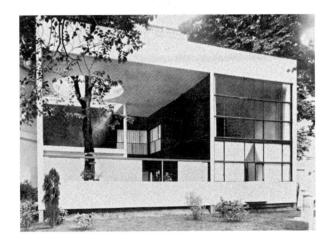

 Fig. 563 Le Corbusier, Pavillon de l'Esprit Nouveau.
 Exposition Internationale des Arts Décoratifs et Industriels Modernes, Paris, 1925. Copyrighted from Le Corbusier, My Work (London: Architectural Press, 1960), p. 72.
 © 2007 Artists/Rights Society (ARS). New York/ADAGP, Paris, FLC.

in order to hide it from public view. Le Corbusier appealed to the Ministry of Fine Arts, and, finally, the fence was removed. "Right now," Le Corbusier announced in triumph, "one thing is sure: 1925 marks the decisive turning point in the quarrel between the old and the new. After 1925, the antique lovers will have virtually ended their lives, and productive industrial effort will be based on the 'new.'"

The geometric starkness of Le Corbusier's design had been anticipated by developments in the arts that began to take place in Europe before World War I. A number of new avant-garde (from the French meaning "advance guard") groups had sprung up, often with radical political agendas, and dedicated to over-turning the traditional and established means of art-making through experimental techniques and styles.

One of the most important was the De Stijl movement in Holland. De Stijl, which is Dutch for "The Style," took its lead, like all the avant-garde styles, from the painting of Picasso and Braque, in which the elements of the real world were simplified into a vocabulary of geometric forms. The De Stijl artists, chief among them Mondrian (see Fig. 730), simplified the vocabulary of art and design even further, employing only the primary colors-red, blue, and yellow-plus black and white. Their design relied on a vertical and horizontal grid, often dynamically broken by a curve, circle, or diagonal line. Rather than enclosing forms, their compositions seemed to open out into the space surrounding them.

Gerrit Rietveld's famous chair (Fig. 564) is a summation of these De Stijl design principles. The chair is designed *against*, as it were, the traditional elements of the armchair. Both the arms and the base of the chair are insistently locked in a vertical and horizontal grid. But the two planes that function as the seat and the back seem almost to float free from the closedin structure of the frame. Rietveld dramatized their separateness from the black grid of frame by painting the seat blue and the back red.

Rietveld's Schröder House, built in 1925, is an extension of the principles guiding his chair design. The interior of the box-shaped house is completely open in plan. The view represented here (Fig. 565) is from the living and dining area toward a bedroom. Sliding

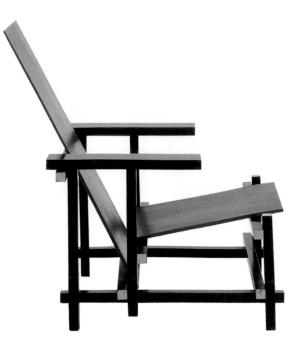

York/Beeldrecht, Amsterdam.

Fig. 565 Gerrit Rietveld, First floor, 1987, view of the stairwell/landing and the living-dining area. In the foreground is the Red and Blue Chair. Rietveld Schröderhlis, 1924, Utrecht, The Netherlands. c/o Stichting Beedldrect, Anstelveen. Centraal Museum Utrecht/Rietveld-Schröder Archive.

Photo: Ernst Moritz, The Hague. © 2007 Artists Rights Society (ARS), New York/Beeldrecht, Amsterdam.

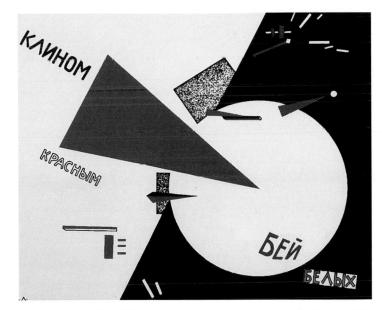

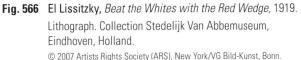

Fig. 567 Alexander Rodchenko, L'Art Décoratif, Moscow-Paris, 1925.

Design for catalog cover, Russian section, Exposition International des Arts Décoratifs et Industriels, Paris, 1925. Rodchenko Archive, Moscow, Russia. Scala/Art Resource, New York. Estate of Alexander Rodchenko/RAO, Russia/Licensed by VAGA, New York.

walls can shut off the space for privacy, but it is the sense of openness that is most important to Rietveld. Space implies movement. The more open the space, the more possibility for movement in it. Rietveld's design, in other words, is meant to immerse its occupants in a dynamic situation that might, idealistically, release their own creative energies.

This notion of dynamic space can also be found in Russian Constructivism, a movement in the new postrevolutionary Soviet state that dreamed of uniting art and everyday life through mass-production and industry. The artists, the Constructivists believed, should "go into the factory, where the real body of life is made." They believed, especially, in employing nonobjective formal elements in functional ways. El Lissitzky's design for the poster *Beat the Whites with the Red Wedge* (Fig. 566), for instance, is a formal design with propagandistic aims. It presents the "Red" Bolshevik cause as an aggressive red triangle attacking a defensive and static "White" Russian circle. Although

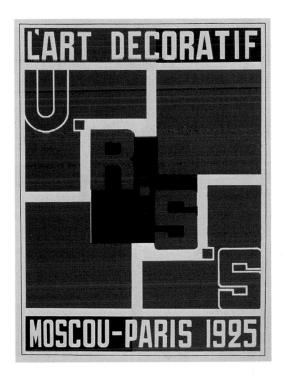

the elements employed are starkly simple, the implications are disturbingly sexual—as if the Reds are male and active, while the Whites are female and passive—and the sense of aggressive action, originating both literally and figuratively from "the left," is unmistakable.

This same sense of geometrical simplification can be found in Alexander Rodchenko's design for a catalog cover for the Russian exhibition at the 1925 Paris Exposition (Fig. 567). Rodchenko had designed the interiors and furnishings of the Workers' Club, which was included in the Soviet exhibit at the Exposition, and the cover design echoes and embodies his design for the Club. The furniture, as Rodchenko described it, emphasized "simplicity of use, standardisation, and the necessity of being able to expand or contract the numbers of its parts." It was painted in only four colorswhite, red, grey, and black-alone or in combination, and employed only rectilinear geometric forms. Chairs could be stacked and folded, tables could serve as screens and display boards if turned on their sides, and everything was moveable and interchangeable.

Typography, too, reflected this emphasis on standardization and simplicity. Gone were the ornamental effects of serif type styles that is, letterforms, such as the font used in this text, which have small lines at the end of the letter's main stroke-and in their place plain and geometric sans-serif ("without serif") fonts came to the fore. One of the great proponents of this new typography was the French poster designer Cassandre. "The poster is not meant to be a unique specimen conceived to satisfy a single art lover," Cassandre wrote, "but a mass-produced object that must have a commercial function. Designing a poster means solving a technical and commercial problem . . . in a language that can be understood by the common man." This meant the poster had to be read by the common man, and in a world where people moved by train, subway, and automobile, passing by commercial images at speed, type had to be plain and simple. Cassandre's poster for the newspaper L'Intransigeant (Fig. 568) embodies his geometrical tendencies. Its simple, clear shapes, merging perspective lines created by the electrical wires and transformers, and its bold uppercase typography are all organized around three circles-the eye, ear, and mouth. Cassandre does not even include the full name of the paper—he can convey his message more simply-nor its entire slogan, "Le plus fort tirage de journaux du soir" ("The best-selling evening paper"), which is cropped simply to read "Le plus fort" ("the strongest"). This play with words evidences the poster's debt to avant-garde artto the oblique angle of the print, evident in El Lissitzky's design for the poster Beat the Whites with the Red Wedge, and to Cubist col-

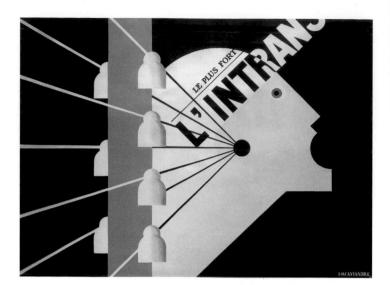

Fig. 568 Cassandre, poster for "L'Intransigeant," 1925. © MOURON. CASSANDRE. All rights reserved. License number 2003-20-11-01

lage (see Fig. 354), which constantly includes only fragments of newspaper, usually to the same kind of witty effect.

The poster campaign Cassandre created for the apertif Dubonnet (Fig. 569) is conceived entirely as a play on words. A man sits at a café table gazing at a glass of wine in his hand. The copy reads simply DUBO, or "*du beau*" ("something beautiful"). Next, we read DUBON, "*du bon*" ("something good"), and the color that was evident only in the glass, arm, and face in the first scene now extends to his stomach. Finally, above the full brand name, the fully colored, and apparently content, gentleman pours himself another glass. The geometri-

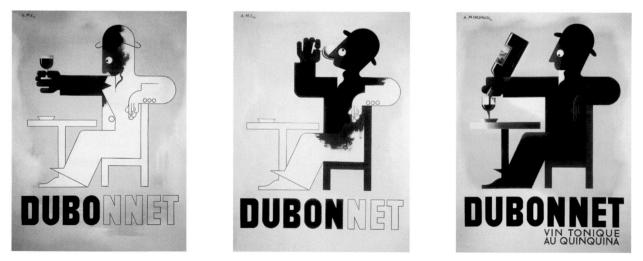

Fig. 569 Cassandre, poster for *Dubonnet*, 1932. © MOURON. CASSANDRE. All rights reserved. License number 2003-20-11-01

cal letterforms of the sans-serif capitals echo the forms of the man himself—the "D" in his hat, the "B" in his elbow, the "N" in his leg's relation to the chair, and the "T" in the table. In another version of the campaign, Cassandre split the image into three separate posters, to be seen consecutively from the window of a train. His typographic style, thus viewed by millions, helped to popularize the geometric simplicity championed by the avant-gardes.

THE BAUHAUS

At the German pavilion at the 1925 Paris Exposition, one could see a variety of new machines designed to make the trials of everyday life easier—for instance, an electric washing machine and an electric armoire in which clothes could be tumble-dried. When asked who could afford such things, Walter Gropius, who in 1919 had founded a school of arts and crafts in Weimar, Germany, known as the **Bauhaus**, replied, "To begin with, royalty. Later on, everybody." Like Le Corbusier, Gropius saw in the machine the salvation of humanity. And he thoroughly sympathized with Le Corbusier, whose major difficulty in putting together his Pavillon de l'Esprit Nouveau had been the unavailability of furniture that would satisfy his desire for "standard things created by industry in factories and mass-produced; objects truly of the style of today." Ironically, at almost exactly that moment, Marcel Breuer, a furniture designer working at Gropius's Bauhaus, was doing just that.

In the spring of 1925, Breuer purchased a new bicycle, manufactured out of tubular steel by the Adler company. Impressed by the bicycle's strength—it could easily support the weight of two riders—its lightness, and its apparent indestructibility, Breuer envisioned furniture made of this most modern of materials. "In fact," Breuer later recalled, speaking of the armchair that he began to design soon after his purchase (Fig. 570), "I took the pipe dimensions from my bicycle. I didn't know where else to get it or how to figure it out."

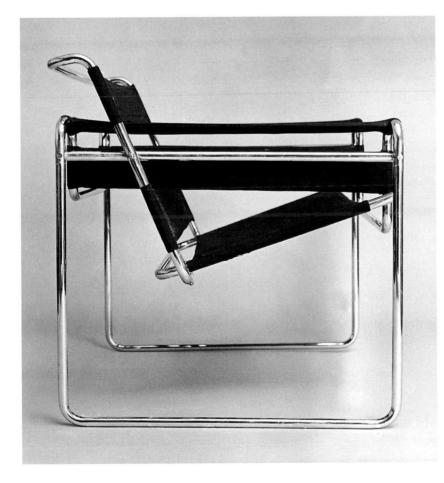

Fig. 570 Marcel Breuer, Armchair, model B3, late 1927 or early 1928.

Chrome-plated tubular steel with canvas slings, height, 28 ¹/₈ in.; width, 30 ¹/₄ in.; depth, 27 ³/₄ in. Museum of Modern Art, New York. Gift of Herbert Bayer.

Photo licensed by Scala/Art Resource, New York. © 1999 Museum of Modern Art, New York/Licenced by Scala/Art Resource, New York. The chair is clearly related to Rietveld's *Red* and Blue Chair (see Fig. 564), consisting of two diagonals for seat and back set in a cubic frame. It is easily mass-produced—and, in fact, is still in production today. But its appeal was due, perhaps most of all, to the fact that it looked absolutely new, and it soon became an icon of the machine age. Gropius quickly saw how appropriate Breuer's design would be for the new Bauhaus building in Dessau. By early 1926, Breuer was at work designing modular tubularsteel seating for the school's auditorium, as well as stools and side chairs to be used throughout the educational complex. As a result, Breuer's furniture became identified with the Bauhaus.

But the Bauhaus was much more. In 1919, Gropius was determined to break down the barriers between the crafts and the fine arts and to rescue each from its isolation by training craftspeople, painters, and sculptors to work on cooperative ventures. There was, Gropius said, "no essential difference" between the crafts and the fine arts. There were no "teachers" either: there were only "masters, journeymen, and apprentices." All of this led to what Gropius believed was the one place where all of the media could interact and all of the arts work cooperatively together. "The ultimate aim of all creative activity," Gropius declared, "is the building," and the name itself is derived from the German words for building (Bau) and house (Haus).

We can understand Gropius's goals if we look at Herbert Bayer's design for the cover of the first issue of Bauhaus magazine, which was published in 1928 (Fig. 571). Each of the three-dimensional forms-cube, sphere, and cone-casts a two-dimensional shadow. The design is marked by the letterforms Bayer employs in the masthead. This is Bayer's Universal Alphabet, which he created to eliminate what he believed to be needless typographical flourishes, including capital letters. Bayer, furthermore, constructed the image in the studio and then photographed it, relying on mechanical reproduction instead of the hand-crafted, highly individualistic medium of drawing. The pencil and triangle suggest that any drawing to be done is mechanical drawing, governed by geometry and mathematics. Finally, the story on the cover of the first issue of Bauhaus is concerned with architecture, to Gropius the ultimate creative activity.

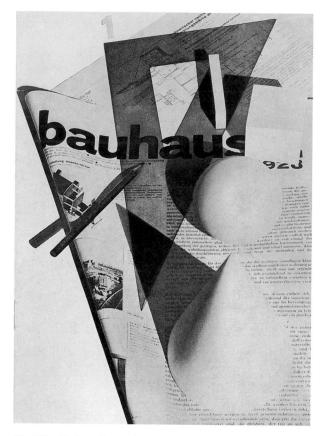

Fig. 571 Herbert Bayer, Cover for *Bauhaus 1*, 1928. Photomontage. Photo: Bauhaus–Archiv, Berlin. © VG Bild-Kunst, Bonn, Germany. © 2007 Artists Rights Society (ARS), New York/VG Bild-Kunst, Bonn.

STREAMLINING

Even as the geometry of the machine began to dominate design, finding particular favor among the architects of the International Style (see Chapter 16), in the ebb and flow between the organic and the geometric that dominates design history, the organic began to flow back into the scene as a result of advances in scientific knowledge. In 1926, the Daniel Guggenheim Fund for the Promotion of Aeronautics granted \$2.5 million to the Massachusetts Institute of Technology, the California Institute of Technology, the University of Michigan, and New York University to build wind tunnels. Designers quickly discovered that by eliminating extraneous detail on the surface of a plane, boat, automobile, or train, and by rounding its edges so that each subform merged into the next by means of smooth transitional curves, air would flow smoothly across the surface of the machine. Drag would thereby be dramatically

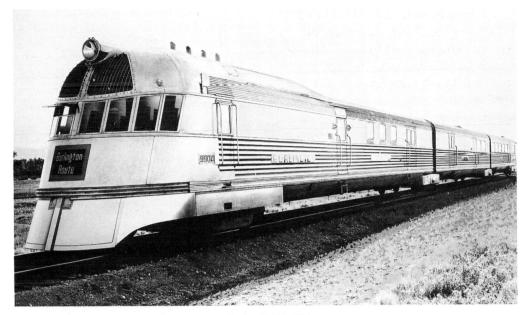

Fig. 572 Burlington Northern Co. Burlington Zephyr #9900, 1934 Photo Courtesy BNSF Railway Company

reduced, and the machine could move faster with less expenditure of energy. "Streamlining" became the transportation cry of the day.

The nation's railroads were quickly redesigned to take advantage of this new technological information. Since a standard train engine would expend 350 horsepower more than a streamlined one operating at top speed, at 70 to 110 mph, streamlining would increase pulling capacity by 12 percent. It was clearly economical for the railroads to streamline.

At just after 5 o'clock on the morning of May 26, 1934, a brand new streamlined train called the Burlington Zephyr (Fig. 572) departed Union Station in Denver bound for Chicago. Normally, the 1,015-mile trip took 26 hours, but this day, averaging 77.61 miles per hour and reaching a top speed of 112 miles per hour, the Zephyr arrived in Chicago in a mere 13 hours and 5 minutes. The total fuel cost for the haul, at $5 \notin$ per gallon, was only \$14.64. When the train arrived later that same evening at the Century of Progress Exposition on the Chicago lakefront, it was mobbed by a wildly enthusiastic public. If the railroad was enthralled by the streamlined train's efficiency, the public was captivated by its speed. It was, in fact, through the mystique of speed that the Burlington Railroad meant to recapture dwindling passenger revenues. Ralph Budd, president of the railroad, deliberately chose not to paint the *Zephyr*'s stainless steel sheath. To him it signified "the motif of speed" itself.

But the Zephyr was more than its sheath. It weighed one-third less than a conventional train, and its center of gravity was so much lower that it could take curves at 60 miles per hour that a normal train could only negotiate at 40. Because regular welding techniques severely damaged stainless steel, engineers had invented and patented an electric welding process to join its stainless steel parts. All in all, the train became the symbol of a new age. After its trips to Chicago, it traveled more than 30,000 miles, visiting 222 cities. Well over 2 million people paid a dime each to tour it, and millions more viewed it from the outside. Late in the year, it became the feature attraction of a new film, The Silver Streak, a somewhat improbable drama about a highspeed train commandeered to deliver iron lungs to a disease-stricken Nevada town.

Wind-tunnel testing had revealed that the ideal streamlined form most closely resembled a teardrop. A long train could hardly achieve such a shape—at bcst it resembled a snake. But the automobile offered other possibilities.

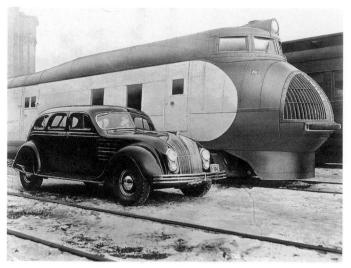

The first production-model streamlined car was the Chrysler Airflow (Fig. 573), which abandoned the teardrop ideal and adopted the look of the new streamlined trains. (It is pictured here with the 1934 Union Pacific Streamliner.) The man who inspired Chrysler to develop the automobile was Norman Bel Geddes. Bel Geddes was a poster and theatrical designer when he began experimenting, in the late 1920s, with the design of planes, boats, automobiles, and trains-things he thought of as "more vitally akin to life today than the theatre." After the stock market crash in 1929, his staff of 20 engineers, architects, and draftsmen found themselves with little or nothing to do, so Bel Geddes turned them loose on a series of imaginative projects, including the challenge to dream up some way to transport "a thousand luxury lovers from New York to Paris fast. Forget the limitations." The specific result was

Fig. 574 Norman Bel Geddes, with Dr. Otto Koller, "Air Liner Number 4," 1929.

Courtesy of the Estate of Edith Lutyens Bel Geddes, Harry Ransom Humanities Research Center, The University of Texas at Austin.

Fig. 573 Chrysler Airflow 4-door Sedan, 1934. Daimler Chrysler Historical Collection, Detroit, Michigan.

his *Air Liner Number 4* (Fig. 574), designed with the assistance of Dr. Otto Koller, a veteran airplane designer. With a wingspan of 528 feet, Bel Geddes estimated that it could carry 451 passengers and 115 crew members from Chicago to London in 42 hours. Its passenger decks included a dining room, game deck, solarium, barber shop and beauty salon, nursery, and private suites for all on board. Among the crew were a nursemaid, a physician, a masseuse and a masseur, wine stewards, waiters, and an orchestra.

Although Bel Geddes insisted that the plane could be built, it was the theatricality and daring of the proposal that really captured the imagination of the American public. Bel Geddes was something of a showman. In November 1932, he published a book entitled Horizons that included most of the experimental designs he and his staff had been working on since the stock market collapse. It was wildly popular. And its popularity prompted Chrysler to go forward with the Airflow. Walter P. Chrysler hired Bel Geddes to coordinate publicity for the new automobile. In one ad, Bel Geddes himself, tabbed "America's foremost industrial designer," was the spokesman, calling the Airflow "the first sincere and authentic streamlined car. . . the first real motor car." Despite this, the car was not a success. Though it drew record orders after its introduction in January 1934, the company failed to reach full production before April, by which time many orders had been withdrawn, and serious production defects were evident in those

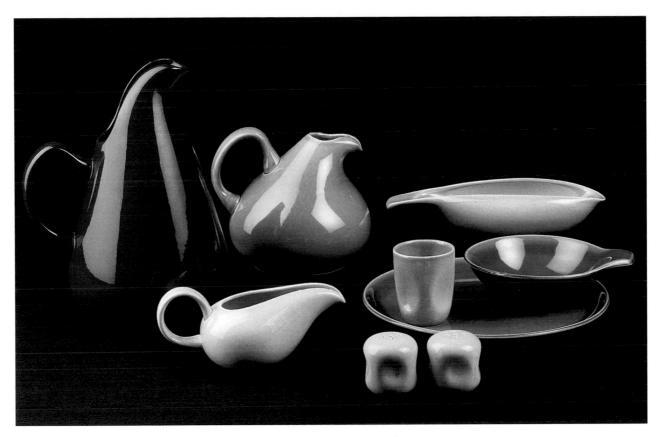

Fig. 575 Russel Wright, American Modern dinnerware, designed 1937, introduced 1939. Glazed earthenware. Department of Special Collections, Russell Wright papers. Syracuse University Library, Syracuse, New York.

Fig. 576 Staubsauger, Champion vacuum cleaner, Type OK, Holland, late 1930s. Photo © Bungartz/Die Neue Sammlung, Staatliches Museum für Angewandte Kunst, Munich. cars the company did manage to get off the line. The *Airflow* attracted more than 11,000 buyers in 1934, but by 1937 only 4,600 were sold, and Chrysler dropped the model.

However, streamlining had caught on, and other designers quickly joined the rush. One of the most successful American designers, Raymond Loewy, declared that streamlining was "the perfect interpretation of the modern beat." To Russel Wright, the designer of the tableware illustrated here (Fig. 575), streamlining captured the "American character." It was the essence of a "distinct American design." Almost overnight, European designers began employing streamlining in their own product design, as evidenced by a Dutch chromiumplated vacuum cleaner from the late 1930s (Fig. 576). Suddenly, to be modern, a thing had to be streamlined. Even more important, to be streamlined was to be distinctly American in style. Thus, to be modern was to be American, an equation that dominated industrial and product design worldwide through at least the 1960s.

THE FORTIES AND FIFTIES

The fully organic forms of Russel Wright's "American Modern" dinnerware announce a major shift in direction away from design dominated by the right angle and toward a looser, more curvilinear style. This direction was further highlighted when, in 1940, the Museum of Modern Art held a competition titled "Organic Design in Home Furnishings." The first prize in that competition was awarded jointly to Charles Eames and Eero Saarinen, both young instructors at the Cranbrook Academy of Art in Michigan. Under the direction of the architect Eliel Saarinen, Eero's father, Cranbrook was similar in many respects to the Bauhaus, especially in terms of its emphasis on interdisciplinary work on architectural environments. It was, however, considerably more open to experiment and innovation than the Bauhaus, and the Eames-Saarinen entry in the Museum of Modern Art competition was the direct result of the elder Saarinen encouraging his young staff to rethink entirely just what furniture should be.

All of the furniture submitted to the show by Eames and Saarinen (Fig. 577) used molded plywood shells in which the wood veneers were laminated to layers of glue. The resulting forms almost demand to be seen from more than a single point of view. The problem, as Eames wrote, "becomes a sculptural one." The furniture was very strong, comfortable, and reasonably priced. Because of the war, production and dis-

Fig. 577 Installation view of the exhibition Organic Design in Home Furnishings, September 24–November 9, 1941. © Museum of Modern Art, New York. Licensed by Scala/Art Resource, New York.

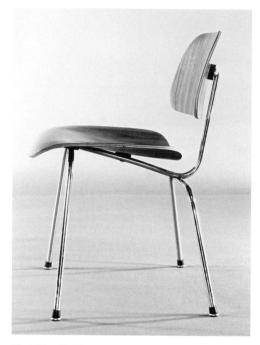

Fig. 578 Charles and Ray Eames, Side chair, model DCM, 1946.

Molded ash plywood, steel rods, and rubber shock mounts, height, 28 ¹/₄ in.; width, 19 ¹/₂ in.; depth, 20 in. Museum of Modern Art, New York. Gift of Herman Miller Furniture. Photo © 1999 Museum of Modern Art, Company. Licensed by Scala/Art Resource, New York.

tribution were necessarily limited, but in 1946, the Herman Miller Company made 5,000 units of a chair Eames designed with his wife, Ray Eames, also a Cranbrook graduate (Fig. 578). Instantly popular and still in production today, the chair consists of two molded-plywood forms that float on elegantly simple steel rods. The effect is amazingly dynamic: The back panel has been described as "a rectangle about to turn into an oval," and the seat almost seems to have molded itself to the sitter in advance.

Eero Saarinen took the innovations he and Eames had made in the "Organic Design in Home Furnishings" competition in a somewhat different direction. Unlike Eames, who in his 1946 chair had clearly abandoned the notion of the one-piece unit as impractical, Saarinen continued to seek a more unified design approach, feeling that it was more economical to stamp furniture from a single piece of material in a machine. His *Tulip Pedestal Furniture* (Fig. 579) is one of his most successful solutions. Saarinen had planned to make the pedestal chair entirely out of plastic, in keeping with his unified approach, but he discovered

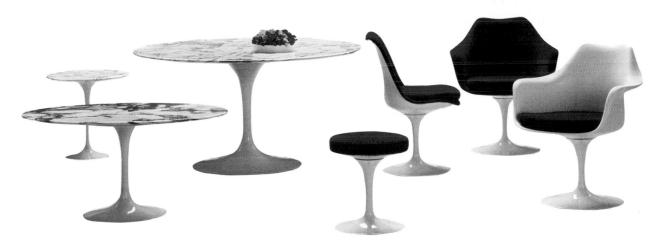

Fig. 579 Eero Saarinen, Tulip Pedestal Furniture, 1955–1957.
 Chairs: plastic seat, painted metal base; tables: wood or marble top, plastic laminate base.
 Saarinen Collection designed by Eero Saarinen in 1956 and 1957.
 Courtesy Knoll Inc.

that a plastic stem would not take the necessary strain. Forced, as a result, to make the base out of cast aluminum, he nevertheless painted it the same color as the plastic in order to make the chair appear of a piece.

The end of World War II heralded an explosion of new American design, particularly attributable to the rapid expansion of the economy, as 12 million military men and women were demobilized. New home starts rose from about 200,000 in 1945 to 1,154,000 in 1950. These homes had to be furnished, and new products were needed to do the job. Passenger car production soared from 70,000 a year in 1945 to 6,665,000 in 1950, and in the following

10 years, Americans built and sold more than 58 million automobiles. In tune with the organic look of the new furniture design, these cars soon sported fins, suggesting both that they moved as gracefully as fish and that their speed was so great that they needed stabilizers. The fins were inspired by the tail fins on the U.S. Air Force's P-38 "Lightning" fighter plane, which Harley Earl, chief stylist at General Motors, had seen during the war. He designed them into the 1948 Cadillac as an aerodynamic symbol. But by 1959, when the craze hit its peak, fins no longer had anything to do with aerodynamics. As the Cadillac (Fig. 580) made clear, it had simply become a matter of the bigger the better.

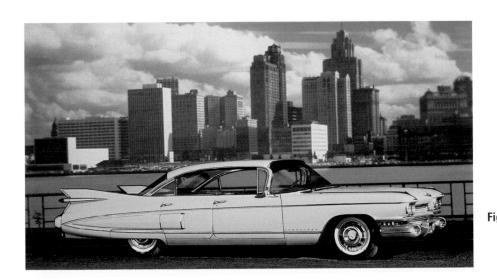

Fig. 580 General Motors 1959 *Cadillac Fleetwood.* General Motors Media Archives.

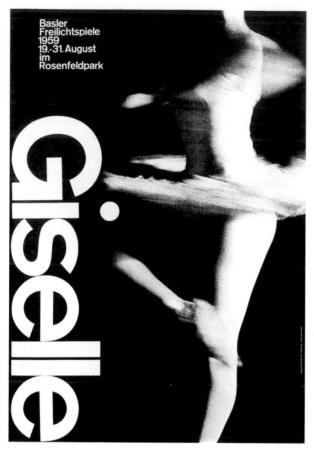

Fig. 581 Armin Hofmann, *Giselle*, 1959. Offset lithograph, 50 ³/₄ × 35 ⁵/₈ in. Courtesy Reinhold-Brown Gallery, New York.

In many ways, the Cadillac's excess defines American style in the 1950s. This was the decade that brought the world fast food (both the McDonald's hamburger and the TV dinner), Las Vegas, Playboy magazine, and a TV in almost every home. But there were, in the 1950s, statements of real elegance. One of the most notable was the graphic design of the Swiss school, notably that of Armin Hofmann. Recognizing, in his words, that "the whole of sensory perception has been shifted by the photographic image," he freely incorporated photographs into his poster designs. Like Saarinen in his air terminal designs (see Fig. 528), Hofmann emphasized finding a symbolic form or image appropriate to the content of his message. The poster for the ballet Giselle (Fig. 581) immediately conveys the idea of dance. It does this through the studied contrast between light and dark, between the blurred, speeding form of the dancer and the static clarity of the type,

between, finally, the geometry of the design and the organic movement of the body. By these means, Hofmann arrives at a synthesis of the competing stylistic forces at work in the history of modern design.

CONTEMPORARY DESIGN

One way to view the evolution of design since 1960 is to recognize a growing tendency to accept the splits between the organic and the geometric and the natural and the mechanical that dominate its history as not so much an either/or situation but as a question of both/and. In its unification of competing and contrasting elements, Hofmann's graphic design anticipates this synthesis. So, indeed, does the Eames chair, with its contrasting steel-support structure and molded-plywood seat and back.

But, as we suggested in the earlier discussion of postmodernism, the contemporary has been marked by a willingness to incorporate anything and everything into a given design. This is not simply a question of the organic versus the geometric. It is, even more, a question of the collisions of competing cultures of an almost incomprehensible diversity and range. On our shrinking globe, united by television and the telephone, by the fax machine and the copier, email, and the World Wide Web, and especially by increasingly interdependent economies, we are learning to accept, perhaps faster than we realize, a plurality of styles.

What we mean when we speak of the stylistic pluralism of contemporary design is clear if we compare a traditional corporate identity package with a conspicuously postmodern one. Although the Coca-Cola bottle has changed over the course of time, the 1957 redesign of the bottle (Fig. 582) makes it slightly more streamlined and sleeker than earlier versions and changes the embossed lettering to white paint. The script logo itself has remained constant almost since the day Dr. John Pemberton first served the concoction on May 8, 1886, at Jacob's Pharmacy in downtown Atlanta, Georgia. Coke claims that today more than 90 percent of the world's men, women, and children easily recognize the bottle.

By contrast, the designers of Swatch watches, the Swiss husband and wife team

Fig. 582 Coca-Cola Contour bottle. "Coca-Cola, Coke and the Contour Bottle design are registered trademarks of The Coca-Cola Company." Used with permission.

Jean Robert and Käti Durrer, conceive of their design identities as kinetic, ever-changing variations on a basic theme (Fig. 583). In recent years, both the television and music industries have more and more turned from producing shows and recordings designed to appeal to the widest possible audience to a concentration on appealing to more narrowly defined, specialized audiences. Television learned this lesson with the series "St. Elsewhere," which had very low overall ratings, but which attracted large numbers of married, young, upper-middle-class professionals—yuppies with enough disposable income to attract, in turn, major advertising accounts.

In light of this situation, it is no longer necessary to standardize a corporate identity. It may not even be desirable. Illustrated here are 8 of the approximately 300 watch designs produced by Robert and Durrer between 1983 and 1988, which were inspired by a variety of cultures—from Japanese to Native American—and styles. Each watch is designed to allow the wearer's individuality to assert itself. "In 1984," Robert and Durrer recall, "we saw a gentleman sitting in the back of his Rolls Royce. We couldn't help noticing a Swatch on his wrist. That showed us how great the breakthrough had been."

Robert and Durrer cater to an increasingly individualistic taste, which is precisely the subject of Andrea Zittel's work, a curious mixture of design and high art, mass-manufacture and one-of-a-kind "originals." "When I drive down the street in my neighborhood," Zittel says,

... every single person's yard is landscaped to represent some fantasy of where they live, whether it be an alpine fantasy or a tropical fantasy or a desert fantasy. And they're all these totally separate little

Fig. 583 Jean Robert and Käti Durrer, Swatch Watches, 1983–1988. Courtesy Swatch AG, Biel, Switzerland.

universes or environments that are completely honed in. So I've been thinking about... how I could actually create a design for a feasible living environment that reflects... capsule living, and how especially... it's more and more about creating your own bubble, your own capsule.

Zittel specializes in the design and construction of functional dwelling spaces for which she also creates furniture and accessories. In the early nineties, she produced self-contained life "management and maintenance units" (Fig. 584), more or less high-end versions of Krzysztof Wodicsko's Homeless Vehicles (see Figs. 86 and 87). These, in turn, inspired her to create three "prototype" travel trailers, with standardized exteriors, produced in fact by a recreational vehicle manufacturer, but with interiors designed to be customized by their owners. In driving her prototype to the San Francisco Museum of Modern Art for exhibition in 1995, she noticed that trailers in RV parks were actually parked permanently, and that "the owners of these trailers actually found their freedom in the intimacy of the small and completely controllable universe that they constructed within their trailers." This realization inspired her A-Z Escape Vehicles (Fig. 585), 10 identical, but wheel-less recreational vehicles that "can be used to escape to one's 'inner world.'" As each vehicle is purchased, the owners design their own fantasy worlds inside.

Fig. 584 Andrea Zittel, A-Z Management & Maintenance Unit: Model 003, 1992. Steel, wood, carpet, plastic, washbasin, hotplates, glass, mirror, 7 ft. 2 in. × 7 ft. 10 in. × 5 ft. 8 in.

Courtesy Andrea Rosen Gallery, New York. © Andrea Zittel, 1992.

Fig. 585

Andrea Zittel, A-Z Escape Vehicles, 1996. Steel, insulating material, wood, glass, each $5 \text{ ft.} \times 3 \text{ ft.} 4 \text{ in.} \times 7 \text{ ft.}$ Courtesy Andrea Rosen Gallery, New York. © Andrea Zittel, 1996.

THE **CRITICAL** PROCESS Thinking about Design

ndrea Zittel asks us to consider what the $\operatorname{Arelationship}$ is between art and design. In fact, perhaps one of the best ways to think of her work is as art that uses design as its subject matter. Her work is, after all, "branded" with the name "A-Z" (at once her own personal initials and a euphemism for "everything"). The "A-Z" logo is stamped on the outside of all her "units," all of which are also instances of the uniform "packaging" that marks brand-name products. Zittel, who received her graduate degree in sculpture from the prestigious Rhode Island School of Design, where she was constantly surrounded by design issues and theory, consciously designs all aspects of her life, from her furniture to her clothes (another basic form of "living unit"). Even when she uses mass-produced items in her daily life, she customizes them to her own ends.

But, that said, her work is very different from design. Consider, for instance, her recent *A-Z Time Tunnels* (Figs. 586 and 587). In a completely self-contained chamber, Zittel conducted a number of "Time Trials" in which she attempted "to shift perception . . . by eliminating the one single reference point of time." In Berlin, for one week, from October 31 to November 6, 1999, she lived without any access to "external" time, by blocking out all sources of natural light and sound, clocks, and any other time referents such as TV, radio, or time settings on her computer. Here she would have, as is stenciled on the top of one of her *A-Z Time Tunnels*, "Time to read every book I ever wanted to read."

One of the most interesting results of this experiment without time is that Zittel considered it to be, in at least some sense, a failure: "I hit the wall with that piece because there was no way to share the experience of living without time with an audience." Perhaps one of the most useful ways to think about the difference between art and design is, in fact, the relative relationship to their audiences. How does the audience for art differ from the audience for design? How does the "art market" differ from the "marketplace"? What demands are placed on the designer that are not necessarily placed on the artist? What, finally, makes Zittel an artist whose subject matter is design?

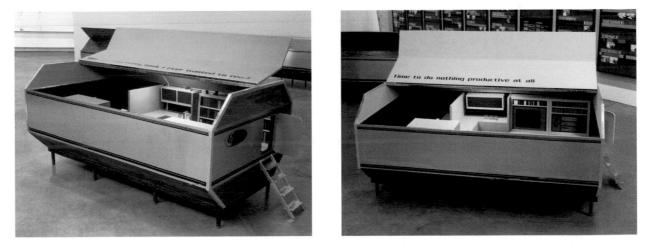

 Figs. 586 and 587
 Andrea Zittel, A-Z Time Tunnel: Time to Read Every Book I Ever Wanted to Read, 2000.

 Aluminum, walnut wood, steel, carpet, vinyl adhesive, MDF, electric lighting, loudspeakers, enclosed, 4 ft. x 4 ft. 41 ½ in. × 6 ft. 8 ¼ in.

 Courtesy Andrea Rosen Gallery, New York. © Andrea Zittel, 2000.

Fig. 588Eugène Delacroix, Liberty Leading the People, 1830.Oil on canvas, 8 ft. 6 3/8 in. × 10 ft. 8 in. Musée du Louvre, Paris.Photo © Erich Lessing/Art Resource, New York.

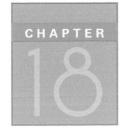

The Ancient World

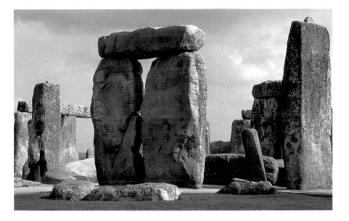

he following chapters are designed to help place the works of art so far discussed in *A World of Art* into a broader historical context. The brief chronological survey and illustrations trace the major developments and movements in art from the earliest to the most recent times. To help you place the illustrations in these and earlier chapters in context, we have listed some important contemporaneous historical events across the tops of the pages. We will see how the history of art is inextricably tied to these broader cultural developments and in many ways reflects them.

THE EARLIEST ART MESOPOTAMIAN CULTURES EGYPTIAN CIVILIZATION AEGEAN CIVILIZATIONS GREEK ART ROMAN ART DEVELOPMENTS IN ASIA

40,000 BCE-

Height of last glacial advance in Europe **22,000 BCE**

40,000 BCE Modern humans arrive in Europe

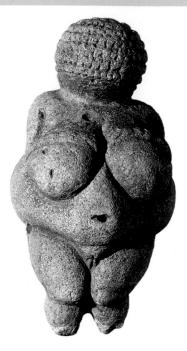

Fig. 589 Venus of Willendorf, Lower Austria, c. 25,000–20,000 BCE. Limestone, height, 4 ½ in. Naturhistorisches Museum, Vienna, Austria. © Photography by Erich Lessing/Art Resource, NY

THE EARLIEST ART

It is not until the emergence of modern humans, Homo sapiens, in the Paleolithic Era, that we find artifacts that might be called works of art. The word "Paleolithic" derives from the Greek palaios, "old," and lithos, "stone," and refers to the use of stone tools, which represent a significant advance beyond the flint instruments used by Neanderthal people. With these tools, works of art could be fashioned. The earliest of these, representing animals and women, are small sculptural objects that serve no evident practical function. Found near Willendorf, Austria, the so-called Venus of Willendorf (Fig. 589) is probably a fertility figure, judging from its exaggerated breasts, belly, and genitals, and lack of facial features. We know little about it, and we can only guess at its significance. Many sculptures of this kind are highly polished, a result of continuous handling.

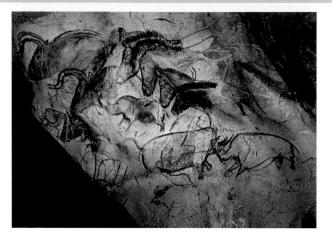

Fig. 590 Horses, Chauvet, Ardèche Gorge, France, c. 30,000 BCE. Sygma. Jean Clottes/Miniterie de la Culture.

The scale of these small objects is dwarfed by the paintings that have been discovered over the course of the last 125 years in caves concentrated in southern France and northern Spain. In 1996, at Chauvet cave in the Ardèche Gorge in southern France, new drawings were discovered that have been carbon-dated to approximately 30,000 BCE. These drawings (Fig. 590) are so expertly rendered, including the use of modeling and even a sense of recessive space, that our sense of prehistoric art has completely changed. Where before we believed that as prehistoric peoples became increasingly sophisticated, their art gained in comparable sophistication. But these drawings, the earliest ever found, suggest that prehistoric peoples possessed, at least potentially, the same level of skill as anyone ever has. They suggest as well that the ability to represent reality accurately is not so much a matter of intellectual or cultural sophistication as it is a function of the desire or need of a culture for such images.

As the Ice Age waned, around 8000 BCE, humans began to domesticate animals and cultivate food grains, practices that started in the Middle East and spread slowly across Greece and Europe for the next 6,000 years, reaching Britain last. Gradually, Neolithic—or New Stone Age peoples abandoned temporary shelters for permanent structures built of wood, brick, and stone.

Cave paintings in France and Spain **15,000 BCE**

8000 BCE

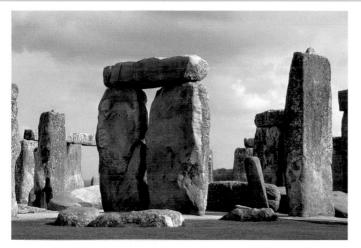

Fig. 591 Stonehenge, Salisbury Plain (Wiltshire), England, c. 2,000 BCE. Spencer Grant/Photo Edit.

Crafts—pottery and weaving, in particular began to flourish. Religious rituals were regularized in shrines dedicated to that purpose.

In Northern Europe, especially in Britain and France, a distinctive kind of monumental stone architecture made its appearance late in the Neolithic period. Known as megaliths, or "big stones," they were constructed without the use of mortar and represent the most basic form of architectural construction. Without doubt the most famous megalithic structure in the world is the cromlech known as Stonehenge (Fig. 591), on the Salisbury Plain about 100 miles west of present-day London. A henge is a circle surrounded by a ditch with built up embankments, presumably for fortification. The site at Stonehenge reflects four major building periods, extending from about 2750 to 1500 BCE. By about 2100 BCE, most of the elements visible today were in place.

Why Stonehenge was constructed remains a mystery, though it seems clear that orientation toward the rising sun at the summer solstice connects it to planting and the harvest. Stonehenge embodies, in fact, the growing importance of agricultural production in the northern reaches of Europe. Perhaps great rituals celebrating the earth's plcnty took place here. But most of all, together with other megalithic 8000 BCE Beginnings of agriculture in Near East

structures of the era, it suggests that the late Neolithic peoples that built it were extremely social beings, capable of great cooperation. They worked together not only to find the giant stones that rise at the site, but also to quarry, transport, and raise them. Theirs was, in other words, a culture of some magnitude and no small skill. It was a culture capable of both solving great problems and organizing itself in the name of creating a great social center.

Remains of highly developed Neolithic communities have been discovered at Jericho, which reached a height of development around 7500 BCE in modern-day Jordan, and at Çatal Hüyük, a community that developed in Turkey about 1,000 years later. Jericho was built around a freshwater spring, vital to life in the near-desert conditions of the region, and was surrounded by huge walls for protection (Fig. 592). Çatal Hüyük was a trade center with a population of about 10,000 people. First excavated between 1961 and 1965, this village was built of mud bricks and timber. There were no streets, only courtyards, and people passed between houses via the rooftops.

Neolithic society developed most quickly in the world's fertile river valleys. By 4000 BCE,

Fig. 592 Early Neolithic wall and tower, c. 7500 BCE. Jericho, Jordan. © Photo Atlanto/Foloo Quilioi.

Invention of writing in Mesopotamia **3500 BCE**

4000 BCE Beginnings of agriculture in China

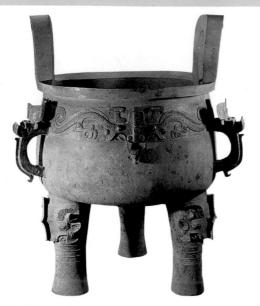

Fig. 593 Five-eared *ding* with dragon pattern, c. 1200 BCE. Bronze, height, 48 in.; diameter at mouth, 32 ³/₄ in. Chunhua County Cultural Museum. Art Resource, New York.

urban societies had developed on the Tigris and Euphrates rivers in Mesopotamia and on the Nile River in Egypt. Similarly complex urban communities were flourishing, by 2200 BCE, in the Indus and Ganges valleys of India and, by 2000 BCE, in the Huang Ho and Yangtze valleys of China (see map on p. 426). Excavations begun at Anyang in northern China, in 1928, have revealed the existence of what is known as the Shang dynasty, which ruled China from about 1766 to 1122 BCE. The great art form of the Shang dynasty was the richly decorated bronze vessel (Fig. 593), made by a casting technique as advanced as any ever used. This vessel was created to hold food during ceremonies dedicated to the worship and memory of ancestors. Many Shang vessels are decorated with symmetrical animal forms, often mythological, and the symmetrical animal mask that decorates it is typical of the bronze work of the period.

MESOPOTAMIAN CULTURES

Between 4000 and 3000 BCE, irrigation techniques were developed on the Tigris and

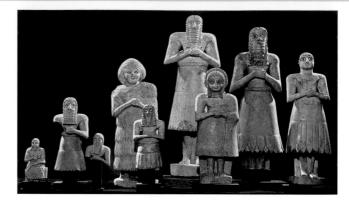

Fig. 594 Worshippers and deities from the Abu Temple, Tell Asmar, Iraq, c. 2900–2600 BCE.
Limestone, alabaster, and gypsum, height of tallest figure, 30 in. Excavated by the Iraq Expedition of the Oriental Institute of the University of Chicago, February 13, 1934.
Courtesy Oriental Institute of the University of Chicago.

Euphrates rivers in Mesopotamia. A complex society emerged, one credited, for instance, with both the invention of the wheel and the invention of writing. By the time they were finally overrun by other peoples in 2030 BCE, a people known as the Sumerians had developed schools, libraries, and written laws. Ancient Sumer consisted of a dozen or more cities, each with a population of between 10,000 and 50,000, and each with its own reigning deity. Each of the local gods had the task of pleading the case of their particular communities with the other gods, who controlled the wind, the rain, and so on. The tallest figure in the collection of Sumerian figures shown here (Fig. 594) is Abu, the Sumerian god of vegetation. Next to him is a mother goddess. The smaller statues represent worshippers and are stand-ins for actual persons, enabling worshippers, at least symbolically, to engage in continuous prayer and devotion. Eyes were considered by the Sumerians to be the "windows to the soul," which explains why the staring eyes in these sculptures are so large.

Communication with the god occurred in a ziggurat, a stepped temple, which rose high in the middle of the city (see Fig. 489). An

Sumerians brew beer from barley **3000–2500 BCE**

2500 BCE

3100 BCE Egypt united in the Early Dynastic Period

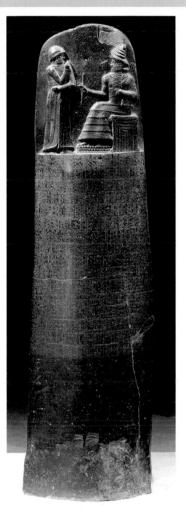

Fig. 595 Stele of Hammurabi, c. 1760 BCE. Basalt, height of stele, approx. 7 ft.; height of relief, 28 in. Musée du Louvre, Paris. BMN/Reunion des Musées Nationaux/Art Resource, New York.

early Mesopotamian text calls the ziggurat "the bond between heaven and earth."

One of the most influential Mesopotamian cultures was that of Babylon, which rose to power under the leadership of Hammurabi in the eighteenth century BCE. The so-called Law Code of Hammurabi is inscribed on a giant stele—the word for an upright stone slab, carved with a commemorative design or inscription. It is a record of decisions and decrees made by Hammurabi (Fig. 595) over the course of some 40 years of his reign. In 282 separate

Fig. 596 Assurnasirpal II Killing Lions, from the palace complex of Assurnasirpal II, Kalhu (modern Nimrud, Iraq), c. 850 BCF. Alabaster, height, approx. 39 in. The British Museum, London. Erich Lessing/Art Resource, New York.

"articles" which cover both sides of the basalt monument, the stele celebrates Hammurabi's sense of justice and the wisdom of his rule. Atop the stele, Hammurabi receives the blessing of Shamash, the sun god, notable for the rays of light that emerge from his shoulders. The god is much larger than Hammurabi; in fact, he is to Hammurabi as Hammurabi is to his people. Hammurabi's Code was repeatedly copied for over a thousand years, establishing the rule of law in Mesopotamia for a millennium.

After the fall of Babylon in 1595 BCE, victim of a sudden invasion of Hittites from Turkey, only the Assyrians, who lived around the city of Assur in the north, managed to maintain a continuing cultural identity. By the time Assurnasirpal II came to power, in 883 BCE, the Assyrians dominated the entire region. Assurnasirpal II built a magnificent capital at Kalhu, on the Tigris River, surrounded by nearly 5 miles of walls, 120 feet thick and 42 feet high. A surviving inscription tells us that 69,574 people were invited by Assurnasirpal to celebrate the city's dedication. Many of its walls were decorated with alabaster reliefs, including a series of depictions of Assurnasirpal Killing Lions (Fig. 596). The scene depicts several consecutive actions at

Great Sphinx and Pyramids of Gaza **2500 BCE**

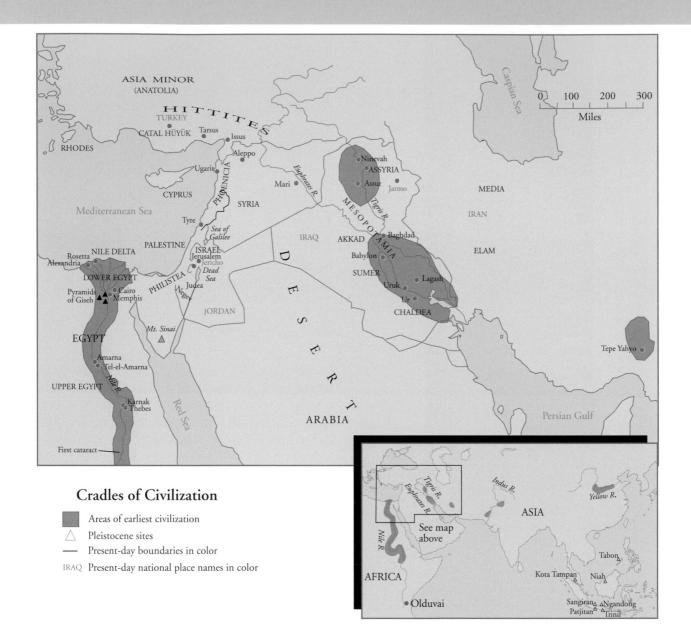

once: As soldiers drive the lion toward the king from the left, he shoots it.

EGYPTIAN CIVILIZATION

At about the same time that Sumerian culture developed in Mesopotamia, Egyptian society began to flourish along the Nile River. As opposed to Sumer, which was constantly threatened by invasion, Egypt was protected on all sides by sea and desert, and it cherished the ideals of order, stability, and endurance. These ideals are reflected in its art.

Egyptian culture was dedicated to providing a home for the ka, that part of the human being that defines personality and that survives life on earth after death. The enduring nature of the karequired that artisans decorate tombs with paintings that the spirit could enjoy after death. Small servant figures might be carved from wood to

2000 BCE Epic of Gilgamesh written in Mesopotamia

Fig. 597 Palette of King Narmer (front and back), Hierakonpolis, Upper Egypt, c. 3000 BCE. Slate, height, 25 in. Art Resource, New York.

serve the departed in the afterlife. The ka could find a home in a statue of the deceased. Mummification—the preservation of the body by treating it with chemical solutions and then wrapping it in linen—provided a similar home, as did the elaborate coffins in which the mummy was placed. The pyramids (see Fig. 488) were, of course, the largest of the resting places designed to house the ka.

The enduring quality of the ka accounts for the unchanging way in which, over the cen-Egyptian figures, especially turies. the pharaohs, were represented. A canon of ideal proportions was developed that was almost universally applied. The figure is, in effect, fitted into a grid. The feet rest on the bottom line of the grid, the ankles are placed on the first horizontal line, the knee on the sixth, the navel on the thirteenth (higher on the female), elbows on the fourteenth, and the shoulders on the nineteenth. These proportions are utilized in the Palette of King Narmer (Fig. 597)-called a "palette" because eye make-up was prepared on it. The tablet celebrates the victory of Upper Egypt, led by King Narmer, over Lower Egypt, in a battle that united the country. Narmer is depicted holding an enemy by the hair, ready to finish him off. On the other side, he is seen reviewing the beheaded bodies of his foes.

Fig. 598 *King Khafre*, Giza, Egypt, c. 2530 BCE. Diorite, height, 66 ¹/₈ in. Egyptian Museum, Cairo. Araldo de Luca/Index Ricerca Iconografica.

Narmer's pose is typical of Egyptian art. The lower body is in profile, his torso and shoulders full front, his head in profile again, though a single cyc is portrayed frontally.

The rigorous geometry governing Egyptian representation is apparent in the statue of Khafre (Fig. 598). Khafre's frontal pose is almost as rigid as the throne upon which he sits. It is as if he had been composed as a block of right angles. If it was the king's face that made his statue recognizable, it is also true that his official likeness might change several times during his reign, suggesting that the purpose of the royal sculpture was not just portraiture but also the creation of the ideal image of kingship.

Earliest Vedic Hymns written in India **1500 BCE**

1766 BCE Bronze Age city-states in China

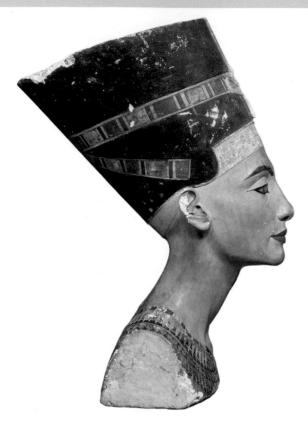

Fig. 599 *Queen Nefertiti,* Tell el Amarna, c. 1365 BCE. Painted limestone, height, 19 % in. Agyptisches Museum, Berlin. Bildarchiv Preussischer Kulturbesitz/Art Resource, New York

For a brief period, in the fourteenth century BCE, under the rule of the Emperor Akhenaten, the conventions of Egyptian art and culture were transformed. Akhenaten declared an end to traditional Egyptian religious practices, relaxing especially the longstanding preoccupation with the ka, and introducing a form of monotheism (the worship of a single god) into polytheistic Egypt. The sun god, manifested as a radiant sun disc-the Aten-embodied all the characterisitcs of the other Egyptian deities, and thus made them superfluous. Though the traditional standardized proportions of the human body were only slightly modified, artists seemed more intent on depicting special features of the human body-hands and fingers, the details of a face. Nowhere is this attention to detail more evident than in the famous bust of Akhenaten's

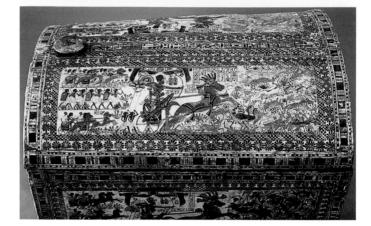

Fig. 600 Painted chest, tomb of Tutankhamen, Thebes, c. 1350 BCE. Length, approx. 20 in. Egyptian Museum, Cairo. Boltin Picture Library.

queen, Nefertiti (Fig. 599). Both the graceful curve of her neck and her almost completely relaxed look make for what seems to be a stunningly naturalistic piece of work, though it remains impossible to say if this is a true likeness or an idealized portrait.

The reason we know this style so well today is because it has survived in the only unplundered Egyptian tomb whose contents have come down to us. The tomb of Akhenaten's successor, Tutankhamen, the famous "King Tut," was discovered at Thebes in 1922. Among the thousands of artifacts recovered at that time was the tomb of King Tut himself. which consists of three coffins, one set within the other. The innermost coffin is made of 243 pounds of beaten gold inlaid in lapis lazuli, turquoise, and carnelian. The scene of the young king hunting, on a painted chest from the tomb (Fig. 600), shows Tutankhamen as larger than life in traditional heirarchical scale. Nevertheless, the sense of movement and action, and the abandonment of the traditional ground line in the wild chaos of the animals on the right, shows the influence of the freer Akhenaten style.

The Akhenaten style did not survive long in Egypt. Soon after King Tut's death, traditional religious practices were reestablished,

Aryan peoples migrate to northwest India 1500 BCE

1750 BCE Emperor Hammurabi's code of law imposed in Mesopotamia

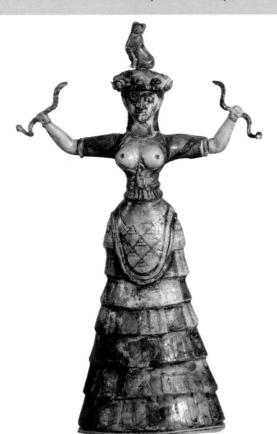

Fig. 601 Snake Goddess or Priestess, c. 1600 BCE. Faience, height, 11 ⁵/₈ in. Archeological Museum, Heraklion, Crete. Erich Lessing/Art Resource, New York. 1500 BCE Rise of Olmec civilization on Gulf Coast of Mexico

and a revival of the old style of art, with its unrelentingly stiff formality, quickly followed. For the next 1,000 years, the Egyptians maintained the conventions and formulas that their forefathers had initiated in the first half of the third millennium BCE.

1500 BCE

AEGEAN CIVILIZATIONS

The Egyptians had significant contact with other civilizations in the eastern Mediterranean, particularly with the Minoan civilization on the island of Crete and with Mycenae on the Greek Peloponnesus, the southern peninsula of Greece. The origin of the Minoans is unclear-they may have arrived on the island as early as 6000 BCE-but their culture reached its peak between 1600 and 1400 BCE. Female figurines representing a snake goddess or priestess occur in several different forms in Minoan culture. As she appears here (Fig. 601), her bare breasts perhaps indicate female fecundity, while the snakes she carries might be associated with male fertility. Nothing like her has been discovered in any other culture.

The so-called "*Toreador*" fresco (Fig. 602), from the Minoan palace at Knossos, does not actually depict a bullfight, as its title suggests.

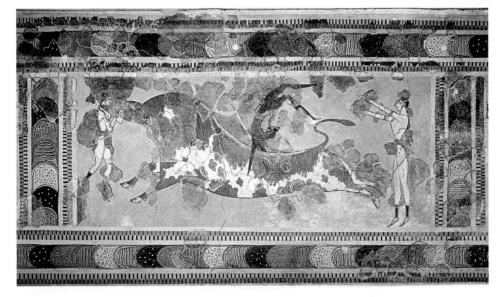

Fig. 602

The *"Toreador"* fresco, Knossos, Crete, c. 1500 BCE. Height including upper border, approx. 24 1/2 in. Archeological Museum, Iraklion, Crete. Studio Kontoc Photostook. Instead, a youthful acrobat can be seen vaulting over the bull's back as one maiden holds the animal's horns and another waits to catch him (traditionally, as in Egyptian art, women are depicted with light skin, men with a darker complexion). The three almost nude figures appear to be toying with a charging bull in what may be a ritual activity, connected perhaps to a rite of passage, or in what may simply be a sporting event, designed to entertain the royal court.

In Minoan culture, the bull was an animal of sacred significance. Legend has it that the wife of King Minos, after whom the culture takes its name, gave birth to a creature halfhuman and half-bull—the *Minotaur*. Minos had a giant labyrinth, or maze, constructed to house the creature, to whom Athenian youths and maidens were sacrificed until it was killed by the hero Theseus. The legend of the labyrinth probably arose in response to the intricate design of the palaces built for the Minoan kings.

It is unclear why Minoan culture abruptly ended in approximately 1450 BCE. Great earthquakes and volcanic eruptions may have destroyed the civilization, or perhaps it fell victim to the warlike Mycenaeans from the mainland, whose culture flourished between 1400 and 1200 BCE. Theirs was a culture dominated by military values. In the The Warrior Vase (Fig. 603) we see Mycenaean soldiers marching to war, perhaps to meet the Dorian invaders who destroyed their civilization soon after 1200 BCE. The Dorian weapons were made of iron and therefore were superior to the softer bronze Mycenaean spears. It is this culture, immortalized by Homer in the Iliad and the Odyssey, that sacked the great Trojan city of Troy. The Mycenaeans built stone fortresses on the hilltops of the Peloponnesus. They buried their dead in so-called beehive tombs, which, dome-shaped, were full of gold and silver, including masks of the royal dead, a burial practice similar to that of the Egyptians.

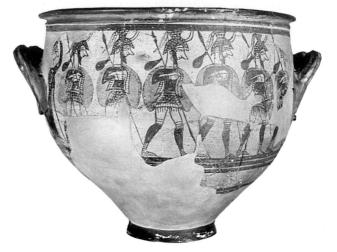

Fig. 603 The Warrior Vase, Mycenae, c. 1200 BCE. Height, approx. 14 in. National Museum, Athens. Scala/Art Resource, New York.

GREEK ART

The rise of the Greek city-state, or *polis*, marks the moment when Western culture begins to celebrate its own human strengths and powers the creative genius of the mind itself—over the power of nature. The Western world's gods now became personified, taking human form and assuming human weaknesses. Though immortal, they were otherwise versions of ourselves, no longer angry beasts or natural phenomena such as the earth, the sun, or the rain.

In about 1200 BCE, just after the fall of Mycenae, the Greek world consisted of various tribes separated by the geographical features of the peninsula, with its deep bays, narrow valleys, and jagged mountains (see the Map of Greece, p. 432). These tribes soon developed into independent and often warring city-states, with their own constitutions, coinage, and armies. We know that in 776 BCE these feuding states declared a truce in order to hold the first Olympic games, a moment so significant that the Greeks later took it as the starting point of their history. Rule of the Hebrew King, David **960–933 BCE**

c. 1000 BCE Agriculture practiced in village communities in American Southwest **c. 800 BCE** Homer writes *Iliad* and *Odyssey* 600 BCE

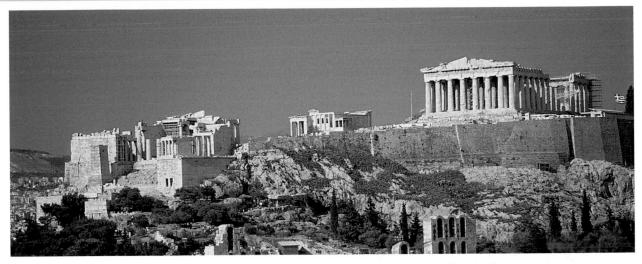

Fig. 604 The Acropolis today, viewed from the southwest, Athens, Greece. Greek National Tourism Organization.

The human figure celebrated in athletic contests is one of the most important subjects of Greek art as well, and the Greeks showed a keen interest in depicting the human form in highly naturalistic detail. By the fifth century BCE, this interest in all aspects of the human condition was reflected throughout Greek culture. The physician Hippocrates systematically studied human disease, and the historian Herodotus, in his account of the Persian Wars, began to chronicle human history. Around 500 BCE in Athens, all free male citizens were included in the political system, and democracy-from demos, meaning "people," and kratia, meaning "power"-was born. It was not quite democracy as we think of it today: Slavery was considered natural, and women were excluded from political life. Nevertheless, the concept of individual freedom was cherished. And by the fourth century BCE, the philosopher Plato had developed theories not only about social and political relations but also about education and aesthetic pleasure.

The values of the Greek city-state were embodied in its temples. The temple was usually situated on an elevated site above the city, and the acropolis, from akros, meaning "top," and polis, "city," was conceived as the center of civic life. The crowning achievement of Greek architecture is the complex of buildings on the Acropolis in Athens (Fig. 604), which was built to replace those destroyed by the Persians in 480 BCE. Construction began in about 450 BCE, under the leadership of the great Athenian statesman, Pericles. The central building of the new complex, designed by Iktinos and Kallikrates, was the Parthenon, dedicated to the city's namesake, Athena Parthenos, the goddess of wisdom. A Doric temple of the grandest scale, it is composed entirely of marble. At its center was an enormous ivory and gold statue of Athena, sculpted by Phidias, who was in charge of all the ornamentation and sculpture for the project. The Athena is long since lost, and we can imagine his achievement only by considering the sculpture on the building's pediment (see Fig. 412) and its friezes, all of which reflect Phidias's style and maybe his design.

Poet Sappho of Lesbos **c. 610–580 BCE**

600 BCE

Confucius in China 551–449 BCE

594 BCE Solon's code of Laws in Athens

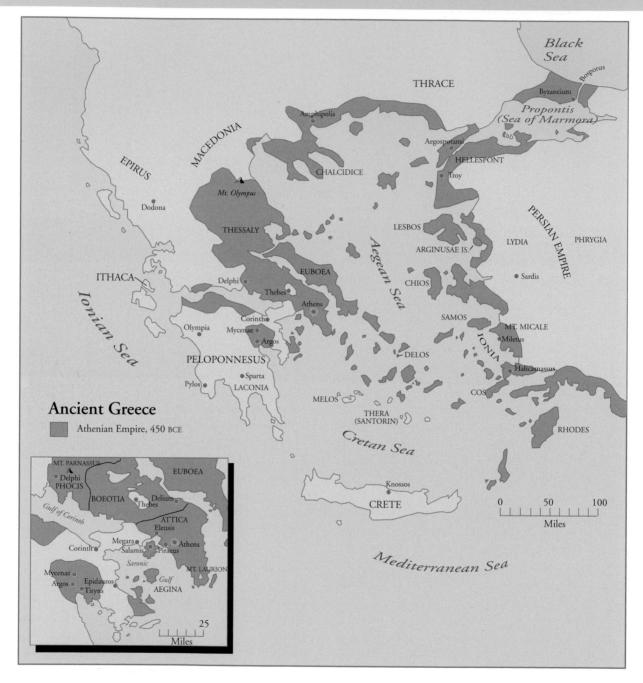

The Phidian style is marked by its naturalness. The human figure often assumes a relaxed, seemingly effortless pose, or it may be caught in the act of movement, athletic or casual. In either case, the precision with which the anatomy has been rendered is remarkable. The relief of *Nike* (Fig. 605), goddess of victory, from the balustrade of the Temple of Nike (see Fig. 495), is a perfect example of the Phidian style. As Nike bends to take off her sandal, the drapery both reveals and conceals the body beneath. Sometimes appearing to be transparent, some-

Iron Age starts in China c. 770 BCE

400 BCE -

5th century Drama of Sophocles, Euripides, Aristophanes. Historical writings of Herodolus, Thucydides

Fig. 605 Nike, from the balustrade of the Temple of Athena Nike, c. 410–407 BCE. Marble, height, 42 in. Acropolis Museum, Athens, Greece. Nimatallah/Art Resource, New York.

times dropping in deep folds and hollows, it contributes importantly to the sense of reality conveyed by the sculpture. It is as if we can see the body literally push forward out of the stone and press against the drapery.

The Greek passion for individualism, reason, and accurate observation of the world continued on even after the disastrous defeat of Athens in the Peloponnesian War in 404 BCE, which led to a great loss of Athenian power. In 338 BCE, the army of Philip, King of Macedon, conquered Greece, and after Philip's death two years later, his son, Alexander the Great, came to power. Because Philip greatly admired Athenian culture, Alexander was educated by the philosopher Aristotle, who persuaded the young king to impose Greek culture throughout his empire. Hellenism, or the culture of Greece, thus came to dominate the Western world. The court sculptor to Alexander the Great was 509 BCE Foundation of Roman Republic

Fig. 606 Apoxyomenos (The Scraper), Roman copy of an original Greek bronze by Lysippos, c. 350–325 BCE. Marble, height, 6 ft. 8 ½ in. Vatican Museums & Galleries, Rome. Scala/Art Resource, New York.

Lysippos, known to us only through later Roman copies of his work. Lysippos challenged the Classical canon of proportion created by Polykleitos (see Fig. 249), creating sculptures with smaller heads and slenderer bodies that lent his figures a sense of greater height. In a Roman copy of a lost original by Lysippos known as the *Apoxyomenos* (Fig. 606), or *The Scraper*, an athlete removes oil and dirt from his body with an instrument called a stirgil. He seems detached from his circumstances, as if recalling his victory, both physically and mentally uncontained by the space in which he stands.

Death of Socrates 399 BCE

Death of Aristotle 322 BCE

336–323 BCE Conquests of Alexander the Great

Fig. 607 Nike of Samothrace, c. 190 BCE. Marble, height, approx. 8 ft. Musée du Louvre, Paris. Musée du Louvre/Art Resource, New York.

In the sculpture of the fourth century BCE, we discover a graceful, even sensuous, beauty marked by *contrapposto* and three-dimensional realism (see Figs. 120 and 411). The depiction of physical beauty becomes an end in itself, and sculpture increasingly seems to be more about the pleasures of seeing than anything else. At the same time, artists strove for an ever greater degree of realism, and in the sculpture of the Hellenistic Age, we find an increasingly animated and dramatic treatment of the figure. The *Nike of Samothrace* (Fig. 607) is a masterpiece of Hellenistic realism. The goddess has been depicted as she alights on the

Fig. 608 The Laocoön Group, Roman copy, perhaps after Agesander, Athenodorus, and Polydorus of Rhodes, 1st century CE. Marble, height, 7 ft. The Vatican Museum, Rome. Scala/Art Resource, New York.

prow of a victorious war galley, and one can almost feel the wind as it buffets her, and the surf spray that has soaked her garment so that it clings revealingly to her torso.

The swirl of line that was once restricted to drapery overwhelms the entire composition of The Laocoön Group (Fig. 608), in which Laocoön, a Trojan priest, and his two sons are overwhelmed by serpents sent by the seagod Poseidon. We are caught in the midst of the Trojan War. The Greeks have sent the Trojans a giant wooden horse as a "gift." Inside it are Greek soldiers, and Laocoön suspects as much. And so Poseidon, who favors the Greeks, has chosen to silence Laocoön forever. So theatrical is the group that to many eyes it verges on melodrama, but its expressive aims are undeniable. The sculptor is no longer content simply to represent the figure realistically; sculpture must convey emotion as well.

Euclid establishes the basic principles of geometry **300 BCE**

500–250 BCE Great age of Etruscan bronze making

Fig. 609 Portrait of a Boy, early 3rd century BCE. Bronze, height, 9 in. Museo Archeologico Nazionale, Florence. Nicolo Orsi Battaglini/Ikona.

ROMAN ART

Although the Romans conquered Greece (in 146 BCE), like Philip of Macedon and Alexander, they regarded Greek culture and art as superior to any other. Thus, like the Hellenistic Empire before it, the Roman Empire possessed a distinctly Greek character. The Romans imported thousands of original Greek artworks and had them copied in even greater numbers. In fact, much of what we know today about Greek art, we know only through Roman copies. The Greek gods were adapted to the Roman religion, Jupiter bearing a strong resemblance to Zeus, Venus to Aphrodite, and so on. The Romans used the Greek architectural orders in their own buildings and temples, preferring especially the highly decorative Corinthian order. Many, if not most, of Rome's artists were of Greek extraction, though they were "Romanized" to the point of being indistinguishable from the Romans themselves.

Roman art derives, nevertheless, from at least one other source. Around 750 BCE, at

Archimedes lays the foundations of calculus **260 BCE**

about the same time the Greeks first colonized the southern end of the Italian peninsula, the Etruscans, whose language has no relation to any known tongue, and whose origin is somewhat mysterious, established a vital set of city-states in the area between present-day Florence and Rome. Little remains of the Etruscan cities, which were destroyed and rebuilt by Roman armies in the second and third centuries BCE, and we know the Etruscans' culture largely through their sometimes richly decorated tombs. At Veii, just north of Rome, the Etruscans established a sculptural center that gave them a reputation as the finest metalworkers of the age. They traded widely, and from the sixth century on, a vast array of bronze objects, from statues to hand mirrors, were made for export. Etruscan art was influenced by the Greeks, as the lifesize head of bronze statue (Fig. 609), with its almost melancholy air, makes clear.

265 BCE-

The Romans traced their ancestry to the Trojan prince Aeneas, who escaped after the sack of Troy and who appears in Homer's *Iliad*. The city of Rome itself was founded early in Etruscan times—in 753 BCE, the Romans believed—by Romulus and Remus, twins nurtured by a *She-Wolf* (Fig. 610). Though Romulus and

Fig. 610 She-Wolf, c. 500 BCE. Brunze, height, 33 1/2 In. Museo Capitolino, Rome. Erich Lessing/Art Resource. New York.

265 BCE Roman Republic rules all of Italy

Fig. 611 Augustus of Primaporta, c. 20 BCE. Marble, height, 6 ft. 8 in. Vatican Museums & Galleries, Rome. SuperStock, Inc.

Remus are Renaissance additions to the original Etruscan bronze, the image served as the totem of the city of Rome from the day on which a statue of a she-wolf, possibly this very one, was dedicated on the Capitoline Hill in Rome in 296 BCE. The she-wolf reminded the Romans of the fiercely protective loyalty and power of their motherland.

Beginning in the fifth century BCE, Rome dedicated itself to conquest and created an empire that included all areas surrounding the Mediterranean and that stretched as far north as present-day England (see the map of the Roman Empire p. 438). By the time the Romans conquered Greece, their interest in

436 Part 5 *The Visual Record*

Rome rules entire Mediterranean, after defeat of Carthage **146 BCE**

> 44–14 BCE End of Roman Republic, rule of Augustus

 Fig. 612 Marcus Agrippa with Imperial Family (south frieze), detail of the Ara Pacis, 13–9 cE.
 Marble, height, 5 ft. 3 in. Museum of the Ara Pacis, Rome. Scala/Art Resource, New York.

the accurate portrayal of human features was long established, and Hellenistic art only supported this tendency. A great ruler was fully capable of idealizing himself as a near-deity, as is evident in the Augustus of Primaporta (Fig. 611), so known because it was discovered at the home of his wife, Livia, at Primaporta, on the outskirts of Rome. The pose is directly indebted to the Doryphoros (Spear Bearer) of Polykleitos (see Fig. 249). The extended arm points toward an unknown, but presumably greater, future. The military garb announces his role as commander-in-chief. The small Cupid riding a dolphin at his feet, makes claim to Augustus's divine descent from Venus. But by and large, the Romans preferred to depict the human figure with absolute realism. The Ara Pacis (Fig. 612), or "Altar of Peace," was built by the Emperor Augustus to celebrate the peace he had brought to Rome. It depicts three generations of his actual family. In this section, Augustus's grandson, Gaius Caesar, stands between Augustus's wife, Livia, and his son-in-law, Marcus Agrippa, the little boy looking up reverentially at his grandmother. Such naturalism is prototypically Roman.

Romans destroy the Hebrew Temple in Jerusalem **70 CE**

30 CE Crucifixion of Jesus

CE

180 CE Pax Romana begins to break down 200 CE -

Fig. 613 The Arch of Constantine, Rome, 313 CE. Marble, height, 70 ft.; width, 85 ft. 8 in. Scala/Art Resource, New York.

The perfection of the arch and dome and the development of structural concrete were, as we have seen in Part IV, the Romans' major architectural contributions. But they were extraordinary monument builders. The largest of their monumental arches was built by the Emperor Constantine the Great (Fig. 613) to commemorate his assumption of imperial power in 312 after defeating his rival Maxentius at the Battle of the Milvian Bridge, the entrance to Rome. Many other triumphal arches still stand across Europe. Another remarkable symbol of Roman power is the Column of Trajan (Fig. 614). Encircled by a spiraling band of relief sculpture 50 inches high and, if it were unwound and stretched out, 625 feet long, the column details the Emperor Trajan's two successful campaigns in present-day Hungary and Romania in the first century BCE. The 150 separate episodes celebrate not only military victories, but Rome's civilizing mission as well.

As the empire solidified its strength under the Pax Romana—150 years of peace initiated by the Emperor Augustus in 27 BCE—a succession of emperors celebrated the glory of the empire in a variety of elaborate public works and monuments, including the Colosseum and the Pantheon (see Figs. 499 and 502). By the first century CE, Rome's population approached one

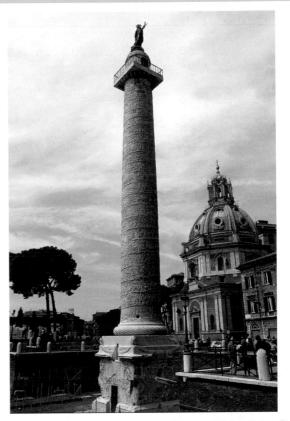

Fig. 614 Attributed to Apollodorus, Column of Trajan, 313 CE, Rome. Marble, height, originally 128 ft.; length of frieze, approx. 625 ft. Robert Frerck/Woodfin Camp and Associates.

million, with most of its inhabitants living in apartment buildings (an archival record indicates that, at this time, there were only 1,797 private homes in the city). They congregated daily at the Forum, a site originally developed by the Etruscans as a marketplace, but in a plan developed by Julius Caesar and implemented by Augustus, a civic center symbolic of Roman power and grandeur, paved in marble and dominated by colonnaded public spaces, temples, basilicas, and state buildings such as the courts, the archives, and the Curia, or senate house.

Though Rome became extraordinarily wealthy, the empire began to falter after the death of the emperor Marcus Aurelius in 180 CE. Invasions of Germanic tribes from the north, Berbers from the south, and Persians from the east wreaked havoc upon the Cyrus the Great establishes the Iranian Empire in Persia 539 BCE

600 BCE

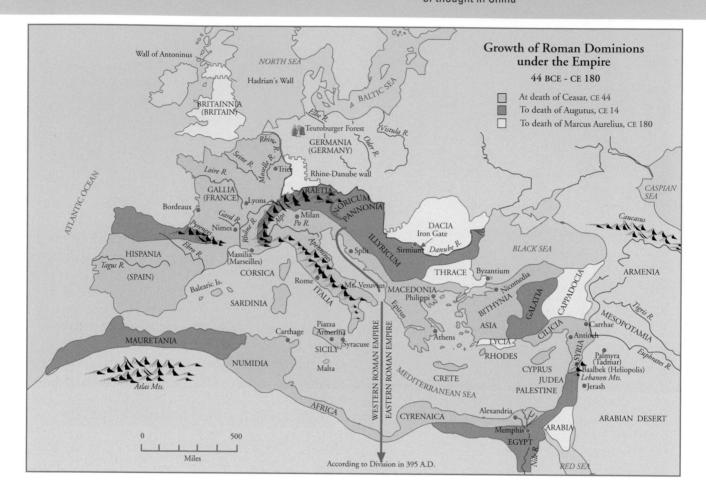

Empire's economic, administrative, and military structure. By the time the Emperor Constantine decided to move the capital to Byzantium in 323 CE—renaming it Constantinople, today's Istanbul—the empire was hopelessly divided, and the establishment of the new capital only underscored the division.

DEVELOPMENTS IN ASIA

Meanwhile, in Asia, the early artistic traditions developed during the Shang dynasty in China, particularly the casting of bronze (see Fig. 593), were continued. Even as the Roman Empire began to disintegrate, bronze casting in China reached new heights of subtlety and elegance. An example is *Flying Horse Poised on One Leg on a Swallow* (Fig. 615). It is perfectly balanced—almost impossibly so, defying gravity itself—so that it seems to have stolen the ability to fly from the bird beneath its hoof.

Though the traditions of bronze casting remained strong, that part of the world developed no less turbulently than the West. By the sixth century BCE, the Chinese empire had begun to dissolve into a number of warring feudal factions. The resulting political and social chaos brought with it a powerful upsurge of philosophical and intellectual thought that focused on how to remedy the declining social order. In the context of this debate, Confucius, who died in 479 BCE, 10 years before the birth of Socrates, introduced the idea that high office should be obtained by merit, not birth, and that all social institutions, from the state to the family, should

The crossbow is invented in China **250 BCE**

300 BCE Cast iron is produced in China

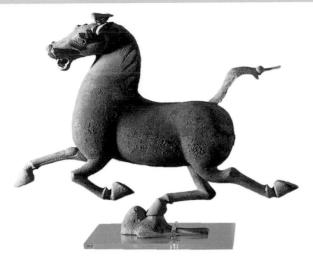

Fig. 615 Flying Horse Poised on One Leg on a Swallow, from a tomb at Wuwei, Kansu, Late Han dynasty, 2nd century CE. Bronze, height, 13 ½ in.; length, 17 ¾ in. The Exhibition of the Archeological Finds of the People's Republic of China. Erich Lessing/Art Resource, New York.

Fig. 616 *Ritual Disc with Dragon Motif (Pi)*, Eastern Zhou Dynasty, Warring States period, 4th–3rd century BCE. Jade, diameter, 6 ½ in. The Nelson-Atkins Museum of Art, Kansas City, Missouri. Purchase: Nelson Trust, 33–81.

250 BCE

base their authority on loyalty and respect, not sheer might. At the same time, the Taoists developed a philosophy based on the universal principle, or Tao—the achievement by the individual of a pure harmony with nature (for an image embodying the Tao in a later Chinese painting, see Fig. 6).

The jade Pi, or disc (Fig. 616), illustrated here symbolizes the desire of the Chinese to unify their country. Made sometime between the sixth and third centuries BCE, the disc is decorated with a dragon and a phoenix, which are today commonly found in the context of the Chinese wedding ceremony, hanging together as a pair over the table at the wedding feast. The tradition goes back to a time when the ancient peoples of China were united in an historic alliance between those from western China, who worshiped the dragon, and those from eastern China, who worshiped the phoenix. This particular disc was found in a tomb, probably placed there because the Chinese believed that jade preserved the body from decay.

Peace lasted in China from 221 BCE, when Shih Huang Ti, the first emperor of Ch'-in, whose tomb was discussed in Chapter 14 (see Fig. 416), united the country under one rule. This lasted until the end of the Han dynasty in 220 CE, when China once again endured a 400year period of disorder and instability. The Han restored Confucianism to prominence. We know through surviving literary descriptions that the Han emperors built lavish palaces, richly decorated with wall paintings. In one of the few imperial Han tombs to have been discovered, that of the Emperor Wu Ti's brother and his wife, both bodies were dressed in suits made of more than 2,000 jade tablets sewn together with gold wire. The prosperity of the Han dynasty was due largely to the expansion of trade, particularly the export of silk. The silk-trading routes reached all the way to Imperial Rome.

The quality of Han silk is evident in a silk banner from the tomb of the wife of the Marquis of Dai discovered on the outskirts of Kushite Empire of Africa reaches its pinnacle **c. 250 BCE** Ch'in Emperor unites all of China **221 BCE**

250 BCE

c. 256–206 BCE Original Great Wall of China built

Fig. 617 Lady of Dai with Attendants, Han dynasty, after 168 BCE. Painted silk banner from the tomb of Dai Hou Fu-ren, Mawangdui Tomb I, Changsha, Hunan, China. Silk, height, 6 ft. 8 ¹/₄ in. Hunan Museum, Changsha, China. Wang Lu/ChinaStock Photo Library.

present-day Changsa in Hunan (Fig. 617). Painted with scenes representing on each of three levels the underworld, the earthly realm, and the heavens, it represents the Han conception of the cosmos. Long, sinuous, tendril-like lines describing dragons' tails, coiling serpents, longtailed birds, and flowing draperies unify the three realms. In right corner of the heavenly realm, above the crossbar of the T, is an image of the sun containing a crow, and in the other corner is a crescent moon supporting a toad. The deceased noblewoman herself stands on the white platform in the middle region of the banner. Three attendants behind her and two figures kneel before her bearing gifts. On the white platform of the bottom realm, bronze vessels contain food and wine for the deceased.

Elsewhere in Asia, the philosophy of Buddha, "The Enlightened One," was taking hold. Born as Siddhartha Gautama around 537 BCE, Buddha achieved nirvana-the release from worldly desires that ends the cycle of death and reincarnation and begins a state of permanent bliss. He preached a message of self-denial and meditation across northern India, attracting converts from all levels of Indian society. The religion gained strength for centuries after Buddha's death and finally became institutionalized in India under the rule of Asoka (273–232 BCE). Deeply saddened by the horrors of war, and believing that his power rested ultimately in religious virtue and not military force, Asoka became a great patron of the Buddhist monks. erecting some 84,000 shrines, called stupas. throughout India, all elaborately decorated with sculpture and painting. The stupa is literally a burial mound, dating from prehistoric times, but by the time the Great Stupa at Sanchi was made (Fig. 618)—it is the earliest surviving

Fig. 618 *The Great Stupa*, Sanchi, India. Begun 3rd century BCE, with later additions. Brick and rubble, originally faced with painted and gilded stucco, with rails of white stone. National Museum of New Delhi. Photo: Richard Todd.

Fig. 619 Colossal Buddha, Cave 20, Yungang, Shanxi, late 5th century. Stone, height, 45 ft. Corbis, NY. Photo: Wolfgang Kaehler.

example of the form-it had come to house important relics of Buddha himself or the remains of later Buddhist holy persons. This stupa is made of rubble, piled on top of the original shrine, which has been faced with brick to form a hemispherical dome that symbolizes the earth itself. A railing-in this case, made of white stone and clearly visible in this photograph-encircles the sphere. Ceremonial processions moved along the narrow path behind this railing. Pilgrims would circle the stupa in a clockwise direction on another wider path, at ground level, retracing the path of the sun, thus putting themselves in harmony with the cosmos and symbolically walking the Buddhist Path of Life around the World Mountain.

CE

In early Buddhist art, Buddha was never shown in figural form. It was believed to be impossible to represent Buddha, since he had already passed to nirvana. But by the fourth century, during the reign of the Gupta rulers in India, Buddha was commonly represented in human form. Typically his head is oval, framed by a halo. Atop his head is a mound, symbolic of his spiritual wisdom. His demeanor is gentle, reposed, and meditative. His elongated ears refer to his royal origins. And his hands are set in one of several symbolic gestures, called *mudra*. The seated Buddha in Figure 619 employs the Dhyana *mudra*, a gesture of meditation and balance. The lower hand represents the physical world of illusion, the upper nirvana and enlightenment. Together they symbolize the path to enlightenment. The *bodhisattva*—a person of very near total enlightenment who has vowed to help others achieve it—standing next to him employs the Abhaya *mudra*, a gesture of reassurance, blessing, and protection.

All the ancient centers of civilization underwent wars, conquests, and dramatic cultural changes. And all produced great philosophers, great art, and great writing, much of which we still find current and useful today. All were organized around religion, and with the dawn of the Christian era, religion contined to play a central role in defining culture.

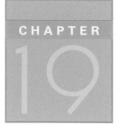

The Christian Era

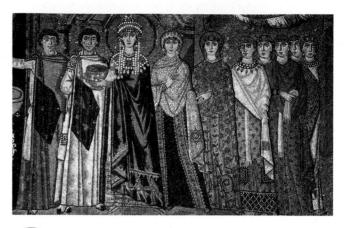

O ur study of the ancient world—from ancient fertility statues, to the Egyptian *ka*, to the rise of Buddhism—shows how powerful religion can be in setting the course of culture, and the advent of Christianity in the Western world makes this abundantly clear. So powerful was the Christian story that even the common calendar changed. From the sixth century on, time was recorded in terms of years "BC" (before Christ) and years "AD" (anno Domini, the year of Our Lord, meaning the year of his birth). Today, usage has changed somewhat—the preferred terms, as we have used them in this text, are BCE (before the common era) and CE (the common era)—but the world's calendar remains Christian.

EARLY CHRISTIAN AND BYZANTINE ART CHRISTIAN ART IN NORTHERN EUROPE ROMANESQUE ART GOTHIC ART

DEVELOPMENTS IN ISLAM AND ASIA

Camels first used for trans-Saharan transport **c. 200** Augustine writes The City of God **426**

400 CE —

c. 300 End of the Olmec civilization in Mexico

EARLY CHRISTIAN AND BYZANTINE ART

Christianity spread through the Roman world at a very rapid pace, in large part due to the missionary zeal of St. Paul. By 250 CE, fully 60 percent of Asia Minor had converted to the religion, and when the Roman Emperor Constantine legalized Christianity in the Edict of Milan in 313 CE, Christian art became imperial art. The classical art of Greece and Rome emphasized the humanity of its figures, their corporeal reality. But the Christian God was not mortal and could not even be comfortably represented in human terms. Though His Son, Jesus, was human enough, the mystery of both Jesus's Virgin Birth and his rising from the dead most interested early Christian believers. The world that the Romans had celebrated on their walls in fresco-a world of still lifes and landscapes—was of little interest to Christians, who were more concerned with the spiritual and the heavenly than with their material surroundings.

Constantine chose to make early Christian places of worship as unlike classical temples as possible. The building type that he preferred was the rectangular **basilica**, which the Romans had used for public buildings, especially courthouses. The original St. Peter's in Rome, constructed c. 333–390 CE but destroyed in the sixteenth century to make way for the present building, was a basilica (see Fig. 512). Equally important for the future of Christian religious architecture was Santa Costanza (Fig. 620), the small mausoleum built c. 354 CE for the tomb of Constantine's daughter, Constantia. Circular in shape and topped with a dome supported by a barrel vault, the building defines the points of the traditional Greek cross, which has four equal arms. Surrounding the circular space is a passageway known as an **ambulatory** that was used for ceremonial processions.

The circular form of Santa Costanza appcars often in later Byzantine architecture. By the year 500, most of the western empire, traditionally Catholic, had been overrun by barbarian forces from the north. When the Emperor Justinian assumed the throne in Con stantinople in 527, he dreamed of restoring the lost empire. His armies quickly recaptured the Mediterranean world, and he began a massive program of public works. At Ravenna, Italy, at one time the imperial capital, Justinian built San Vitale (Fig. 621), a new church modeled on the churches of Constantinople. Although the exterior is octagonal, the interior

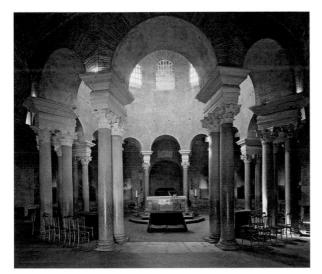

Fig. 620 Santa Costanza, Rome, c. 354 CE. Interior view. Scala/Art Resource, New York.

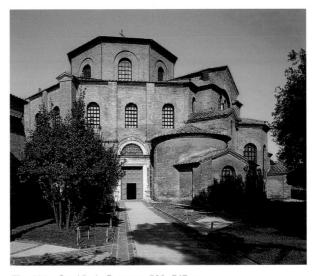

Fig. 621 San Vitale, Ravenna, 526–547 CE. Exterior view. Canali Photobank

Last Roman emperor dethroned **476**

400 CE

c. 400–500 Germanic tribes invade Rome

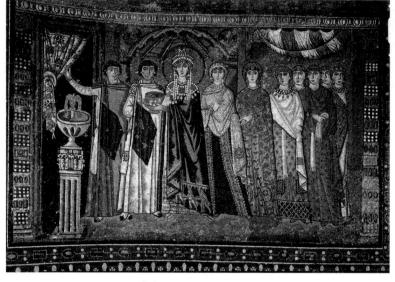

Fig. 622 Theodora and Her Attendants, c. 547. Mosaic, sidewall of the apse, San Vitale. Canali Photobank.

space is essentially circular, like Santa Costanza before it. Only in the altar and the apse, which lie to the right of the central domed area in the floor plan, is there any reference to the basilica structure that dominates western church architecture. Considering that Sant' Apollinare was built at virtually the same time and in virtually the same place, there is some reason to believe that San Vitale was conceived as a political and religious statement, an attempt to persuade the people of the Italian peninsula to give up their Catholic ways and to adopt the Orthodox point of view—that is, to reject the leadership of the Church by the pope.

Sant' Apollinare and San Vitale share one important feature. The facades of both are very plain, more or less unadorned local brick. Inside, however, both churches are elaborately decorated with marble and glittering mosaics. At St. Vitale two elaborate **mosaics**—small stones or pieces of tile arranged in a pattern face each other on the side walls of the apse, one depicting Theodora, the wife of Justinian (Fig. 622), and the other Justinian himself (Fig. 623). Theodora had at one time been a

Fig. 623 San Vitale, interior view, looking into the apse at *Justinian and His Attendants*, c. 547. Canali Photobank.

circus performer, but she became one of the emperor's most trusted advisors, sharing with him a vision of a Christian Roman Empire. In the mosaic, she carries a golden cup of wine, and Justinian, on the opposite wall, carries a bowl containing bread. Together they are bringing to the Church an offering of bread and wine for the celebration of the Eucharist. The haloed Justinian is to be identified with Christ, surrounded as he is by 12 advisors, like the 12 Apostles. And the haloed Theodora, with the three Magi bearing gifts to the Virgin and newborn Christ embroidered on the hem of her skirt, is to be understood as a figure for Mary. In this image, Church and state become one and the same.

These mosaics bear no relation to the naturalism that dominated Greek and Roman culture. Here, the human figures are depicted wearing long robes that hide the musculature and cause a loss of individual identity. Although each face has unique features—some of Justinian's attendants, for example, are bearded, while Founding of Benedictine Order **529**

529 Justinian's law code, the *Corpus Juris Civilis*

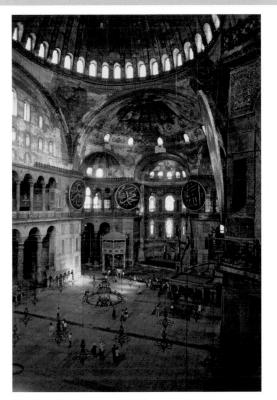

Fig. 624 Anthemius of Tralles and Isidorus of Miletus, Hagia Sophia, Istanbul, 532–537. Interior view. Photo: Walter B. Denny

others are not, and the hairstyles vary—all have identical wide-open eyes, curved brows, and long noses. The feet of the figures turn outward, as if to flatten the space in which they stand. They are disproportionately long and thin, a fact that lends them a heavenly lightness. And they are motionless, standing before us without gesture, as if eternally still. The Greek ideal of sculpture in the round, with its sense of the body caught in an intensely personal, even private moment—Nike taking off her sandal, for instance, or Laocoön caught in the intensity of his torment—is gone. All sense of drama has been removed from the idea of representation.

Mosaics are made of small pieces of stone called **tesserae**, from the Greek word *tesseres*, meaning "square." In ancient Rome, they were a favorite decorative element, used because of their durability, especially to embellish villa floors. But the Romans rarely used mosaic on

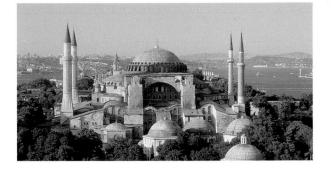

550 CE-

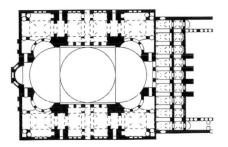

Fig. 625 Anthemius of Tralles and Isidorus of Miletus, Hagia Sophia, Istanbul, and plan, 532–537. Photo © Achim Bednorz, Koln.

their walls, where they preferred the more refined and naturalistic effects that were possible with fresco. For no matter how skilled the mosaic artist, the naturalism of the original drawing would inevitably be lost when the small stones were set in cement.

The Byzantine mosaic artists, however, had little interest in naturalism. Their intention was to create a symbolic, mystical art, something for which the mosaic medium was perfectly suited. Gold *tesserae* were made by sandwiching gold leaf between two small squares of glass, and polished glass was also used. By setting the *tesserae* unevenly, at slight angles, a shimmering and transcendent effect was realized, which was heightened by the light from the church's windows.

Justinian attached enormous importance to architecture, believing that nothing better served to underscore the power of the emperor. The church of Hagia Sophia, mcaning "Holy Wisdom," was his imperial place of worship in Constantinople (Figs. 624 and 625). The huge Angles, Saxons and Jutes invade England **c. 450**

400 CE-

Death of St. Patrick in Ireland **461**

interior, crowned by a dome, is reminiscent of the circular, central plan of Ravenna's San Vitale, but this dome is abutted at either end by half-domes that extend the central core of the church along a longitudinal axis reminiscent of the basilica, with the apse extending in another smaller half-dome out one end of the axis. These half-domes culminate in arches that are repeated on the two sides of the dome as well. The architectural scheme is, in fact, relatively simplea dome supported by four pendentives, the curved, inverted triangular shapes that rise up to the rim of the dome between the four arches themselves. This dome-on-pendentive design was so enthusiastically received that it became the standard for Byzantine church design.

Many of the original mosaics that decorated Hagia Sofia, Justinian's magnificent church in Constantinople, were later destroyed or covered over. During the eighth and ninth centuries, Iconoclasts, meaning "image-breakers," who believed literally in the Bible's commandment against the worship of "graven" images, destroyed much Byzantine art. Forced to migrate westward, Byzantine artists discovered Hellenistic naturalism and incorporated it into later Byzantine design. The mosaic of Christ from Hagia Sophia (Fig. 626) is representative of that later synthesis.

Though only a few of the original mosaics have been restored, and later mosaics were few in number, the light in the interior is still almost transcendental in feeling, and one can only imagine the heavenly aura when gold and glass reflected the light that entered the nave through the many windows that surround it. In Justinian's own words: "The sun's light and its shining rays fill the temple. One would say that the space is not lit by the sun without, but that the source of light is to be found within, such is the abundance of light. . . . The scintillations of the light forbid the spectator's gaze to linger on the details; each one attracts the eye and leads it on to the next. The circular motion of one's

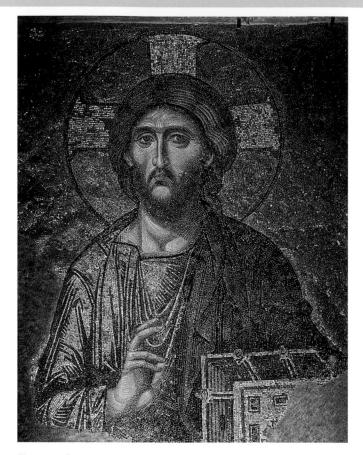

Fig. 626 Christ, from Deësis mosaic, 13th century. Hagia Sophia, Istanbul. Erich Lessing/Art Resource, New York.

gaze reproduces itself to infinity. . . . The spirit rises toward God and floats in the air."

Justinian's reign marked the apex of the early Christian and Byzantine era. By the seventh century, barbarian invaders had taken control of the western empire, and the new Muslim empire had begun to expand to the east. Reduced in area to the Balkans and Greece, the Byzantine empire nevertheless held on until 1453 when the Turks finally captured Constantinople and renamed it Istanbul, converting Hagia Sophia into a mosque. Visigoths in Spain adopt Western Christianity 589

600 CE

597 St. Augustine in England

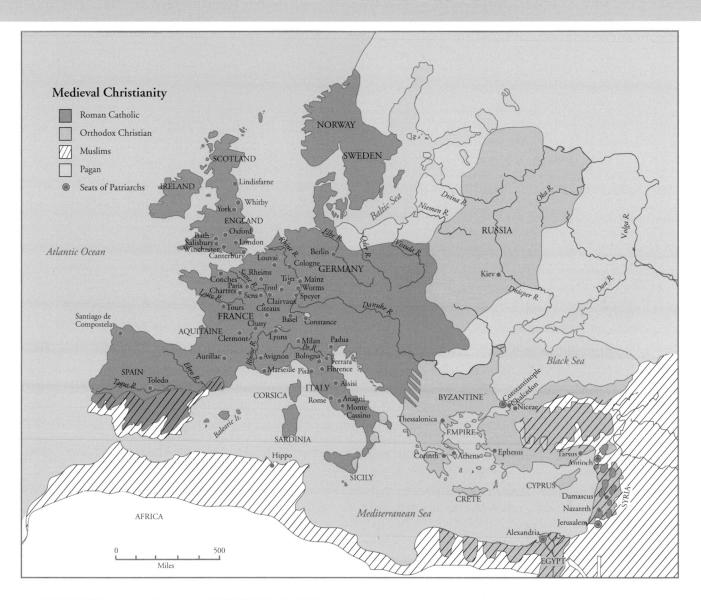

CHRISTIAN ART IN NORTHERN EUROPE

Until the year 1000, the center of Western civilization was located in the Middle East, at Constantinople. In Europe, tribal groups with localized power held sway: the Lombards in what is now Italy, the Franks and the Burgundians in regions of France, and the Angles and Saxons in England. Though it possessed no real political power, the Papacy in Rome had begun to work hard to convert the pagan tribes and to reassert the authority of the Church (see the map of Mcdieval Christianity above). As early as 496, the leader of the Franks, Clovis, was baptized into the Church. Even earlier (c. 430), St. Patrick had undertaken an evangelical mission to Ireland, establishing monasteries and quickly converting the native Celts. These new monasteries were designed to serve missionary as well as educational functions. At a time when only priests and monks could read and write, the sacred texts they produced came to reflect native Celtic designs. These designs are elaborately decorative, highly abstract, and contain no naturalistic Slave trade between sub-Saharan Africa and Mediterranean begins

7th century Anglo-Saxon epic Beowulf is composed

c. 600

600

633–725 Expansion of Islam

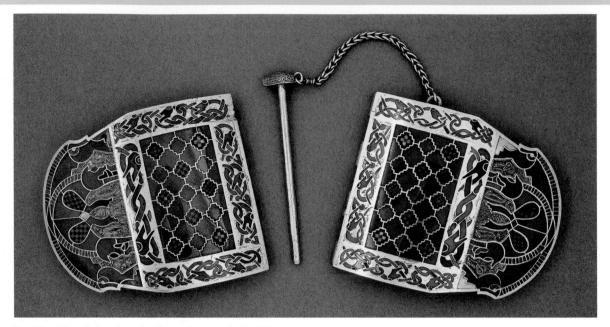

Fig. 627 Hinged clasp from the Sutton Hoo burial ship, 7th century. Gold with garnets, mosaic, glass, and filigree. British Museum, London. © The Trustees of the British Museum.

representation. Thus, Christian art fused with the native traditions, which employed the socalled *animal style*. Some of the best examples of this animal style, such as this hinged clasp (Fig. 627), have been found at Sutton Hoo, north of present-day London, in the grave of an unknown seventh-century East Anglian king. At the round end of each side of the hinge are animal forms, and the entire clasp is covered with intricate traceries of lines and bands.

In 597, Gregory the Great, the first monk to become pope, sent an emissary, later known as Saint Augustine of Canterbury, on a mission to convert the Anglo-Saxons. This mission brought Roman religious and artistic traditions into direct contact with Celtic art, and slowly but surely, Roman culture began to dominate the Celtic-Germanic world.

When Charlemagne (Charles, or Carolus, the Great) assumed leadership of the Franks in 771, this process of Romanization was assured. At the request of the Pope, Charlemagne conquered the Lombards, becoming their King, and on Christmas Day 800, he was crowned Holy Roman Emperor by Pope Leo III at St. Peter's Basilica in Rome. The fusion of Germanic and Mediterranean styles that reflected this new alliance between Church and state is known as **Carolingian art**, a term referring to the art produced during the reign of Charlemagne and his immediate successors.

The transformation in style that Charlemagne effected is evident if we compare the work of an artist trained in the linear Celtic tradition to one created during Charlemagne's era. In the former (Fig. 628), copied from an earlier Italian original, the image is flat, the figure has not been modeled, and the perspective is completely askew. It is pattern and the animal style—that really interests the artist, not accurate representation. But Charlemagne was intent on restoring the glories of Roman civilization. He actively collected and had copied the oldest surviving Cluny monastery founded **910**

Rise of Inca Empire in South America **c. 1000**

1000

c. 800–1000 England and Europe invaded by Vikings, Magyars, and Muslims 980s Russia converted to Christianity

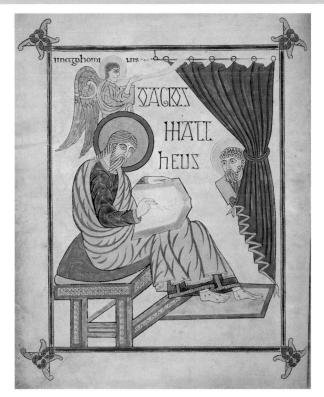

Fig. 628 St. Matthew from the Lindisfarne Gospels, c. 700.
 Approx. 11 × 9 in. British Library, London.
 By permission of the British Library.

texts of the classical Latin authors. He created schools in monasteries and cathedrals across Europe in which classical Latin was the accepted language. A new script, with Roman capitals and new lowercase letters, the basis of modern type, was introduced. A second depiction of St. Matthew (Fig. 629), executed 100 years after the one on the left demonstrates the impact of Roman realism on Northern art. Found in Charlemagne's tomb, this illustration looks as if it could have been painted in classical Rome.

ROMANESQUE ART

After the dissolution of the Carolingian state in the ninth and tenth centuries, Europe disintegrated into a large number of small feudal territories. The emperors were replaced by an

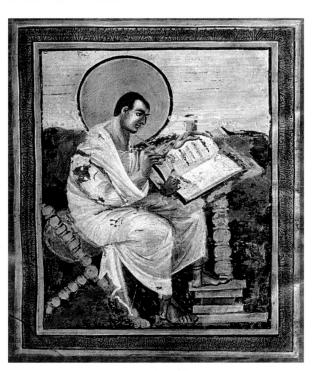

Fig. 629 St. Matthew from the Gospel Book of Charlemagne, c. 800–810. 13 × 10 in. Kunsthistorisches Museum, Vienna.

array of rulers of varying power and prestige who controlled smaller or larger *fiefdoms* (areas of land worked by persons under obligation to the ruler) and whose authority was generally embodied in a chateau or castle surrounded by walls and moats. Despite this atomization of political life, a recognizable style that we have come to call **Romanesque** developed throughout Europe beginning in about 1050. Although details varied from place to place, certain features remained constant for nearly 200 years.

Romanesque architecture is characterized by its easily recognizable geometric masses rectangles, cubes, cylinders, and half-cylinders. The wooden roof that St. Peter's Basilica had utilized was abandoned in favor of fireproof stone and masonry construction, apparently out of bitter experience with the invading nomadic Conquest of England by the Norman French **1066**

1054 Schism between Latin and Greek Christian churches

1071 The fork is introduced to Europe by a Byzantine princess

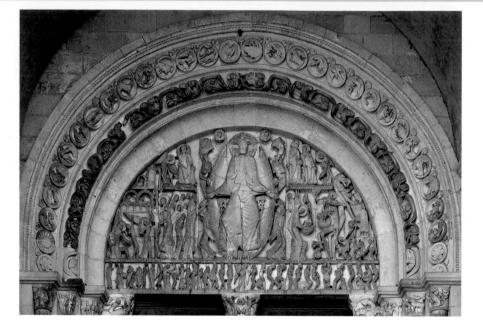

Fig. 630 Gislebertus, *Last Judgment*, tympanum and lintel, west portal, Cathedral, Autun, France, c. 1125–1135. Stone, approx. 12 ft. 6 in. × 22 ft. Photo © Achim Bednorz, Koln.

1000

tribes, who burned many of the churches of Europe in the ninth and tenth centuries. Flat roofs were replaced by vaulted ceilings. By structural necessity, these were supported by massive walls that often lacked windows sufficient to provide adequate lighting. The churches were often built along the roads leading to pilgrimage centers, usually monasteries that housed Christian relics, and they had to be large enough to accommodate large crowds of the faithful. For instance, St. Sernin, in Toulouse, France (see Figs. 503 and 504), was on the pilgrimage route to Santiago de Compostela, in Spain, where the body of St. James was believed to rest.

Thanks in large part to Charlemagne's emphasis on monastic learning, monasteries had flourished ever since the Carolingian period, many of them acting as feudal landlords as well. The largest and most powerful was Cluny, near Maçon, France. Until the building of the new St. Peter's in Rome, the church at Cluny was the largest in the Christian world. It was 521 feet in length, and its nave vaults rose to a height of 100 feet. The height of the nave was made possible by the use of pointed arches. The church was destroyed in the French Revolution, and only part of one transept survives.

With the decline of the Roman Empire, the art of sculpture had largely declined in the West, but in the Romanesque period it began to reemerge. Certainly the idea of educating the masses in the Christian message through architectural sculpture on the facades of the pilgrimage churches contributed to the art's rebirth. The most important sculptural work was usually located on the tympanum of the church, the semicircular arch above the lintel on the main door. It often showed Christ with His Twelve Apostles. Another favorite theme was the Last Judgment, full of depictions of sinners suffering the horrors of hellfire and damnation. To the left of Gislebertus's Last Judgment at Autun, France (Fig. 630), the blessed arrive in heaven, while on the right, the damned are seized by devils. Combining all manner of animal forms, the monstrosity of these creatures recalls the animal style of the Germanic tribes.

Rise of Chivalric poetry written in the vernacular **12th century**

1100 Third Pueblo period in American Southwest 12th and 13th centuries Growth of trade and towns as trading centers 1100

GOTHIC ART

The great era of Gothic art begins in 1137 with the rebuilding of the choir of the abbey church of St. Denis, located just outside Paris. Abbot Suger of St. Denis saw his new church as both the political and the spiritual center of a new France, united under King Louis VI. Although he was familiar with Romanesque architecture, which was then at its height, Suger chose to abandon it in principle. The Romanesque church was difficult to light, because the structural need to support the nave walls from without meant that windows had to be eliminated. Suger envisioned something different. He wanted his church flooded with light as if by the light of Heaven itself. After careful planning, he began work in 1137, painting the old walls of the original abbey, which were nearly 300 years old, with gold and precious colors. Then he added a new facade with twin towers and a triple portal. Around the back of the ambulatory he added a circular string of chapels, all lit with large stained-glass windows, "by virtue of which," Suger wrote, "the whole would shine with the miraculous and uninterrupted light."

It was this light that proclaimed the new Gothic style. Light, he believed, was the physical and material manifestation of Divine Spirit. Suger wrote: "Marvel not at the gold and the expense but at the craftsmanship of the work. Bright is the noble work; but being nobly bright, the work should brighten the minds, so that they may travel, through the true lights, to the True Light where Crist is the true door." As beautiful as the church might be, it was designed to elevate the soul to the realm of God.

As the Gothic style developed, French craftsmen became increasingly accomplished in working with stained-glass, creating windows such as Chartres Cathedrals's famous Rose Window (see Fig. 230). Important architectural innovations also contributed to this goal. The massive stonework of the Romanesque style was replaced by a light, almost lacy play of thin columns and patterns of ribs

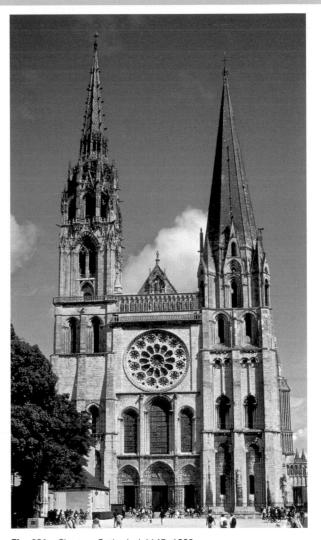

Fig. 631 Chartres Cathedral, 1145–1220. Herve Champollion/Caisse Nationale des Monuments Historique et des Sites, Paris, France.

and windows all pointing upward in a rising crescendo that seems to defy gravity, even as it carries the viewer's gaze toward the heavens. Compare, for instance, the Romanesque south tower of Chartres Cathedral (Fig. 631) to the fully Gothic north tower, which rises high above its starkly symmetrical neighbor. Extremely high naves—the nave at Chartres is 120 feet high, Reims 125, and highest of all is Beauvais at 157 (the equivalent of a 15-story building) made possible by flying buttresses (see Figs. 507 and 508) add to this emphasis on verticality. They contribute a sense of elevation 1100

St. Francis of Assisi 1182–1226 Granting of Magna Carta by King John of England **1215**

1209 Founding of Cambridge University

Fig. 632 Choir of Cologne Cathedral, Germany, 13th and 14th centuries. Caisse Nationale des Monuments Historique. © Svenja-Foto/zefa/Corbis. All rights reserved.

Fig. 633 Florence Cathedral (Santa Maria del Fiore), begun by Arnolfo de Cambio, 1296; dome by Filippo Brunelleschi, 1420–1436. Vanni/Art Resource, New York.

that is at once physical and spiritual, as does the preponderance of pointed rather than rounded arches. In Germany's Cologne Cathedral (Fig. 632), the width of the nave has been narrowed to such a degree that the vaults seem to rise higher than they actually do. The cathedral was not finished until the nineteenth century, though built strictly in accordance with thirteenth-century plans. The stonework is so slender, incorporating so much glass into its walls, that the effect is one of almost total weightlessness.

The Gothic style in Italy is unique. For instance, the exterior of Florence Cathedral (Fig. 633) is hardly Gothic at all. It was, in fact, designed to match the dogmatically Romanesque octagonal Baptistry that stands in front of it. But the interior space is completely Gothic in character. Each side of the nave is flanked by an arcade that opens almost completely into the nave by virtue of four wide pointed arches. Thus nave and arcade become one, and the interior of the cathedral feels more spacious than any other. Nevertheless, rather than the mysterious and transcendental

Islam penetrates sub-Saharan Africa 1000–1100

1100

Fig. 634 Central portal of the west facade of *Reims Cathedral*, c. 1225–1290. The Art Archive/Dagli Orti/Picture Desk, Inc./Kobal Collection.

Fig. 635 Annunciation and Visitation, detail, west portal, Reims Cathedral, c. 1225–1245 Scala/Art Resource, New York.

feelings evoked by most Gothic churches, Florence Cathedral produces a sense of tranquility and of measured, controlled calm.

The Gothic style in architecture inspired an outpouring of sculptural decoration. There was, for one thing, much more room for sculpture on the facade of the Gothic church than had been available on the facade of the Romanesque church. There were now three doors where there had been only one before, and doors were added to the transepts as well. The portal at Reims (Fig. 634), which notably substitutes a stained-glass rose window for the Romanesque tympanum and a pointed for a round arch, is sculpturally much lighter than, for instance, the tympanum at Autun, France (see Fig. 630). The elongated bodies of the Romanesque figures are distributed in a very shallow space. In contrast, the sculpture of the Gothic cathedral is more naturalistic. The proportions of the figures are more natural, and the figures assume more natural poses as well. The space they occupy is deeper—so much so that they appear to be fully realized sculpture in-the-round, freed of the wall behind them. Most important of all, many of the figures seem to assert their own individuality, as if they were actual persons. The generalized "types" of Romanesque sculpture are beginning to disappear. The detail of figures at the bottom of the Reims portal (Fig. 635) suggests that each is engaged in a narrative scene. The angel on the left smiles at the more somber Virgin. The two at the right seem about to step off their pedestals. What is most remarkable is that the space between the figures is bridged by shared emotion, as if feeling can unite them in a common space.

600

First Muslim invasion of India c. 710

1071 Turks capture Jerusalem

644–656 Koran text estabilished 732 Furthest Muslim advances in Western Europe **1096** Beginning of First Crusade

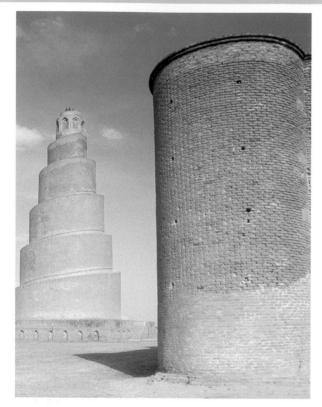

Fig. 636 *Great Mosque* at Samarra, Iraq, 648–852. Photo: Nik Wheeler

DEVELOPMENTS IN ISLAM AND ASIA

In 1096, Pope Urban II declared the First Crusade to liberate Jerusalem from the control by the Muslims. Ever since the Prophet Mohammed had fled Mecca for Medina in 622, the Muslim empire had expanded rapidly. By 640, Mohammed's successors, the Caliphs, had conquered Syria, Palestine, and Iraq. Two years later, they defeated the army of Byzantium at Alexandria, and, by 710, they had captured all of northern Africa and had moved into Spain. They advanced north until 732, when Charles Martel, grandfather of Charlemagne, defeated them at Poitiers, France, But the Caliphs' foothold in Europe remained strong, and they did not leave Spain until 1492. Even the Crusades failed to reduce their power. During the First Crusade, 50,000 men were sent to the Middle East, where they managed to hold Jerusalem and much of Palestine

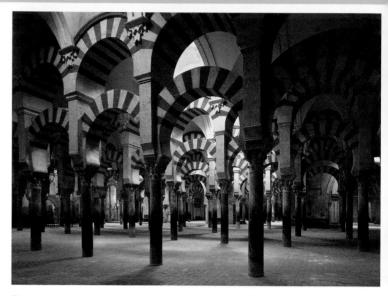

Fig. 637 Interior of the sanctuary of the *Mosque at Córdoba*, Spain, 786–987. Photo © Achim BBednorz, Koln.

for a short while. The Second Crusade, in 1146, failed to regain control, and in 1187, the Muslim warrior Saladin reconquered Jerusalem. Finally, in 1192, Saladin defeated King Richard the Lion-Hearted of England in the Third Crusade.

The major architectural form of Islam was the mosque. Now ruined, the mosque at Samarra was once the largest in the Islamic world. Its single minaret (Fig. 636), or tower, modeled on the ziggurats of ancient Mesopotamia, stood before the entrance, opposite the mihrab on the gibla wall. The *mihrab* is symbolic of the spot in Mohammed's house at Medina where he stood to lead communal prayers. The *gibla* wall faces in the direction of Mecca, the holy site toward which all Muslims turn in prayer. The minaret overlooked a ten-acre wooden roof supported by 464 columns arranged in aisles around an open center court. With its 36 piers and 514 columns, the mosque at Córdoba (Fig. 637) gives us some sense of what Samarra might once have looked like. Between 786 and 987, it was enlarged seven times, showing the versatility of its construction method. All Mus-

Most of Muslim Spain falls to Christian reconquest **Mid-1300s**

1258 Mongols sack and destroy Baghdad

Fig. 638 Manuscript page from the *Our'an*, 9th or 10th century. Six lines of text showing chapter heading from Surat al-Kahf ("The Cave"), Chapter 18. Ink and gold on parchment, 7 ¹/₄ × 10 ¹/₄ in. © The Trustees of the Chester Beatty Library, Dublin.

lim design is characterized by a visual rhythm realized through symmetry and repetition of certain patterns and motifs, a rhythm clearly evident in the interior of the Córdoba mosque.

One of the most important characteristics of Islamic culture is its emphasis on calligraphy. Muslim calligraphers approach the art of handwriting with a attitude different from the way most Westerners are normally used to approaching it. Generally, most people think of handwriting as a form of self-expression, in the way, for instance, that one's signature somehow expresses one's personality. The Muslim calligrapher, on the other hand, is the medium through which Allah expresses himself. The more beautiful the calligraphic script, the more fully Allah's own beauty is realized.

Written from right to left, Arabic script is entirely cursive—that is, "handwritten." As a result, it is eminently susceptible to artful treatment. Consider the page showing the heading for Chapter 18 of the Qur'an, "The Cave" (Fig. 638). The chapter heading is written in richly bordered gold, beginning with a fanciful lcafform that extends into the margin. The first

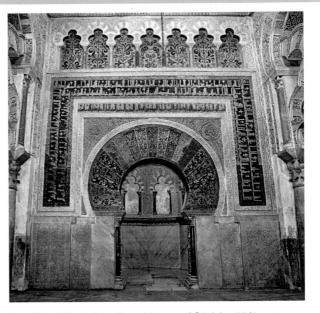

1300

Fig. 639 Mihrab niche, Great Mosque of Córdoba, 11th century. Gold and glass mosaic on marble. © John and Lisda Merrill/Corbis. All rights reserved.

lines of the chapter follow in black. The distinction between chapter heading and text indicates that the former is not part of the "received" message of God, but a conventional name for the verse.

The art of calligraphy was incorporated into Islamic architecture from the beginning. By the mid-ninth century, the walls of palaces and mosques were covered by it, and throughout the following centuries, the decoration became more and more elaborate. The *mihrab* niche at the Great Mosque of Córdoba, Spain, for instance (Fig. 639), which dates from the eleventh century, combines borders of elaborate calligraphy with fanciful organic patterns, intertwining leaf and flower forms known as arabesques.

As early as 1500 BCE, Aryan tribesmen from northern Europe invaded India, bringing a religion that would have as great an impact on the art of India as Islam had on the art of the Middle East. The Vedic traditions of the light-skinned Aryans, written in religious texts called the *Vedas*, allowed for the development of a class system based on racial

Muslim invaders destroy Buddhist and Hindu centers of worship in India **1050–1200**

800

876 The symbol for "zero" is first used in India

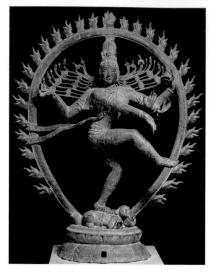

Fig. 640 Shiva Nataraja, (King of Dance). Chola period, Dravidian style. 11th c. From Vellalagaram, Southern India. Bronze. Musée des Arts Asiatiques-Guimet, Paris. Photo: Herve Lewandowski/Reunion des Musées Nationaux/Art Resource, NY.

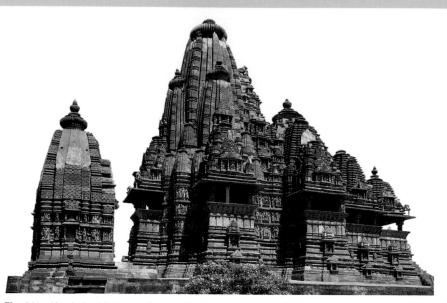

Fig. 641 Kandariya Mahadeva Temple, Khajuraho, India, 10th–11th century. George Holton/Photo Researchers, Inc.

distinctions. Status in one of the four classes—the priests (*Brahmans*), the warriors and rulers (*kshatriyas*), the farmers and merchants (*vaishayas*), and the serfs (*shudras*) was determined by birth, and one could escape one's caste only through reincarnation. Buddhism, which began about 563 BCE, was in many ways a reaction against the Vedic caste system, allowing for salvation by means of individual self-denial and meditation, and it gained many followers.

The Hindu religion, which evolved from the Vedic tradition, has myriad gods, headed by the trinity of Brahma, Vishnu, and Shiva. Brahma is the creator of the cosmos, and contains all things. Pictured here is Shiva Nataraja, or the Dancing Shiva (Fig. 640), whose dance, on the body of a dwarf who symbolizes "becoming," signifies the endlessly cyclic nature of the universe. The fire in the Shiva's left hand represents the destruction of both the physical universe and the ego. The drum in the right hand beats out the rhythms of birth and death. The Hindu Kandariya Mahadeva Temple (Fig. 641) is dedictated to Shiva and symbolically captures the rhythms of Brahma, the cosmos. Completed only a few years before the great Romanesque cathedrals of Europe, the main tower is like a mountain peak, showing the paths one must follow to attain salvation. The entirety is covered by intricate reliefs representing the gods and stories from Hindu tradition.

Beginning in 618, at about the same time that Islam arose in the Middle East, the Tang dynasty reestablished a period of peace and prosperity in China that, except for a brief period of turmoil in the tenth century, would last 660 years. During this period, the pagoda became a favored architectural form in China. A pagoda is a multistoried structure of successfully smaller, repeated stories, with projecting roofs at each story. The design derives from Indian stupas that had grown more and more tower-like by the sixth century CE as well as Han watchtowers. In fact, the pagoda was understood to offer the temple a certain protection. The Wild Goose Pagoda (Fig. 642) was built in 645 for the monk Xuanzang who taught and translated the materials he brought

Kyoto established as the capital of Japan **1023**

1030

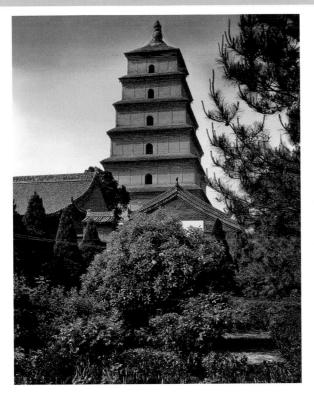

Fig. 642 Great Wild Goose Pagoda at Ci'én Temple, Xi'an, Shanxi, Tang dynasty, first erected 645 cc. Cultural Relics Publishing House, Beijing.

Fig. 643 Guo Xi, *Early Spring*, 1072 (Northern Song dynasty). Hanging scroll, ink, and slight color on silk, length, 60 in. Collection of the National Palace Museum, Taipei, Taiwan, R.O.C.

back with him from a 16-year pilgrimage to India. In its simplicity and symmetry, it represents the essence of Tang architecture.

Since the time of the Song dynasty, which ruled the empire from 960 until it was overrun by Kublai Khan in 1279, the Taoists in China had emphasized the importance of selfexpression, especially through the arts. Poets, calligraphers, and painters were appointed to the most important positions of state. After calligraphy, the Chinese valued landscape painting as the highest form of artistic endeavor. For them, the activity of painting was a search for the absolute truth embodied in nature, a search that was not so much intellectual as intuitive. They sought to understand the *li*, or "principle," upon which the universe is founded, and thus to understand the symbolic meaning and feeling that underlies every natural form. The symbolic meanings of Guo Xi's *Early Spring* (Fig. 643), for instance, have been recorded in a book authored by his son, Guo Si, titled *The Lofty Message of the Forests and Streams*. According to this book, the central peak here symbolizes the Emperor, and its tall pines the gentlemanly ideals of the court. Around the Emperor, the masses assume their natural place, just as around the mountain, the trees and hills fall, like the water itself, in the order and rhythms of nature.

Until the sixth century CE, Japan was a largely agricultural society that practiced Shinto, an indigenous system of belief involving the worship of *kami*, or deities believed to inhabit many different aspects of nature, from trees and rocks to deer and other animals. But

First use of movable type in China **1090**

1040

c. 1040 A Chinese writer describes three forms of gunpowder

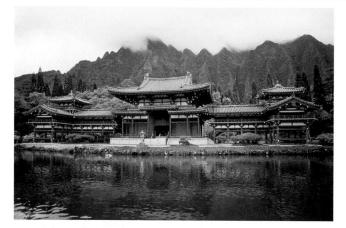

Fig. 644 Byodo-in, Uji, Kyoto prefecture, Heian period, c. 1053 CE. Corbis/Bettmann.

during the Asuka period (552–646 CE), the philopshy, medicine, music, food, and art and architecture of China and Korea were introduced to the culture. Finally, in the Heian period (794–1185 CE), the influence of China was fully absorbed and transformed. An imperial government severed relations with China and, with the support of aristocratic families, established a new capital in Kyoto.

It was a period of enormous splendour and refinement, highlighted by the growing poplarity of Pure Land Buddhism, which held that by merely chanting a mantra to Buddha, paradise, or the Pure Land, could be obtained. One of the most beautiful Pure Land temples is Byodo-in (Fig. 644) in the Uji mountains not far from Kyoto. Often called the Phoenix Hall, not only for the pair of phoenix sculptures on its roof, but for the lightness and airiness of its columns and roofs, which seem to ascend to the Pure Land.

Late in the Heian period, the emperors began to see their authority challenged by regional clans of warriors from outside Heian known as *samurai* (literally, "those who serve"). The absence of tax revenues from the valuable properties and temples controlled by

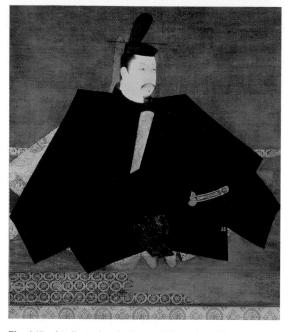

Fig. 645 Attributed to Fujiwara Takanobu, *Minamoto no Yoritomo*, Kamakura period, c. 1150–1200. Ink and color on silk hanging scroll, height, 4 ft. 61/2 in. The Art Archive/Laurie Platt Winfrey. Picture Desk Inc./Kobal Collection

these nobles contributed to a general state of unrest. While the samurai paid lip service to the sovereign, they increasingly exercised complete authority over all aspects of Japanese society.

In 1192, Minamoto no Yoritomo, the greatest samurai of the day, gave himself the title of shogun, general-in-chief of the samurai, inaugurating the first shogunate at Kamakura and what is known as the Kamakura period (1192–1392). Yoritomo is pictured in Figure 645, the sword that is the hallmark of his class protruding from his robe. The painting is a masterful blend of the realism that comes to define the artistic production of the Kamakura period and a powerful compositional abstraction. His face, with its determined eyes, is absolutely realistic, while his robe is a flat geometry of black angles without detail. Almost pyramidal in form, the figure of Yoritomo is above all a symbol of the authority and self-assuredness that defined Japanese culture for years to come.

The Renaissance Through the Baroque

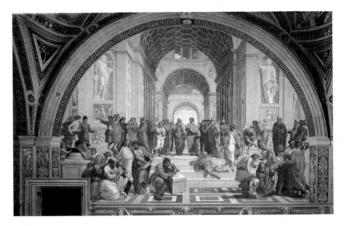

THE EARLY RENAISSANCE THE HIGH RENAISSANCE ART IN CHINA AND JAPAN PRE-COLUMBIAN ART IN MEXICO MANNERISM THE BAROQUE Just when the Gothic era ended and the Renaissance began is by no means certain. In Europe, toward the end of the thirteenth century, a new kind of art began to appear, at first in the South, and somewhat later in the North. By the beginning of the fifteenth century, this new era, marked by a revival of interest in arts and sciences that had been lost since antiquity, was firmly established. We have come to call this revival the **Renaissance**, meaning "rebirth." English defeat French in Battle of Agincourt **1415**

1400

Beginning of Age of Exploration **1420**

early 15th century Gunpowder first used in Europe

The Gothic era has been called a long overture to the Renaissance, and we can see, perhaps, in the sculptures at Reims Cathedral (see Fig. 635), which date from the first half of the thirteenth century, the beginnings of the spirit that would develop into the Renaissance sensibility. These figures are no longer archetypical and formulaic representations; they are almost real people, displaying real emotions. This tendency toward more and more naturalistic representation in many ways defines Gothic art, but it is even more pronounced in Renaissance art. If the figures in the Reims portal seem about to step off their columns, Renaissance figures actually do so. By the time of the Limbourg Brothers' early fifteenthcentury manuscript illumination for Les Très Riches Heures du Duc de Berry (Fig. 646), human beings are represented, for the first time since classical antiquity, as casting actual shadows upon the ground. The architecture is also rendered with some measure of perspectival accuracy. The scene is full of realistic detail, and the potential of landscape to render a sense of actual space, evident in the earlier Pisano Nativity, is fully realized.

THE EARLY RENAISSANCE

The Renaissance is, perhaps most of all, the era of the individual. As early as the 1330s, the poet and scholar Petrarch had conceived of a new Humanism, a philosophy that emphasized the unique value of each person. Petrarch believed that the birth of Christ had ushered in an "age of faith," which had blinded the world to learning and thus condemned it to darkness. The study of classical languages, literature, history, and philosophy-what we call the "humanities"-could lead to a new enlightened stage of history. People should be judged, Petrarch felt, by their actions. It was not God's will that determined who they were and what they were capable of; rather, glory and fame were available to anyone who dared to seize them.

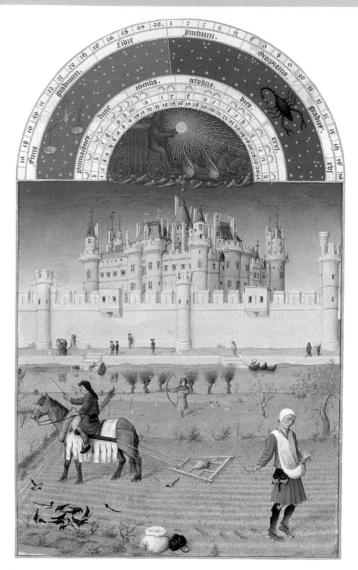

Fig. 646 The Limbourg Brothers, October, from Les Très Riches Heures du Duc de Berry, 1413–1416. Manuscript illumination. Musée Condé, Chantilly, France. © RMN Reunion des Musées Nationaux/Art Resource, New York.

Writing in 1485, the philosopher Giovanni Pico della Mirandola—Pico, as he is known addressed himself to every ordinary (male) person: "Thou, constrained by no limits, in accordance with thine own free will . . . shalt ordain for thyself the limits of thy nature. We have set thee at the world's center . . . [and]

Treaty of Troyes grants French throne to the English king **1420**

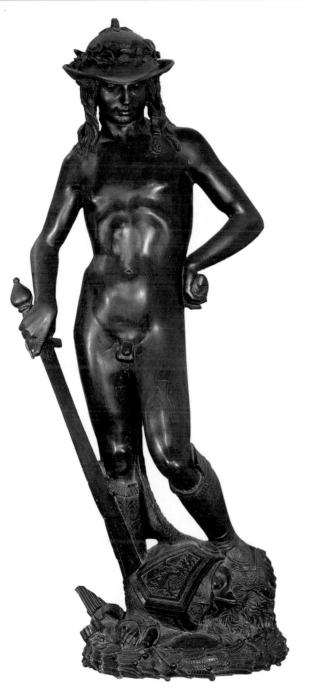

Fig. 647 Donatello, *David*, c. 1425–1430. Bronze, height, 62 ¼ in. Museo Nazionale del Bargello, Florence. 15th century Compass and navigation charts come into use

thou mayst fashion thyself in whatever shape thou shalt prefer." Out of such sentiments were born not only the archetypical Renaissance geniuses—men like Michelangelo and Leonardo—but also Niccolò Machiavelli's wily and pragmatic Prince, for whom the ends justify any means, and the legendary Faust, who sold his soul to the devil in return for youth, knowledge, and magical power.

1430

Under the leadership of the extraordinarily wealthy and beneficent Medici family-with first Cosimo de' Medici and, subsequently, his grandson, Lorenzo the Magnificent, assuming the largest roles-the city of Florence became the cultural center of the early Renaissance. The three leading innovators of the arts in fifteenth-century Florence-the painter Masaccio, who died in 1428 at the age of 27, having worked only six short years; the sculptor Donatello, and the architect Filippo Brunelleschi-were already firmly established by the time Cosimo assumed power in 1434. Brunelleschi was the inventor of geometric, linear perspective, a system he probably developed in order to study the ruins of ancient Rome. In 1420, he accepted a commission to design and build a dome over the crossing of the Florence Cathedral (see Fig. 633). The result, which spans a space 140 feet wide, was a major technological feat. But above all, his sense of measure, order, and proportion defined his sensibility-and that of the Italian Renaissance as a whole. Brunelleschi's God is a reasonable one, not the mysterious force that manifests itself in the ethereal light of the Gothic cathedral.

Donatello had traveled to Rome in 1402 with his friend Brunelleschi. The Greek and Roman statuary he studied there greatly influenced his own work, which reflects the classical interest in the human body in motion and in articulating that body through the use of drapery. The first lifesize nude sculpture since antiquity, Donatello's *David* (Fig. 647) is posed in perfectly classical contrapposto (see Fig. 411). But the young hero—almost antiheroic in the

Joan of Arc executed as a heretic **1431**

1430

15th century Incidence of syphilis increases in Europe

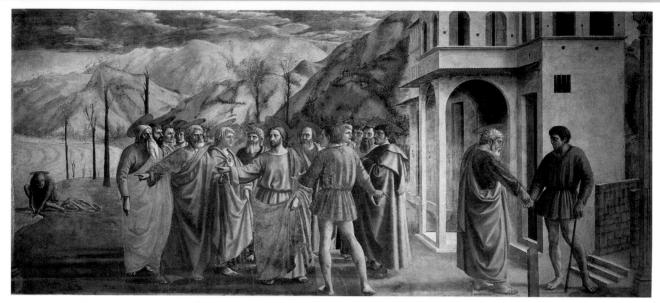

Fig. 648 Masaccio, *The Tribute Money*, c. 1427. Fresco. Brancacci Chapel, Santa Maria del Carmine, Florence. Studio Mario Quattrone.

youthful fragility of his physique—is also fully self-conscious, his attention turned, in what appears to be full-blown self-adoration, upon himself as an object of physical beauty.

Masaccio, 15 years younger than Donatello and 24 years younger than Brunelleschi, learned from them both, translating Donatello's naturalism and Brunelleschi's sense of proportion into the art of painting. In his The Tribute Money (Fig. 648), painted around 1427, Christ's disciples, especially St. Peter, wonder whether it is proper to pay taxes to the Roman government when, from their point of view, they owe allegiance to Christ, not Rome. But Christ counsels them to separate their earthly affairs from spiritual obligations-"Render therefore unto Caesar the things which are Caesar's; and unto God the things that are God's" (Matthew 22:21). To that end, Christ tells St. Peter and the other disciples that they will find the coin necessary to pay the imperial tax collector, whose back is to us, in the mouth of a fish. At the left, St. Peter extracts the coin from the fish's mouth, and, at the right, he pays the required tribute

money to the tax collector. The figures here are modeled by means of chiaroscuro in a light that falls upon the scene from the right (notice their cast shadows). We sense the physicality of the figures beneath their robes. The landscape is rendered through atmospheric perspective, and the building on the right is rendered in a one-point perspective scheme, with a vanishing point behind the head of Christ. All of these artistic devices are in themselves innovations; together, they constitute one of the most remarkable achievements in the history of art, an extraordinary change in direction from the flat, motionless figures of the Middle Ages toward a fully realistic representation.

In the North of Europe, in Flanders particularly, a flourishing merchant society promoted artistic developments that in many ways rivaled those of Florence. The Italian revival of classical notions of order and measure was, for the most part, ignored in the North. Rather, the Northern artists were deeply committed to rendering believable space in the greatest and most realistic detail. *The Mérode Altarpiece*, executed by

Turks conquer Constantinople, Hagia Sofia becomes a mosque **1453**

1453 Gutenberg prints the Mazarin Bible **1455–85** War of the Roses in England 1490

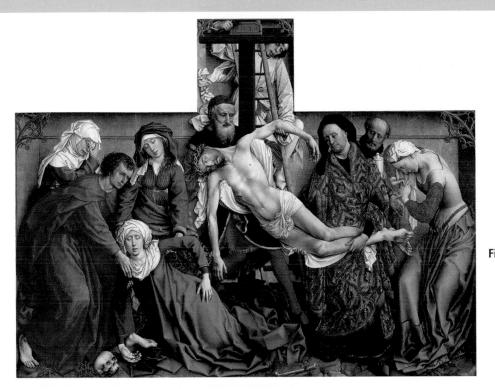

Fig. 649 Rogier van der Weyden, Deposition, c. 1435–1438. Oil on wood, 7 ft. 1 5/8 in. × 8 ft. 7 1/8 in. Museo del Prado, Madrid. Scala/Art Resource, New York

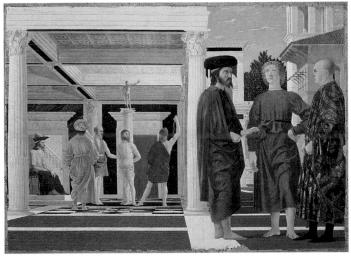

Fig. 650 Piero della Francesca, *The Flagellation of Christ,* c. 1451.

Tempera on wood, 32 ³/₄ × 23 ¹/₃ in. Palazzo Ducale, Galleria Nazionale delle Marche, Urbino. Scala/Art Resource, New York. Robert Campin (see Fig. 338), is almost exactly contemporary with Masaccio's Tribute Money, but in the precision and clarity of its detail-in fact, an explosion of detail-it is radically different in feel. The chief reason for the greater clarity is, as we discussed in Part III, a question of medium. Northern painters developed oil paint in the first half of the fourteenth century. With oil paint, painters could achieve dazzling effects of light on the surface of the painting-as opposed to the matte, or nonreflective, surface of both fresco and tempera. These effects recall, on the one hand, the Gothic style's emphasis on the almost magical light of the stained-glass window. In that sense, the effect achieved seems transcendent. But it also lends the depicted objects a sense of material reality, and thus caters to the material desires of the North's rising mercantile class.

If we compare Rogier van der Weyden's *Deposition* (Fig. 649) to Piero della Francesca's *The Flagellation of Christ* (Fig. 650), the differences between the northern (Flemish) and the southern (Italian) sensibilities become evident. Virtually a demonstration of the rules of

Cosimo de' Medici founds the Platonic Academy **1462**

1460

Lorenzo the Magnificent rules in Florence 1469–1492

1472 Dante's *Divine Comedy* is printed

1478 Spanish Inquisition begins

Shape 1

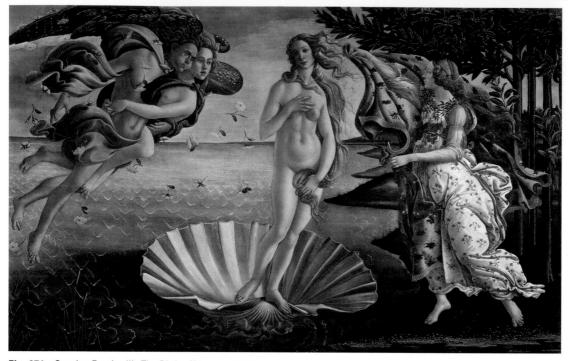

Fig. 651 Sandro Botticelli, The Birth of Venus, c. 1482. Tempera on canvas, 5 ft. 8 ⁷/₈ in. × 9 ft. 1 ⁷/₈ in. Galleria degli Uffizi, Florence. Canali Photobank.

linear perspective, Piero's scene depicts Pontius Pilate watching as executioners whip Christ. Although it is much more architecturally unified, the painting pays homage to Masaccio's Tribute Money. Emotionally speaking, Rogier's Deposition has almost nothing in common with Piero's Flagellation. It is as if Piero has controlled the violence of his emotionally charged scene by means of mathematics, while Rogier has emphasized instead the pathos and human feeling that pervade his scene of Christ being lowered from the cross. While Piero's composition is essentially defined by a square and a rectangle, with figures arranged in each in an essentially triangular fashion, Rogier's composition is controlled by two parallel, deeply expressive, and sweeping curves, one defined by the body of Christ and the other by the swooning figure below him. Next to the high drama of Rogier's painting, Piero's seems almost static, but the understated brutality of Christ's

flagellation in the background of Piero's painting is equally compelling.

THE HIGH RENAISSANCE

When Lorenzo de' Medici assumed control of his family in 1469, Florence was still the cultural center of the Western world (see the map of Italy about 1494 p. 465). Lorenzo's predecessor had founded the Platonic Academy of Philosophy, where the artist Sandro Botticelli studied a brand of Neoplatonic thought that transformed the philosophic writings of Plato almost into a religion. According to the Neoplatonists, in the contemplation of beauty, the inherently corrupt soul could transform its love for the physical and material into a purely spiritual love of God. Thus, Botticelli uses mythological themes to transform his pagan imagery into a source of Christian inspiration and love. His Birth of Venus (Fig. 651), the first monu-

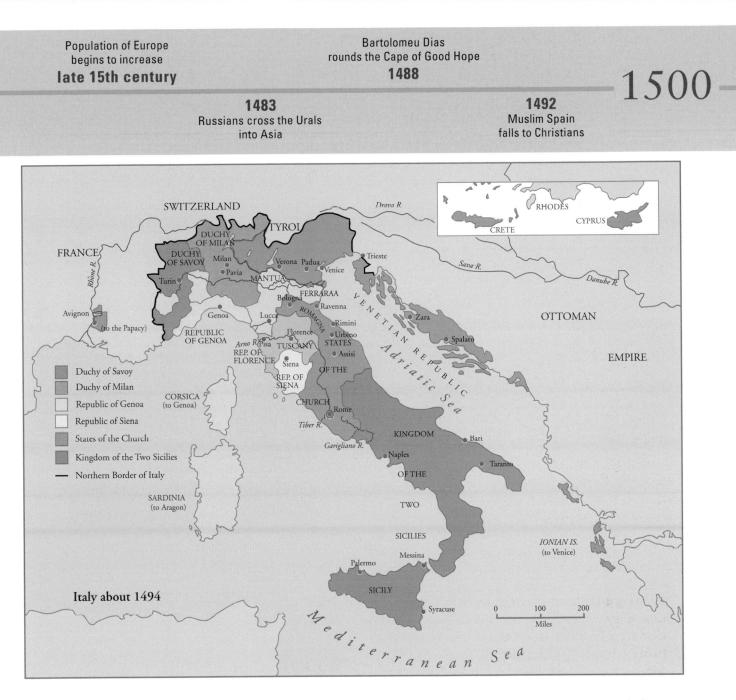

mental representation of the nude goddess since ancient times, represents innocence itself, a divinc bcauty frcc of any hint of the physical and the sensual. It was this form of beauty that the soul, aspiring to salvation, was expected to contemplate. But such meanings were by no means clear to the uninitiated, and when the Dominican monk Girolamo Savonarola denounced the Medicis as pagan, the majority of Florentines agreed. In 1494, the family was banished.

Still, for a short period at the outset of the sixteenth century, Florence was again the focal point of artistic activity. The three great artists of the High Renaissance—Leonardo, Michelangelo, and Raphael—all lived and worked in the city. As a young man, Michelangelo had been a member of Lorenzo de' Mcdici's circle, but with the Medicis's demise in 1494, he fled to Bologna. He returned to Florence seven years later to work on a giant piece of marble left over from an abandoned commission. Out of this, while still in his twenties, he carved his monolithic *David* (see Fig. 82).

Leonardo, some 23 years older than Michelangelo, had left Florence as early as 1481 for Milan. There he offered his services to the great Duke of Milan, Ludovico Sforza, first as a military engineer and, only secondarily, as an architect, sculptor, and painter. His drawing of A Vasco da Gama reaches India by sea **1497**

1500

Portuguese dominate the East Coast of Africa **1506**

c. 1500 Rise of modern European nation-states

Fig. 652 Leonardo da Vinci, A Scythed Chariot, Armored Car, and Pike, c. 1487.
 Pen and ink and wash, 6 ⅔ × 9 ⅔ in.
 The British Museum Great Court, Ltd.
 © The British Museum, London.

Scythed Chariot, Armored Car, and Pike (Fig. 652) is indicative of his work for Sforza. "I will make covered vehicles," he wrote to the duke, "which will penetrate the enemy and their artillery, and there is no host of armed men so great that they will not be broken down by them." The chariot in the drawing is equipped with scythes to cut down the enemy, and the armored car, presented in an upside-down view as well as scooting along in a cloud of dust, was to be operated by eight men. But Leonardo's work for Sforza was not limited to military operations. From 1495 to 1498, he painted his world-famous fresco The Last Supper (see Fig. 133), which many consider to be the first painting of the High Renaissance, in Santa Maria delle Grazie, a monastic church under the protection of the Sforza family. Leonardo left Milan soon after the French invaded in October 1499, and by April he had returned to Florence, where he concentrated his energies on a lifesize cartoon for Madonna and Child with St. Anne and Infant St. John (see Fig. 262). This became so famous that throngs of Florentines flocked to see it. At about this time he also painted the Mona Lisa (Fig. 653). Perhaps a portrait of the wife of the Florentine banker Zanobi del Giocondo, the painting conveys a psychological depth that has contin-

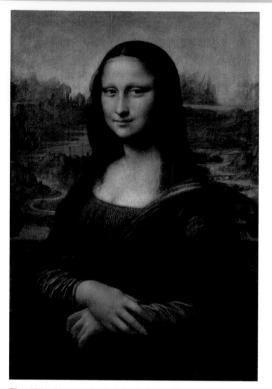

Fig. 653 Leonardo da Vinci, *Mona Lisa*, c. 1503–1505. Oil on wood, 30 ¹/₄ × 21 in. Musée du Louvre, Paris. Lewandoski/LeMage/Art Resource, New York.

ued to fascinate viewers up to the present day. Its power derives, at least in part, from a manipulation of light and shadow that imparts a blurred imprecision to the sitter's features, lending her an aura of ambiguity and mystery. This interest in the psychology, not just the physical looks, of the sitter is typical of the Renaissance imagination.

When Raphael, 21 years old, arrived in Florence in 1504, he discovered Leonardo and Michelangelo locked in a competition over who would get the commission to decorate the city council chamber in the Palazzo Vecchio with pictures celebrating the Florentine past. Leonardo painted a Battle of Anghiari and Michelangelo a Battle of Cascina, neither of which survives. We know the first today only by reputation and early drawings. A cartoon survived well into the seventeenth century and was widely copied, most faithfully by Peter Paul Rubens. Of the Michelangelo we know The Prince written by Niccoló Machiavelli 1513 Martin Luther posts his ninety-five theses 1517

1517

Spain authorizes slave trade between West Africa and New World colonies 1519–22 First circumnavigation of the world 1530

Fig. 654 Raphael, *The School of Athens*, 1510–1511. Fresco. Stanza della Segnatura, Vatican Palace, Rome. Photo: Musci Vaticani.

very little. What is clear, however, is that the young Raphael was immediately confronted by the cult of genius that in many ways has come to define the High Renaissance. Artists of genius and inspiration were considered different from everyone else, and guided in their work by an insight that, according to the Neoplatonists, was divine in origin. The Neoplatonists believed that the goals of truth and beauty were not reached by following the universal rules and laws of classical antiquity-notions of proportion and mathematics. Nor would fidelity to visual reality guarantee beautiful results; in fact, given the fallen condition of the world, quite the opposite was more likely, as Leonardo's studics of the faces of his fellow citizens had demonstrated (see Fig. 32). Instead, the artist of genius had to rely on subjective and personal intuition-what the Neoplatonists called the "divine frenzy" of the creative act—to transcend the conditions of everyday life. Plato had argued that painting was mere slavish imitation of an already existing thing it was a diminished reality. The Neoplatonists turned this argument on its head. Art now exceeded reality. It was a window, not upon nature, but upon divine inspiration itself.

Raphael learned much from both Leonardo and Michelangelo, and, in 1508, he was awarded the largest commission of the day, the decoration of the papal apartments at the Vatican in Rome. On the four walls of the first room, the Stanza della Segnatura, he painted frescoes representing the four domains of knowledge—Theology, Law, Poetry, and Philosophy. The most famous of these is the last, *The School of Athens* (Fig. 654). Raphael's painting depicts a gathering of the greatest Peasants' Rebellion in Germany **1524–25**

1520

1533 Ivan the Terrible ascends the Russian throne

 Fig. 655 Giorgione (probably completed by Titian), Sleeping Venus, c. 1510.
 Oil on canvas, 42 ³/₄ × 69 in. Staatliche Gemäldegalerie, Dresden.
 Staatliche Kuntsammlungen Dresden.

philosophers and scientists of the ancient world. The centering of the composition is reminiscent of Leonardo's Last Supper, but the perspectival rendering of space is much deeper. Where in Leonardo's masterpiece, Christ is situated at the vanishing point, in Raphael's work, Plato and Aristotle occupy that position. These two figures represent the two great, opposing schools of philosophy: the Platonists, who were concerned with the spiritual world of ideas (thus Plato points upwards), and the Aristotelians, who were concerned with the matterof-factness of material reality (thus Aristotle points over the ground upon which he walks). The expressive power of the figures owes much to Michelangelo, who, it is generally believed, Raphael portrayed as the philosopher Heraclitus, the brooding, self-absorbed figure in the foreground.

Raphael's commission in Rome is typical of the rapid spread of the ideals of the Italian Renaissance culture to the rest of Italy and Europe. In Venice, however, painting developed somewhat independently of the Florentine manner. The emphasis in Venetian art is on the sensuousness of light and color and the pleasures of the senses. The closest we have come to it so far is in the mysterious glow that infuses

Fig. 656 Titian, Venus of Urbino, 1538. Oil on canvas, 47 × 65 in. Galleria degli Uffizi, Florence. Scala/Art Resource, New York.

Leonardo's Mona Lisa, but what is only hinted at in Leonardo's work explodes in Venetian painting as full-blown theatrical effect. Partly under the influence of Leonardo, who had visited Venice after leaving Milan in 1499, Giorgione developed a painting style of blurred edges and softened forms. After his teacher's death in the great plague of 1510, Giorgione's student, Titian, took this style even farther, developing a technique that employed a painterly brushstroke to new, sensuously expressive ends. Two paintings of Venus, the first by Giorgione, probably completed by Titian after his teacher's death (Fig. 655), and the second executed 28 years later by Titian himself (Fig. 656), demonstrate the sensuality of the Venetian style. Giorgione's lifesize figure, bathed in luminous light, is frankly erotic, but Titian's is even more so. Positioned on the crumpled sheets of a bed, rather than in a pastoral landscape, she is not innocently sleeping, but gazes directly at us, engaging us in her sexuality.

In the North of Europe, the impact of the Italian Renaissance is perhaps best understood in the work of the German artist Albrecht Dürer. As a young man, he had copied Italian prints, and, in 1495, he traveled to Italy to study the Italian masters. From this point on, he strived to

English Reformation and the dissolution of the monasteries **1535–40**

1550

Fig. 657 Albrecht Dürer, *Self-Portrait*, 1500. Oil on panel, 26 1/4 × 19 1/4 in. Alte Pinakothek, Munich. Scala/Art Resource, New York.

establish the ideals of the Renaissance in his native country. The first artist to be fascinated by his own image, Dürer painted self-portraits (Fig. 657) throughout his career. In this act, he asserts his sense of the importance of the individual, especially the individual of genius and talent, such as he. Meaning to evoke his own spirituality, he presents himself almost as if he were Christ. Yet, as his printmaking demonstrates (see Fig. 308), not even Dürer could quite synthesize the northern love for precise and accurate naturalism—the desire to render the world of real things—with the southern idealist desire to transcend the world of real things.

ART IN CHINA AND JAPAN

In 1275, a young Venetian by the name of Marco Polo arrived in Peking, China, and quickly established himself as a favorite of the Mongol ruler Kublai Khan, first emperor of the Yuan dynasty. Polo served in an adminis-

Fig. 658 Cheng Sixiao, Ink Orchids, Yuan dynasty, 1306. Handscroll, ink on paper, 10 ⅓ × 16 ⅔ in. Municipal Museum of Fine Arts, Osaka/PPS. PPS/Pacific Press Service.

trative capacity in Kublai Khan's court and for three years ruled the city of Yangchow. Shortly after his return to Venice in 1295, he was imprisoned after being captured by the army of Genoa in a battle with his native Venice. While there, he dictated an account of his travels. His description of the luxury and magnificence of the Far East, by all accounts reasonably accurate, was virtually the sole source of information about China available in Europe until the nineteenth century.

At the time of Marco Polo's arrival, many of the scholar-painters of the Chinese court, unwilling to serve under the foreign domination of Kublai Khan, were retreating into exile from public life. In exile, they conscientiously sought to keep traditional values and arts alive by cultivating earlier styles in both painting and calligraphy. According to the inscription on Cheng Sixiao's *Ink Orchids* (Fig. 658), this painting was done to protest the "theft of Chinese soil by invaders," referring to the Mongol conquest of China. The orchids, therefore, have been painted without soil around their roots, showing an art flourishing, even though what sustains it has been taken away.

In 1368, Zhu Yuanzhang (ruled 1368– 1398) drove the Mongols out of China and Death of Song poet Su Tung-p'o **1101**

1100

First Mongol invasion of Japan **1274**

Fig. 659 Yin Hong, Hundreds of Birds Admiring the Peacocks, Ming dynasty, c. late 15th—early 16th century.
Hanging scroll, ink and color on silk, 7 ft. 10 ½ in × 6 ft. 5 in. The Cleveland Museum of Art. Purchase from the J. H. Wade Fund, 74.31.

restored Chinese rule in the land, establishing the dynasty called the Ming ("bright" or "brilliant"), which lasted until 1644. Late in the Ming dynasty, an artist, calligrapher, theorist, and high official in the government bureaucracy, Dong Qichang, wrote an essay that has affected the way we look at the history of Chinese painting ever since, although many scholars, even in Dong Qichang's time, viewed it as oversimplistic. He divided the history of Chinese painting into two schools, northern and southern, although geography had little to do with it. It was not place but the spirit in which the artist approached his painting that determined to which school he belonged.

Hundreds of Birds Admiring the Peacocks (Fig. 659) by Yin Hong, a court artist active in the late fifteenth and early sixteenth centuries, is an example of the northern school, conservative and traditional in his approach. It is de-

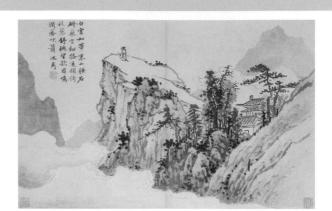

1105 Genghis Khan begins Mongol invasions

Fig. 660 Shen Zhou, Poet on a Mountaintop, leaf from an album of landscapes, painting mounted as part of a handscroll, Ming dynasty, c. 1500. Ink and color on paper, 15 ¹/₄ × 23 ³/₄ in.
 The Nelson-Atkins Museum of Art, Kansas City, Missouri. Purchase: Nelson Trust, 46-51/2.
 Photo: Robert Newcombe.

fined by its highly refined decorative style, which emphasizes the technical skill of the painter, the rich use of color, and reliance on traditional Chinese painting-in this case the birds-and-flowers genre extremely popular in the Song dynasty. Like Guo Xi's Song dynasty painting, Early Spring (see Fig. 643), Yin Hong's painting also takes on a symbolic meaning that refers directly to the emperor. Just as the central peak in Guo Xi's painting symbolizes the emperor himself, with the lower peaks and trees assuming a place of subservience to him, here the emperor is symbolized by the peacock around whom the "hundreds of birds"-that is, the court officials-gather in obeisance.

The southern style was unorthodox, radical, and inventive. Thus, a painting like *Poet on a Mountaintop* (Fig. 660) by Shen Zhou radicalizes traditional Chinese landscape. For the southern artist, reality rested in the mind, not the physical world, and thus selfexpression is the ultimate aim. Here the poet stands as the central figure in the painting, facing out over an airy void in which hangs the very image of his mind, the poem inscribed in the top left of the painting: Chinese voyages to India and Africa begin **1405**

1368 Founding of Ming Dynasty

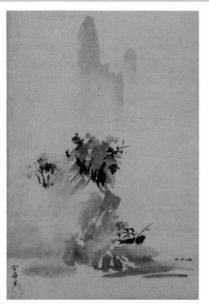

Fig. 661 Sesshu Toyo, Haboku Landscape for Soen (detail), Muramachi period, 1495.

Section of a hanging scroll, ink on two joined sheets of paper, total height 58 $^{1}\!\!/_{4}$ in.

Tokyo National Museum.

TNM Image Archive Source: http://TNMArchives.jp/DNP (Dai Nippon Printing) Archives.com

- White clouds like a belt encircle the mountain's waist
- A stone ledge flying in space and the far thin road.
- I lean alone on my bramble staff and gazing contented into space
- Wish the sounding torrent would answer to your flute.

The southern style ideally synthesizes the three areas of endeavor that any member of the cultural elite—or **literati**, the literary intelligentsia should have mastered: poetry, calligraphy, and painting.

In Japan, the expressive southern style was received with great favor by Zen Buddhist priests who practiced self-discipline and selfdenial, relying on intuitive understanding rather than intellectual reasoning. Wanting to acquaint himself more fully with Chinese traditions, the Zen Buddhist priest Sesshu Toyo traveled to China in 1468–1469 and set about copying the Song dynasty masters.

1450

Fig. 662 Attributed to Saomi, *Garden of the Dasisen-in of Daitokuji*, Kyoto, Japan, Morimachi period, c. 1510–1525. Photo: Paul Quayle.

Haboku Landscape for Soen (Fig. 661) represents an extreme example of this new Zen Buddhist manner. Haboku literally means "broken ink," and the work has the appearance of ink casually splashed onto its surface. No mark on this painting could actually be thought of as representational. Rather, the denser ink suggests trees and rocks, and the softer washes tall mountains in the distance, water, and mist. It was exectued as a farewell gift for Sesshu's pupil, Josui Soen, its inscription fully capturing the spirit of the piece: "My eyes are misty," Sesshu writes, "and my spirit exhausted"—the very essence of a heartfelt farewell.

Zen Buddhists also responded to their religion in gardens distinguished by extreme simplicity and carefully constructed largely from small pebbles, rocks, and a few carefully groomed plantings. Their rock features evoke mountains and their expanses of pebbles and rocks bodies of water—streams, lakes, and even the ocean. An especially remarkable example is a garden usually attributed to a painter named Soami (Fig. 662). It consists of a series of miniature landscapes whose vertical rocks represent mountains. A waterfall, suggested by a vein of white quartz, cascades down one rock, forming a river of white gravel, across which a slab of stone has fallen like a natural bridge connecting islands in the stream.

300 BCE -

Olmec civilization c. 1500–300 BCE Classic period of Teotihuacán civilization **300–900 CE**

before 3000 BCE Maize domesticated in Mexico

c. 164 BCE Oldest Mayan monuments

Fig. 663 Colossal head, Villahermosa, Mexico, Olmec culture, c. 800–200 BCE. Basalt, height, 7 ft. Photo: Suzanne Murphy. Getty Images Inc.-Stone Allstock.

PRE-COLUMBIAN ART IN MEXICO

The term Pre-Columbian refers to the cultures of all the peoples who lived in Mexico, Central America, and South America prior to the arrival of the Europeans at the end of the fifteenth century. The cultures of the Pre-Columbian peoples are distinguished by their monumental architecture and their preference for working in stone, both of which lend their art a quality of permanence that differentiates it from the more fragile art forms of the Native American peoples who lived in what is now the United States and Canada. The permanence of Pre-Columbian art was the result of a cultural stability gained around 4000 BCE, when they developed agricultural, as opposed to nomadic, civilizations based especially on the production of maize, or yellow corn.

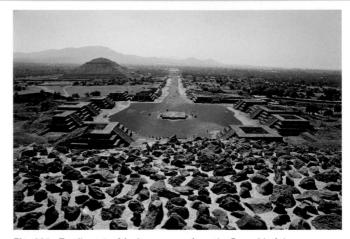

Fig. 664 Teotihuacán, Mexico, as seen from the Pyramid of the Moon, looking south down the Avenue of the Dead, the Pyramid of the Sun at the left, c. 350–650 CE. Photo: Gina Martin. National Geographic Image Collection.

The first Pre-Columbian culture was that of the Olmecs, who lived in present-day Tabasco and Vera Cruz, states on the Southern coast of the Gulf of Mexico. As early as 1500 to 800 BCE, the Olmecs created a huge ceremonial center at La Venta. La Venta's design, the basis of planning in Mexico and Central America for many centuries to come, centered on a pyramid, perhaps echoing the shape of a volcano. This pyramid faced a ceremonial courtyard, laid out on an axis that was determined astronomically. The courtyard was decorated with four giant stone heads, three to the south and one to the north (Fig. 663). More than a dozen such heads have been discovered, some of them twelve feet high. The closest source for the stone used to make this head from La Venta, in present-day Villahermosa, is sixty miles away, across swampland.

By the fourth century CE, Teotihuacán (Fig. 664) had become an important commercial center inhabited by a people of unknown ethnic identity. As opposed to the later Mayan cities, many of which were quickly forgotten and overgrown in the jungle, Teotihuacán remained, a thousand years after it flourished,

Aztecs arrive in the Valley of Mexico **c. 1325**

1350

c. 1000–1500 Inca civilization in South America

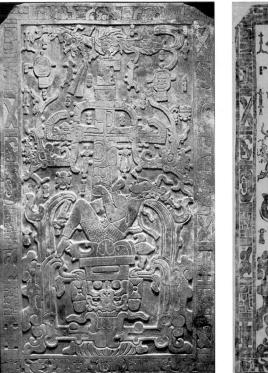

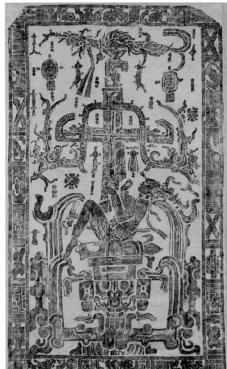

Fig. 665 Funerary lid of the sarcophagus of Pacal and rubbing of the lid, 683 cE. Limestone, 12 ft. 6 in. × 7 ft. National Museum of Archeology, Moxico City. Courtesy of Dr. Merle Greene Buberuson.

the mythic center of Mesoamerican civilization, the site of pilgrimages by even the most important Aztec rulers.

The city is laid out in a grid system, the basic unit of which is 614 square feet, and every detail is subjected to this scheme-the very image of power and mastery. A great, broad avenue, known as the Avenue of the Dead, runs through the city. It links two great pyramids, the Pyramids of the Moon and the Sun, each surrounded by about 600 smaller pyramids, 500 workshops, numerous plazas, 2,000 apartment complexes, and a giant market area. The Pyramid of the Sun is oriented to mark the passage of the sun from east to west and the rising of the stellar constellation, the Pleiades, on the days of the equinox. Each of its two staircases contains 182 steps, which, when the platform at its apex is added, together total 365. The pyramid is thus an image of time. This representation of the solar calendar is echoed in another pyramid at Teotihuacán,

the Temple of Quetzalcoatl, which is decorated with 364 serpent fangs. At its height, in about 500 CE, the population of Teotihuacán was perhaps 200,000, making it one of the largest cities in the world.

Mayan civilization began to reach its peak in southern Mexico and Guatemala around 250 CE, shortly after the rise of Teotihuacán in the north, and it flourished until about the year 900. Among the most important Mayan cities is Palenque, one of the best preserved of all Mayan sites. In 1952, under the Temple of Inscriptions at Palenque, Alberto Ruz, a Mexican archaeologist, discovered the entrance to the tomb of Lord Pacal, the most powerful of Palenque kings, who ruled for 67 years in the seventh century CE. He was buried in a large uterus-shaped sarcophagus weighing more than five tons and covered with jade and cinnabar. The sarcophagus lid was decorated with a relief image of Pacal falling off the Wacah Chan, the Tree of Life (Fig. 665),

Cortés invades Mexico 1519

1350

1369 City of Tenochtitlan founded

which connects the Upperworld, the Middleworld, and the Underworld. At the tree's top sits the feathered serpent, Quetzalcoatl. The tree is encircled by a double-headed serpent, signifying the royal lineage of the deceased. The king was believed to be the embodiment of the Wacah Chan, and when he stood at the top of a pyramid in ritual activity, he was seen as linking the three layers of the universe in his own person. During such rituals, the king would let his own blood in order to give sustenance to the spiritual world. Some scholars now believe that the Wacah Chan can actually be read astronomically as the Milky Way, along which the spirit of the dead travel before being reborn into a new life.

By about the sixth century BCE, widespread use of both a 260-day and a 365-day calendar system began to appear throughout Mexico. The latter corresponds to the true solar year, while the former is based on the length of human gestation, from the first missed menstrual flow to birth. Both calendars were often used simultaneously. A given day in one calendar will occur on the same day in the other every 52 years, and each new 52-year cycle was widely celebrated, particularly by the Aztecs. Such calendar systems, which were inscribed in stone, provide a sense of continuity between the Pre-Columbian cultures. Particularly among the Aztecs, who traced their ancestry to the merging of Mayan and Toltec cultures at Chichen Itzá, on the Yucatán peninsula, the calendar's tie to the menstrual cycle required blood sacrifice. Coatlicue (Fig. 666) was the Aztec goddess of life and death. Her head is composed of two fanged serpents, which are symbolic of flowing blood. She wears a necklace of human hearts, severed hands, and a skull. The connection of blood to fertility is clear in the snake that descends between her legs, which suggests both menstruation and the phallus.

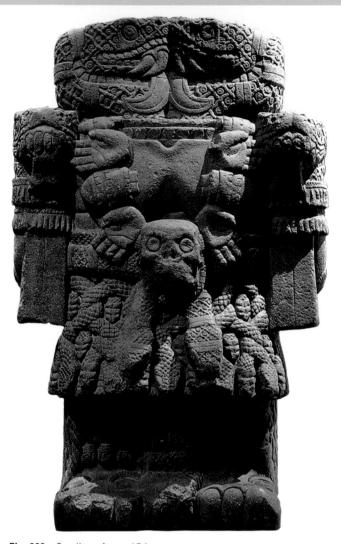

Fig. 666 Coatlicue, Aztec, 15th century. Basalt, height, 8 ft. 3 in. National Museum of Anthropology, Mexico City. Werner Forman/Art Resource, New York. Luther translates New Testament into German 1521–22 Copernicus publishes On the Revolution of the Heavenly Spheres 1543

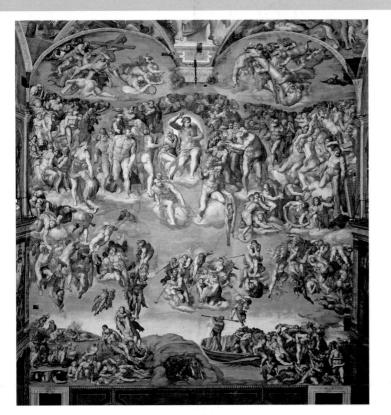

Fig. 667 Michelangelo Buonarroti, The Last Judgment, "Guidizio Universale" (detail), on altar wall of Sistine Chapel, 1534–1541.
Fresco.
The Vatican Museums, Rome.
Photo: A. Bracchetti/ P. Zigrossi. Foto Musei Vaticani.

MANNERISM

Shortly after the Spanish conquest of separatist states within Spain in 1519 and the death of Raphael in 1520, many Italian painters embarked on a stylistic course that come to be known as **Mannerism**. Highly individualistic and *mannered*, or consciously artificial, this **Mannerist** style was dedicated to "invention," and the technical and imaginative virtuosity of the artist became of paramount importance. Each Mannerist artist may, therefore, be identified by his own "signature" style. Where the art of the High Renaissance sought to create a feeling of balance and proportion, quite the oppo**1545–63** Council of Trent reforms Catholic Church in response to Reformation

1560

Fig. 668 Tintoretto, *The Miracle of the Slave*, 1548. Oil on canvas, appro×. 14 × 18 ft. Galleria dell'Academia, Venice. Scala/Art Resource, New York.

site is the goal of Mannerist art. In the late work of Michelangelo, for example, particularly the great fresco of The Last Judgment on the altar wall of the Sistine Chapel (Fig. 667), executed in the years 1534 to 1541, we find figures of grotesque proportion arranged in an almost chaotic, certainly athletic, swirl of line. Mannerist painters represented space in unpredictable and ambiguous ways, so that bodies sometimes seem to fall out of nowhere into the frame of the painting, as in Tintoretto's The Miracle of the Slave (Fig. 668). The drama of Tintoretto's painting is heightened by the descent of the vastly foreshortened St. Mark, who hurtles in from above to save the slave from his executioner. The rising spiral line created by the three central figures-the slave, the executioner holding up his shattered instruments of torture, and St. Mark-is characteristic of Mannerism, but the theatricality of the scene, heightened by its dramatic contrast of light and dark, anticipates the Baroque style, which soon followed.

Often the space of a Mannerist painting seems too shallow for what is depicted, a feeling emphasized by the frequent use of radical Birth of William Shakespeare **1564**

1560

Defeat of Spanish Armada by English fleet **1588**

1584 First English attempt to colonize North America (Roanoke)

Fig. 669 Bronzino, Venus, Cupid, Folly, and Time (The Exposure of Luxury), c. 1546.
Oil on wood, approx. 61 × 56 ³/₄ in.
National Gallery, London.

Fig. 670 Tomb of Galla Placidia, Ravenna. Full interior. c. 425. Courtesy of Marilyn Stokstad, Private Collection.

foreshortening, as in the Tintoretto. Or the figure itself may be distorted or elongated, as in Bronzino's *Venus*, *Cupid*, *Folly*, *and Time (The Exposure of Luxury*) (Fig. 669). The colors are often bright and clashing. At the upper right of Bronzino's painting, Time, and, at the upper left, Truth, part a curtain to reveal the shallow space in which Venus is fondled by her son, Cupid. Folly is about to shower the pair in rose petals. Envy tears her hair out at center left. The Mannerist distortion of space is especially evident in the distance separating Cupid's shoulders and head.

As in El Greco's *The Burial of Count Orgaz* (Fig. 670), Mannerist painting often utilizes more than one focal point, and these often seem contradictory. Born in Crete and trained in Venice and Rome, where he studied the works of Titian, Tin-

toretto, and the Italian Mannerists, El Greco moved to Toledo, Spain, in 1576, and lived there for the rest of his life. In the painting we see here, the realism of the lower ensemble, which includes local Toledo nobility and clergy of El Greco's day (even though the painting represents a burial that took place more than 200 years earlier, in 1323), gives way in the upper half to a much more abstract and personal brand of representation. El Greco's elongated figures-consider St. Peter, in the saffron robe behind Mary on the upper left, with his long piercing fingers on a longer, almost drooping hand, to say nothing of the bizarrely extended arm of Christ himself-combine with oddly rolling clouds that rise toward an astonishingly small representation of Christ. So highly eclectic and individual is this painter's style that it is difficult to label it even as Mannerist.

Death of Elizabeth I of England **1603**

1603 Cervantes begins Don Quixote Jamestown founded in Virginia **1609**

1608 Quebec founded by the French 1611 King James translation of the Bible completed 1620

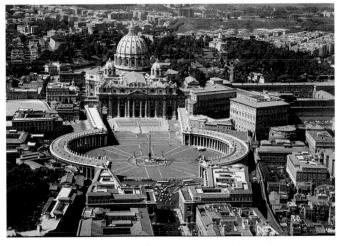

Fig. 671 Aerial view of St. Peter's, Rome. Nave and facade by Carlo Maderno, 1607–1615, colonnade by Gianlorenzo Bernini, 1657.

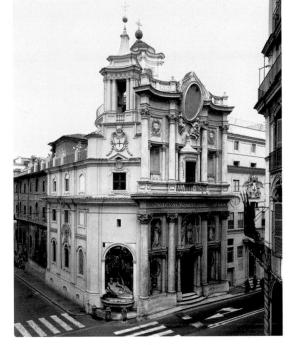

Fig. 672 Francesco Borromini, facade, *San Carlo alle Quattro Fontane,* Rome, 1665–1667. Ikona.

tural embrace, as if the church were reaching out its arms to gather in its flock. The wings that connect the facade to the semicircular colonnade tend to diminish the horizontality of the facade and emphasize the vertical thrust of Michelangelo's dome.

As vast as Bernini's artistic ambitions were, he was comparatively classical in his tastes. If we compare Bernini's colonnade at St. Peter's to Francesco Borromini's facade for San Carlo alle Quattro Fontane in Rome (Fig. 672), we notice immediately how symmetrical Bernini's design appears. Beside Borromini's facade, Bernini's colonnade seems positively conservative, despite its magnificent scale. But Borromini's extravagant design was immediately popular. The head of the religious order for whom San Carlo alle Quattro Fontane was built wrote with great pride, "Nothing similar can be found anywhere in the world. This is attested by the foreigners who try to procure copies of the plan. We have

THE BAROQUE

The Baroque style, which is noted particularly for its theatricality and drama, was, in many respects, a creation of the Papacy in Rome. Around 1600, faced in the North with the challenge of Protestantism, which had steadily grown more powerful ever since Martin Luther's first protests in 1517, the Vatican took action. It called together as many talents as it could muster with the clear intention of turning Rome into the most magnificent city in the world, "for the greater glory of God and the Church." At the heart of this effort was an ambitious building program. In 1603, Carlo Maderno was assigned the task of adding an enormous nave to Michelangelo's central plan for St. Peter's, converting it back into a giant basilica (Fig. 671). Completed in 1615, the scale of the new basilica was even more dramatically emphasized when Gianlorenzo Bernini added a monumental oval piazza surrounded by colonnades to the front of the church. Bernini conceived of his colonnade as an architec-

1615

been asked for them by Germans, Flemings, Frenchmen, Italians, Spaniards, and even Indians." We can detect, in these remarks, the Baroque tendency to define artistic genius more and more in terms of originality, the creation of things never before seen. Bernini's colonnade makes clear that the virtues of the classical were continually upheld, but emerging for the first time, often in the work of the same artist, is a countertendency, a sensibility opposed to tradition and dedicated to invention.

One of the defining characteristics of the Baroque is its insistence on bringing together various media to achieve the most theatrical effects. Bernini's Cornaro Chapel in Santa Maria della Vittoria (Figs. 673 and 674) is perhaps the most highly developed of these dynamic and theatrical spaces. The altarpiece depicts the ecstasy of St. Theresa. St. Theresa, a nun whose conversion took place after the death of her father, experienced visions, heard voices, and felt a persistent and piercing pain in her side. This was caused, she believed, by the flaming arrow of Divine Love, shot into her by an angel: "The pain was so great I screamed aloud," she wrote, "but at the same time I felt such infinite sweetness that I wished the pain to last forever. . . . It was the sweetest caressing of the soul by God."

First African slaves arrive in Virginia 1619

Figs. 673 and 674 Gianlorenzo Bernini, The Cornaro Family in a Theater Box. Marble, lifesize. The Ecstasy of St. Theresa. Marble, lifesize, 1645-1652. Cornaro Chapel, Santa Maria della Vittoria, Rome.

> Fig. 673 © Scala/Art Resource, New York. Fig 674 Canali Photobank.

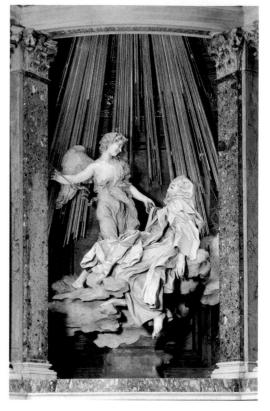

The paradoxical nature of St. Theresa's feelings is typical of the complexity of Baroque sentiment. Bernini fuses the angel's joy and St. Theresa's agony into an image that depicts what might be called St. Theresa's "anguished joy." Even more typical of the Baroque sensibility is Bernini's use of every device available to him to dramatize the scene. The sculpture of St. Theresa is illuminated by a hidden window above, so that the figures seem to glow in a magical white light. Gilded bronze rays of heavenly light descend upon the scene as if from the burst of light painted high on the frescoed ceiling of the vault. To the left and right of the chapel are theater boxes containing marble spectators, like ourselves witnesses to this highly charged, operatic moment.

Descartes publishes his *Laws of Method* **1637**

1640

1630s Japan adopts a national policy of isolation

Fig. 675 Caravaggio, The Calling of St. Matthew, c. 1599–1602.
 Oil on canvas, 11 ft. 1 in. × 11 ft. 5 in. Contarelli Chapel, San Luigi dei Francesci, Rome.
 Canali Photobank.

The Baroque style quickly spread beyond Rome and throughout Europe. Elaborate Baroque churches were constructed, especially in Germany and Austria. In the early years of the seventeenth century, furthermore, a number of artists from France, Holland, and Flanders were strongly influenced by the work of the Italian painter Caravaggio. Caravaggio openly disdained the great masters of the Renaissance, creating instead a highly individualistic brand of painting that sought its inspiration, not in the proven styles of a former era, but literally in the streets of contemporary Rome. When viewing his work, it is often difficult to tell that his subject is a religious one, so ordinary are his people and so dingy and commonplace his settings. Yet despite Caravaggio's desire to secularize his religious subjects, their light imbues them with a spiritual reality. It was, in fact, the contrast in his paintings between light and dark, mirroring the contrast between the spiritual content of the painting and its representation in the trappings of the everyday, that so powerfully influenced painters across Europe.

Caravaggio's naturalism is nowhere so evident as in *The Calling of St. Matthew* (Fig. 675), which was painted, somewhat surprisingly, for a church.

1640

1640 Russians reach the Pacific Ocean

The scene is a tavern. St. Matthew, originally a tax collector, sits counting the day's take with a band of his agents, all of them apparently prosperous, if we are to judge from their attire. From the right, two barefoot and lowly figures, one of whom is Christ, enter the scene, calling St. Matthew to join them. He points at himself in some astonishment. Except for the undeniably spiritual quality of the light, which floods the room as if it were revelation itself, the only thing telling us that this is a religious painting is the faint indication of a halo above Christ's head.

Though not directly influenced by Caravaggio, Rembrandt, the greatest master of light and dark of the age, knew Caravaggio's art through Dutch artists who had studied it. Rembrandt extends the sense of dramatic opposition Caravaggio achieved by manipulating light across a full range of tones, changing its intensity and modulating its brilliance, so that every beam and shadow conveys a different emotional content. In his Resurrection of Christ (Fig. 676), Rembrandt uses the emotional contrast between light and dark to underscore emotional difference. He contrasts the chaotic world of the Roman soldiers, sent reeling into a darkness symbolic of their own ignorance by the angel pulling open the lid of Christ's sepulchre, with the quiet calm of Christ himself as He rises in a light symbolic of true knowledge. Light becomes, in Rembrandt's hands, an index to the psychological meaning of his subjects, often hiding as much as it reveals, endowing them with a sense of mystery even as it reveals their souls.

In Northern Europe, where strict Protestant theology had purged the churches of religious art and classical subjects were frowned upon as pagan, realism thrived. Works with secular, or nonreligious, subject matter became extremely popular: Still life painting was popular (see Jan de Heem's *Still Life with Lobster*, Fig. 340), as were representations of

Fig. 676 Rembrandt van Rijn, Resurrection of Christ, c. 1635–1639.
Oil on canvas, 36 ¼ × 26 ¾ in.
Alte Pinakothek, Munich.
Artothek.

1652 First Cape Colony settlement by Dutch East India Company

 Fig. 677 Annibale Carracci, Landscape with Flight into Egypt, c. 1603.
 Qil on canvas, 48 1/₄ × 98 1/₂ in. Galleria Doria Pamphili, Rome. Canali Photobank.

everyday people living out their lives (genre painting) and landscapes. In Spain, where the royal family had deep historical ties to the North, the visual realism of Velázquez came to dominate painting (see Fig. 239). Spurred on by the great wealth it had acquired in its conquest of the New World, Spain helped to create a thriving market structure in Europe. Dutch artists quickly introduced their own goods-that is, paintings-into this economy, with the Spanish court as one of its most prestigious buyers. No longer working for the Church, but instead for this new international market, artists painted the everyday things that they thought would appeal to the bourgeois tastes of the new consumer.

Of all the new secular subject matter that arose during the Baroque Age, the genre of landscape perhaps most decisively marks a shift in Western thinking. In Annibale Carracci's Landscape with Flight into Egypt (Fig. 677), the figure and the story have become incidental to the landscape. Joseph has dreamed that King Herod is searching for the infant Jesus to kill him, and he flees into Egypt with Mary and the child, to remain there until after Herod's death. But this landscape is hardly Egypt. Rather, Carracci has transferred the story to a highly civilized Italian setting. This is the pastoral world, a middle ground between civilization and wilderness where people can live free of both the corruption and decadence of city and court life and the uncontrollable forces of nature. One of the most idyllic of all landscape painters goes even further. Claude Lorrain-Claude, as he is usually known-casts the London Plague kills 100,000 people **1665**

1660

Construction of Versailles Palace begins outside Paris **1668**

1669

Ottoman Turks seize

the island of Crete

Native American population reduced to around 70,000 **1675**

1667 Publication of Milton's *Paradise Lost*

Fig. 678 Claude Lorrain, *A Pastoral Landscape*, c. 1650. Oil on copper, 15 $\frac{1}{2} \times 21$ in. Yale University Art Gallery, New Haven. Leo C. Hanna Fund. Yale University Art Gallery.

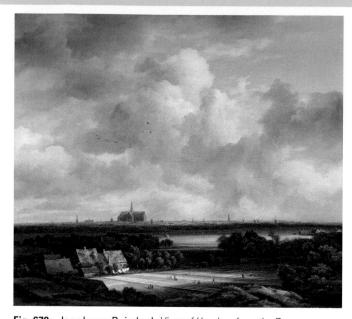

Fig. 679 Jacob van Ruisdael, View of Haarlem from the Dunes at Overveen, c. 1670.
Oil on canvas, 22 × 24 % in.
Royal Cabinet of Painting Mauritshuis, The Haque.

world in an eternally poetic light. In his *A Pastoral Landscape* (Fig. 678), he employs atmospheric perspective to soften all sense of tension and opposition and to bring us to a world of harmony and peace. In this painting, and many others like it, the best civilization has to offer has been melded with the best of a wholly benign and gentle nature.

Landscape painters felt that because God made the earth, one could sense the majesty of his soul in his handiwork, much as one could sense emotion in a painter's gesture upon canvas. The grandeur of God's vision was symbolically suggested in the panoramic sweep of the extended view. Giving up two-thirds of the picture to the infinite dimensions of the heavens, Jacob van Ruisdael's View of Haarlem from the Dunes at Overveen (Fig. 679) is not so much about the land as it is about the skyand the light that emanates from it, alternately casting the earth in light and shadow, knowledge and ignorance. Rising to meet the light, importantly, is the largest building in the landscape, the church. The beam of light that in

Caravaggio's painting suggests the spiritual presence of Christ becomes, in landscape, a beam of light from the "Sun/Son," a pun popular among English poets of the period, including John Donne. By the last half of the seventeenth century, it is as if the real space of the Dutch landscape had become so idealized that it is almost Edenic.

The example of landscape offers us an important lesson in the direction art took from the late seventeenth century down to our own day. The spiritual is no longer found exclusively in the church. It can be found in nature, in light, in form, even, as we progress toward the modern era, in the artist's very self. And by the end of the seventeenth century, the church is no longer the major patron of art as it had been for centuries. From Spanish kings, to wealthy Dutch merchants, to an increasingly large group of middle-class bourgeoisie with disposable incomes and the desire to refine their tastes, the patrons of art changed until, by the middle of the twentieth century, art came to be bought and sold in an international "art market."

The Eighteenth and Nineteenth Centuries

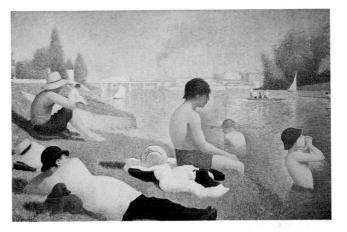

he conflict of sensibility that became evident when, in the last chapter, we compared the architecture of Bernini to that of his contemporary Borromini—the one enormous in scale but classical in principle, the other extravagant in form and so inventive that it seems intentionally anticlassical—dominates the history of European art in the eighteenth century. In France, especially, anticlassical developments in Italian art were rejected. As early as 1665, Jean-Baptiste Colbert had invited Bernini to Paris to complete construction of the Louvre, the palace of King Louis XIV. But Louis considered Bernini's plans too elaborate—he envisioned demolishing all the extant palace—and the Louvre

THE ROCOCO

NEOCLASSICISM

ROMANTICISM

Works in Progress Théodore Géricault's *The Raft of the Medusa*

REALISM

IMPRESSIONISM

POST-IMPRESSIONISM

La Salle takes possession of Mississippi River for France **1682** Glorious Revolution establishes constitutional monarchy in Britain **1688–89**

1680

1687 Newton publishes his law of motion

1690

Fig. 680 Claude Perrault, with Louis Le Vau, and Charles Lebrun, east front of the Louvre, Paris, 1667–1670. Photo: © Achim Bednorz, Koln.

Fig. 681 Nicolas Poussin, Landscape with St. John on Patmos, 1640. Oil on canvas, $40 \times 53 \frac{1}{2}$ in. Art Institute of Chicago A. A. Munger Collection, 1930.500. Photo © 2007, The Art Institute of Chicago. All rights reserved.

finally was built in a highly classical style, based on the plan of a Roman temple (Fig. 680).

The classicism of Bernini's colonnade for St. Peter's in Rome has been fully developed here. All vestiges of Baroque sensuality have been banished in favor of a strict and linear classical line. At the center of the facade is a Roman temple from which wings of paired columns extend outward, each culminating in a form reminiscent of the Roman triumphal arch.

One of the architects of this new Louvre was Charles Lebrun, a court painter who had studied in Rome with the classical painter Nicolas Poussin. Poussin believed that the aim of painting was to represent the noblest human actions with absolute clarity. To this end, distracting elements—particularly color, but anything that appeals primarily to the senses—had to be suppressed. In Poussin's *Landscape with St. John on Patmos* (Fig. 681), the small figure of St. John is depicted writing the *Revelations*. Not only do the architecture and the architectural ruins lend a sense of classical geometry to the scene, but even nature has been submitted to Poussin's classicizing order. Notice, for instance, how the tree on the left bends just Louis XV assumes the French throne 1715 Christianity banned in China 1742

1750

18th century Literacy becomes widespread **1726** Gulliver's Travels published mid-18th century Beginning of Industrial Revolution

Fig. 682 Rubens, Peter Paul *The Disembarkation of Marie de' Medici at the Port of Marseilles on November 3*, 1600.
Oil on canvas, 13 × 10 ft. Musée du Louvre/RMN Reunion des Musées Nationaux, France.
Erich Lessing/Art Resource, New York.

enough as it crosses the horizon to form a right angle with the slope of the distant mountain.

As head of the Royal Academy of Painting and Sculpture, Lebrun installed Poussin's views as an official, royal style. By Lebrun's standards, the greatest artists were the ancient Greeks and Romans, followed closely by Raphael and Poussin; the worst painters were the Flemish and Dutch, who not only "overemphasized" color and appealed to the senses, but also favored "lesser" genres, such as landscape and still life.

By the beginning of the eighteenth century, Lebrun's hold on the French Academy was questioned by a large number of painters who championed the work of the great Flemish Baroque painter Peter Paul Rubens over that of Poussin. Rubens, who had painted a cycle of 21 paintings celebrating the life of Marie de' Medici, Louis XIV's grandmother, was a painter of extravagant Baroque tastes. Where the design of Poussin's Landscape with St. John on Patmos (see Fig. 681) is based on horizontal and vertical elements arranged parallel to the picture plane, Rubens's forms in The Disembarkation of Marie de' Medici (Fig. 682) are dispersed across a pair of receding diagonals. In this painting, which depicts Marie's arrival in France as the new wife of the French king, Henry IV, our point of view is not frontal and secure, as it is in the Poussin, but curiously low, perhaps even in the water. Poussin, in his design, focuses on his subject, St. John, who occupies the center of the painting. whereas Rubens creates a multiplicity of competing areas of interest. Most of all, Poussin's style is defined by its linear clarity. Rubens's work is painterly, dominated by a play of color, dramatic contrasts of light and dark, and sensuous, rising forms. Poussin is restrained, Rubens exuberant.

THE ROCOCO

With the death of Louis XIV in 1715, French life itself became exuberant. This was an age whose taste was formed by society women with real, if covert, political power, especially Louis XV's mistress, Madame de Pompadour. The salons, gatherings held by particular hostesses on particular days of the week, were the social events of the day. A famous musician might appear at one salon, while artists and art lovers would always gather at Mme. Geoffrin's on Mondays. A highly developed sense of wit, irony, and gossip was necessary to succeed in this society. So skilled was the repartee in the salons, that the most biting insult could be made to sound like the highest compliment. Sexual intrigue was not merely commonplace but expected. The age was obsessed with sensuality, and one can easily trace the origins James Watt invents the steam engine **1760** American War of Independence 1775–83 United States Constitution 1789

1750

1774 Louix XVI assumes French throne **1776** Adam Smith publishes *Wealth of Nations*

Fig. 683 Jean-Honoré Fragonard, Bathers, c. 1765. Oil on canvas, 25 1/4 × 31 1/2 in. Musée du Louvre, Paris. Scala/Art Resource, New York.

of Fragonard's *Bathers* (Fig. 683) back to the mermaids at the bottom of Rubens's painting (see Fig. 682). Fragonard was Madame de Pompadour's favorite painter, and the *Bathers* was designed to appeal to the tastes of the eighteenth-century French court.

It is the age of the Rococo, a word derived from the French rocaille, referring to the small stones and shells that decorate the interiors of grottos, the artificial caves popular in landscape design at the time. The Rococo was deeply indebted to the Baroque sensibility of Rubens, as Fragonard's Bathers demonstrates. It was, in some sense, the Baroque eroticized, conceived to lend an erotic tone to its environment. Vigée-Lebrun's portrait of The Dutchess of Polignac (Fig. 684) combines in exquisite fashion all of the tools of the Baroque sensibility, from Rembrandt's dramatic lighting to Rubens's sensual curves and, given the musical score in the Duchess's hand, even Bernini's sense of the theatrical moment.

NEOCLASSICISM

Despite the Rococo sensibility of the age, the seventeenth-century French taste for the classical style that Lebrun had championed did not

Fig. 684 Marie-Louise-Elisabeth Vigée-Lebrun, *The Duchess of Polignac*, 1783. Oil on canvas, 38¾ × 28 in. © The National Trust Waddesdon Manor, England. Bridgeman-Giraudon/Art Resource, New York. U.S. Bill of Rights 1791 Eli Whitney invents the cotton gin 1793

1789 Beginning of French Revolution 1793 Louis XVI of France is beheaded **1798** Wordsworth and Coleridge publish the *Lyrical Ballads*

1800

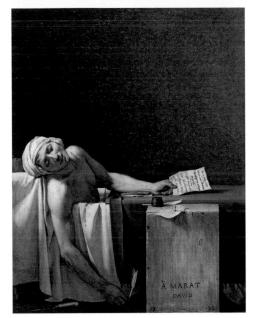

Fig. 685 Jacques Louis David, The Death of Marat, 1793. Oil on canvas, 65 × 50 ½ in. Musées Royaux des Beaux-Arts de Belgique, Brussels.

disappear. When Herculaneum and Pompeii were rediscovered, in 1738 and 1748, respectively, interest in Greek and Roman antiquity revived as well. The discovery fueled an increasing tendency among the French to view the Rococo style as symptomatic of a widespread cultural decadence, epitomized by the luxurious lifestyle of the aristocracy. The discovery also caused people to identify instead with the publicminded values of Greek and Roman heroes, who placed moral virtue, patriotic self-sacrifice, and "right action" above all else. A new classicism—a *neoclassicism*—supplanted the Rococo almost overnight.

The most accomplished of the Neoclassical painters was Jacques Louis David, whose *Death* of Socrates was was discussed in Chapter 5 (see Figs. 108 and 109). David took an active part in the French Revolution in 1789, recognizing as an expression of true civic duty and virtue the desire to overthrow the irresponsible monarchy that had, for two centuries at least, squandered France's wealth. His *Death of Marat* (Fig. 685) celebrates a fallen hero of the Revolution. Slain

Fig. 686 Angelica Kauffmann, Cornelia, Pointing to Her Children as Her Treasures, c. 1785.
Oil on canvas, 40 × 50 in. Virginia Museum of Fine Arts, Richmond. The Adolph D. and Wilkins C. Williams Fund. Photo: Katherine Wetzel. © Virginia Museum of Fine Arts.

in his bath by a Monarchist—a sympathizer with the overthrown king—Marat is posed by David as Christ is traditionally posed in the Deposition (compare, for instance, Rogier's *Deposition*, see Fig. 649), his arm draping over the edge of the tub. A dramatic Caravaggesque light falls over the revolutionary hero, his virtue embodied in the Neoclassical simplicity of David's design.

Virtue is, in fact, the subject of much Neoclassical art—a subject matter distinctly at odds with the early Rococo sensibility. Women are no longer seen cavorting like mermaids, or even luxuriously dressed like the Duchess of Polignac. In Angelica Kauffmann's *Cornelia*, *Pointing to Her Children as Her Treasures* (Fig. 686), Cornelia demonstrates her Neoclassical virtue by declaring her absolute devotion to her family, and, by extension, to the state. Her virtue is reinforced by her clothing, particularly the simple lines of her bodice.

The same sensibility informs the Neoclassical architecture of Thomas Jefferson. For Jefferson, the Greek orders embodied democratic ideals, possessing not only a sense of order and harmony but also a moral perfection deriving from measure and proportion. He uti lized these themes on the facade of his own home

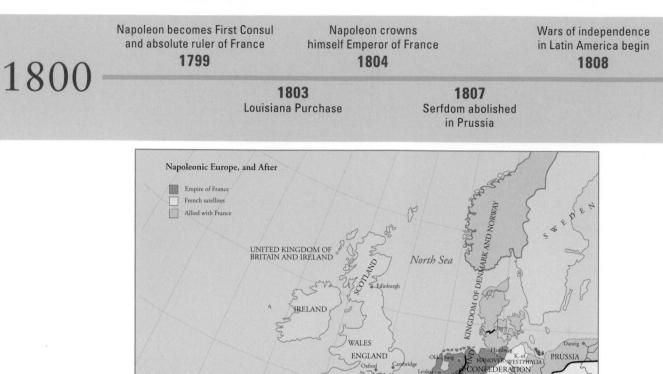

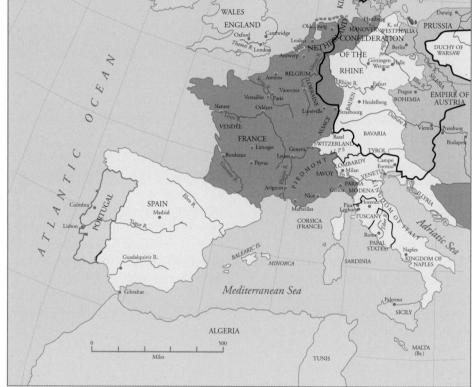

at Monticello (Fig. 687). The colonnade thus came to be associated with the ideal state, and, in the United States, Jefferson's Neoclassical architecture became an almost official Federal style.

Neoclassicism found official favor in France with the rise of Napoleon Bonaparte (see map of Napoleonic Europe, above). In 1799, Napoleon brought the uncertain years that followed the French Revolution to an end when he was declared First Consul of the French Republic. As this title suggests, Napoleon's government was modeled on Roman precedents. He established a centralized government and instituted a uniform legal system. He invaded Italy and brought home with him many examples of classical sculpture, including the *Laocoön* (see Fig. 608) and the *Apollo Belvedere* (see Fig. 30). In Paris itself, he built triumphal Roman arches, including the famous Arc de Triomphe, a column modeled on Trajan's in Rome, and a church, La Madeleine, modeled after the temples of the first Roman emperors. In 1804, Napoleon was himself crowned Emperor of the largest European empire since Charlemagne's in the ninth century.

Neoclassical art was used to legitimate this empire. David saw Napoleon as the salvation of

Napoleon defeated at Battle of Waterloo **1815**

1835

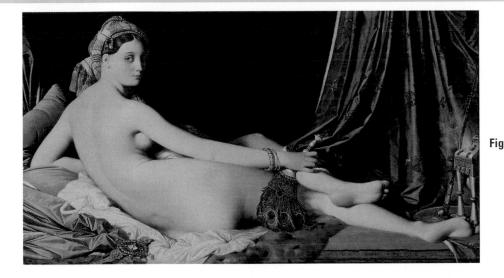

Fig. 688 Jean-Auguste-Dominique Ingres, Grande Odalisque, 1814. Oil on canvas, 35 ¼ × 63 ¾ in. Musée du Louvre, Paris. Herve Lewandowski/RMN Reunion des Musées Nationaux, France/Art Resource, New York.

France (so chaotic had Revolutionary France been that David himself had been imprisoned, a sure sign, he thought, of the confusion of the day), and he received important commissions from the new emperor. But it was David's finest pupil, Jean-Auguste-Dominque Ingres, who became the champion of Neoclassical ideals in the nineteenth century. In 1806, he was awarded the Prix de Rome. He then departed for Italy, where he remained for 18 years, studying Raphael in particular and periodically sending new work back to France.

Ingres's Neoclassicism was "looser" than his master's. Looking at a painting such as the *Grande Odalisque* (Fig. 688), with its long, gently curving limbs, we are more clearly in the

Fig. 687 Thomas Jefferson, *Monticello*, Charlottesville, Virginia, 1770–1784; 1/96–1806. Corbis/Bettmann. Photo: David Muench

world of Mannerist painting than that of the Greek nude. Ingres's color is as rich as Bronzino's in *The Exposure of Luxury* (see Fig. 669), and, in fact, his theme is much the same. Like his odalisques in *The Turkish Bath* (see Fig. 122)—an "odalisque" is a harem slave—Ingres's subject seems more decadent than not, deeply involved in a world of satins, peacock feathers, and, at the right, hashish. Certainly, it is not easy to detect much of the high moral tone of earlier Neoclassical art.

Beside Eugène Delacroix's own Odalisque (Fig. 689), Ingres's classicism becomes more

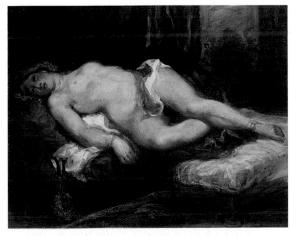

Fig. 689 Eugène Delacroix, Odalisque, 1845–1850. Oil on canvas, 14 ⁷/₈ × 18 ¹/₄ in. © Fitzwilliam Museum, University of Cambridge, England. The Dridgeman Art Library.

First British Reform Act widens suffrage **1832**

1830s First European railroads **1833** Slavery abolished in British Empire

readily apparent. To Ingres, Delacroix, who was a generation younger, represented a dangerous and barbaric Neo-Baroque sensibility in contrast to his own Neoclassicism.

Ingres and Delacroix became rivals. Each had his critical champions, each his students and followers. For Ingres, drawing was everything. Therefore, his painting was, above all, linear in style. Delacroix, however, was fascinated by the texture of paint itself, and in his painterly attack upon the canvas, we begin to sense the artist's own passionate temperament. Viewed beside the Delacroix, the pose of the odalisque in Ingres's painting is positively conservative. In fact, Ingres felt he was upholding traditional values in the face of the onslaught represented by the uncontrolled individualism of his rival.

ROMANTICISM

1830

We have come to call the kind of art exemplified by Delacroix **Romanticism**. At the heart of this style is the belief that reality is a function of each individual's singular point of view, and that the artist's task is to reveal that point of view. Individualism reigned supreme in Romantic art. For this reason, Romanticism sometimes seems to have as many styles as it has artists. What unifies the movement is more a philosophical affirmation of the power of the individual mind than a set of formal principles.

One of the most individual of the Romantics was the Spanish painter Francisco de Goya y Lucientes. After a serious illness in 1792, Goya turned away from a late Rococo style and began to produce a series of paintings depicting inmates of a lunatic asylum and a hospital for wounded soldiers. When Napoleon invaded Spain in 1808, Goya recorded the atrocities both in paintings and in a series of etchings, *The Disasters of War*, which remained unpublished until long after his death. His last, so-called "Black Paintings" were brutal interpretations of mythological scenes that revealed a universe operating outside the bounds of reason, a

 Fig. 690 Francisco Goya, Saturn Devouring One of His Sons, 1820–1822.
 Fresco, transferred to canvas, 57 ⁷/₈ × 32 ⁵/₈ in. Museo del Prado, Madrid. Derechos reservados © Museo Nacional del Prado, Madrid

world of imagination unchecked by a moral force of any kind. In one of these, *Saturn Devouring One of His Sons* (Fig. 690), which was painted originally on the wall of the dining room in Goya's home, Saturn is allegorically a figure for Time, which consumes us all. But it is the incestuous cannibalism of the scene, the terrible monstrosity of the vision itself, that tells us of Goya's own despair. The inevitable conclusion is that, for Goya, the world was a place full of terror, violence, and horror.

WORKS IN PROGRESS Théodore Géricault's THE RAFT OF THE MEDUSA

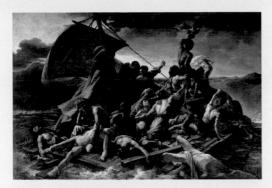

Fig. 691 Théodore Géricault, The Raft of the Medusa, 1819.
Oil on canvas, 16 ft. 1 ¼ in. × 23 ft. 6 in. Musée du Louvre, Paris.
Photo: Herve Lewandowski, Inv.: RF 2229.

© Reunion des Musées Nationaux/Art Resource, NY.

n July 2, 1816, the French frigate *Medusa* was wrecked on a reef off the African coast. The overloaded ship had been carrying soldiers and settlers to Senegal. The captain and

other senior officers escaped in lifeboats, leaving 150 behind to fend for themselves on a makeshift wooden raft. After 12 harrowing days on the raft, only 15 survived. The naval officer who rescued them reported: "These unhappy people had been obliged to fight a great number of their comrades who staged a revolt in the hope of taking over the remaining provisions. The others had been swept out to sea, had died of hunger, or gone mad. The ones I saved had been feeding on human flesh for several days, and when I found them, the ropes serving as maststays were loaded with pieces of such meat, hung there for drying."

The incident infuriated the young painter Théodore Géricault. The captain's appointment had depended on his connections with the French monarchy, which had been restored after Napoleon's defeat at Waterloo. Here, therefore, was clear evidence of the nobility's decadence. To illustrate his beliefs and feelings, Géricault planned a giant canvas, showing the raft just at the moment that the rescue ship, the *Argus*, was spotted on the horizon (Fig. 691). He went to the Normandy coast to study the movement of water. He visited hospitals and morgues to study the effects of illness and death on the human body. He had a model of the raft constructed in his studio and arranged wax figures upon it. His student, Delacroix, posed face down for the central nude.

And all the while he was sketching. An early sketch (Fig. 692) is horizontal in composition, a crowded scene from early on in the ordeal, a claustrophobic and amorphous mass of humanity, with no real focal point or sense of order. The final painting turns the raft on its axis, creating two contradictory pyramidal points of tension. On the left, the mast not only suggests the crucifix but also reveals that the raft is sailing away from its rescuers, while on the right, the survivors climb desperately in their attempt to be seen. Géricault's horrifying picture, exhibited only a few months after it was conceived, fueled the Romantic movement with the passion of its feelings.

Fig. 692 Théodore Géricault, *The Mutiny on the Raft* of the Medusa, 1818.

Black-and-white chalk, black crayon, brown and blue-green watercolor, and white gouache on dark brown modern laid paper, 15 $\frac{3}{4} \times 20$ in. Courtesy of The Fogg Art Museum, Harvard University Art Museums, Cambridge, Massachusetts. Bequest of Grønville L. Winthrop.

Photo © President and Fellows of Harvard College, Harvard University. 1943.824.

Ralph Waldo Emerson publishes *Nature* **1836**

1835

First regular Atlantic steamship service **1840**

1837 Victoria assumes British throne **1844** First telegraphic message

Fig. 693 Caspar David Friedrich, *Monk by the Sea*, 1809–1810. Oil on canvas, 42 ½ × 67 in. Schloss Charlottenburg, Berlin. Joerg P. Anders/Bildarchiv Preussischer Kulturbesitz/Art Resource, New York.

This sense of the terrible is by no means unique to Goya (compare, for instance, Géricault's Raft of the Medusa; see Works in Progress, p. 491). In his own journal, Delacroix wrote, "[The poet] Baudelaire . . . says that I bring back to painting . . . the feeling which delights in the terrible. He is right." It was in the face of the sublime that this enjoyment of the terrible was most often experienced. Theories of the sublime had first appeared in the seventeenth century, most notably in Edmund Burke's Inquiry into the Origin of Our Ideas of the Sublime and the Beautiful (1756). For Burke, the sublime was a feeling of awe experienced before things that escaped the ability of the human mind to comprehend them-mountains, chasms, storms, and catastrophes. The sublime exceeded reason; it presented viewers with something vaster than themselves, thereby making them realize their smallness, even their insignificance, in the face of the infinite. The sublime evokes the awe-inspiring forces of Nature, as opposed to the Beautiful, which is

associated with Nature at her most harmonious and tranquil. A pastoral landscape may be beautiful; a vast mountain range, sublime.

No painting of the period more fully captures the terrifying prospect of the sublime than Caspar David Friedrich's *Monk by the Sea* (Fig. 693). It indicates just how thoroughly the experience of the infinite—that is, the experience of God—can be found in Nature. But the God faced by this solitary monk is by no means benign. The infinite becomes, in this painting, a vast, dark, and lonely space—so ominous that it must surely test the monk's faith. The real terror of this painting lies in its sense that the eternal space stretching before this man of faith may not be salvation but, instead, a meaningless void.

American landscape painters such as Albert Bierstadt (see Fig. 5), Thomas Moran (see Fig. 300), and Frederic Church continually sought to capture the sublime in their paintings of the vast spaces of the American West. Church even traveled to South America Age of the realistic novel begins **1840s**

> **1847** Charlotte Brontë, *Jane Eyre*

1848

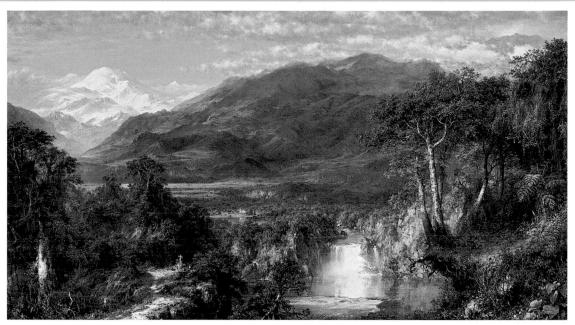

Fig. 694 Frederic Edwin Church, The Heart of the Andes, 1859.
 Oil on canvas, 66 ¼ × 119 ¼ in. Metropolitan Museum of Art, New York. Bequest of Margaret E. Dows, 1909 (09.95).
 Photo © 1979 Metropolitan Museum of Art.

to bring evidence of its exotic and remarkable landscapes to viewers in America and Europe. His painting The Heart of the Andes (Fig. 694) was first exhibited in 1859 in New York in a one-picture, paid-admission showing. The dramatic appeal of the piece was heightened by brightly lighting the picture and leaving the remainder of the room dark, and by framing it so that it seemed to be a window in a grand house looking out upon this very scene. Deemed by critics "a truly religious work of art," it was a stunning success. The insignificance of humanity can be felt in the minuteness of the two figures, barely visible in this reproduction, praying at the cross in the lower left, but the scene is by no means merely sublime. It is also beautiful and pastoral in feeling, and, in the careful rendering of plant life, it is almost scientific in its fidelity to nature.

The Romantic painter was, in fact, interested in much more than the sublime. A Romantic artist might render a beautiful scene as well as a sublime one, or one so pastoral in feeling that it recalls, often deliberately, Claude's soft Italian landscapes (see Fig. 678). It was the love of Nature itself that the artist sought to convey. In Nature, the American poet and essayist Ralph Waldo Emerson believed, one could read eternity. It was a literal "sign" for the divine spirit.

The painter, then, had to decide whether to depict the world with absolute fidelity or to reconstruct imaginatively a more perfect reality, out of a series of accurate observations. As one writer put it at the time, "A distinction must be made . . . between the elements generated by . . . direct observation, and those which spring from the boundless depth and feeling and from the force of idealizing mental power." As we have seen in our discussion of painting in Chapter 12, the idealizing force of the imagination in painting distinguished it from mere copywork. Nevertheless, and though Church's The Heart of the Andes is an idealist compilation of diverse scenes, in many of its details-in, for instance, the accuracy with which the foliage has been rendered-it depends on direct observation.

Revolutions across Europe, in France, Vienna, Rome, Venice, Berlin, Milan, and Prague **1848**

1848

1848

The Communist Manifesto

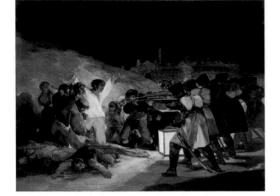

Fig. 695 Francisco Goya, The Third of May, 1808, 1814–1815.
Oil on canvas, 8 ft. 9 in. × 13 ft. 4 in. Museo del Prado, Madrid.
© Museo Nacional del Prado. Photo: Oronoz.

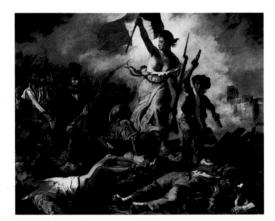

 Fig. 696 Eugène Delacroix, Liberty Leading the People, 1830.
 Oil on canvas, 8 ft. 6 ³/₈ in. × 10 ft. 8 in. Musée du Louvre, Paris.
 Bridgeman-Giraudon/Art Resource, New York.

REALISM

Church's accurate rendering of foliage reflects the importance of scientific, empirical observation to the nineteenth century as a whole, an urge for **realism** that runs counter to, and exists alongside, the imaginative and idealist tendencies of the Romantic sensibility. If we compare three history paintings from the first half of the nineteenth century, we can see how the idealizing tendency of the Romantic sensibility gradually faded away. Faced with the reality of war, idealism seemed absurd. Francisco Goya's *The*

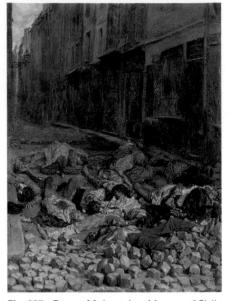

Fig. 697 Ernest Meissonier, Memory of Civil War (The Barricades), 1849.
Oil on canvas, 11 ¹/₂ × 8 ³/₄ in. Musée du Louvre, Paris. Scala/Art Resource, New York.

Third of May, 1808 (Fig. 695) depicts an actual event, the execution of citizens of Madrid by Napoleon's invading army. Its dramatic lighting and the Christ-like outstretched arms of the man about to be shot reflect the conventions of Baroque religious art, but the promise of salvation seems remote. The church in the background is shrouded in darkness, and the man will fall forward, like the others before him, a bloody corpse. Eugène Delacroix's Liberty Leading the People (Fig. 696) represents Liberty as an idealized allegorical figure, but the battle itself, which took place during the July Revolution of 1830, is depicted in a highly realistic manner, with figures lying dead on the barricades beneath Liberty's feet and Notre Dame Cathedral at the distant right shrouded in smoke. In Ernest Meissonier's Memory of Civil War (The Barricades) (Fig. 697), all the nobility of war has been drained from the picture. The blue, white, and red of the French flag have been reduced to piles of tattered clothing and blood, what one contemporary gruesomely described as an "omelette of men."

World population reaches about 1.1 billion **1850** Admiral Perry's visit ends Japanese isolation **1854**

1854

1851 Herman Melville, *Moby Dick*

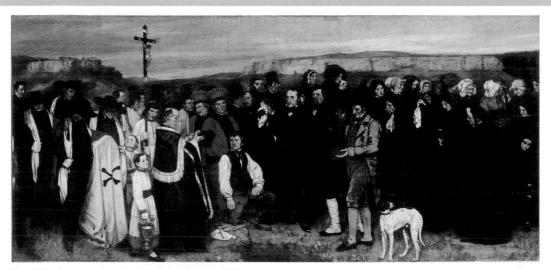

 Fig. 698 Gustave Courbet, Burial at Ornans, 1849.
 Oil on canvas, 10 ft. 3 ¹/₂ in. × 21 ft. 9 in. Musée d'Orsay, Paris. RMN Reunion des Musées Nationaux/Art Resource, New York.

Fig. 699 Honoré Daumier, Fight between Schools, Idealism and Realism, 1855. Embassy of the Federal Republic of Germany.

So thoroughly did the painter Gustave Courbet come to believe in recording the actual facts of the world around him that he declared, in 1861, "Painting is an essentially concrete art and can only consist of the presentation of real and existing things. It is a completely physical language, the words of which consist of all visible objects." Courbet and others ascribing to realism believed artists should confine their representation to accurate observation and notation of the phenomena of daily life. No longer was there necessarily any

"greater" reality beyond or behind the facts that lay before their eyes. Courbet's gigantic painting Burial at Ornans (Fig. 698) seems, at first glance, to hold enormous potential for symbolic and allegorical meaning, but just the opposite is the case. In the foreground is a hole in the ground, the only "eternal reward" Courbet's scene appears to promise. No one, not even the dog, seems to be focused on the event itself. Courbet offers us a panorama of distraction, of common people performing their everyday duties, in a landscape whose horizontality reads like an unwavering line of monotony. If the crucifix rises into the sky over the scene, it does so without deep spiritual significance. In fact, its curious position, as if it were set on the horizon line, lends it a certain comic dimension, a comedy that the bulbous faces of the red-cloaked officers of the parish also underscore. The painting was rejected by the jury of the Universal Exposition of 1855. To emphasize his disdain for the values of the establishment, Courbet opened a one-person exhibition outside the Exposition grounds, calling it the Pavilion of Realism. The cartoonist Honoré Daumier immediately responded with a cartoon depicting the Fight between Schools, Idealism and Realism (Fig. 699).

1854

1859 Charles Darwin, *The Origin of Species*

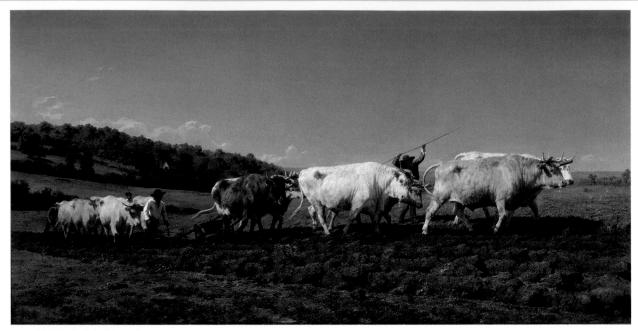

Fig. 700 Rosa Bonheur, *Plowing in the Nivernais*, 1849.
 Oil on canvas, 5 ft. 9 in. × 8 ft. 8 in. Musée d'Orsay, Paris.
 Gerard Blot/Reunion des Musées Nationaux. Art Resource, New York.

The Courbet-like realist, with his square palette, house painter's brush, and wooden shoes, battles the aged, classically nude idealist, who wears the helmet of a Greek warrior.

It was, at least in part, the realist impulse that led to the invention of photography in the 1830s (see Figs. 364 and 365) And it was also in this spirit that Karl Marx, in The Communist Manifesto, declared: "All that was solid and established crumbles away, all that was holy is profaned, and man is at last compelled to look with open eyes upon his conditions of life and true social relations." Marx's sentiments, written in response to the wave of revolutions that swept Europe in 1848, are part and parcel of the realist enterprise. Rosa Bonheur's Plowing in the Nivernais (Fig. 700) was commissioned in response to the French Revolution of 1848. It reveals her belief in the virtue of toil and the common life of the French peasant. But it is her realism, her extraordinary ability to depict animals, that made her the most famous female artist of her day. It was, suddenly, socially and aesthetically important, even imperative, to paint neither the sublime nor the beautiful nor the picturesque, but the everyday, the commonplace, the low, and the ugly. Painters, it was felt, must represent the reality of their time and place, whatever it might look like.

As Daumier's cartoon makes clear, the art of the past, exemplified by the Classical model, was felt to be worn out, incapable of expressing the realities of contemporary life. As the poet Charles Baudelaire put it, "*Il faut être de son temps*"—"it is necessary to be of one's own time." He looked everywhere for a "painter of modern life." The modern world was marked by change, by the uniqueness of every moment, each instant, like a photograph, different from the last. Painting had to accommodate itself to this change. There were no longer any permanent, eternal truths. Emancipation of serfs in Russia **1861** Slavery abolished in United States 1863

1865

1861–65 American Civil War **1864** Development of pasteurization process

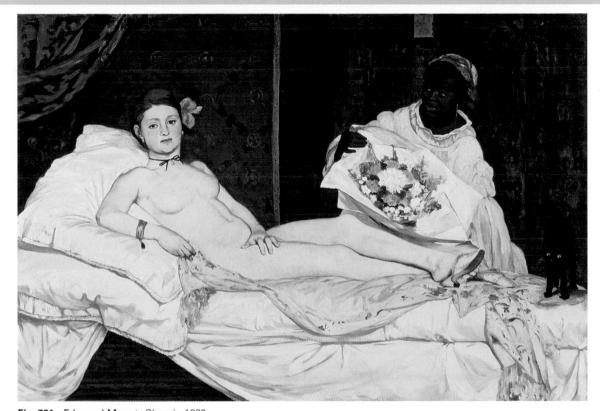

Fig. 701 Edouard Manet, Olympia, 1863. Oil on canvas, 51 × 74 ³/₄ in. Musée d'Orsay, Paris. RMN Reunion des Musées Nationaux/Art Resource, NY. © 2007 Edouard Manet/Artists Rights Society (ARS), New York.

Baudelaire's painter of modern life was Edouard Manet. As we have already seen in Chapter 4, Manet's Luncheon on the Grass (see Fig. 71), more commonly known by its French name Déjeuner sur l'herbe, caused an outcry when it was first exhibited in 1863. Two years later, at the Salon of 1865, Manet exhibited another picture that caused perhaps an even greater scandal. Olympia (Fig. 701) was a depiction of a common prostitute posed in the manner of the traditional odalisque. Though it was not widely recognized at the time, Manet had, in this painting, by no means abandoned tradition completely in favor of the depiction of everyday life in all its sordid detail. Olympia was directly indebted to Titian's Venus of Urbino (compare Fig. 656), just as the Déjeuner sur l'herbe had been based on a composition by Raphael (see Fig. 72)

Manet's sources were classical. His treatment, however, was anything but. What most irritated both critics and public was the apparently "slipshod" nature of his painting technique. Olympia's body is virtually flat. Manet painted with large strokes of thick paint. If he distorted perspective in *Le Déjeuner*—the bather in the background seems about to spill forward into the picnic—then he eliminated perspective altogether in the shallow space of the *Olympia*, where the bed appears to be no wider than a foot or two.

Manet's rejection of traditional painting techniques was intentional. He was drawing attention to his very modernity, to the fact that he was breaking with the past. His manipulation of his traditional sources supported the same intentions. In Marx's words, Manet is looking "with open eyes upon his conditions Fyodor Dostoyevsky, Crime and Punishment **1866**

1865

Suez Canal links Mediterranean and Red Seas **1869**

1869 *The Subjugation of Women,* by John Stuart Mill **1869** Tolstoy completes *War and Peace*

of life and true social relations." Olympia's eyes directly confront us. The visitor, who is implicitly male, becomes a voyeur, as the female body is subjected to the male gaze. It is as if the visitor, who occupies our own position in front of the scene, has brought the flowers, and the cat, barely discernible at Olympia's feet, has arched its back to hiss at his approach. The Venus that once strode the heights of Mt. Olympus, home of the gods, is now the common courtesan. "Love" is now a commodity, something to be bought and sold.

In his brushwork, particularly, Manet pointed painting in a new direction. His friend, the novelist Emile Zola, who was the first to defend Olympia, described it this way: "He catches his figures vividly, is not afraid of the brusqueness of nature and renders in all their vigor the different objects which stand out against each other. His whole being causes him to see things in splotches, in simple and forceful pieces." Manet was something of a professional observer-a famous *flâneur*, a Parisian of impeccable dress and perfect manners who strolled the city, observing its habits and commenting on it with the greatest subtlety, wit, and savoirfaire. The type can be seen strolling toward the viewer in Gustave Caillebotte's Place de l'Europe on a Rainy Day (see Fig. 134). Wrote Manet's friend Antonin Proust: "With Manet, the eye played such a big role that Paris has never known a *flâneur* like him nor a *flâneur* strolling more usefully."

Edgar Degas's *The Glass of Absinthe* (Fig. 702) was painted a decade after Manet's *Olympia*, but it was directly influenced by Manet's example. Degas's wandering eye has caught the underside of Parisian café society. Absinthe was an alcoholic drink that attacked the nerve centers, eventually causing severe cerebral damage. Especially popular among the working classes, it was finally banned in France in 1915. In the dazed, absent look of this young woman, Degas reveals the consequences of absinthe consumption with a shockingly direct realism worthy of Courbet.

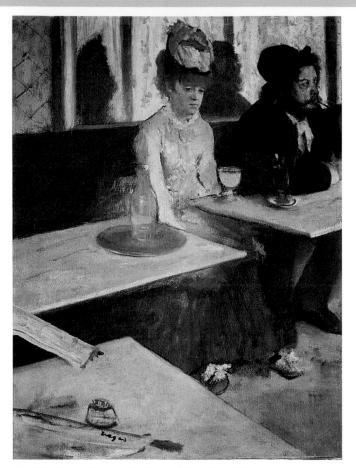

Fig. 702 Edgar Degas, *The Glass of Absinthe*, 1876. Oil on canvas, 36 × 27 in. Musée d'Orsay, Paris. Scala/Art Resource, New York.

European powers carve up Africa 1870s and 1880s

1880

1870s European birth and death rates begin to decline

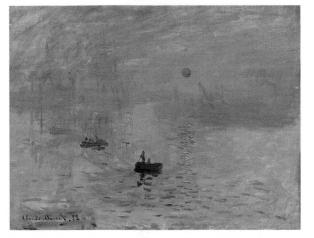

Fig. 703 Claude Monet, Impression-Sunrise, 1872. Oil on canvas, 19 1/2 × 25 1/2 in. Musée Marmottan, Paris. Giraudon-Bridgeman Art Library, International Ltd.

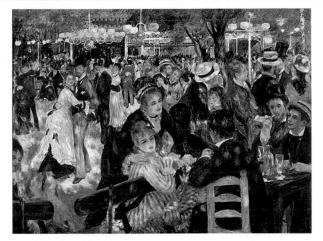

Fig. 704 Auguste Renoir, La Moulin de la Galette, 1876.
 Oil on canvas, 51 ¹/₂ × 69 in. Musée d'Orsay, Paris.
 © Bridgeman-Giraudon/Art Resource, New York.

IMPRESSIONISM

In the late 1860s, the young painter Claude Monet began to employ the same rich, thick brushstrokes Manet was already using, but with an even looser hand. Combining two or more pigments on a single wide brush, he allowed them to blend as they were brushed onto the canvas. He would paint "wet on wet"—with wet pigment over and through an already painted surface that had not yet dried. Most of all, he painted with the intense hues made possible by the development of synthetic pigments.

Others followed his lead, and together, in April 1874, they held a group exhibition. They called themselves "Painters, Sculptors, Engravers, etc. Inc.," but before long they were known as the **Impressionists**. The painting that gave them their name was Monet's *Impression-Sunrise* (Fig. 703). Monet, the critic Théodore Duret wrote in 1878, "is the Impressionist painter par excellence. . . . [He] has succeeded in setting down the fleeting impression which his predecessors had neglected or considered impossible to render with the brush . . . the fleeting appearances which the accidents of atmosphere present to him . . . a singularly lively and striking sensation of the observed scene. His canvases really do communicate impressions." The paintings, in fact, have the feel of sketches, as if they were executed spontaneously, even instantaneously, in the manner of photographic snapshots.

The Impressionists' subject matter sets them apart from their predecessors at least as much as their technique does. Unlike the Realist painters of a generation earlier, the Impressionists were less interested in social criticism than in depicting in their work the pleasures of life, including the pleasures of simply seeing. If Impressionism is characterized by a way of seeing-by the attempt to capture the flecting effects of light by applying paint in small, quick strokes of color-it is also defined by an intense interest in images of leisure. The Realists would have rejected these images as unworthy of their high moral purposes. The Impressionists painted life in the Parisian theaters and cafés, the grand boulevards teeming with shoppers, country gardens bursting with flowers, the racetrack and seaside, the suburban pleasures of boating and swimming on the Seine. Auguste Renoir's La Moulin de la Galette (Fig. 704) is typical. All of the figures in the painting are Renoir's Invention of phonograph **1877**

1877 First public telephone system installed in New Haven, Connecticut

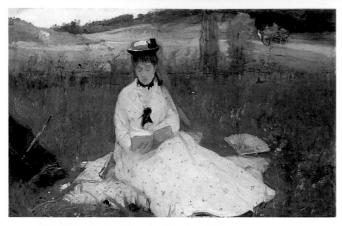

1877

Fig. 705 Berthe Morisot, *Reading*, 1873.
Oil on canvas, 17 ³/₄ × 28 ¹/₂ in.
The Cleveland Museum of Art. Gift of the Hanna Fund, 1950.89.
© 1999 The Cleveland Museum of Art.

friends. One of his closest, Georges Rivière, seated at the table at the far right, described the painting soon after it was shown at the third Impressionist exhibition in 1877: "It is a page of history, a precious monument to Parisian life, done with rigorous exactitude. No one before Renoir had thought of portraying an event in ordinary life on a canvas of such big dimensions."

The distance of Impressionist painting from its Realist predecessors is summed up in Berthe Morisot's *Reading* (Fig. 705), probably one of four paintings Morisot exhibited at the first Independents Exhibition in 1874. In the background, a farmer's cart heads down the road, the proper subject matter of the Realist. But Morisot's sister, depicted in the painting, has no interest in what passes behind her, and neither really does the painter herself. The cart is rendered in a few loose, rapid brushstrokes, as is the entire landscape. Leisure is Morisot's subject.

Increasingly, this urge to observe the world in its most minute particulars led to the investigation of optical reality in and for itself. As early as the 1870s, in his paintings of boats on the river at Argenteuil (see Fig. 41), Monet began to paint the same subject over and over again, studying the ways in which the changing light transformed his impressions. This working

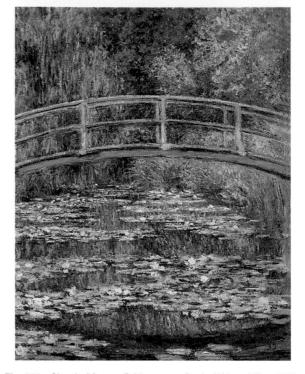

Fig. 706 Claude Monet, Bridge over a Pool of Water Lilies, 1899.
 Oil on canvas, 36 ¹/₂ × 29 in. Metropolitan Museum of Art, New York. H. O. Havemeyer Collection. Bequest of Mrs. H. O. Havemeyer, 1929 (29.100.113).
 Photo © 1984 Metropolitan Museum of Art.

method led to his later serial studies of the grainstacks (see Figs. 29 and 193), Rouen Cathedral, and his garden at Giverny (Fig. 706), where he moved in 1883. By the turn of the century, he had given up painting "modern life" altogether, concentrating instead on capturing the "presentness" of his garden, the panoramic views that would be installed in the Orangerie in Paris in 1927 (see Fig. 211).

For many artists, painting began to be an end in itself, a medium whose relation to the actual world was at best only incidental. In England, the American expatriate James McNeill Whistler equated his paintings to musical compositions by titling them "nocturnes" and "symphonies." He painted, he said, "as the musician gathers his notes, and forms his chords, until he brings forth from chaos glorious harmony." Painting was, for Whistler, primarily an abstract

1880 Invention of electric lights Germany introduces the first social security laws **1883**

1883

First skyscraper built in Chicago

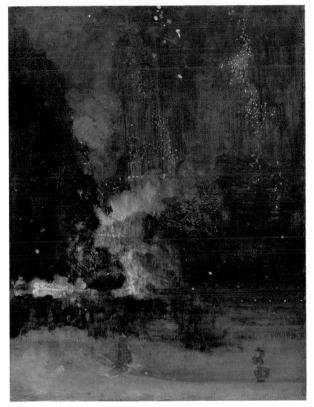

Fig. 707 James McNeill Whistler, Nocturne in Black and Gold, the Falling Rocket, c. 1875.
Oil on oak panel, 23 ³/₄ × 18 ³/₈ in. Detroit Institute of Arts. Gift of Dexter M. Ferry, Jr., 46.309. The Bridgeman Art Library Inc.

arrangement of shapes and colors; only incidentally did it refer to the world. Believing that art should possess strong moral content, the English essayist John Ruskin was blind to Whistler's abstraction. After viewing *Nocturne in Black and Gold, the Falling Rocket* (Fig. 707), an image of fireworks falling over the Thames, Ruskin wrote that Whistler was "flinging a pot of paint in the public's face." Whistler, in turn, sued Ruskin for libel. A lengthy trial followed, and in 1878 Whistler finally won his case, but he was awarded damages of only a farthing, approximately half a U.S. cent. If artists were free to paint anything they wanted, they also had to accept whatever criticism came their way. 1884–85 International Conference in Berlin to decide the future of Africa 1885

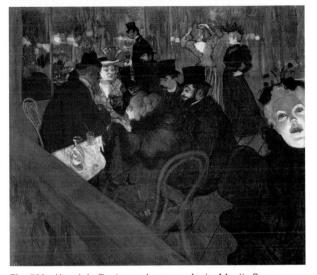

Fig. 708Henri de Toulouse-Lautrec, At the Moulin Rouge,
1892–1895.Oil on canvas, 48 3/8 × 55 1/4 in. Art Institute of Chicago.
Helen Birch Bartlett Memorial Collection, 1928.610.

Photo © 2006 Art Institute of Chicago. All rights reserved.

POST-IMPRESSIONISM

Although, by the 1880s, many artists had come to see Impressionism's subject matter as trivial, they were still interested in investigating and extending its formal innovations and in reexamining the symbolic possibilities of painting. Monet's work at Giverny can be seen as an example of just such an ongoing formal exploration. A number of other painters-among them Henri de Toulouse-Lautrec, Vincent van Gogh, Paul Gauguin, Georges Seurat, and Paul Cézanne-embarked on a similar brand of Post-Impressionism, each dedicated to redirecting the Impressionist enterprise. Toulouse-Lautrec returned to the kind of direct criticism of modern life that had marked the work of Manet and Degas. His painting At the Moulin Rouge (Fig. 708), for instance, celebrates Parisian night life like the work of the Impressionists before him, but the grotesquely gas-lit features of the woman on the right capture a decadence that, by century's end, pervaded Parisian life. Van Gogh and Gauguin, it was Kodak camera invented 1888

1889 Eiffel Tower built in Paris

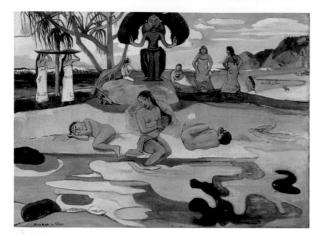

Fig. 709 Paul Gauguin, *The Day of the Gods (Mehana no Atua),* 1894.

Oil on canvas, 26 $\frac{7}{8} \times 36 \frac{1}{8}$ in. Art Institute of Chicago. Helen Birch Bartlett Memorial Collection, 1926.198. Photo © 2007 Art Institute of Chicago. All rights reserved.

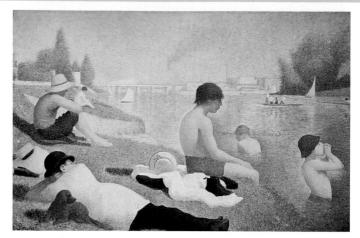

Fig. 710 Georges Seurat, The Bathers, 1883–1884. Oil on canvas, 79 ½ × 118 ½ in. The National Gallery, London. Reproduced by courtesy of the Trustees. Erich Lessing/Art Resource, New York.

felt even at the time, released artists from the need to copy nature. Color could now be used arbitrarily to express emotions (see van Gogh's *Night Café*, Fig. 199).

Like Toulouse-Lautrec, Paul Gauguin criticized the conditions of modern life, but he did so by leaving Europe and seeking out a new life in the South Seas. There, in paintings such as *The Day of the Gods (Mahana no Atua)* (Fig. 709), he tried to capture the mystery and magic of the "primitive" culture, a world of unity, peace, and naked innocence far removed from the turmoil of civilized life. The perfect balance of the painting's composition and the brilliant color of the scene are structural realizations of paradise on earth.

In paintings such as A Sunday on La Grande Jatte (see Fig. 186), Georges Seurat sought to impose a formal order upon the world, and in the process, he revealed its rigidity, its lack of vitality. Though Seurat's subject matter in *The Bathers* (Fig. 710) is Impressionist, his composition is not. It is architectural, intentionally returning to the seventeenthcentury compositional principles of Poussin (see Fig. 681). And it subtly critiques the image of Impressionist leisure. These are not well-to-do middle-class Parisians, but workers (their costume gives them away) swimming in the Seine just downriver from the factory town of Asnières. Smokestacks belch soot in the distance. The spot, as observant Parisians knew, was directly across from the outlet of the great collective sewer from Paris. In the summer of 1884, according to the local press, "more than 120,000 cubic feet of solids had accumulated at the sewer's mouth; several hundred square meters of which are covered with a bizarre vegetation, which gives off a disgusting smell." Suddenly, the green material floating in the water is transformed.

Of all the Post-Impressionist painters, Paul Cézanne, working alone in the south of France, most thoroughly emphasized the formal aspects of painting at the expense of subject matter, and in this he looked forward most to the direction of art in the twentieth century. Cézanne pushed toward an idea of painting that established for the picture an independent existence, to be judged in terms of the purely formal interrelationships of line, color, and plane. In his *Still Life with Cherries and*

Discovery of radium
1898

1895 Invention of motion picture camera

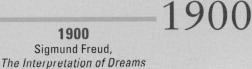

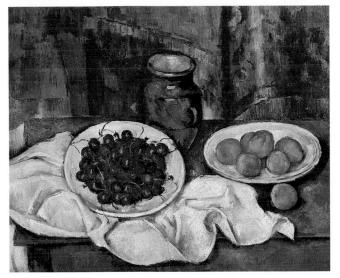

Fig. 711 Paul Cézanne, Still Life with Cherries and Peaches, 1885–1887.

Oil on canvas. 19 $\frac{3}{4} \times 24$ in. Los Angeles County Museum of Art. Gift of Adele R. Levy Fund. Inc., and Mr. and Mrs. Armand S. Deutsch, M.61.1. Photo © 2005 Museum Associates/LACMA.

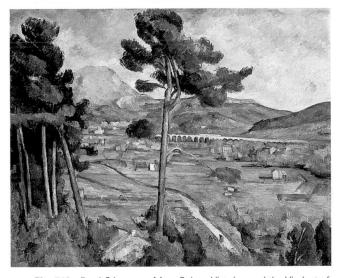

Fig. 712 Paul Cézanne, Mont Sainte-Victoire, and the Viaduct of the Arc River Valley, 1882–1885.
Oil on canvas, 25 ³/₄ × 32 ¹/₈ in. Metropolitan Museum of Art, New York. H. O. Havemeyer Collection. Bequest of Mrs. H. O. Havemeyer, 1929 (29.100.64).
Photo © 1984 Metropolitan Museum of Art.

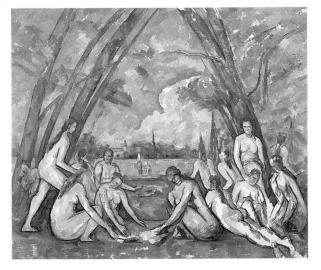

Fig. 713 Paul Cézanne, *The Large Bathers*, 1906.
Oil on canvas, 82 × 99 in. Philadelphia Museum of Art.
Purchased with the W. P. Wilstach Fund, W 1937-1-1.

Peaches (Fig. 711), he emphasizes the act of composition itself, the process of seeing. It is as if he has rendered two entirely different views of the same still life simultaneously. The peaches on the right are seen from a point several feet in front of the table, while the cherries on the left have been painted from directly above. As a consequence, the table itself seems to broaden out behind the cherries.

Similarly, Mont Sainte-Victoire and the Viaduct of the Arc River Valley (Fig. 712) collapses the space between foreground and background by making a series of formal correspondences between them: By the repetition of the shape of the lower right-hand branch of the tree, for instance, the road below it, and the shape of the mountain itself. Finally, in The Large Bathers (Fig. 713), the pyramidal structure of the composition draws attention to the geometry that dominates even the individual faceting of the wide brushstrokes, which he laid down as horizontals, verticals, and diagonals. The simplification of the human body evident here, as well as Cézanne's overall emphasis on form, had a profound effect on painting in the twentieth century. It is in Cézanne that the art of the twentieth century dawns.

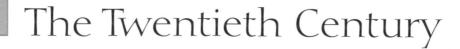

n the autumn of 1906 and throughout 1907, Pablo Picasso painted his portrait of Gertrude Stein (see Fig. 52) and then embarked on his monumental and groundbreaking painting Les Demoiselles d'Avignon (see Fig. 66). At the time, Paris was inundated with exhibitions of the work of Cézanne, which were to have a profound effect on the development of modern art. Soon after Cézanne died, in October 1906, a retrospective of 79 of his last watercolors was exhibited at the Bernheime-Jeune Gallery. At the Salon in the autumn of 1907, another retrospective of Cézanne's late paintings, mostly oils, appeared. In his letters to the painter Emile Bernard, which were published posthumously in the Paris press, Cézanne advised painters to study nature in terms of "the cylinder, the sphere, the cone."

CUBISM THE FAUVES GERMAN EXPRESSIONISM FUTURISM DADA AND SURREALISM Works in Progress Pablo Picasso's Guernica

AMERICAN MODERNISM AND ABSTRACT EXPRESSIONISM

CHAPTER

POP ART AND MINIMALISM

POSTMODERN DIRECTIONS

■ Works in Progress Frank Gehry's Guggenheim Bilbao

The Critical Process Thinking about the History of Art

First radio message sent across the Atlantic **1901**

1901 Ragtime jazz develops in United States

1905 Revolution in Russia 1905

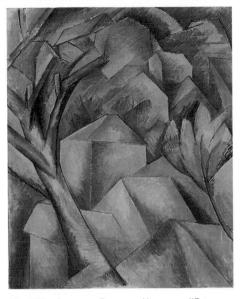

 Fig. 714 Georges Braque, Houses at l'Estaque, 1908.
 Oil on canvas, 28 ³/₄ × 23 ³/₄ in. Hermannn and Margit Rupf Foundation.
 © 2007 Artists Rights Society (ARS), New York/ADAGP, Paris.

CUBISM

Picasso was already under the influence of Cézanne when he painted Les Demoiselles, and when Georges Braque saw first Picasso's painting and then Cézanne's retrospective, he began to paint a series of landscapes based on their formal innovations. His Houses at l'Estaque (Fig. 714) takes Cézanne's manipulation of space even farther than the master did. The tree that rises from the foreground seems to meld into the roofs of the distant houses near the top of the painting. At the right, a large, leafy branch projects out across the houses, but its leaves appear identical to the greenery that is growing between the houses behind it. It becomes impossible to tell what is foreground and what is not. The houses descending down the hill before us are themselves spatially confusing. Walls bleed almost seamlessly into other walls, walls bleed into roofs, roofs bleed into walls. Braque presents us with a design of triangles and cubes as much as he does a landscape.

Together, over the course of the next decade, Picasso and Braque created the movement known

Fig. 715 Georges Braque, Violin and Palette, Autumn 1909.
Oil on canvas, 36 ¼ × 16 ⅔ in. Solomon R. Guggenheim Museum, New York. 54.1412.
© The Solomon R. Guggenheim Foundation, New York. Photo by David Heald. © 2007 Artists Rights Society (ARS), New York/ADAGP, Paris.

as **Cubism**, of which Braque's *Houses at l'Estaque* is an early example. The name derived from a comment made by the critic Louis Vauxcelles in a small review that appeared directly above a headline announcing the "conquest of the air" by the Wright brothers: "Braque . . . reduces everything, places and figures and houses, to geometric schemes, little cubes." It was, as the accidental juxtaposition of Cubism and the Wright brothers suggested, a new world.

Other artists soon followed the lead of Picasso and Braque, and the impact of their art can be felt everywhere. For the Cubist, art was primarily about form. Analyzing the object from all sides and acknowledging the flatness of the picture plane, the Cubist painting represented the three-dimensional world in increasingly two-dimensional terms. The curves of the violin in Braque's *Violin and Palette* (Fig. 715) are flattened and cubed, so much so that Einstein's Theory of Relativity **1905**

1905 Debussy, *La Mer*

in places the instrument seems as flat as the sheets of music above it. The highly realistic, almost *trompe-l'oeil* nail at the painting's top introduces another characteristic of Cubist work. Casting its own shadow, it can be seen either as part of the painting, holding up the palette, or as real, holding the painting to the wall. Such play between the reality of painting and the reality of the world soon led both Picasso and Braque to experiment with collage, which we discussed in Chapter 12. Perhaps most important, Cubism freed painting of the necessity to represent the world. Henceforth, painting could be primarily about painting.

THE FAUVES

1905

Though the Cubists tended to deemphasize color in order to emphasize form, Henri Matisse favored the expressive possibilities of color. Matisse, in a sense, synthesized the art of Cézanne and Seurat, taking the former's broad, flat zones of color and the latter's interest in setting complementary hues beside one another. Under the influence of Van Gogh, whose work had not been seen as a whole until an exhibition at the Bernheim-Jeune Gallery in 1901, Matisse felt free to use color arbitrarily. A number of other young painters joined him, and in the fall of 1905 they exhibited together at the Salon, where they were promptly labeled Fauves ("Wild Beasts"). Not long after the exhibition, Matisse painted a portrait of his wife known as The Green Stripe (Fig. 716) for the bright green stripe that runs down the middle of her face. The painting is a play between zones of complementary colors, and in its emphasis on blue-violet, red-orange, and green, it relies on the primary colors of light, not pigment. Although some critics ridiculed them, the Fauves were seen by others as promising a fully abstract art. The painter Maurice Denis wrote of them: "One feels completely in the realm of abstraction. Of course, as in the most extreme departures of van Gogh, something still remains of the origiRobert E. Perry reaches the North Pole **1909**

1910 Japan annexes Korea

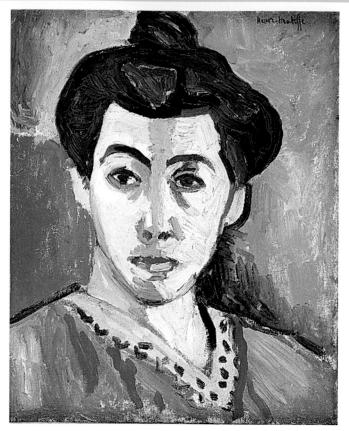

Fig. 716 Henri Matisse, The Green Stripe (Madame Matisse), 1905.

Oil and tempera on canvas, 15 $\frac{7}{8} \times 12 \frac{7}{8}$ in. Statens Museum for Kunst, Copenhagen. J. Rump Collection. © 2007 Succession H. Matisse, Paris/Artists Rights Society (ARS) New York.

nal feeling of nature. But here one finds, above all in the work of Matisse, the sense of . . . painting in itself, the act of pure painting."

GERMAN EXPRESSIONISM

It was in Germany that Denis's idea of "pure painting" fully took hold. In Dresden, a group of artists known as *Die Brücke* ("The Bridge"), among them Ernst Kirchner and Emil Nolde (see Fig. 293), advocated a raw and direct style, epitomized by the slashing gouges of the woodblock print. A group of Titanic sinks on its maiden voyage **1912**

Panama Canal opens 1914

1914

1910 Stravinsky, *The Firebird* **1914** 10.5 million immigrants enter the U.S.

Fig. 717 Wassily Kandinsky, "Sketch I for Composition VII," 1913. Oil on canvas. 30 $\frac{3}{4} \times 39 \frac{3}{8}$ in (78 × 100 cm). Private Collection. © Artists Rights Society (ARS), New York, NY.

artists known as *Der Blaue Reiter* ("The Blue Rider") formed in Munich around the Russian Wassily Kandinsky. They believed that through color and line alone works of art could *express* the feelings and emotions of the artist directly to the viewer—hence the name **Expressionism.**

In the 1890s, Kandinsky had seen an exhibition of Monet's "Grainstacks." Noting how the grainstacks themselves seemed to disintegrate in the diffuse light, Kandinsky was convinced that "the importance of an 'object' as the necessary element in painting" was suspect. Nothing of the geometry of Cubism can be detected in Kandinsky's early paintings such as *Sketch I for "Composition VII"* (Fig. 717). Like Whistler before him, Kandinsky considered his painting to be equivalent to music, and his works are alive in nonfigurative movement and color. Each D. W. Griffith, Birth of a Nation **1915** Worldwide influenza epidemic **1918–19**

1914–18 World War I

1914

1917 Bolsheviks seize power in Russia

1920 Carl Jung publishes *Psychological Types*

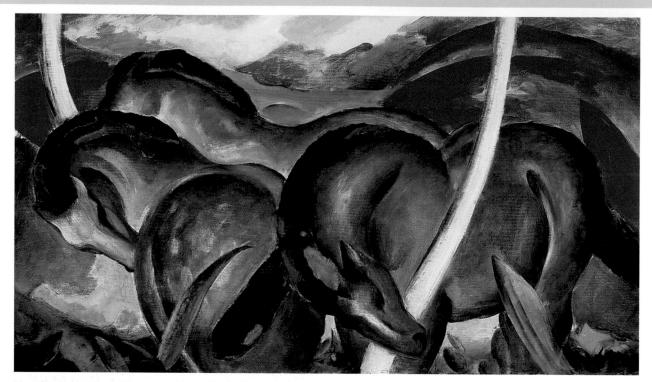

Fig. 718 Franz Marc, Die grossen blauen Pferde (The Large Blue Horses), 1911.
 Oil on canvas, 41 ⁵/₁₆ × 71 ¹/₄ in. Walker Art Center, Minneapolis.
 Gift of the T. B. Walker Foundation, Gilbert M. Walker Fund, 1942.

color and each line carried, for Kandinsky, explicit expressive meaning (see Fig. 200). He believed that paintings like his had "the power to create [a] spiritual atmosphere" that would "lead us away from the outer to the inner basis."

The paintings of the Fauves (see Fig. 716) convinced Kandinsky that through color he could eliminate the object altogether. "Color," Kandinsky wrote in his 1911 essay *Concerning the Spiritual in Art*, "is able to attain what is most universal yet at the same time most elusive in nature: its inner force."

Kandinsky's ideas find remarkable expression in the work of another member of the Blue Rider group, Franz Marc, who adopted Kandinsky's color symbolism to the depiction of animals. "I try to heighten my feeling for the organic rhythm of all things," Marc wrote, "to feel myself pantheistically into the trembling and flow of the blood of nature." More than any other German painter, Marc understood the sensuality of Matisse's line and employed it in his work. His use of color, which echoes, of course, the name of the movement to which he belonged, is liberated from the world of appearance, but it is highly emotional. He painted horses over and over again (Fig. 718). Sometimes they were blue—Marc associated blue with masculinity, strength, and purity—sometimes red, sometimes yellow, depending on his emotions as he was painting. Marc never fulfilled his promise as a painter. He was killed fighting in World War I in 1916.

FUTURISM

If abstraction was the hallmark of the new century, certain thematic concerns defined it as well. The world had become, quite literally, a Arnold Schoenberg develops 12-tone music **1921** Adolf Hitler, Mein Kampf 1925

1925

Formulation of

quantum mechanics

1925

1922 Mussolini assumes power in Italy

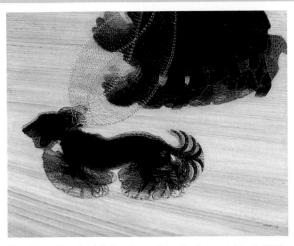

Fig. 719 Giacomo Balla, Dynamism of a Dog on a Leash, 1912.
Oil on canvas, 35 ⅔ × 43 ½ in. Albright-Knox Art Gallery, Buffalo, New York. Bequest of A. Conger Goodyear and Gift of George F. Goodyear, 1964.
© 2007 Artists Rights Society (ARS), New York/SIAE, Rome.

new place. In the summer of 1900, with the opening of the World's Fair, Paris found itself electrified, its nights almost transformed to day. The automobile, a rarity before the new century, dominated the city's streets by 1906. People were flying airplanes. Albert Einstein proposed a new theory of relativity and Niels Bohr a new model for the atom. Many people felt that there could be no tradition, at least not one worth imitating, in the face of so much change.

In February 1909, an Italian poet named Filippo Marinetti published in the French newspaper Le Figaro a manifesto announcing a new movement in modern art, Futurism. Marinetti called for an art that would champion "aggressive action, a feverish insomnia, the racer's stride ... the punch and the slap." He had discovered, he wrote, "a new beauty; the beauty of speed. A racing car whose hood is adorned with great pipes, like serpents of explosive breath . . . is more beautiful than the Victory of Samothrace." He promised to "destroy the museums, libraries, academies" and "sing of the multicolored, polyphonic tides of revolution in the modern capitals." There were, at the time, no Futurist painters. Marinetti had to leave Paris, go back to

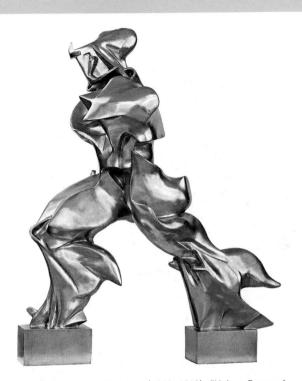

Fig. 720 Boccioni, Umberto (1882–1916), "Unique Forms of Continuity in Space". 1913.
Bronze. 43 ⁷/₈ × 34 ⁷/₈ × 15 ³/₄ in. Acquired through the Lillie P. Bliss Bequest. (231.1948).
Digital Image © The Museum of Modern Art/Licensed by SCALA / Art Resource, NY.

Italy, and recruit them. But as they exhibited their show of Futurist painting around Europe from 1912 until the outbreak of World War I in 1914, outraging as many as they pleased, these painters—Umberto Boccioni, Carlo Carrà, Luigi Russolo, Giacomo Balla, and Gino Severini embodied the spirit of the machine and of rapid change that seemed to define the century itself. Balla's *Dynamism of a Dog on a Leash* (Fig. 719) captures the Futurist fascination with movement. It demonstrates, as well, its debt to new technological media—in particular, photography, as in Muybridge's and Marey's work (see Figs. 74–76), and the new art of film.

Umberto Boccioni's *Unique Forms of Continuity in Space* (Fig. 720) gives the sense of a figure striding forward, clothing flapping in the wind. But Boccioni probably means to represent a nude, its musculature stretched and swollen to

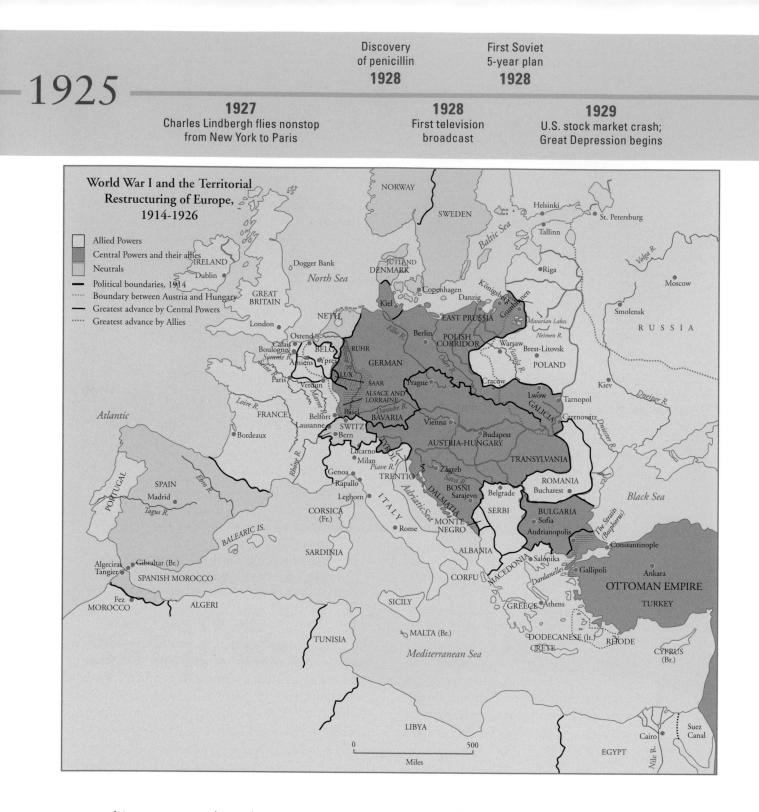

reveal its movement through space and time. It could probably best be thought of as an organic response to Marcel Duchamp's mechanical *Nude Descending a Staircase* (see Fig. 73).

World War I more than dampened this exuberance. The war was catastrophic (see map of World War I and the Territorial Reconstruction of Europe above). As many as 10 million people were killed and 20 million wounded, most in grueling trench warfare on the Western front, a battleline that remained virtually stationary for three years and ran from Oostend on the Dutch coast, past Rheims and Verdun, to Lunéville in France. World War I represented to many the bankruptcy of Western thought, and it served notice that all that had come before needed to be swept away. Amelia Earhart first woman to fly across the Atlantic alone **1932**

> **1932** 30 million unemployed in U. S. and Europe

Hitler comes to power in Germany **1933**

1932 - 33

Mass famine

in the U.S.S.R.

1933

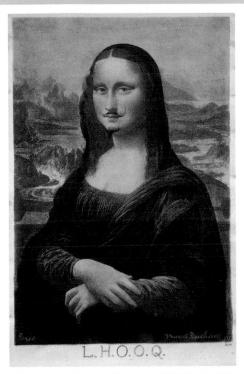

Fig. 721 Marcel Duchamp, Mona Lisa (L.H.O.O.O.), 1919.
 Rectified Readymade (reproduction of Leonardo da Vinci's Mona Lisa altered with pencil), 7 ³/₄ × 4 ¹/₈ in. The Louise and Walter Aronsborg Colloction. Lynn Rosenthal, 1998/Philadelphia Museum of Art.
 © 2007 Artists Rights Society (ARS), New York.

DADA AND SURREALISM

Founded simultaneously in Zurich, Berlin, Paris, and New York during the war, Dada took up Futurism's call for the annihilation of tradition but, as a result of the war, without its sense of hope for the future. Its name referred, some said, to a child's first words; others claimed it was a reference to a child's hobbyhorse; and still others celebrated it as a simple nonsense sound. As a movement, it championed senselessness, noise, and illogic. Dada was, above all, against art, at least art in the traditional sense of the word. Its chief strategy was insult and outrage. Perhaps Dada's chief exponent, Marcel Duchamp, always challenged tradition in a spirit of fun. His L.H.O.O.Q. (Fig. 721) is an image of Leonardo's Mona Lisa with a mous-

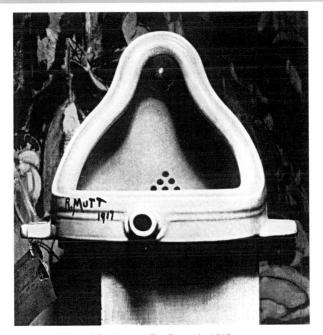

Fig. 722 Marcel Duchamp, *The Fountain*, 1917.
Fountain by R. Mutt. Glazed sanitary china with black print.
Photo by Alfred Stieglitz in *The Blind Man*, No. 2 (May 1917); original lost.
© Philadelphia Museum of Art. The Louise and Walter

Arensberg Collection, 1950. 1998 74 1. © 2007 Artists Rights Society (ARS), New York, ADAGP, Paris/Succession Marcel Duchamp

tache drawn on her upper lip. Saying the letters of the title with French pronunciation reveals it to be a pun, *elle a chaud au cul*, roughly translated as "she's hot in the pants." Such is the irreverence of Dada.

In New York, Duchamp submitted a common urinal to the Independents Exhibition in 1917, titled it *Fountain*, signed it R. Mutt, and claimed for it the status of sculpture (Fig. 722). At first it was rejected, but when Duchamp let it be known that he and R. Mutt were one and the same, it was accepted. Thus, whether something was art depended on who made it—or found it, in this case. It also depended on where it was seen—in the museum it was one thing, in the plumbing store, quite another. Furthermore, on its pedestal, in the context of the museum, Duchamp's "fountain" looked to some as if it were indeed sculpture. Duchamp did not so much invalidate art as authorize the

1935

Social Security Act passed in U. S. **1935**

1935 Mussolini invades Ethiopia

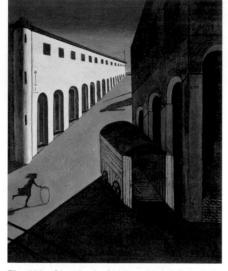

Fig. 723 Giorgio de Chirico, Melancholy and Mystery of a Street, 1914.
Oil on canvas, 24 ¼ × 28 ½ in. Private collection. Acquavella Galleries, Inc., New York.
© 2007 Artists Rights Society (ARS), New York/SIAE, Rome.

art world to consider all manner of things in aesthetic terms. His logic was not without precedent. Cubist collage had brought "real things" like newspaper clippings into the space of painting, and photography, especially, often revealed aesthetic beauty in common experience. But Duchamp's move, like Dada generally, was particularly challenging and provocative. "I was interested," he explained, "in ideas—not merely in visual products."

The art of **Surrealism** was born of Dada's preoccupation with the irrational and the illogical, as well as its interest in ideas. When the French writer André Breton issued the First Surrealist Manifesto in 1924, clearly the nihilist spirit of Dada was about to be replaced by something more positive. Breton explained the direction his movement would take: "I believe in the future resolution of these two states, dream and reality, which are seemingly so contradictory, into a kind of absolute reality, a surreality." To these ends, the new art would rely on chance operations, automatism (or random, thoughtless, and unmotivated notation of any kind), and

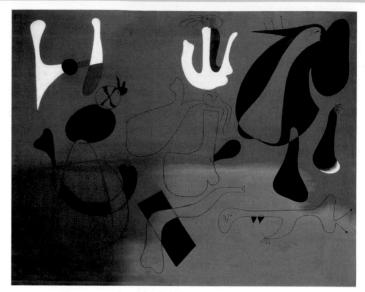

 Fig. 724 Joan Miró, Painting, 1933.
 Oil on canvas, 51 ⅔ × 64 ⅓ in. Wadsworth Atheneum, Hartford. The Ella Gallup Sumner and Mary Catlin Sumner Collection Fund.
 Courtesy Wadsworth Atheneum, Harford Connecticut. © 2007 Artists Rights Society (ARS), New York/ADAGP, Paris.

dream images—the expressions of the unconscious mind. Two different sorts of imagery resulted. The first contained recognizable, if fantastic, subject matter. It was typified by the work of Salvador Dali and René Magritte (see Figs. 53 and 18), and Giorgio de Chirico, who was acknowledged as an important precursor to the Surrealist movement by the Surrealists themselves. De Chirico claimed not to understand his own paintings. They were simply images that obsessed him, and they conveyed, Breton felt, the "irremediable anxiety" of the day. Thus, in *Melancholy and Mystery of a Street* (Fig. 723), the little girl rolls her hoop toward the ominous black shadow of a figure lurking behind the wall.

The other type of Surrealist painting was virtually abstract, presenting us with a world of indecipherable visual riddles. The painting of the Spanish artist Joan Miró and many of the early mobiles of Alexander Calder (see Fig. 95) fall into this category. In Miró's *Painting* (Fig. 724), biomorphic, amoebalike forms float in a space that suggests a darkened landscape. If we look closely, however, faces,

Germany occupies Austria **1938**

1936–39 Spanish Civil War James Joyce, Finnegan's Wake **1939**

1939

1939 Germany invades Poland; World War II begins

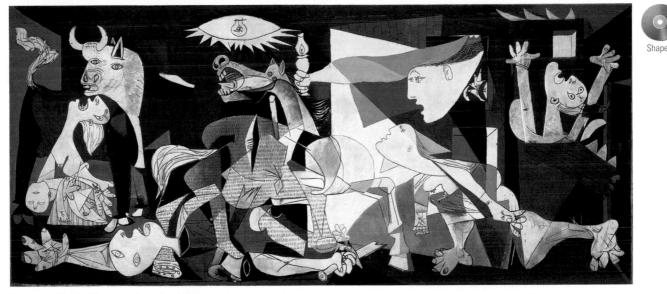

 Fig. 725 Pablo Picasso, Guernica, 1937.
 Oil on canvas, 11 ft. 5 ½ in. × 25 ft. 5 ¼ in. Museo Nacional Centro de Arte Reina Sofia, Madrid. John Bigelow Taylor/Art Resource, New York © 2007 Estate of Pablo Picasso/Artists Rights Society (ARS), New York.

hair, and hands begin to appear. Everything in this composition appears fluid, susceptible to continuing and ongoing mutation, back and forth between representation and abstraction.

One of the greatest paintings of the Surrealist era is Pablo Picasso's Guernica (Fig. 725). It represents an event in the Spanish Civil War that occurred on April 26, 1937. That day, Republican Basque troops, who were fighting the Fascist forces of General Francisco Franco, were retreating toward Bilbao on the northern Spanish coast. A bridge over the Mandaca River, at the edge of a town of 7,000 people called Guernica, was the last escape route for vehicles in the area, and the German air force, which had come to the aid of Franco, was determined to destroy it. The attack was planned by Wolfram von Richthofen, the cousin of the almost-mythical German ace of World War I, Manfred von Richthofen, the Red Baron, and a man eager to create his own legend. The strike force consisted of three squadrons-a total of 33 planes. Each was loaded with 3,000 pounds of bombs, as well as several hundred small incendiary cylinders. The attack, a type of sudden coordinated strike that soon was known as a *blitzkrieg*, commenced at 4:30 in the afternoon and lasted continuously for three-and-a-quarter hours. The first bombs were dropped near the railroad station—the bridge was ignored—and from that point on, the planes released their bombs indiscriminately into the smoke and dust raised by the first explosions. By the time the fires subsided three days later, the entire central part of the town—15 square blocks—was totally destroyed. Nearly 1,000 people had been killed.

Picasso, who was sympathetic to the Republican side and who considered himself exiled in Paris, was outraged at the events. Many elements of the painting refer to surrealist dream symbolism. The horse, at the center left, speared and dying in anguish, represents the fate of the dreamer's creativity. The entire scene is surveyed by a bull, which represents at once Spain itself, the simultaneous heroism and tragedy of the bullfight, and the Minotaur, the bull-man who for the Surrealists stood for the irrational forces of the human psyche. The significance of the electric lightbulb, at the top center of the painting, and the oil lamp, held by the woman reaching out the window, has been much debated, but they represent, at least, old and new ways of seeing.

WORKS IN PROGRESS Pablo Picasso's GUERNICA

 Fig. 726 Pablo Picasso, Sketch 1, Composition Study, 1 May 1937.
 Pencil, 8 ¹/₄ × 10 ⁵/₈ in. Arxiu Mas, Barcelona, Spain. Museo Nacional Centro de Arte Reina Sofia.
 © 2007 Estate of Pablo Picasso/Artists Rights Society (ARS), New York.

n January 1937, nearly four months before the bombing of Guernica, Picasso had been approached by representatives of the freely elected Republican government of Spain, who hoped that he might contribute a large mural for the entrance hall of a Spanish pavilion at the 1937 World's Fair in Paris. On May 1, as Paris papers headlined the tragedy that had occurred four days before, Picasso took pencil to paper, executing six sketches for the 25¹/₂foot painting. Time was short. The pavilion was scheduled to open on May 28. Picasso would finish the painting on June 4.

The first sketch (Fig. 726) outlines the idea in the most cursory fashion. The bull is present, and so is the woman reaching out of the house, oil lamp in hand. Rising in the middle is the shape that will become the twisted neck and head of the horse. By the end of the day, the composition's themes have begun to be worked out (Fig. 727). Out of the wound in the horse's side, the animal's spirit seems to take wing. A slain soldier lies beneath it, and the bull watches over the scene. Here, the theme of the bullfight is introduced the victorious bull, the slain picador (the chief an-

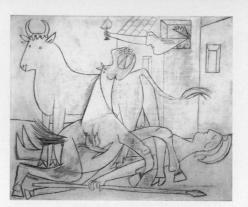

Fig. 727 Pablo Picasso, Sketch 6, Composition Study, 1 May 1937.
Pencil, 21 ¼ × 25 ½ in. Arxiu Mas, Barcelona, Spain. Museo Nacional Centro de Arte Reina Sofia.
© 2007 Estate of Pablo Picasso/Artists Rights Society (ARS), New York.

tagonist of the bull who, on horseback, torments him with a lance), and the fallen horse are equated with the war in Spain. But the bull's victory is temporary. In the bullfight, the bull's death is inevitable, just as death is inevitable for us all.

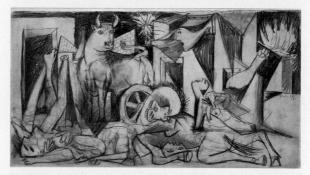

Fig. 728 Pablo Picasso, Sketch 15, Composition Study, 9 May 1937.
 Pencil, 9¹/₂ × 17⁷/₈ in. Arxiu Mas, Barcelona, Spain. Museo Nacional Centro de Arte Reina Sofia.
 © 2007 Estate of Pablo Picasso/Artists Rights Society (ARS), New York.

Within a week, Picasso had essentially arrived at the final composition. In a sketch of May 9 (Fig. 728), the idea of mass human suffering is finally introduced. The dead lying across the ground, the woman lifting her dead child in a scream of terror, the dramatic contrast between light and dark, all point to the final composition, which Picasso would arrive at four days later, on May 13.

U.S. enters World War II **1941** Enrico Fermi splits the atom 1942

1940 Germans invade France 1941–45 The Holocaust

 Fig. 729 Lee Krasner, Untitled, c. 1940.
 Oil on canvas, 30 × 25 in.
 © Estate of Lee Krasner. Courtesy Robert Miller Gallery, New York. © 2007 Pollock-Krasner Foundation/Artists Rights Society (ARS), New York.

1944

Allied invasion of Europe,

led by U.S. forces

1945

Fig. 730 Piet Mondrian (1872–1944), Composition II with Red, Blue, and Yellow, 1930.
Oil on canvas, 28 ¼ × 21 ¼ in.
© 2007 Mondrian/Holtzman Trust, c/o HCR International, Warrenton, VA, USA

AMERICAN MODERNISM AND ABSTRACT EXPRESSIONISM

With the outbreak of World War II, Picasso decided that *Guernica* should stay in the United States. He arranged for it to be kept at the Museum of Modern Art in New York, where it was to be held until the death of Franco and the reestablishment of public liberty in Spain. Franco, however, did not die until 1975, two years after Picasso himself. The painting was returned to Spain, finally, in 1981. It hangs today in a special annex of the Prado Museum in Madrid.

The painting profoundly affected American artists. "Picasso's *Guernica* floored me," Lee Krasner reported. "When I saw it first . . . I rushed out, walked about the block three times before coming back to look at it. And then I used to go to the Modern every day to see it." Krasner's own Untitled painting (Fig. 729), done soon after Guernica's arrival in New York in 1939, reflects Guernica's angular forms and turbulent energy. But it differs in important ways from Guernica. It is totally abstract, and where Guernica is a monochrome gray-brown, like burnt newsprint, Krasner's painting is vibrant with color. Probably more than any other artist of her day, Krasner understood how to integrate the competing aesthetic directions of European abstraction, fusing the geometric and expressionist tendencies of modern art in a single composition.

Like Krasner, and somewhat earlier, the Dutch painter Piet Mondrian, who had himself emigrated to New York in 1940, purged from his work all reference to the world. In paintings such as *Composition II with Red*, *Blue*, *and Yellow* (Fig. 730), he relied only upon horizontal Atomic bombs dropped on Hiroshima and Nagasaki; World War II ends 1945

1945

United Nations chartered

First computer, ENIAC, built 1946

1947

Israel granted independence by U.N. 1948

Invention of the transistor

1945

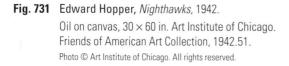

and vertical lines, the three primary colors, and black and white, which were, he felt, "the expression of pure reality." Like the Russian Suprematists before him (see Fig. 28), who had sought to create a new art to match the spirit of the Russian Revolution, Mondrian's aims were, essentially, ethical-he wanted to purify art in order to purify the spirit. Krasner complicates, as it were, Mondrian's art, opening it to the color of the German Expressionists, and to the sometimes terrifying whirl of modern life that Picasso had captured in his art.

Until 1940, abstraction such as Krasner's was not very well accepted in the United States. To be sure, American Modernism had been responsive to trends in European painting since the early years of the century, but instead of pushing toward abstraction, as had happened in Europe, American modernists tended to utilize European painting's formal innovations in more realist painting. Many artists preferred a realist approach, which was supported, on the one hand, by the growing popularity of photography, and, on the other, by an increasing conviction that art, in the face of the harsh realities of the Great Depression of the 1930s, should deal with the problems of daily life. Still, these artists were willing to learn from the formal discoveries of their more abstraction-oriented contemporaries, and we are often as attracted to the form of their

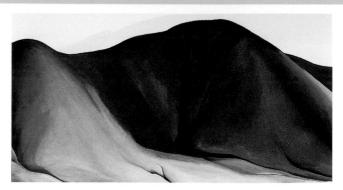

Fig. 732 Georgia O'Keeffe, Purple Hills Near Abiquiu, 1935. Oil on canvas, 16×30 in. San Diego Museum of Art. Gift of Mr. and Mrs. Norton S. Walbridge, 1976:216. © 2007 The Georgia O'Keeffe Foundation/Artists Rights Society (ARS), New York

work as to their subject matter. In a painting like Nighthawks (Fig. 731), Edward Hopper depicts the emotional isolation of the average American. But the composition is powerfully supported by the visual simplicity of his design, a geometry inspired by the example of Mondrian. It is as if his figures are isolated from one another in the vast horizontal expanse of the canvas. In her Purple Hills Near Abiquiu (Fig. 732), Georgia O'Keeffe utilizes the sensuous line of the German Expressionist painter Franz Marc (see Figure 718) to create a landscape that almost seems to be alive, a body capable of moving and breathing like one of Marc's animals.

The Great Depression and the outbreak of World War II, nevertheless, provided the impetus for the development of abstract painting in the United States. President Roosevelt's WPA (Works Progress Administration) had initiated, in 1935, a Federal Art Project that supported artists financially and thus allowed them to work as they pleased. Furthermore, many leading European artists emigrated to the United States to escape ever-worsening conditions in Europe. Suddenly, in New York, American painters could not only see Picasso's Guernica, but also found themselves in the company of Fernand Léger, Piet Mondrian, Yves Tanguy, Marcel Duchamp, and André Breton. A style of painting referred to as Abstract Expressionism soon developed. It George Orwell, *1984* **1949** Ray Kroc begins franchising McDonald's restaurants **1954**

1950–53 Korean War **1954** Brown v. Board of Education ushers in U.S. civil rights movement

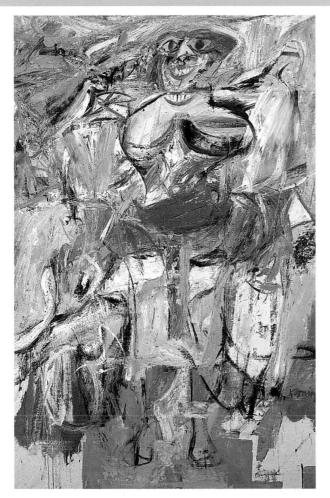

Fig. 733 Willem de Kooning, Woman and Bicycle, 1952–1953.
 Oil on canvas, 76 ¹/₂ × 49 in. Whitney Museum of American Art, New York. Purchase, 55.35.
 © 2007 Willem de Kooning Foundation/Artists Rights Society (ARS), New York.

harkened back to Kandinsky's nonobjective work of 1910 to 1920, but it was not unified in its stylistic approach. Rather, the term grouped together a number of painters dedicated to the expressive capacities of their own individual gestures and styles.

Jackson Pollock was deeply influenced by the Surrealist notion of *automatism*, the direct and unmediated expression of the self. Pouring and flinging paint onto canvas, usually on the floor, he created large "all-over"—completely covered, large-scale—surfaces with no place for the cyc to rest (see Figs. 213–215). Because of

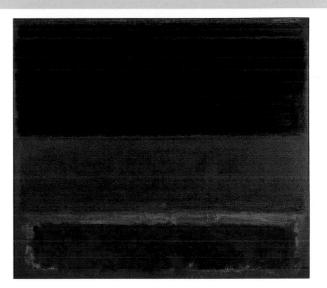

1954

Fig. 734 Mark Rothko, Four Darks in Red, 1958.
Oil on canvas, 102 × 116 in. Whitney Museum of American Art, New York. Purchase, with funds from the Friends of the Whitney Museum of American Art, Mr. and Mrs. Eugene M. Schwartz, Mrs. Samuel A. Seaver, and Charles Simon, 68.9.
© 2007 Kate Rothko Prizel & Christopher Rothko/Artists Rights Society (ARS), New York.

the energy and movement of such paintings, the Abstract Expressionism of Pollock has been labeled "Action Painting." Willem de Kooning's work, with its visible application of paint to the surface, is the definitive example of this approach. Though his paintings of women, including Woman and Bicycle (Fig. 733), are often seen as an attack upon women, de Kooning's hashed-out, scribbled-over, loosely gestural painting is equally a celebration of his own freedom from the conventions of figural representation. "I do not think . . . of art," he explained, "as a situation of comfort." What de Kooning liked most in Mondrian's work, for instance, was the instability, the vibration that occurs where black lines cross (see Fig. 730). This shimmer, he said, made him feel like he was about to fall out of the painting.

The monumental quietness of Mark Rothko's canvases (Fig. 734) conveys almost the opposite feeling. To call this "Action Painting" would be a misnomer. The painting produces a Montgomery, Alabama bus boycott 1956

1955

Communist revolution in Cuba 1959

1956 First transatlantic telephone service

1957 Soviets launch Sputnik, first artificial satellite

meditative, not active, space. In place of action, we find a carefully modulated field of color that suggests the luminous space and light of Monet's Grainstacks, only without the realistic image. However, because Rothko emphasizes the horizontal band and the horizon line, his paintings often suggest the point where land meets sky. The bands of color bleed mysteriously into one another or into the background, at once insisting on the space they occupy by the richness of their color and dissolving at the edges like mist. "I am interested only in expressing the basic human emotions-tragedy, ecstasy, doom, and so on," Rothko explained, "and the fact that lots of people break down and cry when confronted with my pictures shows that I communicate with those basic human emotions. The people who weep before my pictures are having the same religious experience I had when I painted them."

POP ART AND MINIMALISM

By the middle of the 1950s, as Abstract Expressionism established itself as the most important style of the day, a number of young painters began to react against it. Robert Rauschenberg parodied the high seriousness of the Action Painters by using their gestures-supposed markers of the artists' sincerity-to paint over literal junk. Like the Cubists before him, he cut out materials from newspapers and magazines and silkscreened media images onto his prints (see Fig. 320). Rauschenberg went further, however, incorporating stuffed animals, tires (see Fig. 358), and all manner of things, into the space of art. In Odalisk (Fig. 735), Rauschenberg parodies the nineteenth-century tradition of painting the nude (see Figs. 688 and 689). A stuffed rooster struts atop the construction, a pin-up nude decorates its side, and the whole rests, ironically, on a pillow-all a wry commentary on contemporary sexuality.

In the 1960s, inspired by Rauschenberg's example, a group of even-younger artists, led by Andy Warhol, Claes Oldenburg, and Roy Lichtenstein, invented a new American real-

518 Part 5 *The Visual Record*

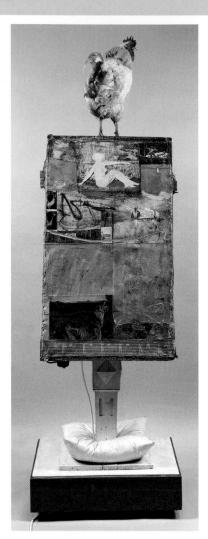

Fig. 735 Robert Rauschenberg, Odalisk, 1955–1958. Oil, watercolor, pencil, fabric, paper, photographs, metal, glass, electric light fixtures, dried grass, steel wool, necktie, on wood structure with four wheels, plus pillow and stuffed rooster, $83 \times 25 \frac{1}{2} \times 25 \frac{1}{8}$ in. Museum Ludvig Köln, Rheinisches Bildarchiv, Köln. Photo courtesy Rheinisches Bildarchiv, Köln. © Robert Rauschenburg/Licensed by VAGA, New York

ism, Pop Art. Pop represented life as America lived it, a world of Campbell's soup cans, Coca-Cola bottles, and comic strips. Based on an actual Sunday cartoon strip, Lichtenstein's giant painting Whaam! (Fig. 736) indicates, by its very size, the powerful role of popular culture

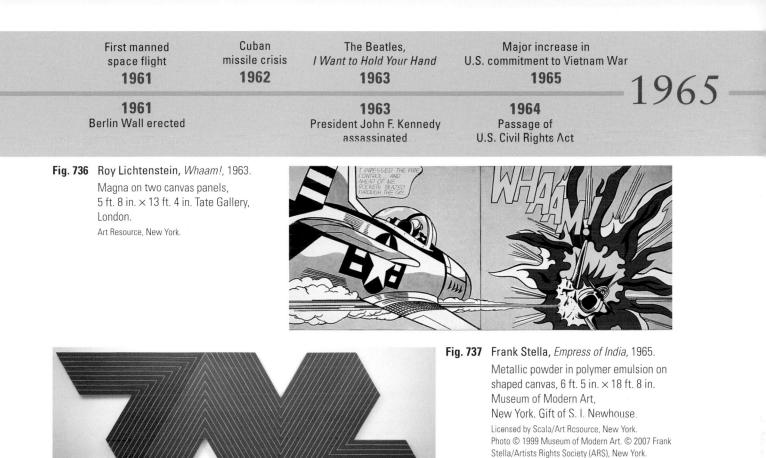

in our emotional lives. This is an image of power, one that most American boys of the 1950s were raised to believe in wholly. One of the chief tactics of the Pop artists, in fact, was to transform the everyday into the monumental, as Oldenburg turned objects such as spoons, marachino cherries, and clothespins into giant sculptural objects (see Figs. 242 and 321). Most important, perhaps, Pop Art left behind traditional artistic media like painting. Artists turned instead to slick renderings made by mechanical reproduction techniques, such as photolithography, that evoked commercial illustration more than fine art.

Another reaction against Action Painting led, in the same period, to a style of art known as **Minimalism**. In contrast to Pop works, Minimalist pieces were, in their way, elegant. They addressed notions of space—how objects take up space and how the viewer relates to them spatially—as well as questions of their dogmatic material presence. For Frank Stella, the shape of the painting determined its content, which might consist of a series of parallel lines that could have been drawn with a compass or protractor. "I always get into arguments with people who want to retain the old values in painting," Stella muses. "My painting is based on the fact that only what can be seen is there. It is really an object. . . . All I want anyone to get out of my paintings, and all I ever get out of them, is the fact that you can see the whole idea without confusion. What you see is what you see." Thus, despite its title, Empress of India (Fig. 737) is contentless painting. It has no spiritual aspirations. It does not contain the emotions of the painter. It is simply there, four interlocked V's, before the viewer, a fact in and of itself. Stella has deliberately set out to make a work of art that has no narrative to it, that cannot, at least not very easily, be written about.

POSTMODERN DIRECTIONS

From the time of Gauguin's retreat to the South Pacific and Picasso's fascination with African masks, Western artists have turned to non-Western cultures for inspiration, seeking

First manned moon landing **1969**

1965

1965–69 Cultural Revolution in China

Fig. 738 Jimmie Durham, Headlights, 1983. Car parts, antler, shell, etc. Private collection. Courtesy of the artist.

"authentic" new ways to express their emotions in art. The African features of the two figures on the right in Picasso's Les Demoiselles d'Avignon (see Fig. 66) are a prime example of this. At the same time, other cultures have been dramatically affected by Western traditions. Although we normally think of the Western world's impact on these other cultures in negative terms-in the process of Westernization, ancient customs are lost, and cultural artifacts are looted and carried off for display in Western museums-many non-Western artists have incorporated the art of the West into their own art in positive ways. As Native American artist Jimmie Durham has put it, "We took glass beads, horses, wool blankets, wheat flour for frybread, etc., very early, and immediately made them identifiably 'Indian' things. We are able to do that because of our cultural integrity and because our societies are dynamic and able to take in new ideas." Similarly, the aboriginal painters of Australia have adopted the use of acrylic paint, integrating the medium into their own cultural traditions (see Fig. 7). Durham himself makes what he calls "fake Indian artifacts." Categorically non-Indian materials, such as the bright chrome automobile fender depicted here (Fig. 738), are transformed into

Fig. 739 Jaune Quick-to-See Smith, Petroglyph Park, 1986. Pastel on paper, 30 × 22 in. Private collection. © Jaune Quick-to-See Smith. Courtesy of the artist.

something that looks completely Indian. But the cultural forces at work are highly complex. As much as Indian culture has the ability to absorb Western materials and make them its own, anything an Indian makes, Durham knows, is always seen by the dominant Anglo-American culture as an "artifact," a surviving fragment of a "lost" people that does not quite qualify as "art" proper. His "fake" artifacts expose this assumption.

Native American painter Jaune Quick-to-See Smith, who studied at the University of New Mexico, puts it this way: "With a university training, you're exposed to classic art and traditions from around the world. You wouldn't be true to yourself if you didn't incorporate what you were familiar with." In

Roe v. Wade legalizes abortion in U.S. **1973**

early 1970s Rise of the modern feminist movement 1973–74 Energy crisis in Western countries 1975

 Fig. 740 David P. Bradley White Earth Oijbwe and Mdewakaton Dakota, Indian Country Today, 1996–1997.
 Acrylic on canvas, 72 × 60 in. Peabody Essex Museum, Salem, Massachusetts. Museum Purchase through the Mr. and Mrs. James Krebs Fund. E300409.
 Photograph courtesy of Peabody Essex Museum.

her *Petroglyph Park* (Fig. 739), Quick-to-See Smith makes direct allusion to the Blue Rider of Kandinsky and Marc, drawing an analogy between the fate of the wild horse and the fate of Native Americans. Everything in this painting refers to lost peoples—from the makers of the petroglyphs to Marc's early death in World War I—and the presence of those peoples in our memory. The simultaneous presence of diverse traditions in a single work is indicative of what we have come to call **Postmodernism**.

The postmodern condition is imaged with particular power in Native American artist David Bradley's *Indian Country Today* (Fig. 740). Bradley depicts a traditional Kachina dance taking place in the square of

the pueblo. Performed by male dancers who impersonate Kachinas, the spirits who inhabit the clouds, rain, crops, animals, and even ideas such as growth and fertility, the dances are sacred and, although tourists are allowed to view them, photography is strictly prohibited. The actual masks worn in ceremonies are not considered art objects by the Pueblo people. Rather, they are thought of as active agents in the transfer of power and knowledge between the gods and the men who wear them in dance. Kachina figurines are made for sale to tourists, but they are considered empty of any ritual power or significance. This commercialization of native tradition is further imaged by the train passing behind the pueblo-the Sante Fe Railroad's "Chief." Behind the train, at the right, is the Four Corners Power Plant, in northwestern New Mexico, one of the largest coal-fired generating stations in the United States and one of the greatest polluters, spewing smoke into the air. Behind the power plant is an open pit strip mine. The city of Sante Fe-a major tourist attraction-and an Indian-run casino, its parking lot full of buses, occupy the left side of the image. But overlooking all is a giant mesa, with Kachina-like eyes and mouth, suggesting that even in the contemporary world, where tradition and progress appear to be in a state of constant tension, the spirits still oversee and protect their peoples.

As the world of art has become increasingly diverse and plural in character, new voices have continually entered into the arena, particularly African-American voices. Artists such as Jacob Lawrence (see Fig. 350) and Romare Bearden (see Fig. 355) have enjoyed major retrospective exhibitions. Martin Puryear (see Figs. 124 and 483) has established himself as one of America's leading sculptors. And African-American artists of succeeding generations have placed their work in the collections of the country's leading museums. In 1995, for instance, the Art Institute of Chicago purchased Kerry James Death of Mao Tse-Tung **1976**

1975

1975

South Vietnam falls

to Vietcong

Islamic fundamentalist revolution in Iran; U.S. hostages held **1979**

> **1979** Egypt–Israeli peace treaty

Fig. 741 Kerry James Marshall, *Many Mansions*, 1994. Acrylic and collage on unstretched canvas, 114 × 135 in. Jack Shainman Gallery.

Marshall's *Many Mansions* (Fig. 741), one of a series of paintings inspired by Marshall's observation that so many public housing projects in the United States have "garden" in their name. This painting depicts Chicago's Stateway Gardens (officially known as IL2-22, as inscribed at the top right of Marshall's work), an immense complex of eight high-rise apartment buildings on Chicago's South Side. Three young men in white shrits and ties are working in the garden in what is at once an ironic commentary on the virtual impossibility of transforming the concrete urban environment into a garden and a sincere attempt on Marshall's part to contradict the false, negative image of the African-American male. At the left, two bluebirds support a banner that reads "Bless Our Happy Home." Floating above the entire scene is a red ribbon that reads "In My Mother's House There Are Many Mansions." An adaptation of a Biblical passage from the Gospel of John that begins "In my father's house . . .," it is a reference to the matriarchal structure of urban African-American culture. Easter baskets embody the promise of hope and renewal even as they project a crass materialism. The painting is typically postmodern in its unwillingness to adopt a single point of view and in its embrace of contradiction. First CDs marketed 1983 Mikhail Gorbachev introduces glasnost in U.S.S.R. **1984**

1980s Beginnings of AIDS epidemic

Fig. 742 Frida Kahlo (1907–1954 Mexico), "The Two Fridas (Las Dos Fridas)" 1939.
Öil on canvas, 5 ft. 9 in. × 5 ft. 9 in. (173 × 173 cm.) Bob Schalkwijk/Art Resource, NY. © Banco de Mexico Diego Rivera & Frida Kahlo Museums Trust. Av. Cinco de Mayo No. 2, Col. Centro, Del.

Cuauhtemoc 06059, Mexico, D.F. Reproduction authorized by the Instituto Nacional de Bellas Artes y Literatura.

One of the most important of the voices to emerge in the last half of the twentieth cenury has been that of feminism. Since the early 1970s, when the feminist movement began to take hold in this country, women have played an increasingly vital role in defining the issues and directions of contemporary art. One important consequence is that women have retrieved for art history artists previously relegated to the sidelines or ignored altogether, among them Frida Kahlo. Kahlo was married to a successful painter, the Mexican muralist Diego Rivera (see Fig. 335), and her Las Dos Fridas (The Two Fridas) (Fig. 742) represents Rivera's rejection of her. According to Kahlo, the Frida on the right, in native Tehuana costume, is the Frida whom Rivera had loved. The Frida on the left is the rejected Frida. A vein runs between them both, originating in a small photo of Rivera as a child on the onceloved Frida's lap, through both hearts, and terminating in the unloved Frida's lap, cut off **1984** Apple Macintosh computer first sold **1984** Ozone hole above Antarctica discoverd 1984

 Fig. 743 Judy Chicago, The Dinner Party, 1979.
 Mixed modia, 48 × 48 ft × 40 ft. installed. Collection of The Brooklyn Museum of Art. Gift of the Elizabeth A. Sackler Foundation.
 Photo © Donald Woodman. © 2007 Judy Chicago/Artists Rights Society (ARS), New York.

by a pair of surgical scissors. But the flow of blood cannot be stopped, and it continues to drip, joining the embroidered flowers on her dress.

A work that contributed significantly to the resuscitation of women's place in the art world was Judy Chicago's The Dinner Party (Fig. 743). Chicago was trained as a painter, but she abandoned painting because, in the 1960s and 1970s, it was dominated by what she saw as men's way of thinking (see Fig. 27). The art world at the time emphasized formal issues and devalued personal narrative of the kind evident in, for instance, Frida Kahlo's work. This led Chicago and colleagues like Suzanne Lacy (see Fig. 88), Miriam Schapiro (see Fig. 208), and Joyce Kozloff (see Fig. 458) to explore new means of expression. Performance art was an immediate outgrowth of this attitude. So too was an interest in traditional craft media and collaborative art processes.

U. S. space shuttle Challenger explodes 1986

Fig. 744 Cindy Sherman, "Untitled #90," 1981. Color photograph, 24 × 48 in. Courtesy Metro Pictures, New York.

The Dinner Party was a collaborative project that involved more than 300 woman artisans working together over a period of five years to create a visual celebration of women's history. Shaped as a triangle, the earliest symbol of female power, it is set with 39 places, 13 on a side, each celebrating a woman who has made an important contribution to world history. The names of 999 additional women, all of whom have made significant contributions to history in their own right, are inscribed in ceramic tiles along the table's base. Each place setting consists of a needleworked fabric runner and a ceramic plate in honor of the woman whom it celebrates. The first plate is dedicated to the Great Goddess, and the third to the Cretan Snake Goddess (see Fig. 601). Around the table, the likes of Eleanor of Aquitaine, English author Virginia Woolf, and painters Artemisia Gentileschi and Georgia O'-Keeffe are celebrated.

An important aspect of feminist art has been its critique of traditional ways of seeing, ways of seeing prescribed and institutionalized by men. As our assumptions and expectations have become increasingly challenged, the art world has become increasingly unbound by any rules or by any ruling "isms." Artists can draw on personal experiences or stylistic trends and address their work to a wide audience or a relatively narrow

1989 Communists defeated in free elections in Soviet Union

Fig. 745 Barbara Kruger, Untitled (We won't play nature to your culture), 1983.
 Photograph, 72 × 48 in.
 Courtesy Ydessa Hendeles Art Foundation, Toronto.

one. But one overriding characteristic of contemporary art is its struggle with the question of identity. Cindy Sherman's untitled photographs, for instance, are self-portraits (Fig. 744), sometimes presented at the scale of the film still and other times at the scale of a large poster. They are actually performances that address the ways in which our culture "views" women. In this case, we are witness to a highly ironic, if empathetic, display of female passivity.

The implication is that Sherman's life, and by extension our own, is a series of performances, that, chameleonlike, we change identities as readily as we change our clothes, picking and choosing who we are from media images. The mass media—from television and video to electronic signboards and commercial photography—are increasingly not only the subject of contemporary art but its means. Barbara Kruger's word-and-photograph pieces relate to billboard imagery, but they continue the feminist imperative of contemporary art, addressing issues of gender. In *Untitled (We won't play nature to your culture)* (Fig. 745), Kruger exposes the Nelson Mandela released from prison in South Africa **1990** End of Communist rule in Russia; breakup of Soviet Union **1991**

> 1993 Israel and Palestinians

sign peace accord

Nelson Mandela becomes President of South Africa **1994**

1994

1990 Reunification of East and West Germany; Berlin Wall torn down

Fig. 746 Anne Truitt, Nicea, 1977. Acrylic on wood, $84 \frac{1}{2} \times 10 \times 8$ in. Danese, New York.

traditional nature/culture dichotomy for what it is—a strategy that authorizes the cultural and intellectual domination of the male over a passive and yielding female nature.

Anne Truitt's sculptures, such as *Nicea* (Fig. 746), seem minimalist and nonobjective, but like Sherman's work, they are autobiographical. The formal innovation of this subtly colored piece lies in the way its colors "turn" the corner, at once emphasizing the verticality of the column and drawing us around it. But it is also deeply autobiographical, relating directly to the architectural forms of Truitt's youth in Delaware, and can best be approached through her published journals, *Daybook* (1982) and *Turn* (1986). In *Turn* she describes her love for geometric simplicity, tracing its source back to her childhood:

Fig. 747 Yasumasu Morimura, *Portrait (Twins),* 1988. Color photograph, clear medium, 6 ft. 13 ¹/₂ in. × 9 ft. 10 in. NW House, Tokyo. Courtesy of the artist and Luhring Augustine, New York.

The people around me, except for my baby nurse . . . and my father when he was well, were not only inexpressive but preoccupied. I turned to my physical environment, the garden's trees, grass, flowers, bushes. The garden was bisected by a brick path. I noticed the pattern of its rectangles, and then saw that they were repeated in the brick walls of the houses of Easton [Delaware]; their verticals and horizontals were also to be found in clapboard walls, in fences, and in lattices. In my passion (no other word will do for the ardor I felt) for something to love, I came to love these proportions—and years later, in 1961, when I was forty years old, this love welled up in me and united with my training in sculpture to initiate and propel the work that has occupied me ever since.

Truitt's work seems, superficially, to fulfill the desire of modernism to create art that explores the formal dimensions of its own medium. But it is her autobiographical anecdote that lends the work its special richness.

In painting, the styles of the past—from the Renaissance to the Rococo, from Cubism to Abstract Expressionism—have been raided and appropriated to the context of the present. Yasumasu Morimura's *Portrait (Twins)* (Fig. 747) Almost 19,000 McDonald's restaurants in business worldwide **1996**

1995

1995 Oklahoma City bombing

Fig. 748 Brice Marden, *Cold Mountain 3*, 1989–1991. Oil on linen, 9 × 12 ft. Courtesy Mary Boone Gallery, New York. © 2007 Brice Marden/Artists Rights Society (ARS), New York.

is a case in point. Morimura has posed himself here as both Manet's *Olympia* (see Fig. 701) and her maid, manipulating the photograph with a computer in his studio. On the one hand, like Japanese culture as a whole, he is copying the icons of Western cutlure, but he undermines them even as he does so. For one thing, he draws attention to the fact that the courtesan and her maid share the same identity—they are "twins"—both essentially slaves to the dominant (male) forces of Western society. He places Japanese culture—and in particular the Japanese male—in the same position, prostitute and slave to the West.

A second, more painterly example is Brice Marden's *Cold Mountain 3* (Fig. 748), one of a series of recent works that takes its name from the Chinese poet called Cold Mountain. This painting is like a minimalist version of Jackson Pollock. It is as if the high energy of Pollock had turned meditative, and the quick, almost violent motion of Pollock's line had been reinvented as a sort of slow dance suspended in a quiet space.

As Morimura's work suggests, the cultural specificity of artists' work is becoming, in the

 Fig. 749 Shahzia Sikander, *Pleasure Pillars*, 2001.
 Watercolor, dry pigment, vegetable color, tea, and ink on wasli paper, 12 × 10 in.
 Collection of Amita and Purnendu Chatterjee.
 Courtesy Sikkema Jenkins & Co., New York.

postmodern world, increasingly irrelevant. Today, artists tend to see themselves as "international" rather than Middle Eastern, or French, or even American. Shahzia Sikander, for instance, addresses the heterogeneity of her background in works such as Pleasure Pillars (Fig. 749), combining her training as a miniature artist in her native Pakistan with her graduate studies at the Rhode Island School of Design. In the center of the composition is a self-portrait with spiraling horns. Below it are two bodies, one a Western Venus, the other the Hindu goddess of fertility, rain, health, and nature, Devi, who is said to hold the entire universe in her womb. Between them two hearts pump blood—perhaps a reference to Frida Kahlo's Dos Fridas (see Fig. 742), her Western

WORKS IN PROGRESS

Frank Gehry's GUGGENHEIM MUSEUM BILBAO

start drawing sometimes," architect Frank Gehry has said, "not knowing exactly where I am going. I use familiar strokes that evolve into the building. Sometimes it seems directionless, not going anywhere for sure. It's like feeling your way along in the dark, anticipating that something will come out usually. I become voyeur of my own thoughts as they develop, and wander about them. Sometimes I say 'boy, here it is, here it is, it's coming.' I understand it. I get all excited."

Gehry's early drawings of the north, riverfront facade for the Guggenheim Museum in Bilbao, Spain (Fig. 750), executed only three months after he had won the competition to design the building in 1991, reveal his process of searching for the form his buildings eventually take. These semiautomatic "doodles" are explorations that are surprisingly close to Gehry's finished building (Fig. 752). They capture the fluidity of its lines, the flowing movement of the building along the riverfront space.

Gehry moves quickly from such sketches to actual scale models. The models, for Gehry, are like sculpture: "You forget about it as architecture, because you're focussed on this sculpting process." The models, finally, are transformed into actual buildings by means of Catia, a computer program originally developed for the

Fig. 750 Frank Gehry, *Guggenheim Museum Bilbao*, north elevations, October 1991. Sketch by Frank Gehry, 1991. © Frank O. Gehry & Associates.

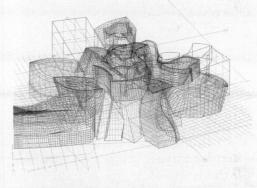

Fig. 751 Frank Gehry, Guggenheim Museum Bilbao. © Gehry Partners, LLP.

French aerospace industry (Fig. 751). This program demonstrated to builders, contractors and the client—that Gehry's plan was not only buildable, but affordably so.

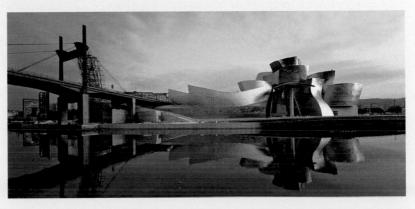

Fig. 752 Frank Gehry, Guggenheim Museum Bilbao, 1997.
© The Solomon R. Guggenheim Foundation, New York. Photo: David Heald. 1997 Princess Diana dies in auto accident

1997

inspiration, just as the dancers surrounding her self-portrait are her Eastern inspiration. Western and Eastern images of power also inform the image—the fighter jet at the top of the image and the image of a lion killing a deer at the bottom left, copied from an Iranian miniature of the Safavid dynasty (1499–1736).

As discussed at the end of Chapter 16, architecture is arguably the most "international" of the arts. Frank Gehry's design for the Guggenheim Museum Bilbao is a case in point (see the Works in Progress, p. 527). So too is the work of Zaha Hadid, the first woman to receive the Pritzker Prize, architecture's most prestigious award. Designer of everything from a towering ski jump in Innsbruck, Austria, to the new Center for Contemporary Art in Cincinnati, Ohio, and a new Guggenheim Museum in Taiwan, the Iraq-born British citizen is noted for her innovative approach to the urban environment. The main volume of the Phaeno Science Center (Fig. 753), for instance, is supported by columns in the shape of inverted cones that also provide access to the building above. The Center is lifted in order to allow the space below to become a new kind of urban space, a covered artificial landscape with gently undulating hills and valleys, extending out

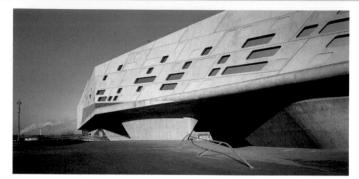

Fig. 753 Zaha Hadid, Phaeno Science Center, Wolfsburg, Germany, 1999–2005. Zaha Hadid Ltd. Photo: Werner Huthmacher.

into the surrounding area. The distorted shape of the building is a strategy used by Hadid to convey movement and a sense of transformation, even as it offers the visitor a continuous series of fresh perspectives and views, a metaphor for the acts of discovery that inform science and technology. Like Gehry's architecture, Hadid's transforms our ideas and assumptions of what architecture can be, and will become in the future.

THE **CRITICAL** PROCESS Thinking about the History of Art

T wo days after the tragic events of September 11, 2001, *The New York Times* asked its cultural critics to contribute to a special edition of The Arts section of the newspaper entitled "The Expression of Grief and the Power of Art." The section was introduced by editor Bruce Weber. "Nothing provokes the artistic sensibility like grief," he wrote.

In the artist, events like those of Tuesday morning bring about a meeting of universal emotions and an individual will to unearth them, expose them, understand them and accept if not outlast them.

In grief is a myriad of human terrors: the visceral blow that brings rage and outrage, the insidious settling in of pain and sadness; the concentric waves of anguish that continue through time. All of these have been evoked through the centuries with the power of great imaginations.

From Homer's tales of Troy to Picasso's "Guernica," . . . from the bloody dramas of Sophocles and Shakespeare to

In Memoriam. September 11, 2001

 Fig. 754 Troy Brauntuch, Untitled (Shirts 2), 2005.
 Conté crayon on cotton, 63 × 51 in. Collection of Alberto and Maria de la Cruz.
 Courtesy Friedrich Petzel Gallery. New York.

Maya Lin's Vietnam Memorial, artists have always combated grave tragedy with grave beauty.

Tony Brauntuch's image of shirts stacked in a men's clothing store (Fig. 754) at first seems entirely banal. But the ghostlike image turns out to be based on newspaper photographs of shirts covered in dust after the fall of the World Trade Center towers. The rich sensuality of Brauntuch's surface—he uses no actual blacks or whites, only a range of grays, from blue-gray to white-gray—stands in stark contrast to the pathos of the image itself.

But since the 9/11 tragedy, the art world has also responded with humor and hope. For the 2005 Venice Biennale, Jennifer Allora and Cuillermo Calzadilla, who live and work in Puerto Rico, created *Hope Hippo* (Fig. 755), a lifesize sculpture of a hippopotamus (literally a "river horse," a nod to Venice's military equestrian statuary) out of mud dredged from the

2007

Fig. 755Jennifer Allora and Guillermo Calzadilla, Hope
Hippo, 2005.Installation view, Venice Biennale, 2005. Mud,
whistle, daily newspaper, and live person,
dimensions variable. Collection of the artists.
Courtesy of Jennifer Allora and Guillermo Calzadilla and Lisson
Gallery, London. Photo: Giorgio Boato.

Venetian lagoon. Each day throughout the fivemonth exhibition, "whistleblowers" mounted the hippo and read from the daily newspaper, blowing on a referee's whistle every time they came across a report of perceived injustice, from sports to world events.

How can Allora and Calzadilla's work be understood as a response to the political situation that precipitated the events of 9/11? What do you make of the juxtaposition of the live human and the "sleeping" hippo? What hope does it offer? How, one finally has to ask, does it compare to the expression of gricf—and outrage—embodied in Brauntuch's work? What, finally, do both tell us about art's purpose?

THE CRITICAL PROCESS Thinking Some More about the Chapter Questions

CHAPTER 1 Andy Warhol's Race Riot, 1963

Warhol seems most interested in the second traditional role of the artist: to give visible or tangible form to ideas, philosophies, or feelings. He is clearly disturbed by the events in Birmingham. By depicting the attack on Martin Luther King, Jr., in the traditional red, white, and blue colors of the American flag, he suggests that these events are not just a local issue but also a national one. Thus, to a certain degree, he also reveals a hidden truth about the events: All Americans are implicated in Bull Connor's actions. Perhaps he also wants us see the world in a new way, to imagine a world without racism. The second red panel underscores the violence and anger of the scene. As horrifying as the events are, it is possible to imagine a viewer offended not by the police actions but by Warhol's depiction of them, his willingness to treat such events as "art."

CHAPTER 2 Two representations of a *Treaty Signing at Medicine Lodge Creek*

Taylor's version of the events is the more representational by traditional Western standards, Howling Wolf's the more abstract. In many ways, however, Howling Wolf's version contains much more accurate information. Formally, they are very different. As a reporter, Taylor tries to convey the actual grove of trees under which the treaty signing ceremony occurred. It seems as important to him to represent the trees and grasses accurately as the people present at the scene, but the scene could be anywhere. In contrast, by portraying the confluence of Medicine Lodge Creek and the Arkansas River, Howling Wolf describes the exact location of the signing ceremony. Taylor focuses his attention on the U.S. government officials at the center of the picture, suggesting their individual importance. The Native Americans in Taylor's picture are relegated to the periphery of the action. Even in the foreground, their individual identities are masked in shadow. From Taylor's ethnocentric perspective, the identities of the Native Americans present is of no interest. In contrast, Howling Wolf's aerial view shows all those present, including women, equally. Each person present is identified by the decoration of the dress and tipis. Women are valued and important members of the society. Their absence in Taylor's work suggests that women have no place at important events. In fact, it is possible to argue that Taylor's drawing is about hierarchy and power, while Howling Wolf's is about equality and cooperation.

CHAPTER 3 Robert Mapplethorpe's Parrot Tulip, 1985

Like the cut flower in Philippe de Champaigne's Vanitas, Mapplethorpe's tulip represents the temporary and conditional nature of beauty. Unlike the flower in Vanitas, however, Mapplethorpe's tulip is dying in its vase, drooping down toward the floor. It becomes a symbol of Mapplethorpe's own imminent demise. Both the painting and the photograph depend on a dramatic contrast of light and dark, as if darkness and death surround the things of this world. The light's origin to the left suggests that it is late in the day. Time is running out. The tulip is itself a sexual organ-stamen and pistil-and as it droops over the vase's edge it suggests both sexual completion and sexual impotence. The aesthetic beauty of the work depends not only on its formal qualities, such as the contrast between light and dark and between the black vase and the brilliantly colored flower, as well as the rhythm of curves created by the vase and the stem, but also on our sense that this aesthetic beauty is extraordinarily fragile, a thing of the moment soon to be lost. And yet the photograph captures the moment forever, as if miraculously.

CHAPTER 4 Suzanne Lacy's Whisper, the Waves, the Wind, 1993–1994

Lacy's work clearly gives tangible form to her feelings about the experiences of aging women in America. By isolating them on a beach, separated from those who need to hear them, she underscores their isolation. In doing so, she also represents the experience of aging in America, the experience of being caught in between the culture's compassion for the aging and its willingness to ignore them. The image of these women, in white, in this setting, also helps us to understand the beauty of their aging, a fact that we might otherwise ignore, and thus Lacy helps us understand our world in a new way, eliciting not only our admiration but also a certain hope for our own endurance, the dignity of our own maturation. The stark contrast between the orderliness and "civilized" quality of the tables on the beach and the natural "wildness" of the shoreline suggests the power of the human imagination to transform our prejudices through art.

CHAPTER 5 Jean-Auguste-Dominique Ingres's *The Turkish Bath*, 1862

Ingres distorts every feature of the female anatomy—from breasts, to bellies, to eyebrows and chins, to emphasize their circular qualities. The sense of touch is emphasized by the women's fondling of one another, smell by the perfume bottle, taste by the still-life platter of food, sound by the figure playing her instrument, and sight by the voyeuristic qualities of the work as a whole. As viewer, you assume the position of the sultan, overlooking his harem, whose presence is implied in the rectilinear architecture of the room and pool.

CHAPTER 6 Michael Scroggins and Stewart Dickson's Topological Slide, 1993

The prefixes "cyber-" and "hyper-" suggest a lot about the nature of this space. *Cyber* refers to *cybernetics*, the study of mechanical and electrical systems designed to replace human functions. *Hyper* is a common prefix that usually means excessive or exaggerated in English but literally means "over" in Greek. Thus this space is mechanical and electrical, other than human, and "over" or beyond our space, in another dimension. It is two-dimensional insofar as it is created out of two-dimensional images. It is three-dimensional insofar as we enter it physically. If in experiencing such spaces we seem to move in and through a two-dimensional image, this space must be totally illusory. It suggests that we exist, or at least can exist, within illusion. The entertainment possibilities of such spaces are limitless and exciting, but in the wrong hands, such spaces could be used as devices of social manipulation and control.

CHAPTER 7 Tony Cragg's Newton's Tones/New Stones, 1982

Cragg's plastic pieces are arranged in a spectrum like that created by a prism. Not only light but also our whole material world passes through Cragg's prism. These fragments of everyday things are the "new stones" of postindustrial culture, a plastic conglomerate of debris. "Newton's tones" are the colors of the spectrum itself. The irony of Cragg's piece, of course, is that color transforms this waste into a thing of beauty, a work of art. The aesthetic beauty of this work is at odds with the material out of which it is made.

CHAPTER 8 Bill Viola's Room for St. John of the Cross, 1983

The simple geometric architecture of the small cell contrasts dramatically with the wild natural beauty of the scene on the large screen. The former is closed and contained, classically calm, the latter open and chaotic, romantically wild. The former is still and quiet, the latter active and dynamic. The larger room, lit only by the screen image, seems dark and foreboding. The cell, lit by a soft yellow light, seems inviting. Time is a factor in terms of our experience of the work. If we approach the cell, our view of the screen is lost. When we stand back from the cell, the rapid movement on the screen disrupts our ability to pay attention to the scene in the cell. The meditative space of the cell stands in stark contrast to the turbulent world around it. And yet the cell represents captivity, the larger room freedom, both real freedom and the freedom of imaginative flight. **CHAPTER 9** Claude Monet's *The Railroad Bridge, Argenteuil*, 1874

Monet uses one-point linear perspective to create the bridge. A gridlike geometry is established where the bridge's piers cross the horizon and the far riverbank. The wooden support structure under the bridge echoes the overall structure of grid and diagonals. In this the picture is classical. But countering this geometry is the single expression of the sail, a curve echoed in the implied line that marks the edge of the bushes at the top right. A sense of opposition is created by the alternating rhythm of light to dark established by the bridge's piers and in the complementary color scheme of orange and blue in both the water and the smoke above. The almost perfect symmetrical balance of the painting's grid structure is countered by the asymmetrical balance of the composition as a whole (its weight seems to fall heavily to the right). There are two points of emphasis, the bridge and the boat. We seem to be witness to the conflicting forces of nature and civilization.

CHAPTER 10 Theresa Duncan and Jeremy Blake's *The History* of *Glamour*, 1998

Cartoon animation captures the shallowness of Valentine's story, reducing it to the level of pop culture that it in fact embodies. The drawings are themselves "inanime"—that is, lifeless, as real actors and actresses could never be. The drawing itself is what might be called "mainstream." There is nothing "original" about it, just as there is nothing about Charles Valentine, until she abandons the "scene," that is not itself a pure product of television media.

CHAPTER 11 Andy Warhol's Marilyn Monroe, 1967, and San Francisco Silverspot, 1983

Marilyn Monroe died a suicide in 1963, as much an endangered species as the Silverspot butterfly, a human being whose identity had been stripped, reducing her to an "image," whose real personality and humanity meant almost nothing to anyone. But Warhol understands that being transformed into a media image might have its positive effects as well, that where Marilyn was destroyed by Hollywood image-making, the Silverspot might be saved. It is color makes Marilyn and the butterfly garlsh, but it draws attention to the plight of both. And both are images that challenge their viewers to change, images that confront our collective indifference.

CHAPTER 12 Fred Tomaselli's Airborne Event, 2003

Almost by definition, the medium of collage, which Tomaselli can be said to take to almost new heights, suggests the artificiality of our perceived environment, a world in which almost all visual experience is constructed and manipulated by others, a world in which our "highs" are no longer naturally, but instead artificially, induced. If in Fra Andrea Pozzo's *Glorification of St. Ignatius* (Fig. 332) St. Ignatius soars toward heaven, in the contemporary world, Tomaselli suggests, such religious transcendence is increasingly only attainable by artificial (i.e., drug-induced) means.

CHAPTER 13 Jeff Wall's A Sudden Gust of Wind, 1993

The greatest transformation is that the pastoral world of the Hokusai print has been replaced by what appears to be an industrial wasteland. The businessmen, of course, have created this landscape. No mountain could be seen in Wall's work, even if there were one. The sky is thick with what appears to be pollution. There is nothing spiritual about this place. Wall's photograph is like a "still" from a motion picture. It implies that we are in the midst of a story. But what story? How can we ever know what is "really" happening here? Knowing that Wall has completely fabricated the scene, we recognize that, in fact, nothing is "really" happening here. Wall's is a world of complete illusion, in which meaning flies away as surely as the papers on a sudden gust of wind.

CHAPTER 14 Eleanor Antin's The Artist's Studio, 2001

Antin's photograph is a summary of three-dimensional sculptural techniques. Examples of both relief and in-the-round sculpture abound, in both marble and bronze—that is, in carved, modeled, and cast media. But the "live" figures are themselves models in Antin's performance art, characters in a "drama" of art that eroticizes sculpture as a medium even as it captures a certain flavor of soft-porn popular magazines such as *Playboy*. Antin, in short, thematizes what might be called a cult of the body that informs Western sculpture as a whole.

CHAPTER 15 Ann Hamilton's 'a round,' 1993

Hamilton's 'a round,' is a highly complex work of art that addresses issues both formal and political. The pillars and thread, as well as the piles of cotton bags surrounding the room, are sculptural. Hamilton's material is fiber, and hence related to the craft media. The physical activity of weaving is performanceoriented, as well as the periodic eruption of the mechanized punching bags. The "feminine" activity of sewing takes place in an environment of "masculine" sport-wrestling and boxing. In probably no other work activity did men exploit women as much as in the textile industry. This appearance of "woman's work" in "masculine" space is one of the many "crossings" in the work. Women have always worked in the context of men's violence. Other crossings include passive quiet and violent noise, the live body and the sawdust "dummies." The thread goes endlessly around and around the pillars, while each "round" in a boxing match lasts for a limited time, like the installation itself. The "dummies" form a membrane around the room that evokes skin, but at the same time they are like piled bodies, victims of some mindless carnage.

CHAPTER 16 Studio Daniel Libeskind's and THINK design's plans for the World Trade Center, 2002–2003

Above all, THINK's plan was valued because of its transformation of the site into a World Cultural Center and its almost "ghostlike" tribute to the original twin towers of the Trade Center. Many people, however, questioned the propriety of the Museum level, especially which some felt looked like a plane crashing through the structure. The various elements of Libeskind's plan had strong symbolic appeal, though many still question the practicality of its giant "garden" spire.

CHAPTER 17 Andrea Zittel's A-Z Time Tunnel, 2000

The audience for design is twofold: manufacturers, who see the designer as key to making their products attractive to consumers, and the consumers themselves, who respond, often subconsciously, or at least without thinking very much about it, to the product's "look." Thus, one of the things that distinguishes the art audience from the design audience is the level of thought that the two audiences bring to the work. Art audiences tend to be much more thoughtful audiences, less susceptible to trends in fashion. One of the special difficulties faced by the designer is the need to appeal to a mass, relatively unthinking audience. An artist needs to find one person who responds to his or her work. Designers have to appeal to as many people as possible. Thus, the art market tends to value the unique object, while the marketplace values objects with broad, even mass, appeal. It is Zittel's appeal to a relatively small and thoughtful audience, and her production of very "limited editions" of her work, that helps to define her as an artist, not a designer.

CHAPTER 22 Tony Brauntuch's Untitled (Shirts 2), 2005, and Jennifer Allora and Guillermo Calzadilla's Hope Hippo, 2005 If 9/11 created a sense of hopelessness and impotence in the face of forces that seemed beyond the scope of normal understanding, Brauntuch addresses that reality by presenting us with an image of stark, but undeniable, beauty. Allora and Calzadilla step beyond that by asserting that the facts are otherwise, that 9/11 was the result of injustice, and, they also imply, injustice is something that we can all address every day. The media regularly report on injustices. The hippo is a symbol of how deeply embedded in the "mud" of our experience injustice lies. We need only pay attention, blow the whistle, see the "hippo" for what it is, expose injustice, and bring it out of the murky waters that it perpetually inhabits. If Brauntuch's image captures the true sorrow of 9/11, both works insist that we cannot afford to ignore the underlying realities that inform the tragedy and its continuing aftermath.

GLOSSARY

Words appearing in italics in the definitions are also defined in the glossary.

- **absolute symmetry** Term used when each half of a composition is exactly the same. (page 165)
- **abstract** In art, the rendering of images and objects in a stylized or simplified way, so that though they remain recognizable, their formal or *expressive* aspects are emphasized. Compare both *representational* and *non-objective art*. (page 21)
- **Abstract Expressionism** A painting style of the late 1940s and early 1950s, predominantly American, characterized by its rendering of *expressive* content by *abstract* or *nonobjective* means. (page 516)
- **acropolis** The elevated site above an ancient Greek city conceived as the center of civic life. (page 431)
- **acrylic** A plastic resin that, when mixed with water and pigment, forms an inorganic and quick-drying paint *medium*. (page 264)
- **actual weight** As opposed to *visual weight*, the physical weight of material in pounds. (page 165)
- **additive** (1) In color, the adjective used to describe the fact that when different *hues* of colored light are combined, the resulting mixture is higher in *key* than the original hues and brighter as well, and as more and more hues are added, the resulting mixture is closer and closer to white. (2) In sculpture, an adjective used to describe the process in which form is built up, shaped, and enlarged by the addition of materials, as distinguished from *subtractive* sculptural processes, such as carving. (pages 130, 300)

aerial perspective See atmospheric perspective. (page 116)

- **aesthetic** Pertaining to the appreciation of the beautiful, as opposed to the functional or utilitarian, and, by extension, to the appreciation of any form of art, whether overtly "beautiful" or not. (page 48)
- **afterimage** In color, the tendency of the eye to see the *complementary color* of an image after the image has been removed. (page 134)
- **ambulatory** A covered walkway, especially around the *apse* of a church. (page 443)
- **analogous colors** Pairs of colors, such as yellow and orange, that are adjacent to each other on the *color wheel.* (page 133)
- **analytic line** Closely related to *classical line*, a kind of line that is mathematical, precise, and rationally organized, epitomized by the vertical and horizontal grid, as opposed to *expressive line*. (page 82)
- **animation** In film, the process of sequencing still images in rapid succession to give the effect of live motion. (page 284)
- **anime** From Japan, a medium of animation often employing computer-assisted animation techniques. (page 214)
- **apse** A semicircular recess placed, in a Christian church, at the end of the *nave*. (page 371)

- **aquatint** An *intaglio* printmaking process in which the acid bites around powdered particles of resin, resulting in a *print* with a granular appearance. The resulting *print* is also called an aquatint. (page 230)
- **arbitrary color** Color that has no *realistic* or natural relation to the object that is depicted, as in a blue horse or a purple cow, but that may have emotional or *expressive* significance. (page 141)
- **arch** A curved, often semicircular architectural form that spans an opening or space built of wedge-shaped blocks, called *voussoirs*, with a *keystone* centered at its top. (page 368)
- architrave In architecture, the *lintel*, or horizontal, weight-bearing beam, that forms the base of the *entablature*. (page 368)
- **Art Deco** A popular art and design style of the 1920s and 1930s associated with the 1925 Exposition Internationale des Arts Décoratifs et Industriels Modernes in Paris and characterized by its integration of organic and geometric forms. (page 404)
- **Art Nouveau** The art and design style characterized by undulating, curvilinear, and organic forms that dominated popular culture at the turn of the century, and that achieved particular success at the 1900 International Exposition in Paris. (page 401)
- **assemblage** An *additive* sculptural process in which various and diverse elements and objects are combined. (page 316)
- **asymmetrical balance** Balance achieved in a composition when neither side reflects or mirrors the other. (page 161)
- **atmospheric perspective** A technique, often employed in landscape painting, designed to suggest *three-dimensional space* in the *two-dimensional space* of the *picture plane*, and in which forms and objects distant from the viewer become less distinct, often bluer or cooler in color, and contrast among the various distant elements is greatly reduced. (page 104)
- **avant-garde** Artists whose works can be characterized as unorthodox and experimental. (page 406)
- **axonometric projection** A technique for depicting space, often employed by architects, in which all lines remain parallel rather than receding to a common *vanishing point* as in *linear perspective*. (page 104)
- **Baroque** A dominant style of art in Europe in the seventeenth century characterized by its theatrical, or dramatic, use of light and color, by its ornate forms, and by its disregard for *classical* principles of composition. (page 477)
- **barrel vault** A masonry roof constructed on the principle of the *arch*, that is, in essence, a continuous series of arches, one behind the other. (page 369)

- **basilica** In Roman architecture, a rectangular public building, entered on one of the long sides. In Christian architecture, a church loosely based on the Roman design, but entered on one of the short ends, with an *apse* at the other end. (page 443)
- **Bauhaus** A German school of design, founded by Walter Gropius in 1919 and closed by Hitler in 1933. (page 409)
- **bilateral symmetry** Term used when the overall effect of a composition is one of *absolute symmetry*, even though there are clear discrepancies side to side. (page 165)
- **binder** In a *medium*, the substance that holds *pigments* together. (page 195)
- **buon fresco** See fresco. (page 244)
- **burin** A metal tool with a V-shaped point used in *engraving*. (page 225)
- **burr** In *drypoint* printing, the ridge of metal that is pushed up by the *engraving* tool as it is pulled across the surface of the plate and that results, when inked, in the rich, velvety *texture* of the drypoint *print*. (page 230)
- **calligraphy** The art of handwriting in a fine and aesthetic way. (page 18)
- **calotype** The first photographic process to utilize a negative image. Discovered by William Henry Fox Talbot in 1841. (page 277)
- **Canon** (of *proportion*) The "rule" of perfect proportions for the human body as determined by the Greek sculptor Polykleitos in a now lost work, known as the *Canon*, and based on the idea that each part of the body should be a common fraction of the figure's total height. (page 182)
- **cantilever** An architectural form that projects horizontally from its support, employed especially after the development of reinforced concrete construction techniques. (page 377)
- **capital** The crown, or top, of a *column*, upon which the *entablature* rests. (page 367)
- **Carolingian art** European art from the mid-8th to the early 10th century, given impetus and encouragement by Charlemagne's desire to restore the civilization of Rome. (page 448)
- **cartoon** As distinct from common usage, where it refers to a drawing with humorous content, any full-size drawing, subsequently transferred to the working surface, from which a painting or *fresco* is made. (page 193)
- **cast iron** A rigid, strong construction material made by adding carbon to iron. (page 373)
- **cast shadow** In *chiaroscuro*, the shadow cast by a figure, darker than the shadowed surface itself. (page 118)
- **casting** The process of making sculpture by pouring molten material—often bronze—into a mold bearing the sculpture's impression. See also *lost-wax casting*. (page 312)
- **ceramics** Objects formed out of clay and then hardened by *firing* in a very hot oven, or *kiln*. (page 310)
- **chiaroscuro** In drawing and painting, the use of light and dark to create the effect of *three-dimensional*, *modeled* surfaces. (page 118)
- **cire-perdue** See *lost-wax casting*. (page 312)

classical line Closely related to *analytic line*, a kind of line that is mathematical, precise, and rationally organized, epitomized by the vertical and horizontal grid, as opposed to *expressive line*. (page 83)

closed palette See *palette*. (page 139)

close-up See *shot*. (page 285)

- **coiling** A method of *ceramic* construction in which long ropelike strands of clay are coiled on top of one another and then smoothed. (page 337)
- **collage** A work made by pasting various scraps or pieces of material—cloth, paper, photographs—onto the surface of the *composition*. (page 266)
- **colonnade** A row of *columns* set at regular intervals around the building and supporting the base of the roof. (page 367)
- **color wheel** A circular arrangement of *hues* based on one of a number of various color theories. (page 129)
- **column** A vertical architectural support, consisting of a *shaft* topped by a *capital*, and sometimes including a base. (page 367)
- **complementary colors** Pairs of colors, such as red and green, that are directly opposite each other on the *color wheel*. (page 133)
- **composition** The organization of the formal elements in a work of art. (page 26)
- **connotation** The meaning associated with or implied by an image, as distinguished from its *denotation*. (page 242)
- **Constructivism** A Russian art movement, fully established by 1921, that was dedicated to *nonobjective* means of communication. (page 407)
- **Conté crayon** A soft drawing tool made by adding clay to graphite. (page 201)
- **content** The meaning of an image, beyond its overt *subject matter*; as opposed to *form*. (page 27)
- **contour line** The perceived line that marks the border of an object in space. (page 75)
- **contrapposto** The disposition of the human figure in which the hips and legs are turned in opposition to the shoulders and chest, creating a counter-positioning of the body. (page 307)
- **convention** A traditional, habitual, or widely accepted method of representation. (page 28)
- **cornice** The upper part of the *entablature*, frequently decorated. (page 368)
- **craft** Expert handiwork, or work done by hand. (page 335)
- **cross-cutting** In film technique, when the editor moves back and forth between two separate events in increasingly shorter sequences in order to heighten drama. (page 286)
- **cross-hatching** Two or more sets of roughly parallel and overlapping lines, set at an angle to one another, in order to create a sense of *three-dimensional*, *modeled* space. See also *hatching*. (page 120)
- **crossing** In a church, where the *transepts* cross the *nave*. (page 371)
- **Cubism** A style of art pioneered by Pablo Picasso and Georges Braque in the first decade of the 20th century,

noted for the geometry of its forms, its fragmentation of the object, and its increasing abstraction. (page 505)

cyberspace See virtual reality. (page 113)

- **Dada** An art movement that originated during World War I in a number of world capitals, including New York, Paris, Berlin, and Zurich, which was so antagonistic to traditional styles and materials of art that it was considered by many to be "anti-art." (page 511)
- **daguerreotype** One of the earliest forms of photography, invented by Louis Jacques Mandé Daguerre in 1839, made on a copper plate polished with silver. (page 275)
- **delineation** The descriptive representation of an object by means of *outline* or *contour* drawing. (page 199)
- **denotation** The direct or literal meaning of an image, as distinguished from its *connotation*. (page 242)
- **De Stijl** A Dutch art movement of the early 20th century that emphasized abstraction and simplicity, reducing form to the rectangle and color to the *primary colors*—red, blue, and yellow. (page 406)
- **diagonal recession** In *perspective*, when the lines recede to a *vanishing point* to the right or left of the *vantage point*. (page 100)
- **dimetric projection** A kind of *axonometric projection* in which two of the three measurements—height, width, and depth—employ the same *scale*, while the third is different. (page 105)
- **dome** A roof generally in the shape of a hemisphere or half-globe. (page 370)
- **drypoint** An *intaglio* printmaking process in which the copper or zinc plate is incised by a needle pulled back across the surface leaving a *burr*. The resulting *print* is also called a drypoint. (page 230)
- **earthenware** A type of *ceramics* made of porous clay and fired at low temperatures that must be *glazed* if it is to hold liquid. (page 338)
- **earthwork** An *environment* that is out-of-doors. (page 304)
- **editing** In filmmaking, the process of arranging the sequences of the film after it has been shot in its entirety. (page 285)
- edition In printmaking, the number of *impressions* authorized by the artist made from a single master image. (page 216)
- **elevation** The side of a building, or a drawing of the side of a building. (page 367)
- **embroidery** A traditional fiber art in which the design is made by needlework. (page 350)
- **encaustic** A method of painting with molten beeswax fused to the support after application by means of heat. (page 243)
- **engraving** An *intaglio* printmaking process in which a sharp tool called a *burin* is used to incise the plate. The resulting *print* is also called an engraving. (page 225)
- **entablature** The part of a building above the *capitals* of the *columns* and below the roof. (page 367)
- **entasis** The slight swelling in a *column* design to make the column appear straight to the eye. (page 367)
- **environment** A sculptural space that is large enough for the viewer to move around in. (page 304)

- **etching** An *intaglio* printmaking process in which a metal plate coated with wax is drawn upon with a sharp tool down to the plate and then placed in an acid bath. The acid eats into the plate where the lines have been drawn, the wax is removed, and then the plate is inked and printed. The resulting *print* is also called an etching. (page 228)
- **ethnocentric** Pertaining to the imposition of the point of view of one culture upon the works and attitudes of another. (page 28)
- **Expressionism** An art that stresses the psychological and emotional content of the work, associated particularly with German art in the early 20th century. See also *Abstract Expressionism*. (page 507)
- **expressive line** A kind of line that seems to spring directly from the artist's emotions or feelings—loose, gestural, and energetic—epitomized by curvilinear forms; as opposed to *analytic* or *classical line*. (page 79)
- extreme close-up See shot. (page 285)
- Fauvism An art movement of the early 20th century characterized by its use of bold *arbitrary color*. Its name derives from the French word "fauve," meaning "wild beast." (page 506)
- **figure-ground reversal** Term used to describe a *two-dimensional* work in which the relationship between a form or figure and its background is reversed so that what was figure becomes background and what was background becomes figure. (page 97)
- firing The process of baking a *ceramic* object in a very hot oven, or *kiln*. (page 336)
- **fixative** A thin liquid film sprayed over *pastel* and charcoal drawings to protect them from smudging. (page 200)
- **flashback** A narrative technique in film in which the editor cuts to episodes that are supposed to have taken place before the start of the film. (page 286)
- fluting The shallow vertical grooves or channels on a *column*. (page 366)
- flying buttress On a Gothic church, an exterior *arch* that opposes the lateral thrust of an arch or vault, as in a *barrel vault*, arching inward toward the exterior wall from the top of an exterior *column* or pier. (page 372)
- **focal point** In a work of art, the center of visual attention, often different from the physical center of the work. (page 171)
- **foreshortening** The modification of *perspective* to decrease distortion resulting from the apparent visual contraction of an object or figure as it extends backward from the *picture plane* at an angle approaching the perpendicular. (page 108)
- **form** (1) The literal *shape* and *mass* of an object or figure. (2) More generally, the materials used to make a work of art, the ways in which these materials are utilized in terms of the formal elements (line, light, color, etc.), and the *composition* that results. (page 26)
- **fresco** Painting on plaster, either dry (*fresco secco*) or wet (*buon*, or true *fresco*). In the former, the paint is an independent layer, separate from the plaster proper; in the latter, the paint is chemically bound to the plaster, and is integral to the wall or support. (page 244)
- fresco secco See fresco. (page 244)

- **frieze** The part of the *architrave* between the *entablature* and the *cornice*, often decorated. (page 302)
- **frontal recession** In *perspective*, when the lines recede to a *vanishing point* directly across from the *vantage point*. (page 100)
- **frottage** The technique of putting a sheet of paper over textured surfaces and then rubbing a soft pencil across the paper. (page 150)
- full shot See shot. (page 285)
- **Futurism** An early 20th century art movement, characterized by its desire to celebrate the movement and speed of modern industrial life. (page 509)
- **genre** In painting, the representation of scenes from daily life. (page 44)
- **gesso** A plaster mixture used as a *ground* for painting. (page 250)
- **glaze** In oil painting, a thin, transparent, or semitransparent layer put over a color, usually in order to give it a more luminous quality. (page 336)
- **glazing** In *ceramics*, a material that is painted on a ceramic object that turns glassy when fired. (page 254)
- **Golden Section** A system of *proportion* developed by the ancient Greeks obtained by dividing a line so that the shorter part is to the longer part as the longer part is to the whole, resulting in a ratio that is approximately 5 to 8. (page 182)
- **Gothic** A style of architecture and art dominant in Europe from the 12th to the 15th century, characterized, in its architecture, by features such as *pointed arches*, *flying buttresses*, and a verticality symbolic of the ethereal and heavenly. (page 451)
- **gouache** A painting *medium* similar to *watercolor*, but opaque instead of transparent. (page 262)
- grid A pattern of horizontal and vertical lines that cross each other to make uniform squares or rectangles. (page 83)
- **groined vault** A masonry roof constructed on the *arch* principle and consisting of two *barrel vaults* intersecting at right angles to one another. (page 369)
- **ground** A coating applied to a canvas or printmaking plate to prepare it for painting or *etching*. (page 243)
- **Happenings** Spontaneous, often multimedia, events conceived by artists and performed not only by the artists themselves but often by the public present at the event as well. (page 327)
- hatching An area of closely spaced parallel lines, employed in drawing and *engraving*, to create the effect of shading or *modeling*. See also *cross-hatching*. (page 119)
- **heightening** The addition of *highlights* to a drawing by the application of white or some other pale color. (page 199)
- **Hellenism** The culture of ancient Greece. (page 433)
- highlights The spot or one of the spots of highest key or *value* in a picture. (page 118)
- high (haut) relief A sculpture in which the figures and objects remain attached to a background plane and project off of it by at least half their normal depth. (page 302)

hue A color, usually one of the six basic colors of the *spectrum*—the three *primary colors* of red, yellow, and blue, and the three *secondary colors* of green, orange, and violet. (page 121)

hyperspace See virtual reality. (page 113)

- **iconography** The study or description of images and symbols. (page 31)
- **illusionistic art** Generally synonymous with *representational art*, but more specifically referring to an image so natural that it creates the illusion of being real. (page 21)
- **impasto** Paint applied very thickly to canvas or support. (page 148)
- **implied line** A line created by movement or direction, such as the line established by a pointing finger, the direction of a glance, or a body moving through space. (page 75)
- **impression** In printmaking, a single example of an *edition*. (page 216)
- **Impressionism** A late-19th-century art movement, centered in France and characterized by its use of discontinuous strokes of color meant to reproduce the effects of light. (page 36)
- **infrastructure** The systems that deliver services to people—water supply and waste removal, energy, transportation, and communications. (page 389)
- installation An environment that is indoors. (304)
- **installation art** Sculptural and other materials introduced into a space in order to transform our experience of it. (page 322)
- intaglio Any form of printmaking in which the line is incised into the surface of the printing plate, including *aquatint, drypoint, etching, engraving,* and *mezzotint.* (page 224)
- **intensity** The relative purity of a color's *hue*, and a function of its relative brightness or dullness; also known as *saturation*. (page 130)
- intermediate colors The range of colors on the *color* wheel between each primary color and its neighboring secondary colors; yellow-green, for example. (page 130)
- **International Style** A 20th-century style of architecture and design marked by its almost austere geometric simplicity. (page 382)
- **in-the-round** As opposed to *relief*, sculpture that requires no wall support and that can be experienced from all sides. (page 303)
- **investment** In *lost-wax casting*, a mixture of water, plaster, and powder made from ground-up pottery used to fill the space inside the wax lining of the mold. (page 313)
- **iris shot** In film, a *shot* that is blurred and rounded at the edges in order to focus the attention of the viewer on the scene in the center. (page 286)
- **isometric projection** A kind of *axonometric projection* in which all three measurements—height, width, and depth—employ the same *scale*. (page 105)
- ka In ancient Egypt, the immortal substance of the human, in some ways equivalent to the Western soul. (page 306)

- **keystone** The central and uppermost *voussoir* in an *arch*. (page 368)
- kiln An oven used to bake ceramics. (page 310)

kinetic art Art that moves. (page 76)

- **kiva** In Anasazi culture, the round, covered hole in the center of the communal plaza in which all ceremonial life took place. (page 364)
- **line** A mark left by a moving point, actual or implied, and varying in direction, thickness, and density. (page 74)
- **linear perspective** A system for depicting *threedimensional space* on a *two-dimensional* surface that depends on two related principles: that things perceived as far away are smaller than things nearer the viewer, and that parallel lines receding into the distance converge at a *vanishing point* on the horizon line. (page 100)
- **linocut** A form of *relief* printmaking, similar to a *woodcut*, in which a block of linoleum is carved so as to leave the image to be printed raised above the surface of the block. The resulting *print* is also known as a linocut. (page 224)
- **literati** A tendency in Chinese calligraphy and ink painting that celebrates the personality of the erudite artist, as opposed to the artist's technique. (page 471)
- **lithography** A printmaking process in which a polished stone, often limestone, is drawn upon with a greasy material; the surface is moistened and then inked; the ink adheres only to the greasy lines of the drawing; and the design is transferred to dampened paper, usually in a printing press. (page 231)
- **load-bearing construction** In architecture, construction where the walls bear the weight of the roof. (page 365)
- **local color** As opposed to *optical color* and *perceptual color*, the actual *hue* of a thing, independent of the ways in which colors might be mixed or how different conditions of light and atmosphere might affect color. (page 139)
- **long shot** In film, a *shot* that takes in a wide expanse and many characters at once. (page 286)
- **lost-wax** A bronze-casting method in which a figure is molded in wax and covered with clay; the whole is fired, melting away the wax and hardening the clay; and the resulting hardened mold is then filled with molten metal. (page 312)
- **low (bas) relief** A sculpture in which the figures and objects remain attached to a background plane and project off of it by less than one-half their normal depth. (page 302)
- manga Comic books or graphic novels from Japan. (page 214)
- **Mannerism** The style of art prevalent especially in Italy from about 1525 until the early years of the 17th century, characterized by its dramatic use of light, exaggerated *perspective*, distorted forms, and vivid colors. (page 475)
- **mass** Any solid that occupies a *three-dimensional* volume. (page 96)

matrix In printmaking, the master image. (page 216)

medium (1) Any material used to create a work of art. Plural form, media. (2) In painting, a liquid added to paint that makes it easier to manipulate. (pages 130, 191)

medium shot See *shot*. (page 285)

- **megalith** Literally, a "big stone" used in prehistoric construction. (page 423)
- **megaliths** From the Greek *meaga* meanning "bib," and *lithos*, meaning "stone." A huge stone used in prehistoric architecture. (page 423)
- **metalpoint** A drawing technique, especially *silverpoint*, popular in the 15th and 16th centuries, in which a stylus with a point of gold, silver, or some other metal was applied to a sheet of paper treated with a mixture of powdered bones (or lead white) and gumwater. (page 198)
- **mezzotint** An *intaglio* printmaking process in which the plate is ground all over with a *rocker*, leaving a *burr* raised on the surface that if inked would be rich black. The surface is subsequently lightened to a greater or lesser degree by scraping away the burr. The resulting *print* is also known as a mezzotint. (page 230)
- **mihrab** A niche set in the wall of a mosque indicating the direction of Mecca. (page 454)
- **mimesis** The concept of imitation, involving the creation of *representations* that transcend or exceed mere appearance by implying the sacred or spiritual essence of things. (page 242)
- **minaret** A tall, slender tower attached to a mosque from which the people are called to prayer. (page 454)
- **Minimalism** A style of art, predominantly American, that dates from the mid-20th century, characterized by its rejection of expressive content and its use of "minimal" formal means. (page 519)
- **mixed media** The combination of two or more *media* in a single work. (page 265)
- **modeling** In sculpture, the shaping of a form in some plastic material, such as clay or plaster; in drawing, painting, and printmaking, the rendering of a form, usually by means of *hatching* or *chiaroscuro*, to create the illusion of a *three-dimensional form*. (pages 118, 310)
- **Modernism** Generally speaking, the various strategies and directions employed in 20th-century art—*Cubism*, *Futurism*, *Expressionism*, etc.—to explore the particular formal properties of any given *medium*. (page 516)
- **monotype** A printmaking process in which only one *impression* results. (page 238)
- **montage** In film, the sequencing of widely disparate images to create a fast-paced, multifaceted visual impression. (page 286)
- **mosaic** An art form in which small pieces of tile, glass, or stone are fitted together and embedded in cement on surfaces such as walls and floors. (page 444)
- **mudra** The various hand positions of the Buddha. (page 32)
- **naturalistic art** Generally synonymous with *representational art*, but more specifically meaning "like nature"; descriptive of any work that resembles the natural world. (page 21)
- **nave** The central part of a church, running from the entrance through the *crossing*. (page 371)

- **negative shape** or **space** Empty space, surrounded and shaped so that it acquires a sense of form or volume. (page 98)
- **Neoclassicism** A style of the late 18th and early 19th centuries that was influenced by the Greek *Classical style* and that often employed Classical themes for its subject matter. (page 487)
- **nonobjective art** Art that makes no reference to the natural world and that explores the inherent expressive or aesthetic potential of the formal elements—line, shape, color—and the formal *compositional* principles of a given *medium*. (page 21)

nonrepresentational art See *nonobjective art*. (page 21)

- **oblique projection** A system for projecting space, commonly found in Japanese art, in which the front of the object or building is parallel to the picture plane, and the sides, receding at an angle, remain parallel to each other, rather than converging as in *linear perspective*. (page 105)
- **oculus** A round, central opening at the top of a *dome*. (page 370)
- **one-point linear perspective** A version of *linear perspective* in which there is only one *vanishing point* in the *composition*. (page 100)

open palette See *palette*. (page 139)

- **optical painting (Op Art)** An art style particularly popular in the 1960s in which line and color are manipulated in ways that stimulate the eye into believing it perceives movement. (page 154)
- **order** In Classical architecture, a style characterized by the design of the *platform*, the *column*, and its *entablature*. (page 367)
- **original print** A *print* created by the artist alone and that has been printed by the artist or under the artist's direct supervision. (page 216)
- **outline** The edge of a shape or figure depicted by an actual line drawn or painted on the surface. (page 74)
- **overlap** A way to create the illusion of space by placing one figure behind another. (page 99)
- **palette** Literally, a thin board, with a thumb hole at one end, upon which the artist lays out and mixes colors, but, by extension, the range of colors used by the artist. In this last sense, a *closed* or *restricted palette* is one employing only a few colors and an *open palette* is one utilizing the full range of *hues*. (page 131)
- **pan** In film, a *shot* in which the camera moves across the scene from one side to the other. (page 286)
- **pastel** (1) A soft crayon made of chalk and pigment; also, any work done in this *medium*. (2) A pale, light color. (page 203)
- **patina** In sculpture, a chemical compound applied to bronze by the artist; it then forms on the surface after exposure to the elements. (page 315)
- pattern A repetitive motif or design. (page 147)
- **pencil** A drawing tool made of graphite encased in a soft wood cylinder. (page 201)
- **pendentive** A triangular section of a masonry hemisphere, four of which provide the transition from the vertical sides of a building to a covering *dome*. (page 446)

- **penumbra** The lightest of the three basic parts of a shadowed surface, providing the transition from the lighted area to the *umbra*, or core of the shadow. (page 118)
- **performance art** A form of art, popular especially since the late 1960s, that includes not only physical space but also the human activity that goes on within it. (page 327)
- **perspective** A formula for projecting the illusion of *threedimensional space* onto a *two-dimensional* surface. See also *linear perspective*, *one-point linear perspective*, *two-point linear perspective*, and *atmospheric perspective*. (page 99)
- **photogenic drawing** With the *daguerreotype*, one of the first two photographic processes, invented by William Henry Fox Talbot in 1839, in which a negative image is fixed to paper. (page 275)
- **picture plane** The flat, *two-dimensional* surface of a painting. (page 99)
- pigments The coloring agents of a *medium*. (page 195)
- **planographic printmaking process** Any printmaking process in which the *print* is pulled from a flat, planar surface, chief among them *lithography*. (page 231)
- platform The base upon which a *column* rests. (page 367)
- **plein-air painting** Painting done on site, in the open air. (page 140)
- **pointed arch** An *arch* that is not semicircular but rather rises more steeply to a point at its top. (page 372)
- **polychromatic color scheme** A color composition consisting of a variety of *hues*. (page 139)
- **ponderation** The principle of the weight shift, in which the relaxation of one leg serves to create a greater sense of naturalism in the figure. (page 306)
- **Pop Art** A style arising in the early 1960s characterized by emphasis on the forms and imagery of mass culture. (page 518)
- **porcelain** The type of *ceramics* fired at the highest temperature that becomes virtually translucent and extremely glossy in finish. (page 338)
- **position** In the art process, a method of establishing space in a *two-dimensional* work by placing objects closer to the viewer lower and objects farther away from the viewer higher in the picture. (page 105)
- **post-and-lintel construction** A system of building in which two posts support a crosspiece, or *lintel*, that spans the distance between them. (page 366)
- **Post-Impressionism** A name that describes the painting of a number of artists, working in widely different styles, in France during the last decades of the 19th century. (page 501)
- **Postmodernism** A term used to describe the willfully plural and eclectic art forms of contemporary art. (page 187)
- **potter's wheel** A flat disk attached to a flywheel below that is kicked by the potter or driven by electricity, allowing the potter to pull clay upward in a round, symmetrical shape. (page 338)
- **Pre-Columbian** The cultures of all the peoples of Mexico, Central America, and South America prior to the arrival of the Europeans at the end of the 15th century. (page 472)

- **primary colors** The *hues* that in theory cannot be created from a mixture of other hues and from which all other hues are created—namely, in *pigment*, red, yellow, and blue, and in refracted light, red-orange, green, and blue-violet. (page 129)
- **print** Any one of multiple *impressions* made from a master image. (page 216)
- **proof** A trial *impression* of a *print*, made before the final *edition* is run, so that it may be examined and, if necessary, corrected. (page 216)
- **proportion** In any composition, the relationship between the parts to each other and to the whole. (page 176)
- **qibla wall** The wall of a mosque that, from the interior, is oriented in the direction of Mecca, and that contains the *mihrab*. (page 454)
- **radial balance** A circular composition in which the elements project outward from a central core at regular intervals, like the spokes of a wheel. (page 170)
- **realism** Generally, the tendency to render the facts of existence, but, specifically, in the 19th century, the desire to describe the world in a way unadulterated by the imaginative and idealist tendencies of the Romantic sensibility. (page 494)

realistic art See representational art. (page 21)

- **registration** In printmaking, the precise alignment of *impressions* made by two or more blocks or plates on the same sheet of paper, utilized particularly when printing two or more colors. (page 224)
- **relief** (1) Any sculpture in which images and forms are attached to a background and project off it. See *low-relief* and *high-relief*. (2) In printmaking, any process in which any area of the plate not to be printed is carved away, leaving only the original surface to be printed. (page 216)
- **Renaissance** The period in Europe from the 14th to the 16th century characterized by a revival of interest in the arts and sciences that had been lost since antiquity. (page 459)
- repetition See *pattern* and *rhythm*. (page 183)
- **replacement** A term for casting, by, for instance, the *lost-wax* process, in which wax is replaced by bronze. (page 313)
- **representational art** Any work of art that seeks to resemble the world of natural appearance. (page 21)
- **reserve** An area of a work of art that retains the original color and texture of the untouched surface or *ground*. (page 98)
- **rhythm** An effect achieved when shapes, colors, or a regular *pattern* of any kind is repeated over and over again. (page 183)
- **rocker** A sharp, curved tool utilized in the *mezzotint* printmaking process. (page 230)
- **Rococo** A style of art popular in the first three-quarters of the 18th century, particularly in France, characterized by curvilinear forms, *pastel* colors, and light, often frivolous subject matter. (page 486)
- **Romanesque art** The dominant style of art and architecture in Europe from the 8th to the 12th century, characterized, in architecture, by Roman precedents,

particularly the round *arch* and the *barrel vault*. (page 449)

- **romantic** Pertaining to works of art possessing the characteristics of *Romanticism*, including the expression of all feelings and passions. (page 84)
- **Romanticism** A dramatic, emotional, and *subjective* art arising in the early 19th century in opposition to the austere discipline of *Neoclassicism*. (page 490)
- **sans-serif** Letter type styles that are plain and geometric, as opposed to *serif* type styles. (page 408)
- saturation See intensity. (page 130)
- **scale** The comparative size of an object in relation to other objects and settings. (pages 99, 176)
- **secondary colors** Hues created by combining two *primary colors*; in *pigment*, the secondary colors are traditionally considered to be orange, green, and violet; in refracted light, yellow, magenta, and cyan. (page 129)
- **serif type** Letter forms that have small lines at the end of the letter's main stroke. (page 407)
- **serigraphy** Also known as screenprinting, a stencil printmaking process in which the image is transferred to paper by forcing ink through a mesh; areas not meant to be printed are blocked out. (page 237)
- shade A color or *hue* modified by the addition of another color, resulting in a *hue* of lower *key* or *value*, in the way, for instance, that the addition of black to red results in maroon. (page 121)
- shaft A part of a column. (page 367)
- shape A two-dimensional area, the boundaries of which are measured in terms of height and width. More broadly, the form of any object or figure. (page 96)
- **shell system** In architecture, one of the two basic structural systems in which one basic material both provides the structural support and the outside covering of a building. (page 365)
- shot In film, a continuous sequence of film frames, including a *full shot*, which shows the actor from head to toe, a *medium shot*, which shows the actor from the waist up, a *close-up*, showing the head and shoulders, and an *extreme close-up*, showing a portion of the face. Other shots include the *long shot*, the *iris shot*, the *pan*, and the *traveling shot*. (page 285)
- **silkscreen** Also known as a serigraph, a print made by the process of *serigraphy*. (page 237)
- silverpoint See *metalpoint*. (page 198)
- **simultaneous contrast** A property of *complementary colors* when placed side by side, resulting in the fact that both appear brighter and more intense than when seen in isolation. (page 133)
- **sinopie** The *cartoon* or underpainting for a *fresco*. (page 200)
- **site-specific** A work of art created for a specific location and designed to relate to that location. (page 322)
- **sizing** An astringent crystalline substance called alum brushed onto the surface of paper so that ink will not run along its fibers. (page 220)
- skeleton-and-skin system In architecture, one of the two basic structural systems, which consists of an interior

frame, the skeleton, that supports the more fragile outer covering of the building, the skin. (page 365)

- **slab construction** A method of *ceramic* construction in which clay is rolled out flat, like a pie crust, and then shaped by hand. (page 337)
- **solvent** A thinner that enables paint to flow more readily and that also cleans brushes; also called *vehicle*. (page 243)
- **spectrum** The colored bands of visible light created when sunlight passes through a prism. (page 129)
- **springing** The lowest stone of an *arch*, resting on the supporting post. (page 370)
- star In the popular cinema, an actor or actress whose celebrity alone can guarantee the success of a film. (page 287)
- **state** In printmaking, an *impression* pulled part way through the process so that the artist can study how the image is progressing. (page 226)
- **stippling** In drawing and printmaking, a pattern of closely placed dots or small marks employed to create the effect of shading or *modeling*. (page 225)
- **stoneware** A type of *ceramics* fired at high temperature and thus impermeable to water. (page 338)
- **stopping out** In *etching*, the application of varnish or *ground* over the etched surface in order to prevent further etching as the remainder of the surface is submerged in the acid bath. (page 229)
- stupa A large mound-shaped Buddhist shrine. (page 440)
- **stylobate** The base, or *platform*, upon which a *column* rests. (page 367)
- **subject matter** The literal, visible image in a work of art, as distinguished from its *content*, which includes the *connotative*, symbolic, and suggestive aspects of the image. (page 22)
- **sublime** That which impresses the mind with a sense of grandeur and power, inspiring a sense of awe. (page 4)
- **subtractive** (1) In color, the adjective used to describe the fact that, when different *hues* of colored *pigment* are combined, the resulting mixture is lower in *key* than the original hues and duller as well, and as more and more hues are added, the resulting mixture is closer and closer to black. (2) In sculpture, an adjective used to describe the process in which form is discovered by the removal of materials, by such means as carving, as distinguished from *additive* sculptural processes, such as *assemblage*. (pages 130, 300)
- **support** The surface on which the artist works—a wall, a panel of wood, a canvas, or a sheet of paper. (page 243)
- **Surrealism** A style of art of the early 20th century that emphasized dream imagery, chance operations, and rapid, thoughtless forms of notation that expressed, it was felt, the unconscious mind. (page 44)
- **symmetry** Term used when two halves of a *composition* correspond to one another in terms of size, shape, and placement of forms. (page 165)
- **tapestry** A special kind of *weaving*, in which the *weft* yarns are of several colors that the weaver manipulates to make a design or image. (page 350)
- **technology** The materials and methods available to a given culture, (page 362)

- **tempera** A painting *medium* made by combining water, pigment, and, usually, egg yolk. (page 250)
- **temperature** The relative warmth or coolness of a given *hue*; hues in the yellow-orange-red range are considered to be warm, and hues in the green-blue-violet range are considered cool. (page 133)
- **tenebrism** From the Italian *tenebroso*, meaning murky, a heightened form of *chiaroscuro*. (page 124)
- **tensile strength** In architecture, the ability of a building material to span horizontal distances without support and without buckling in the middle. (page 365)
- **tesserae** Small pieces of glass or stone used in making a *mosaic*. (page 445)
- texture The surface quality of a work. (page 147)
- **three-dimensional space** Any space that possesses height, width, and depth. (page 97)
- **time** and **motion** The primary elements of temporal media, linear rather than spatial in character. (page 147)
- **tint** A color or *hue* modified by the addition of another color resulting in a hue of higher *key* or *value*, in the way, for instance, that the addition of white to red results in pink. (page 121)
- **topography** The distinct landscape characteristics of a local site. (page 362)
- **transept** The crossarm of a church that intersects, at right angles, with the *nave*, creating the shape of a cross. (page 371)
- **traveling shot** In film, a *shot* in which the camera moves back to front or front to back. (page 286)
- **trimetric projection** A kind of *axonometric projection* in which all three measurements—height, width, and depth—employ a different *scale*. (page 105)
- **trompe l'oeil** A form of *representation* that attempts to depict the object as if it were actually present before the eye in *three-dimensional space*; literally "deceit of the eye." (page 254)
- **truss** In architecture, a triangular framework that, because of its rigidity, can span much wider areas than a single wooden beam. (page 374)
- tunnel vault See *barrel vault*. (page 369)
- **tusche** A greasy material used for drawing on a *lithography* stone. (page 236)
- **two-dimensional space** Any space that is flat, possessing height and width, but no depth, such as a piece of drawing paper or a canvas. (page 98)
- **two-point linear perspective** A version of *linear perspective* in which there are two (or more) *vanishing points* in the *composition*. (page 102)
- **tympanum** The semicircular *arch* above the *lintel* over a door, often decorated with sculpture. (page 450)
- **ukiyo-e** A style of Japanese art, meaning "pictures of the transient or floating world," that depicted, especially, the pleasures of everyday life. (page 220)
- **umbra** The heart, or core, of a shadow. (page 118)
- **value** See *key*. Also, a work's intrinsic worth to an individual and to society. (page 121)

- vanishing point In *linear perspective*, the point on the horizon line where parallel lines appear to converge. (page 100)
- **vanitas** A kind of still-life painting designed to remind us of the vanity, or frivolous quality, of human existence. (page 51)
- vantage point In linear perspective, the point where the viewer is positioned. (page 100)

- video art An art form that employs television as its *medium*. (page 290)
- **virtual reality** An artificial three-dimensional *environment*, sometimes called *hyperspace* or *cyberspace*, generated through the use of computers, that the viewer experiences as real space. (page 113)
- **visual literacy** The ability to recognize, understand, and communicate the meaning of visual images. (page 17)
- visual weight As opposed to *actual weight*, the apparent "heaviness" or "lightness" of a shape or form. (page 165)
- **voussoir** A wedge-shaped block used in the construction of an *arch*. (page 368)
- **warp** In *weaving*, the vertical threads, held taut on a loom or frame. (page 350)
- **wash** Large flat areas of ink or *watercolor* diluted with water and applied by brush. (page 211)

- **watercolor** A painting *medium* consisting of *pigments* suspended in a solution of water and gum arabic. (page 260)
- **weaving** A technique for constructing fabrics by means of interlacing horizontal and vertical threads. (page 350)
- weft In *weaving*, the loosely woven horizontal threads, also called the *woof*. (page 350)
- wet-plate collodion process A photographic process, developed around 1850, that allowed for short exposure times and quick development of the print. (page 277)
- **wood engraving** Actually a *relief* printmaking technique, in which fine lines are carved into the block, resulting in a *print* consisting of white lines on a black ground. The resultant print is also called a wood engraving. (page 222)
- **woodcut** A *relief* printmaking process, in which a wooden block is carved so that those parts not intended to print are cut away, leaving the design raised. The resultant *print* is also called a woodcut. (page 217)
- **wood-frame construction** A true skeleton-and-skin building method, commonly used in domestic architecture to the present. (page 374)
- woof See *weft*. (page 350)
- **ziggurats** Pyramidal structures, built in ancient Mesopotamia, consisting of three stages or levels, each stage stepped back from the one below. (page 363)

vehicle See *solvent*. (page 243)

PRONUNCIATION GUIDE

an—man, tan ay—day, play aw—draw, saw ah—that, cat eh—pet, get er—her, fur ih—fit, spit oh—toe, go ohn—phone, tone ow—cow, now uh—bud, fuss eye—sky, try No pronunciation guide is perfect, and this one is like all others. It is meant solely to assist North American readers in pronouncing, with some assurance that they will not be embarrassed, unfamiliar names and phrases. Foreign names and phrases, particularly, are not rendered here with perfect linguistic accuracy. Many of the subtleties of French pronunciation are ignored (in part because many North Americans cannot hear them), as are the gutteral consonants of German and its related languages. The Guide suggests, for instance, that Vincent van Gogh be pronounced "van GOH"—a perfectly acceptable North American pronunciation that wholly ignores the throaty glottal click of the the Dutch "g." Often, there is, even among scholars, disagreement about how a name is pronounced. We have tried to offer alternatives in such instances.

A simplified phonetic system has been employed. Some of the less obvious conventions are listed at the left.

Abakanowicz, Magdalena mahg-daw-LAY-nuh aw-baw-kaw-NOH-vich Akhenaton aw-keh-NAH-ten Anthemius of Tralles ahn-THAY-mee-us of TRAW-layss Aphrodite ahph-roh-DYE-tee architrave ARK-ih-trayv Baca, Judith F. BAW-CAW Balla, Giacomo JAH-coh-moh BAW-law Barela, Patrocinio pah-troh-CHEE-nee-oh baw-RELL-uh Bartolommeo, Fra fraw bar-toh-loh-MAY-oh Baselitz, Georg GAY-ohrg BAZ-eh-litz Basquiat, Jean-Michel jawn mee-SHELL boss-kee-AW Bel Geddes, Norman bel geh-DEES Bellini, Giovanni jyoh-VAI IN-ee bell-EE-nee Benin beh-NEEN Bernini, Gianlorenzo jawn-loh-REN-soh behr-NEE-nee Beuys, Joseph YO-sef BOYS Bonheur, Rosa buhn-ER Bonnard, Pierre pee-AIR boh-NAWR Borromini, Francesco frahn-CHAY-skoh bore-oh-MEE-nee Botticelli, Sandro SAN-droh boh-tee-CHEL-lee Boucher, François frahn-SWAH boo-SHAY Braque, Georges jorih BRAHK Breuer, Marcel mar-SELL BROO-er Bronzino brawn-ZEEN-oh Brueghel, Pieter PAYT-ur BROY-gul burin BYOOR-in Caillebotte, Gustave goos-TAWV kye-BAWT camera obscura KAM-er-aw ob-SKOOR-uh Caravaggio caw-raw-VAW-jyoh Carracci, Annibale on-NEE-ball-ay car-RAW-chee Cartier-Bresson, Henri on-REE car-TEE-ay Bress-OH(n) Cassatt, Mary kaw-SAWT Cellini, Benvento bin-vin-OOT-oh chel-EEN-nee Cézanne, Paul say-ZAN Chardin, Jean Baptiste Siméon jawn ba-TEEST see-may-ohn shar-DAN Chartres SHAR-tr' Chauvet shoh-VAY Cheng Sixiao jong see-SHO chiaroscuro kee-ar-oh-skoor-oh Chihuly, Dale Chih-HOO-lee Chirico, Giorgio de JOR-gee-oh day Kee-ree-coh Christo KRIS-toh Cimabue chee-maw-BOO-ay cire perdue seer payr-DOO Clodion, Claude-Michel klodh-mee-SHELL kloh-dee-OII(n) contrapposto kohn-traw-POH-stoh Corbusier, Le luh kor-boo-SEE-ay

Cortona, Pietro da pee-AY-troh daw kor-TOHN-naw Courbet, Gustave goos-TAWV koor-BAY Daguerre, Louis Jacques Mandé loo-ee JAWK man-DAY daw-GAYR Dali, Salvador sal-vaw-DOHR DAW-lee or daw-LEE Daumier, Honoré ohn-ohr-AY dohm-YAY David, Jacques Louis jawk loo-EE daw-VEED Degas, Edgar ed-GAWR deh-GAW Déjeuner sur l'herbe, Le luh day-joon-AY ser LAIRB de Kooning, Willem VILL-um duh KOON-ing Delacroix, Eugène you-JEHN duh-law-KRWAW Delaunay, Sonia de-law-NAY Demoiselles d'Avignon, Les lay duh-mwoi-ZELL dah-veen-YON Derain, André awn-DRAY deh-RAN Diebenkorn, Richard DEE-ben-korn Donatello dohn-aw-TAY-loh Dubuffet, Jean jawn doo-boo-FAY Duchamp, Marcel mar-SELL doo-SHAW(n) Dürer, Albrecht AWL-breckt DYUR-er Eggleston, William EHG-ul-stun El Greco ell GRAY-koh El Lissitzky ell lih-ZITZ-kee entasis EN-taw-sis Fauve fohv Fragonard, Jean-Honoré jawn oh-noh-RAY fraw-goh-NAWR Frankenthaler, Helen FRANK-en-thawl-er Friedrich, Caspar David FREED-rik frieze freez Gaudí, Antoni ahn-TOH-nee gow-DEE Gauguin, Paul goh-GAN Gehry, Frank GAIR-ee Gentileschi, Artemisia ar-tay-MEES-jyuh jen-till-ESS-kee Géricault, Théodore tay-oh-DOHR jeh-ree-COH gesso JESS-oh **Giorgione** gee-or-gee-OH-nay Giotto gee-YAW-toh Giovanni da Bologna joh-VAWN-ee daw bo-LOHN-yaw Gislebertus geez-lay-BARE-tuss Goethe, Wolfgang von GUH-tuh Gohlke, Frank GOHL-kee Gómez-Peña, Guillermo Ghee-AIR-moh GOH-mes PAIN-yuh gouache gwawsh Goya, Francisco de frawn-SEES-coh day GOY-yaw Grünowald, Matthias maw-TEE-css GROON-ch-vawlt Guernica GARE-nee-caw Gulmard, Hector heck-TOR GWEE-mar

Guo Xi gow zee Hasegawa, Itsuko eet-SOO-koh haw-say-GAW-waw haut-relief OH ree-leef Hesse, Eva hess Hiroshige, Ando AWN-doh heer-oh-SHEE-gay Höch, Hannah HOHK Hokusai, Katsushika kat-s'-SHEE-kaw HOH-k'-sye Hung Liu hung loo impasto im-PAW-stoh Ingres, Jean Auguste Dominique jawn oh-GOOST dohm-een-EEK AING-r' intaglio in-TAWL-yoh ka kaw Kahlo, Frieda FREE-duh KAW-loh Kandinsky, Wassily vaw-SEE-lee kan-DIN-skee Kaprow, Allan KAP-roh Kirchner, Ernst Airnst KEERCH-nair Klimt, Gustav goos-TAHV KLEEMT Knossos KNAW-sohs Koetsu, Hon'ami HOHN-aw-mee ko-ET-zoo Kollwitz, Käthe KAYT-eh KOHL-vitz Kwei, Kane KAYN KWAY Laocoön lay-AW-coh-un Lascaux las-COH Ledoux, Claude-Nicolas klawd-NEE-coh-law Leh-DOO Léger, Fernand fair-NAN LAY-zhay Leonardo da Vinci lay-oh-NAHR-doh daw VEEN-chee (in the U.S., often lee-oh-NAHR-doh) Liang Kai lee-ong kye Limbourg lam-BOOR(g) Loewy, Raymond LOH-ee Lorrain, Claude Klodh lor-REHN Maciunas, George mass-ee-YOU-nehs Magritte, René reh-NAY ma-GREET Malevich, Kasimir kaw-zee-MEER MAW-lay-veech Manet, Edouard avd-WAHR ma-NAY Mantegna, Andrea awn-DRAY-uh mawn-TAYN-yaw Mapplethorpe, Robert MAYP-'l-thorp Marey, Etienne-Jules ay-TEE-an jool ma-RAY Marisol Maw-ree-SOHL Masaccio maw-SAW-chee-oh Matisse, Henri on-REE ma-TEESE Maya MYE-yaw Mesa Verde MAY-suh VAYR-day mezzotint MET-soh-tint Michelangelo mye-kel-AN-jel-oh; also mee-kel-AN-jel-oh Mies van der Rohe, Ludvig LOOD-vig meese van dur ROH(uh) mihrab MEE-rawb Miró Joan HWAHN meer-OH Mondrian. Piet PAYT MOHN-dree-awn Monet, Claude klodh moh-NAY Morisot, Berthe BAYR-t' mohr-ee-SOH mudra muh-DRAW Muybridge, Eadweard ED-ward MY-bridj Mycenae my-SEEN-ay or my-SEEN-ee Nauman, Bruce NOW-man Neri, Manuel man-WHALE NAY-ree Nolde, Emile ay-MEEL KNOWL-d' Olmec OHL-mek Paik, Nam June NAWM joon PIKE Pei, I. M. PAY Pfaff, Judy paff **Philippe de Champaigne** fee-LEEP duh sham-PAYN Piero della Francesca pee-AYR-oh DAY-law frawn-CHEE-skaw Piéta pee-ay-TAW plein air PLEHN-air

Pollaiuolo poh-LYE-you-oh-loh Pollock, Jackson PAWL-uck Polykleitos pawl-ee-KLY-tohs Pont du Gard pohn doo GAHR Poussin, Nicolas nee-coh-LAW poo-SAN Pozzo, Fra Andrea fraw an-DRAY-uh POHTS-zoh Quarton, Enguerrand in-gher-AWN kwar-TON quiblah KEEB-law Raphael RAF-fye-ell, or RAFF-yell Rauschenberg, Robert ROW-shen-burg Rembrandt van Rijn rem-BRANT fahn RINE Renoir, Pierre-August pee-ayr oh-GOOST rehn-WAHR Rietveld, Gerrit GARE-it REET-felld Rococo roh-coh-COH Rodchenko, Alexander rohd-CHINK-oh Rodin, Auguste oh-GOOST roh-DAN Rogier van der Weyden roh-JEER van dur VYE-den Rubens, Peter Paul ROO-bins Ruisdael, Jacob van YAW-kohb fahn ROYS-dawl Saarinen, Eero EER-roh SAWR-uh-nen Saenredam, Peter SANE-reh-dawm Safdie, Moshe MOSH-uh SAWF-dee St. Denis san deh-NEE St. Sernin san sayr-NAN St. Vitale san vee-TAHL-ay Samaras, Lucas sah-MARE-us santos SAWN-tohs Seurat, Georges jorjh suh-RAW Siqueiros, David Alfaro see-KAYR-ohs Sirani, Elisabetta ay-leez-eh-BAY-tuh seer-AW-nee Sottsass, Ettore ay-TOR-ay SAWT-sahs Steir, Pat steer Stieglitz, Alfred STEEG-litz stupa STOO-paw Teotihuacán tay-OH-tee-hwaw-CAWN tesserae TESS-er-ee Tiepolo, Giovanni Battista gee-oh-VAWN-ee baw-TEEStaw tee-EH-poh-loh Tinguely, Jean jawn TANG-lee Tintoretto teen-toh-RAY-toh Titian TEE-shan, or TISH-an **Tlingit** KLING-it Toorop, Jan YAWN tour-AWP Toulouse-Lautrec, Henri de awn-REE deh too-LOOS loh-TREK trompe l'oeil trump LOY Tutankhamum toot-an-KAW-mun Uelsmann, Jerry OOLS-mawn Ukeles, Mierle merl YOU-kell-ees Ukiyo-e OO-kee-oh-ee Utamaro, Kitagawa kee-taw-GAW-waw oo-taw-MAR-oh Vallayer-Coster, Anna AWN-naw val-law-YAH cohs-TAY Van Doesburg, Théo TAY-oh van DOHS-burg Van Eyck, Jan YAWN van IKE Van Gogh, Vincent van GOH vanitas VAWN-ee-taws Van Ruisdael, Jacob YAW-cub van ROYS-dawl Vasari, Giorgio gee-OR-gee-oh va-SAHR-ee Velázquez, Diego dee-YAY-goh vay-LAWSS-kess Vermeer, Jan YAWN Vare-MEER Vigée-Lebrun, Elisabeth ay-leez-eh-BETT vee-SJAY leh-BROH(n) Viola, Bill vee-OH-luh Voulkos, Peter VOOL-kohs voussoir voo-SWAWR Willendorf VILL-en-dohrf Wodiczko, Krzysztof KRIST-off woh-DEESH-koh Wu Chen woo JEHN

Index

All references are to page numbers. Italic numbers indicate an illustration.

Ahearn, John, Pat, 21, 21, 24

A

Abakanowicz, Magdalena, Backs in Landscape, 353-354, 353 AB 57 solvent, 131 Aboriginal landscape, 7-8, 7 Abramovíc, Marina The House with the Ocean View, 332, 332 Imponderabilia, 329, 329 Absolute symmetry, 165 Abstract art, 21, 24, 142 Abstract Expressionism, 44, 258-259, 516-518, 517 Abu Temple, Worshippers and deities, Sumerian, 424, 424 Académie Royale, 171 Accident (Rauschenberg), 236-237, 236 Acropolis Maidens and Stewards, Parthenon, 302, 302 Parthenon, 182, 182, 431, 431 present view of, 431, 431 Temple of Athena Nike, 368, 368, 432 Three Goddesses, Parthenon, 307-308, 307 Acrylic resins, 264-265 Action painting, 156-157, 517 Adam and Eve (Dürer), 226-227, 226, 227 Additive processes, 130, 300-301 Adoration of the Magi, The (Tiepolo), 210, 211 Aegean civilizations, 429-430 Aerial perspective, 116-118 Aesthetic art, 48 African American artists Bearden, Romare, 133, 133, 266-267, 267, 521 Jones, Ben, 126-127, 126 Lawrence, Jacob, 183, 183, 185, 262, 263, 521 Marshall, Kerry James, 521-522, 522 Puryear, Martin, 96, 96, 358, 358, 521 Ringgold, Faith, 14, 15, 352-353, 352 Searles, Charles, 138, 139 African art/artists feast-making spoon, Dan people, Liberia/Ivory Coast, 98, 98 funerary shrine clothe, Nigerian, 127, 127 Head of a King, Ife, Nigeria, 127, 127 Head of an Oba, Benin, Nigeria, 312, 312 Kentridge, William, 212-213, 213 Kwei, Kane, 47, 47 African masks Baule, Ivory Coast, 29, 29, 31 Sang tribe, Gabon, West Africa, 28-29, 28 Afterimage, 134 After the Bath, Woman Drying Herself (Degas), 204, 204 Agesander, The Laocoön Group, 434, 434

Airborne Event (Tomaselli), 272, 272 Airflow sedan (Chrysler Corp.), 412-413, 412 Air Liner Number 4, (Bel Geddes), 412, 412 Akhenaten, 428 Alabaster Basket Set with Oxblood Wraps (Chihuly), 344-345, 344 Alba Madonna, The (Raphael), 196-197, 196, 197 Albers, Anni, Wall Hanging, 351, 351 Alexander the Great, 433 Ali, Laylah, Untitled, 184-185, 185 Allegory of Painting (The Painter and His Model as Klio), The (Vermeer), 190, 191 Allies Day, May 1917 (Hassam), 12, 12 Allora, Jennifer, Hope Hippo, 529, 529 Altarpieces Annunciation, from Mérode Altarpiece (Campin-Master of Flémalle), 252, 252 Annunciation of the Death of the Virgin, from the Maestà Altarpiece (Duccio), 100-101, 100 Crucifixion panel from Isenheim Altarpiece (Grünewald), 54-55, 54 God, from the Ghent Altarpiece (Van Eyck, Jan), 42, 42 Ambulatory, 443 Amenhotep III, 301 American art architecture, 375-379, 375-379 landscapes, 4-5, 5, 8-9, 9 Modernism and Abstract Expressionism, 515-518, 515, 516, 517 American Art News, 60 American Modern dinnerware (Wright), 413, 413 America Tropical (Siqueiros), 180 Amiens Cathedral, 371-372, 371 Analogous color schemes, 133 Analytic lines, 82-83 Anasazi, 364, 364 Andre, Carl, Stone Field Sculpture, 64-65,64 Angel Appearing to the Shepherds, The (Rembrandt), 228, 229 Anglo-Saxons, 448 Animal Spirit Channeling Device for the Contemporary Shaman (Feodorov), 170-171, 171 Animal style, 151, 448 Animation, 289 Anime, 214 Annie G. Cantering, Saddled (Muybridge), 61, 61 Annunciation, Mérode Altarpiece (Campin-Master of Flémalle), 252, 252, 462-463 Annunciation, Reims Cathedral, facade and portale, 453, 453

Annunciation of the Death of the Virgin. from the Maestà Altarpiece (Duccijo), 100-101, 100 Anthemius of Tralles, Hagia Sophia, Istanbul, 445-446, 445, 446 Antin, Eleanor The Artist's Studio, from The Last Days of Pompeii, 333, 333 Minetta Lane—A Ghost Story, 322-323, 323 Aphrodite of Knidos (Praxiteles), 92, 92 Apollinaire, Guillaume, 142 Apollo Belvedere, 28, 28, 489 Apollodorus, Column of Trajan, 437, 437 Apotheosis of Homer Vase (Wedgwood), 335.335 Apoxyomenos (The Scraper) (Lysippos), 433, 433 Applebroog, Ida, Emetic Fields, 168, 169,170 Apse, 371 Aquatint, 230-231 Arad, Michael, 393 Ara Pacis (Altar of Peace), Marcus Agrippa with Imperial Family, 436, 436 Arbitrary color, 141 Arbutus Menziesii Pursh (Watkins), 20, 20 Arc de Triomphe, Paris, 488 Archer, Frederick, 277 Arches, 368-369, 368, 372, 372 Architecture American, 375-379, 375-379 Anasazi, 364, 364 arches, vaults and domes, 368-370, 372 Art Nouveau, 403, 403 Baroque, 477-478, 477 bungalow style, 375, 375 Byzantine, 445, 445 cast-iron, 373-374 Chinese, 456-457, 457 Christian, early, 443-444, 443 columns, Greek, 366-367, 367 Egyptian, 362-363, 363, 427 frame, 374-375 Gothic, 371-373, 371, 372, 451-453, 451, 452 Greek, 182, 182, 366-368, 366, 367, 368, 431, 431 green, 49 Indian, 440, 440 International Style, 380-383, 380-383 Islamic, 454-455, 454 Japanese, 458, 458 load-bearing, 365 Mycenaean, 365-366, 365 Neoclassicism, 487-488, 488 Neolithic, 423, 423 post-and-lintel, 365-367 Renaissance, 452–453, 452, 461 Roman, 368–370, 368, 369, 370, 137 138, 137

Architecture (cont.) Romanesque, 370-371, 371, 449-450 steel and reinforced concrete, 375-385 Sumerian, 363, 363, 424-425 Architrave, 368 Arch of Constantine, Rome, 437, 437 Arena Chapel, Lamentation (Giotto), 245-246, 246 Aristotle, 433 Armchair (Breuer), 409-410, 409 Armory Show (1913), New York City, 61 Arneson, Robert, Case of Bottles, 310, 311 'a round,' (Hamilton), 359, 359 Arrival and Reception of Marie de' Medici at Marseilles, The (Rubens), 485, 485 Art and Virtual Environment Project, 113 Art Deco, 404-405 Art in America, 111 Artistic Culture in America, 401 Artists, traditional roles/views of, 4-9, 58 Artist's House at Argenteuil, The (Monet), 40.40 Artist's Studio, The from The Last Days of Pompeii (Antin), 333, 333 Art Moderne, 404 Art Nouveau, 401-403 Art of Painting, The (Vasari), 241 Arts and Crafts Movement, 396-401 Arts in Public Places Program, 63-70 Ashbee, C. R., 375 Asoka, 440 Asparagus, The (Manet), 46-47, 46 Assemblage, 316-321 Assumption and Consecration of the Virgin (Titian), 77, 77 Assurnasirpal II Killing Lions, 425-426, 425 Assyrian sculpture, 425-426, 425 Asymmetrical balance, 166-170 Athena, 431 Temple of Athena, 368, 368, 432 Atheneum, New Harmony, Indiana (Meier), 386, 386 Athenodorus, The Laocoön Group, 434, 434 Athens. See Acropolis Athens (Cartier-Bresson), 282, 282 Atlan (Turrell), 324, 324 Atlas Bringing Herakles the Golden Apples, Temple of Zeus, Olympia, 302-303, 302 "Atlas" Slave (Michelangelo), 305, 305, 316 Atmospheric perspective, 116-118 At the Moulin Rouge (Toulouse-Lautrec), 501.501 At the Time of the Louisville Flood (Bourke-White), 282-283, 282 Auden, W. H., 188 Auerbach, Frank, View from Primrose Hill, 148-149, 148 Augustine, saint, 448 Augustus of Primaporta, 436, 436 Aulenti, Gae, Musée d'Orsay, 97, 97 Australian art, Aboriginal landscape, 7-8,7 Automatism, 517 Autumn Rhythm (Pollock), 156, 156 Avant-Gardes, 405-409 Axonometric projections, 104-105, 104 A-Z Escape Vehicles (Zittel), 418, 418

A-Z Management & Maintenance Unit (Zittel), 418, 418

Aztec, 474 A-Z Time Tunnel: Time to Read Every Book I Ever Wanted to Read (Zittel), 419, 419

B

Baby Girl (Marisol), 24, 24 Babylonian sculpture, 425, 425 Baca, Judith F. The Great Wall of Los Angeles, Division of the Barrios and Chavez Ravine, 265, 265 La Memoria de Nuestra Tierra, 180-181, 180, 181 Backs in Landscape (Abakanowicz), 353-354, 353 Balance asymmetrical, 166-170 radial. 170-171 symmetrical, 165-166 Balla, Giacomo, Dynamism of a Dog on a Leash, 509, 509 Ballet Mécanique (Léger), 285, 285 Balloon frame construction, 374 Ban, Shigeru, 394 Banana Flower (O'Keeffe), 200, 201 Barber Shop (Lawrence), 183, 183, 185 Bardon, Geoff, 8 Barela, Patrocinio, Nativity, 305-306, 305 Barker, George, Sunset-Niagara River, 106, 106 Baroque architecture, 477-478, 477 painting, 479-482, 479, 480, 481, 482 sculpture, 478, 478 Barr, Alfred H., Jr., 380 Barrel vault, 369, 369 Bars and String-Pieced Columns (Pettway), 351-352, 351 Bartolommeo, Fra, Study for a Prophet Seen from the Front, 199-200, 200 Baselitz, Georg, Untitled, 262, 262 Basilica, 443 Basket of Apples, The (Cézanne), 72, 73-74 Basquiat, Jean-Michel, Untitled, 186-187, 186 Bas-relief, 302 Bath, The (Cassatt), 219, 219 Bathers (Fragonard), 486, 486 Bathers, The (Seurat), 502, 502 Battleship Potemkin (Eisenstein), 286, 286 Baudelaire, Charles, 496 Bauhaus, 409-410 Bauhaus, cover for (Bayer), 410, 410 Bayard-Condict Building (Sullivan), 376, 377 Bayer, Herbert, Bauhaus, cover for, 410, 410 Beard, Richard, Maria Edgeworth, 276, 276 Bearden, Romare, 521 The Dove, 266-267, 267 She-ba, 133, 133 Beat the Whites with the Red Wedge (Lissitzky), 407, 407 Bed hangings (M. Morris), 399, 399 Bel Geddes, Norman, Air Liner Number 4, 412, 412

Benito, Edouardo Garcia, Vogue cover, 405, 405 Bent-Corner Chest, Heiltsuk, 356, 357 Bergman, Ingmar, 289 Bernard, Emile, 80, 504 Bernini, Gianlorenzo, 483 Comaro Family in a Theater Box, 478, 478 David, 152-153, 153 Ecstasy of St. Theresa, 478, 478 St. Peter's piazza, 477, 477 Betty (Richter), 254-255, 255 Beuys, Joseph, I Like America and America Likes Me, 328-329, 328 Bierstadt, Albert, 492 Matterhorn, The, 10, 10 Rocky Mountains, The, 4-5, 5, 10, 21 Biker (Rothenberg), 255, 255 Bilateral symmetry, 165 Binders, 195, 243 Bing, Siegfried, Galeries de l'Art Nouveau, 401 Birchler, Alexander, Detached Building, 160-161, 160 Birth of a Nation, The (Griffith), 285-286, 285 Birth of Venus, The (Botticelli), 464-465, 464 Blackburn, Robert, 237 Blackburn: Song of an Irish Blacksmith (Smith), 304, 304 Black Face and Arm Unit (Jones), 126-127, 126 Black Lines (Kandinsky), 145, 145 Black Pirate, The, 288 Blake, Jeremy, The History of Glamour, 214, 214 Bloomberg, Michael, 394 Blue Rider, 507 Boccioni, Umberto, Unique Forms of Continuity in Space, 509-510, 509 Bologna, Giovanni da, The Rape of the Sabine Women, 303, 303 Bonheur, Rosa, Plowing in the Nivernais, 496, 496 Bonnard, Pierre, 401 The Terrace at Vernon, 141, 141 Book of the Artists (Tuckerman), 4 Borromini, Francesco, San Carlo alle Quattro Fontane, 477-478, 477 Boston Common at Twilight (Hassam), 168, 169 Botticelli, Sandro The Birth of Venus, 464-465, 464 Primavera, 250-251, 251 Bourke-White, Margaret, At the Time of the Louisville Flood, 282-283, 282 Bradbury, R. E., 312 Bradley, David P., Indian Country Today, 521, 521 Brady, Matthew, 278 Brague, 266 Braids (Wyeth), 251, 251 Braque, Georges Houses at l'Estaque, 505, 505 Violin and Palette, Autumn, 505-506, 505 Brauntuch, Tony, Untitled (Shirts 2), 529, 529 Brazilian feather mask, Cara Grande, 134-135, 135 Breton, André, 44, 512 Breuer, Marcel, Armchair, 409-410, 409

Bridge over a Pool of Water Lilies (Monet), 500, 500 Bronze casting, Han dynasty, 438-439, 439 Bronze vessel, Shang dynasty, 424, 424 Bronzino, Venus, Cupid, Folly, and Time (The Exposure of Luxury), 476, 476 Brown, Robert, 154 Brueghel the Elder, Pieter, The Wedding Dance, 103, 103 Brunelleschi, Filippo, 461 Florence Cathedral, Italy, 452-453, 452 Buchanan, Beverly Monroe County House with Yellow Datura, 207, 207 Ms. Mary Lou Furcron's House, 206, 206 Richard's Home, 206-207, 206 Buddha Colossal, 441, 441 Great Stupa, Sanchi, India, 440-441, 440 on serpent Mucilinda, 32, 32 subduing Mara, 32, 32 Buglaj, Nicolai, "Rac"ing Sideways, 126, 126 Bungalow style, 375, 375 Buon fresco, 244, 245 Burgee, John, College of Architecture, University of Houston, 360, 361-362, 362 Burghers of Calais, The (Rodin), 314-315, 314, 316 Burial at Ornans (Courbet), 495, 195 Burial of Count Orgaz, The (El Greco), 476, 476 Burin, 225 Burke, Edmund, 492 Burlington Northern & Santa Fe Railway Co., Burlington Zephyr, 411, 411 Burne-Jones, Edward, Works of Geoffrey Chaucer Newly Augmented, 398, 398 Burr, 230 Bushfire and Corroboree Dreaming (Motna), 7-8, 7 Byodo-in, Heian period, Japan, 458, 458 Byzantine art, 443-446

С

Cabinet (Süe and Mare), 404, 404 Cadillac Fleetwood, General Motors Corp, 415, 415 Caesar, Julius, 437 Café Concert (Seurat), 202, 202 Cai Guo-Qiang, Transient Rainbow and drawing for, 128-129, 128, 129 Caillebotte, Gustave, Place de l'Europe on a Rainy Day, 102-103, 102, 498 Calatrava, Santiago, 393 Turning Torso residential tower, 384, 384 Calder, Alexander, 512 La Grand Vitesse, 63-64, 63 Sequential view of Dots and Dashes in motion, 76-77, 76 Callas, Peter, 342 Calligraphy, 18, 211 Islamic, 455, 455 Calling of St. Matthew, The (Caravaggio), 479-480, 479 Calotype, 277

529 Camera See also Photography obscura, 274-275, 274 use of term, 274 Cameron, Julia Margaret, Portrait of Thomas Carlyle, 277, 277 Campbell, Nancy, 232 Campin, Robert (Master of Flémalle), The Mérode Altarpiece, The Annunciation, 252, 252, 462-463 Canon, 182 Capitals, column, 367-368 Cara Grande, Brazilian feather mask, 134-135, 135 Caravaggio, The Calling of St. Matthew, 479-480, 479 Carlyle, Thomas, 277, 277 Carolingian art, 448-449 Carracci, Annibale, Landscape with Flight into Egypt, 481, 481 Cartier-Bresson, Henri, 281 Athens, 282, 282 Carving, 304-310 Case of Bottles (Arneson), 310, 311 Cassandre Dubonnet, poster, 408-409, 408 L'Intransigeant, poster, 408, 408 Cassatt, Mary The Bath, 219, 219 The Coiffure, 119, 119 In the Lodge, 122, 122, 123 The Map (The Lesson), 230, 230 Young Mother, Daughter, and Son, 204, 205 Casting, 300-301, 312-315 Cast-iron construction, 373-374 Çatal Hüyük, 423 Cave art Anasazi, 364, 364 Chauvet, 422, 422 Cellini, Benvenuto, Saltcellar for Francis I, 355-357, 355 Celmins, Vija, Untitled (Ocean), 202, 202 Celtic art, 447-448, 448 Cendrars, Blaise, 142-143 Central Mountain, The (Wu Chen), 6-7, 6 - 7Central Park (Olmsted and Vaux), 2-3, 387, 387 Ceramics, 310 See also Pottery coiling, 336, 337, 337 defined, 336 potter's wheel, 338 slab construction, 336, 337, 337 throwing, 336 types of, 338-340 Cézanne, Paul, 504 Basket of Apples, The, 72, 73-74 The Large Bathers, 503, 503 Mme. Cézanne in a Red Armchair, 110-111, 110 Mont Sainte-Victoire and the Viaduct of the Arc River Valley, 503, 503 Still Life with Cherries and Peaches, 502-503, 502 Chair, side (Eames and Eames), 414, 414 Chalk and charcoal, 199-200 Champaigne, Philippe de, Still Life or Vanitas, 51, 51

Calzadilla, Cuillermo, Hope Hippo, 529,

Chaplin, Charlie, in The Gold Rush, 287, 287 Charlemagne, 448-449 Chartres Cathedral, 451-452, 451 rose window, 170, 170, 451 stained-glass window, 33, 33 Chauvet cave art, France, 422, 422 Cheng Sixiao, Ink Orchids, 469, 469 Chest from tomb of Tutankhamen, 428, 428 Chiaroscuro, 118, 200, 250 Chicago, Judy The Dinner Party, 523-524, 523 Pasadena Lifesavers Red Series #3, 24-26, 25Chicago, Marshall Field Wholesale Store, 376, 376 Chihuly, Dale Alabaster Basket Set with Oxblood Wraps, 344-345, 344 Victoria and Albert Chandelier, 345, 345 Childs, David, 393 Chinese art architecture, 456-457, 457 Ch'ing dynasty, porcelain vase, 339, 339 Han dynasty, 438-440, 439, 440 Koolhaas, Rem, Central China Television's headquarters, 384-385, 385 landscapes, 6-7, 6-7, 457, 457 Ming dynasty, 339, 339, 470, 470 sculpture, 311, 311, 441, 441 Shang dynasty bronze vessel, 424, 424 Tang dynasty, 456-457, 457 Yuan dynasty, 469, 469 Zhou dynasty, 439, 439 Chinese artists Cheng Sixiao, 469, 469 Guo Xi, 457, 457, 470 Huan, Zhang, 332, 332 Liang Kai, 211-212, 211 Liu, Hung, 86-89, 87, 88, 89 Shen Zhou, 470-471, 470 Wu Chen, 6-7, 6-7 Yin Hong, 470, 470 Ch'ing dynasty, porcelain vase, 339, 339 Christ, mosaic from Hagia Sophia, Istanbul, 446, 446 Christian art early, 443-446 Gothic, 451-453 in northern Europe, 447-449 Romanesque, 449-450 Christian calendar, 442 Christo, Gates, New York City, Central Park, The, xxiv, 1-4, 2, 3 Chronophotographs, 62 Chrysler, Walter P., 412 Chrysler Corp., Airflow sedan, 412-413, 412 Church, Frederic, 492 The Heart of the Andes, 493, 493 Churches, Gothic, 48, 48 Cimabue, Madonna Enthroned, 242, 242 Cire-perdue, 312 *Citizen Kane*, 288, 288 *Civilisation* (Clark), 28, 53 Civil War, photography and, 278, 278 Clark, Kenneth, 28, 29, 53 Classical lines, 83-87 Claude Lorrain, 481 A Pastoral Landscape, 482, 482

Clemenceau, Georges, 154 Clifton Chenier, from Rounds (Serra), 205, 205 Close, Chuck, 134 Stanley, 136-137, 136, 137 Clothing, as art, 48, 48 Clovis, 447 Clowns (Demuth), 98-99, 99 Cluny, 450 Coatlicue, Aztec, 474, 474 Coca-Cola Co., Bottles, 416, 417 Coconut grater, Micronesia, 47-48, 47 Coffin Orange, in the Shape of a Cocoa Pod (Kwei), 47, 47 Coiffure, The (Cassatt), 119, 119 Coiling, 336, 337, 337 Colbert, Jean-Baptiste, 483 Cold Mountain 3 (Marden), 526, 526 Cole, Henry, 396 Cole, Thomas The Course of Empire, The Consummation of Empire, 39, 39 The Course of Empire, Desolation, 39, 39 The Course of Empire, Destruction, 39, 39, 40-41 The Course of Empire, The Pastoral or Arcadian State, 38-39, 39 The Course of Empire, The Savage State, 38, 38 View from Mount Holyoke, Northampton, Massachusetts, after a Thunderstorm—The Oxbow, 124-125, 125 Collage, 266-269 [collection] (Flanagan), 112, 112 College of Architecture, University of Houston (Burgee and Johnson), 360, 361-362, 362 Cologne Cathedral, Germany, 452, 452 Colonnade, 367 Color(s) arbitrary, 141 cultural differences, 144 intermediate, 130 local, 139 photography, 283-284 primary, 129 in representational art, 139-141 schemes, 133-139 secondary, 129-130 symbolic use of, 144-145 terminology, 129-133 wheel, 129-130, 129, 134, 135 Color and Information (Winters), 111-112, 111 Color Construction (van Doesburg and van Eesteren), 105, 105 Colossal Buddha (cave 20), China, 441, 441 Colossal head, Olmec, 472, 472 Colosseum, Rome, 369, 369 Column of Trajan (Apollodorus), Rome, 437, 437 Columns, Greek, 366-367, 367 Comaro Family in a Theater Box (Bernini), 478, 478 Communist Manifesto, The (Marx), 496 Complementary colors, 133 Composition, 26, 74 Composition (Blue, Red, and Yellow) (Mondrian), 515-516, 515 Concerning the Spiritual in Art (Kandinsky), 508

Confucius, 438 Connell, Clyde, Swamp Ritual, 318-319, 319 Connotation, 242 Considering Mother's Mantle (McCoy), 326, 327 Constable, John, 10 Constantine the Great, 437, 443 Constantinople, 445-446 Constructivists, 407 Conté, Nicholas-Jacques, 201-202 Conté crayon, 201-202 Contemporary art. See Modern art Contemporary Museum, 348-349, 349 Content, 27-28 Contingent (Hesse), 320-321, 320, 321 Contour, 74-75 Contrapposto, 307, 434, 461 Conventions, 28-31 Córdoba, Spain, Great Mosque, 454-455, 454, 455 Corinthian order, 367, 367 Cormont, Renaud de, 372 Cormont, Thomas de, 372 Cornelia, Pointing to Her Children as Her Treasures (Kauffmann), 487, 487 Cornice, 368 Coronation of the Virgin (Quarton), 166, 166, 171 Corps de Dame (Dubuffet), 208, 209 Corset, Vogue, 405, 405 Courbet, Gustave, Burial at Ornans, 495, 495 Course of Empire, The Consummation of Empire (Cole), 39, 39 Course of Empire, Desolation (Cole), 39, 39 Course of Empire, Destruction (Cole), 39, 39, 40-41 Course of Empire, The Pastoral or Arcadian State (Cole), 38-39, 39 Course of Empire, The Savage State (Cole), 38, 38 Crafts ceramics, 310, 336-340 defined, 335 fiber, 350-354 glassware, 340-341, 344-347 metal, 354-356 wood, 356-358 Craftsman, The, 399 Cragg, Tony, Newton's Tones/New Stones, 146, 146 Crane, Walter, 398 Crayon, 228-229 Crayon, Conté, 201-202 Creation of Adam, The (Michelangelo), Sistine Chapel, 130-131, 131, 133 Criss-Crossed Conveyors-Ford Plant (Sheeler), 280, 280 Cross-hatching, 119-120 Crossing, 371 Cruci-fiction Project, The (Gómez-Peña and Sifuentes), 67, 67, 70, 180 Crucifixion panel from Isenheim Altarpiece (Grünewald), 54-55, 54 Crusades, 454 Crux (Hill), 296, 296 Crystal Palace (Paxton), 396, 396 Cuauhtémoc against the Myth (Siqueiros), 263-264, 263 Cubism, 505-506, 505 Cut with the Kitchen Knife Dada through the Last Weimar Beer Belly Cultural

268-269, 268, 269 Cyberspace, 113 Dada, 268-269, 511-512, 511 Daguerre, Louis Jacques Mandé, Le Boulevard du Temple, 275, 275, 276 Daguerreotype, 275-277 Dali, Salvador, 512 The Persistence of Memory, 44, 44 Dancing Shoes (Passlof), 256, 256, 260 Dan people, Liberia/Ivory Coast, feastmaking spoon, 98, 98 Dante, 242 Daughters of Edward Darley Boit, The (Sargent), 176-177, 177 Daumier, Honoré Fight between Schools, Idealism and Realism, 495-496, 495 Rue Transnonain, 232, 232 David, Jacques Louis The Death of Marat, 487, 487 The Death of Socrates, 84, 84, 487 Study for the Death of Socrates, 84, 84 David (Bernini), 152-153, 153 David (Donatello), 461-462, 461

Epoch of Germany (Höch),

D

Death, Woman and Child (Kollwitz), 229, 229 Death of Marat, The (David), 487, 487 Death of Sardanapalus (Delacroix), 84, 85 Death of Socrates, The (David), 84, 84, 487 De Chirico, Giorgio, Melancholy and Mystery of a Street, 512, 512 Decorative patterns, 151–152 Degas, Edgar

David (Michelangelo), 66-67, 66, 465

Dead Christ, The (Mantegna), 108, 108

Davis, Stuart, Summer Landscape,

Day of the God (Mahana no Atua)

(Gauguin), 502, 502

139-140, 139

Daybook (Truitt), 525

- After the Bath, Woman Drying Herself, 204, 204 The Glass of Absinthe, 498, 498
- de Heem, Jan, Still Life with Lobster, 254, 254, 480
- Déjeuner sur l'herbe (Luncheon on the *Grass)* (Manet), 58, 59, 60, 497 de Kooning, Elaine, 232
- Lascaus #4, 233, 236

de Kooning, Willem

- Door to the River, 256, 257 Rivers, Larry, Willem de Kooning, 202-203, 203
 - Seated Woman, 203, 203
- Woman and Bicycle, 517, 517
- Delacroix, Eugène, 492 Death of Sardanapalus (Delacroix), 84.85
 - Liberty Leading the People, 420, 494, 494
- Odalisque, 489-490, 489
- Study for the Death of Sardanapalus, 84.85
- Delaroche, Paul, 276
- de la Tour, Georges, Joseph the Carpenter, 172, 172
- Delaunay, Robert, Premier Disque (Simultaneous Disks), 142, 142

Delaunay-Terk, Sonia Electric Prism (Prismes Electriques), 142-143, 143 in a simultaneous dress, 142, 142 Deliverance (DiBenedetto), 99, 99 Deluge, Hurricane over Horsemen and Trees (Leonardo da Vinci), 194-195, 195, 234 De Maria, Walter, Lightning Field, 326, 326 Demuth, Charles, Clowns, 98-99, 99 Denis, Maurice, 506 Denotation, 242 Deodorant (Wegman), 291 Deposition (Van der Weyden), 463-464, 463 Der Blaue Reiter, 507 Design Art Deco, 404-405 Art Nouveau, 401-403 Arts and Crafts Movement, 396-401 Avant-Gardes, 405-409 Bauhaus, 409-410 Organic Design in Home Furnishings (Museum of Modern Art), 414-416, 414, 415, 416 pluralism of contemporary, 416-419 streamlining, 410-413 use of term, 163, 395 Design for a Colossal Clothespin Compared to Brancusi's Kiss (Oldenburg), 237-238, 237 De Stijl (The Style), 406 Detached Building (Hubbard and Birchler), 160-161, 160 Diagonal, 100 Diamond, William, 65 DiBenedetto, Steve, Deliverance, 99, 99 Dickson, Jane, Stairwell, 230-231, 231 Dickson, Stewart, Iopological Slide, 113, 113 Die Brücke, 506 Die grossen blauen Pferde (The Large Blue Horses) (Marc), 508, 508 Diehl, Carol, 111 Digital photography, 284 Dimetric projection, 105 Dinner Party, The (Chicago), 523-524, 523 Disasters of War, The (Goya), 490 Disc (Pi) with Dragon Motif, jade, Zhou dynasty, 439, 439 Disney, Walt, 289 Divine Comedy (Dante), 242 Domes, 370, 370 Domino Housing Project (Le Corbusier), 380, 380 Donatello, David, 461-462, 461 Dong Qichang, 470 Door to the River (de Kooning), 256, 257 Doric order, 367, 367 Doryphoros (Spear Bearer) (Polykleitos), 182, 182, 436 Dove, The (Bearden), 266-267, 267 Draftsman Drawing a Reclining Nude (Dürer), 107, 107 Drawing as art, 192-195 materials, 195-214 Drawing Lesson, Part I, Line #1 (Steir), 77-78,78 Drawing Lesson, Part I, Line #5 (Steir), 78-79,79

Dream Horse (Scholder), 238-239, 238 Drift 2 (Riley), 154-155, 155 Drip Drop Plop (Wilson), 346, 346 Drums, 366 Dry media, 198-207 Drypoint, 230 Dubonnet, poster (Cassandre), 408-409, 408 Dubuffet, Jean, Corps de Dame, 208, 209 Duccio, Annunciation of the Death of the Virgin, from the Maestà Altarpiece, 100-101, 100 Duchamp, Marcel The Fountain, 511-512, 511 Mona Lisa (L.H.O.O.O.), 511, 511 Nude Descending a Staircase, 60, 60, 62,510 Duchess of Polignac, The (Vigée-Lebrun), 486, 486 Duncan, Theresa, The History of Glamour, 214, 214 Dürer, Albrecht, 224, 468 Adam and Eve, 226-227, 226, 227 Draftsman Drawing a Reclining Nude, 107, 107 Great Piece of Turf, The, 41, 41 Self-Portrait, 469, 469 Duret, Théodore, 499 Durham, Jimmie, Headlights, 520, 520 Durrer, Käti, Swatch watches, 416-417, 417 Dynamism of a Dog on a Leash (Balla), 509.509 Eames, Charles

Organic Design in Home Furnishings (Museum of Modern Art), 414-415, 414, 415 Side chair, 414, 414 Eames, Ray, Side chair, 414, 414 Earl, Harley, 415 Early Spring (Guo Xi), 457, 457, 470 Earthenware, 338 Earthworks, 8-9, 301, 304, 325-327 École des Beaux-Arts, 1890 exhibition, 219 Ecstasy of St. Theresa (Bernini), 478, 478 Edgeworth, Maria, 276 Editing film, 285 Edition, 216 Egyptian art architecture, 362-363, 363, 427 encaustic painting, 243-244, 244 ka and mummification, 426-427 sculpture, 301, 301, 306, 306, 427-428, 427, 428 Eiffel, Gustave, 373 Eiffel Tower, 373-374, 373 Eisenstein, Sergei, Battleship Potemkin, 286, 286 Electric Prism (Prismes Electriques) (Delaunay-Terk), 142-143, 143 Elegy to the Spanish Republic XXXIV (Motherwell), 44, 45, 49-50 Elevation, 367 El Greco, The Burial of Count Orgaz, 476, 476 Ellison, Ralph, 266, 267 Embroidery, 350 Emetic Fields (Applebroog), 168, 169, 170Emphasis, 171-173

Empress of India (Stella), 519, 519 Encaustic, 243-244 England, Stonehenge, Salisbury Plain, 423, 423 Engraving, 225 Entablature, 367 Entasis, 367 Environment, 304 Ernst, Max, Europe After the Rain, 150, 150 Erosion and Strip Farms (Garnett), 150, 150 E.T., 290 Etching, 228-229 Etruscans, 435 Europe After the Rain (Ernst), 150, 150 Euthymides, Revelers, 338, 338 Evans, Walker, Roadside Store between Tuscaloosa and Greensboro, Alabama, 274, 274 Every Icon (Simon), 297 Ewing, Susan, Inner Circle Teapot, 356, 357 Exploration of the Colorado River of the West, Noon-Day Rest in Marble Canyon (Powell), 222-223, 222 Expressionism Abstract, 44, 258–259, 516–518, 517 German, 217, 506-508, 507, 508 Expressive lines, 79-82

Fairbanks, Douglas, 287, 288 Fallingwater, Kaufmann House, Pennsylvania (Wright), 378-379, 378, 379 Family, The (King), 107-108, 107 Fantasia, 289, 289 Farnsworth House (Miës van der Rohe), 382, 382 Fauves, 506, 506 Feast-making spoon, Dan people, Liberia/Ivory Coast, 98, 98 Fellini, Federico, 289 Feodorov, John, Animal Spirit Channeling Device for the Contemporary Shaman, 170-171, 171 Fiber art, 350-354 Fickle Type, from Ten Physiognomies of Women (Utamaro), 220, 220 Fight between Schools, Idealism and Realism (Daumier), 495-496, 495 Figurines Minoan, 429, 429 Venus of Willendorf, Austria, 422, 422 Filàs for Sale (Searles), 138, 139 Film early, 285-287 popular cinema, 287-290 shots and techniques, types of, 285-286 Filo, John Paul, Kent State-Girl Screaming over Dead Body, 280-281, 280 Firdawsi, Shahnamah, 18, 19, 20 Firing, 336 Five Characters in a Comic Scene (Leonardo da Vinci), 29, 29 Fixatives, 200 Flagellation of Christ, The (Piero della Francesca), 463-464, 463 Flanagan, Mary, [collection], 112, 112 Flood (Frankenthaler), 264, 264

Floral Vase and Shadow (Woodman), 340.340 Florence, 452-453, 461-462, 464-465 Florence Cathedral, Italy, 452-453, 452, 461 Fluting, 366 Flying buttresses, 372-373, 372 Flying Horse Poised on One Leg on a Swallow (Han dynasty), 438, 439 Focus, 171-173 Folk arts, 151-152 Ford, Henry, 280 Foreshortening, 106-108 Form and content, 26-28 photography and, 278-283 Forum, 437 Fountain, The (Duchamp), 511-512, 511 Four Darks in Red (Rothko), 517-518, 517 Fox (movie company), 287, 288 Fragonard, Jean-Honoré, Bathers, 486, 486 Frame construction, 374–375 Franco, Francisco, 513, 515 Frankenthaler, Helen, Flood, 264, 264 Frankl, Paul T., Skyscraper Bookcase, 404, 404 Franks, 447, 448 French art See also Paris Chauvet cave art, 422, 422 Gothic architecture, 371-373, 371, 372, 451-452, 451 Gothic sculpture, 453, 453 Fresco, 244-250 Minoan, 429-430, 429 secco, 244-245 Fresh Kills Landfill (Ukeles), 390-391, 390 Friedrich, Caspar David, Monk by the Sea, 492, 492 Frieze, 302, 368 From the Shelton, New York (Stieglitz), 279.279 Frontal, 100 Frottage, 150 Fullfillment (Stoclet Frieze) (Klimt), 403, 403 Funerary shrine clothe, Nigerian, 127, 127 Furniture Art Deco, 404 Bauhaus, 409-410, 409 Morris and Company, 396-399, 397, 398 Organic Design in Home Furnishings (Museum of Modern Art), 414-416, 414, 415, 416 Settee (Stickley), 400, 400 Tiffany glassware, 402, 402 Tiffany lamp, 401, 401 Wright's designs, 400-401, 400, 401 Fusco, Coco, Two Undiscovered Amerindians, 68, 68 Fushimi Inari Shrine, 3-4, 3 Futurism, 508-510, 509

G

Gable, Clark, 288 Galeries de l'Art Nouveau, 401 Gannett, William C., 400 Garden of the Dasisen-in of Daitokuji (Saomi), 471, 471 Garnett, William A., Erosion and Strip Farms, 150, 150 Garrard, Mary D., 240 Gates, New York City, Central Park, The (Christo and Jeanne-Claude), xxiv, 1-4, 2, 3Gates of Hell with Adam and Eve (Rodin), 184, 184 Gaudí, Antoni, Oak Armchair for the Casa Calvet, 357, 357 Gaudier-Brzeska, Henri, Standing Female from the Back, 74, 75, 75 Gauguin, Paul The Day of the Gods (Mahana no Atua), 502, 502 Watched by the Spirit of the Dead (Manao Tupapau), 223, 223 Geffroy, Gustave, 27-28 Gehry, Frank Gehry House, 164-165, 164, 187 Guggenheim Museum Bibao, Spain, 527, 527 General Motors Corp, Cadillac Fleetwood, 415, 415 Genres, 288 Gentileschi, Artemisia Judith and Maidservant with the Head of Holofernes, 124, 124, 172 Self-Portrait as the Allegory of Painting, 241, 241, 272 Géricault, Théodore, The Raft of the Medusa, 491, 491 German art Bauhaus, 409-410 Expressionism, 217, 506-508, 507, 508 Gothic architecture, 452, 452 German Pavilion, International Exposition, Spain (Miës van der Rohe), 380-381, 381 Gertrude Stein (Picasso), 43-44, 43, 504 Gesso, 250 Gifford, Sanford R., October in the Catskills, 132, 133 Giorgione, Sleeping Venus, 468, 468 Giotto Lamentation, Arena Chapel, 245-246, 246 Madonna and Child Enthroned, 242, 242, 243 Giselle (Hofmann) 416, 416 Gislebertus, Last Judgment, Autun, France, 450, 450 Giuliani, Rudolph W., 57 Giza, pyramids at, 362-363, 363 Glass, Philip, 293 Glass House, New Canaan, Connecticut (Johnson), 383, 383 Glass of Absinthe, The (Degas), 498, 498 Glassware and art, 340-341, 344-347 Tiffany Favrile, 402, 402 Glazing, 254, 336 Glorification of Saint Ignatius, The (Pozzo), 246, 247, 272 Goat Island, How Dear to Me the Hour When Daylight Dies, 330-331, 330, 331 Gober, Robert, Untitled, 317-318, 318 God, from the Ghent Altarpiece (Van Eyck, Jan), 42, 42 Godard, Jean-Luc, 289 God Bless America (Ringgold), 14, 15

Goethe, Johann Wolfgang von, 125

Golden section, 182

180 The Temple of Confessions, 69, 69 Two Undiscovered Amerindians, 68, 68 Gone with the Wind, 288 Gonzalez-Torres, Felix, Untitled, 178-179, 179 Goodman, Nelson, 12 Gordon, Douglas, 24 Hour Psycho, 287, 287 Gospel Book of Charlemagne, St. Matthew from the, 449, 449 Gothic art architecture, 371-373, 371, 372, 451-453, 451, 452 sculpture, 453, 453 Gottlieb, Adolph, 63 Gouache, 262 Goya, Francisco de The Disasters of War, 490 Saturn Devouring One of His Sons, 490, 490 The Third of May, 1808, 494, 494 Grainstack (Monet), 27-28, 27, 140, 140, 153 Grande Odalisque (Ingres), 489, 489 Graphite, 200-203 Graves, Nancy Variability and Repetition of Similar Forms, II, 315, 315, 316 Zeeg, 167, 167 Gray scale, 120, 120 Great Exposition (1851), 396 Great Mosque, Córdoba, Spain, 454-455, 454, 455 Great Mosque, Samarra, Iraq, 454, 454 Great Piece of Turf, The (Dürer), 41, 41 Great Stupa, Sanchi, India, 440-441, 440 Great Wall of Los Angeles, Division of the Barrios and Chavez Ravine, The (Baca), 265, 265 Great Wave off Kanagawa, from the series Thirty-Six Views of Mount Fuji (Hokusai), 178, 178, 218, 220 Greek art amphora vase, 338, 338 architecture, 182, 182, 366-368, 366, 367, 368, 431, 431 city-states, 430-431 painting, encaustic, 243 sculpture, 182, 182, 302-303, 302. 306-307, 306, 307, 310, 432-434, 433, 434 Green architecture, 49 Green River (Colorado) (O'Sullivan), 278, 279 Green Stripe (Madame Matisse), The (Matisse), 506, 506 Greeting, The (Viola), 294-295, 294, 295 Gregory the Great, 448 Grenon, Gregory, It's That Woman in the Red Dress Again, 346-347, 347 Griffin bracelet (Persian), 355, 355

Gold Rush, The, 287, 287

Hazel leaves, 91-92, 92

Reconstructed Icicles Around a Tree,

Yellow Flowers on Rock, 74, 74

Golub, Leon, Mercenaries III, 134, 134

Cruci-fiction Project, The, 67, 67, 70,

Goldsworthy, Andy

Gold work, 355, 355

Gómez-Peña, Guillermo

74,74

- Griffith, D. W., The Birth of a Nation, 285–286, 285
- Gris, Juan, The Table, 266, 266
- Groined vault, 369, 369
- Gropius, Walter, 409, 410
- Grosman, Tatyana, 232, 236, 237
- Ground, 228, 243
- Grünewald, Matthias, Crucifixion panel from Isenheim Altarpiece, 54–55, 54
- *Guernica* (Picasso), 513–514, 513, 514, 515
- Guggenheim Museum Bibao, Spain (Gehry), 527, 527
- Guimard, Hector, Paris Métro entrance, 373, 373
- Guo Si, The Lofty Message of the Forests and Streams, 457
- Guo Xi, *Early Spring*, 457, 457, 470 Gursky, Andreas, 99 Cent, 284, 284 Gutenberg Bible, 215

Н

Haboku Landscape for Soen (Sesshu Toyo), 471, 471 Hadid, Zaha, Phaeno Science Center, Germany, 528, 528 Haeberle, Ron, Q. And Babies? A. And Babies, 281, 281 Hagia Sophia (Anthemius of Tralles and Isidorus of Miletus), Istanbul, 445-446, 445, 446 Hamilton, Ann, 'a round,' 359, 359 Hamilton, Edward, 234 Hammons, David, Spade with Chains, 316, 316 Hammurabi, stele of, 425, 425 Han dynasty, 438-440, 439, 440 Happenings, 327 Haring, Keith, Untitled, 76, 76 Harmony in Red (The Red Room) (Matisse), 109, 109 Harry Potter series (movies), 290 Harvest of Death, Gettysburg, Pa. (O'Sullivan), 278, 278 Hassam, Childe Allies Day, May 1917, 12, 12 Boston Common at Twilight, 168, 169 Hatching and cross-hatching, 119-120 Hausmann, Raoul, 268, 269 Haut-relief, 302 Havemeyer, Mrs. H. O., 205 Hawaiian art, 42-43, 43 Hazel leaves (Goldsworthy), 91-92, 92 Headlights (Durham), 520, 520 Head of a King, from Ife, Nigeria, 127, 127 Head of an Oba, Benin, Nigeria, 312, 312 Head of a Satyr (Michelangelo), 120, 120 Hearst, William Randolph, 288 Heart of the Andes, The (Church), 493, 493 Heightening, 199 Heiltsuk chest, 356, 357 Heiner, Dennis, 57 Hellenism, 433 Hepworth, Barbara, Two Figures, 97-98, 97 Herculaneum, 245 Hermes and Dionysos (Praxiteles), 307, 307 Herodotus, 431

Contingent, 320-321, 320, 321 High relief, 302 Hill, Gary, Crux, 296, 296 Hindu art, 456, 456 Hinged clasp, Sutton Hoo burial ship, 448.448 Hippocrates, 431 Hirst, Damien, Mother and Child Divided, 316-317, 317 Hispanic American artists See also Mexican-American artists Barela, Patrocinio, 305-306, 305 History of Glamour, The (Duncan and Blake), 214, 214 Hitchcock, Alfred, 287 Hittites, 425 Hixson, Lin, 330 Höch, Hannah, Cut with the Kitchen Knife Dada through the Last Weimar Beer Belly Cultural Epoch of Germany, 268-269, 268, 269 Hoffman, Josef, Palais Stoclet, 403, 403 Hofmann, Armin, Giselle, 416, 416 Hokusai, Sakino The Great Wave off Kanagawa, from the series Thirty-Six Views of Mount Fuji, 178, 178, 218, 220 Shunshuu Ejiri, from the series Thirty-Six Views of Mount Fuji, 298, 298, 299 Holly Solomon Gallery, 340 Holt, Nancy, Sun Tunnels, Great Basin Desert, Utah, 325, 325 Holy Family with a Kneeling Monastic Saint, The (Sirani), 208, 208 Holy Virgin Mary, The (Ofili), 56-57, 57 Homeless Vehicle in New York City (Wodiczko), 70, 70, 418 Homer, Winslow, A Wall, Nassau, 260-261, 260 Hope Hippo (Allora and Calzadilla), 529, 529 Hopper, Edward, Nighthawks, 516, 516 Horn, Roni, This is Me, This is You, 158-160, 158-159 Horses, Chauvet cave art, France, 422, 422 House (Smith), 74-75, 75 House Beautiful, The, (Gannett), 400 Household (Kaprow), 328, 328 House of Education (Ledoux), 461, 461 Houses at l'Estaque (Braque), 505, 505 House with the Ocean View, The (Abramovíc), 332, 332 How Dear to Me the Hour When Daylight Dies (Goat Island), 330-331, 330, 331 Howling Wolf, Treaty Signing at Medicine Lodge Creek, 34-35, 35 Huan, Zhang, To Raise the Water Level in a Fish Pond, 332, 332 Hubbard, Teresa, Detached Building, 160-161.160 Hulsenbeck, Richard, 268 Humanism, 460 Hundreds of Birds Admiring the Peacocks (Yin Hong), 470, 470 Hurricane over Horsemen and Trees (Leonardo da Vinci), 194-195, 195, 234 Hyperspace, 113

Hesse, Eva, 319

Iconography, 31-33 Iktinos, Parthenon, 182, 182, 431, 431 I Like America and America Likes Me (Beuys), 328-329, 328 Illuminated manuscripts, 151, 151 Illusionistic work, 21, 98-99 Illustration of Proportions of the Human Figure (Leonardo da Vinci), 163-164, 164, 165 Imagination, power of, 41-44 I Make Maintenance Art One Hour Every Day (Ukeles), 390 Imitation, 241-243 Impasto, 148 Implied lines, 75-77 Imponderabilia (Abramovíc and Ulay), 329, 329 Impression, 216 Impressionism color and, 140 defined, 36 painting, 499-501, 499, 500, 501 Impression-Sunrise (Monet), 499, 499 India embroidered rumals, 350, 350 Great Stupa, Sanchi, India, 440-441, 440 Hindu art in, 456, 456 Indian Country Today (Bradley), 521, 521 Infrastructure, 389 Ingres, Jean-Auguste-Dominique Grande Odalisque, 489, 489 The Turkish Bath, 94, 94, 489 Ink Orchids (Cheng Sixiao), 469, 469 In Mourning and In Rage (Lacy and Labowitz), 71 Inner Circle Teapot (Ewing), 356, 357 Inquiry into the Origin of Our Ideas of the Sublime and the Beautiful (Burke), 492 Installations, 301, 304, 322-324 Insurrection! (Our Tools Were Rudimentary, Yet We Pressed On) (Walker), 322, 322 Intaglio processes, 224-231, 224, 225 Intensity, 130 Intermediate colors, 130 International Exposition (1889), Paris, 401 International Exposition (1929), Spain, German Pavilion (Miës van der Rohe), 380-381, 381 International Exposition of Modern Decorative and Industrial Arts (1925), Paris, 403, 404, 405, 407 International Style, 380-383, 380, 381, 382, 383 Internet art, 112, 112, 296-298, 297 In the Lodge (Cassatt), 122, 122, 123 In-the-round, 303, 303 Investment, 313 Invisible Man (Ellison), 266 Ionic order, 367, 367 Ippolito, Jon, 298 Isenheim Altarpiece, Crucifixion panel from (Grünewald), 54-55, 54 Ishihara Test for Color Deficiency, 114-115, 114 Isidorus of Miletus, Hagia Sophia, Istanbul, 445-446, 445, 446 Islamic art, 454-455, 454, 455 Isometric projection, 105

Istanbul, Hagia Sophia (Anthemius of Tralles and Isidorus of Miletus), 445–446, 445, 446

Italian art Baroque architecture, 477–478, 477 Gothic architecture, 452, 452 Renaissance painting, 462–465, 462, 463, 464 Renaissance sculpture, 461–462, 461

It's That Woman in the Red Dress Again (Grenon), 346–347, 347

J

James, Henry, 177 Japanese art anime, 214 architecture, 458, 458 Karaori kimono, 48, 48 oblique projection, 105 painting, Kamakura period, 458, 458 painting, Muramachi period, 471, 471 ukiyo-e prints, 220-221, 220, 221 woodblock printing, 217-221, 217-221 **Japanese** artists Hokusai, Sakino, 178, 178, 218, 219, 298, 298, 299 Koetsu, Hon'ami, 337, 337 Morimura, Yasumasu, 525-526, 525 Saomi, 471, 471 Sesshu Toyo, 471, 471 Takanobu, Fujiwara, 458, 458 Utamaro, Kitagawa, 219, 219, 220-221, 220, 221 Japonaiserie: The Courtesan (after Kesai Eisen) (Van Gogh), 218-219, 218 Jar (Martinez), 337, 337 Jazz Singer, The, 288 Jean-Marie Tjibaou Cultural Center (Piano), New Caledonia, 49, 49 Jeanne-Claude, Gates, New York City, Central Park, The, xxiv, 1-4, 2, 3 Jeanneret, Villa Savoye, 380, 380 Jefferson, Thomas, Monticello, Virginia, 487-488, 488 Jericho, Neolithic wall and tower, 423, 423 Jewelry, Griffin bracelet (Persian), 355, 355 Johns, Jasper Numbers in Color, 83, 83 Three Flags, 12, 13, 244 Johnson, Philip College of Architecture, University of Houston, 360, 361-362, 362 Glass House, New Canaan, Connecticut, 383, 383 Seagram Building, 382–383, 382 Jolson, Al, 288 Jones, Ben, Black Face and Arm Unit, 126-127, 126 Jones, Owen, 396 Joseph the Carpenter (de la Tour), 172, 172 Judgment of Paris, The (Raimondi), 58, 59.225 Judgment of Paris, The (Raphael), 58, 60, 225 Judith and Maidservant with the Head of Holofernes (Gentileschi), 124, 124, 172

Jugendstil, 402-403

Justinian, emperor, 443

Justinian and His Attendants, San Vitale, Ravenna, 444–445, 444 Just in Time (Murray), 188, 188

Κ

Kahlo, Frida, Las Dos Fridas (The Two Fridas), 523, 523 Kallikrates, Parthenon, 182, 182, 431, 431 Kandariya Mahadeva Temple, Khajuraho, India, 456, 456 Kandinsky, Wassily Black Lines, 145, 145 Concerning the Spiritual in Art, 508 Sketch I for Composition VII, 507-508, 507 Kaprow, Allan Happenings, 327 Household, 328, 328 Karaori kimono, Japan, 48, 48 Kauffmann, Angelica, Cornelia, Pointing to Her Children as Her Treasures, 487, 487 Kaufmann, Edgar, 378, 379 Kaufmann, Lillian, 378 Kaufmann House, Fallingwater, Pennsylvania (Wright), 378-379, 378.379 Kelley, Mike, More Love Hours Than Can Ever Be Repaid, 353, 353 Kelmscott Press, 398 Kentridge, William, drawings from WEIGHING ... and WANTING, 212-213, 213 Kent State-Girl Screaming over Dead Body (Filo), 280-281, 280 Kermis, The (Rubens), 104, 104 Keystone, 368 Khafre, statue of, 427, 427 Kiefer, Anselm Les Reins de France, 173, 173 Parsifal I, 172-173, 172 Kilns, 310, 336, 337, 342 Kimmelman, Michael, 3 Kinetic art, 76 King, Marcia Gygli, The Family, 107-108, 107 King Khafre, 427, 427 Kirchner, Ernst, 506 Kivas, Anasazi, 364, 364, 365 Klimt, Gustav, Fullfillment (Stoclet Frieze), 403, 403 Knockout (Wayne), 234-235, 235 Koberger, Anton, 215 Koetsu, Hon'ami, Tea Bowl Named Amagumo, 337, 337 Kollwitz, Käthe, 269 Death, Woman and Child, 229, 229 Self-Portrait, Drawing, 200, 201, 255 Koolhaas, Rem, Central China Television's headquarters, 384-385, 385 Kouros (Kritios Boy), 306-307, 306 Kozloff, Joyce, Plaza Las Fuentes, 340, 341.523 Krasner, Lee, Untitled, 515, 515 Kruger, Barbara, Untitled (We won't play nature to your culture), 524-525, 524 Kublai Khan, 469 Kukailimoku, Hawaiian, 42-43, 43 Kumano Mandala, Japan, 105, 105 Kwei, Kane, Coffin Orange, in the Shape of a Cocoa Pod, 47, 47

Labowitz, Leslie, In Mourning and In Rage, 71 Lacy, Suzanne, 523 In Mourning and In Rage, 71 Mapping the Terrain: New Genre Public Art, 58 Whisper, the Waves, the Wind, 71, 71 Ladder for Booker T. Washington (Puryear), 358, 358 La Dolce Vita, 289 Lady of Dai with Attendants, Han dynasty, 439-440, 440 La Grand Vitesse (Calder), 63-64, 63 La Memoria de Nuestra Tierra (Baca), 180-181, 180, 181 Lamentation, Arena Chapel (Giotto), 245-246, 246 La Moulin de la Galette (Renoir), 499-500, 499 Lamps (Tiffany), 401, 401 La Nature (Muybridge), 61 Landscapes American, 4-5, 5, 8-9, 9, 492-493 Australian Aboriginal, 7-8, 7 Baroque, 481-482, 481, 482 Chinese, 6-7, 6-7, 457, 457 Landscape with Flight into Egypt (Carracci), 481, 481 Landscape with St. John on Patmos (Poussin), 484, 484, 485 Languages of Art, The (Goodman), 12 Laocoön Group, The (Agesander, Athenodorus, and Polydorus of

Rhodes), 434, 434, 489

La Pittura, 240–243 Large Bathers, The (Cézanne), 503, 503 L'Art Décoratif, Moscow-Paris (Rodchenko), 407, 407 Lascaus #4 (E. de Kooning), 233, 236 Las Dos Fridas (The Two Fridas) (Kahlo), 523, 523 Las Meninas (The Maids of Honor) (Velázquez), 174–175, 175 L'Association Mensuelle, 232 Last Judgment (Gislebertus), Autun, France, 450, 450 Last Judgment, The (Michelangelo), Sistine Chapel, 475, 475 Last Supper, The (Leonardo da Vinci), 101, 101, 102, 245, 466, 468 Lattice-beam construction, 373 Lavadour, James, The Seven Valleys and the Five Valleys, 186, 186 Lawrence, Jacob, 521 Barber Shop, 183, 183, 185 You can buy bootleg whiskey for twenty-five cents a quart, 262, 263 Laysiepen, Uwe. See Ulay Learning from Las Vegas (Venturi), 187 Le Boulevard du Temple (Daguerre), 275, 275, 276 Lebrun, Charles, 484-485 Louvre, 484, 484 Le Corbusier Domino Housing Project, 380, 380 Notre-Dame-du-Haut, 115-116, 115 Pavillon de l'Esprit Nouveau, 405-406, 405 Villa Savoye, 380, 380 Ledoux, Claude-Nicolas, House of Education, 461, 461 Léger, Fernand, Ballet Mécanique, 285, 285

Leigh, Vivien, 288 Lemons, May 16, 1984 (Sultan), 96, 96 Lenin, Vladimir, 286 Leonardo da Vinci, 465 Five Characters in a Comic Scene, 29, 29 Hurricane over Horsemen and Trees (Deluge), 194-195, 195, 234 Illustration of Proportions of the Human Figure, 163–164, 164, 165 The Last Supper, 101, 101, 102, 245, 466.468 Madonna and Child with St. Anne and Infant St. John the Baptist, 193, 193,466 Madonna of the Rocks, 116-117, 116, 121 Map of the River Arno and Proposed Canal, 389, 389 Mona Lisa, 466, 466, 468 Notebooks, 116 Scythed Chariot, Armored Car, and Pike, A, 466, 466 Study for a Sleeve, 194, 194 Le Pont de l'Europe (Monet), 40-41, 40 Les Demoiselles d'Avignon (Picasso), 52-53, 53, 504, 520 Les Reins de France (Kiefer), 173, 173 Les Très Riches Heures du Duc de Berry, October from (Limbourg Brothers), 460, 460 Le Vau, Louis, Louvre, 484, 484 LeWitt, Sol, 297, 322 Wall Drawing No. 681 C, 82-83, 82, 83 Liang Kai, The Poet Li Bo Walking and Chanting a Poem, 211-212, 211 Liberty Leading the People (Delacroix), 420, 494, 494 Libeskind, Daniel, World Trade Center, plans for Ground Zero, 392-394, 392, 393 Libyan Sibyl (Michelangelo) Sistine Chapel, 248-249, 248, 249 Lichtenstein, Roy, Whaam!, 518-519, 519 Life, 283 Light, 115 atmospheric (aerial) perspective, 116-118 chiaroscuro, 118 hatching and cross-hatching, 119-120 value, 120, 121, 124-127 Lightning Field (De Maria), 326, 326 Limbourg Brothers, October from Les Très Riches Heures du Duc de Berry, 460, 460 Lin, Maya Ying, Vietnam Memorial, 62-63, 62 Lindisfarne Gospels, 151, 151 St. Matthew from, 448, 449 Linear perspective, 99-104 Line in the Himalayas, A (Long), 90, 90 Line Made by Walking in England, A (Long), 90, 90 Lines analytic or classical, 82-87 cultural convention and, 91-93 expressive, 79-82 implied, 75-77 movement and, 87, 90-91 outline and contour, 74-75 qualities of, 77-79 of sight, 77

Linocut, 224 L'Intransigeant poster (Cassandre), 408, 408 Lion Gate, The, Mycenaean, 365-366, 365 Liquid media, 208-212 Lisa Lyon (Mapplethorpe), 93, 93 Lissitzky, El, Beat the Whites with the Red Wedge, 407, 407 Lithography, 231-237 Liu, Hung Relic 12, 86-87, 87 Three Fujins, 88-89, 89 Virgin/Vessel, 88, 88 Lives of the Painters (Vasari), 193 Livia, wife of Augustus, 436 Load-bearing construction, 365 Local color, 139 Loewy, Raymond, 413, 417 Lofty Message of the Forests and Streams, The (Guo Si), 457 Lombards, 447, 448 London, Crystal Palace (Paxton), 396, 396 Long, Richard A Line in the Himalayas, 90,90 A Line Made by Walking in England, 90.90 Lord of the Rings trilogy (movie), 290 Lorenzo the Magnificent. See Medici, Lorenzo de Lorrain, Claude. See Claude Lorrain Los Angeles freeway interchange, 389, 389 Lost-wax method, 312-313, 313 Louis XIV, king of France, 483, 485 Louis XV, king of France, 485 Louis XVI, king of France, 171 Louvre (Perrault, Le Vau and Lebrun), 484, 484 Lower Manhattan Development Corp. (LMDC), 394 Low relief, 302 Lucas, George, 289 Lumière brothers, 62 Luncheon of the Boating Party, The (Renoir), 44, 45, 46 Luncheon on the Grass (Déjeuner sur l'herbe) (Manet), 58, 59, 60, 497 Luncheon on the Grass (Picasso), 224, 224 Luzarches, Robert de, 372 Lyons, Lisa, 136 Lysippos, Apoxyomenos (The Scraper), 433, 433 M Machiavelli, Niccolò, 461 Madame de Pompadour, 485 Maderno, Carlo, St. Peter's, 477, 477 Madonna and Child Enthroned (Giotto), 242, 242, 243 Madonna and Child with St. Anne and Infant St. John the Baptist (Leonardo da Vinci), 193, 193, 466 Madonna Enthroned (Cimabue), 242, 2.42

Madonna of Chancellor Rolin, The (Van Eyck), 199, 252, 253

Madonna of the Rocks (Leonardo da Vinci), 116–117, 116, 121 Maartà Altarbiaca, Amuniciption of the

Maestà Altarpiece, Annunciation of the Death of the Virgin trom the (Duccio), 100–101, 100 Magritte, René, 512 The Treason of Images, 18, 18 Maidens and Stewards, Parthenon, Acropolis, 302, 302 Maids of Honor, The (Las Meninas) (Velázquez), 174-175, 175 Maintenance art, 390 Malevich, Kasimir, Suprematist Painting, 26, 26, 27 Manct, Edouard The Asparagus, 46-47, 46 Déjeuner sur l'herbe (Luncheon on the Grass), 58, 59, 60, 497 Olympia, 497-498, 497 The Races (Les Courses), 232, 232 Manifesto for Maintenance Art (Ukeles), 390 Man in Black Suit with White Stripe Down Side of Chronophotograph Motion Experiment (Marey), 61-62, 61 Mannerism, 475-476, 475, 476 Mantegna, Andrea, The Dead Christ, 108,108 Man Walking in Black Suit with White Stripe Down Sides (Marey), 61-62, 62 Man with Big Shoes, 106, 106 Many Mansions (Marshall), 521-522, 522 Map of the River Arno and Proposed Canal (Leonardo da Vinci), 389, 389 Map (The Lesson), The (Cassatt), 230, Mapping the Terrain: New Genre Public Art (Lacy), 58 Mapplethorpe, Robert Lisa Lyon, 93, 93 Parrot Tulip, 55, 55 Marc, Franz, 516 Die grossen blauen Pferde (The Large Blue Horses), 508, 508 Marco Polo, 469 Marcus Agrippa with Imperial Family, Ara Pacis, 436, 436 Marden, Brice, Cold Mountain 3, 526, 526 Mare, Andre, Cabinet, 404, 404 Marey, Etienne-Jules, 285 Man in Black Suit with White Stripe Down Side of Chronophotograph Motion Experiment, 61-62, 61 Man Walking in Black Suit with White Stripe Down Sides, 61-62, 62 Maria Edgeworth (Beard), 276, 276 Marilyn Monroe (Warhol), 239, 239 Marinetti, Filippo, 509 Marisol, Baby Girl, 24, 24 Marriage of Giovanni Arnolfini and Giovanna Cenami, The (Van Eyck, Jan), 30, 31-32, 31 Marshall, Kerry James, Many Mansions, 521-522, 522 Marshall Field Wholesale Store (Richardson), 376, 376 Martinez, María Montoya, Jar, 337, 337 Marx, Karl, 60, 269, 496, 497-498 Masaccio, 461 The Tribute Money, 462, 462 Mass, 96-97 Master of Flémalle (Robert Campin), The Mérode Altarpiece, The

Annunciation, 252, 252

Masterpiece, The (Zola), 58 Matisse, Henri The Green Stripe (Madame Matisse), 506, 506 Harmony in Red (The Red Room), 109, 109 *Venus*, 212, 212 Matrix, 216 Matterhorn, The (Bierstadt), 10, 10 Mayans, 472-473 McCoy, Karen, Considering Mother's Mantle, 326, 327 Media. See Medium (media) Medical Student, Sailor, and Five Nudes in a Bordello (Picasso), 52, 52 Medici, Cosimo de', 461 Medici, Lorenzo de', 461, 464 Medici, Marie de', 485 Medici family, 465 Medium (media) defined, 130, 191, 243 drawing, 192-214 dry, 198-207 liquid, 208-212 mixed, 265-267 synthetic, 262-265 Meeting of Saint Anthony and Saint Paul, The (Sassetta), 153, 153 Megaliths, 423 Meier, Richard, Atheneum, New Harmony, Indiana, 386, 386 Meissonier, Ernest, Memory of Civil War (The Barricades), 494, 494 Melancholy and Mystery of a Street (De Chirico), 512, 512 Memory of Civil War (The Barricades) (Meissonier), 494, 494 Mendieta, Ana, Siluetas, 24, 25 Menkaure and His Queen, Khameremebty II, Egypt, 306, 306 Mercenaries III (Golub), 134, 134 Mérode Altarpiece, The Annunciation (Campin-Master of Flémalle), 252, 252.462-463 Mesopotamian cultures and art, 424-426 Metalpoint, 198-199 Metalwork, 354-356 casting, 300-301, 312-315 Etruscan, 435, 435 Metro-Goldwyn-Mayer (MGM) (movie company), 287 Mexican-American artists Baca, Judith F., 180-181, 180, 181, 265, 265 Mexican artists Gómez-Peña, Guillermo, 67-70, 67, 68, 69, 180 Martinez, María Montoya, 337, 337 Orozco, José Clemente, 180, 262-263 Rivera, Diego, 180, 250, 250, 262 Sifuentes, Roberto, 67, 67, 69, 69, 70 Siqueiros, David Alfaro, 180, 262, 263-264, 263 Mexico, pre-Columbian art, 472-474, 472, 473, 474 Meyerowitz, Joel, Porch, Provincetown, 283-284, 283 Mezzotint, 230 Michelangelo, 304 "Atlas" Slave, 305, 305, 316 The Creation of Adam, Sistine Chapel, 130-131, 131, 133 David, 66-67, 66, 465 Head of a Satyr, 120, 120

The Last Judgment, Sistine Chapel, 475.475 The Libyan Sibyl, Sistine Chapel, 248-249, 248, 249 Pietà, 148, 148, 167 Micronesian art, 47-48, 47 Miës van der Rohe, Ludvig Farnsworth House, 382, 382 German Pavilion, International Exposition, Spain, 380-381, 381 Seagram Building, 382-383, 382 Mihrab, 454 Mill, The (Rembrandt), 118, 118 Mimesis, 242 Mimosoidea Suchas, Acacia (Talbot). 275.27 Minamoto no Yoritomo (Takanobu), 458, 458 Minaret, 454 Minetta Lane-A Ghost Story (Antin), 322-323, 323 Ming dynasty, 339, 339, 470, 470 Minimalism, 519, 519 Minoans, 429-430, 429 Miracle of the Slave, The (Tintoretto), 475, 475 Miró, Joan, Painting, 512-513, 512 Mistress and Maid (Vermeer), 14, 14 Mitchell, William J., 112, 296-297 Mixed media, 265-267 Mme. Cézanne in a Red Armchair (Cézanne), 110-111, 110 Mobiles, Calder, 76-77, 76 Modeling, 118, 119, 310-311 Modern art, 60-64 Abstract Expressionism, 44, 258-259, 516-518, 517 Armory Show (1913), New York City, 61 Art Deco, 404-405 Art Nouveau, 401-403 Avant-Gardes, 405-409 Bauhaus, 409-410 Dada, 268-269, 511-512, 511 Futurism, 508-510, 509 Minimalism, 519, 519 Modernism, American, 515-516, 515, 516 Organic Design in Home Furnishings (Museum of Modern Art), 414-416, 414, 415, 416 pluralism of, 416-419 Pop Art, 518-519, 518 streamlining, 410-413 Surrealism, 44, 512-514, 512, 513, 514 Modernism, American, 515-516, 515, 516 Mona Lisa (Leonardo da Vinci), 466, 466, 468 Mona Lisa (L.H.O.O.Q.) (Duchamp), 511, 511 Monasteries, 447-448, 450 Mondrian, 406 Mondrian, Piet, Composition (Blue, Red, and Yellow), 515-516, 515 Monet, Claude The Artist's House at Argenteuil, 40, 40 Bridge over a Pool of Water Lilies, 500, 500 Grainstack, 27-28, 27, 140, 140, 153 Impression-Sunrise, 499, 499 Le Pont de l'Europe, 40-41, 40

The Railroad Bridge, Argenteuil, 189. 189 The Regatta at Argenteuil, 36-37, 37 Waterlillies, Morning: Willows, 154, 154.155 Monk by the Sea (Friedrich), 492, 492 Monogram (Rauschenberg), 270-271, 270, 271 Monotypes, 238-239 Monroe County House with Yellow Datura (Buchanan), 207, 207 Montage, 286 Monticello, Virginia (Jefferson), 487-488, 488 Mont Sainte-Victoire and the Viaduct of the Arc River Valley (Cézanne), 503, 503 Moore, George, 204 Moorman, Charlotte, 290-291 Moran, Thomas, 223, 492 More Love Hours Than Can Ever Be Repaid (Kelley), 353, 353 Morimura, Yasumasu, Portrait (Twins), 525-526, 525 Morisot, Berthe, Reading, 500, 500 Morris, Jane, 398-399 Morris, May, Bed hangings, 399, 399 Morris, William, 396-399 Works of Geoffrey Chaucer Newly Augmented, 398, 398 Morris and Company, 396-399 Sussex rush-seated chairs, 397-398, 398 Woodpecker, The, 397, 397 Mosaics Hagia Sophia, 445-446, 446 San Vitale, Ravenna, 444-445, 444 Mosques Great Mosque, Córdoba, Spain, 454-455, 454, 455 Great Mosque, Samarra, Iraq, 454, 454 Mother and Child Divided (Hirst), 316-317, 317 Motherwell, Robert, Elegy to the Spanish Republic XXXIV, 44, 45, 49-50 Motion, time and, 152-161 Motion picture, 62 Motna, Erna, Bushfire and Corroboree Dreaming, 7-8, 7 Mount Holyoke College Printmaking Workshop, 232 Movement, lines and, 87, 90-91 Movement (Marey), 61 Mr. Smith Goes to Washington, 288 Ms. Mary Lou Furcron's House (Buchanan), 206, 206 Mujer Pegada Series (Neri), 149, 149 Mummy Portrait of a Man, Faiyum, Egypt, 244, 244 Munsell, Albert, Color wheel, 134, 135 Murray, Elizabeth, Just in Time, 188, 188 Muschamp, Herbert, 394 Musée d'Orsay (Aulenti), 97, 97 Museum of Modern Art, Organic Design in Home Furnishings, 414-416, 414, 415, 416 Mustard-Seed Garden, The, 220 Muybridge, Eadweard, 285 Annie G. Cantering, Saddled, 61, 61 La Nature, 61 Mycenaean architecture, 365-366, 365 The Warrior Vase, 430, 430

Ν

Namer, king, 427, 427 Namuth, Hans, 156, 157 Napier, Mark, net.flag, 297-298, 297 Napoleon Bonaparte, 488-489 Napoleon III, 58 National Endowment for the Arts (NEA), 63,64 Native American art/artists Anasazi, 364, 364 Bradley, David P., 521, 521 Durham, Jimmie, 520, 520 Feodorov, John, 170-171, 171 Heiltsuk chest, 356, 357 Howling Wolf, 34–35, 35 Scholder, Fritz, 238-239, 238 Smith, Jaune Quick-to-See, 74-75, 75, 520-521, 520 Nativity (Barela), 305-306, 305 Naturalistic work, 21 Nave, 371 Necklines (Simpson), 22, 22 Nefertiti, 428, 428 Neoclassicism, 486-490, 487, 488, 489 Neolithic art, 423-424 Neoplatonists, 464 Neri, Manuel, Mujer Pegada Series, 149, 149 Neshat, Shirin, Passage, 292-293, 293 net.flag (Napier), 297-298, 297 New Harmony, Indiana, Atheneum (Meier), 386, 386 Newton's Tones/New Stones (Cragg), 146, 146 New York City Bayard-Condict Building (Sullivan), 376, 377 Central Park (Olmsted and Vaux), 2-3, 387, 387 Seagram Building (Miës van der Rohe and Johnson), 382-383, 382 TWA Terminal, Kennedy International Airport (Saarinen), 383, 383 World Trade Center, plans for Ground Zero, 392-394, 392, 393, 394 New York School, 258 New York Times, 528 Nicea (Truitt), 525, 525 Nigerian art funerary shrine clothe, 127, 127 Head of a King, 127, 127 Head of an Oba, 312, 312 Night Café, The (Van Gogh), 144, 144, 502 Night Chrysanthemum (Steir), 121, 121, 153 Nighthawks (Hopper), 516, 516 Night Shade (Schapiro), 152, 152, 340 Nike, 432-433, 433 Nike of Samothrace, 434, 434 99 Cent (Gursky), 284, 284 Nippon Television Network Corp., 131 Noblet, Jean, 237 Nocturne in Black and Gold, the Falling Rocket (Whistler), 501, 501 Nolde, Emile, Prophet, 217, 217, 506 Nonobjective work, 24-26 No Sign of the World (Ritchie), 86, 86 Nostrums, 168, 170 Notebooks (Leonardo da Vinci), 116-117, 116 Notre-Dame-du-Haut (Le Corbusier), 115-116, 115 Nouvel, Jean, Torre Agbar, 385, 385

Nude Descending a Staircase (Duchamp), 60, 60, 62, 510 Numbers in Color (Johns), 83, 83 No. 29, 1950 (Pollock), 156–157, 157, 173 Nuremberg Chronicle: View of Venice, The (Schedel), 215, 216

0

Oak Armchair for the Casa Calvet (Gaudí), 357, 357 Oblique projection, 105 O'Connor, John, 57 October from Les Très Riches Heures du Duc de Berry (Limbourg Brothers), 460, 460 October in the Catskills (Gifford), 132, 133 Oculus, 370 Odalisk (Rauschenberg), 518, 518 Odalisque (Delacroix), 489-490, 489 Office for Metropolitan Architecture (OMA), 384-385 Ofili, Chris, 354 The Holy Virgin Mary, 56-57, 57 Oil painting, 252-260 Oil sticks, 205 O'Keeffe, Georgia Banana Flower, 200, 201 Purple Hills Near Abiquiu, 516, 516 Oldenburg, Claes, 518, 519 Design for a Colossal Clothespin Compared to Brancusi's Kiss, 237-238, 237 Spoonbridge and Cherry, 176, 176, 188 Olmecs, 472 Olmsted, Frederick Law Central Park, 2-3, 387, 387 Riverside, Illinois, 388, 388 Olympia (Manet), 497-498, 497 One-point linear perspective, 100, 100 Op Art (optical painting), 154 Open Door, The (Talbot), 277, 277 Orange Crush (Poons), 173, 173 Order, column, 367 Organic Design in Home Furnishings (Museum of Modern Art), 414-416, 414, 415, 416 Original print, 216 Orozco, José Clemente, 180, 262-263 O'Sullivan, Timothy Green River (Colorado), 278, 279 Harvest of Death, Gettysburg, Pa., 278, 278 Outline, 74-75 Overlap, 99 Oxbow, The (Cole), 124-125, 125 Oxus treasure, Griffin bracelet (Persian), 355, 355

P

Pacal, sarcophagus lid of Lord, 473–474, 473 Pagodas, Chinese, 456–457, 457 Paik, Nam June TV Bra for Living Sculpture, 290–291, 291 TV Buddha, 290, 290 Painting See also Cave art; Landscapes Abstract Expressionism, 44, 258–259, 516–518, 517

Baroque, 479-482, 479, 480, 481, 482 Cubism, 505-506, 505 Dada, 268-269, 511-512, 511 encaustic, 243-244 Expressionism, German, 217, 506-508, 507, 508 Fauves, 506, 506 fresco, 244–250 Futurism, 508-510, 509 gouache, 262 Impressionism, 499-501, 499, 500, 501 La Pittura, 240–243 Mannerism, 475-476, 475, 476 Minimalism, 519, 519 mixed media, 265-267 Modernism, American, 515-516, 515, 516 Neoclassicism, 486-490, 487, 489 oil, 252-260 Pop Art, 518-519, 518 Post-Impressionism, 501-503, 501, 502, 503 Postmodernism, 187, 519-529, 520-529 Realism, 494-498, 494-498 Renaissance, 462-469, 462, 463, 464, 466, 467, 468, 469 Rococo, 485-486, 486 Romanticism, 490-493, 490, 491, 492, 493 Surrealism, 44, 512-514, 512, 513, 514 synthetic media, 262-265 tempera, 250-251 terminology, 242-243 watercolor, 260-262 Painting (Miró), 512-513, 512 Palais Stoclet (Hoffman), 403, 403 Paleolithic Era, 422 Palette, 131 Palette of King Narmer, 427, 427 Pantheon, Rome, 370, 370 Paramount (movie company), 287 Paris Arc de Triomphe, 488 Eiffel Tower, 373-374, 373 Galeries de l'Art Nouveau, 401 Louvre (Perrault, Le Vau and Lebrun), 484, 484 Métro entrance (Guimard), 373, 373, 389 Paris Illustré, "Le Japon," 218, 218 Park, The (Simpson), 22-23, 23, 237 Parrhasius, 241, 243 Parrot Tulip (Mapplethorpe), 55, 55 Parsifal I (Kiefer), 172-173, 172 Parthenon (Iktinos and Kallikrates), 182, 182, 431, 431 Maidens and Stewards, frieze, 302, 302 Three Goddesses, 307-308, 307 Pasadena Lifesavers Red Series #3 (Chicago), 24-26, 25 Passage (Neshat), 292-293, 293 Passlof, Pat, Dancing Shoes, 256, 256, 260 Pastel, 203-205 Pastoral Landscape, A (Claude Lorrain), 482, 482 Pat (Ahearn and Torres), 21, 21, 24 Pataki, George, 394 Pattern, 147, 151-152 Pattern and Decoration movement, 340

Pavillon de l'Esprit Nouveau (Le Corbusier), 405-406, 405 Paxton, Joseph, Crystal Palace, 396, 396 Pen and ink, 208 Pencil, 201–202, 229 Pencil of Nature, The (Talbot), 277 Pennsylvania, Fallingwater, Kaufmann House (Wright), 378-379, 378, 379 Performance art, 301, 327-332 Pericles, 431 Perrault, Claude, Louvre, 484, 484 Perry, Lilla Cabot, 36 Persistence of Memory, The (Dali), 44, 44 Perspective, atmospheric (aerial), 116-118 Perspectives: Angles on African Art (Vogel), 29 Petrarch, 460 Petroglyph Park (Smith), 520-521, 520 Pettway, Jessie T., Bars and String-Pieced Columns, 351-352, 351 Phaeno Science Center (Hadid), Germany, 528, 528 Phidias, 431 Philip, king of Macedon, 433 Philip IV, King of Spain (Velázquez), 174, 174 Photogenic drawing, 275 Photography chronophotographs, 62 color, 283-284 digital, 284 early history, 274-278 form and content, 278-283 Marey, 61-62, 61, 62, 285 Muybridge, 61, 61, 285 Piano, Renzo, Jean-Marie Tjibaou Cultural Center, New Caledonia, 49,49 Picasso, Pablo, 266 Gertrude Stein, 43-44, 43, 504 Guernica, 513-514, 513, 514, 515 Les Demoiselles d'Avignon, 52-53, 53, 504, 520 Luncheon on the Grass, 224, 224 Medical Student, Sailor, and Five Nudes in a Bordello, 52, 52 Seated Bather by the Sea, 50-51, 50 Study for the Crouching Demoiselle, 53, 53 Woman with Stiletto (Death of Marat), 179, 179 Pickford, Mary, 287 Pico della Mirandola, 460-461 Piero della Francesca, The Flagellation of Christ, 463-464, 463 Pietà (Michelangelo), 148, 148, 167 Pigments, 195, 243 Pilchuck Glass School, 344 Pink Chrysanthemum (Steir), 121, 121, 153 Pinocchio, 289 Place de l'Europe on a Rainy Day (Caillebotte), 102-103, 102, 498 Planographic printmaking, 231 Plastic arts, 152 Platform, 367 Plato, 431 Platonic Academy of Philosophy, 464 Plaza Las Fuentes (Kozloff), 340, 341 Pleasure Pillars (Sikander), 526, 526, 528 Plein-air painting, 140 Pliny, 241

Plowing in the Nivernais (Bonheur), 496, 496 Poet Li Bo Walking and Chanting a Poem, The (Liang Kai), 211-212, 211 Poet on a Mountaintop (Shen Zhou), 470-471, 470 Pointed arches, 372, 372 Pointillism, 134, 136-137 Pollaiuolo (?), Youth Drawing, 192, 192 Pollock, Jackson, 154, 262, 517, 526 Autumn Rhythm, 156, 156 No. 29, 1950, 156-157, 157, 173 Polychromatic, 139 Polydorus of Rhodes, The Laocoön Group, 434, 434 Polygnotus, 243 Polykleitos, 433 Doryphoros (Spear Bearer), 182, 182, 436 Pompeii, 245 Ponderation, 306 Pont du Gard, Nîmes, France, 368-369, 368, 389 Pontormo, Jacopo da, The Visitation, 294, 295Poons, Larry, Orange Crush, 173, 173 Pop Art, 518-519, 518 Porcelain, 338-340 Porch, Provincetown (Meyerowitz), 283-284, 283 Portland Vase (Wedgewood), 336, 336 Portrait of a boy (Etruscan), 435, 435 Portrait of Queen Mariana (Velázquez), 174, 174 Portrait of Thomas Carlyle (Cameron), 277.277 Portrait (Twins) (Morimura), 525-526, 525 Post-and-lintel construction, 365-367 Poster for Delftsche Slaolie (Salad Oil) (Toorop), 402, 402 Posters, avant-garde, 407-409, 407, 408 Post-Impressionism, 501-503, 501, 502, 503 Postmodernism, 187, 519-529, 520-529 Potter's wheel, 338 Pottery See also Ceramics ornamental, 335, 336 useful, 335-336 Poussin, Nicolas, Landscape with St. John on Patmos, 484, 484, 485 Powell, J. W., Exploration of the Colorado River of the West, Noon-Day Rest in Marble Canyon. 222-223, 222 Pozzo, Fra Andrea, The Glorification of Saint Ignatius, 246, 247, 272 Prairie House, 377 Praxiteles Aphrodite of Knidos, 92, 92 Hermes and Dionysos, 307, 307 Pre-Columbian art, 472-474, 472, 473, 474 Premier Disque (Simultaneous Disks) (R. Delaunay), 142, 142 Primary colors, 129 Primavera (Botticelli), 250-251, 251 Print defined, 216 original, 216 Printmaking, 215-216 planographic, 231

Pritzker Prize, 528 Proofs, 216 Prophet (Nolde), 217, 217 Proportion, 176 Prud'hon, Pierre Paul, Study for La Source, 118, 118, 119 Public art, Arts in Public Places Program, 63-70 Public Figures (Suh), 176, 176 Pugin, A. W. N., 396 Purple Hills Near Abiquiu (O'Keeffe), 516, 516 Puryear, Martin, 521 Ladder for Booker T. Washington, 358, 358 Self, 96, 96 Pyramid of the Amphora (Voulkos), 342-343, 343 Pyramids at Giza, Egyptian, 362-363, 363 Q. And Babies? A. And Babies (Haeberle), 281, 281 Qibla wall, 454 Quarton, Enguerrand, Coronation of the Virgin, 166, 166, 171 Quattrocento drawings, 193 Queen Nefertiti, 428, 428 Queen's Ware kitchen ware (Wedgwood), 335-336, 335 Quiltwork, 351-352, 351 Qur'an, page from, 455, 455 R Race Riot (Warhol), 16, 16 Races (Les Courses), The (Manet), 232, 2.32 "Rac"ing Sideways (Buglaj), 126, 126 Radial balance, 170-171 Raft of the Medusa, The (Géricault), 491, 491 Rage and Depression (Wegman), 291, 291 Railroad Bridge, Argenteuil, The (Monet), 189, 189 Raimondi, Marcantonio, The Judgment of Paris, 58, 59, 225 Rain, Steam, and Speed-The Great Western Railway (Turner), 117-118, 117 Rape of the Sabine Women, The (Bologna), 303, 303 Raphael, 466 The Alba Madonna, 196-197, 196, The Judgment of Paris, 58, 60, 225 Saint Paul Rending His Garments, 199, 199 The School of Athens, 467-468, 467 Rauschenberg, Robert, 202, 274 Accident, 236-237, 236 Monogram, 270-271, 270, 271 Odalisk, 518, 518

silkscreen, 237-238

142-143, 143

Prismes Electriques (Delaunay-Terk),

- Ravenna, San Vitale, 443-445, 443, 444
- Reading (Morisot), 500, 500
- Realism, 21-22, 494-498, 494-498
- Reconstructed Icicles Around a Tree
- (Goldsworthy), 74, 74 Red and Blue Chair (Rietveld), 406, 406

Red House, The (Webb), 396, 397 Regatta at Argenteuil, The (Monet), 36-37, 37 Registration, 224 Reid, Laurie, Ruby Dew (Pink Melon Joy), 261-262, 261 Reims Cathedral, facade and portals, 453, 453 Relic 12 (Liu), 86-87, 87 Relief defined, 216 high versus low, 302 processes, 216-224 sculpture, 301-303 woodblock prints, 216-224 Rembrandt van Rijn The Angel Appearing to the Shepherds, 228, 229 The Mill, 118, 118 Resurrection of Christ, 480, 480 A Sleeping Woman, 211, 211 The Three Crosses, 78, 78 Renaissance early, 460-464 high, 464-469 use of term, 459 Renoir, Pierre Auguste La Moulin de la Galette, 499-500, 499 The Luncheon of the Boating Party, 44, 45, 46 Repetition and rhythm, 183-185 Replacement method, 313 Representational art, 21-22, 38-41 color in, 139-141 Resnais, Alain, 289 Resnick, Milton, 256 U + Me, 258-259, 258, 259 Restoration, of The Creation of Adam (Michelangelo), Sistine Chapel, 130-131, 131, 133 Resurrection of Christ (Rembrandt), 480, 480 Revelers (Euthymides), 338, 338 Reverence (Sardonis), 308-309, 308, 309 Rhythm, 183-185 Richard's Home (Buchanan), 206-207, 206 Richardson, Henry Hobson, Marshall Field Wholesale Store, 376, 376 Richter, Gerhard Betty, 254-255, 255 256 Farben (256 Colors), 140-141, 140, 173 Rietveld, Gerrit Red and Blue Chair, 406, 406 Schröder House, 406-407, 406 Riley, Bridget, Drift 2, 154-155, 155 Ringgold, Faith God Bless America, 14, 15 Tar Beach, 352–353, 352 We Flew Over the Bridge: The Memoirs of Faith, 352 Ritchie, Matthew, 84 No Sign of the World, 86,86 Rivera, Diego, 180, 262, 523 Sugar Cane, 250, 250 Rivers, Larry, Willem de Kooning, 202-203, 203 Rivers and Tides: Working with Time, 90-91 Riverside, Illinois (Olmsted and Vaux), 388, 388

Roadside Store between Tuscaloosa and Greensboro, Alabama (Evans), 274, 274 Robert, Jean, Swatch watches, 416-417, 417 Robie House (Wright), 377, 377 Rocky Mountains, The (Bierstadt), 4-5, 5, 10, 21 Rococo, 485-486, 486 Rodchenko, Alexander, L'Art Décoratif, Moscow-Paris, 407, 407 Roden Crater (Turrell), 323-324, 325 Rodin, Auguste, 313 The Burghers of Calais, 314-315, 314, 316 Gates of Hell with Adam and Eve, 184, 184 The Thinker, 184 Three Shades, 184, 184, 185 Roman art architecture, 368-370, 368, 369, 370, 437-438, 437 mosaic glass bowl, 341, 341 sculpture, 303, 303, 435-436, 435, 436 Romanesque art architecture, 370-371, 371, 449-450 sculpture, 450, 450 Romantic, use of term, 84 Romanticism, 490-493, 190, 491, 492, 493 Rome Arch of Constantine, 437, 437 Colosseum, 369, 369 Column of Trajan, 437, 437 Pantheon, 370, 370 St. Peter's Basilica, 374, 374, 477, 477 San Carlo alle Quattro Fontane, 477-478, 477 Santa Costanza, 443, 443 Room for St. John of the Cross (Viola), 161-162, 161 Roosevelt, Franklin D., 516 Roosevelt, Theodore, 60 Rose window, Chartres Cathedral, 170, 170,451 Rossetti, Dante Gabriel, Sofa, 398, 398 Rothenberg, Susan, Biker, 255, 255 Rothko, Mark, Four Darks in Red, 517-518, 517 Rounds, Clifton Chenier from (Serra), 205, 205 Royal Academy of Painting and Sculpture, 484 Rubens, Peter Paul The Arrival and Reception of Marie de' Medici at Marseilles, 485, 485 The Kermis, 104, 104 Rubin vase, 96-97, 97 Ruby Dew (Pink Melon Joy) (Reid), 261-262, 261 Rue Transnonain (Daumier), 232, 232 Rumals, Indian embroidered, 350, 350 Rupert, Prince, The Standard Bearer, 230, 230 Ruskin, John, 396, 501 Russell, John Peter, 80 Russian Constructivists, 407

S

Saarinen, Eero Organic Design in Home Furnishings (Museum of Modern Art), 414–415, 414, 415

Tulip Pedestal Furniture, 414-415, 415 TWA Terminal, Kennedy International Airport, New York, 383, 383 Saarinen, Eliel, 414 Sainte Chapelle, Paris, 48, 48 St. Denis, France, 451 Saint Luke Drawing the Virgin and Child (Van der Weyden), 198-199, 198 St. Matthew from the Gospel Book of Charlemagne, 449, 449 St. Matthew from the Lindisfarne Gospels, 448, 449 St. Patrick, 447 Saint Paul Rending His Garments (Raphael), 199, 199 St. Peter's Basilica, Rome Maderno and Bernini, nave and façade, 477, 477 Michelangelo's central plan, 374, 374 St. Sernin, Toulouse, France, 371, 371, 450 Saladin, 454 Salon des Refusés, 58 Salons, 485 Saltcellar for Francis I (Cellini), 355-357, 355 Samarra, Iraq, Great Mosque, 454, 454 San Carlo alle Quattro Fontane (Borromini), 477-478, 477 San Francisco Silverspot (Warhol), 239, 239 Sanserif fonts, 408 Sant' Apollinare, 444 Santa Costanza, Rome, 443, 443 San Vitale, Ravenna, 443-445, 443, 444 Saomi, Garden of the Dasisen-in of Daitokuji, 471, 471 Sardonis, Jim, Reverence, 308-309, 308, 309 Sargent, John Singer, The Daughters of Edward Darley Boit, 176-177, 177 Sassetta, The Meeting of Saint Anthony and Saint Paul, 153, 153 Saturation, 130 Saturn Devouring One of His Sons (Goya), 490, 490 Savonarola, Girolamo, 192, 465 Scale, 99, 176 Schapiro, Miriam, Night Shade, 152, 152, 340, 523 Schedel, Hartmann, The Nuremberg Chronicle: View of Venice, 215, 216 Scholder, Fritz, Dream Horse, 238-239, 238 School of Athens, The (Raphael), 46%-468, 46% Scraper, The (Apoxyomenos) (Lysippos), 433, 433 Schröder House (Rietveld), 406-407, 406 Schwartz, Frederic, 394 Scroggins, Michael, Topological Slide, 113, 113 Sculpture additive and subtractive processes, 300-301 assemblage, 316-321 Assyrian, 425-426, 425 Babylonian, 425, 425 Baroque, 478, 478 carving, 304–310 casting, 300-301, 312-315 Chinese, 311, 311, 441, 441 earthworks, 301, 304, 325-327

Sculpture (cont.) Egyptian, 301, 301, 306, 306, 427-428, 427, 428 Gothic, 453, 453 Greek, 182, 182, 302-303, 302, 306-307, 306, 307, 310, 432-434, 433, 434 installations, 301, 304, 322-324 in-the-round, 303, 303 lines in, 92-93, 92, 93 modeling, 310-311 performance art, 301, 327-332 pre-Columbian, 472, -474, 472, 473, 474 public, 64-67 relief, 301-303 Renaissance, 461-462, 461 Roman, 303, 303, 435-436, 435, 436 Romanesque, 450, 450 Sumerican, 424, 424 Scythed Chariot, Armored Car, and Pike, A (Leonardo da Vinci), 466, 466 Seagram Building (Miës van der Rohe and Johnson), 382-383, 382 Searles, Charles, Filàs for Sale, 138, 139 Seated Bather by the Sea (Picasso), 50-51.50 Seated Woman (de Kooning), 203, 203 Secondary colors, 129–130 Seeing physical process of, 13-14 psychological process of, 14-15 Self (Puryear), 96, 96 Self-Portrait (Dürer), 469, 469 Self-Portrait, Drawing (Kollwitz), 200, 201,255 Self-Portrait as the Allegory of Painting (Gentileschi), 241, 241, 272 Senefelder, Alois, 231 Sensation: Young British Artists from the Saatchi Collection, 56 Senwosret I, White Chapel, Karnak, Thebes, 301, 301 September 11, 2001, impact of, 528-529 Sequential view of Dots and Dashes in motion (Calder), 76-77, 76 Serif type styles, 407–408 Serigraphs, 237-238 Serra, Richard Clifton Chenier, from Rounds, 205, 205 Tilted Arc, 65-66, 65 Sesshu Toyo, Haboku Landscape for Soen, 471, 471 Settee (Stickley), 400, 400 Seurat, Georges Pierre Bathers, The, 502, 502 Café Concert, 202, 202 A Sunday on La Grande Jatte, 134, 135, 502 Seven Valleys and the Five Valleys, The (Lavadour), 186, 186 Sforza, Ludovico, 465, 466 Shade, 121 Shaft, 367 Shahnamah (Firdawsi), 18, 19, 20 Shang dynasty bronze vessel, 424, 424 Shape, 96-97 Shaving a Boy's Head (Utamaro), 219, 219 She (Simpson), 20-21, 21 She-ba (Bearden), 133, 133 Sheeler, Charles, Criss-Crossed Conveyors-Ford Plant, 280, 280

Shell system, 365 Shen Zhou, Poet on a Mountaintop, 470-471, 470 Sherman, Cindy, Untitled #96, 524, 524 She-Wolf (Etruscan/Roman), 435-436, 435 Shih Huang Ti, tomb of, 311, 311, 439 Shiva Nataraja (Dancing Shiva), Thanjavur, India, 456, 456 Shonibare, Yinka, Victorian Couple, 354, 354 Shunshuu Ejiri, from the series Thirty-Six Views of Mount Fuji (Hokusai), 298.298.299 Sifuentes, Roberto The Cruci-fiction Project, 67, 67, 70 The Temple of Confessions, 69, 69 Sikander, Shahzia, Pleasure Pillars, 526, 526, 528 Silkscreens, 237-238 Siluetas (Mendieta), 24, 25 Simon, John F., Jr. Every Icon, 297 Unfolding Object, 297, 297 Simpson, Lorna, 318 Necklines, 22, 22 Park, The, 22-23, 23, 237 She, 20-21, 21 Simultaneous contrast, 133-134 Simultaneous Disks (R. Delaunay), 142, 142 Sinopie, 200 Siqueiros, David Alfaro, 262 America Tropical, 180 Cuauhtémoc against the Myth, 263-264, 263 Sirani, Elisabetta, The Holy Family with a Kneeling Monastic Saint, 208, 208 Sistine Chapel The Creation of Adam (Michelangelo), 130-131, 131, 133 The Last Judgment (Michelangelo), Sistine Chapel, 475, 475 The Libyan Sibyl (Michelangelo), 248-249, 248, 249 Site specific installations, 322 Sizing, 220 Skeleton-and-skin system, 365, 374 Sketch I for Composition VII (Kandinsky), 507-508, 507 Skidmore, Owings & Merrill, 393 Skyscraper Bookcase (Frankl), 404, 404 Skyscrapers, 380, 382-385 Slab construction, 336, 337, 337 Sleeping Venus (Giorgione), 468, 468 Sleeping Woman, A (Rembrandt), 211, 211 Smith, David, Blackburn: Song of an Irish Blacksmith, 304, 304 Smith, Gordon, 63 Smith, Jaune Quick-to-See House, 74-75, 75 Petroglyph Park, 520-521, 520 Smith, Ken, 394 Smithson, Robert, Spiral Jetty, 8-9, 9, 10-11, 11, 325 Snake Goddess or Priestess, Minoan, 429, 429 Snow Storm: Steamboat off a Harbor's Mouth (Turner), 225, 225 Snow White and the Seven Dwarfs, 289 Sofa (Rossetti), 398, 398 Solodkin, Judith, 235

Solvent, 243

Sony Portapak, 290 Sower, The (Van Gogh), 80-81, 81 Space axonometric projections, 104-105 distortion of, and foreshortening, 106 - 108linear perspective, 99-104 modern experiments with, 109-113 oblique projection, 105 shape and mass, 96-97 three-dimensional, 97-98 two-dimensional, 98-99 Spade with Chains (Hammons), 316, 316 Spanish art/artists Gaudí, Antoni, 356, 357 German Pavilion, International Exposition (Miës van der Rohe), 380-381, 381 Goya, 490, 490 Great Mosque, Córdoba, 454-455, 454, 455 Guggenheim Museum Bibao (Gehry), 527, 527 Miró, Joan, 512-513, 512 Picasso, Pablo, 43-44, 43, 50-53, 50, 52, 53, 179, 179, 224, 224, 266, 504, 513-514, 513, 514 Torre Agbar (Nouvel), 385, 385 Turning Torso residential tower (Calatrava), 384, 384 Spear Bearer (Doryphoros) (Polykleitos), 182, 182, 436 Spectrum, 129 Spiral Jetty (Smithson), 8-9, 9, 10-11, 11, 325 Spoonbridge and Cherry (Oldenburg), 176, 176, 188 Springing, 370 Spruce Tree House, Anasazi, 364, 364 Stagecoach, 288 Stained-glass windows at Chartres Cathedral rose window, 170, 170, 451 stained-glass window, 33, 33 Stairwell (Dickson), 230-231, 231 Standard Bearer, The (Rupert), 230, 230 Standing Female from the Back (Gaudier-Brzeska), 74, 75, 75 Stanford, Leland, 61 Stanley (Close), 136-137, 136, 137 Starry Night, The (Van Gogh), 79, 79, 82 Star Wars, 289 Stations (Viola), 292, 292 Staubsauger, Vacuum cleaner, 413, 413 Steel construction, 375-385 Stein, Gertrude, 262 Steir, Pat Drawing Lesson, Part I, Line #1, 77-78,78 Drawing Lesson, Part I, Line #5, 78-79, 79 Night Chrysanthemum, 121, 121, 153 Pink Chrysanthemum, 121, 121, 153 Stele of Hammurabi, 425, 425 Stella, Frank, Empress of India, 519, 519 Stellar Roil, Stellar Winds 5 (Wayne), 234, 234 Stereoscope/stereographs, 106, 106 Stewart, Jimmy, 288 Stickley, Gustav, 375, 399 Settee, 400, 400 Stieglitz, Alfred, From the Shelton, New York, 279, 279

Still Life or Vanitas (Champaigne), 51, 51 Still life painting, 51, 72, 73-74, 245 Still Life with Cherries and Peaches (Cézanne), 502-503, 502 Still Life with Eggs and Thrushes, Villa of Julia Felix, 245, 245 Still Life with Lobster (de Heem), 254, 254,480 Still Life with Lobster (Vallayer-Coster), 171, 171 Stippling, 225 Stockhausen, Karlheinz, 290-291 Stone Field Sculpture (Andre), 64-65, 64 Stonehenge, Salisbury Plain, England, 423, 423 Stone Quarry Hill Art Park, Cazenovia, New York, 326, 327 Stoneware, 338 Stopping out, 229 Streamlining, 410-413 Study for a Prophet Seen from the Front (Bartolommeo), 199-200, 200 Study for a Sleeve (Leonardo da Vinci), 194, 194 Study for La Source (Prud'hon), 118, 118, 119 Study for the Crouching Demoiselle (Picasso), 53, 53 Study for the Death of Sardanapalus (Delacroix), 84, 85 Study for the Death of Socrates (David), 84,84 Stupa (Great), Sanchi, India, 440-441, 440 Stylobate, 367 Stylus, 198 Sublime, 4, 492 Subtractive processes, 130, 300-301 Suburbs, growth of, 388-389 Sudden Gust of Wind, A (Wall), 298-299, 299 Süe, Louis, Cabinet, 404, 404 Sugar Cane (Rivera), 250, 250 Suger, abbot, 451 Suh, Do-Ho, Public Figures, 176, 176 Sullivan, Louis H., 375-377 Bayard-Condict Building, 376, 377 Sultan, Donald, Lemons, May 16, 1984, 96,96 Sumerian architecture, 363, 363, 424-425 sculpture, 424, 424 Summer Landscape (Davis), 139-140, 139 Sunday on La Grande Jatte, A (Seurat), 134, 135, 502 Sunset-Niagara River (Barker), 106, 106 Sun Tunnels, Great Basin Desert, Utah (Holt), 325, 325 Support, 243 Suprematist Painting (Malevich), 26, 26, 27 Surrealism, 44, 512-514, 512, 513, 514 Surrealism and Painting (Breton), 44 Sussex rush-seated chairs (Morris and Co.), 397-398, 398 Sutton Hoo burial ship, Hinged clasp from, 448, 448 Swamp Ritual (Connell), 318-319, 319 Swatch watches (Durrer and Robert), 416-417, 417 Symbolic use of color, 144-145

Synthetic media, 262-265 Table, The (Gris), 266, 266 Table lamp (Wright), 400, 401 Takanobu, Fujiwara, Minamoto no Yoritomo, 458, 458 Talbot, William Henry Fox, 276 Mimosoidea Suchas, Acacia, 275, 275 The Open Door, 277, 277 The Pencil of Nature, 277 Tamarind Lithography Workshop, 232, 234 Tang dynasty, 456-457, 457 Taoism, 439 Tapestry, 350 Woodpecker, The (Morris and Co.), 397, 397 Tar Beach (Ringgold), 352-353, 352 Taylor, John, Treaty Signing at Medicine Lodge Creek, 34-35, 34 Tea Bowl Named Amagumo (Koetsu), 337, 337 Technologies, 191-192 Tempera, 250-251 Temperature, color, 133 Temple of Athena Nike, Acropolis, Athens, 368, 368, 432 Temple of Confessions, The (Gómez-Peña and Sifuentes), 69, 69 Temple of Hera (First), Paestum, Italy, 366-367, 367 Temple of Zeus, Olympia, Atlas Bringing Herakles the Golden Apples, 302-303, 302 Tenebrism, 124 Tensile strength, 365 Teotihuacán, 472-473, 472 Terrace at Vernon, The (Bonnard), 141, 141 Tesserae, 445 Textiles and fiber art, 350-354 Texture actual, 148-149 defined, 147, 148 visual, 149, 150 Theodora and Her Attendants, San Vitale, Ravenna, 444-445, 444 THINK, World Trade Center, plans for Ground Zero, 394, 394 Thinker, The (Rodin), 184 Third of May, 1808, The (Goya), 494, 494 This is Me, This is You (Horn), 158-160, 158-159 Three Crosses, The (Rembrandt), 78, 78 Three-dimensional space, 97-98 Three Flags (Johns), 12, 13, 244 Three Fujins (Liu), 88-89, 89 Three Goddesses, Parthenon, Acropolis, 307-308, 307 Three Shades (Rodin), 184, 184, 185 Through the Flower: My Struggle as a Woman Artist (Chicago), 25 Tiepolo, Giovanni Battista, The Adoration of the Magi, 210, 211 Tiffany, Louis Comfort glassware, Favrile, 402, 402 lamps, 401, 401 Tilted Arc (Serra), 65-66, 65 Time and motion, 147, 152-161 Tint, 121

Symmetrical balance, 165-166

Tintoretto, The Miracle of the Slave, 475, 475 Titanic, 290 Titian Assumption and Consecration of the Virgin, 77, 77 Venus of Urbino, 468, 468 Tomaselli, Fred, Airborne Event, 272, 272 Tomb of Emperor Shih Huang Ti, 311, 311 Toorop, Jan, Poster for Delftsche Slaolie (Salad Oil), 402, 402 Topography, 362-364 Topological Slide (Scroggins and Dickson), 113, 113 To Raise the Water Level in a Fish Pond (Huan), 332, 332 Toreador fresco, Minoan, 429-430, 429 Torre Agbar (Nouvel), Barcelona, 385, 385 Torres, Rigoberto, Pat, 21, 21, 24 Touch Sanitation (Ukeles), 390 Toulouse, France, St. Sernin, 371, 371, 450 Toulouse-Lautrec, Henri de, 401 At the Moulin Rouge, 501, 501 Trajan, Column of, Rome, 437, 437 Transepts, 371 Transient Rainbow and drawing for, (Cai Guo-Qiang), 128-129, 128, 129 Treason of Images, The (Magritte), 18, 18 Treaty Signing at Medicine Lodge Creek (Howling Wolf), 34-35, 35 Treaty Signing at Medicine Lodge Creek (Taylor), 34-35, 34 Tribute Money, The (Masaccio), 462, 462 Trimetric projection, 105 Trompe l'oeil, 254 Truitt, Anne Daybook, 525 Nicea, 525, 525 Turn, 525 Truss, 374, 374 Tuckerman, H. T., 4 Tulip Pedestal Furniture (Saarinen), 414-415, 415 Tunnel vault, 369, 369 Turkish Bath, The (Ingres), 94, 94, 489 Turn (Truitt), 525 Turner, J. M. W. Rain, Steam, and Speed-The Great Western Railway, 117-118, 117 Snow Storm: Steamboat off a Harbor's Mouth, 225, 225 Turning Torso residential tower (Calatrava), 384, 384 Turrell, James Atlan, 324, 324 Roden Crater, 323-324, 325 Tusche, 236 Tutankhamen, 428 TV Bra for Living Sculpture (Paik), 290-291, 291 TV Buddha (Paik), 290, 290 TWA Terminal, Kennedy International Airport, New York (Saarinen), 383, 383 24 Hour Psycho (Gordon), 287, 287 Iwo-dimensional space, 98-99 Two Figures (Hepworth), 97-98, 97

256 Farben (256 Colors) (Richter), 140-141, 140, 173 Two-point linear perspective, 102-103, 103 Two Undiscovered Amerindians (Gómez-

Peña and Fusco), 68, 68 Tympanum, 450

U

Ukeles, Mierle Laderman Fresh Kills Landfill, 390-391, 390 I Make Maintenance Art One Hour Every Day, 390 Manifesto for Maintenance Art, 390 Touch Sanitation, 390 Wash, 390 Ukiyo-e prints, 220-221, 220, 221 Ulay, Imponderabilia, 329, 329 Unfolding Object (Simon), 297, 297 Unicorn in Captivity, 350, 350 Unique Forms of Continuity in Space (Boccioni), 509-510, 509 United Artists (movie company), 287 Unity and variety, 185-188 Universal Exposition (1900), Paris, 401, 402 Universal Limited Art Editions (ULAE), 232 Universal (movie company), 287 Untitled (Ali), 184-185, 185 Untitled (Baselitz), 262, 262 Untitled (Basquiat), 186-187, 186 Untitled (Gober), 317-318, 318 Untitled (Gonzalez-Torres), 178-179, 179 Untitled (Haring), 76, 76 Untitled (Krasner), 515, 515 Untitled #96 (Sherman), 524, 524 Untitled (Ocean) (Celmins), 202, 202 Untitled (Shirts 2) (Brauntuch), 529, 529 Untitled (We won't play nature to your culture) (Kruger), 524-525, 524 Untitled (Voulkos), 342, 342 U + Me (Resnick), 258-259, 258, 259 Ur, Sumerian ziggurat, 363, 363 Utamaro, Kitagawa The Fickle Type, from Ten Physiognomies of Women, 220, 220 Shaving a Boy's Head, 219, 219 Utamaro's Studio, 220-221, 221 Utamaro's Studio, 220-221, 221

V

Vacuum cleanrer, Staubsauger, 413, 413 Vallayer-Coster, Anna, Still Life with Lobster, 171, 171 Value, 120, 121, 124-127 Van der Weyden, Rogier Deposition, 463-464, 463 Saint Luke Drawing the Virgin and Child, 198-199, 198 Van Doesburg, Theo, Color Construction, 105, 105 Van Eesteren, Cornelius, Color Construction, 105, 105 Van Eyck, Jan God, from the Ghent Altarpiece, 42, 42 The Madonna of Chancellor Rolin, 199, 252, 253 The Marriage of Giovanni Arnolfini and Giovanna Cenami, 30, 31-32,

Van Gogh, Vincent Japonaiserie: The Courtesan (after Kesai Eisen), 218-219, 218 letter to John Russell, 80, 80 The Night Café, 144, 144, 502 The Sower, 80-81, 81 The Starry Night, 79, 79, 82 Vanishing point, 100, 100 Vanitas, 51 Van Ruisdael, Jacob, View of Haarlem from the Dunes at Overeen, 482, 482 Vantage point, 100 Variability and Repetition of Similar Forms, II (Graves), 315, 315, 316 Vasari, Giorgio The Art of Painting, 241 Lives of the Painters, 193 Vases Apotheosis of Homer Vase (Wedgwood), 335, 335 Ch'ing Dynasty porcelain, 339, 339 Floral Vase and Shadow (Woodman), 340, 340 Greek amphora, 338, 338 Portland Vase (Wedgewood), 336, 336 The Warrior, Mycenaean, 430, 430 Vaults, 369, 369 Vaux, Calvert Central Park, 2-3, 387, 387 Riverside, Illinois, 388, 388 Vedas, 455, 456 Vehicle, 243 Velázquez, Diego, 481 Las Meninas (The Maids of Honor), 174-175, 175 Philip IV, King of Spain, 174, 174 Portrait of Queen Mariana, 174, 174 Venice Biennale (2003), 345 Venturi, Robert, 187 Venus (Matisse), 212, 212 Venus, Cupid, Folly, and Time (The Exposure of Luxury) (Bronzino), 476, 476 Venus of Urbino (Titian), 468, 468 Venus of Willendorf, Austria, 422, 422 Vermeer, Jan The Allegory of Painting (The Painter and His Model as Klio), 190, 191 Mistress and Maid, 14, 14 Woman Holding a Balance, 165-166, 165.167 Vessels, Shang dynasty bronze, 424, 424 Victoria and Albert Chandelier (Chihuly), 345, 345 Victorian Couple (Shonibare), 354, 354 Videos anime, 214, 214 art, 290-296 Hill, Gary, 296, 296 Hubbard (Teresa) and Birchler (Alexander), 160–161, 160 Neshat, Shirin, 292-293, 293 Paik, Nam June, 290-291, 290, 291 Viola, Bill, 161-162, 161, 292, 292, 294-295, 294, 295 Wegman, William, 291, 291 Vietnam Memorial (Lin), 62-63, 62 View from Mount Holyoke, Northampton, Massachusetts, after a Thunderstorm—The Oxbow (Cole), 124-125, 125 View from Primrose Hill (Auerbach), 148-149, 148

View of Haarlem from the Dunes at Overeen (Van Ruisdael), 482, 482 Vigée-Lebrun, Marie-Louise-Elisabeth, The Duchess of Polignac, 486, 486 Villa Savoye (Le Corbusier and Jeanneret), 380, 380 Viñoly, Rafael, 394 Viola, Bill The Greeting, 294-295, 294, 295 Room for St. John of the Cross, 161-162, 161 Stations, 292, 292 Violin and Palette, Autumn (Braque), 505-506, 505 Virgin/Vessel (Liu), 88,88 Virtual reality, 113 Visitation, The (Pontormo), 294, 295 Visitation, Reims Cathedral, facade and portals, 453, 453 Visual literacy conventions and art, 28-31 defined, 17 describing the world, 21, 24-26 form and content, 26-28 iconography, 31-33 words and images, 18, 20-21 Visual texture, 149, 150 Visual weight, 165 Vogel, Susan, 29 Vogue cover (Benito), 405, 405 Voulkos, Peter Pyramid of the Amphora, 342-343, 343 Untitled, 342, 342 X-Neck, 342, 343 Voussoirs, 368 W Walker, Kara, Insurrection! (Our Tools Were Rudimentary, Yet We Pressed On), 322, 322 Wall, Jeff, A Sudden Gust of Wind, 298-299, 299 Wall, Nassau, A (Homer), 260-261, 260 Wall Drawing No. 681 C (LeWitt), 82-83, 82, 83 Wall Hanging (Albers), 351, 351 Wall painting, fresco, 244-250 Warhol, Andy, 518 Marilyn Monroe, 239, 239 Race Riot, 16, 16 San Francisco Silverspot, 239, 239 Warner Brothers (movie company), 287, 288 War of the Worlds (Wells), 288 Warp, 350 Warrior Vase, The, Mycenaean, 430, 430 Wash (Ukeles), 390 Wash and brush, 211–212 Watched by the Spirit of the Dead (Manao Tupapau) (Gauguin), 223, 223 Watercolor, 260-262 Waterlillies, Morning: Willows (Monet), 154, 154, 155 Watkins, C. E., Arbutus Menziesii Pursh, 20, 20 Wayne, John, 288 Wayne, June, 232, 234-235, 234, 235 Knockout, 234-235, 235 Stellar Roil, Stellar Winds 5, 234, 234

Wind Veil, Stellar Winds 3, 234, 235 Weaving, 350

Webb, Philip, The Red House, 396, 397 Weber, Bruce, 528-529

31

Wedding Dance, The (Brueghel the Elder), 103.103 Wedgwood, Josiah Apotheosis of Homer Vase, 335, 335 Portland Vase, 336, 336 Queen's Ware kitchen ware, 335-336, 335 We Flew Over the Bridge: The Memoirs of Faith (Ringgold), 352 Weft, 350 Wegman, William Deodorant, 291 Rage and Depression, 291, 291 WEIGHING ... and WANTING (Kentridge), 212-213, 213 Weight actual, 165 visual, 165 Wells, H. G., 288 Wells, Orson, in Citizen Kane, 288, 288 Wet-plate collodion, 277 Whaam! (Lichtenstein), 518-519, 519 Whisper, the Waves, the Wind (Lacy), 71, 71 Whistler, James McNeill, 500 Nocturne in Black and Gold, the Falling Rocket, 501, 501 White Chapel, Karnak, Thebes (Senwosret I), 301, 301 Wildflowers (Wright), 400, 400 Wild Goose Pagoda, Tang dynasty, 456-457, 457 Willem de Kooning (Rivers), 202-203, 203 Wilson, Fred, 345 Drip Drop Plop, 346, 346 Mining the Museum, 349, 349 Nicholas Carroll estate inventory, 348, 348 Wilson, Ted, 126 Wind Veil, Stellar Winds 3 (Wayne), 234, 235 Winters, Terry, Color and Information, 111-112, 111 Wizard of Oz, The, 288, 288 Wodiczko, Krzysztof, Homeless Vehicle in New York City, 70, 70, 418 Woman and Bicycle (de Kooning), 517, 517 Woman Holding a Balance (Vermeer), 165-166, 165, 167 Woman with Stiletto (Death of Marat) (Picasso), 179, 179 Women artists Abakanowicz, Magdalena, 353-354, 353 Abramovíc, Marina, 329, 329, 332, 332 Albers, Anni, 351, 351 Ali, Laylah, 184-185, 185 Allora, Jennifer, 529, 529 Antin, Eleanor, 322-323, 323, 333, 333 Applebroog, Ida, 168, 169, 170 Baca, Judith F., 180–181, 180, 181, 265, 265 Bourke-White, Margaret, 282-283, 282 Buchanan, Beverly, 206-207, 206, 207 Cameron, Julia Margaret, 277, 277 Campbell, Nancy, 232 Carracci, Annibale, 481, 481 Cassatt, Mary, 119, 119, 122, 122, 123, 204, 205, 219, 219, 230, 230

Chicago, Judy, 24-26, 25, 523-524, 523 Connell, Clyde, 318-319, 319 de Kooning, Elaine, 232, 33, 236 Delaunay-Terk, Sonia, 142-143, 143 Dickson, Jane, 230-231, 231 Duncan, Theresa, 214, 211 Durrer, Käti, 416-417, 417 Eames, Ray, 414, 414 Ewing, Susan, 356, 357 Flanagan, Mary, 112, 112 Frankenthaler, Helen, 264, 264 Fusco, Coco, 68, 68 Gentileschi, Artemisia, 124, 124, 172, 241, 241, 272 Graves, Nancy, 167, 167, 315, 315, 316 Grosman, Tatyana, 232, 236, 237 Hadid, Zaha, 528, 528 Hamilton, Ann, 359, 359 Hepworth, Barbara, 97-98, 97 Hesse, Eva, 319, 320-321, 320, 321 Höch, Hannah, 268-269, 268, 269 Holt, Nancy, 325, 325 Horn, Roni, 158-160, 158-159 Hubbard, Teresa, 160-161, 160 Kahlo, Frida, 523, 523 Kauffmann, Angelica, 487, 487 King, Marcia Gygli, 107-108, 107 Kollwitz, Käthe, 200, 201, 229, 229, 255, 269 Kozloff, Joyce, 340, 341, 523 Kruger, Barbara, 524-525, 524 Labowitz, Leslie, 71 Lacy, Suzanne, 58, 71, 71, 523 Lin, Maya Ying, 62-63, 62 Liu, Hung, 86-89, 87, 88, 89 Martinez, María Montoya, 337, 337 McCoy, Karen, 326, 327 Mendieta, Ana, 24, 25 Morisot, Berthe, 500, 500 Morris, Jane, 398-399 Morris, May, 399, 399 Murray, Elizabeth, 188, 188 O'Keeffe, Georgia, 200, 201, 516, 516 Passlof, Pat, 256, 256, 260 Pettway, Jessie T., 351-352, 351 Reid, Laurie, 261-262, 261 Riley, Bridget, 154-155, 155 Ringgold, Faith, 14, 15, 352-353, 352 Robert, Jean, 416-417, 417 Rothenberg, Susan, 255, 255 Schapiro, Miriam, 152, 152, 340, 523 Sherman, Cindy, 524, 524 Sikander, Shahzia, 526, 526, 528 Simpson, Lorna, 20-21, 21, 22-23, 22, 23, 237, 318 Sirani, Elisabetta, 208, 208 Smith, Jaune Quick-to-See, 74-75, 75, 520-521, 520 Solodkin, Judith, 235 Steir, Pat, 77-79, 78, 79, 121, 121, 153 Truitt, Anne, 525, 525 Ukeles, Mierle Laderman, 390-391, 390 Vallayer-Coster, Anna, 171, 171 Vigée-Lebrun, Marie-Louise-Elisabeth, 486, 486 Walker, Kara, 322, 322 Wayne, June, 232, 234-235, 234, 235 Woodman, Betty, 339-340, 340 Zittel, Andrea, 417-419, 418, 419 Women's Guild of Art, 399

Women's work, 151-152 Wood, as a medium, 357-358 Woodcuts, 217-221, 217-221 Wood engraving, 222-223, 222, 223 Wood frame construction, 374, 374 Woodman, Betty, 339 Floral Vase and Shadow, 340, 340 Woodpecker, The (Morris and Co.), 397, 397 Woof, 350 Works of Geoffrey Chaucer Newly Augmented (Morris and Burne-Jones), 398, 398 Works Progress Administration (WPA), Federal Art Project, 516 World Flag Ant Farm, The (Yanagi), 14-15, 15, 297 World Trade Center, plans for Ground Zero, 392-394, 392, 393, 394 Worshippers and deities, Abu Temple, Sumerian, 424, 424 Wright, Frank Lloyd Fallingwater, Kaufmann House, Pennsylvania, 378-379, 378, 379 Prairie House, 377 Robie House, 377, 377 Table lamp, 400, 401 Wildflowers, 400, 400 Wright, Russel, American Modern dinnerware, 413, 413 Wu Chen, The Central Mountain, 6-7, 6-7 Wu Ti, 439 Wyeth, Andrew, Braids, 251, 251 Х X-Neck (Voulkos), 342, 343 Y Yanagi, Yukinori, World Flag Ant Farm, The, 14-15, 15, 297 Yellow Flowers on Rock (Goldsworthy), 74,74 Yin and yang, 6-7 Yin Hong, Hundreds of Birds Admiring the Peacocks, 470, 470 Yoritomo, Minamoto no, 458, 458 You can buy bootleg whiskey for twentyfive cents a quart (Lawrence), 262, 263

Young Mother, Daughter, and Son (Cassatt), 204, 205 Youth Drawing (Pollaiuolo (?)), 192, 192 Yuan dynasty, 469, 469

Ζ

Zeeg (Graves), 167, 167 Zen Buddhism, 471 Zeus, or Poseidon, 92, 92 Zeuxis, 241, 243 Zhou dynasty, 439, 439 Zhu Yuanzhang, 469-470 Ziggurat at Ur, Sumerian, 363, 363, 424-425 Zittel, Andrea, 417 A-Z Escape Vehicles, 418, 418 A-Z Management & Maintenance Unit, 418, 418 A-Z Time Tunnel: Time to Read Every Book I Ever Wanted to Read, 419, 419 Zola, Emile, 58, 498

A WORKSHEET COMPANION TO PAINTING, DRAWING, AND PRINTMAKING

Artist:					
Location	:				
Medium	: 🗖 oil	acrylic	🗅 tempera	☐ fresco	□ watercolor
	mixed media	a 🖵 electronic	media		
	D pencil	charcoal	pastel	🗅 ink	□ other:
	woodcut	engraving	etching	🗅 lithograp	ph
	silkscreen	other:			
Support:	🖵 canvas	□ wood	🛛 paper	🗅 wall	□ other:
What is	the subject m a	tter of the wo	ork?		
	religious	🗅 mythologia	al	🛛 portrai	it ם still life
	Iandscape	☐ history	🗅 daily life (genre)	
	nonrepresen	tational			
 Consid 	der the work's tit	e.			
 Does t 	he title help you	interpret what	you see?		
 Can yo 	ou imagine differ	ent treatments	of the same	subject matte	er that would change the wa
	ad the work?				
 If the v 	work is nonrepre	sentational, wh	nat feelings do	oes it evoke?	(

k

Consider the formal elements of the work and how they relate to its subject matter.

- · How is line employed in the work?
- Does it seem to regulate or order the composition?
- Does it seem to fragment the work?
- Is it consistent with traditional laws of perspective or does it violate them?
- What is the relation of shape to space in the work?
- How do light and dark function in the work? Is there a great deal of tonal contrast, or is it held to a minimum?
- What is the predominant color scheme of the work? Are complementary or analogous colors employed?
- What other elements seem important? Is your attention drawn to the work's texture? Does time seem an important factor in your experience of the work?

What principles of design are used to organize composition?

- Is there significant use of visual rhythm and repetition of elements?
- Is the composition balanced? Symmetrically? Asymmetrically?
- Do the work's various elements seem proportional, and how does the question of scale affect your perception?
- Does the composition seem unified or not?

A

Has the artist's choice of **medium** played a role in the presentation of the various elements and their organization or design?

- Are effects achieved that are realizable only in this particular medium?
- If more than one medium is involved, what is their relation?

What is the meaning of the work? What is its content, as opposed to its subject matter?

- What are the artist's intentions? How do these intentions manifest themselves in the composition? Are there other feelings or attitudes that the composition seems to evoke, and what specific elements or design choices account for those feelings?
- Are there symbolic meanings in the work?
- Does the work seem to have personal meaning to the artist-that is, is it biographical?
- Is the work a political or social commentary?
- Is there some larger philosophical, historical, or social context that informs the work?
- · Finally, what does the work mean to you?

A WORKSHEET COMPANION TO SCULPTURE AND INSTALLATION

X

Artist:				
Title:				
Date:	Dimension	6:		
Location:				
Process: 🛛 casting	modeling	assemblage		
Type: 🛛 relief	☐ free-standing	earthwork	installation	
Material: 🛛 stone	🗅 metal 🔷 clay	🛛 wood	D plaster	
mixed media	electronic media	other:		
What is the subject mat	ter of the work?			
religious	mythological	portrait	heroic	
the environme	ent	nonrepresentational		
 Consider the work's title 	·.			
• Does the title help you i	nterpret what you see?			
Can you imagine differe	nt treatments of the sam	e subject matter tha	at would change the	
you read the work?				
 If the human figure is its 	s subject matter, how is t	he figure treated?		
 If the work is nonrepres 	entational, what feelings	does it evoke?		
		. *		

Consider the formal elements of the work and how they relate to its subject matter.

- How is line employed in the work?
- Does line seem to regulate or order the composition?
- Does it seem to fragment the work?
- What is the relation of the work to the space it occupies?
- What is its relation to the viewer?
- Does the work move, or require you to move?
- Does light play a role in the compostion?
- Does color play a role in the work?
- Is your attention drawn to the work's texture?
- Does time seem to be an important factor in your experience of the work?

What principles of design are used to organize composition?

- Is there significant use of visual rhythm and repetition of elements?
- Is the composition balanced? Symmetrically? Asymmetrically?
- Do the work's various elements seem proportional, and how does the question of scale affect your perception?
- Does the composition seem unified or not? How do the parts relate to the whole?

Has the artist's choice of **medium** played a role in the presentation of the various elements and their organization or design?

- Are effects achieved that are realizable only in this particular medium?
- If more than one medium is involved, what is their relation?

What is the meaning of the work? What is its content, as opposed to its subject matter?

- What are the artist's intentions? How do these intentions manifest themselves in the composition? Are there other feelings or attitudes that the composition seems to evoke, and what specific elements or design choices account for those feelings?
- Are there symbolic meanings in the work?
- Does the work seem to have personal meaning to the artist-that is, is it biographical?
- Is the work a political or social commentary?
- Is there some larger philosophical, historical, or social context that informs the work?
- · Finally, what does the work mean to you?

k

A WORKSHEET COMPANION TO ARCHITECTURE

Ł

::					·
build	ling:				
r Cliei	nt:				
constr	uction:				
:					
ons/Si	ize:				
g D p	ost and lint	el 🖵 rounded	arch	pointed arch	🗅 dome
🗅 tr	russ	wood fra	ame	steel and rein	forced concrete
s 🗆 s	tone	🛛 wood	🗅 cast iron	steel	concrete
o 🛛	ther:				
the p	ourpose of	the building	?		
🗆 re	eligious	🗅 civic	residentia	al 🗆 c	ommercial
🗋 a	rts and ente	ertainment	L transport	ation 🗆 e	ducation
n does	s the buildi	ng serve?			
			luence its desi	an?	
	-			-	se?
1065 1	ne bunung				56:
	build r Clie constr cons/S g l p l tr l s l o the r l a n does toes t	building: r Client: construction: cons/Size: g g post and lint g truss g stone g other: the purpose of g religious g arts and enter h does the building	building:	building:	 post and lintel i rounded arch i pointed arch truss i wood frame i steel and rein stone i wood i cast iron i steel other: the purpose of the building? religious i civic i residential i c arts and entertainment i transportation i e

Consider the building's **use of ornament and decoration**. Which of the following does it employ?

	🛛 t	he classical orders		Doric col	umns		Ionian colui	mns
		Corinthian columns		🗅 entablatu	ıre		pediment	cornice
	 e	engaged columns		moldings	6		arcade or c	olonnade
	🛛 p	olatform		towers			decorative	portal or doors
		other ornamentation	– des	scribe:				
No.								
		n an						
Describ	e the	e building's facade	elevat	tion — that	is, the vert	ical d	esign of its	s front.
Describ	e the	e building's facade	elevat	tion — that	is, the vert	ical d	esign of its	s front.
Describ		e building's facade		tion — that	is, the vert	ical d	lesign of its	s front.
Describ				tion — that	is, the vert	ical d	esign of its	s front.

k

- Does color play a role in the building's design?
- Is your attention drawn to the texture of the building's materials?

What principles of design inform the architectural scheme?

- Is there significant use of visual rhythm and repetition of elements?
- Does the building's façade seem balanced? Symmetrically? Asymmetrically?
- Do the building's various elements seem proportional, and how does the question of its scale affect your relation to it?
- How do the building's parts relate to the whole?
- · How does the building's exterior relate to its interior?
- What is the relation of the building to the site it occupies?

What is the **importance** of the building? Does it possess **meaning** beyond its purely functional purpose?

- What are the architect's intentions? How do these intentions manifest themselves in the building?
- Are there symbolic elements in the building's design?
- Are there political or social aspects to the building?
- Is there some larger philosophical, historical, or social context that informs the work?
- Finally, what does the work mean to you?

X

SINGLE PC LICENSE AGREEMENT AND LIMITED WARRANTY

READ THIS LICENSE CAREFULLY BEFORE OPENING THIS PACKAGE. BY OPENING THIS PACKAGE, YOU ARE AGREEING TO THE TERMS AND CONDITIONS OF THIS LICENSE. IF YOU DO NOT AGREE, DO NOT OPEN THE PACKAGE. PROMPTLY RETURN THE UNOPENED PACKAGE AND ALL ACCOMPANYING ITEMS TO THE PLACE YOU OBTAINED THEM.

1. GRANT OF LICENSE and OWNERSHIP: The enclosed computer programs <<and data>> ("Software") are licensed, not sold, to you by Pearson Education, Inc. publishing as Pearson Prentice Hall ("We" or the "Company") and in consideration of your purchase or adoption of the accompanying Company textbooks and/or other materials, and your agreement to these terms. We reserve any rights not granted to you. You own only the disk(s) but we and/or our licensors own the Software itself. This license allows you to use and display your copy of the Software on a single computer (i.e., with a single CPU) at a single location for academic use only, so long as you comply with the terms of this Agreement. You may make one copy for back up, or transfer your copy to another CPU, provided that the Software is usable on only one computer.

2. RESTRICTIONS: You may not transfer or distribute the Software or documentation to anyone else. Except for backup, you may not copy the documentation or the Software. You may not network the Software or otherwise use it on more than one computer or computer terminal at the same time. You may not reverse engineer, disassemble, decompile, modify, adapt, translate, or create derivative works based on the Software or the Documentation. You may be held legally responsible for any copying or copyright infringement that is caused by your failure to abide by the terms of these restrictions.

3. TERMINATION: This license is effective until terminated. This license will terminate automatically without notice from the Company if you fail to comply with any provisions or limitations of this license. Upon termination, you shall destroy the Documentation and all copies of the Software. All provisions of this Agreement as to limitation and disclaimer of warranties, limitation of liability, remedies or damages, and our ownership rights shall survive termination.

4. LIMITED WARRANTY AND DISCLAIMER OF WARRANTY: Company warrants that for a period of 60 days from the date you purchase this SOFTWARE (or purchase or adopt the accompanying textbook), the Software, when properly installed and used in accordance with the Documentation, will operate in substantial conformity with the description of the Software set forth in the Documentation, and that for a period of 30 days the disk(s) on which the Software is delivered shall be free from defects in materials and workmanship under normal use. The Company does not warrant that the Software will meet your requirements or that the operation of the Software will be uninterrupted or error-free. Your only remedy and the Company's only obligation under these limited warranties is, at the Company's option, return of the disk for a refund of any amounts paid for it by you or replacement of the disk. THIS LIMITED WARRANTY IS THE ONLY WARRANTY PROVIDED BY THE COMPANY AND ITS LICENSORS, AND THE COMPANY AND ITS LICENSORS DISCLAIM ALL OTHER WARRANTIES, EXPRESS OR IMPLIED, INCLUDING WITHOUT LIMITATION, THE IMPLIED WARRANTIES OF MERCHANTABILITY AND FITNESS FOR A PARTICULAR PURPOSE. THE COMPANY DOES NOT WARRANT, GUARANTEE OR MAKE ANY REP-RESENTATION REGARDING THE ACCURACY, RELIABILITY, CURRENTNESS, USE, OR RESULTS OF USE, OF THE SOFTWARE.

5. LIMITATION OF REMEDIES AND DAMAGES: IN NO EVENT, SHALL THE COMPANY OR ITS EMPLOYEES, AGENTS, LICENSORS, OR CONTRACTORS BE LIABLE FOR ANY INCIDENTAL, INDIRECT, SPECIAL, OR CONSE-QUENTIAL DAMAGES ARISING OUT OF OR IN CONNECTION WITH THIS LICENSE OR THE SOFTWARE, INCLUD-ING FOR LOSS OF USE, LOSS OF DATA, LOSS OF INCOME OR PROFIT, OR OTHER LOSSES, SUSTAINED AS A RESULT OF INJURY TO ANY PERSON, OR LOSS OF OR DAMAGE TO PROPERTY, OR CLAIMS OF THIRD PARTIES, EVEN IF THE COMPANY OR AN AUTHORIZED REPRESENTATIVE OF THE COMPANY HAS BEEN ADVISED OF THE POSSIBILITY OF SUCH DAMAGES. IN NO EVENT SHALL THE LIABILITY OF THE COMPANY FOR DAMAGES WITH RESPECT TO THE SOFTWARE EXCEED THE AMOUNTS ACTUALLY PAID BY YOU, IF ANY, FOR THE SOFTWARE OR THE ACCOMPANYING TEXTBOOK. BECAUSE SOME JURISDICTIONS DO NOT ALLOW THE LIMITATION OF LIA-BILITY IN CERTAIN CIRCUMSTANCES, THE ABOVE LIMITATIONS MAY NOT ALWAYS APPLY TO YOU.

6. GENERAL: THIS AGREEMENT SHALL BE CONSTRUED IN ACCORDANCE WITH THE LAWS OF THE UNITED STATES OF AMERICA AND THE STATE OF NEW YORK, APPLICABLE TO CONTRACTS MADE IN NEW YORK, EXCLUDING THE STATE'S LAWS AND POLICIES ON CONFLICTS OF LAW, AND SHALL BENEFIT THE COMPANY, ITS AFFILIATES AND ASSIGNEES. THIS AGREEMENT IS THE COMPLETE AND EXCLUSIVE STATEMENT OF THE AGREEMENT BETWEEN YOU AND THE COMPANY AND SUPERSEDES ALL PROPOSALS OR PRIOR AGREEMENTS, ORAL, OR WRITTEN, AND ANY OTHER COMMUNICATIONS BETWEEN YOU AND THE COMPANY OR ANY REPRESENTATIVE OF THE COMPANY RELATING TO THE SUBJECT MATTER OF THIS AGREEMENT. If you are a U.S. Government user, this Software is licensed with "restricted rights" as set forth in subparagraphs (a)-(d) of the Commuter Software clause at DFARS 252.227-7013, and similar clauses, as applicable.

Should you have any questions concerning this agreement or if you wish to contact the Company for any reason, please contact in writing: Legal Department, Prentice Hall, 1 Lake Street, Upper Saddle River, NJ 07450 or call Pearson Education Product Support at 1-800-677-6337.